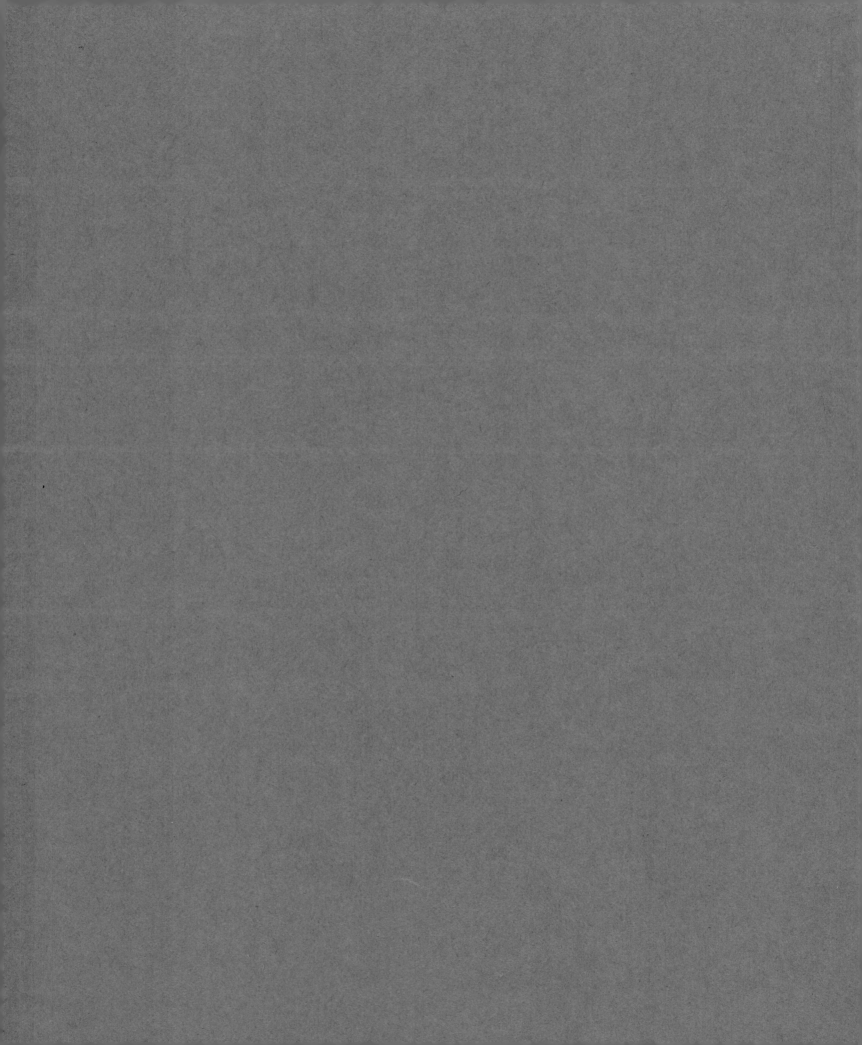

The Ontario Collection

The Ontario Collection

FERN BAYER

PUBLISHED FOR
THE ONTARIO HERITAGE FOUNDATION
BY FITZHENRY & WHITESIDE

The Ontario Collection

by Fern Bayer

© Ontario Heritage Foundation 1984

Published by Fitzhenry & Whiteside,
195 Allstate Parkway, Markham, Ontario L3R 4T8

Production coordination: Ian Gillen
Design: Sandra Meland/Word & Image
Editing: Olive Koyama
Colour separations and litho prep: Graphitech, Inc.
Typesetting: Colborne & Cox Phototypesetting; Jay Tee Graphics
Printing and binding: The Bryant Press Limited

Printed and bound in Canada

PHOTOGRAPHY

Illustrations are photographed by Thomas Moore Photography Inc., with the following exceptions:

Applied Photography 81 (t.), 90, 168 (l.); Archives of Ontario 24 (r.), 43, 149 (b.); James A. Chambers 160; City of Toronto Archives 148; City of Toronto Archives, James Collection 157; Courtesy Art Gallery of Ontario 10, 16, 22, 23, 60 (l.), 92; Courtesy Haydn Davies 290; Courtesy Douglas R. Kennedy, M.P.P. Mississauga South 170; Courtesy Ludwig Kosche, Canadian War Museum/National Museum of Man/National Museums of Canada 152 (l.); Courtesy David MacDonald 169, 171; Courtesy Megginch Castle, Scotland 153 (r.); Courtesy Trudy Niezen 49; Henry Feather 293; Andrew McKim 268 (t.l.), 271 (l.); David Nasby 308 (b.); Metropolitan Toronto Library 41, 45, 51, 56 (r.), 149 (t.), 154 (t.r.); J. Ross Robertson Collection, Metropolitan Toronto Library 147; Ontario Department of Public Works 277, 280, 281, 282, 283, 284, 334 (r.); Ontario Legislative Library 12; National Gallery of Canada 125; Public Archives Canada 164 (t.l.), 165 (l.); Sandra Russell 155; George Symons, Guernsey 164 (b.l.); Toronto Star 154 (b.r.); Toronto General Hospital 168 (r.); Woodstock Art Gallery 61;

Canadian Cataloguing in Publication Data

Bayer, Fern
 The Ontario collection

Bibliography: p.
Includes index.
ISBN 0-88902-979-2

1. Ontario Collection – Catalogs. 2. Art – Ontario – Catalogs.
3. Art, Modern – Ontario – Catalogs. I. Title.

N5208.5.058B39 1984 708.11'3 C84-099627-6

Contents

ONTARIO

OFFICE OF
THE LIEUTENANT GOVERNOR
QUEEN'S PARK, TORONTO

It is my honour, as Lieutenant Governor of Ontario, to inhabit both historic and artistic quarters in the Legislative Building of Queen's Park. Surrounded as I am by the architecture and art of this Province, I can truly say that the entire building, and the Lieutenant Governor's suite in particular, reflects the evolving tastes and traditions of Ontarians, and is a beautiful testimony to the energy and foresight of those who have gone before us.

This catalogue of over 1,100 works of the Government of Ontario Art Collection is an historically significant undertaking. Its existence ensures succeeding generations a rewarding entry into the fullness of their cultural heritage. Here, the past is readily perceived, and merges with the present to become a source of inspiration for the future.

I commend the Ontario Heritage Foundation and the Ministry of Government Services on the publication of this beautiful book, especially in this Bicentennial year.

John Aird
Lieutenant Governor

*T*he Ontario Collection is about people as well as art, and so is the story of the collection's first one hundred and twenty-nine years. People have built this fine collection with affection and expertise. Artists in Ontario and abroad have painted and sculpted our social, political and physical landscapes; and countless Ontario residents and visitors have admired the results of these creative labours over the years.

Those who have been privileged to serve as Members of the Legislative Assembly at Queen's Park have often acquired a special affinity for that part of the collection displayed in the Legislature. The stern gaze from portraits of the great leaders of the past is a daily reminder to politicians and officials alike to make the most of their public calling.

Ontario's history, as portrayed in these works of art, is neither dull nor placid. Among the opportunities of our Bicentennial celebration has been the discovery of its rich colours and textures. This publication is intended to illuminate the personages, artifacts and official measures concerning our cultural heritage which were pursued much earlier and more vigorously than many of us had thought. The book's theme relates to the ongoing rediscovery of historic works collected under various official auspices between 1855 and 1914, together with later works acquired through accession programs still currently in effect. As well as Ontario Heritage Foundation accessions, these latter include official portraits and art-in-architecture commissions. The Honourable George Ashe, who as Minister of Government Services oversees both the collection's curatorial unit and the contemporary art-in-architecture program, has been constant in his support for this publication. The Honourable Susan Fish, Minister of Citizenship and Culture, is likewise a source of guidance and strength through her responsibility to the Legislature for the Foundation and other government activities for heritage and the arts.

The Ontario Heritage Foundation is a Crown Agency formed in 1968. Reconstituted under The Ontario Heritage Act of 1974, the Foundation is today the province's lead agency in the field of heritage preservation. A range of granting programs and trusteeship responsibilities are directed toward artistic heritage, archaeology, architectural conservation, history, and natural heritage protection. Part of this mandate is fulfilled through the Foundation's role as official recipient of gifts and bequests to The Crown in right of Ontario (including real estate and cultural property of demonstrable heritage significance).

Works of fine art entrusted to the Foundation are usually loaned to public institutions such as the Royal Ontario Museum, the Art Gallery of Ontario, and many others throughout the province. While these institutions may also accept donations directly, there are two special public collections which rely absolutely on the Foundation for new accessions by gift and bequest – our own Firestone Art Collection, based in Ottawa, and the Ontario Collection.

This fundamentally cooperative role between the Foundation and Ontario Collection has evolved in recent years following the latter's curatorial revival beginning in 1978. The publication of this book is a product of our partnership in the interest of heritage awareness and education. The Ontario Heritage Foundation is pleased indeed to acknowledge the accomplishments of Miss Fern Bayer, not least of which is authorship of this book's narrative and the coordination of its catalogue entries, which may now be shared with the people and friends of Ontario for greater appreciation of their art collection.

In conclusion may I thank once again the hundreds of Ontario men and women who have given their treasures to the Ontario Heritage Foundation for the enjoyment of the people of Ontario.

October 1984

John White
Chairman
Ontario Heritage Foundation

*I*n undertaking a project as massive as this catalogue, no single individual is solely responsible. Quite simply, this book has been a collective effort, and it is a tribute as well to the foresight and vision of a number of remarkable individuals who over the years have understood the importance of outlining the role of the provincial government in the aesthetic development of Ontario society. Of the many deserving credit, Mr. John White, Chairman, and the Board of Directors of the Ontario Heritage Foundation, stand apart. At an important juncture in the history of this project, they ensured that the catalogue would become a reality.

Indeed, the Heritage Foundation has made the catalogue its special Bicentennial project, and John Court, in his capacity as Executive Secretary, Heritage Trust for the Foundation and the Ministry of Citizenship and Culture, has been invaluable to the project. In fact, his excellent advice and guidance enabled us to realize this publication. Mr. Bill Kettlewell, a distinguished member of the Foundation's Board of Directors, has freely given both his encouragement and his talented artist's eye to the visual presentation of this book.

While the Ontario Heritage Foundation contributed to the catalogue's publication, the Ministry of Government Services during the past seven years has generously supported all those who have worked on the project. Within the Ministry, however, no one has helped and encouraged this project more than R. J. Brockington, Chief of Interior Design, who originally hired me in 1977 to make a list of the government's art holdings. I remain grateful to him for this opportunity. During those early years, Dara Dastur, Director of the Design Services Branch of the Ministry of Government Services and J. C. Thatcher, my first Deputy Minister, played similarly key roles. To my current Deputy Minister, Glenn R. Thompson and Barbara Myers, Director, Communications Branch, my sincere thanks.

The Ontario Collection is inherently "political" in its composition. Indeed much of it consists of portraits of the province's leading political figures, and even more saliently, much of the collection was acquired through the impetus of political figures. I am grateful to the Members of the Legislature who, over the years, have enthusiastically supported the collection's "rediscovery." From the beginning of the project, former Speaker of the Legislature, John E. Stokes (M.P.P. Lake Nipigon) and R. J. Fleming, Director of Administration of the Legislative Assembly, have understood the importance of keeping that portion of the collection in the Legislative Building in pristine condition. Along with my present Minister, the Honourable George Ashe, who has always given his unqualified support, I would like to thank his predecessors, Douglas J. Wiseman (M.P.P. Lanark) and Margaret Scrivener (M.P.P. St. David), who started the art recovery program. Similarly supportive have been the Honourable Bette Stephenson, M.D., Minister of Education and the Honourable Tom Wells, Minister of Intergovernmental Affairs.

My greatest pleasure at this time is to be able at last to express in writing, my appreciation to all those who have worked on the compilation of this catalogue. I would especially like to thank Robert Stacey, who undertook a major portion of the research over the years and uncovered much invaluable information. To the team who worked to the wire, preparing the manuscript and illustrations, I owe my heartfelt gratitude. Marilyn Burnett and Mary McLennon, as professional colleagues, provided essential art historical skills and insight into both the catalogue and the collection itself and prepared most of the catalogue entries for publication. I am indebted to the many people who have helped us in the office over the past year, but special thanks must go as well to Carole Ann Wilneff, whose organizational skills kept the project moving on schedule. Sandra Russell, who tracked down many of our illustrations, Ben Freedman and Teresa Menezes who entered most of the initial documentation into the word processor, also deserve special mention.

The people involved in the initial phases of the

cataloguing project were: Susan Nasgaard, Jane Douglas, Sarah Bendell, Kent Burles, Wendy Cooper, Marilyn Crowe, Leann Henry, Ingrid Jenkner, Corea Ladner, Judith Margles, Lynne Millar, Teresa Naylor and Pamela Smith. Thanks also to Margaret Bickle who typed and re-typed hundreds of records when cataloguing began.

Colleagues at various other institutions were most helpful in providing research data and suggestions. In this regard I must mention Donald Webster of the Canadiana Department, Royal Ontario Museum; Jim Burant of the Picture Division, Public Archives Canada; Robert Hubbard, former cultural advisor at Rideau Hall, Ottawa; William Ormsby, Art Murdoch, John Mezaks and Ken MacPherson of the Ontario Archives; Conrad Graham, McCord Museum, Montreal; Dorothy Farr and Frances Smith, Agnes Etherington Art Centre, Kingston; Edith Firth, formerly head of the Canadian History Department, Metropolitan Toronto Library; Stephen Otto, Ontario Bicentennial Office; Judith Saunders, former curator of the Market Gallery, Toronto; Charles Hill of the National Gallery of Canada, Ottawa; Carol Lowrey, Larry Pfaff and Randall Speller, Librarians, Art Gallery of Ontario; George Swinton, Carleton University; the Hon. Mrs. Jean Cherry Drummond, eleventh of Megginch; Rosemary San Juan, University of Guelph; Professor F. Beaudouin, Kunsthistorische Musea, Antwerp; Mary Fitz-Gibbon, Royal Ontario Museum; Ludwig Kosche, Librarian, Canadian War Museum, Ottawa; and particularly, the dedicated research staff at the Legislative Library.

Others who have provided continued support in the realization of this catalogue are Joe Silver and Robin Farr of the Ministry of Government Services; Ray McNeil, Office of the Premier; Terry Russell, Deputy Minister of Revenue; Larry Kent, Ministry of Intergovernmental Affairs; John Parsons and Lorne Ste. Croix of the Ministry of Citizenship and Culture.

During the seven years in which this catalogue has been in gestation, numerous people have been my inspiration and patient tutors on the lore of Ontario history and the Legislative Buildings. The late Eric Arthur; L. R. (Duke) MacTavish, Q.C., former Senior Legislative Counsel; Eric Silk, Q.C., former Commissioner of the Ontario Provincial Police; and my former professor, W. McAllister Johnson, of the University of Toronto who gave me the "tools" to do the job, for which I am forever grateful.

A special thanks to the staff of the Legislative Services Branch at Queen's Park, most especially Frank Raposo, along with Roger Muller, George Taylor, John Walls and their colleagues, who over the years have patiently moved, hung and rehung paintings from one end of Queen's Park to another.

Being essentially a visual person, I am grateful to the editors of my manuscript, notably Beverley Beetham-Endersby, whose good humour during the writing and re-writing of the chapters was unending; Olive Koyama, who had the difficult task of editing the catalogue entries as well as the manuscript; and most particularly, Robert Collison, who guided my visual thinking into a written form. Special thanks, too, to Ian Gillen, Fitzhenry & Whiteside, and designer Sandi Meland for their endless patience.

Finally, on a personal note, I would like to thank friends who've encouraged me over the years to persevere with my "dream" when my energies occasionally flagged. In particular, special thanks to three people: "M.W.", who has always counselled wisely; Victor H., who inspired me at a despondent moment; and my mother, Gloria, who took me to my first art exhibition when I was five and passed on to me, intact, her love of art.

F.B.
October 1984

*T*he publication describes 1,103 works by 450 artists, works acquired by the Government of Ontario through purchase, donation, or commission from the 1850s to December 31, 1983. Commissioned proposals for "art-in-architecture" projects incomplete as of that date are not included. The book is divided into four chapters reflecting the different collecting periods or styles of work and an historical account precedes the catalogue entries in each chapter.

Chapter 1 lists early copies, casts, and original works of art, most purchased by Egerton Ryerson. Copies and casts are arranged alphabetically by title, followed by the name of the original master, his school and dates. Details of the copyist are given in the notes following each entry. Original works are arranged alphabetically by artist.

Catalogue entries in *Chapters 2* and *4* are arranged alphabetically by artist, including any societal affiliations, place and date of birth and death and, where indicated, biographical information on the artist. Works by each artist are then listed in chronological order, beginning with undated works. Notes on historical significance or references to preparatory drawings or sketches are included where deemed relevant.

The portrait catalogue (*Chapter 3*) is arranged alphabetically by sitter, followed by a brief biographical sketch. When a sitter is represented by more than one portrait, entries are presented in chronological order, beginning with undated works. Details of the work, where appropriate, appear in the notes following the entry. Data on the portrait artists are given at the end of the chapter.

In each catalogue entry, title is followed by date; medium; dimensions in centimetres and inches, height preceding width, followed (in the case of sculpture) by depth. Unless otherwise specified, dimensions are those of the mat or frame opening (sight). For original prints the size of both the impression (image) and mat opening (sight) are given.

Signatures and dates are recorded exactly as in the artist's hand. An oblique (/) in the transcription indicates a new line. [] indicates interpolation by the author.

A provenance line, including the method and date of acquisition, is followed by the accession number.

Due to lack of documentation on the collection over the years, information is provided only where authoritative records exist.

Abbreviations:	a.p.	artist's proof
	u.l.	upper left
	l.l.	lower left
	u.r.	upper right
	l.r.	lower right
	u.c.	upper centre
	l.c.	lower centre
	c.r.	centre right
	c.l.	centre left
	t. to b.	top to bottom
	act.	active
	fl.	flourished

(Facing Page) Théophile Hamel,*The Rev. Dr. Adolphus Egerton Ryerson, c.* 1850-51

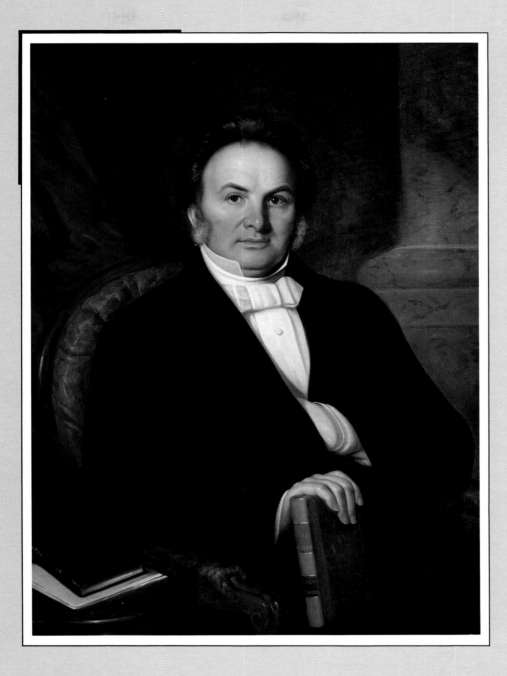

Introduction

*W*hen Paul Arthur suggested, in 1978, that I write a chapter on the Government of Ontario's art collection for the seminal book on the history of the province's legislative buildings, *From Front Street to Queen's Park* — written by his father, architectural historian Eric Arthur — I never imagined that I would find myself playing the role of art sleuth. But that is exactly what has come about. Nor did I think that my researches would uncover a story of "lost treasures." But that, too, is what happened.

Quite unexpectedly, I discovered that in 1912, the year the government closed the picture galleries in the Educational Museum founded at the Toronto Normal School by Egerton Ryerson in the mid-nineteenth century, a remarkable collection of paintings and casts was lost in a seeming fit of official absentmindedness. In trying to trace the whereabouts of these works of art, I found myself piecing together the story of the acquisition of a truly extraordinary collection and its subsequent "abandonment." The "Ontario Collection," as it was called in its heyday, is remarkable in purely art historical terms for it included many fine paintings. But the collection is also an intriguing testament to the evolution of Ontario society in the nineteenth century. From being merely a backwater of the British Empire when the collection began in the 1850s, by 1914 when the government ended its art-acquisition program, Ontario had become pivotal in the formation of a dynamic Canadian nation. When the Ontario Collection began, it reflected the tastes of a ruling class who looked to Europe for ideas about art and aesthetics. But by 1914 the government of Ontario was busily collecting "contemporary" Canadian art. Quite simply, the Ontario Collection symbolizes the transformation of Ontario from an essentially colonial to an essentially national culture.

The fact that the Ontario government possessed a collection of extraordinary art objects did not in itself come as a surprise. Nor, sadly, did the fact that the "collection" had endured years of neglect come as a great shock. I had been hired early in 1977 by the Ministry of Government Services for the sole purpose of cataloguing the artworks under the Ministry's jurisdiction at the Queen's Park complex of buildings. The last catalogue of the collection had been completed in 1905. Although in the 1950s and 1960s a couple of fitful attempts had been made to update it, the government in fact had really little knowledge of the exact scope and value of its holdings. Curiously, it was the government's auditors who were the initial impetus for my being hired as a three-month temporary employee. They were eager to bring the government's art holdings under their "asset inventory control system," and I occasionally wonder, in retrospect, if the auditors, or the government itself, would have hired me if they had had any idea of the magnitude of the project ahead. Indeed, I often wonder if I would have taken the job if I had known. Whatever the answer to such speculative questions, the fact is that the government did persevere, and this catalogue is a testament to their faith, as well to that of the Ontario Heritage Foundation, which gave its generous support at critical phases in the life of this project.

Looking back, clues to the task ahead were plainly visible. I recall the first day on the job. My boss took me to the art-storage room in the Ferguson Block at Queen's Park. Scattered about the room were paintings in an appalling condition. Some had no stretchers; others had mildewed; most had holes in the canvas. But despite their pitiable state, it was clear that they constituted a collection of uncommon interest. Just how uncommon would soon become apparent.

Of course, for years much of the province's art collection has been on permanent display in the Legislative Building. For, in essence, Ontario possesses two quite distinct collections. There is

the "political" collection of portraits which has been carefully preserved at Queen's Park. And then there are the remnants of the old Ontario Collection, acquired in the nineteenth century.

When it is not functioning as the seat of the provincial government, the Legislative Building is rather like an art museum devoted to Ontario's political history. In the park itself is a collection of late-Victorian public sculpture of considerable artistic merit. *Queen Victoria, Sir John A. Macdonald, the Hon. George Brown* and sundry nineteenth-century Ontario premiers stoically preside over the political manoeuvres going on within Queen's Park. And inside the building, on the walls of the Grand Staircase and the state reception rooms, are glorious portraits of the province's statesmen — its governors, premiers, speakers, and famous historical figures like Sir Isaac Brock and Laura Secord. Today these portraits of our political "grandees" form the heart of the collection. Unlike other parts of the Ontario Collection, they've had a relatively uneventful life since they were first commissioned and then installed at either Queen's Park or, while Ontario still possessed one, at Government House, the official residence of the Lieutenant Governor. (Chorley Park, the last Government House, was closed in 1937 by Premier Mitchell Hepburn as a budget-cutting gesture.)

Originally, the motivation behind the commissioning of the lieutenant governors' portraits was the construction of a new Government House at King and Simcoe Streets, just after Confederation. Similarly, the collection of premiers' and speakers' portraits was inaugurated by the completion in 1893 of the new Legislature at Queen's Park. In both cases, the province's paramount political buildings had miles of empty walls to fill.

But if the political portraits have a high "profile" at Queen's Park, any intrepid visitor to the building will discover paintings with an even more colourful history. It may be a George Reid, or an Arthur Lismer, or a monumental canvas that evokes Titian or Domenichino. These are what remain of the fabled Ontario

Collection, and the story of their acquisition, abandonment, and subsequent rediscovery constitutes a curious chapter in the cultural life of this province. Like refugees from a war zone, they've "come home" only after years of indignity and deportation; many others, sadly, are still "reported missing."

The collection itself was acquired in three distinct phases. In the 1850s and 1860s, Egerton Ryerson, the Chief Superintendant of Education for Canada West, as Ontario was then called, travelled to Europe and brought back a treasure trove of copies and casts of great European masterpieces for the Educational Museum he established at the old Toronto Normal School.

Between 1873 and 1914, various Ontario governments purchased a selection of paintings from the annual exhibitions of the Ontario Society of Artists. This was probably the first occasion that any Canadian government systematically patronized "contemporary" Canadian art and, although the art was acquired under various premiers, George Ross, first as Minister of Education under Premiers Mowat and Hardy, then as premier himself, deserves special credit. As well, in the 1880s, Ross commissioned a series of portrait busts of "Distinguished Canadians" for the Educational Museum to complement Ryerson's busts of heroic figures from British and classical Greek and Roman history. These two collections — the Ryerson copies and the O.S.A. selections — along with the political portraits comprise the initial elements of the Ontario Collection.

In subsequent years, other paintings were added. The artist George Agnew Reid, a former principal of the Ontario College of Art, donated 459 of his own works to the province with the proviso that they be circulated to the province's secondary schools. In the 1920s, C.W. Jefferys was commissioned by the Department of Education to illustrate a series of Canadian history texts. His watercolours and drawings were eventually hung in the Minister's boardroom. Not until the Robarts government instituted its "art-in-architecture" policy in the 1960s — that is, the commissioning of new works of art for the

public areas of new government buildings — were there any significant additions to the government's holdings.

On first glance, it would appear that this collection developed rather randomly, without any guiding principles. And in part, that is true. But from another perspective, its very evolution symbolizes the maturing of Ontario from the mid-nineteenth century to the present day.

If any single individual is the "father" of the collection, it is Egerton Ryerson. This remarkable man is today widely regarded as the founder of mass popular education in Ontario, and probably the greatest public servant the province has ever produced. But Ryerson, through his collection, played a significant role in the development of an aesthetic life in the province as well. To Ryerson, these two ideals — education for the masses and the cultivation of the arts — were complementary. Consequently, Ryerson played an indispensable role in helping to incorporate the whole tradition of Western art into a burgeoning Ontario community. And as such, he can be construed as *one* of the progenitors of such great institutions as the National Gallery of Canada and the Art Gallery of Ontario. He helped create the cultural environment in which such institutions could flourish. That he can be credited with such a distinction is even more intriguing in the context of the art he bought. The Ryerson purchases, simply put, are "fakes" — copies of European Old Masters.

At the time, it was the fashion in Europe to hang such copies in public galleries. Even by the late nineteenth century, only the very rich and privileged could afford to make the "Grand Tour" to view the masterpieces of the Renaissance and classical antiquity. If Europe's increasingly well-educated middle classes could not travel to Italy, museums such as London's Victoria and Albert brought Italy to the people. At the V & A, for example, there are galleries full of plaster-cast copies of famous sculptures like Michelangelo's *David*. Today, of course, outfitting public museums with such "fakes" would be considered folly. But in the 1850s it was considered an indispensable tool of public education. Ryerson's rather "eccentric" collection was a part of this tradition, and in a raw society like Ontario in the 1850s it helped both to "civilize" the frontier and to keep recent immigrants in touch with their Old World values and traditions.

The contrast between Ryerson's collecting and that inaugurated three decades later by Premiers Hardy, Ross, and Whitney reflects the growing self-assurance of late nineteenth-century Ontario. For all his accomplishments, Ryerson, like such Upper Canadian worthies as Chief Justice Sir John Beverley Robinson who was his accomplice in buying the copies, was essentially a "colonial" man. Ryerson and Robinson looked to Europe as their cultural home. But by Premier Ross' time, Canada was manifesting a new sense of national identity, and for the first time Canadians were actively beginning to cultivate their own artistic garden.

In encouraging native-born talent, Ontario, more than any other province, showed the way. During the period when the government actively collected Ontario art at the turn of the century, various factions vied for the government's attention and its monies. Even this squabbling had its merits, for it helped to breed an art community, with all its passions and rivalries, from which all great art develops. And although many of these early artists — William Blatchly, Robert F. Gagen — never became household names in Canadian art history, others like the Group of Seven's J.E.H. MacDonald and Arthur Lismer did. Perhaps not surprisingly, the Group emerged in the generation following the early painters of the Ontario Society of Artists.

Almost inevitably, the government's art acquisition program fell victim to the fiscal austerity demanded by the war effort in 1914. And the ignominious fate that befell the Ontario Collection was almost as much a matter of happenstance as its original amassing. From its inception, the bulk of the collection had been housed in the Educational Museum at the Toronto Normal School. In 1912, when the government closed down the museum's picture

galleries, the paintings were distributed among the six Normal Schools in various parts of the province. Each of them received an average of fifteen "contemporary" paintings and twenty-two of the Old Master copies. Once these art-works left Toronto, they no longer came under any centralized curatorial supervision. As a consequence, in the ensuing years they "disappeared."

When I began to track down these works in 1978, lamentably I could find only a handful. Of the approximately 250 Ryerson and O.S.A. paintings distributed around the province, only 27 remain in the government's collection. When the six Normal Schools were closed in the 1970s, some of the paintings were transferred to institutions like the Art Gallery of Peterborough; two Old Masters and ten contemporary works were donated to Nipissing University College when the old Normal School in North Bay was closed. Unfortunately, most were lost, and the ones I uncovered in my sleuthing were often in a decrepit condition. Several Old Master copies were found in the boiler room of the old

Toronto Teachers' College on Pape Avenue and another turned up, torn, under plate glass, in the attic of a London, Ontario, school.

Of the Reid donation of 1944, dispersed in 1946, only 20 of the 250 paintings that were sent out to the secondary schools have been located. And of Ryerson's magnificent collection of busts — the majority of which had been given to the Ontario College of Art — only four remain, along with one "amputated" hand. (It's reputed that in the 1960s someone destroyed them, thinking they were useless. Such was the conceit of 1960s abstract art.)

Today, all the recovered paintings and plaster casts have been carefully restored, cleaned, and catalogued. Over the last few years many of them have refound places of honour at Queen's Park, an enduring testament to the artistic and cultural development of the province. If any single cultural phenomenon symbolizes the growth of our society from colony to nation, it is quite possibly the rediscovered Ontario Collection.

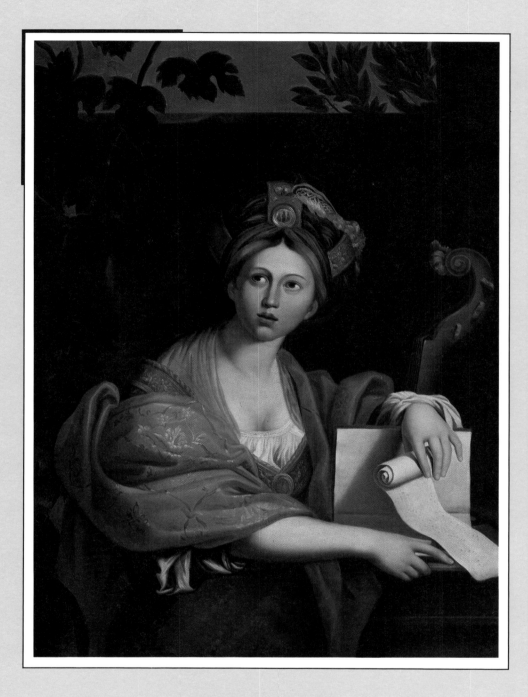

"Objects of Taste"

RYERSON'S COLLECTION

*B*uilding a collection of fine art for the province was largely the responsibility of the Chief Superintendent of Education for Canada West, the Rev. Dr. Egerton Ryerson. He set the stage for nearly one hundred and thirty years of collecting by the provincial government. During his "Grand Tour" of Europe in 1855 and 1856 Ryerson acquired, much on his own initiative, "with a view to encourage the Fine Arts in Upper Canada," 236 copies of paintings by the Old Masters of the great schools of painting and nearly 1,000 plaster casts of antique statuary, portrait busts of famous men from all ages, and casts of architectural ornamental decorations.[1] These "objects of taste" were displayed prominently in the province's first public museum and Canada's first fine art museum, the Educational Museum of Upper Canada, opened in 1857 in the Normal School at St. James Square in Toronto.

The Ryerson acquisitions provided the natural foundation for the development of a provincial collection of "contemporary" works of art by Ontario artists which the government began amassing in 1875. It was also influential in the development of a vast commissioning program of official portraiture of leading Canadian statesmen and heroes of the province which began in the 1880s.

That a collection of provincial significance should begin with an assortment of copies of Old Master paintings and plaster casts of antique sculpture now seems odd and eccentric, if not downright silly. However, in the nineteenth century such collections were considered *de rigueur*. Wealthy private collectors acquired copies and casts and almost every European nation had a public collection of such items, seen as a necessary adjunct to the system of popular education which was sweeping developed countries as a result of the Industrial Revolution.

Cast collections began to appear about 1800 in Europe and the United States. As early as 1805

the Pennsylvania Academy of Fine Arts boasted a large collection. Another was established in 1816 in New York at the American Academy of Fine Arts, and another at the Boston Atheneum before 1828. These were intended to aid in art education, primarily in drawing classes, although they were also put on public exhibition. Perhaps the most significant collection could be found in the Ecole des Beaux Arts in Paris, France; however, the most famous was that built by the director of the Berlin Museum in 1836. This assortment consisted of thousands of casts of antique statuary. The British government established, in 1841, a large collection for the School of Design in London. This was later taken to the Museum of Manufactures which opened in Marlborough House in 1852, and was eventually placed in the new Educational Museum of South Kensington, which opened in 1857. This museum, later re-named the Victoria and Albert Museum, ultimately housed the largest and most famous European collection of copies and casts. The original collections acquired in the 1850s, having fallen out of favour in the early twentieth century, have been revived, and the casts are again on public exhibit in the "Cast Courts" — an impressive reminder of this peculiar collecting mania of the nineteenth century.

The British Museum and the Musée du Louvre are known to have had artisans, or "moulders," on staff readily available to fill orders for copies from their collections for both private individuals and institutions. Copies and casts were also enormously popular exhibits at the great tourist attractions of the nineteenth century. The Exhibition of All Nations, held at the Crystal Palace in Hyde Park, London, in 1851 set the stage for this type of exhibit. The Palace, re-located to Sydenham in 1854, was for several decades a popular attraction. The Universal Exhibitions held in Paris in 1855 and 1867 had vast numbers of copies and casts on display as well.

Generally, these specimens of surrogate

culture served two purposes: to educate, and to amuse a willing public. To the Chief Super-intendent of Education for Canada West, the end was as intriguing as the means, as he was to say in retrospect:

> . . . in Canada, where there are no such Art Treasures, where we are so remote from them, where there is no private wealth available to procure them to any great extent, a collection (however limited) of copies of those paintings and statuary, which are most attractive and instructive in European Museums, and with which the trained teachers of our public schools may become familiar, and which will be accessible to the public, cannot fail to be a means of social improvement, as well as a source of enjoyment, to numbers in all parts of Upper Canada.[2]

It seems at once fitting and ironic that Ryerson would become the self-appointed pur-veyor of borrowed tradition and in so doing create the groundwork for an indigenous tradi-tion of support for the visual arts in this province. He took it upon himself, without prior approval for his exorbitant spending, to travel abroad in quest of instructive materials in general with a grand altruistic vision; later he would be called upon to justify this first impor-tation of culture into Canada West.

When Ryerson set out on his educational tour in 1855 he had no intention of transforming it into the "Grand Tour" of a dilettante connois-seur, nor did he plan to return to Canada West with more than 200 paintings and nearly 1,000 casts of antique Greek and Roman statuary for the people of the province. However, once his imagination was captured by the notion of such a collection he set out, as he had done all his life, single-mindedly to accomplish his ends. Any judgement of the aesthetic value of these copies and casts made from the rather conve-nient perspective of hindsight must be tempered with admiration for the man who selected them.

Adolphus Egerton Ryerson was born on March 24, 1803, near the village of Vittoria in the Township of Charlotteville in what was then called the London District.[3] He was the son of United Empire Loyalists who had settled in Long Point Bay on the shores of Lake Erie, where Port Ryerse in Norfolk County still com-memorates the family's original name. Born of middle-income parents, Ryerson was able to attend the London District Grammar School, where he was particularly proficient in Latin and English. A born scholar with unbounded curio-sity, he continued his studies at the Gore District Grammar School in Hamilton.

Ryerson's family were members of the Anglican Church. However, in the wave of Wesleyan Methodism which swept Upper Canada from the 1790s on, and much to Ryerson's father's dismay, his wife and five of his sons converted to this evangelical denomination. Egerton Ryerson had his own "conversion" at the age of sixteen. By his twenty-second birthday he had begun his first career; he became a Methodist itinerant preacher, criss-crossing the province preaching sermon after sermon. For a time he was a missionary to the Ojibway Indians at the Credit River Settlement. Ultimately, Ryerson turned his gift for rhetoric to the earthly sphere and became a journalist.

In 1826 Egerton Ryerson found notoriety by attacking in print the Family Compact and one of its leading personages, the Rector of York, the Rev. John Strachan. In the May 1826 issue of *The Colonial Advocate* Ryerson attacked the Anglican claims to the Clergy Reserves — a sensitive issue throughout the years of turmoil in the province during the 1820s and 1830s — and leaped instantly to the forefront of political affairs. As proponent of the rights of Methodists and other non-conformist religious groups, Ryerson was elected the first editor of the newly founded Methodist newspaper, *The Christian Guardian*.

The newspaper focused vociferously on the issues of good government, education, and religion. Its great success was largely attribut-able to Ryerson's guidance. He served as its editor intermittently from 1829 to the 1840s, during which time he also founded the Methodist Book Concern, an adjunct to the newspaper, which later became The Ryerson Press.

Ryerson's prominence in the Methodist com-

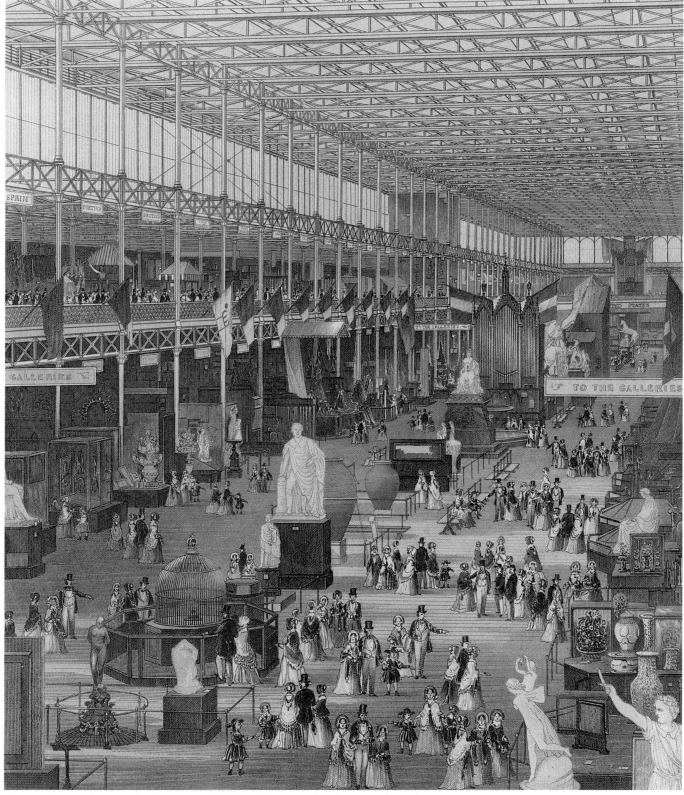

The Great Exhibition of All Nations, held at the Crystal Palace, Hyde Park, London, England, 1851

munity led him to be appointed chief negotiator for the colonial church of Upper Canada, which in the 1830s was separating from the American Wesleyan Church and aligning itself with the British counterpart. In this capacity he travelled to England to represent the Methodist alternative to the Anglican Upper Canada College, the Upper Canada Academy at Cobourg. The issuance of a Royal Charter for the school in 1837 and funding from both the imperial government and the British Methodist Church was largely the result of Ryerson's excellent lobbying abilities.

In 1841 Ryerson gave up his career as journalist and Methodist lobbyist to enter the field of education. When Upper Canada Academy was renamed and given university status, he became Victoria College's first principal. His tenure at the college was short; on October 14, 1844, he was called upon by Governor General Sir Charles Metcalfe to become Canada West's Assistant Superintendent of Common Schools. He was then forty-one years of age, of proven political wisdom and a superlative administrator. Although Ryerson has often been associated with the Reform movement, he was primarily a moderate. It has been suggested that he took advantage of the political situation of the time — the issue of patronage and the Governor General's insistence on making his own political appointments without consent of the Executive Council — to get himself an appointment within the administration. Since his early days in the political arena, Ryerson had had a large influence over the Methodist and moderate vote; he often used his considerable talents in this regard to sway politicians in order to accomplish his own ends as chief administrator of educational matters for the province. His title was changed to Chief Superintendent of Education in 1846 and he himself controlled all aspects of educational matters until his retirement in 1876, at which time the responsibilities for education were placed under the authority of the Executive Council and a Minister of Education was appointed.

Attributed to Samuel Gardner, *Sir Charles Theophilus Metcalfe, c.* 1847

Ryerson did not invent the educational system of Ontario, as is often claimed; he inherited it. The system had serious weaknesses and required a man of determination and doggedness (both traits characteristic of Ryerson's personality) to bring about change. Reporting directly to the Governor General of the Province of Canada through the Provincial Secretary, Ryerson drafted legislation which was then formally introduced into the House by the Attorney General for Canada West. Not surprisingly, the flexibility of the reporting procedure gave Ryerson the scope to effect significant change in educational policy, and the school system as we know it today is primarily the result of his efforts.

Ryerson's first major school act, passed in 1846, allowed for the establishment of a Normal School for teacher education. It is in relationship to this school that the art collection was to develop to its full maturity.

The Normal School for Upper Canada, Toronto, 1852

The Province's first Normal School was opened in Toronto on November 1, 1847, in rooms made available in Government House, the official residence of the Governor General, temporarily vacated as the itinerant legislature was then sitting in Montreal. This house, first called Elmsley House, had been the residence of the Chief Justice, the Hon. John Elmsley, from 1796 to 1802, and had been purchased by the government in 1814 after the province's first official residence had been blown up during the invasion of York by the American forces in 1813. It served as the vice-regal residence intermittently until after the time of the Union. However, its term as the province's Normal School was short-lived; the residence was required in 1849 by Lord Elgin, then Governor General, as the Legislature was moving back to Toronto after the burning of the Parliament Buildings in Montreal over the controversial *Rebellion Losses Act*. The Normal School was moved to Temperance Hall, which had been

built by Jesse Ketchum, the vice-president of the Temperance Reformation Society. The school remained in this building until the new Normal School for Upper Canada was officially opened at St. James Square, Toronto, on November 4, 1852.

Erected on a 7½ acre property purchased from the Hon. Peter McGill of Montreal, the new school was an impressive structure. The design competition had been awarded to the firm of Colonel Frederick Cumberland and Thomas Ridout. Its design was described as "Palladian in character" with an impressive façade and a tall tower, numerous classrooms, offices for the Education Department, a library, a book depository, a museum, and a school of art.[4]

The school of art never really materialized until 1876, the year of Ryerson's retirement from the Education Department. In fact, even though in 1855 the extensive art collection he acquired in Europe was sold to the legislators on the basis that it was an integral part of an art

school, he never seemed to have much interest in such a school. He even stated in 1857 that it was unlikely that "one such School will be required in the Country for some time to come."[5] What Ryerson was more interested in was his museum.

His original idea of a museum was that it "be as Canadian as possible," yet that it be based on the American trend towards museums of natural history, illustrating the resources and pursuits of the country and promoting "mechanical and agricultural improvements" to "encourage the study of different branches of Natural History."[6] This concept was not new in Canada; in 1833 Charles Fothergill, a Member of the Legislative Assembly of Upper Canada, had suggested that a "Lyceum of Natural History and the Fine Arts" be established for the town of York. Little became of Fothergill's proposal until Ryerson created his museum in the Normal School. Examples of natural history museums could be found elsewhere; in New Brunswick, Gesner's Museum, a private venture, opened in 1843 and is credited with being the ancestor of that province's museum today. McGill and Laval Universities had similar types of museums by the late 1850s. Not long after Ryerson established his museum, its collection could boast of a large number of specimens including some rather exotic samples of birds' eggs and nests and a wide variety of bizarre natural history specimens and geological samples. Also on view were modern inventions, samples of agricultural implements, and the latest examples of teaching apparatus, acquired by Ryerson at the Crystal Palace Exhibition while he was in Europe on his educational tour of 1851.

Concerned to make additions to his collections in the museum, Ryerson decided in 1855 to take advantage of the Universal Exhibition which was being held in Paris, France, that year from May until November. On view, apparently, would be all the latest teaching apparatus and manufacturing specimens from the developed nations. Funding for the trip was available. The School Act of 1850 (*An Act for the Better Establishment and Maintenance of Common Schools*

in Upper Canada) allocated an annual amount of £200 "for Plans and Publications for the improvement of School Architecture and Practical Science" and the School Act of 1853 (*An Act Supplementary to the Common Schools Act for Upper Canada of 1850*) similarly allocated £500 per annum "to purchase from time to time Books, Publications, Models, Objects, suitable for a Canadian Library and Museum. . . ." On June 1, 1855, Ryerson requested permission to travel from his superior, Governor General Sir Edmund Walker Head, through the Provincial Secretary, George-Etienne Cartier:

> I submit this application on both Personal and Public grounds. During the last ten years I have experienced, after a very long and severe mental affliction, alarming attacks in my head, followed by great pain and general prostration for two or three days. I have applied to several Physicians, and they all recommend relaxation from labours and change of scene by travelling. . . . I find that every journey I take (such as that to New Brunswick last Autumn, and that to Quebec a few weeks since) beneficial to me. . . . I think that a few months relaxation and travel will restore to me my former vigour and power of endurance.[7]

The "public" grounds cited were the availability of funds, which had been deposited in the bank, collecting interest, for two years.

Approval was rapidly granted, with the stipulation that a portion of the allocated funds be used towards his travelling expenses but not to those of his travelling companion, his nineteen-year-old daughter, Sophia.

The pair set off on July 4, 1855, from Boston on the Cunard steamship *Asia*. The crossing to Liverpool took eleven days. Upon arrival they headed immediately for London and from there to Paris, Brussels, Antwerp, Florence, and Rome, to return in ten months' time with a vast and impressive array of "objects of taste."

Ryerson's original intention of purchasing interesting samples of teaching apparatus and specimens for his museum had been supplanted by a mania for collecting objects of aesthetic value. Ryerson himself claims that this radical change in philosophy had been suggested or recommended to him in London one morning

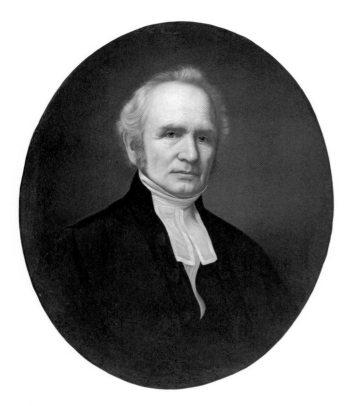

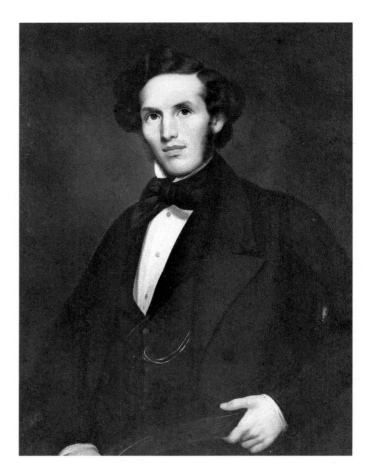

(*Left*) George T. Berthon, *Sir John Beverley Robinson, C.B., Bart.*

(*Right*) Théophile Hamel, *John George Hodgins, LL.B., LL.D.*, 1851

over breakfast with the Chief Justice of Upper Canada, Sir John Beverley Robinson, and Robinson's son-in-law, Captain John Henry Lefroy, an old friend of Ryerson's.[8]

What these two men recommended to Ryerson was that his efforts at collecting for the museum be extended to embrace "objects of taste" with a view to promoting some level of discernment in Canada; as they said, "taste is deplorably wanting in America universally."[9] The "objects of taste" to which they referred were the copies of paintings by the Old Masters and plaster casts of antique statuary that were to preoccupy Ryerson for the duration of his trip abroad.

Cautious and politically astute, as always, Ryerson set about to discuss the suggestion and muster support among the "conspicuous figures of the Canadian Administration" who were then summering in England and France: the former Governor General, the Earl of Elgin; the Hon. William MacNab, then President of the Legislative Council of the Province of Canada; Sir Francis Hincks, the former Premier of Canada West and recently appointed Governor General to the Windward Islands; the Hon. John Ross, then Speaker of the Legislative Council; and the Hon. Chief Justice Robinson. These powerful political players were in total agreement with the idea and recommended that Ryerson take the lead role in bringing culture to the rather backward colonial province of Canada West. The importation of European "objects of taste" was perceived to be essential; in a truly colonial fashion, it was taken for granted that a cultural tradition should be amassed from elsewhere. As Ryerson said:

From the introduction into our country of these new elements, of civilization and refinement, I anticipate the happiest results as in places in Europe where there is an order and propriety of conduct in the labouring classes, a gentleness and cheerfulness of manners that I have not observed among the same classes elsewhere. If all cannot read and speculate on abstract questions, all can see, and feel, and derive both pleasure and instruction from what the creations of Art present to the eye, the heart and to the imagination.[10]

With sanction in principle and a detailed letter from Captain Lefroy on the subject of how to develop such a collection, Ryerson set off on his quest for culture.

Ryerson's adventures in Europe are documented in a series of weekly letters to his Deputy Superintendent at the Education Department, John George Hodgins. As his collecting reached its zenith in the winter of 1856, one can sense Ryerson's growing excitement with the prospect of buying art for the nation and his vision of a national museum to be created from his purchases. These letters, unfortunately vigorously edited, were published by the faithful and devoted Hodgins in his monumental twenty-eight volume work, *Documentary*

History of Education in Upper Canada (Ontario).[11]

From this source and Ryerson's own *Account Book* which details his expenditures in city after city where purchases were made, the enthusiasm of the ten-month spree unfolds. Ryerson fairly consistently recorded the name of the art dealer or copyist from whom the work was acquired, its title, and details about the original artist and the public museum in which the original was located. Enthusiastic as he was, upon his return and only one year after the opening of the Educational Museum where the collection was on display, a detailed catalogue was published giving the same data provided in Ryerson's ledger.[12] Ryerson had become not only a connoisseur but also an art historian.

Ryerson admitted that he had very little knowledge of art matters, hardly surprising in a man whose career had evolved from Methodist preacher to journalist and then to educator and public servant. He revelled, however, in his new-found interest. He soon learned, on the advice of Captain Lefroy in particular, that the best plaster casts could be acquired in England or France while the copies of Old Master

Photograph of a page from the Account Book of the Chief Superintendent of Education

paintings would necessitate travel to Belgium and Italy, the latter being, of course, the major centre of Old Master painting. Copyists abounded in these places as well. So, systematically, the Chief Superintendent set out to build his collection. In London he visited all the "principal establishments of Antique and Modern statuary." These included the Crystal Palace at Sydenham where he eventually purchased a large number of casts,[13] the British Museum, the Museum of Manufactures at Marlborough House, and the Architectural Museum, from which he acquired an array of various architectural ornamental specimens with the help of Frederick Cumberland, architect of the Toronto Normal School, who was then vacationing in England.

In Paris he went to the Louvre and the Ecole des Beaux Arts; their "moulders" were particularly adept at making plaster casts, and Ryerson, always worried about the cost, found prices lowest in the French capital. While in Paris he still kept somewhat to his original intent by acquiring a minimal selection of modern machinery specimens, objects of natural history, and some examples of teaching apparatus from the wildly successful Universal Exhibition; however, his sights were clearly set on the importation of "objects of taste." By November 1, 1855, he had already acquired several hundred pieces of statuary, and a week later more than 250 portrait busts of ancient philosophers, leaders, and thinkers had been selected. In addition to these he acquired many large casts of antique statuary, all examples of the finest works of the period. Clearly, Ryerson developed a passion for portrait busts — more than 400 were finally selected. He wrote of these to Hodgins, outlining a plan for their display in the Toronto Normal School:

> I am afraid I am purchasing too much Statuary; but I gain much by purchasing so many, both in packing and prices. These show better in proportion to the cost, and are better for historical and literary purposes than any others. They will have to be placed on Shelves, or Brackets, around the Rooms, and on raised steps, one above the other, in the centre of the Room, lengthwise. The historical ones should, of course be arranged chronologically — the Greek and Roman separately, — and the Mythological in a Collection by themselves....[14]

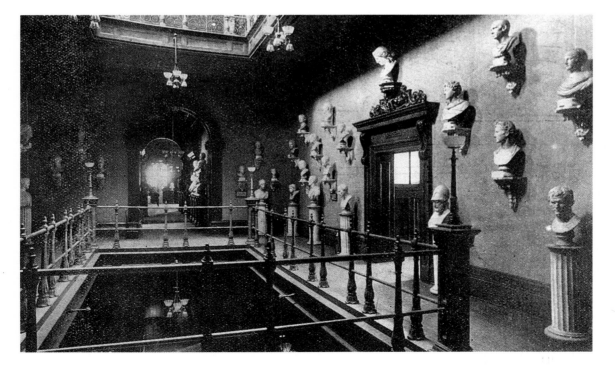

Photograph of the collection of plaster casts of "famous men from all ages," Educational Museum, Toronto Normal School

Of the hundreds of examples purchased by Ryerson in the autumn of 1855 only two portrait busts remain: those of the Roman censor, *Cato the Elder* and Emperor Marcus Aurelius' wife, *Empress Faustina II*, famous in classical literature for her reputed infidelities. One small statuette, in parian marble, also remains — the *Venus de Milo.* Ryerson must have become infatuated with the Venus — three casts of her were selected, two life-size and a portrait bust. Later photographs taken of the rooms in the Educational Museum convey some idea of how Ryerson had planned the display of his collection. No photographs have been located showing the copies of Old Masters, more than 200 of which he acquired on the continent after the close of the Universal Exhibition in Paris in November 1855.

Ryerson and Sophia then set out to buy paintings for the collection. In November he had written from Paris to Governor General Sir Edmund Walker Head of his intention to extend his trip in order to acquire copies. He needed an extra three months' leave to accomplish his aims, based on Robinson's and Lefroy's suggestions, as he so noted in the letter. He would not

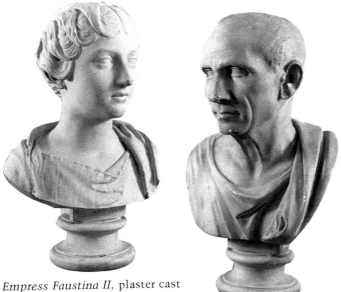

Empress Faustina II, plaster cast after an original Roman marble

Cato the Elder, plaster cast after an original Roman marble

receive an answer until a month later but by then he had already purchased 182 paintings, copies and originals, in Antwerp, a city Ryerson described as "The Athens of the Flemish School of Painting." The book that Ryerson used as his guide was the Bible of any nineteenth century art connoisseur, Franz Kugler's *Handbook of Painting.* When it was first published in 1842 it became an instant success and its four volumes were translated into English in the early 1850s. Governor General Head had edited Kugler's two volumes on the Northern Schools of painting. These volumes were to be Ryerson's guide throughout his visit to the northern countries. When in Italy he would rely on the subsequent two volumes on Italian painting edited by Sir Charles Eastlake.[15]

As Ryerson himself recounts, he found the *Handbook* to be indispensable. He would arrive in a city, read what was written of the great collections there, visit the museums, find the originals to which Kugler referred, and then go to copyists' *ateliers* either to order a copy or to acquire one from the artist's existing stock. He wrote from Antwerp during his three-week stay:

> . . . here a large number of Artists are constantly employed in copying these Paintings for sale. This is the best season for buying Paintings cheap here. Many Americans and others, who have visited the Paris Exhibition, have come here and bought Paintings. But the season was over some weeks ago, and there is not a prospect that the Paintings, newly copied, can be disposed of before next year, and the Artists will sell them about one-third cheaper than they had ready for sale, two, or three, months ago.[16]

From the 182 Antwerp purchases only a few copies after Old Masters have survived in the government's collection, including the *Pietà* copy after an original by the school of Quentin Massys. Ryerson did, however, purchase some significant original paintings in this Flemish city:

> Many that I have bought are affirmed to be Originals, and declared by Artists, and men of taste and integrity in Antwerp. But I bought them at the price of copies.[17]

Five originals survive in the collection today, among them the seventeenth-century painting of

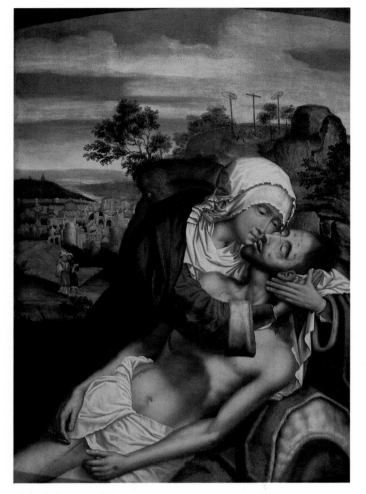

After follower of Quentin Massys, *Pietà, c.* 1855

Esther before Ahasuerus by Peeter Thys, a pupil of Sir Anthony van Dyck, and the small mid-nineteenth-century landscape by Jan Baptiste De Jonghe, *Landscape in the Neighbourhood of Brussels* of which Ryerson carefully annotated in his *Account Book* that the animals in the painting had been done by the well-known Flemish animal painter Eugène Verboeckhoven. Many other presumably significant works by such artists as Maarten and Cornelius de Vos are now lost.

From Antwerp, father and daughter set off for Munich, where they spent their Christmas holidays. Several copies were acquired there as well; however, the only one to remain is the copy after the Spanish artist Bartolomé Esteban Murillo's painting, *Children Counting Money.* Ryerson purchased five copies of works by Murillo while in Munich, all based on originals which were then, and are still today, part of the collection of the museum in Munich, the Alte Pinakothek. However, his major additions to the collection from this city were engravings. Several hundred were acquired from a dealer, including originals by the early seventeenth-century French master Callot as well as works by Adrian van Ostade and "85 Sketches drawn and engraved by Rembrandt, (original) A.D. 1606-1665." All of these have now disappeared, presumably lost when the print collection was decentralized in 1880 and when several hundred were transferred to the Agricultural College in Guelph.

By now Ryerson's collection was beginning to take shape in his own mind. As he wrote to Provincial Secretary George-Etienne Cartier in January 1856 from Munich, the collection was to consist of several art historical differentiations and to be classed along these lines for maximum educational benefit. The categories were common in Europe and America in the nineteenth century. The first category included works of a scriptural nature and theme which were "calculated to touch the heart . . . please the eye, and gratify the taste." The second comprised historical subjects and events, serving to illustrate "costumes of different ages and Countries, important events of History and celebrated Characters." The genre pictures were to represent "Common life in its everyday relations . . . illustrating the Costumes, Habits, Usages of the People of Holland, Belgium and Germany." The other categories were landscapes and marine scenes, reflective "of Animal Nature in action, at rest, alive and dead." The last category was that of still life, serving to show fruit and flowers, "in undecaying beauty and brilliance . . . sometimes animated with examples of Insect life."[18] The best examples of the first two categories were to be found in Italy.

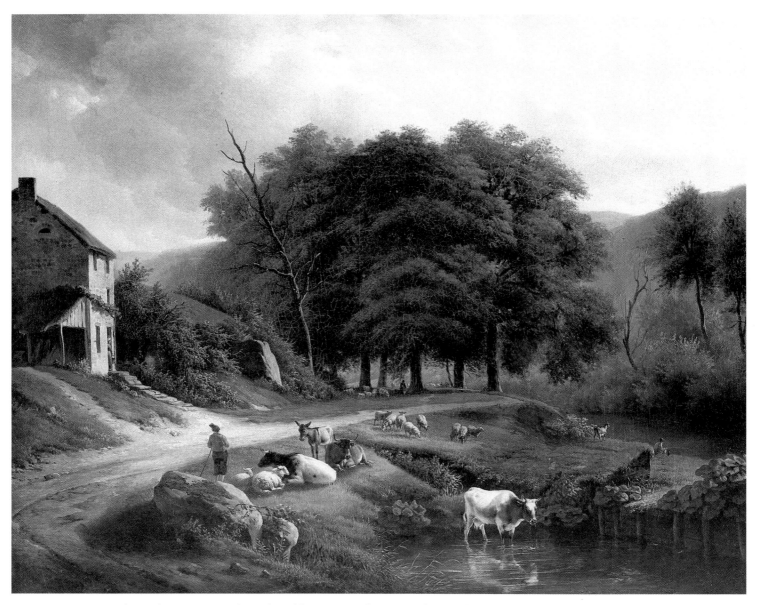

Jan Baptiste De Jonghe and Eugène Joseph Verboeckhoven, *Landscape in the Neighbourhood of Brussels, c.* 1850

Sophia and her father crossed the Alps to Verona and from there travelled to Mantua and Bologna before arriving in Florence by the middle of January 1856. No purchases were made at this time; Ryerson decided to visit the museums, palazzi, churches, and artists' studios before acquiring any copies. At this time they met the most famous of all nineteenth-century copyists, the French-Canadian painter Antoine-Sebastien Falardeau. A Knight of Tuscany, Chevalier Falardeau's life was a romantic one. He married a niece of the Pope, owned a huge Florentine Renaissance palace, and entertained royalty from throughout Europe, all of whom came to Florence to admire his copies of paintings of the great masters. When Ryerson

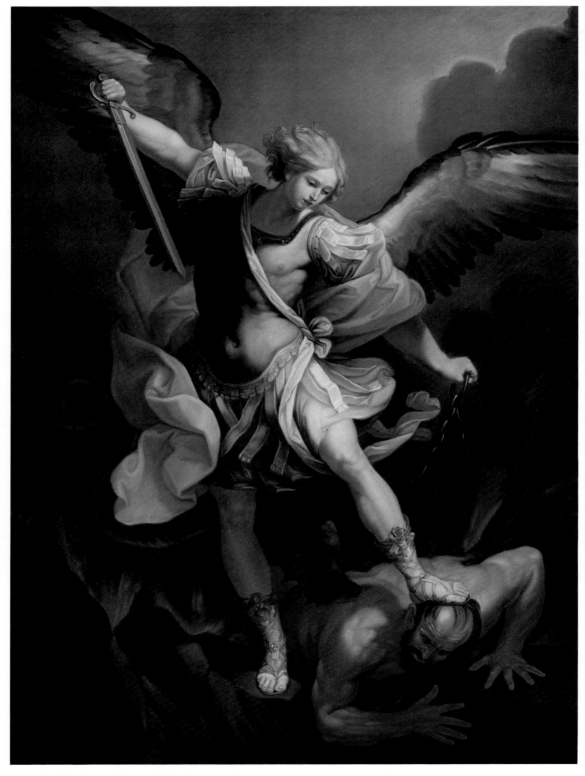

After Guido Reni, *Saint Michael the Archangel*, c. 1856

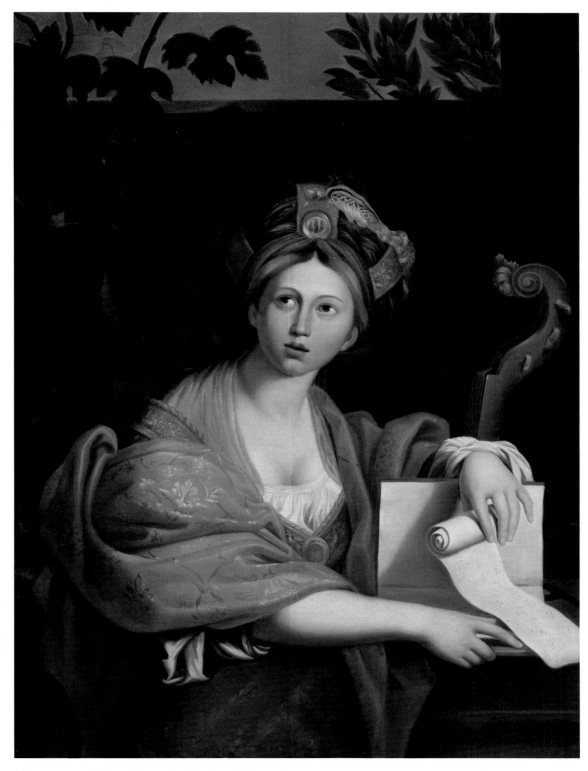

After Domenichino, *Cumaean Sibyl, c.* 1856

returned to Florence in February 1856, he acquired a significant number of Falardeau's celebrated copies.

Pressing on to Rome, the pair made a brief stop in Siena. Ryerson's quest in Italy was aided by the abundance of guidebooks available to the English traveller; the most widely used of these were John Murray's various guides to Tuscany and the Papal States.[19] Often Murray's *Guidebook* provided information on copyists and their addresses. Two artists are recorded by Murray for the benefit of the traveller in Rome: Giuseppe Mazzolini, from whom Ryerson purchased the painting of *St. George and the Dragon*, and Raimondo Campanile from whom four works have survived, *St. Michael the Archangel* after a painting by the Roman artist Guido Reni, and a series of three sibyls. In addition to these source books Ryerson had available to him letters of introduction to aristocrats, ambassadors, and other dignitaries, all of whom he maintains advised him in his choices. Ryerson was not, however, totally dependent on advice from "rank and taste;" he had an innate good eye. From the few paintings that remain, the superior quality of the copies selected is obvious, although later critics would ridicule many of his choices. Most of the significant extant copies were acquired in Florence, the majority being of originals in the Pitti Palace and the Uffizi, including copies after Andrea del Sarto's *Medici Holy Family*, Jacopo Palma il Vecchio's *Supper at Emmaus*, and Falardeau's copy of the celebrated *Conspiracy of Catiline*.

While Ryerson explored the lofty realm of aesthetics in Florence, things remained conspicuously earthbound at home where economics ruled. A letter to him from Governor General Head via Cartier expressed a change of heart, and he was advised that under no circumstances was he to go over budget. In previous correspondence Ryerson had alluded to the establishment of a provincial art collection, which he was well on the way to completing — now, it seemed, without authority. The Governor General stated that he found no problem in Ryerson's acquisitions at the Paris Universal

Exhibition of specimens of agricultural implements and examples of natural history, but that with regard to the "objects of taste," full sanction from the Legislature had not been given, and no funding had been allocated by the Assembly for any purchase. He was instructed to make no further purchases.[20] It was undoubtedly a dejected Ryerson who made his way home. He and Sophia left Florence in early March and travelled ten days back to Paris, through Northern Italy and Switzerland.

Elaborate arrangements had to be made regarding the transportation of the objects home. Particular care was taken by Ryerson's Parisian dealer, Henri Bossange & Fils, with the large and fragile plaster casts of statuary. Once the goods were crated and shipped to Le Havre for the cross-Atlantic transport, Ryerson and Sophia returned to London, to prepare for their journey home. Some last-minute purchases of large casts of antique statuary were made from Domenico Brucciani, who in the early 1860s would become the famous "moulder" of casts at the Museum at South Kensington.[21] Full-sized castings of the *Boy Extracting Thorn*, the *Apollo Belvedere*, the *Dying Gladiator*, and the *Laocoon* were acquired in London, probably from the Crystal Palace exhibition at Sydenham. All of these have since vanished.

Photograph of (*Above*) *Boy Extracting Thorn* (Capitoline Museum, Rome), (*Right*) *The Apollo Belvedere* (Vatican, Rome) and (*Left*) *The Dying Gladiator* (Capitoline Museum, Rome), from the guide book by Owen Jones, *The Statuary of the Crystal Palace, Sydenham, 1854*, used by Ryerson in making selections of plaster casts of antique statuary

The crossing was apparently uneventful; they arrived in early April, 1856, having been away ten months. In total, 236 paintings had been acquired, representing the works of 144 masters of the Italian, French, Dutch, Flemish, German, and Spanish schools. Nearly 1,000 plaster casts had been acquired including more than 100 examples of architectural details, along with several suits of armour, examples of ancient weapons and arms, and more than 200 items of agricultural implements and school apparatus. Ryerson had overspent his allocation by £3,500.

Ryerson's ideal of a national museum would never be fully realized. Once home, despite the support he had garnered in Europe from "conspicuous members of the Canadian administration," he was unable to muster much interest in his collection or his vision of a great showcase of culture for the province. Presumably the difficulties encountered were directly traceable to overexpenditure of budget and public funds. In fact, in 1857 John Langton, the first Auditor General, investigating the accounts of the Education Department, found

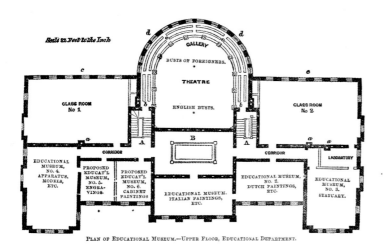

Plan of the galleries, upper floor, Educational Museum of Upper Canada, 1858, Toronto Normal School

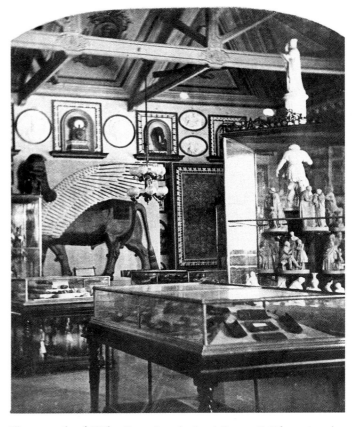

Photograph of "The Egyptian Artists' Room," Educational Museum, Toronto Normal School, c. 1880

that Ryerson had personally collected interest on public funds which had been held in his name in the bank. While this practice was evidently not uncommon at the time, Ryerson was nevertheless called before the Legislature's Public Accounts Committee to testify. Although he was found guilty and asked to repay the amount, a sympathetic administration awarded him sufficient back pay to cover the "loan."[22] Beset by administrative wrangling, Ryerson maintained his vision for a national museum, but he had to settle for a departmental museum in the Normal School.

The Educational Museum of Upper Canada opened in the Toronto Normal School with little fanfare in 1857. There was no official ceremony, no speeches or accolades for this colonist's vision of culture in a new land. From this time onward Ryerson's justification for his collecting mania would be that it was inspired by the Educational Museum and School of Art opened in South Kensington, London, in 1857.

Ryerson's museum was well attended and frequently praised. However, there were dissenting opinions. A reporter for the satirical magazine, *The Grumbler*, who visited the Museum in 1863 wrote:

Nothing could exceed the urbanity with which we were received by Dr. Ryerson (the Founder and Filler of the Gallery). . . . Many of the paintings here stored are good copies of celebrated works. . . . But then again, the Doctor has some how got into his hands, some of the most unhappy failures, pompous turgidities, and profane comicalities that ever kept the flies off the newly papered walls; so that we must fear that an ingenuous public might receive more harm than good from a general inspection. . . .[23]

Educational in intent, Ryerson's museum was a product of its time and its creator, who for one brief moment of his otherwise splendid career was swept away by a wild idea.

Ryerson never purchased another copy of an Old Master. Plaster casts were again acquired in 1857 when the Chief Superintendent returned to England for a short trip.[24] From the Crystal Palace in Sydenham he acquired casts of eight examples of "modern" English sculpture, 33

Greek portrait busts, 80 casts of Roman busts, and another 80 of English portrait busts.

Ten years later, in 1867, additional purchases were made for the Educational Museum, the last additions to a fascinating and eclectic collection. Unable to complete the intended purchases for the museum, Ryerson delegated his Deputy Superintendent, John George Hodgins, to proceed to England to make the necessary arrangements for the additions to the collection. Hodgins' major contributions to the collection in 1867 were plaster casts of Assyrian and Egyptian antiquities.[25] The British Museum was busily providing casts of the Near Eastern collection of Austen Layard's discoveries at Nineveh in Asia Minor, discovered in 1854, and Hodgins acquired ten large-scale replicas. In addition, select castings were made from the famous Arundel collection of ivories, and he also acquired several sets of the Great Seals of England, medallions of the kings and queens of England, and a myriad of portrait busts and plaster casts of statuary after modern and ancient artists. The portrait bust in plaster of British Prime Minister the Rt. Hon. Benjamin Disraeli, the only example to have survived from Hodgins' selection at the time of Confederation, probably dates from this period.

A special room was allocated in the Normal School to house the Near Eastern collection of casts. This "Egyptian Artists' Room" was to become one of the more popular exhibits in the museum. On reflection, Egerton Ryerson surveying his collection of "objects of taste" in 1867 must have thought it a considerable contribution toward improving the lives of the average citizens of the province. Here was displayed the natural adjunct to the system of popular education which he had worked so hard to achieve since his appointment in 1844.

Obviously the museum was only a small part of his career as the chief architect of the province's educational system. Nevertheless, it must have been a fascinating sideline and afforded him the opportunity to make numerous "junkets," as one somewhat acerbic critic of the time noted of Ryerson's career:

> It must be owned that he proved himself a most beneficent despot, and that in no other way, and perhaps by no other man then in Canada could the great edifice of our Public School System have been so successfully upreared. Never was public servant so munificently paid. Trip after trip to Europe was taken by this indefatigable holiday-maker at the public expense.[26]

Ryerson retired in 1876 at the age of seventy-three. That year he made his last trip to Europe — at his own expense — to research a book which he had always wanted to write, *The Loyalists of America and their Times.*[27] He died in Toronto of pneumonia on February 19, 1882, at the age of seventy-nine. A statue was erected in 1889 in his memory at the entrance to the Toronto Normal School which he had opened in 1852.

Ryerson's contributions to the encouragement of the fine arts in the province cannot be underestimated. The Educational Museum was for many years the only fine art collection of its nature available to the people and as one artist and art chronicler, Robert Ford Gagen, would say at the turn of the century in its defence, it had become:

> the fashion for those who set themselves up as Art connoisseurs to deride these copies, but it cannot be denied that to the untravelled, who had not seen any of the originals, they gave a better idea of an Old Master than any portrayal by description could do.[28]

Ryerson's museum encouraged an interest in the fine arts in the province by bringing to an essentially frontier society a tradition of western European art. Such institutions as the Royal Ontario Museum, the Art Gallery of Ontario, and the National Gallery of Canada owe their existence, in a curious way, to Ryerson's own vision of a public museum accessible to all the people. More directly, in the context of the government's support of the arts, his collection formed the basis for a formal acquisition policy which would develop from 1875 with the purchase of works from the annual exhibitions of the Ontario Society of Artists. Ryerson's collection at the Educational Museum "sowed the seeds of that aesthetic life"[29] in the province which ultimately would evolve into a truly Canadian art form.

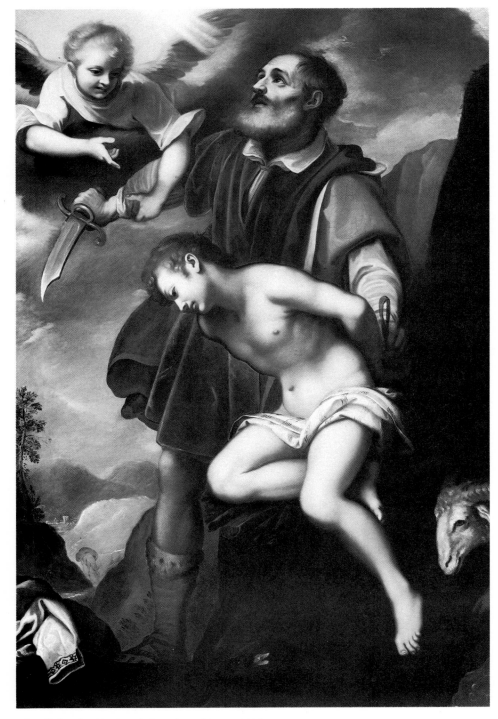

After Il Cigoli, *Abraham's Sacrifice of Isaac*, 1854

Copies and Casts

Abraham's Sacrifice of Isaac 1854
(after Il Cigoli, Italian, 1559-1613)
Oil on canvas, 159.1 x 108 cm/
62⁵/₈ x 42¹/₂"
Inscribed (verso): Petrini Fece 1854
Purchase, Florence, Italy, 1856.
MGS 622113

Ryerson's Account Book (p. 68), now in
the Archives of Ontario, records
payment on 27 February 1856 to the
copyist Alessandro Petrini for a painting
of "Abraham Sacrifice and Frame – C.
Allori." The 1858 Educational Museum
catalogue (p. 33) records the artist
copied as Alessandro Allori, and the
location of the original as the Uffizi,
Florence. The original, painted about
1604-1605, was formerly attributed to
Cristofano Allori, but modern scholars
attribute it to Ludovico Cardi, called Il
Cigoli, a student of Alessandro Allori
and teacher of Cristofano Allori. Il
Cigoli's original has always been part of
the collection of the Pitti Palace,
Florence.

The subject, from the Old Testament
(Genesis), shows how Abraham's faith is
tested when God orders him to sacrifice
his beloved son, Isaac. The depiction is
of the moment in which Abraham,
about to kill his son, is stopped by an
angel of the Lord. This work was on
loan to the Stratford Normal School
from 1912 and was returned to Queen's
Park in 1978.

L'Aurora
(after Guido Reni, Italian, 1575-1642)
Oil on canvas, 95.2 x 172.7 cm/
37¹/₂ x 68"
Purchase, Rome, Italy, 1856.
MGS 622032

Ryerson's Account Book (p. 75) records
payment on 23 February 1856 to copyist
or dealer Augusto Ratti.

Guido Reni's original ceiling fresco
was commissioned by Cardinal Scipione
Borghese between 1613 and 1614 to
decorate his Casino at the Palazzo di
Montecavallo (later re-named the
Rospigliosi-Pallavinci Palace) in Rome.

In classical mythology Aurora, the
goddess of the dawn, was one of the
daughters of the Titans. Traditional
iconography shows her guiding the

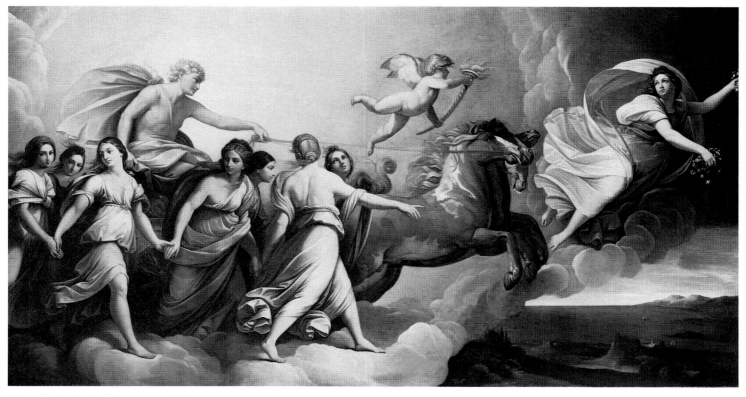

After Guido Reni, *L'Aurora*, c. 1856

chariot of the god Apollo (also called Phoebus), the sun, through the clouds.

La Bella

(after Jacopo Palma il Vecchio, Italian, c. 1480-1528)
Oil on canvas, 99.1 x 89.2 cm/
39 x 35⅛"
Purchase, Florence, Italy, 1856.
MGS 622047

Ryerson's Account Book records two payments for "La Bella — Tiziano." One was made on 27 February 1856 to the copyist or dealer Antonio Sasso (p. 73), and another (for which no date is given; presumably February 1856) to Agostino Gagliardi (p. 75). The 1858 Educational Museum catalogue (p. 32) lists only one work and gives the location of the original copied as the Uffizi, Florence, which is incorrect.

The attribution of the original by Ryerson to Titian is also erroneous; however, Jacopo Palma il Vecchio was greatly influenced by the work of that master and his career was spent mainly in Venice. The original by Palma was painted about 1520 to 1525. From the 17th to the early 20th century Palma's work was in the Sciarra Collection in Rome. Since 1959 it has been in the Thyssen Collection, Villa Favorita, Lugano, Switzerland.

Children Counting Money

(after Bartolomé Esteban Murillo, Spanish, 1617-1682)
Oil on canvas, 78.7 x 61 cm/31 x 24"
Purchase, Munich, Germany, 1856.
MGS 619793

Ryerson records in his Account Book (p. 66) purchase on 2 January 1856 from Henry Nimmer [?] of this painting. Nimmer [?] was in all likelihood a dealer rather than a copyist, for while in Munich Ryerson also purchased hundreds of engravings from him. Murillo's original, painted about 1670, was then in the Alte Pinakothek in Munich where it still forms part of the Murillo collection.

Murillo painted genre scenes like this throughout his life. As they sweetened the imagery of working-class children, they are often given a sociological interpretation. It is likely, however, that such subjects were merely a pretext to display his skill, evidenced here in the painting of still-life passages.

The Conspiracy of Catiline

(after Niccolo Cassana, Italian, 1659-1714)
Oil on canvas, 100.3 x 120.6 cm/
39½ x 47½"
Purchase, Florence, Italy, c. 1856.
MGS 623802

Ryerson's Account Book (p. 74) records payment on 10 May 1856 to the copyist Antoine-Sebastien Falardeau, for a "copy of the Conspiracy of Catiline by Salvator Rosa at the Pitti Palace with frame ⅔ size of original." The original from which this copy was painted was attributed to Salvator Rosa until 1937

After Bartolomé Murillo, *Children Counting Money, c.* 1855

when A. Iahn-Rusconi (*La R. Galleria Pitti in Firenze*, Rome, 1937) established that the artist of the Pitti painting was, in fact, the Venetian artist Niccolo Cassana. Cassana copied Rosa's original of 1663, now in the Casa Martelli, Florence, some time in the late 17th century.

Antoine-Sebastien Falardeau was one of the most famous copyists of the 19th century. A French-Canadian, born at Cap-Santé, Quebec on 13 August 1822, he spent most of his adult life in Florence, Italy. He was made a Knight of Tuscany in 1885 and died in Florence on 14 July 1889. Another larger copy of this subject by Falardeau, painted in 1864, is in the National Gallery of Canada, Ottawa, acquired in 1884.

In 63 B.C. Lucius Sergius Catiline rose to political prominence in Rome by orchestrating an anti-government uprising. His conspiracy was easily crushed by Cicero, but Cataline became famous for reckless ambition.

This painting was on loan to the Ottawa Normal School from 1912 until 1980 when it was returned to Queen's Park.

Madonna del Sacco

(after Perugino, Italian, 1446-1524)
Oil on wood panel, 89.9 x 85.4 cm/
35³/₈ x 33⁵/₈"
Purchase, Florence, Italy, 1856.
MGS 619792

Ryerson's Account Book (p. 73) records payment to the copyist Antonio Sasso on 27 February 1856. The title is derived from the little cushion on which the infant Christ is seated, near his cousin, St. John the Baptist. The original wood panel in the Pitti Palace, Florence, was painted *c.* 1500; most modern critics agree that it is partly the work of Raphael's master Perugino, and partly the work of his workshop.

Madonna of the Lilies

(after Carlo Dolci, Italian, 1616-1686)
Oil on canvas, 91.4 x 78.4 cm/36 x
30⁷/₈"
Purchase, Florence, Italy, 1856.
MGS 622049

Ryerson's Account Book (p. 75) records payment (no date, presumably Florence, February 1856) to Agostino Gagliardi, a

After Perugino, *Madonna del Sacco*, c. 1856

After Niccolo Cassana, *The Conspiracy of Catiline*, c. 1856

dealer or copyist active in Florence, for a "Madonna – Carlo Dolci." The Educational Museum catalogue, 1858 (p. 34), lists this copy as being after an original in the Pitti Palace, in Florence. It cannot be substantiated whether Dolci's original of 1649 was ever in the Pitti collection; today it is in the collection of the Schleissheim near Munich.

Dolci was famous for his overly-sentimental images of the Virgin and Child. The artist's interest in still-life finds expression in the delicacy of the flowers held by the Virgin. A very similar work by Carlo Dolci, dated 1642, is located in the Musée Fabre in Montpellier, France.

Madonna with St. Elizabeth and St. John (also known as **The Medici Holy Family**)

(after Andrea del Sarto, Italian, 1487-1530)
Oil on canvas, 135.9 x 103.5 cm / 53½ x 40¾"
Purchase, Florence, Italy, 1856.
MGS 622048

Ryerson's Account Book (p. 68) records payment on 26 February 1856 to Luigi Pompignoli, a popular copyist in 19th century Florence. Murray's *Handbook to Tuscany, Lucca and Florence* (London, 1858, 7th edition) mentions for travellers' information that "Pompignoli is a good copyist of old masters in the Piazza

Santa Croce." Del Sarto's original was commissioned by Ottaviano de' Medici about 1529 and it has been in the Pitti Palace inventory since 1635. It is known to have been copied many times.

This painting was on loan to the London Normal School from 1912 and returned to Queen's Park in 1979.

Pietà

(after follower of Quentin Massys, Flemish, 1460-1529)
Oil on wood panel, 104.8 x 72.4 cm / 41¼ x 28½"
Purchase, Antwerp, Belgium, 1855.
MGS 623092

Ryerson's Account Book (p. 52) records payment on 11 December 1855 to the copyist Henry Leiffers for a "Copy of the Painting in Antwerp Museum (by H. Leiffers) after Q. Massys." Presumably Henry Leiffers, who is known to have copied works by Rubens, acted as both a dealer and a copyist.

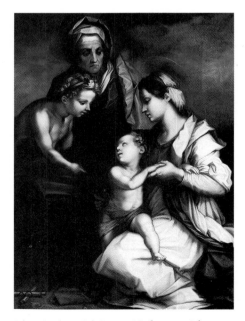

After Andrea del Sarto, *Madonna with Elizabeth and St. John*, also know as *The Medici Holy Family*, c. 1856

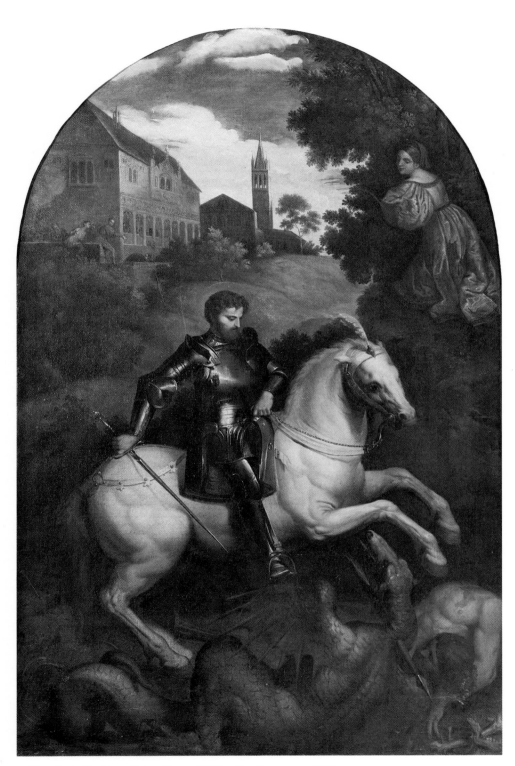

After Paris Bordone, *Saint George Killing the Dragon, c.* 1856

The original on which this copy is based has not yet been determined. From Massys' circle there are two known paintings presenting similar figures of Christ and the Virgin in the same attitudes, but different surroundings. One is in the Musée royaux des beaux-arts de Belgique, Brussels, but that in the Koninklijk Museum voor Schone Kunsten in Antwerp is probably the work to which Ryerson refers.

This scene of lamentation over the dead Christ by his mother, the Virgin Mary, took place between the Deposition and the Entombment. The iconography of the pietà typically shows Christ supported by the weeping Virgin while the setting of Calvary is suggested by the three empty crosses in the background.

The Repenting Magdalene

(after an unknown Old Master)
Oil on canvas, 49.6 x 37.5 cm/
19¹/₂ x 14³/₄"
Purchase, probably in Antwerp, Belgium, 1855. MGS 619790

Although several copies depicting St. Mary Magdalene after European masters are known to have been purchased by Ryerson, no clear attribution of the source for this painting has yet been possible. Copies after Correggio, Carlo Dolci, and Boyermans (a pupil of Rubens) are listed in the Ryerson Account Book, but known paintings by these artists cannot be closely identified with the *Repenting Magdalene*. Furthermore, an inscription on the back of this canvas identifying it as "La Magdalene del Guercino" cannot be confirmed by studying the documentary sources, nor is there a work of comparable composition in the oeuvre of the Italian painter Guercino himself.

Saint Catherine of Alexandria

(after Mariotto Albertinelli, Italian, 1474-1515)
Oil on canvas, 105.4 x 66 cm/41¹/₂ x 26"
Purchase, Florence, Italy, 1856.
MGS 692680

Ryerson's Account Book (p. 71) records payment on 22 January 1856 to the copyist Antoine-Sebastien Falardeau for a "Copy of St. Catherine of Siena as well

as the Holy Mary, original in the Academy of Fine Arts, Siena by Fra Bartolomeo." The copy of "The Holy Mary" is now lost. (For information on Falardeau see the catalogue entry for the *Conspiracy of Catiline*.)

The original work, dated 1521, on which Falardeau's copy is based was one of two known panels (the other depicting Mary Magdalene) thought to have originally been the side wings of a large altarpiece. The centre panel was already lost when in the mid-18th century the two side panels were transferred from the Monastery of Santo Spirito in Siena to the Academy of Fine Arts. Originally believed to have been the work of Fra Bartolomeo, they were re-attributed to the artist Mariotto Albertinelli in 1897. Albertinelli, an early 16th century Florentine artist, was a member of Fra Bartolomeo's workshop in San Marco, Florence and was associated with him on a number of projects.

St. Catherine of Alexandria, born to a royal family in the 4th century, was a convert to Christianity and a brilliant dialectician who engaged the Roman Emperor Maximus and his advisors in debate. A wheel, the instrument of her torture, is her most common attribute, but here she is shown wearing a crown and holding a martyr's palm and a book symbolizing her learning.

Saint George Killing the Dragon

(after Paris Bordone, Italian, 1500-1571)
Oil on canvas, 96.5 x 63.5 cm / 38 x 25"
Signed: (l.l.) G. Mazzolini
Purchase, Rome, Italy, 1856.
MGS 692678

Ryerson's Account Book (p. 75) records payment on 20 February 1856 to the copyist Guiseppe Mazzolini for a painting of "St. George and Dragon — Giorgio de Castelfranco," that is, Giorgione. The copyist Mazzolini was a favourite in Rome and was recorded by John Murray in his famous *Handbook for Travellers in Central Italy including the Papal States, Rome and the Cities of Etruria* (London, 1843) as: "Among the copyists of old masters...." Ryerson's attribution of the original to the Venetian painter, Giorgione, is erroneous. The original was in fact painted about 1525 by Paris Bordone

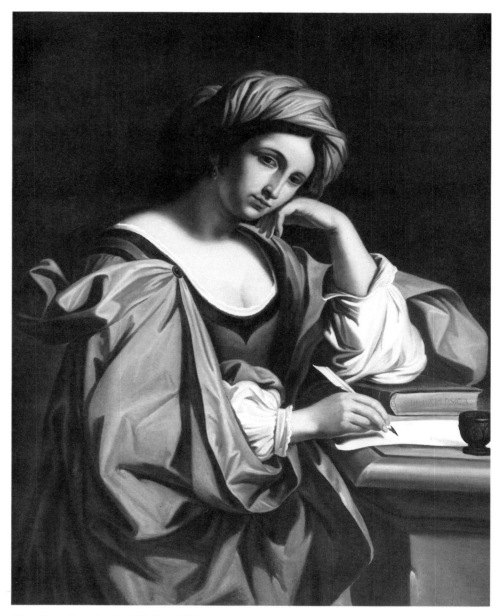

After Guercino, *Persian Sibyl, c.* 1856

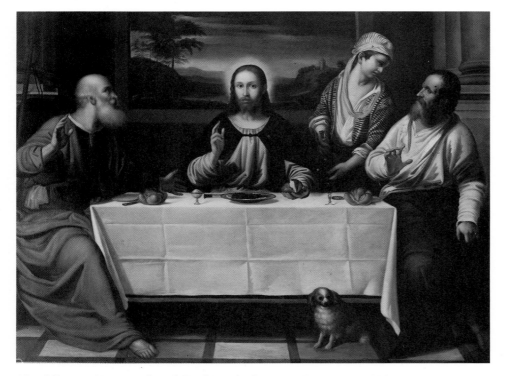

After follower of Jacopo Palma il Vecchio, *The Supper at Emmaus, c.* 1856

who was trained in Venice by Titian. The work was originally located in the Church of S. Giorgio a Noale in Trevisto but was purchased in Venice in 1789. It is now located in the Pinacoteca, Vatican, Rome.

St. George is the patron saint of England and is known from the medieval source, Varagine's *The Golden Legend*, as a Christian version of the Greek god, Perseus. St. George is said to have saved the life of the Princess Silene of Libya by slaying a dragon. The iconography serves as an allusion to the battle of good over evil.

Saint Michael the Archangel

(after Guido Reni, Italian, 1575-1642)
Oil on canvas, 121.9 x 90.2 cm/
48 x 35¹/₂"
Purchase, Rome, Italy, 1856.
MGS 619786

Ryerson's Account Book (p. 76) records payment on 23 February 1856 to the copyist Raimondo Campanile for this work. Campanile is recorded in John Murray's *A Handbook of Rome and its Environs* (London, 1869) under the category of "Artists' Studios, Painters, Copyists." Ryerson purchased three other copies from Campanile in 1856 including three *Sibyls*. Guido Reni's original, painted in 1635, has been since that time in the Church of Santa Maria della Concezione in Rome. It was commissioned by Cardinal Sant' Onofrio, the brother of Pope Urban VIII.

According to the New Testament (Revelations) St. Michael, the Archangel-Warrior, is said to have fought and defeated Satan and his hordes. He is therefore considered the protector of soldiers and is usually depicted in battle with the devil.

The Sibyls

These paintings of three of the ancient Sibyls were purchased from the Roman copyist Raimondo Campanile (fl. 1850), from whom Ryerson also acquired *St. Michael The Archangel*.

In classical antiquity, a sibyl was a prophetess inspired by the god Apollo, and writings of the time mention as many as ten different sibyls — Persian, Libyan, Delphian, Cimmerian, Erythraean, Samian, Cumaean, Hellespontine or Trojan, Phrygian, and Tiburtine. By the Middle Ages Christian writers had adopted the sibyls as the pagan counterparts to the Old Testament prophets, claiming that they foretold the coming of Christ, and adding two more — European, Agrippine — to the original ten. Their attributes vary and there is no agreement on their prophecies.

Cumaean Sibyl

(after Domenichino, Italian, 1581-1641)
Oil on canvas, 123.2 x 90.2 cm/
48¹/₂ x 35¹/₂"
Purchase, Rome, Italy, 1856.
MGS 622046

Ryerson's Account Book (p. 76) records payment on 23 February 1856 to the copyist Raimondo Campanile for "1 Sibyl of Domenichino." For information on the copyist see the catalogue entry for *Saint Michael The Archangel*.

Campanile's painting is copied after a work by Domenichino, a Bolognese artist of the Baroque period. The original was painted in 1616-17, purchased by Cardinal Scipione Borghese in 1617 and now hangs in the Borghese Gallery, Rome. Although the Domenichino original has traditionally been thought to represent the Cumaean Sibyl, the attributes of music (here, a scroll and a stringed instrument) are more commonly associated with the Samian Sibyl. The Cumaean Sibyl, also named Amalthaea, was the most famous of the original ten prophetesses. It was she who conducted Aeneas to the underworld (Virgil, *The Aeneid*, VI).

Persian Sibyl

(after Guercino, Italian, 1591-1666)
Oil on canvas, 120.6 x 87.6 cm/
47¹/₂ x 34¹/₂"
Purchase from the artist, Rome, Italy, 1856. MGS 622045

Ryerson's Account Book (p. 76) records payment on 23 February 1856 to the copyist Raimondo Campanile for "2 Sibyls of Guercino and Vilano." This copy is not listed in the Educational Museum catalogue (1858). For information on the copyist see the

catalogue entry for *Saint Michael the Archangel.*

This and the following painting were copied by Campanile after originals by Guercino (Gian Franceso Barbieri), an Emilian painter trained in Bologna in the school of Lodovico Carracci. Guercino's original of the *Persian Sibyl* was painted in 1647 and now hangs in the Galleria Capitolina in Rome. It is one of a set of Sibyls by Guercino which includes those in the collections of the Uffizi, Florence, Hampton Court, London, and the Palazzo Reale in Genoa.

Samian Sibyl

(after Guercino, Italian, 1591-1666)
Oil on canvas, 118.1 x 94 cm/46½ x 37"
Purchase, Rome, Italy, 1856.
MGS 622044

For details on this copy's purchase by Ryerson see the note for the entry above, *The Persian Sibyl.* Ryerson erroneously attributed *The Samian Sibyl* to Vilano.

Guercino's original was painted either in 1644 or 1653 and is in the Uffizi in Florence. Another version (1651) of this subject by Guercino now hangs in the Palazzo Reale in Genoa. The Samian Sibyl was first mentioned by Aelian and Varro, and is often associated with music (although this attribute is missing in Guercino's work). Compare this sibyl with the *Cumaean Sibyl* recorded above.

The Supper at Emmaus

(after follower of Jacopo Palma il Vecchio, Italian, *c.* 1480-1528)
Oil on canvas, 153 x 203.8 cm/
60¼ x 80¼"
Purchase, probably Florence or Rome, 1856. MGS 622042

No reference to this copy can be found in Ryerson's Account Book. It is, however, listed in the Educational Museum catalogue, 1858 (p. 32).

The original canvas, located in the Pitti Palace, Florence, was until the 20th century believed to be the work of the master, Palma il Vecchio. It is now attributed to one of Palma's many followers. According to the New Testament (St. Luke), after the Resurrection when the body of Christ was found missing from the sepulchre, Cleopas and an unnamed disciple met a stranger on the road to the village of

Emmaus. They invited him to supper, and when the stranger blessed the bread they knew him to be Jesus Christ, at which moment he vanished from their eyes.

This work was on loan to the Stratford Normal School from 1912 until 1978, when it was returned to Queen's Park.

Virgin and Child

(after style of Peter Paul Rubens, Flemish, 1577-1640)
Oil on canvas, 102.9 x 75.2 cm/
40½ x 29⅝"
Purchase, Antwerp, Belgium, 1855.
MGS 622043

Ryerson's Account Book (p. 45) records payment to the dealer and copyist, Henry Leiffers, on 9 December 1855 for a "Holy Family, Virgin with Inft. Jesus after the picture by Rubens in the Museum of Antwerp." Although certain parts of the painting, especially the Child, recall the style of the Flemish master, Peter Paul Rubens, it is not the work of the master or any of his known students, followers or assistants, and the attribution to its original artist still remains to be determined.

Cato the Elder, Marcus Porcius Cato; called the Censor

(after a Roman bust of the Hellenistic Period, *c.* 150-100 B.C.)
Plaster cast, 58.4 x 31.1 x 34.3 cm/
23 x 12½ x 13½"
Purchase, Paris, France, 1856.
MGS 623121

Ryerson's Account Book (p. 36) records payment to his French dealer, H. Bossange & Fils, on 7 July 1856, for "Cato — Rome, Vatican."

The original bust, located in the Vatican Museum, Rome, is from the Hellenistic period and dates to 150-100 B.C. Cato the Elder (Marcus Porcius Cato), a political personality and orator of immense stature, was a vigorous defender of traditional Roman society and values against the encroachment of new influences. He held the consulship of 195 B.C. with Lucius Valerius Flaccus. Elected Censor in 184, he asserted the censor's traditional role as moral guardian of the state.

The Rt. Hon. Benjamin Disraeli, K.G., first Earl of Beaconsfield Plaster cast of a bust, *c.* 1867

The Rt. Hon. Benjamin Disraeli, K.G., first Earl of Beaconsfield

Plaster cast, 41.3 x 20.3 x 20.3 cm/
16¼ x 8 x 8"
Purchase, London, England, *c.* 1867.
MGS 622104

No firm purchase records have yet been found for this bust of a young Disraeli wearing his hair in the ringlets characteristic of his personal style. It was probably purchased by the Deputy Superintendent of Education, Dr. John G. Hodgins during his trip to England in 1867 when he acquired a vast number of busts of famous leaders and plaster casts of Assyrian and Egyptian antiquities for the Educational Museum of Upper Canada. The bust of Disraeli is recorded in the 1884 Educational Museum catalogue (cat. no. 563).

The Rt. Hon. Benjamin Disraeli (b. 21 December 1804, in London, England; d. 19 April 1881 in London, England) received his early training as a lawyer, and was also a talented writer and an enthusiastic traveller. His long political career began in 1837, with his election to the House of Commons as the Conservative member for Maidstone, Kent. In 1848 he was chosen leader of the Conservatives, and assumed the task of rebuilding a unified party and healing the internal discord which had developed during Sir Robert Peel's leadership. Disraeli was Prime Minister of England from 1867 to 1868, and again from 1874 to 1880. He was created the

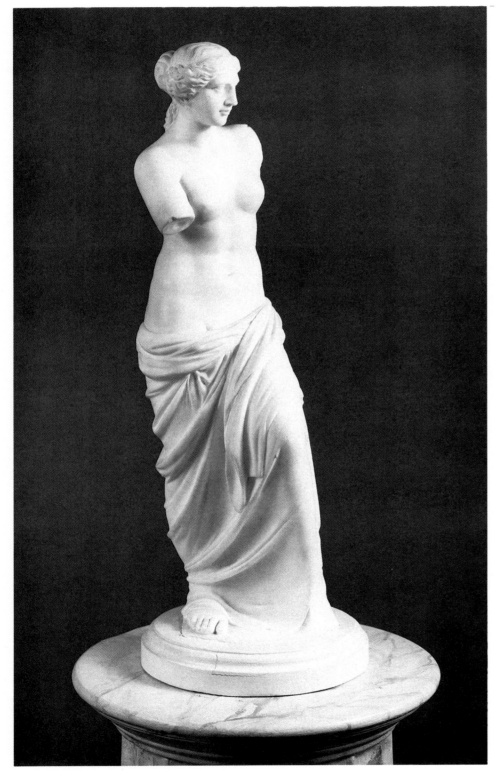

Venus de Milo statuette copied from the original Greek marble

first Earl of Beaconsfield in 1877, and became a Knight of the Garter (K.G.) the following year. Disraeli was an accomplished orator who combined aggressive foreign policies with a domestic platform of advocacy for the rights of labour and protective trade legislation.

Empress Faustina II

(after a Roman bust of the Antonine Period, *c.* 150-200 A.D.)
Plaster cast, 53.3 x 33 x 19 cm/
21 x 13 x 7½"
Purchase, Paris, France, 1856.
MGS 623120

Ryerson's Account Book (p. 41) records payment to his French dealer, H. Bossange & Fils, on 1 December 1856 for "Bust of Faustina." The original bust dates to 150-200 A.D. and is located in the Capitoline Museum, Rome (1858 Educational Museum catalogue, p. 22).

Faustina II, daughter of Antoninus Pius and his Empress Faustina I, was married to Emperor Marcus Aurelius in 145 and bore him twelve or thirteen children. She was with him in the East when she died in the foothills of the Taurus Mountains, in a small village which was renamed Faustinopolis in her honour. Ancient sources have a good deal of gossip about her supposed infidelities.

Venus de Milo (also known as the Aphrodite of Melos)

(after the Hellenistic marble, *c.* 100 B.C.)
Marble, 61 x 17.8 x 19 cm/24 x 7 x 7½"
Purchase, Paris, France, 1856.
MGS 623010

Ryerson's Account Book (p. 31) records payment to his French dealer, H. Bossange & Fils, on 8 May 1856 for this statuette. Two other life-size casts were purchased along with a portrait bust of the Venus during Ryerson's trip abroad in 1855/56.

The original statue is a Hellenistic marble, over life-size, which dates to *c.* 100 B.C. and may have been the work of a sculptor named Alexander or Hagesander, who was from Antioch on the Maeander River in Asia Minor. Purchased on the Island of Melos in

Greece in 1820 by the French Ambassador to Turkey, the famous Venus arrived in Paris in 1821 and was placed in the Louvre where it has been ever since. Venus or Aphrodite was the goddess of love, fertility, and beauty. She is said to have been born of sea foam, and her cult was probably introduced into Greece from Asia Minor, where the goddess Astarte had similar characteristics.

Original Works

Artist unknown

(Dutch or Flemish School)

Untitled
(19th century Dutch or Flemish)
Oil on canvas, 57.2 x 77.5 cm/
22^1/$_2$ x 30^1/$_2$"
Purchase, probably Antwerp, Belgium, 1855. MGS 619787

This northern school landscape is probably one of many "modern paintings" (that is, early to mid-19th century) which Ryerson purchased while in Antwerp in the winter of 1855. Despite the Chief Superintendent's extensive notations in his Account Book, no attribution to the artist of this canvas can yet be made.

Ippolito Caffi

(Italian School)
Born: 1809
Died: 1866

Carnival in Rome
Oil on canvas, 73.7 x 99.1 cm/29 x 39"
Signed: (l.l.) Caffi
Purchase, Rome, Italy, 1856.
MGS 694037

Ryerson records payment to the artist on 23 February 1856 in his Account Book (p. 76). Caffi was a pupil of the Venetian School of painting and studied in both Venice and Rome. This work is one of the dozens of versions of this subject painted by the artist after his great popular success with his 1837 *Il carnevale. I moccoletti*, now in the Museo Correr, Venice.

Caffi's painting depicts evening festivities during one of the many Roman carnivals. Artificial illumination

Ambrosius Francken the Elder, *The Last Supper*, c. 1580

is strung along the façades of the palazzi lining the Corso in the papal state of Rome. The French flag is probably flying in commemoration of the freeing of the Pope from exile by the French forces.

Jan Baptiste De Jonghe

(Flemish School)
Born: 1785
Died: 1844

Eugène Joseph Verboeckhoven

(Flemish School)
Born: 1798
Died: 1881

Landscape in the Neighbourhood of Brussels
Oil on canvas, 72.4 x 87.6 cm/
28^1/$_2$ x 34^1/$_2$"
Signed:(l.l.) J. B. De Jonghe
Purchase, Antwerp, Belgium, 1855.
MGS 619788

Ryerson's Account Book (p. 45) records that he purchased this work on 9 December 1855 from Henry Leiffers, an Antwerp dealer and copyist from whom several other works were purchased. The Chief Superintendent annotated

that "the animals [were] painted by Eugène Verboeckhoven." This artist was often a collaborator in landscape pictures, being particularly adept at painting animals. Rural landscapes in which domestic animals are gathered under the watchful eyes of an attendant were popular subjects for Dutch and Flemish painters from the seventeenth century onwards.

Ambrosius Francken the Elder

(Flemish School)
Born: 1544
Died: 1618

The Last Supper c. 1580
Oil on wood panel, 71.8 x 102.9 cm/
28^1/$_4$ x 40^1/$_2$"
Inscribed: (verso, on label): [illegible] from/Pourbus Le/Jeune.
Purchase, Antwerp, Belgium, 1855.
MGS 619791

Ryerson's Account Book (p. 46) records payment on 10 December 1855 to the dealer F. De Neerdt, for a "Last Supper with 12 Apostles by A. Franck." The 1858 Educational Museum catalogue (p. 35) records that this work was a copy of

Ippolito Caffi, *Carnival in Rome*, c. 1856

Franz Francken II, *The Feast of Belshazzar*, c. 1630-40

Francis Pourbus' painting in the Louvre, Paris, France. An old label affixed to the frame makes the same reference, yet the painting bears no resemblance to Pourbus' painting of the same subject.

Ambrosius Francken the Elder was the brother of Franz Francken the Elder and uncle to Franz Francken II, *(q.v.)*. Little is known of him although he was a pupil of Frans Floris and was influenced by Martin de Vos. He settled in Antwerp in 1573. A similar version of *The Last Supper* painted by Francken the Elder *c.* 1580 is in the collection of the Koninklijk Museum voor Schone Kunsten, Antwerp. Presumably many of the minor masters' works were still easily obtainable on the art market in Antwerp in the mid-19th century.

Franz Francken II (Flemish School)

Born: 1581

Died: 1642

The Feast of Belshazzar c. 1630-40
Oil on wood panel, 74.3 x 121.9 cm/
29¼ x 48"
Purchase, Antwerp, Belgium, 1855.
MGS 619803

Ryerson's Account Book (p. 48) records payment on 11 December 1855 to P.A. Verlinde for a "Feast of Belshazzar after Paul Veronese by Frans Franck." This painting is probably a previously undocumented original by Franz Francken II. Francken, one of the minor masters of the late 16th and early 17th centuries, was the son and student of Franz Francken the Elder and is known to have spent three years working in Venice before settling in Antwerp. R.H. Wilenski, *Flemish Painters 1430-1830* (London, 1960, 2 vols.) refers to Francken II as having painted this subject *c.* 1630-40. He records its whereabouts as unknown, although this wood panel is presumably the lost original. The composition is one conventionally adopted by Flemish painters of the time. It bears no resemblance to the Venetian artist Veronese's work on the same subject. Presumably, learning that Francken II had worked in Venice, Ryerson mis-interpreted the information in his records.

Many originals by such minor masters as Francken II, Peeter Thys and Ambrosius Francken the Elder, were still

on the art market in the middle of the 19th century, especially in Antwerp. Pierre Antoine Verlinde (b. January 1801, Bergues-Saint-Winnoc, France; d. Antwerp, 1877) from whom Ryerson purchased this work was active as an art dealer in Antwerp, where he moved in 1827. Ryerson also purchased another original from him, *Esther before Ahasuerus*, by Peeter Thys. Verlinde was also known as a painter of portraits and still-lifes and had an active restoration business.

The painting shows an event described in the Old Testament (Book of Daniel). During a feast in which Belshazzar, last King of Babylon, used the captured Jewish temple vessels for wine drinking, the words *Mene, Mene, Tekel, Upharsin* miraculously appeared on a wall. These words are said to have foretold the fall of Babylon (539 B.C.) to the Medes and Persians.

Peeter Thys (Flemish School)
Born: 1634
Died: 1677

Esther Before Ahasuerus c. 1650
Oil on canvas, 148.6 x 181 cm/
58½ x 71¼"
Signed: (l.c.) Peeter Thys
Purchase, Antwerp, Belgium, 1855.
MGS 623803

Ryerson's Account Book (p. 48) records payment on 11 December 1855 to P.A. Verlinde for an "Esther before Ahasuerus – after Van dyck by Pierre Thys." This painting is a previously unrecorded original by Thys. Thys, a student of Sir Anthony van Dyck, was active in Antwerp but went to England around 1649 to paint William of Orange and remained there. Thys, said to have been in the employ of van Dyck while that master was in England, was reputed to

Peeter Thys, *Esther before Ahasuerus, c.* 1650

have been one of his best imitators. Presumably this association with van Dyck led Ryerson to record that this work by Thys was a copy after an original by van Dyck, although van Dyck has never been known to paint this subject.

The scene, from the Old Testament (Book of Esther), was a popular one in 17th century Holland. The King of Persia, Ahasuerus (485-465 B.C.) was married to the Jewish exile Esther. Ahasuerus was being implored by his Vizier, Haman, to slaughter and plunder the Jewish community. Esther's relative,

Mordecai, persuaded her to intervene, and although unsummonsed appearances were punishable by death, the beautiful queen entered the King's private rooms and her plea for her people was answered. As intercessor for her people, Esther was regarded in Christian literature as foreshadowing the Virgin who was considered the intercessor for all mankind.

This work was on loan to the Ottawa Normal School from 1912 until 1980 when it was returned to Queen's Park. It had suffered severe damage and paint loss during this period.

(Facing Page) Frederick Bell-Smith,
Westminster Bridge, c. 1897

Politics and Painters

THE GOVERNMENT AND THE ONTARIO SOCIETY OF ARTISTS

*E*gerton Ryerson, in giving the people of the province the beginnings of aesthetic judgement with his "objects of taste," created not only the foundations of a tradition in the visual arts but also the forum for debate necessary to refine it. The second major part of the Ontario Collection was established in 1875 when the government, under the auspices of the Education Department, began a program of acquiring "contemporary" works of art. These were obtained over a period of thirty-nine years from the annual exhibitions of the Ontario Society of Artists by a variety of selection methods and committees. Primarily oils and watercolours, these paintings were intended to form a provincial collection and were seen as an adjunct to the copies and casts brought back by Ryerson in 1856 and 1867. The European and Canadian paintings were exhibited side by side in the Educational Museum in the Toronto Normal School which was expanded in the 1890s.

The government developed its acquisition policy in collaboration with the Ontario Society of Artists. The story of this part of the collection is largely the story of the combustible relationship between the O.S.A. and the government during three distinct phases of collecting. The first was the selection of the early purchases which covered the years 1875 to 1895. The second phase consisted of those works selected for the government's collection by the drawing of ballots by the members of the Society. These became known as the annual "Ballot Pictures" and this program continued from 1895 to 1912. The third phase was the purchase of works from the "$800 annual grant" allocation; these were selected by a variety of government-appointed committees between 1897 and 1912.[1]

In 1912 the Education Department decided to close the picture galleries of the Educational Museum and to decentralize the collection. Both the copies of Old Master paintings and the collection of contemporary art which had developed as a result of the policies described above were divided among the Normal Schools of the province. Additional selections were also made in 1913 and 1914 specifically for the provincial Normal Schools. Collecting came to an effective halt in 1914; it was not resumed until the institution of the "art-in-architecture" policy in 1966, except, of course, for the on-going program of commissioning official portraiture for the Legislative Building at Queen's Park.

Although several hundred works of art were acquired as a result of the relationship with the O.S.A., only forty remain in the collection today. This is largely a result of the distribution of 1912 and the fact that virtually no records were kept until the few remaining examples were relocated to the Legislative Building when the provincial Normal Schools closed during the 1970s. Despite the paltry number of works remaining, this collection is significant for it reflects the government's commitment, made in the early 1870s, to support the visual artists of the province and to bring to the museum at the Normal School examples of a living Canadian art. The government's involvement in local Canadian art only began eighty years after the province had been founded. Although there was a long tradition of pre-Confederation art in Upper Canada and later in Canada West, its story is, by necessity, limited.

In French Canada, church officials and wealthy merchants had long acted as keen and generous patrons, but in Upper Canada, settled by the United Empire Loyalists, the business of culture had no place in a pioneer environment that provided little incentive for art patronage. The province's first Lieutenant Governor, John Graves Simcoe, is reputed to have had little interest in cultural matters, even though his wife, Elizabeth, was an avid sketcher in watercolour. Art, at the time, consisted of the work of well-to-do amateurs who recorded, in precise topographical detail, their travels in the new

The Ontario Society of Artists, 1908

Back row, from left: Dr. A.P. Coleman, F. McG. Knowles, F.M. Bell-Smith, C.M. Manly, R.F. Gagen, W.E. Atkinson, C.W. Jefferys.

Middle row, from left: H. Spiers, W. Cutts, J.T. Rolph, Miss Martin, Miss Spurr, James Smith, G.A. Reid, W. Cruikshank, O.P. Staples.

Front row, from left: J.D. Kelly, F.S. Challener, J.W. Beatty.

land. It was not until the 1830s, with the arrival of Lieutenant Governor Sir John Colborne, that a milieu sympathetic to the visual arts was to flourish. In 1830, Lady Colborne organized the first York Annual Bazaar; it was held on the lawn of Government House, and several amateur artists showed their works in the tiny area made available for the display of fine arts. In 1831, Colborne and the Archdeacon of Toronto, John Strachan, founded the Literary and Philosophical Society, a society whose chief aim was the study of and encouragement of the fine arts. Strachan brought the architect John Howard to the forefront of the developing interest in the arts by appointing him drawing master at Upper Canada College in 1833, a post he held until 1868.

Howard was one of the founders of the Society of Artists and Amateurs of Toronto, the first organization of artists in the province. In 1834 they held their first and only exhibition at the Legislative Building on Front Street West. Some 196 works by 18 artists were on view. Among the exhibitors were Paul Kane, James Hamilton, the portrait painter Nelson Cook, and Charles Fothergill, Member of the Legislative Assembly, the man who first proposed a "Lyceum of Natural History and Fine Arts" for the town of York. Unfortunately, the exhibition was poorly attended. Not until 1847 would artists of the province form another society and exhibit their works.

Unlike its predecessor, the Toronto Society of Artists limited its membership to professionals, of whom almost all were portrait painters, for the portrait was rapidly becoming a popular art form among patrons in Toronto's developing social ranks. The objectives of the society were to hold annual exhibitions and to promote proper art education. In pursuit of the latter they even advocated the importation of classical casts to be used for art classes. Some eight years later Ryerson imported more than 1,000 plaster casts, thereby aiding, albeit belatedly, in the attainment of one of the society's objectives. Regarding the other objective, the society's only exhibition was held at City Hall at the corner of

Front and Jarvis streets (now the St. Lawrence Market) in 1847. The portraitists were the most popular exhibitors, especially Hoppner Meyer and George Theodore Berthon; within a few years the latter was to become the darling of Toronto's fashionable and rich.

Although exhibitions in the city were moderately well attended, in general the response to art throughout the province was one of apathy. In 1847 a period of increased interest in the fine arts began with the first annual fair held by the Upper Canada Agricultural Exhibition Society. Artists were given space to show their works in the small section devoted to the fine arts, nestled in among the more popular agricultural and industrial exhibits. The annual exhibitions were hosted alternately by the cities of London, Ottawa, Hamilton, and Toronto. *The Canadian Illustrated News* aptly, if rather dishearteningly, remarked on the nature of these exhibitions:

> we all know the class of pictures exhibited at these shows in conjunction with the mammoth squashes and wonderful worsted work.[2]

Competition from squash and handicrafts notwithstanding, the government was apparently in the habit of giving prize money for the best pictures at these exhibitions.

Besides the opportunity for much-needed exposure, these agricultural fairs gave the artists a chance to meet, and to discuss their works. Not until the early 1870s did the artistic focus shift from rural to urban subjects. This change was marked by the formation of the Ontario Society of Artists.

The Ontario Society of Artists was founded at the home of the artist John A. Fraser on June 25, 1872. Fraser had moved to Toronto from Montreal to establish a branch of the successful photographic firm, Notman and Fraser. He had always been active in the art community in Montreal and was one of the founders of the Canadian Society of Artists there. Finding no such society in Toronto, he became instrumental in the establishment of one for the Province of Ontario.

Banded together that day were six other artists, who became the founding members of

The Ontario Society of Artists' 1st Annual Exhibition, 1873 (*Canadian Illustrated News*, April, 1873)

the O.S.A.: J.W. Bridgeman, Robert Gagen, James Hoch, Marmaduke Matthews, C.S. Millard, and T. Mower Martin. The aim of these painters was the creation of a society to foster ''original'' art in the province by holding annual exhibitions of the society members' works, and by forming an Art Library and a School of Art.

Their first president was the art patron W.H. Howland, son of the province's first Ontario-born Lieutenant Governor, Sir William Pearce Howland (1868-73). John Fraser became the Vice-President of the society.[3]

The society's first exhibition was held in April 1873 at the new Art Gallery which had been

opened in the back room of the Notman and Fraser studio on King Street West (site of the present-day King Edward Hotel). The show was a tremendous success. More than 5,000 visitors were reported to have attended to view some 252 works of art by 22 exhibitors. As was usual for the time, the works were jammed into the small 30-foot by 50-foot gallery; some were "skyed," others — more favoured by the hanging committee — were placed "on the line." *The Canadian Monthly and National Review*, first published that year, reported the sale of more than 100 pictures, to a value of $6,665.[4]

From this exhibition the government purchased its first contemporary Ontario works of art. A sum of $1,065 was spent to this end, although it is still unknown which works from the exhibition were acquired or how many. *The Canadian Monthly and National Review* remarked:

> we doubt not the day will come . . . for a permanent collection of native art worthy of the Province and of the Dominion of Canada.[5]

This day would come two years later.

Although the government made selections from the first exhibition of the O.S.A., only in 1875 was a firm policy established for the formation of a "contemporary" collection. In that year, an agreement was drawn up whereby the Ontario Society of Artists would obtain from the government an annual grant of $500. Although the terms of reference for this arrangement are ambiguous, it would appear that the $500 grant was provided to the society to purchase paintings or watercolours for the "Ontario Collection." Selections for the "Ontario Collection" were made by the members of the society themselves, who would then make their recommendations to a government committee. On the day of the private viewing, prior to the official opening of the show, this committee would then review the recommended selections. Limitations were set as to the price of the works selected, and guidelines were established stipulating a minimum price of $75 and restricting the number of works by an artist to one per year.

Daniel Fowler, *Water Mill, Berncastle on the Moselle*, 1876

Apparently, the specified minimum price of the work was not always adhered to; works selected, for which records exist, were generally priced under $75, even though it had been suggested in 1876 that the minimum price be raised to $100. The question of the price of the work selected would be a constant point of discussion until 1914. It would appear that the society equated price with the quality of the work exhibited.

Throughout this period there are only a few documented purchases and only two works of those known to have been selected are in the collection today: Daniel Fowler's watercolour, *Summer Has Come Again*, selected from the

1875 exhibition, and his *Water Mill, Near Berncastle on the Moselle* selected at the following year's exhibition. The society generally would select works amounting to the total granted amount of $500. In fact, in 1877 they went over budget and spent $520. Although selection lists still exist for the years 1879 and 1880, no works have survived. There may have been purchases made between 1881 and 1895 but no documentation of these exists.

The general lack of records during the period of the "early purchases" makes it incredibly difficult to get a true picture of the collection. Moreover, it is uncertain whether the collection was to be owned by the government or by the Ontario Society of Artists. This confusion results primarily from a 1917 notation in which some of the early works listed as having been purchased for the "Ontario Collection" were also listed on an inventory of the society's holdings. In fact, in 1878, the O.S.A. held an auction of works from the Ontario collection "not fully representing the artists nor doing credit to the collection."[6]

The confusion over ownership of these early purchases is enhanced by the fact that the two Daniel Fowler watercolours in the collection, acquired in 1875 and 1876, have always been in government hands. In addition, there are several early works of art in the collection today for which no purchase records have been found. It is highly likely that these were part of the selections made for the "Ontario Collection" from this period. A few examples of these are John Fraser's *Willow over Stream*, James Hoch's *Woodland Path*, George Harlow White's *Entrance to the Lledr Valley* and *The Market Place, Quebec* and the large oil by Homer Watson, *Untitled*, a landscape probably of Doon, Ontario. All of these artists were members of the O.S.A. and active exhibitors at the annual shows. As the $500 annual grant was legislated to the society, unfortunately *Public Accounts of Ontario* cannot help in determining monies expended for particular works of art.

From time to time the government would purchase other works of art from the various picture dealers in Toronto; these purchases

The Ontario Society of Artists' 4th Annual Exhibition, 1876

James Hoch, *Woodland Path*

G. Harlow White, *Market Place, Quebec*, 1877

(*Above*) Photograph of a drawing class at the School of Art, using plaster casts acquired by Dr. Egerton Ryerson
(*Right*) A.D. Patterson, *The Hon. Sir George William Ross, LL.D., F.R.S.C.*, 1902

would be recorded in the *Public Accounts*. Purchase of these works was not, however, governed by the collection *per se*, and they were probably acquired for use in ministers' offices, in public areas of the Legislative Building then on Front Street West, or in the new Government House at King and Simcoe Streets.

In piecing together the collecting activity of this early period a further difficulty arises. It is virtually impossible to determine to what use the society put the $500 annual grant during the period between 1881 and 1895. Although there are works in the collection dating from these years, it appears that not too many purchases were made for the "Ontario Collection" during this time. Perhaps significantly, this period is also marked by a growing animosity between the government and the Ontario Society of Artists. The contentious issue was that of a school of art for the province. Although the groundwork had been laid by Egerton Ryerson, a generation earlier, there was little progress until 1876, when the government provided a grant of $1,000 to the society so that it could open the

long-needed school. On October 30, 1876, in rented rooms on King Street West, the school was opened. Courses were based on those outlined by the South Kensington School of Art and Design in London, England. Ryerson had brought the teaching guidelines of this British example to the province's attention, and some of the "Ryerson casts" were very aptly loaned to the school for the drawing classes.

From its very inception, the school faced financial difficulties. The society advanced funds to help sustain it, but what was needed was the umbrella of the provincial educational system. At first the government was reluctant, and even from year to year lowered its grants. By the 1880s things had reached crisis proportions and the Education Department was called in to study the situation and make recommendations. Dr. S. Passmore May of the Department and Superintendent of the Educational Museum recommended that the school be moved to the Education Department in the Normal School. Rooms were made available on the first floor of the Normal School and the School of Art opened

there on October 10, 1882. The new program concentrated on drawing; particular emphasis was given to training in industrial art. As a result of this emphasis and the gradual takeover of the management of the school by the Education Department, the Ontario Society of Artists formally severed its links with the school in 1884. Not until 1912, with the incorporation of the Ontario College of Art, would the issue of a school of art for the province be resolved.[7]

In the severing of the connection between the O.S.A. and the School of Art, the newly appointed Minister of Education, the Hon. George William Ross, inaugurated a new relationship with the society, and in 1895 the government's art acquisition policy changed dramatically with the beginning of Ross' active participation in the program.

George Ross was without question the most singular influence on the "contemporary collection." He and Egerton Ryerson were together the most important figures in the formation of the art collection as a whole. Ross' influences can be seen in the increased allocation of funding for works selected from the annual exhibitions of the O.S.A., in the collection of portrait busts of leading Canadian citizens which he inaugurated for the Education Department at the Normal School in 1887, and in the vast commissioning program of political portraits for the Legislative Building for which he was responsible when he became premier in 1899.

Ross was born in London, Ontario, in 1841. He became a teacher in 1857 and was a school inspector for the Department of Education before entering public life as a federal Liberal member for West Middlesex in 1872. He joined provincial politics in 1883, and in that year was appointed the second Minister of Education of Ontario. Ross held the education portfolio until 1899 when he was called upon to replace Premier Arthur S. Hardy as leader of the Ontario Liberal Party. He served as Premier from 1899 to 1905. The election of 1905 saw an end to 32 years of Liberal government in Ontario. Two years after his defeat, Ross was appointed to the Senate where he remained until his death in

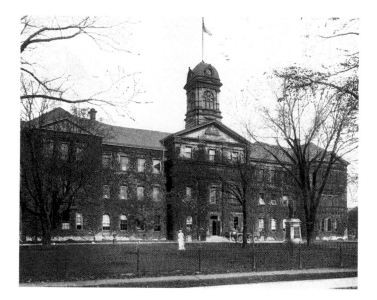

The Toronto Normal School, 1897

1914. In 1910 he was knighted for his contributions to Ontario's political life.

Ross' interests extended beyond politics; he was an avid collector and connoisseur of art and would often visit artists' studios and the dealers' galleries about town. As Minister of Education he began what was then called a "Provincial Collection for the Education Department" and was the major force behind its growth.

A man of his times, responsive to public opinion, Ross probably felt something had to be done not only in terms of government patronage of the arts but also with the Education offices at St. James Square. Jimmie Rembrandt, the vociferous art critic for *Toronto Saturday Night*, summed up the state of the visual arts in the 1880s:

> For a city of its size and population Toronto is an artistic sloth. . . . Art is not understood here as it should be, all things considered. . . . If the people of Toronto really desire to stimulate the growth of Canadian art, they should inaugurate a judicious system of Government patronage.[8]

As well as instituting a system of government patronage of the arts, Ross also established a picture gallery in the Normal School to house the works of art acquired from 1895 to 1912.

In 1893 the Normal School was in a state of

considerable disrepair. No major renovations had been undertaken since the building was opened in 1852. Renovation began with the addition of a new third floor, providing more room and spacious halls. A new tower, completed in 1897, radically changed the building's exterior character. About the same time, it was decided that the archaeological collections from the Provincial Archaeological Museum, located since 1886 at the Canadian Institute building, should be transferred to the Normal School and amalgamated with the natural history collection started by Ryerson some 55 years previously. The famed Ontario archaeologist David Boyle acted as curator of the collection which had largely been developed through his own good efforts. Upon the retirement of the Superintendent of the Educational Museum, Dr. S.P. May, in 1905, Boyle was appointed and remained in that capacity until his death in 1911.

Coincident with the merging of the Archaeological Museum and Ryerson's Educational Museum, and the renovations and expansion of the Normal School, the Minister of Education entered into a new agreement with the Ontario Society of Artists. The agreement, formed in 1895, put the art policy under the effective control of the Education Department and served to commence "a Canadian Art Gallery at the Education Department."[9] The policy also served as a conciliatory gesture toward the society, smoothing if only temporarily the roughness of its relations with the government, a condition that had existed since the 1880s.

The policy essentially affected the disposition of the $500 grant awarded to the society annually by the government. The new terms of reference specified that two pictures a year, priced at $100 each, were to be selected by "ballot" by the members of the O.S.A. from the society's annual exhibitions. These two works would then become the property of the Education Department and part of the provincial collection. The paintings and watercolours selected in this manner from the annual shows became known as the annual "Ballot Pictures." It is presumed that the society could spend the

remaining $300 of the annual grant on society business. The first "Ballot Pictures" for the collection were selected from the O.S.A.'s 24th Annual Exhibition, held in 1896. This selection arrangement continued for the duration of the program, that is, until 1912. Little controversy surrounds the selection of these "Ballot Pictures" as they were chosen by the society's own membership. In fact, for a short time the O.S.A. and the government appear to have enjoyed a remarkably genial association. In 1897, the apparent truce was ended over the matter of the "$800 annual grant."

The renovations to the Normal School were complete in 1897, and the Canadian art gallery, prefigured in the policy established two years earlier, was now ready. The minister was probably eager to fill the new gallery; at the rate of two "Ballot Pictures" per year, it must have seemed to him to be an impossible goal. Accordingly, Ross entered into yet another agreement with the O.S.A. which was ratified on April 14, 1897. The society agreed to arrange an annual exhibit of works from its membership for one of the exhibition galleries in the Normal School, the "Provincial Art Gallery," from which the Department of Education would purchase works annually for an amount not less than $800.

This arrangement at the Provincial Art Gallery served two purposes. It provided an alternative selection of works from which the government could draw for its own collection, and it also gave the people of the province an opportunity to see the accomplishments of young artists on display in a public gallery space, accessible daily throughout the year. The Provincial Art Gallery was the first of its kind in the province, a position it would enjoy until the incorporation of the Art Museum of Toronto (later the Art Gallery of Ontario), founded in 1900 and opened to the public in a permanent home at The Grange in 1912.

The pilot project was a success; the exhibitions were well attended until the arrangement ceased in 1912. The first exhibition hung by the O.S.A. opened in 1897. In accordance with the agreement the Education Department was to

The Provincial Art Gallery, Educational Museum, Toronto Normal School, 1908

purchase works for its own collection to a total cost of $800. From this moment controversy raged.

The selection committee for this first purchasing arrangement consisted of George Ross, the Minister, and the Superintendent of the Museum, Dr. May. Ross had made it known that he also intended to select works from artists' studios and art dealers' establishments with the funding available. Needless to say the press was made aware of the minister's intentions, and in some quarters concern was expressed that this new acquisition policy would encourage political favouritism and patronage. As *Toronto Saturday Night* reported at the time:

We take it for granted that those who do the selecting of these works of art, which are to become the property of the country to convey to the coming centuries an idea of the art of Canada in 1898, are fully up to the requirements of qualified judges of paintings. We assume that this $800 yearly shall be spent with a sincere desire to obtain the greatest amount of good for the money, as all public money we suppose is always spent. We also assume that only motives of purest devotion to the country, and appreciation of the value of art to it, sway the said purchases and neither for political ends nor for any favouritism to friends will any painting obtain a place in this permanent gallery. . . . For the sake of the future reputation of the purchasers also, it would be prudent to do wisely and well in this important act of purchasing art for a country.[10]

Robert Gagen, *Fine Weather in Memphremagog's Hills, Quebec*, 1897

And, in fact, for all of Ross' good works, there was perhaps a legitimate basis of concern. Mildred Peel, sister of Paul Peel, was one artist favoured by Ross over the years. While he was Minister of Education, she was commissioned to do a vast number of portrait busts for the collection at the Normal School, and when he was premier he gave her a considerable number of commissions for portraits of former Speakers of the Legislature. Eventually, when Ross left provincial politics in 1907, the two were married. In retrospect, however, this episode is a minor flaw in Ross' otherwise exemplary contribution to the growth of the collection. The two-man committee selected some very fine works for the collection including F.M. Bell-Smith's *Westminster Bridge*, Robert Gagen's *Fine Weather in Memphremagog's Hills* and T. Mower Martin's *The Road through the Beeches.* A total of fourteen was chosen from the Normal School exhibition.

The critic from *Toronto Saturday Night* did point out another issue which raised dissension within the society — the qualifications of the selectors. This concern would spark debate until in 1912 all arrangements between the O.S.A.

William Atkinson, *October*, 1904

and the government ceased. It was finally agreed, after much discussion, that pictures for the $800 annual grant would be chosen from two places only — the O.S.A.'s annual exhibitions and those held at the Normal School. A further restriction was imposed on the government: selections from the annual society exhibitions could only be by those artists who also had works hanging in the Provincial Art Gallery exhibits in the Normal School. The minister reluctantly consented to this rather confining arrangement.

Friction between the O.S.A. and the government continued uninterrupted for thirty-seven years. Luckily Ross was able to disentangle himself from the society in 1899 when he resigned as minister to become Liberal leader and premier replacing the Hon. Arthur S. Hardy. He nevertheless shaped the character of the collection and did much toward its development during his years in provincial politics. His contribution to the portrait collection, which will be discussed in the next chapter, should not be underestimated; he helped develop a tradition

G.A. Reid, *The Berry Pickers, 1890*
Oil on canvas; 167.6 × 127 cm/ 66 × 50''
Nipissing University College Collection, North Bay

in the genre which continues to this day.

The new Minister of Education was the Hon. Richard Harcourt, sworn in on October 21, 1899. He retained this ministerial responsibility until the Liberal government was defeated at the polls in 1905 by James Pliny Whitney's Conservatives. Little is known of Harcourt except that, from all accounts of his relations with the cantankerous society, he was a very patient man. In an effort to deflect any charges of political favouritism and patronage, he appointed an independent advisory committee to make selections for the Education Department collection. This independent body, the Toronto Guild of Civic Art, was responsible from 1900 to 1907 for the funded selections. The Guild was a group of lay persons interested in the progress of art in Canada; its mandate included the promotion and encouragement of the embellishment of the city and its public buildings. In the meantime, "Ballot Pictures" continued to be selected by the O.S.A. membership.

The first selections made by the Guild in 1900 were five works from the O.S.A. annual exhibition and two works on display at the Provincial Art Gallery. The most remarkable of the Guild's selections is the famed *Berry Pickers* by George Reid. This work was later transferred to the North Bay Normal School and, in the early 1970s, given by the government to Nipissing University College.

Three years into its existence, the government's advisory body would be riddled with controversy over the qualifications of the Guild's members. It appears that in 1903, the Guild had altered its membership policy to include more laymen in the art-selection committee. According to the society, these gentlemen were not qualified to make judgements in art matters and aesthetics. By 1904, the level of debate over this issue resulted in the society sending a petition to Minister Harcourt, requesting that the agreement into which the society had entered in 1897 to provide paintings for exhibition at the Provincial Art Gallery be terminated.

It seems logical to conclude that the quality of works exhibited at the Normal School was poor since few selections were made from these exhibits. In fact, in 1904 none were selected from the school's exhibit. Of the selections made by the Guild committee from the O.S.A. annual exhibitions, only two works survive in government hands today: William Atkinson's *October* and Frederick H. Brigden's watercolour *Sunset Glow*.

In 1905, the society suggested to the minister that, should he not abolish the society's requirements that the pictures exhibited at the Provincial Art Gallery be changed annually, the annual funds of $800 should be deposited in the bank for a period of five years, after which the accumulated revenue would be used to buy one or more works selected by what they maintained, rather haughtily, would be "a competent committee." Presumably the concerns voiced by the society were those reported by the art critic for *The Canadian Magazine*, J.A. Radford, namely that the Guild of Civic Art Committee was:

> hybrid in its character, not one artist being upon it. It was composed of two newspaper writers, a picture dealer, a manufacturing chemist, an ethnologist and a lawyer.[11]

Hybrid though it was, the committee did make some creditable selections, witnessed by the two that remain in the collection today — William Cutts' "*Men May Come and Men May Go*" and Gertrude Spurr Cutts' *The Vale of Tintern*, both from the 1906 annual exhibition of the Ontario Society of Artists. O.S.A. criticisms of the selections and the selectors are hard to fathom, since all of the pictures were, in fact, originally chosen by the society's own Hanging Committee who judged the works before they were accepted for exhibition. It would be easier to understand criticism of the "Ballot Pictures" selected by the society's own membership: Clara Hagarty's *A Dutch Interior*, selected by the society in 1907, is a particularly poor painting, if not a particularly good example of the level of aesthetic judgement involved in these selections.

(*Above*) Gertrude Spurr Cutts, *The Vale of Tintern*, 1893

(*Right*) "Hanging Committee" of the Ontario
Society of Artists.

It seems reasonable to surmise that there was
a certain degree of arrogance on the part of the
society in the belief that its membership was
the only competent judge of works of art for a
provincial collection. Another concern voiced to
the Minister of Education by the society helps to
put this in perspective. The O.S.A. recom-
mended that a minimum price of $100 be estab-
lished for works and that, in future, only two
works be selected at $400 each. This recommen-
dation was never adopted but it tends to recall
the early discussions of the society on the
merits of the early "Ontario Collection" in
which price was obviously equated with quality.

The inevitable result of the ongoing alterca-
tions was that the Guild of Civic Art was finally
ousted from participation in the selection
process for the $800 annual grant. The new
Minister of Education, the Hon. Robert Allan
Pyne, had been sworn in on February 8, 1905,
and it would seem that he was a less tolerant
man than his predecessor. In fact, Pyne seems to
have had little interest in art matters at all,
since it was he who brought collecting to an end
in 1914. Similarly he was responsible for the
distribution of the entire collection (both the
Ryerson Old Master copies and the collection of
contemporary works) to the provincial Normal
Schools in 1912.

The final break with the Toronto Guild of
Civic Art occurred over their selections of works
in 1907. Pyne had accepted the O.S.A.'s pro-
posal that an artist be included on the
committee, and A.H. Howard was appointed by
the society as its representative. Apparently, the
Guild neglected to inform Howard of the date on
which the selections were to be made and,
without the artist's participation, selected two
pictures which were to horrify the O.S.A. The
quality of the works was not the issue; the
horror was that the two artists, Archibald
Browne and Franklin Brownell, were ineligible.
Their membership fees to the society were in
arrears and, according to the 1897 agreement
with Minister Ross, they were also ineligible
because they did not have works on exhibit in
the Provincial Art Gallery at the Normal School.
Following a deputation to Minister Pyne by the
enraged society delegation, the Guild of Civic
Art was relieved of any further participation in
the selection of pictures for the annual grant. No
doubt the minister delighted in keeping the con-
troversial paintings in the collection; Browne's
Night Pale Queen and Brownell's *Frosty
Morning* were on exhibit for years, until their
disappearance, at an unknown date, from the
inventory of the Normal School in Toronto.

Upon the demise of the Guild of Civic Art,

George Chavignaud, *Fishing Boats, Heyst-sur-Mer*

another committee was charged with the selection of pictures for the Education Department's collection. This new body, referred to as the Education Department's Special Committee, consisted of one government representative, one O.S.A. member and two, or sometimes three, laymen appointed by the society. Rules governing the actual selection of works of art, however, remained unchanged. This committee functioned from 1908 to 1912, beset, as one comes to expect, with controversies.

In 1908, their first selections were heavily criticized by *The Canadian Magazine*'s art writer:

This year eight pictures were bought for the Provincial Art collection. They certainly were a bargain. Think of it: eight pictures of Provincial importance for $1,000. Presumably the purpose of the appropriation by the Government is to encourage art, but surely it is no encouragement to an artist who paints a picture of sufficient importance to hang in a Provincial gallery and then receives only seventy-five or a hundred dollars for it. . . . The trouble seems to lie in the fact that the

J.E.H. MacDonald, *By the River, (Early Spring)*, 1911

Government has put no limit on the number of pictures that may be bought for their thousand dollars, and also in the fact that the committee seems to think that it is necessary to give, at least, quantity.[12]

The basis of this criticism is not unfamiliar; however, it is difficult to evaluate the critic's comments as so many of the works selected are lost — including C.W. Jefferys' significant canvas *Autumn on the Prairies*. The most expensive picture selected by this new committee was F. McGillivray Knowles' *In Time of Peace*, sold for $300, which is still in the collection.

In 1909, the Ontario Society of Artists again suggested, as they had two years previously, that their exhibition at the Provincial Art Gallery in

the Normal School be abolished inasmuch as the limitations of the grant placed too great a strain on the society. They also suggested that the grant be increased in order to allow selections to be purchased from the society's annual exhibits and from the Canadian Art Club, which had been founded in 1907. No action was taken by the government and the society decided that now, at least, the current rules governing selections be respected. In fact, the established procedures remained in effect until the entire program came to an abrupt halt in 1912.

Despite the turmoil, selections continued to be made: that year, 1909, George Chavignaud's *Fishing Boats, Heyst-sur-Mer* and J.W. Beatty's *On the Moors, Laren (North Holland)* were pur-

C.W. Jefferys, *Wheat Stacks on the Prairies*, 1907

chased, the latter receiving accolades from the art press: ''and this time his Dutch scenes are among the most pleasing and interesting on view.''[13]

Better still perhaps were the ''Ballot Pictures'' chosen by the society's membership in 1911. Luckily, both are still in the collection: J.E.H. MacDonald's *By the River (Early Spring)* and Herbert Palmer's *In the Grand Valley*. These two paintings prefigure the advent a few years later of the Group of Seven, of which MacDonald was a founding member.

For the $800 annual grant that same year the minister's committee selected only two works from the society's annual exhibition: the J.W. Beatty oil *Early Autumn*, now lost, and *The*

Herbert S. Palmer, *In the Grand Valley*

Paintings on the stairs, Educational Museum, Toronto Normal School

Educational Museum, ''Room E,'' Toronto Normal School, *c.* 1907. Identifiable paintings on the wall are, from left to right, portrait of *The Hon. John Sandfield Macdonald*, portrait of *Mrs. Peak*, both now lost, and portrait by A.D. Patterson of *The Hon. George Ross*; and below, William Cutts' *Squally Weather in the Channel*, and plaster casts of *Boy Extracting Thorn* (see p. 23) and Canova's *The Three Graces.*

Castle by the Sea, a watercolour by W. St. Thomas Smith.

None of the pictures selected in 1912 remain in the collection. Two very significant selections were made, however: J.E.H. MacDonald's *Morning Shadows* and J.W. Beatty's *Fishing Boats, North Sea*, and both were donated in 1972 to the Art Gallery of Ontario. It does appear that in anticipation of the end of the agreement to purchase works for the collection, the government allocated an extra $1,000 to purchase four additional paintings. These were selected from the society's final exhibition at the Normal School's Provincial Art Gallery. The only one to have survived is C.W. Jefferys' *Wheat Stacks on the Prairie*. This work had, in fact, been shown five years earlier at the 35th Annual O.S.A. exhibit and it was then described by *The Canadian Magazine* as a painting that ''every Westerner simply gloats over.''[14]

The reasons for the government's sudden decision to cancel the $800 allotment and the annual ''Ballot Picture'' selection are still unknown. It may have been the result of increasing dissatisfaction on the part of the Department of Education in its dealings with the Ontario Society of Artists. That year, 1912, the minister also decided to close the Provincial Art Gallery; again the reason is not known but in all likelihood it was because the Provincial Art Gallery would become redundant when the Art Museum of Toronto opened that year.

By 1912 a fairly substantial collection had been amassed. The catalogue of the museum published in 1905 gives a clear picture of the collection and how it was displayed on the top floor of the Normal School. Seven galleries had been given over to the exhibition of the collection — both the contemporary permanent collection and the copies of Old Master paintings and plaster casts acquired by Ryerson. The displays in each of these galleries were eclectic: Old Masters, large statuary, contemporary works, portrait busts and showcases with medals, seals and other artifacts acquired by Ryerson and Hodgins. Most of the plaster busts of statesmen were displayed in the corridors, probably serving to complement Ryerson's collection of busts of

"famous men of all ages."

The varied nature of the items displayed in the Museum galleries makes it somewhat difficult to provide a stylistic overview of the whole collection. Although most major Ontario artists, active prior to the formation of the Group of Seven are represented, the quality of the works collected is uneven. The continual change of the selection-committee structure from 1895 on may be a reason for this variation. Without a consistent overview it would have been difficult for committee members to select works to fill gaps. Hence the collection is a curious mixture of trends and styles popular in the province during those early years. The other factor contributing to the difficulty in establishing a true picture of the collection as it was developed in those years was the decentralization, beginning in 1912, of the collections to the provincial Normal Schools. It was after this time, and no doubt as a consequence of that measure, that the vast majority of works went missing.

Decentralization involved not only the contemporary works from the permanent collection but also the copies of Old Masters which had been on exhibit at the Normal School since 1857. From 1875 to 1909 additional Normal Schools had been opened in Ottawa, Hamilton, Peterborough, London, Stratford, and North Bay. It was to these schools that the works were sent. It is possible but unlikely that the motives for the decentralizing were altruistic; it is more likely that the intent was strictly educational. In either event the works no doubt served simply as decoration for the walls of the Normal Schools.

In 1912, each school received an average of twenty-two copies of Old Master paintings from the Ryerson collection and an average of fifteen works from the collection by Ontario artists. Assisting the Department of Education in the distribution of these works was the President of the Ontario College of Art, the artist George Agnew Reid. In 1946, Reid himself saw the distribution of the large collection of his own works donated to the province in 1944.

Florence Carlyle, *The Threshold*

In an effort to provide a full complement of those works sent to the provincial schools, and probably to provide one last gesture of support to the artists' society, the Department of Education purchased yet more works. These were acquired in 1913 and 1914 with the full intent that they be sent to the Normal Schools. A new selection committee was established to this end.

This new group was called the Minister of Education's Special Committee and special they must have been, for they made some spectacular selections. In 1913, Florence Carlyle's *The Threshold* was selected and received good reviews in the local press. More important, however, were the selection of Tom Thomson's *Northern Lake*, now in the collection of the Art Gallery of Ontario, and Arthur Lismer's *The Clearing*. These paintings were among the seven selected from the O.S.A.'s annual exhibition. A

Arthur Lismer, *The Clearing*, 1913

Marc Aurèle Suzor-Coté, *The River Magog*, 1913

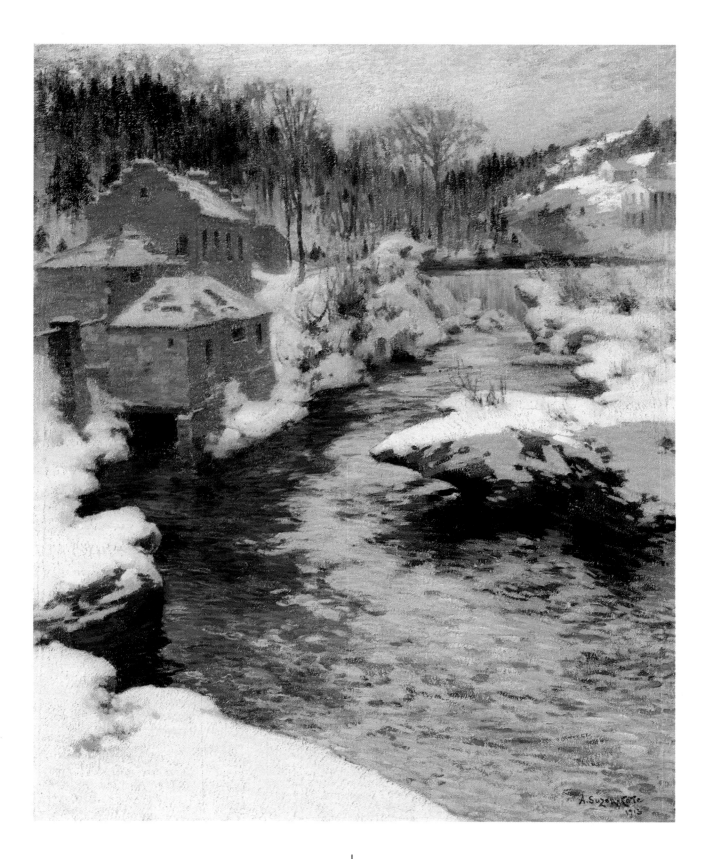

total of $1,325 was spent by the Department. In addition, five works were selected from the 6th Annual Exhibition of the Canadian Art Club, for a sum of $1,150.

The last selections were drawn from the O.S.A.'s 42nd Annual Exhibition of 1914. Eleven pictures were chosen for distribution to the Normal Schools for which $2,125 was spent. The most important of these, and the only one which still remains in the collection today, is Marc Aurèle de Foy Suzor-Coté's *The River Magog*.

The year 1914 marked a 52-year halt to the government's commitment to consistent purchases of works of art for a provincial collection. Except for works acquired from time to time from dealers and the commissioned official portraits and statuary, nothing was added to the collection until 1966, when the "art-in-architecture" policy, established for the commissioning of contemporary works of art for new government buildings, reinstated systematic collecting practices of the government.

After 1912 when the collection was decentralized, few records were kept.[15] By the late 1970s, just after the closing of all the Normal Schools, when the cataloguing program began, most of the distributed works had vanished. Those remaining from the Peterborough Normal School were donated by the province to form the nucleus of the collection of the Art Gallery of Peterborough,[16] opened in 1973. The two Old Master copies and ten Canadian works which survived from the North Bay Normal School were given to Nipissing University College in 1974.[17] Only two Old Masters from the Ottawa Normal School survived, and only one Canadian work was located. These and the few examples which had survived the 1953 fire at the Hamilton Normal School were returned to Queen's Park. A fair number survived from the Stratford Normal School, which was closed in 1973. These, which included only two Old Master copies and eleven Canadian works, were returned for public exhibit at Queen's Park in 1978. In the London Normal School, closed in 1973, only one Old Master copy survived and no Canadian works were found.

A number of works from both the Ryerson and the "contemporary" collection must have remained in the Normal School in Toronto. When the school was finally closed in 1941 and re-located to Pape Avenue in Toronto, approximately 54 of the remaining Old Masters were sent to the Legislative Building for display until, in the late 1950s, they were relegated to storage. In 1977, at the inception of the cataloguing project, only eleven of these were found. A few were located in 1979 in the wet basement of the Toronto Teachers' College (Pape Avenue) and were placed in Queen's Park when the school closed for good.

At the Educational Museum, in 1912, the casts were still there, and save for a few paintings remaining as part of the small collection for the Toronto Normal School, the museum was once again taking on an increased natural history flavour. Since the arrival of David Boyle as curator in 1897 and during his tenure as Superintendent of the Museum from 1905 to 1911, the collections were becoming increasingly scientific in character with archaeological, zoological, and geological additions being made. No catalogue of the art collection was compiled after 1905. However, Boyle produced a few on the other collections housed at the Museum.[18] One might conclude that the museum had gone full circle — from its creation as a museum of natural history in 1853 through the cycle of the fine arts from 1855 to 1912 and back to its original intent. It would continue this last phase until it closed in 1933.

In 1933 the Provincial Museum of Ontario, as it had been renamed, closed to the public for good. A special committee was appointed by Premier George Henry to determine the distribution of the contents of the Provincial Museum. The Provincial Archivist, Colonel A. Fraser, chaired the committee. Other members were Charles Trick Currelly, the Ontario-born egyptologist, representing the Royal Ontario Museum, Fred Haines, for the Ontario College of Art, and Mr. R.E. Virtue, for the Provincial Museum.

It was recommended that all material of an archaeological nature and those specimens of a zoological, geological, mineralogical, and palaeontological nature go to the Royal Ontario Museum, established in association with the University of Toronto in 1913, which had better staff and better facilities to manage and display collections of that nature. The botanical collection was to be placed in the Botany Department of the University of Toronto. All items of an "artistic" nature were to be placed in the custody of the Ontario College of Art; by then these were primarily Ryerson's plaster casts and a few stuffed birds. Some remaining models of plaster portrait busts were to go to the Archives of Ontario, along with some pictures. Some of the military items were to be placed in Fort George at Niagara-on-the-Lake, and a few casts of classical busts were to be given to McMaster University in Hamilton. The recommendations received approval and an Order-in-Council was signed by Lieutenant Governor the Hon. Dr. Herbert Bruce on May 12, 1933.[19]

What happened to all of these? By the 1970s no records remained of the collection given to the ROM. Apparently, Dr. Currelly had a tendency to commit facts to memory rather than to paper and it is likely that some items were absorbed into the existing collections of the museum without reference to their origins.[20] A few of the military weapons remain in the collection at Fort George, but no records were found as to the whereabouts of the busts sent to McMaster University. As to the casts received by the Ontario College of Art, only one — a fragmented hand acquired by Ryerson in Europe in 1855-56 for use in drawing classes — remains today. In the mid-1970s there were still fifteen plaster casts at the Ontario College of Art. All, except for the hand, have now disappeared. Only four of the casts which must have been retained by the government remain — *Cato*, *Faustina*, *Disraeli*, and the *Venus de Milo*. These four are

the remaining legacy of the more than 1,000 examples purchased by Ryerson and Hodgins in the last century. Of the 236 paintings acquired by Ryerson only twenty-four are today in the collection; of the several hundred works by contemporary artists acquired between 1875 and 1914 only forty are presently in government hands. The distributions of 1912 and 1933 serve as the visible end of what had been the province's first public museum. All that remained when the Normal School was relocated from St. James Square were the Chief Superintendent's desk and chair. These last vestiges are preserved today at the new school erected on the old site — Ryerson Polytechnic Institute.

The story of the Ryerson and O.S.A. collections was partially redeemed through the rediscovery, in the 1970s, of what remains of the once vast assemblage of works that was at the centre of the development of aesthetic life in Ontario. Centralized now for public exhibit, the skeletal remains of Ryerson's original vision repose in historic juxtaposition to the official portraits, busts, and statuary that became the focus of the next phase of government patronage of the visual arts.

Fragment of a hand used for drawing classes, acquired by Dr. Ryerson *c.* 1855

Carl Ahrens, *Ripe Corn Time, c.* 1895

Carl Henry von Ahrens,
O.S.A., A.R.C.A.

Born: Winfield, Canada West,
15 February 1862

Died: Toronto, Ontario,
27 February 1936

Ripe Corn Time *c.* 1895
Oil on canvas, 64.8 x 80 cm/
25½ x 31½"
Signed: (l.l.) Carl Ahrens
Purchase from the artist, 1896.
MGS 619806

This work was exhibited at the 16th
Annual R.C.A. Exhibition (Toronto)
1895 (cat. no. 1). *Public Accounts*
indicate that the Committee of the
House for Art Purposes acquired it in
1896. It probably was painted in New
York, where Ahrens had been sent by
Lucius O'Brien to study under William
Merritt Chase and Edwin Elwell in the
mid-1890s. Ahrens' principal influence
during this period was the Hudson River
School landscape painter, George Inness,
whose studio he visited.

William Armstrong, A.R.C.A.

Born: Dublin, Ireland, 28 July 1822
Died: Toronto, Ontario, 8 June 1914

Untitled [*Fort William*] 1872
Watercolour on paper, 42.8 x 66 cm/
16⅞ x 26"
Signed and dated: (l.r.) Armstrong '72.
MGS 692672

Armstrong emigrated to Toronto in 1851
and sketched and worked around lakes
Huron and Nipigon in the 1850s and
60s. During 1870-71 he accompanied
Col. Garnet Wolseley's expedition to
quell Riel's Red River Rebellion, acting
as chief engineer with the rank of
captain. Engravings based on his
drawings and watercolours of the North-
West were published in *Canadian
Illustrated News* in 1870, '71 and '72.

Other treatments of Head-of-Lake-
Superior scenery by Armstrong, usually
featuring (as in this watercolour) Mount
McKay and Thunder Cape, are in the
Public Archives Canada, Ottawa, and
the Royal Ontario Museum Canadiana
Collection, Toronto.

*Jacques Cartier in Canada
(1 July 1534)* 1875
Watercolour on paper, 51.4 x 72.4 cm/
20¼ x 28½"
Signed and dated: (l.r.) Armstrong '75.
MGS 619741

No purchase records have yet been
found for this work which until recently
was known as *Jacques Cartier on the
Way to Hochelaga.* However,
Armstrong's watercolour appears to be
derived from a print by Etienne David
published in 1862 in Paris by Lemercier
of a painting by the French marine artist
Baron Jean-Antoine-Theodore Gudin
(1802-1880) entitled *Voyage de J. Cartier
en Canada (1 July 1534).* Gudin, who
never visited North America, would
likely have copied from an existing
work, interpreting an incident occurring
in 1534 during Cartier's first voyage to
Canada.

Artist unknown

Untitled 1897
Pastel on paper, 32.4 x 49.8 cm/
12¾ x 19⅝"
Initialed and dated: (l.r.) N. W. '97
Gift of Mr. and Mrs. D. B. Sutherland to
the Ontario Heritage Foundation, 1983;
on loan to the Government of Ontario.
MGS 632976

An early view, looking northward along
a then tree-lined University Avenue in
Toronto, toward the red sandstone
façade of the Legislative Building
which had been completed in 1893.

Artist unknown

Untitled
Oil on canvas, 52.1 x 41.9 cm/
20½ x 16½"
Initialed: (l.r., superimposed letters)
S.M. [or M.S.]
MGS 605055

The young woman depicted in this
portrait has not yet been identified.

Artist unknown

Village Politicians
(after Sir David Wilkie, R.A., British,
1785-1841)
Engraving; 47 x 57.2 cm / 18½ x 22½"
(sight), 41.9 x 55.9 cm / 16½ x 22"
(image)
Inscribed: (l.l.) DAV. WILKIE RA
PINXIT; (l.c.) VILLAGE POLITICIANS /
To the Right Honourable The Earl of
Mansfield, this Engraving from the
Original Picture in his Lordship['s]
Possession is respectfully dedicated;
(l.r.) A RAIMBACH & C / Second Plate.
MGS 620502

This work may have entered the
collection around 1956 as a gift of
Sigmund Samuel. Wilkie's *Village
Politicians* was exhibited in 1806 at the
Royal Academy, after which it was
acquired by Lord Mansfield. Wilkie's
travelling companion during an 1814
tour of The Netherlands was the English
engraver Abraham Raimbach
(1776-1843), whose company had
published this print of Wilkie's painting.

Artist unknown, *Untitled*, 1897

William Edwin Atkinson,
O.S.A., A.R.C.A.
Born: Toronto, Canada West,
22 March 1862
Died: Toronto, Ontario,
2 August 1926

Indian Summer Evening, Normandy
1899
Watercolour on paper, 38.7 x 27.9 cm /
15¼ x 11"
Signed and dated: (l.l.) W. E. Atkinson '99
Inscribed: (verso) "Indian Summer
Evening" Normandie; (circular stamp,
verso) W. E. Atkinson — 30 Ferry
Terrace, Plymouth.
MGS 622080

Atkinson painted in Holland, Belgium
and Devonshire, England from 1898 to
1901. A watercolour titled *Indian
Summer* was exhibited at the 32nd
Annual O.S.A. Exhibition (Toronto),
1904 (cat. no. 1), but no records have yet
been found to substantiate its purchase
at that time by the Government. The
work was on loan to the Stratford
Normal School from 1912 and was
returned to Queen's Park in 1978.

William Atkinson, *The Old Town, Brittany, Night Effect*, 1913

William Armstrong, *Jacques Cartier in Canada (1 July 1534)*, 1875

October 1904
Oil on canvas, 74.3 x 99.7 cm /
29¼ x 39¼"
Signed and dated: (l.l.) W. E. Atkinson
1904
Purchase from the artist, 1904.
MGS 619831

Purchased from the 32nd Annual O.S.A.
Exhibition (Toronto), 1904, (cat. no. 2)
as part of the Toronto Guild of Civic Art
Committee selection for the $800
Annual Grant. The composition of
October is essentially the same as that
of *Indian Summer Evening, Normandy*,
dated 1899, except that the vertical
format has been converted into a
horizontal arrangement, with the same
flock of sheep now appearing in the
lower left-centre sector of the canvas.

*The Old Town, Brittany, Night
Effect* 1913
Oil on canvas, 45.7 x 58.4 cm / 18 x 23"
Signed and dated: (l.l.) W. E. Atkinson
1913
Purchase from the artist, 1913.
MGS 622038

Purchased from the 6th Annual
Canadian Art Club Exhibition (Toronto),

1913, (cat. no. 4), by the Minister of
Education's Special Committee. It was
sent to the Hamilton Normal School in
1913 and was returned to Queen's Park
in 1979.

Archibald George Barnes,
O.S.A., R.C.A., O.I.P.

Born: London, England,
19 March 1887

Died: Toronto, Ontario,
18 November 1972

*Building a Squared Pine Timber Raft,
1881*
Oil on canvas, 59.7 x 90.2 cm /
23½ x 35½"
Signed: (l.l.) BARNES
Gift of Mr. George William Rayner,
M.E.I.C. MGS 622073

This canvas is based on a photograph by
Ottawa photographer William James
Topley of cookery on J. R. Booth's raft,
c. 1880 (PAC). The painting's title was
derived from an old label on the frame.
J. R. Booth (1826 - 1925) was the greatest
of the Ottawa River timber and lumber

barons, earning the title "King of the
Ottawa." A raft of the type depicted by
Barnes might consist of 100 "cribs," logs
tied together sideways with chains and
at the end by cap pieces. "Sweeps,"
oars, were used to steer the cribs. Sails
were hoisted in favourable weather.
Rafts were manned by "river men" or
"*draveurs*," who lived on board them
during the drive from the upper Ottawa
to the timber coves at Quebec. The
crews slept in small cabins; food was
prepared on a sand-floored open fire in a
"camboose" built on one of the cribs.

The rafts were broken up at Quebec
and the timber piled in the buyers' coves
to await shipment to Europe. The last of
the square-timber rafts was assembled in
1908 by J. R. Booth and was sent down
the Ottawa to commemorate the
tercentenary of Quebec.

Ontario Sportsman
Oil on canvas, 127 x 101.6 cm / 50 x 40"
Signed: (l.l.) BARNES
Gift of the artist, 1963. MGS 624439

The donation was made through the
Ontario Institute of Painters for hanging
in Ontario House, London, England; it
was returned to Toronto in 1980.

Francesco Bartolozzi, R.A.

Born: Florence, Italy, 1725

Died: Lisbon, Portugal, 1815

*Esq. Thornhill persuades Olivia to
Elope with him* 1787
(after Johann Heinrich Ramberg,
German, 1763-1840)
Stipple engraving; 36.8 x 33 cm /
14½ x 13" (sight), diameter 29.2
cm / 11½" (image)
Inscribed: (l.l. to l.r., below tondo) H.
Ramberg Invt. et Delt. F. Bartolozzi. RA.
Sculpt.
Inscribed and dated: (l.l. to l.c.) ESQR.
THORNHILL perswades OLIVIA to
Elope with him.; (l.c. to l.r.)
MONSIEUR THORNHILL persuade à
OLIVE de s'echapper avec lui; (l.c.) Vide
Dr. Goldsmiths Vicar of Wakefield. Voll.
1. Chap. 17. / London. Pub.d August 1.
1787. by Jas Birchall. N°. 473 Strand.
MGS 632700

Pietro Barucci

Born: 20 April 1845

Died: 1921

Untitled 1874
Oil on canvas, 74.9 x 100.3 cm/
29½ x 39½"
Signed and dated: (l.l.) P. Barucci 1874
Inscribed (l.l.) / ROMAS
Purchase, 1902. MGS 619846

John William Beatty, O.S.A., R.C.A.
Born: Toronto, Ontario, 30 May 1869
Died: Toronto, Ontario,
10 October 1941

Evening on the Seine, Near Paris
1903
Oil on canvas, 50.8 x 66 cm/20 x 26"
Signed and dated: (l.l.) J. W. BEATTY 03
Purchase from the artist, 1903.
MGS 622065

Purchased from the 31st Annual O.S.A.
Exhibition (Toronto), 1903 (cat. no. 7) as
part of the Toronto Guild of Civic Art
Committee Selection for the $800
Annual Grant. It was on loan to the
Stratford Normal School from 1912 to
1978, when it was returned to Queen's
Park. Beatty studied in Paris at the
Académie Julian under Jean Paul
Laurens and Jean Joseph Benjamin
Constant in 1900, returning to Toronto
in 1901. This work is undoubtedly based
on a sketch, possibly a watercolour,
made during his Parisian sojourn.

On the Moors, Laren, N.H. [*North
Holland*] 1909
Oil on canvas, 69.9 x 82.6 cm/
27½ x 32½"
Signed and dated: (l.l.) J. W. BEATTY
'09
Purchase from the artist, 1910.
MGS 622063

Purchased from the O.S.A. Normal
School Exhibition (Toronto), 1909-10
(cat. no. 4) as part of the Department of
Education's Special Committee
selection for the $800 Annual Grant. It
was on loan to the Stratford Normal
School from 1912 to 1978, when it was
returned to Queen's Park.

The work was painted during Beatty's
second stay in Europe, from 1906 to
1909, during which he studied at the
Colarossi, the Académie Julian, and
several other schools in Paris, and at the
Chelsea Polytechnic in London, under
E. Borough Johnson. Illustration jobs

Archibald Barnes, *Building a Squared Pine Timber Raft, 1881*

provided by an expatriate Canadian, A.
A. Martin, co-founder of London's
Carlton Studios, allowed Beatty to
continue his European travels.

Upon his return to Toronto, Beatty
sketched in Algonquin Park (1910), after
which he concentrated almost
exclusively on the painting of Canadian
scenery, as did Tom Thomson and the
Group of Seven in following years.

Frederick Marlett Bell-Smith,
O.S.A., R.C.A.
Born: London, England,
26 September 1846
Died: Toronto, Ontario,
23 June 1923

In England in the summer of 1895, F. M.
Bell-Smith obtained a personal sitting
with Queen Victoria. Both his portrait
of the Queen, and a slightly later canvas
recording the sitting itself and titled *The
Artist Painting Queen Victoria* (c. 1897),
are now in the collection of the National
Gallery of Canada. Bell-Smith returned
to London in 1897 to record the
pageantry of Queen Victoria's Diamond
Jubilee, and other subjects as well, such
as London's famous Westminster Bridge.

Archibald Barnes, *Ontario Sportsman*

J.W. Beatty, *Evening on the Seine, Near Paris*, 1903

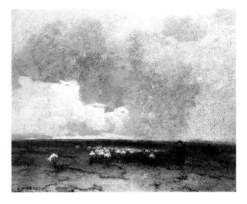

J.W. Beatty, *On the Moors, Laren, N.H. [North Holland]*, 1909

In the Woods 1898
Watercolour on paper, 63.5 x 45.7 cm / 25 x 18"
Signed and dated: (l.l.) W. D. Blatchly 1898.
MGS 692607

This work was exhibited in the 18th Annual R.C.A. Exhibition (Toronto), 1898 (cat. no. 135), but no records have yet been found to establish its purchase by the government at that time.

Path to the Mill Race 1899
Watercolour on paper, 51.4 x 67.3 cm / 20¼ x 26½"
Signed and dated: (l.r.) W. D. Blatchly 1899.
MGS 692603

This work was exhibited at the 20th Annual R.C.A. Exhibition (Toronto), 1899 (cat. no. 154), but there are no records to substantiate its purchase by the government at that time.

Frederick Henry Brigden,
O.S.A., C.S.P.W.C., R.C.A.
Born: London, England,
9 April 1871
Died: Bolton, Ontario,
24 March 1956
President, C.S.P.W.C. 1926-28

An Upland Pasture c. 1903
Watercolour on paper, 52.7 x 71.1 cm / 20¾ x 28"
Signed: (l.l.) F.H. BRIGDEN
Purchase from the artist, 1903.
MGS 609960

Arrival of Queen Victoria at St. Paul's on 22 June 1897 1897
Watercolour on paper, 23.5 x 33.7 cm / 9¼ x 13¼"
Signed and dated: (l.l.) F. M. Bell-Smith. 97.
Purchase, 1897. MGS 692617

This work is part of a sequence of watercolours depicting Her Majesty's progress through the streets of London. Bell-Smith focuses attention on the Queen's ceremonial coach as it draws up before the crowded steps of the great cathedral.

Westminster Bridge c. 1897
Oil on canvas, 61 x 46 cm / 24 x 18⅛"
Signed: (l.l.) F. M. Bell-Smith.
Purchase from the artist, 1898/99.
MGS 622111

Purchased from the O.S.A Normal School Exhibition (Toronto), 1898/99 (cat. no. 55), as part of the Education Department Committee selection for the $800 Annual Grant. The work was on loan to the Stratford Normal School from 1912 and was returned to Queen's Park in 1978.

William Daniel Blatchly, O.S.A.
Born: England, 1838
Died: Toronto, Ontario, 1903

Untitled 1897
Watercolour on paper, 66 x 52.1 cm / 26 x 20½"
Signed and dated: (l.l.) W. D. Blatchly 1897.
MGS 692604

A Quiet Pool 1898
Watercolour on paper, 64.1 x 45.7 cm / 25¼ x 18"
Signed and dated: (l.r.) W. D. Blatchly 1898
Purchase from the artist, 1898.
MGS 622112

Purchased from the 26th Annual O.S.A. Exhibition (Toronto), 1898 (cat. no. 123) as a "Ballot Picture." A line reproduction was reproduced in James Mavor's *Notes on Appreciation of Art and on Art in Ontario with remarks on the Ontario Society of Artists MDCCCXCVIII* (Toronto: George N. Morang, 1898).

Purchased from the 31st Annual O.S.A. Exhibition (Toronto), 1903 (cat. no. 128) as a "Ballot Picture."

Sunset Glow *c.* 1904
Watercolour on board, 49.5 x 72.4 cm/
19¹/₂ x 28¹/₂"
Signed: (l.r.) F. H. BRIGDEN.
Inscribed: (u.c., verso) Sunset Glow/
F. H. Brigden
Purchase from the artist, 1904.
MGS 619848

Purchased from the 32nd Annual O.S.A. Exhibition (Toronto), 1904 (cat. no. 146) as part of the Toronto Guild of Civic Art Committee selection for the $800 Annual Grant. A graphite sketch of the same subject appears on the reverse.

Newtonbrook Pastures
Oil on canvas, 59.7 x 74.9 cm/
23¹/₂ x 29¹/₂"
Signed: (l.r.) F. H. BRIGDEN
MGS 619847

Brigden sketched in the area of the valley of the upper Don River near Newtonbrook, north of Toronto, in 1913. In 1921 he moved into "Valley View," a small cottage in the area, and lived there until his death in 1956. The countryside has now been completely developed as part of the city of North York.

Peleg Franklin Brownell,
R.C.A., O.S.A.
Born: New Bedford, Massachusetts, U.S.A., 27 July 1857
Died: Ottawa, Ontario, 15 March 1946

Percé Rock
Oil on canvas, 50.2 x 52.1 cm/
19³/₄ x 20¹/₂"
Signed: (l.l.) F. brownell
Inscribed: (verso) F. brownell, R.C.A.
MGS 623329

This work was on loan to the Ottawa Normal School from 1912 and was returned to Queen's Park at an unknown date.

Fishing Boats – Percé 1912
Oil on canvas, 38.6 x 53.2 cm/
15³/₁₆ x 20¹⁵/₁₆"
Signed: (l.r.) F. Brownell
Dated: (verso) –12
Inscriptions: (verso) JF b – R.C.A. – 12
MGS 622098

Frederick Bell-Smith, *Arrival of Queen Victoria at St. Paul's on 22 June 1897*, 1897

This work was on loan to the Stratford Normal School from 1912 and was returned to Queen's Park in 1978.

William Brymner, O.S.A., R.C.A.
Born: Greenoch, Scotland, 14 December 1855
Died: Wallasey, Cheshire, England, 18 June 1925
Honours: C.M.G.

Ottertail Range 1894
Oil on canvas, 137.2 x 243.8 cm/
54 x 96"
Signed and dated: (l.l.) Wm. Brymner 1894.
MGS 619850

William Brymner first travelled to western Canada via the newly completed Canadian Pacific Railway in May 1886, to visit the Blackfoot Indian reservation at Gleichen, in what is now southern Alberta. In the spring of 1886, Sir George Stephen, president of the C.P.R., and Sir William Van Horne, who succeeded Stephen as president in 1888, decided to encourage painters to explore the newly accessible scenery of the

Rocky Mountains, which were regarded as being C.P.R. territory. The painters who accepted their initial offer of free passes were John A. Fraser, Lucius O'Brien, Robert F. Gagen and Brymner.
Brymner and John Hammond worked in the mountains in the summer of 1892 (concentrating on the Lake Louise vicinity). *Ottertail Range* would have been worked up in Brymner's Montreal studio from field-notes made on the site.

This work belongs to the second major phase of Rocky Mountain landscapes, being painted in oils rather than in the watercolour medium preferred by Matthews, Fraser, O'Brien and Gagen, executed on a grander scale, and often painted on commission. There is yet no evidence to establish whether Brymner painted this work on commission to the railway or to a private client, or whether he did it on speculation. The Brymner oil might have been displayed in a C.P.R. hotel, as was, for instance, Cyrus Cuneo's *A Glengarry Settler*, and may have entered the government collection as a gift of the C.P.R.

The Ottertail Range is situated in what is now Yoho National Park, in southeastern British Columbia, south of Banff National Park. The Kicking Horse

William Blatchly, *Untitled*, 1897

William Blatchly, *In the Woods*, 1898

and Ottertail Rivers join just below the C.P.R. station of Otter, southwest of Field, B.C.

Bonsecours Church and Market
Watercolour on cardboard,
50.8 x 35.6 cm / 20 x 14"
Signed: (l.r.) W. Brymner
Purchase from the artist, 1913.
MGS 622084

Purchased from the 6th Annual Canadian Art Club Exhibition (Toronto), 1913, (cat. no. 23) by the Minister of Education's Special Committee. It was sent to the Stratford Normal School in 1913 and was returned to Queen's Park in 1978.

Notre-Dame de Bonsecours, the oldest church in Montreal, was built in 1657 and twice reconstructed following fires. Known as "The Seaman's Chapel" for its proximity to the harbour, the present chapel was erected in 1771, with alterations being made in 1885. The site of the modern Marché Bonsecours had been occupied by the palace of the French regime administrator between 1698 and 1798. The present market place, completed in 1852, was used as a City Hall and reception hall until 1878. Thereafter, the building was used exclusively as a market until 1964,

when it was converted into municipal offices.

John Burnet, F.R.S.
Born: Musselburgh, Midlothian, Scotland, 1784
Died: 1868

The Reading of a Will
(after Sir David Wilkie, R.A., British, 1785-1841)
Engraving; 46 x 61 cm / 18⅛ x 24"
(sight), 39.4 x 60 cm / 15½ x 23⅝"
(image)
Inscribed: (l.l.) Painted by David Wilkie, R.A.; (l.c.) THE READING OF A WILL; (l.r.) Engraved by John Burnet.
MGS 620501

This work may have entered the collection around 1956 as a gift of Sigmund Samuel. Burnet was a fellow-pupil with David Wilkie at the Trustees' Academy of Edinburgh, and in 1806 followed Wilkie to London, where he established his reputation as an engraver of other artists' works. Wilkie's *The Reading of the Will* was painted for the King of Bavaria between 1819 and 1822, and is now in the Neue Pinakothek, Munich.

Frederick Brigden, *Newtonbrook Pastures*

Florence Carlyle, O.S.A., A.R.C.A.
Born: Galt, Canada West, 17 September 1864
Died: Crawborough, Sussex, England, 7 May 1923

The Threshold
Oil on canvas, 100.7 x 80.4 cm / 39⅝ x 31⅝"
Signed: (l.l.) F. Carlyle
Purchase from the artist, 1913.
MGS 623839

Purchased from the 41st Annual O.S.A. Exhibition (Toronto), 1913 (cat. no. 22), by the Minister of Education's Special Committee. The work was sent to the Ottawa Normal School in 1913 and later transferred to Woodstock Collegiate, Woodstock, Ontario, where it remained on display until December 1975. According to records in the Woodstock Art Gallery, this canvas was painted in "Englewood," the Carlyle home on Wilson Street, Woodstock, in the summer of 1912. The model was a friend of the artist, Juliet Hastings.

George Chavignaud, O.S.A.
Born: near Brest, France, 24 September 1865
Died: Meadowvale, Ontario, 3 May 1944

Fishing Boats, Heyst-sur-Mer
Oil on canvas, 101.6 x 129.5 cm / 40 x 51"
Signed twice: (l.l.) George Chavignaud; (l.r.) G. Chavignaud
Purchase from the artist, 1909.
MGS 692885

Purchased from the 37th Annual O.S.A. Exhibition (Toronto), 1909 (cat. no. 24) by the Department of Education's Special Committee selection for the $800 Annual Grant. This work was on loan to the Ottawa Normal School from 1912 and was returned to Queen's Park at an unknown date.

The Brittany-born artist arrived in Toronto in 1884 but returned to Europe from time to time for travel and study. This work might have been produced during one of his visits to Belgium. In 1901 Chavignaud exhibited a water-

colour entitled *On the Sands near Heyst* at the 22nd Annual R.C.A. Exhibition (Toronto) (cat. no. 160).

Near Sluis 'The Dead,' Sunset Glow
1901
Oil on canvas, 39.4 x 54.6 cm / 15½ x 21½"
Signed and dated: (l.r.) G. Chavignaud 1901
Purchase from the artist, 1901.
MGS 605046

Purchased from the 29th Annual O.S.A. Exhibition (Toronto), 1901 (cat. no. 7) as part of the Toronto Guild of Civic Art Committee Selection for the $800 Annual Grant. Sluis (Zeeuwsvlaanderen) is a village in The Netherlands on the border with Belgium.

John Wesley Cotton, O.S.A.
Born: Simcoe County, Ontario, 29 October 1869
Died: Toronto, Ontario, 24 November 1931

Franklin Brownell, *Percé Rock*

William Brymner, *Ottertail Range*, 1894

Over the Marshlands, Dundas Valley
1916
Etching; 38.1 x 29.2 cm / 15 x 11½"
(sight), 34.9 x 27.3 cm / 13¾ x 10¾"
(image)
Signed and dated: (l.r.) J. Cotton / 16.
MGS 622149

The Dundas Valley runs west from the western tip of Lake Ontario, north of Hamilton. The subject of this etching is the marshlands of the Dundas Valley, visible from the Niagara Escarpment.

Jules Courtin

The Ambuscade
(after "Ortego")
Engraving; 50.8 x 59.7 cm / 20 x 23½"
(sight), 44.5 x 55.2 cm / 17½ x 21¾"
(image)
Signed: (l.r., in pencil) Jules Courtin
Inscribed: (l.l., on plate) Ortego 1874;
(l.l.) [drawing of two crossed swords].
MGS 622151

"Ortego" may be the Spaniard Francisco Javier Ortego y Vereda (c. 1833-1881), an illustrator and painter of genre and history subjects.

Parting Song　1890
(after Ferdinand Roybet, French, 1840-1920)
Engraving; 54 x 38.4 cm / 21¼ x 15⅛"
(sight), 47 x 33.7 cm / 18½ x 13¼"
(image)
Signed and dated: (l.r., on plate) J. Courtin 90; (in pencil) Jules Courtin
Inscribed: (l.l., on plate) F. Roybet 1883;
(l.l.) [musical staff with treble clef and notes].
MGS 622015

Cyrus Cincinatto Cuneo

Born: San Francisco, California, 1879
Died: London, England, 1916

A Glengarry Settler
Oil on canvas, 235 x 180.3 cm / 92½ x 71"
Signed: (l.r.) CYRUS CUNEO
Gift of the Canadian Pacific Railway.
MGS 605050

This work was presented by Edward Beatty, then President of the C.P.R., to Dr. Alexander Fraser, Provincial

Archivist of Ontario, at one of the Highland Gatherings sponsored by the Railway and held annually at Banff from 1927-1930. The Festival, and the painting itself, are indicative not only of the Scottish presence in Canada, but also of the C.P.R.'s complex role in western expansion. The C.P.R. campaigned actively to promote immigration to the recently opened Canadian west, and encouraged residents of eastern and central Canada to join the vast numbers of American, European and British homesteaders being carried to the prairies via the company's tracks.

The "Glengarry" in Cuneo's painting is Glengarry County in southeastern Ontario, on the north shore of the St. Lawrence River. It was first settled in 1784 by Roman Catholic Highlanders, and continued to draw emigrants from Scotland in the nineteenth century. Cuneo's *Glengarry Settler* was reproduced in colour in *Scots in Canada: A History of the Settlement of the Dominion from the Earliest Days to the Present Time* (London: Kegan Paul, Trench, Trubner and Co., 1911). The intention of the author, the C.P.R.'s director of advertising (1913-45), J. Murray Gibbon, was clearly to demonstrate the progress of the Scottish settlers in Canada by contrasting the crude husbandry of the Glengarry farmer with the up-to-date equipment of his self-sufficient successor in Saskatchewan.

Cyrus Cuneo, a native of San Francisco and a pupil of J.A.M. Whistler, had been a "special artist" for the *Illustrated London News* and other periodicals, working on commission from the Railway. In 1910-11 he also painted landscapes along the C.P.R. line between Calgary and Vancouver.

Gertrude Eleanor Spurr Cutts, O.S.A., A.R.C.A.

Born: Scarborough, Yorkshire, England, 1858
Died: Port Perry, Ontario, 21 July 1941

A Quiet Afternoon, Beaupré
Oil on canvas, 33 x 85.1 cm / 13 x 33½"
Signed: (l.l.) G. E. Spurr
Purchase from the artist, 1905.
MGS 622064

George Chavignaud, *Near Sluis 'The Dead,' Sunset Glow*, 1901

Purchased from the 33rd Annual O.S.A. Exhibition (Toronto), 1905 (cat. no. 124) as a "Ballot Picture." It remained at the Toronto Normal School and was returned to Queen's Park in 1979.

The Beaupré district of Quebec lies on the north shore of the St. Lawrence River, to the east of Quebec City. Its centre is Ste Anne-de-Beaupré.

Gertrude Spurr married painter and teacher William Malcolm Cutts in 1909.

The Vale of Tintern 1893
Oil on canvas, 34 x 49.2 cm /
13⅜ x 19⅜"
Signed and dated: (l.l.) G. E. Spurr 1893
Purchase from the artist, 1906.
MGS 622089

Purchased from the 34th Annual O.S.A. Exhibition (Toronto), 1906 (cat. no. 116) as part of the Toronto Guild of Civic Art Committee selection for the $800 Annual Grant.

The Vale of Tintern is situated in Monmouthshire, Wales, in the valley of the River Wye, and Tintern Abbey stands at the point where the Wye ceases to be tidal. The Abbey was founded in 1131 by Walter de Clare for the Cistercians, the monks of Citeau in France. Abandoned after Henry VIII's Act of Dissolution (1536), the roofless abbey stands by itself in a meadow beside the river. Its picturesque ruins were a favourite subject for the Romantic landscape painters of the nineteenth century.

A Surrey Heath 1898
Oil on canvas, 30.5 x 61 cm / 12 x 24"
Signed and dated: (l.l.) G. E. Spurr 1898
Purchase from the artist, 1898/99.
MGS 622103

Purchased from the O.S.A. Normal School Exhibition (Toronto), 1898/99 (cat. no. 58) as part of the Education Department Committee selection for the $800 Annual Grant.

William Brymner, *Bonsecours Church and Market, Montreal*

Cyrus Cuneo, *A Glengarry Settler*

William Malcolm Cutts,
O.S.A., A.R.C.A.

Born: Allahabad, India, 1857
Died: Port Perry, Ontario,
29 January 1943

Squally Weather in the Channel
Oil on canvas, 91.4 x 60.3 cm / 36 x 23¾"
Signed: (l.r.) W. Cutts
Purchase from the artist, 1902.
MGS 622034

Purchased from the 30th Annual O.S.A.
Exhibition (Toronto), 1902 (cat. no. 11)
as a "Ballot Picture." This work may
have been painted during one of Cutts'
trips to the Cornish coast of England,
the first of which occurred in 1902. It
was on loan to the London Normal
School from 1912 and was returned to
Queen's Park at an unknown date.

"Men May Come and Men May Go"
Oil on canvas, 50.2 x 61 cm / 19¾ x 24"
Signed: (l.r.) W. Cutts.
Purchase from the artist, 1906.
MGS 622035

Purchased from the 34th Annual O.S.A.
Exhibition (Toronto), 1906 (cat. no. 34)
as part of the Toronto Guild of Civic Art
Committee selection for the $800
Annual Grant. Its title is from "The
Brook," a poem by Alfred, Lord Tennyson:
"For men may come, and men may go,
But I go on forever."

Gertrude Spurr Cutts, *A Quiet Afternoon, Beaupré*

John Wycliffe Lowes Forster,
O.S.A., A.R.C.A.
Born: Norval, Canada West,
31 December 1850
Died: Toronto, Ontario, 24 April 1938

Plough Deep While Sluggards Sleep
Oil on canvas, 99.1 x 128.9 cm /
39 x 50¾"
Signed: (l.l.) J. W. L. Forster
MGS 623357

Although no purchase records have been
found, this work may have been
purchased from the 19th Annual O.S.A.
Exhibition (Toronto), 1891. It was
illustrated (cat. no. 8) in the catalogue of
that exhibition.

Daniel Fowler, O.S.A., R.C.A.
Born: Champion Hill, Surrey,
England, 10 February 1810
Died: Amherst Island, Ontario,
14 September 1894

Summer Has Come Again 1874/75
Watercolour on paper, 69.4 x 48.3 cm /
27⁵/₁₆ x 19"
Signed and dated twice: (l.r.) 1874 / D.
Fowler / D Fowler / 1875
Purchase from the artist, 1875.
MGS 619799

Purchased from the 3rd Annual O.S.A.
Exhibition (Toronto), 1875 (cat. no. 8).

William Cutts, *"Men May Come and Men May Go"*

Daniel Fowler, *Summer Has Come Again*, 1874/75

The double signature suggests that the painting may have been re-worked by the artist, and may in fact have been the watercolour exhibited at the 2nd Annual O.S.A. Exhibition (Toronto), 1874 (cat. no. 163) as *Lilacs*, the title under which the work was exhibited several times following its purchase by the Government of Ontario. However, the painting's correct identification as *Summer Has Come Again* was made by Fowler cataloguer Frances K. Smith, based on a marked copy of the 1875 exhibition catalogue and on a newspaper review of that exhibition (*The Globe*, Toronto, 5 May 1875).

Water Mill, near Berncastle on the Moselle 1876
Watercolour on paper, 77.1 x 61.6 cm/ 30³/₈ x 24¹/₄"
Signed and dated: (l.r.) D. Fowler/1876
Purchase from the artist, 1876.
MGS 692621

Purchased from the 4th Annual O.S.A. Exhibition (Toronto), 1876 (cat. no. 67). The water mill at Bernkastel-Kues on the Moselle River between Trier and Koblenz was a favourite subject for Fowler; it appears in three other versions: two dated 1837 and one dated 1892. Fowler would have sketched this landmark originally in June or July of 1837, during a sketching tour of the Rhineland and the Moselle Valley in what is now West Germany.

Amherst Island Works

Daniel Fowler first stayed on Amherst Island in 1843. His brother-in-law had already settled on this island south of Kingston, in Lake Ontario's Bay of Quinte, and Fowler himself eventually became a resident after purchasing a hundred acre farm, *The Cedars*. In 1857, on the eve of a visit to England, Fowler recommenced his painting career, which had lapsed since his move to the island.

Edge of the Woods 1882
Watercolour on paper, 47 x 68.6 cm/ 18¹/₂ x 27"
Signed and dated: (l.l.) D. Fowler / 1882.
MGS 622011

Beech Trees 1886
Watercolour on paper, 26.7 x 39.4 cm/ 10¹/₂ x 15¹/₂"
Signed and dated: (l.l.) D. Fowler / 1886.
MGS 692613

Head of Amherst Island 1890
Watercolour on paper, 28.3 x 38.7 cm/
11¹/₈ x 15¹/₄"
Signed and dated: (l.l.) D. Fowler / 1890.
MGS 619872

Probably the work exhibited in the 12th
Annual R.C.A. Exhibition (Toronto),
1891 (cat. no. 164) under this title. This
watercolour depicts the extreme western
end of the island, near where Fowler's
farm was situated.

John Arthur Fraser, O.S.A., R.C.A.
Born: London, England,
9 January 1838
Died: New York, New York,
U.S.A., 1 January 1898
Founding member, O.S.A.

Willow over Stream
Watercolour on paper, mounted on
cardboard, 34.3 x 35.6 cm/13¹/₂ x 14"
Signed: (l.r.) J A FRASER
MGS 692611

No purchase records for this work have
been located to date. Although undated,
it stylistically resembles the water-
colour landscapes Fraser produced
during his visit to England and Scotland
in 1888-89. It may be the watercolour
entitled *By the Meadow Stream* that he
showed at the 14th Annual R.C.A.
Exhibition (Montreal), 1893 (cat. no.
198) alongside another Fraser water-
colour, the government's *The Weird
House in the Moat* (cat. no. 199).

 Grey Weather and *Weird House* were
purchased from the 1897 Toronto
auction of Townsend and Co. by the
noted London, Ontario collector W.
Thompson Smith Jr., from whom they
were acquired by the Hon. George W.
Ross, Premier of Ontario (1899-1905).
The works were intended to be hung
together at Government House (King
and Simcoe Streets), Toronto, at the
request of the daughter of then
Lieutenant Governor Sir Oliver Mowat
(1897-1903).

Grey Weather in Haytime 1889
Watercolour on paper, 41.9 x 55.9 cm/
16¹/₂ x 22"
Signed: (l.r.) J A FRASER
Inscribed: (on label, verso) 1889
Purchase, 1900. MGS 694146

Fraser's handwritten label on the back of
this painting locates the scene near

Daniel Fowler, *Edge of the Woods*, 1882

Daniel Fowler, *Beech Trees*, 1886

J.A. Fraser, *Grey Weather in Haytime*, 1889

Chiddingstone Hoath in Kent, England. Chiddingstone Hoath and nearby Chiddingstone, Surrey are both reputedly named after the former's most famous feature, a great sandstone boulder known as the "chiding stone," said to be a Druidical seat reserved for nagging wives. The watercolour was still in the artist's possession as late as October 1897, when it was listed in the catalogue of the auction of Fraser's works held in Toronto at Townsend and Co. (cat. no. 5).

The Weird House in the Moat 1889

Watercolour on paper, 34.9 x 52.1 cm/
13³/₄ x 20¹/₂"
Signed: (l.l.) J A FRASER
Inscribed: (on label, verso) August 1889
Purchase, 1900. MGS 694145

This building is identified on a label attached to the back of the painting as Ightham Mote or Moot House, near Ightham, Kent. Originally built in the mid-fourteenth century, it is one of the few remaining moated manor-houses in England. The watercolour was shown at the World's Columbian Exposition in Chicago in 1893 (cat. no. 153).

Robert Ford Gagen,
O.S.A., R.C.A., C.S.P.W.C.
Born: London, England, 10 May 1847
Died: Toronto, Ontario, 2 March 1926
Founding member, O.S.A; Founding member, C.S.P.W.C., Honorary President, 1925-26

Fine Weather in Memphremagog's Hills 1897

Watercolour on paper, 45.1 x 63.5 cm/
17³/₄ x 25"
Signed and dated: (l.l.) R. F. GAGEN/
1897
Purchase from the artist, 1898/99.
MGS 619853

Purchased from the O.S.A. Normal School Exhibition (Toronto), 1898/99 (cat. no. 40) as part of the Education Department Committee selection for the $800 Annual Grant. This work was on loan to the Ottawa Normal School from 1912 and was returned to Queen's Park at an unknown date.

The subjects of this watercolour and of *Magog Hills* are the hills surrounding lakes Magog and Memphremagog, in Sherbrooke, Stanstead and Brome

counties in the Eastern Townships, Quebec.

Magog Hills 1898

Watercolour on paper, 91.4 x 71.1 cm/
36 x 28"
Signed and dated: (l.r.) R. F. GAGEN./
1898.
MGS 622079

On loan to the Ottawa Normal School from 1912, it was returned to Queen's Park at an unknown date.

The Vanguard of the Coast 1899

Watercolour on paper, 50.8 x 67.3 cm/
20 x 26¹/₂"
Signed and dated: (l.l.) R. F. GAGEN/
1899.
Purchase from the artist, 1899.
MGS 619859

Deep Sea Fishers 1902

Watercolour on paper, 54.9 x 74.9 cm/
21⁵/₈ x 29¹/₂"
Signed and dated: (l.r.) R. F. GAGEN./
1902
Purchase from the artist, 1903.
MGS 622108

Purchased from the 31st Annual O.S.A. Exhibition (Toronto), 1903 (cat. no. 152) as part of the Toronto Guild of Civic Art Committee selection for the $800 Annual Grant.

John Sloan Gordon, O.S.A., A.R.C.A.
Born: Brantford, Ontario, 6 July 1868
Died: Hamilton, Ontario,
13 October 1940

A Naiad

Oil on canvas, 67.9 x 91.4 cm/
26³/₄ x 36"
Signed: (l.l.) J. S. GORDON
Purchase from the artist, 1909.
MGS 623097

Purchased from the 37th Annual O.S.A. Exhibition (Toronto), 1909 (cat. no. 52) as a "Ballot Picture." It was on loan to the Ottawa Normal School from 1912 and was transferred to Hamilton in the 1950s until it was returned to Queen's Park in 1979.

Few paintings of nudes were made in the early twentieth century in Ontario because of restrictions in the name of "good taste." As a result, many artists chose mythological subjects, such as

this naiad or water-nymph, as an excuse for academic studies of nudes.

Clara Sophia Hagarty,
O.S.A., A.R.C.A.
Born: Toronto, Ontario, June 1871
Died: Toronto, Ontario,
18 January 1958

Flower Market, Paris 1900
Oil on canvas, 36.2 x 45.7 cm/
14¼ x 18"
Signed and dated: (l.r.) C. S. HAGARTY.
1900
Purchase from the artist, 1903.
MGS 622097

Purchased from the 31st Annual O.S.A.
Exhibition (Toronto), 1903 (cat. no. 44)
as part of The Toronto Guild of Civic
Art Committee Selection for the $800
Annual Grant. It was on loan to the
Stratford Normal School from 1912 and
was returned to Queen's Park in 1978.

A Dutch Interior 1906
Oil on canvas, 62.2 x 46.4 cm/
24½ x 18¼"
Signed and dated: (l.r.) Clara S. Hagarty
06
Purchase from the artist, 1907.
MGS 623992

Purchased from the 35th Annual O.S.A.
Exhibition (Toronto), 1907 (cat. no. 63),
as a "Ballot Picture." It was on loan to
the Ottawa Normal School from 1912
and was returned to Queen's Park at an
unknown date.
 Hagarty studied in Paris and Holland
in the late nineteenth century and is
reputed to have made a special study of
interiors. She returned to Toronto in
1899.

Attributed to **Clara Sophia Hagarty**
Untitled [*Portrait of a Woman*]
Oil on canvas, 52.1 x 41.9 cm/
20½ x 16½"
MGS 619869

No purchase records have been found to
indicate when and how this portrait was
acquired by the province.

John Hammond, O.S.A., R.C.A.
Born: Montreal, Canada East,
11 April 1843

J.A. Fraser, *The Weird House in the Moat,* 1889

Died: Sackville, New Brunswick,
10 August 1939
Honours: LL.D.

Jackfish Bay – Lake Superior 1894
Oil on canvas, 132.1 x 242.6 cm/
52 x 95½"
Signed: (l.r.) J. Hammond
Dated: (l.l.) 1894.
MGS 605058

The title of this work is derived from
information on a label originally affixed
to its frame. Jackfish Bay is on the north
shore of Lake Superior, between Mara-
thon on the east and Terrace Bay on the
west, with Jackfish Channel to the
south. The C.P.R. follows the coastline
closely around the bay.
 Hammond was one of the artists com-
missioned by Sir William Van Horne
(founder of the Canadian Pacific
Railway) to paint a number of large
murals and paintings depicting the
scenery of Western Canada and the
C.P.R.'s part in opening the West. This
painting, along with one by Brymner,
was probably part of the series and may
have entered the collection as a gift of
the C.P.R., as did the painting by Cyrus
Cuneo.

Clara Hagarty, *A Dutch Interior,* 1906

Robert Gagen, *Deep Sea Fishers*, 1902

Inscribed: (l.r.) copyright © 18
Gift of the Imperial Order of the
Daughters of the Empire, John G.
Howard Chapter, Toronto.
MGS 692623

James Hoch, O.S.A.
Born: St. Kitts, British West Indies,
7 November 1827
Died: Toronto, Ontario, 1 May 1878
Founding member, O.S.A.

Woodland Path
Watercolour on paper, 28.6 x 39.4 cm/
11¼ x 15½"
Signed: (l.r.) J. Hoch
MGS 619870

The subject of this watercolour may be
the countryside just outside Toronto.
Hoch taught art at Trinity College and
Bishop Strachan School, Toronto, and at
Whitby Ladies' College.

Herbert Hancock, O.S.A.
Born: 1830
Died: 1882

Untitled 1873
Oil on canvas, 67.3 x 120 cm/
26½ x 47¼"
Signed and dated: (l.l.) Hancock 1873.
MGS 619818

No purchase records have been found for
this work although its date might
suggest that it was purchased from the
1st Annual O.S.A. Exhibition (Toronto)
1873. A work entitled *Indian Summer,
Eastern Townships* was exhibited by
Hancock that year (cat. no. 69).
Hancock, an architect by profession,
specialized in Eastern Townships
landscapes and exhibited several views
of this picturesque area of Quebec in the
annual exhibitions between 1873 and
1877.

Arthur Merton Hazard
Born: North Bridgewater,
Massachusetts, U.S.A., 1872
Died: 1930

*Not Unto Death, But Life
Everlasting* 1918
Oil on canvas, 196.2 x 139.7 cm/
77¼ x 55"
Signed and dated: (l.l.) A. M. HAZARD
'18

Otto Reinhold Jacobi, O.S.A., R.C.A.
Born: Konigsberg, East Prussia,
27 February 1812
Died: Ardoch, North Dakota, U.S.A.,
8 February 1901
President, R.C.A. 1890-93

John Hammond, *Jackfish Bay — Lake Superior*, 1894

Rugged Chutes, Kaministiquia River
1888
Watercolour on paper, 48.3 x 73.7 cm/
19 x 29"
Signed, dated and inscribed: (l.r.)
O.R. Jacobi 1888 Rugged Schutes
Caministiquia R.
Purchase, 1896. MGS 622087

This work is recorded in *Public
Accounts* (1896) as "Logging Schute." It
was painted on the Kaministiquia River,
which flows from Dog Lake into Lake
Superior at Thunder Bay (formerly Port
Arthur).

Charles William Jefferys,
O.S.A., R.C.A., C.S.P.W.C.

Born: Rochester, Kent, England,
25 August 1869

Died: York Mills, Ontario,
8 October 1951

President, O.S.A. 1913-19; Founding
member, C.S.P.W.C.; President,
1928-31

Honours: LL.D.

Clara Hagarty, *Flower Market, Paris*, 1900

Wheat Stacks on the Prairies 1907
Oil on canvas, 58.4 x 88.9 cm/23 x 35"
Signed and dated: (l.l.) C. W. JEFFERYS
07
Purchase from the artist, 1912.
MGS 619864

Purchased from the O.S.A. Normal
School Exhibition (Toronto), 1912/13
(cat. no. 44) as part of the Department of
Education's Special Committee

selection. It was one of four additional
purchases made in 1912.

Painted during, or on the basis of,
sketches made in the course of Jefferys'
expedition in 1906 to the province of
Manitoba, it is part of a series of prairie
harvesting scenes begun in Manitoba
and continued in Saskatchewan in
1911. A companion piece is the now lost
Autumn on the Prairie of 1908,
purchased by the Government of
Ontario that year.

**Farquhar McGillivray Strachan
Stewart Knowles,** O.S.A., R.C.A.

Born: Elora, Canada West,
22 May 1859

Died: Toronto, Ontario, 9 April 1932

Notre Dame, Paris 1895
Oil on canvas, 58.4 x 63.5 cm/23 x 25"
Signed and dated: (l.l.) F. McGILLIVRAY
KNOWLES 1895
Purchase from the artist, 1896.
MGS 619867

Purchased from the 24th Annual O.S.A.
Exhibition (Toronto), 1896 (cat. no. 94)

Herbert Hancock, *Untitled*, 1873

Arthur Hazard, *Not unto Death, but Life Everlasting*, 1918

as a "Ballot Picture." Knowles went to Europe in 1891, studying in London for two years and then in Paris for four years under the instruction of Benjamin Constant, Jean Paul Laurens, Henri Gervais and Veir Schmidt at the Académie Julian. This work was shown on his return to Toronto at the O.S.A. Exhibition of 1896.

In Time of Peace 1907
Oil on canvas, 90.2 x 64.8 cm/
35¹⁄₂ x 25¹⁄₂"
Signed and dated: (l.l.) F. McGILLIVRAY KNOWLES 1907.
Purchase from the artist, 1908.
MGS 605047

Purchased from the 36th Annual O.S.A. Exhibition (Toronto), 1908 (cat. no. 69) as part of the Department of Education's Special Committee selection for the $800 Annual Grant. The exhibition review of 1908 gives the location for this harbour scene as Quebec City.

Arthur Lismer,
O.S.A., R.C.A., C.G.P.
Born: Sheffield, England,
27 June 1885
Died: Montreal, Quebec,
23 March 1969
Original member, Group of Seven,
1920
Honours: C.C., LL.D.

The Clearing 1913
Oil on canvas, 80.6 x 95.9 cm/
31³⁄₄ x 37³⁄₄"
Signed and dated: (l.l.) A. LISMER/'13
Purchase from the artist, 1913.
MGS 622110

Purchased from the 41st Annual O.S.A. Exhibition (Toronto), 1913 (cat. no. 56) by the Minister of Education's Special Committee. It was sent to the Stratford Normal School in 1913 and returned to Queen's Park in 1978.

 The Clearing appears to be a worked-up studio painting based on an oil sketch by Lismer entitled *Clearing, York Mills* and dated 1913 (John T. Band Collection, Toronto). Both paintings were done within two years of Lismer's arrival in Canada from England and just prior to his first discovery of the north. According to the artist's biographer, John A.B. McLeish (*September Gale: A Study of Arthur Lismer and the Group of*

Seven, 1955) Lismer had painted this work while sketching with Tom Thomson on a Sunday in early spring at York Mills. This popular sketching site was a small mill town located just north of the Toronto city limits, at the junction of Bayview Avenue and the west branch of the Don River.

James Edward Hervey MacDonald,
O.S.A., R.C.A.

Born: Durham, England, 12 May 1873

Died: Toronto, Ontario,
26 November 1932

Original member, Group of Seven,
1920

By the River, (Early Spring) 1911
Oil on canvas, 48.3 x 69.9 cm/
19 x 27½"
Signed and dated: (l.r.) J. E. H.
MacDonald. '11
Purchase from the artist, 1911.
MGS 622106

Purchased from the 39th Annual O.S.A. Exhibition (Toronto), 1911 (cat. no. 127) as a "Ballot Picture." In *Toward a People's Art: The History of Painting in Canada* (Toronto: NC Press, 1974), Barry Lord erroneously listed the Art Gallery of Hamilton as owner of this work, no doubt because at the time of publication it was hanging in the Hamilton Teachers' College, where it had been sent in 1912 and from which it was returned to Queen's Park in 1979.

Timber drives on the upper Humber supplied the sawmills at Lambton Mills during the late eighteenth and nineteenth centuries, and continued sporadically into the early years of the twentieth, increasingly impeded by the building of dams across the river.

Charles MacDonald Manly,
O.S.A., A.R.C.A.

Born: Englefield Green, Surrey,
England, September 1855

Died: Toronto, Ontario, 3 April 1924

President, O.S.A. 1903-04

The Summer's Pride
Oil on canvas, 90.2 x 135.9 cm/
35½ x 53½"
Signed: (l.l.) C. M. Manly
MGS 619810

F. McGillivray Knowles, *Notre Dame, Paris*, 1895

Dartmoor 1897
Watercolour on paper, 61 x 83.8 cm/
24 x 33"
Signed and dated: (l.r.) C. M. Manly. 97.
MGS 622083

Although no purchase records have yet been found for this work, it was probably painted during one of at least four trips to Great Britain made by Manly between 1885 and 1898, and may have been one of several moorland scenes which the artist showed at the annual exhibitions of the O.S.A. and R.C.A. during the 1890s. Dartmoor, celebrated in the poems and novels of Thomas Hardy, is a mainly treeless and uncultivated plateau of granite covered with peat, lying between Exeter on the east, and Plymouth on the west, in the southwest England county of Devon.

Pick and Shovel 1921
Watercolour on paper, 57.2 x 80 cm/
22½ x 31½"
Signed and dated: (l.l.) C. M. Manly/21
MGS 619785

F. McGillivray Knowles, *In Time of Peace*,
1907

C.M. Manly, *Dartmoor*, 1897

Henry Martin, *Holy Cross Abbey*

Exhibited at the 50th Annual O.S.A. Exhibition (Toronto), 1922 (cat. no. 121). An old government document records its purchase from the Garfield Gallery, Toronto, although this acquisition information cannot be substantiated.

Henry D. Martin, O.S.A., A.R.C.A.
Born: Painswick, Gloucestershire, England, *c.* 1832
Died: Toronto, Ontario, *c.* 1904

Holy Cross Abbey
Watercolour on paper, 42.6 x 65.4 cm/ 16³/₄ x 25³/₄"
Signed: (l.l.) H. MARTIN.
MGS 622146

On loan to the Stratford Normal School from 1912, it was returned to Queen's Park in 1978. The subject is a twelfth-century abbey built in County Tipperary, Ireland for the Order of Tiron, later occupied by the Cistercians, and remodelled in the fifteenth century. A relic of the True Cross gave the abbey its name and made it the object of pilgrimages.

Untitled 1872
Watercolour and pastel on paper, 65.4 x 85.1 cm/25³/₄ x 33¹/₂"
Signed and dated: (l.l.) H. MARTIN '72.
MGS 608596

The site depicted here has not yet been identified; however, it is likely that (unless imaginary) it is a hospital, asylum, school, or government edifice. A red ensign flies atop the main cupola.

Thomas Mower Martin,
O.S.A., R.C.A.
Born: London, England, 5 October 1838
Died: Toronto, Ontario, 15 March 1934
Founding member, O.S.A.

Indians Breaking Camp – Northern Ontario
Oil on board, 41.9 x 67.3 cm/ 16¹/₂ x 26¹/₂"
Signed: (l.r.) T M Martin
MGS 632918

Muskoka Scene
Oil on compressed cardboard,
91.4 x 149.9 cm / 36 x 59"
Purchase, 1904
MGS 619789

The Road Through the Beeches
1894
Oil on canvas, 88.9 x 134.6 cm / 35 x 53"
Signed and dated: (l.r.) T. Mower.
Martin. R.C.A. / 1894
Purchase from the artist, 1898/99.
MGS 692758

Purchased from the O.S.A. Normal
School Exhibition (Toronto) 1898/99
(cat. no. 7) as part of the Education
Department Committee selection for
the $800 Annual Grant. This work may
have been exhibited under different
titles prior to its purchase for the
government collection; for example, a
work called *The Path Through the
Woods* was included in the 14th Annual
R.C.A. Exhibition (Montreal), 1894 (cat.
no. 85), while a *Road Through the
Woods* was shown in Ottawa in the
following year's R.C.A. Exhibition (cat.
no. 88).

C.M. Manly, *Pick and Shovel*, 1921

Attributed to **Thomas Mower Martin**

Untitled
Oil on canvas, 114.3 x 75.6 cm /
45 x 29³⁄₄"
MGS 619811

Attributed to
Ambrose Wilcock Mason

Born: Devonshire, England,
16 February 1851

Untitled 1881
Watercolour on paper, 35.2 x 46.2 cm /
13⁷⁄₈ x 18³⁄₁₆"
Dated: (l.l.) June 1881.
MGS 622145

This structure, identified on the original
architectural drawings as "The Deaf and
Dumb Institution, Belleville," was
designed by James Smith and built in
1870. It was demolished in 1922-23 to
make room for the present building,
which at that time was renamed the Sir
James Whitney School for the Blind and
Deaf, and which is now called simply
the Sir James Whitney School. The artist
was first a pupil, and later a drawing
master, at this school.

Marmaduke Matthews Matthews,
O.S.A., R.C.A.

Born: Barcheston, Warwickshire,
England, 29 August 1837
Died: Toronto, Ontario,
13 September 1913

Founding member, O.S.A.;
President, 1894-95; Founding
member, R.C.A.

Untitled 1892
Watercolour on paper, 63.5 x 97.8 cm /
25 x 38¹⁄₂"
Signed and dated: (l.r.) M Matthews
1892.
MGS 619736

No purchase records have yet been
found for this watercolour. It may have
been worked up from an on-site sketch
made during one of the artist's expedi-
tions to the Rockies in 1887 and 1889, or
it may in fact have been copied from a
virtually identical painting by Matthews
entitled *Mount Burgess with Emerald
Lake in the Foreground, c.* 1887-89,
formerly in the collection of the
Glenbow Museum, Calgary. However,
the implication that Matthews indeed
revisited the west and executed a

second, slightly larger, painting of this
famous site in 1892, is supported by the
fact that in the R.C.A. Exhibitions of
1892 and 1893 he showed a total of
twelve Rocky Mountain pictures, and in
the World's Columbian Exposition held
in Chicago in 1893 he was represented
by five watercolours of British
Columbia scenery. He in fact continued
to exhibit western compositions until
his death in 1913. The subject of this
watercolour, Mount Burgess, is located
in British Columbia's Yoho National
Park, near the B.C.-Alberta border; the
peak is familiar to Canadians through its
appearance on the old ten dollar bill.

Untitled 1892
Watercolour on paper, 56.5 x 79 cm /
22¹⁄₄ x 31¹⁄₈"
Signed and dated: (l.r.) M. Matthews/
1892.
MGS 694031

No purchase records have yet been
found for this work; however, it may
have been acquired from the 21st
Annual O.S.A. Exhibition (Toronto),
1893, whose catalogue lists two western
watercolours by Matthews: *In the Valley
of the Fraser* (cat. no. 75) and *On the*

T. Mower Martin, *The Road Through the Beeches*, 1894

Marmaduke Matthews, *Untitled*, 1892

Fraser (cat. no. 52). It would seem that the present work is of lower Fraser Valley scenery; the C.P.R. line is visible on the right (east) side of the river-bank.

Medland

Untitled
Watercolour on paper, 33 x 48.3 cm/ 13 x 19"
Signed: (l.r.) Medland del
MGS 619862

No purchase records have yet been found for this work, nor has it been possible to attribute it to one individual among the several Medlands practising topographical landscape painting in eighteenth and nineteenth century Britain. The subject here is likely to be an English town or village.

Edmund Montague Morris,
A.R.C.A., O.S.A.
Born: Perth, Ontario,
18 December 1871
Died: Portneuf, Quebec,
21 August 1913

According to Morris' manuscript "list of pictures and owners" (i.e. of works painted and sold or bequeathed between 1897 and 1912) in the Ethnology Department, Royal Ontario Museum, the artist presented to the Ontario Government two works entitled *Indians Descending the Pic River* and *The Country of the Ojibway*. They were sketched by Morris during the course of the federal and Ontario government expedition of 1906 to James Bay Territory to oversee the signing of Treaty No. 9 with those Cree and Ojibway Indians who had not signed the Treaty in 1905. Morris' official assignment was to execute pastel portraits of the Indians whose lands were acquired by means of this final treaty. Morris met the treaty party, led by Indian Affairs Deputy Superintendent Duncan Campbell Scott (1862-1947), at Biscotasing, northwest of Sudbury. In an unpublished diary (Queen's University Archives, Douglas Library, Kingston), Morris describes the journey westward and northward via many lakes and rivers, among them the Pic River, northeast of Lake Superior in Ontario. (Aside from the two paintings

catalogued below, the principal output of Morris' trip was the government-commissioned collection of fifty Plains and ten James Bay district Ojibway and Cree Canadian Indian portraits, transferred from the Provincial Museum to the newly established Royal Ontario Museum in July 1913.)

Indians Descending the Pic River
c. 1906
Oil on canvas, 74.9 x 99.1 cm/
29^{1}/$_{2}$ x 39"
Signed: (l.l.) Edmund Morris
Bequest of the artist, *c*. 1913.
MGS 619860

The present title of this work, depicting three Ojibway Indians poling a birchbark canoe down a rapids on the Pic River, is taken from Morris' own account book. However, it has twice been exhibited under an alternative title, *A Northern River:* first, at the 1908 Canadian Art Club exhibition (Toronto), 1908 (cat. no. 28), and, more recently, in the retrospective exhibition, *Edmund Morris: "Kyaiyii" 1871-1913* (Norman Mackenzie Art Gallery, University of Regina, January-February, 1984, cat. no. 17).

Included in his journal of the James Bay expedition are two very rough sketches from which Morris worked up this painting, one of them showing the figures in a canoe. In 1906 Morris also produced a more finished version in pastels of the same subject, also titled *Indians descending the Pic River,* the format of which is square rather than rectangular.

Pic River – The Country of the Ojibway 1906
Oil on canvas, 74.9 x 99.1 cm/
29^{1}/$_{2}$ x 39"
Signed and dated: (l.l.) Edmund Morris 1906.
Bequest of the artist, *c*. 1913.
MGS 619861

Lucius Richard O'Brien,
O.S.A., R.C.A.
Born: Shanty Bay, Upper Canada,
15 August 1832
Died: Toronto, Ontario,
13 December 1899
Founding member, R.C.A;
President 1880-90

T. Mower Martin, *Indians Breaking Camp*

Edmund Morris, *Indians Descending the Pic River, c.* 1906

Lucius O'Brien, *Cape Gaspé (Quebec)*, 1894

Waterfall 1876
Watercolour on paper, 35.6 x 24.8 cm/
14 x 9³/₄"
Signed and dated: (l.l.) O'Brien/1876.
MGS 619823

Cape Gaspé (Quebec) 1894
Oil on canvas, 108 x 73.7 cm/42¹/₂ x 29"
Signed and dated: (l.r.) O'Brien 1894
Inscribed: (l.r.) Cape Gaspé.
Purchase, 1900. MGS 619824

This picture is listed as "picture,
Gaspé," in *Public Accounts of Ontario,
1900.* It was subsequently exhibited as
Mist in the Hills when it was loaned to
the Art Museum of Toronto's *Fourth
Loan Exhibition Catalogue of Works by
Deceased Canadian Artists,* 1911 (cat.
no. 181). O'Brien travelled extensively
within Canada and visited the Gaspé
region of Quebec at least twice — in
1882 and 1884. This canvas, presumably
a product of the second trip, was
probably the one exhibited by the artist
under the title of *Cape Gaspé* in 1895 at
the *Annual Spring Exhibition of the Art
Museum of Montreal* (cat. no. 86).
 Cape Gaspé is a promontory at the
northeastern tip of the Gaspé Peninsula,
facing into the Gulf of St. Lawrence. It
now lies within the boundaries of the
Forillon National Park, Quebec.

Herbert Sydney Palmer,
O.S.A., R.C.A.
Born: Toronto, Ontario,
15 June 1881
Died: Toronto, Ontario,
28 November 1970

In the Grand Valley
Oil on canvas, 59.7 x 73.7 cm/
23¹/₂ x 29"
Signed: (l.l.) HERBERT S. PALMER
Purchase from the artist, 1911.
MGS 622067

Purchased from the 39th Annual O.S.A.
Exhibition (Toronto), 1911 (cat. no. 149)
as a "Ballot Picture." It was on loan to
the Ottawa Normal School from 1912
and was returned to Queen's Park at an
unknown date. The Grand River flows
southward through southern Ontario
from its source, Luther Lake, in
Dufferin County, to Lake Erie at
Dunnville in Simcoe County.

S.R.H. Penson

Lake Scene with Rock Formation
Watercolour on paper, 24.1 x 35.6 cm/
9½ x 14"
Signed: (l.l.) S.R.H. PENSON
Gift of Miss Agnes MacGillivray to the
Ontario Heritage Foundation, 1977. On
loan to the Government of Ontario.
MGS 634901

Henri Perré, O.S.A., R.C.A.
Born: Strasbourg, Alsace, France, 1828
Died: Toronto, Ontario, 1890

Muskoka 1875
Oil on canvas, 54.6 x 80 cm/
21½ x 31½"
Signed and dated: (l.l.) H. Perré/1875.
Purchase, 1896. MGS 619842

Henri Perré, *Muskoka*, 1875

The George Agnew Reid Collection

George Agnew Reid,
O.S.A., R.C.A., C.S.P.W.C.
Born: Wingham, Canada West,
25 July 1860
Died: Toronto, Ontario,
23 August 1947
President, O.S.A. 1896-1902;
President, R.C.A. 1906-09;
President, Ontario College of Art
1912-1929

George Agnew Reid is the best
represented artist in the collection,
largely by virtue of his generous gift of
459 of his own works to the Ontario
Department of Education in 1944. Reid
had a long-standing interest in art
education and had been working with
successive Departments of Education
since the 1880s. He decided, soon before
his death, that his personal collection
would be donated to the province to
form the nucleus of a government-
owned educational collection for public
buildings and institutions.

The placement of the 459 works of art
soon after their donation is recorded in
the *catalogue raisonné* appended to

Muriel Miner's biography of the artist,
G.A. Reid – Canadian Artist (Toronto:
Ryerson, 1946). The larger canvases
were placed in the Legislative Building
at Queen's Park; the medium-sized
canvases were to be lent to the Normal
and larger secondary schools of the
province; and the vast collection of
"small pictures," oils, watercolours and
pastels were to be grouped into exhibits
travelling to the elementary and
secondary schools in connection with
their courses in art education. These
eleven travelling exhibits ceased about
1950. The "small pictures" were then
returned to the Education Department
headquarters.

Virtually no records were kept after
the distribution in 1946. When
cataloguing of the Government of
Ontario Art Collection was begun in
1977 less than 200 of the original gift of
459 works of art could be found. What
happened to the missing works still
remains a mystery. Less than a dozen
were, however, donated by the
government to the Art Gallery of
Ontario, the Art Gallery of Peter-
borough, and Nipissing University

College in North Bay in the early 1970s.
It was decided that the remaining works
in institutions around the province be
returned to Queen's Park for
cataloguing, photography and, where
necessary, restoration. Certain paintings
were then returned to the schools to
which they had been distributed in
1946. The "small pictures" were housed
in the Mowat Block at Queen's Park.
Through the initiative of then Minister
of Education, the Hon. Thomas Wells, it
was decided that all these remaining
paintings be centralized for public
exhibition in the Legislative Building.

The earliest pictures in the collection
are primarily genre studies of Canadian
rural life, set in the artist's native Huron
County, Ontario. Fuller accounts of
specific locales and Reid's historical or
autobiographical sources are appended
to individual catalogue entries.

Although most of the Reid gifts depict
Ontario landscapes and historical
scenes, there are also a number of views
of Onteora, in the Catskill Mountains of
upstate New York. In the summer of
1891 Reid and his American-born first
wife Mary Hiester Reid decided to

The artist in his studio, completing *Foreclosure of the Mortgage* (George Reid Scrapbook, E.P. Taylor Reference Library, Art Gallery of Ontario, Gift of Mrs. G.A. Reid, 1957)

sketch in the Catskills. During their stay they learned of the art colony at near-by Onteora, which had been organized by a Mrs. Wheeler, the president of the Women's Art Association of New York City. The Canadian visitors met several members of the club, and were subsequently invited to join and to spend the remainder of their vacation there. Thus began a quarter-century's association with the area. Reid designed a studio-cottage for the picturesque Catskills setting, and in the summer of 1894 held his first Onteora art classes. Among pupils and visitors from Toronto were F.S. Challener, Mary E. Wrinch, Harriet Ford and C.W. Jefferys.

The Reids' association with Onteora ended in 1917, after which they spent their summers teaching and painting in Ontario, with occasional travels abroad. In the summer of 1925, after spending a month at the new Ontario College of Art summer school at Port Hope, Ontario, Reid and his second wife, Mary Wrinch made their first trip to Algoma and the valley of the Agawa River. The following summer was spent in Quebec City and the Ile d'Orleans. The Reids were not won over, however, by Quebec's scenery, and returned to Algoma in the summer of 1927 and to Temagami in 1928, taking

advantage of the offer made by the Hon. William Finlayson, then Minister of Lands and Forests, to accommodate such members of the Ontario Society of Artists as wished to paint the Ontario northland. In the fall of 1929, the Reids' destination was the spectacular Abitibi Canyon and Lake Nipigon.

Thereafter, George Reid devoted his energies to his mural commissions, and never again so concentratedly dwelt on wilderness landscape themes. In 1931 he painted in the Bruce Peninsula and on Manitoulin Island; in 1932, on the Ottawa River and at Herridge Lake; again at Lake Temagami in 1934, and at Lake Dorset in 1936 and 1938.

A number of Reid's works in this collection should be seen in the context of the artist's long-standing interest both in historical subject matter and in executing thematically linked series of works. Similarly, Reid's art is often intended to serve a didactic and commemorative function, as well as an aesthetic one. Reid's name is often associated with major decorative schemes intended for public and private settings. An example of the former is a group of murals completed in 1899 for the entrance lobby of Toronto City Hall, portraying leading figures from civic and provincial history. Several years later

(1902-1907) The Toronto Guild of Civic Art, under Reid's direction, proposed an extensive mural program for the Legislative Building at Queen's Park. Although this ambitious vision was never realized, some of the historical themes suggested for Queen's Park were later executed (1928-1930) in a series of mural panels in the auditorium of Jarvis Collegiate in Toronto. His last mural sequence was painted for the Royal Ontario Museum, in Toronto, in 1935-1938: a series of panels depicting the evolution of the earth up to the time of prehistoric man.

The Discoverers

The development of the "Arts and Crafts" style at the turn of the century had moved Reid to undertake a number of decorative schemes for architectural projects — thematically linked wall-decoration, paintings, chairs, benches, and chests, all having painted panels inserted into or on them. One such scheme was presumably commissioned by Sigmund Samuel (1867-1962), the noted Toronto businessman, connoisseur and amateur historian whose Canadiana collection was housed in the Sigmund Samuel Canadiana Building of the Royal Ontario Museum, on Queen's Park Crescent, in 1949.

Reid's proposal for Mr. Samuel included two walnut chests, one of which carried a continuous landscape around the sides. The other, *The Discoverers*, bore an adaptation of two panels of the mural sequence commissioned for Jarvis Collegiate. Chalk and watercolour sketches for the chest appear between pages 402 and 405 of the Reid Scrapbook (Art Gallery of Ontario, E.P. Taylor Reference Library), along with sketches of companion-pieces: a large, framed, semicircular painting of ships; two double chairs or benches, the backs of which depicted scenes from La Salle's explorations; and a pair of single-seated chairs decorated with smaller scenes of early life in Canada.

The seven panels of *The Discoverers* feature thirteen principal explorers, from the earliest navigators to the adventurers of the great age of discovery (1400s-1600s). The crest of a sponsoring country is displayed at the centre top of each panel. The panels are arranged in chronological order, moving from left to right as the chest is viewed.

G.A. Reid, *The Discoverers*, 1930

The Discoverers 1930
Oil on board, inset into oak chest; seven inset panels, each 31.8 x 31.8 cm/ 12½ x 12½"

Overall: 121.9 x 243.8 x 51 cm/ 48 x 96 x 20"

Signed and dated: (l.l., each panel) G. A. Reid 1930

Inscribed (u.l. to u.r.): 1) ERIC THE RED 984 NORWAY ERICSON 1000
2) MARCO POLO 1295 ITALY PRINCE HENRY 1467
3) DIAZ 1487 PORTUGAL DA GAMA 1498
4) COLUMBUS 1492 SPAIN CABOT 1497
5) CORTEREAL 1500 FRANCE CARTIER 1535
6) FROBISHER DRAKE ENGLAND GILBERT 1576-1583
7) CHAMPLAIN 1608 HOLLAND HUDSON 1610

Gift of Sigmund Samuel, *c.* 1955.
MGS 619834

Panel No. 1
On the left end of the chest, representations of the Norwegian sailor Erik Thorvaldsson, better known as Erik the Red, and his young son Leif Eriksson, or Lief the Lucky, sight what was probably the coast of Greenland on their colonizing expedition of 985-6. The right side of the panel refers to Lief the Lucky's visit to the coast of North America, which probably occurred in the year 1000.

Panel No. 2
The left side of this panel shows the Venetian traveller Marco Polo (1254-1324) and his father on their return to Venice in 1295 after spending over twenty years in the court of the emperor of Cathay, Kublai Khan. On the right, the great patron Prince Henry of Portugal (1394-1460), known as Prince Henry the Navigator, is shown with one hand resting on a globe, while before him his chronicler records the account of one of the mariners. In their mission to chart the African coast, Prince Henry's men developed navigational instruments that were essential to the later discovery of the New World.

Panel No. 3
Shown at left is the Portuguese navigator Bartholomew Diaz (*c.* 1450-1500), who accidentally discovered the southern route around continental Africa to the Indian Ocean. A gale forced his ship eastward at the southern tip of Africa, around the Cape, which he named "Cape of Storms." His frightened crew prevented him from following this new sea-route to the orient, insisting that they return to Portugal.

The right side of the panel shows Vasco da Gama (*c.* 1469-1525) who followed the route that Diaz had discovered 10 years earlier. In May 1498, he sailed to Calcutta on the west coast of India, claiming the land for Portugal. Upon da Gama's return to his own country, King John II renamed the Cape of Storms "Cape of Good Hope" to encourage more exploration.

Panel No. 4
Holding a Spanish flag, Christopher Columbus (1451-1506) faces the Genoa-born, naturalized British navigator John Cabot (1425 - *c.* 1500), who is shown

with his three sons. The dates inscribed following their names refer to Columbus' first trans-Atlantic voyage, his 1492 discovery of the West Indies, and to Cabot's receipt of the royal charter of 1497, by which Henry VII instructed him to sail westward in search of Cathay or India. Cabot coasted the eastern shores of North America and landed at Cape Breton or Newfoundland, before returning to England, convinced that he had reached Asia.

Panel No. 5
The Portuguese explorer Gaspar Corte-Real (c. 1450 - c. 1501) is shown mapping the coast of North America, which he named Cortrealis. The object of his expedition from the Azores to Newfoundland in 1500 was not only to confirm Portuguese claim to the rich fishing grounds of the Grand Banks, but also to find a westward sea-route to Asia; however, he was lost at sea.

At the right, the French explorer Jacques Cartier (1491-1557) is depicted in a scene from his second voyage to Canada in 1535. On his earlier voyage, in 1534, he had reached the Gaspé Peninsula, and was the first European to return to North America since John Cabot had discovered the mainland. Cartier, still seeking the passage to India, sailed up the St. Lawrence to Stadacona (now Quebec) and then to Hochelaga (now Montreal) where the Indians greeted him as a god who might heal their sick. In this panel, he is holding the New Testament from which he recited the Gospel according to St. John to the Indians of Hochelaga.

Panel No. 6
This panel presents three British explorers of the Elizabethan Age. On the left stands Sir Martin Frobisher (c. 1535-1594), in the centre Sir Francis Drake (c. 1540-1596), and on the right, Sir Humphrey Gilbert (1537-1583). Frobisher made an Arctic voyage in each of three years, from 1576 to 1579. On his first voyage, Frobisher thought he had discovered the northwest route to Cathay, and gave his name to the "passage" which turned out to be a bay on the south-east coast of Baffin Island. His two other voyages were equally unsuccessful.

Drake left England in 1577. He sailed through the Straits of Magellan and up the west coast of the Americas as far as

G.A. Reid, *The Discoverers*, 1930 (detail, Panel No. 6)

southern British Columbia, but was forced to turn back by cold weather. He continued his westward voyage in the South Pacific, returning to England as the second man (after Magellan in 1521) to successfully circumnavigate the globe.

Sir Humphrey Gilbert, who sailed west in 1583 to take possession of Newfoundland for Queen Elizabeth I, is shown receiving the document of submission from the Portuguese and Basque fishermen who had settled the island.

Panel No. 7
On the end of the chest, the French explorer Samuel de Champlain (1567-1635) is being welcomed to New France on his third expedition in 1608. On the right, the English navigator Henry Hudson (active 1607-11) and his son study the charts they are using in their search for the Northwest Passage.

Although unsuccessful in their quest, they discovered and entered Hudson Bay in the winter of 1610. In 1609 and 1610, the paths of these two explorers nearly crossed as they explored the territory around modern Lake Champlain and the Hudson River.

The crest of Holland on the top centre of this panel indicates the Dutch East India Company's involvement in Hudson's two North American expeditions.

Historical Series

Around the same time as he was completing the Jarvis Collegiate murals and *The Discoverers* chest, Reid was also painting several of the early explorers of Canada in a group of framed works, a project begun in 1908. His

(*Above*) G.A. Reid, *Erickson Discovers the New Land on the Coast of Nova Scotia, 1100*, 1930

(*Right*) G.A. Reid, *Cabot Discovers America, 1497*, 1930

biographer Muriel Miner gives the general title of "Historical Series" to this set of twelve paintings, all having approximately the same dimensions, with which six of the eight works catalogued below can be identified. The titles for many of these works are derived from labels attached to the paintings' supports at some time after their completion. In a few cases, these labels are at variance with the titles as listed by Miner. The remaining two paintings (*Arrival of La Salle...*, *The Short Portage...*) are included here because they are related to works in the historical series, although they differ in size.

Erickson Discovers the New Land on the Coast of Nova Scotia, 1100 [*sic*]
1930
Pastel on paper, 43.8 x 59.1 cm/
17¼ x 23¼"
Signed and dated: (l.r.) G. A. Reid
1930.40
Gift of Dr. John Peterson to the Ontario Heritage Foundation, 1983; on loan to the Government of Ontario.
MGS 632968

In the spring of the year 1000 or 1001, the Norwegian sailor Lief the Lucky (Lief Eriksson, son of Erik the Red) visited the North American continent, although attempts to establish a permanent colony at that time were unsuccessful.

Cabot Discovers America, 1497
1927
Oil on card, 48.9 x 62.2 cm/19¼ x 24¼"
Signed and dated: (l.l.) G. A. Reid, 1930
Gift of Dr. John Peterson to the Ontario Heritage Foundation, 1983; on loan to the Government of Ontario.
MGS 632964

Reid included scenes of John Cabot's expedition in search of a sea-route to India in both the Jarvis Collegiate mural and *The Discoverers* chest. Here, the Indians of the eastern coast of Canada dominate the foreground and reveal their bewilderment at the sight of the strange ships at sea and of Cabot's men around the cross.

Cartier Discovers the St. Lawrence and Reads a Chapter from the New Testament to the Assembled Natives, 1534 1929
Pastel on paper, 38.7 x 59.1 cm/
15¼ x 23¼"
Signed and dated: (l.r.) G. A. Reid, 1929
Gift of Dr. John Peterson to the Ontario Heritage Foundation, 1983; on loan to the Government of Ontario.
MGS 632965

G.A. Reid, *Cartier Discovers the St. Lawrence and Reads a Chapter from the New Testament to the Assembled Natives, 1534*, 1929

Jacques Cartier Erects a Cross, 1536
193__ [?]
Oil on card, 45.1 x 59.7 cm/
17¾ x 23½"
Signed and dated: (l.r.) G. A. Reid, 193__[?]
Gift of Dr. John Peterson to the Ontario Heritage Foundation, 1983; on loan to the Government of Ontario.
MGS 632969

If the title on the back of this work

G.A. Reid, *Jacques Cartier Erects a Cross, 1536*

G.A. Reid, *Champlain Arrives at Quebec, 1608,* 1932

correctly dates the event, the painting illustrates Cartier's presence at Stadacona (now Quebec City) in 1536, two years after his first landing at Gaspé. On both occasions, he ceremoniously erected a cross on the shore to mark France's claim to the territory. A number of works showing Cartier's deeds, including several pictures of the Gaspé and Stadacona incidents, appear in Miner's *catalogue raisonné*, although only a few can still be traced.

Champlain Arrives at Quebec, 1608
1932
Pastel on paper, 48.9 x 62.2 cm /
19¼ x 24½"
Signed and dated: (l.r.) G. A. REID 1932
Gift of Dr. Peterson to the Ontario Heritage Foundation, 1983; on loan to the Government of Ontario.
MGS 632966

On his third voyage to Canada, in 1608, when Champlain arrived at Quebec on 3 July, the Indians paddled their canoes out to the ship to welcome the French. This work is based on a re-enactment of Champlain's arrival at Quebec, performed during Quebec's Tercentenary ceremonies in 1908. Reid obtained permission to attend and make sketches of the pageants performed at these celebrations.

Champlain Writes his Memoirs in the Great Bear Lodge while the Men Sleep with their Feet towards the Fire
Oil on canvas, 43.2 x 58.4 cm / 17 x 23"
Signed and dated: (l.r.) G. A. Reid, 19___[?]
Gift of Dr. John Peterson to the Ontario Heritage Foundation, 1983; on loan to the Government of Ontario.
MGS 632967

Reid shows the explorer in a setting described by Champlain himself in his *Voyage et Decouvertures faites...en La Nouvelle France, depuis l'année 1615 jusqu'à la fin de l'année 1618* (Paris, 1619), and in Part I, Book III of the 1632 edition of his *Voyages*. Champlain had been forced to spend the winter of 1615-16 in Cahiague (near what is now Hawkestone, on Lake Simcoe). Among his memoirs of the lodge-life and social customs of the Attigouantan or Bear tribe of the Hurons was the observation

that "in winter they [the Indians] lie below [the sleeping platforms used in summer] on mats near the fire, in order to be warmer."

Arrival of La Salle at the Mouth of the Humber River 1681
Oil on board, 29.8 x 87.6 cm/
11³/₄ x 34¹/₄"
Gift of Dr. John Peterson to the Ontario Heritage Foundation, 1983; on loan to the Government of Ontario.
MGS 632963

The Short Portage – The Carrying Place, La Salle on the way over the Humber River to the Holland River and on to Lake Simcoe
Oil on board, 29.8 x 87.6 cm/
11³/₄ x 34¹/₂"
Gift of Dr. John Peterson to the Ontario Heritage Foundation, 1983; on loan to the Government of Ontario.
MGS 632970

Although their titles correspond with two of the works listed in this historical series (Miner, p. 204), these panels were probably designed for two benches (described in note on *The Discoverers*) as part of a decorative scheme for a room in a private home. René-Robert Cavelier La Salle (1643-1687) of Montreal set forth in 1680 on his third and last expedition in search of the mouth of the Mississippi. He followed the Indian trail leading from the mouth of the Humber River (in the west end of present-day Toronto) via the Holland River to Lake Simcoe and Lake Huron. In the first panel (*The Arrival of La Salle*) La Salle and his men are greeted by the Indians upon their arrival at the mouth of the Humber; *The Short Portage...* shows the men setting off on their portage of approximately 48 kilometres to Lake Simcoe.

Scenes from Early Canada

Mortgaging the Homestead 1890
Oil on canvas, 27.9 x 43.2 cm/11 x 17"
Signed and dated: (l.l.) G. A. Reid 1890
Gift of the artist, 1944.
MGS 623111

This small painting is a sketch for a large oil of the same title and date in the

G.A. Reid, *Champlain Writes his Memoirs in the Great Bear Lodge while the Men Sleep with their Feet towards the Fire*

G.A. Reid, *Arrival of La Salle at the Mouth of the Humber River, 1681*

G.A. Reid, *Foreclosure of the Mortgage*, 1893-1935

G.A. Reid, *Mortgaging the Homestead*, 1890

R.C.A. Diploma Collection of the National Gallery of Canada, Ottawa, deposited 1891. The sketch was on loan to St. Mary's Collegiate, St. Mary's, Ontario until the 1960s, when it was transferred to the St. Mary's District Museum. In 1983 it was returned to Queen's Park.

Although Reid did not claim any didactic or reformist purpose for this scene or its sequel, *The Foreclosure of the Mortgage*, two specific events inspired the work: the plight of farmers in the American Dakotas in the winter of 1890, and (an autobiographical element) the fact that his own family's farm had had to be mortgaged, out of bitter necessity. The much acclaimed culmination to this sketch, the diploma picture, struck an immediate emotional chord in the Canadian public.

Foreclosure of the Mortgage
1893-1935
Oil on canvas, 180.3 x 276.9 cm/
71 x 109"
Signed and dated: (l.r.) G. A. Reid, 1893-1935.
Gift of the artist, 1944. MGS 619809

An invalid father and his family gather to witness the legal re-possession of their home by a bailiff of the court. This canvas was copied from an original executed by Reid in 1892-93, which was widely exhibited and admired in North America. Its visual impact is suggested by preparatory sketches which survive in private and public collections: for example, a "First sketch" for this work, in graphite, is affixed to page 21 of the Reid Scrapbook (Art Gallery of Ontario, E.P. Taylor Reference Library). The date 1893 was probably added by Reid after the actual execution, since the painting itself had been exhibited in 1892 at the 20th Annual O.S.A. Exhibition (Toronto), cat. no. 169.

Reid's original work entered a private collection, and was destroyed in a warehouse fire in London, England, in 1918. His 1935 re-painting was based on his own original sketches and studies, although there are changes in the spacing of the figures and in minor items of furniture, such as the addition of a stool and of a shelf with a cup. The 1935 painting was re-discovered in 1966, after having been stored in anonymity for many years.

G.A. Reid, *Coming of the White Man*, 1912

G.A. Reid, *The Homeseekers*, 1910

One of the models for the *Foreclosure* has been identified as Mrs. George Stephenson, *née* Alice Dixon, who had posed as the girl at the window in *Foreclosure* as well as for Reid's *The Berry Pickers* (see p. 54).

The Woodcutter 1907
Oil on canvas, 133.4 x 104.1 cm/
52½ x 41"
Signed and dated: (l.r.) G. A. Reid. 1907
Inscribed: (verso) The Woodcutter/
G. A. Reid 1907.
Gift of the artist, 1944. MGS 619708

The Homeseekers 1910
Oil on canvas, 180.3 x 273 cm/
71 x 107½"
Signed and dated: (l.l.) G. A. Reid. 1910.
Gift of the artist, 1944. MGS 619838

Reid depicts a pioneer family en route through forests to a new home in the wilderness. The covered wagons being led across the ford are Conestoga wagons, introduced into Upper Canada by the Loyalist Pennsylvania "Dutch" (i.e. Deutsch) after the American Revolution. Preparatory oil studies of the heads of the man and woman in the foreground are found in the Art Gallery of Ontario collection.

Twenty-five years after completing the painting, Reid was commissioned by William Perkins Bull to do a replica. The later version, dated 1935 and titled *The Homeseekers Fording the Credit* (perhaps in deference to Bull's loyalty to Peel County, through which the Credit River flows), appears as item no. 124a in the *Perkins Bull Collection*, a privately printed catalogue (first edition 1934, revised edition 1935). The replica painting was donated to the Brampton

High School and later transferred to the Brampton Centennial Secondary School.

The Homeseekers 1910
Pastel on paper, 43.2 x 62.9 cm/
17 x 24¾"
Signed and dated: (l.l.) G. A. Reid 1910
Gift of the artist, 1944. MGS 622026

This work, a sketch for Reid's large canvas of the same title, hung in the Hamilton Normal School from 1946 until its return to Queen's Park in 1979.

Coming of the White Man 1912
Oil on canvas, 180.3 x 238.8 cm/
71 x 94"
Signed and dated: (l.l.) G. A. Reid 1912
Gift of the artist, 1944. MGS 605016

This work was inspired by the historical pageantry surrounding the Quebec Tercentenary celebrations of 1908, and may be an imaginative "re-creation" of Jacques Cartier's expedition up the St. Lawrence in 1535 (unsigned typescript in G. A. Reid file, Fine Art Department, Metropolitan Toronto Library). Reid made at least two pastel studies for this major painting: the *Indian Panel*, 1911 (present location unknown), and a 1912

work, also titled *The Coming of the White Man*, which now hangs in the O'Neill Collegiate and Vocational Institute, Oshawa (gift of R. S. McLaughlin).

Shingle Makers 1926
Oil on canvas, 75.6 x 101 cm/
29¾ x 39¾"
Signed and dated: (l.r.) G. A. Reid 1926
Gift of the artist, 1944. MGS 619826

The Prospectors 1933
Oil on canvas, 101.6 x 120.3 cm/
40 x 50½"
Signed and dated: (l.l.) G. A. Reid 1933
Inscribed: (verso) Ontario Society of Artists/Annual Exhibition 1934/40 x 50
Gift of the artist, 1944. MGS 622028

The Prospectors was loaned to the Stratford Normal School in 1946 and was returned to Queen's Park in 1978. The setting is presumed to be Northern Ontario. There is a photograph in the Reid Scrapbook (Art Gallery of Ontario, E. P. Taylor Reference Library, p. 16) of a preparatory work for this painting, titled *Study for Prospectors*, 1932 (30 x 40").

G.A. Reid, *The Prospectors*, 1933

The Treaty Line 1933
Oil and pastel on board,
30.5 x 54.6 cm / 12 x 21¹/₂"
Inscribed: (verso) Study for over mantle
[*sic*] for W. A./Elliot, Brandon/oil on
board/and pastel/Wingham School
Gift of the artist, 1944. MGS 622052

Since 1946 this painting has been on
loan to the F. E. Madill Secondary
School in Reid's home town of
Wingham, Ontario. The study is one of
three known preliminary works for
Reid's "overmantel painting," *The
Treaty Line*, executed for W. A. Elliott of
Brandon, Manitoba (Miner, p. 201). A
rough pencil sketch and a coloured-
pencil study of the oil are in the Reid
Scrapbook (Art Gallery of Ontario, E. P.
Taylor Reference Library, pp. 17 and 92
respectively).

Figurative and Genre Works

Head of a Nun 1885
Oil on board, 30.5 x 25.4 cm / 12 x 10"
Signed and dated: (l.l.) G. A. Reid / 1885
Inscribed: (verso) Head of a Nun / By G.
A. Reid / 1885 12 x 10 / o / b
Gift of the artist, 1944. MGS 621219

A Life Study 1889
Oil on board, 31.1 x 21.6 cm / 12¹/₄ x 8¹/₂"
Signed and dated: (l.l.) G. A. REID. /
1889.
Inscribed: (l.l.) [illegible]; (verso) A Life
Study / G. A. Reid 1889 / 9 x 13
Gift of the artist, 1944. MGS 621218

G.A. Reid, *Head of a Nun*, 1885

*Portrait of S. M. Jones (Sam Jones)
not the Evangelist* 1893
Oil on board, 38.7 x 28.9 cm /
15¹/₄ x 11³/₈"
Signed and dated: (l.l.) G. A. Reid. 1893.
Inscribed: (verso) Portrait of S. M.
Jones / (Sam Jones) not the /
Evangelist / by G. A. Reid 1891
Gift of the artist, 1944. MGS 622025

The subject of this painting is probably
Sam Jones, a designer of stained-glass
panels for the McCausland Glass Co.,
Toronto, a member of the Toronto Art
Students' League and of the O.S.A. In
1890 Reid had exhibited a portrait
entitled *S.M. Jones Esq.* in the 18th
Annual O.S.A. Exhibition (cat. no. 161),
which may in fact depict the Reverend

Septimus Jones of the Anglican Church of the Redeemer, the only clergyman bearing this name who appears in Toronto city directories for the 1890s. This would explain Reid's decision to include "not the Evangelist" in the title for the work now in the collection.

Although this work is inexplicably missing from Miner's *catalogue raisonné*, a work of larger size, titled *Sam Jones, Stained-Glass Painter*, dated 1896, *is* listed in that publication, as part of the Ontario Government's Reid collection (p. 214). The relationship between *S.M. Jones (Sam Jones) not the Evangelist* and the 1896 portrait has not yet been determined.

City and Country 1893
Oil on canvas, 91.4 x 72.4 cm/
36 x 28¹/₂"
Signed and dated: (l.l.) G. A. REID, 1893.
Purchase from the artist, 1900.
MGS 619841

Portrait of Henrietta Vickers, Artist
c. 1894
Oil on canvas, 87.6 x 54 cm/
34¹/₂ x 21¹/₄"
Inscribed: (u.r.) C.A. Reid 18____[?] [It is questionable whether this is a signature in the artist's own hand.]
Gift of the artist, 1944. MGS 605049

Little is known about the subject of this painting, Canadian artist Henrietta Moodie Vickers. She was apparently a student of Reid's from 1895 until 1897, when she went abroad. She eventually settled permanently in Tangier although she also maintained a studio in Paris. According to Miner, Reid painted Henrietta Vickers twice before 1897, and this portrait is listed as having been painted in 1894. However, a photograph of the Toronto Arcade Building studio occupied by Reid between 1895 and 1899 shows this portrait in the corner, identified in the caption as "Miss Hettie Vickers as a 'Canadian Girl'" and dated 1895 (Reid Scrapbook, Art Gallery of Ontario, E. P. Taylor Reference Library, p. 187). The work is strongly influenced by that of Thomas Eakins, under whom Reid studied at the Pennsylvania Academy of Fine Arts, Philadelphia, from 1882 to 1885, but a looser handling of pigment reflects Reid's contact with Impressionism in the early 1890s.

G.A. Reid, *A Life Study*, 1889

(*Above*) G.A. Reid, *City and Country*, 1893

(*Page 103, right*) G.A. Reid, *Portrait of Henrietta Vickers, Artist*

The Drinking Place 1895
Oil on canvas, 35.6 x 30.5 cm/14 x 12"
Signed and dated: (l.l.) G. A. Reid. 1895.
Inscribed: (verso) The Drinking Place/
12 [deleted] x 14/G. A. Reid 1895
14 x 12
Gift of the artist, 1944. MGS 622060

On loan to the Goderich District
Collegiate Institute, Goderich, from
1946 to 1979, when it was returned to
Queen's Park.

Reading 1900
Pastel on paper, 59.7 x 44.5 cm/
23$^{1}/_{2}$ x 17$^{1}/_{2}$"
Signed and dated: (l.r.) G. A. Reid 1900
Purchase from the artist, 1900.
MGS 623112

Purchased from the 28th Annual O.S.A.
Exhibition (Toronto), 1900 (cat. no. 55)
as a "Ballot Picture." It was on loan to
the Hamilton Normal School from 1912
until 1979, when it was returned to
Queen's Park.

Among the Daisies 1903
Oil on canvas laid on board,
61 x 45.7 cm/24 x 18"
Signed and dated: (l.l.) G. A. REID
R.C.A. 1903; G. A. REID...
Inscribed: (verso) Among the Daisies/
G. A. Reid 1903/24 x 18
Gift of the artist, 1944. MGS 622027

On loan to the Woodstock Collegiate
Institute from 1946 to 1979, when it was
returned to Queen's Park.

The Wheelbarrow 1905
Oil on canvas, 13.7 x 21.4 cm/
5$^{3}/_{8}$ x 8$^{7}/_{16}$"
Signed and dated: (l.l.) G. A. Reid. 05.
Gift of the artist, 1944. MGS 622601

On loan to the Goderich District
Collegiate Institute, from 1946 to 1979,
when it was returned to Queen's Park.

Contemplation 1906
Pastel on paper, 30.5 x 25.4 cm/12 x 10"
Signed and dated: (l.r.) G. A. Reid. 1906.
Inscribed: (verso) Contemplation G. A.
Reid 1906/Study for larger picture/
12 x 10
Gift of the artist, 1944. MGS 622056

On loan to the Collingwood Collegiate
Institute from 1946 to 1979, when it was
returned to Queen's Park.

G.A. Reid, *Adam Reid AE 83*, 1911

Angel Panel c.1910
Pastel on paper, 30.2 x 113.7 cm /
11⁷/₈ x 44³/₄"
Gift of the artist, 1944. MGS 622040

On loan to the Wingham Public School,
since 1946.

Portrait of Norah Blake c. 1910
Pastel on paper, 75.6 x 50.2 cm /
29³/₄ x 19³/₄"
Gift of the artist, 1944. MGS 622021

The subject of this portrait has not been
identified. The pastel was on loan to the
Sir Adam Beck Collegiate Institute,
London, Ontario from 1946 until 1979,
when it was returned to Queen's Park.

Adam Reid AE 83 1911
Pastel on paper, 22.9 x 21 cm / 9 x 8¹/₄"
Signed and dated: (l.l.) G. A. Reid 1911
Inscribed: (u.l.) ADAM/REID./AE.83-
Gift of the artist, 1944. MGS 621212

Adam Reid, the artist's father, was born
c. 1827/28 and emigrated to Canada
from Scotland around 1850, settling first
in Wingham, Ontario, and later in Bruce
Mines at the head of Lake Huron. Adam
Reid opposed his youngest son's plan to
become an artist, and attempted to
divert his talents by apprenticing him to
a local architect in 1877. Within a year,
however, George Reid was studying at
the Ontario School of Art in Toronto.

G.A. Reid, *Untitled*, 1942

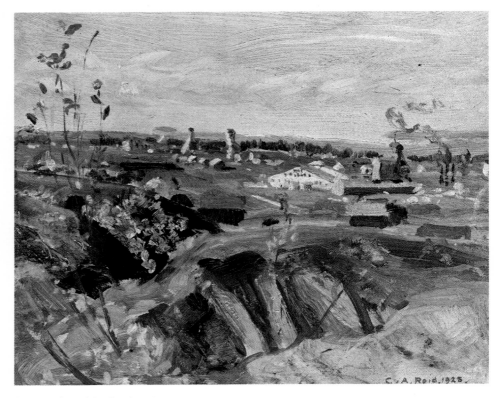

G.A. Reid, *Kirkland Lake, the Mines*, 1928

Reid executed several portraits of his father, and this one, depicting the sitter at age 83, appears to be the latest one extant. Although Reid's biographer omits mention of this 1911 pastel, she does include earlier portraits in her *catalogue raisonné*. For example, an 1886 painting, *Adam Reid*, has survived (London Regional Art Gallery, London, Ontario), while a small pastel of 1887, titled *Adam Reid: Father of the Artist*, is presently unlocated. This latter work may be related to one identified as a *Portrait of Adam Reid* of "about 1888" in a photograph in the Reid Scrapbook (Art Gallery of Ontario, E.P. Taylor Reference Library, facing p. 1).

Cherub Panel c. 1911
Pastel on paper, 28.9 x 113.7 cm/
11³/₈ x 44³/₄"
Gift of the artist, 1944. MGS 622053

On loan to the Wingham Public School, since 1946.

Reading the Bible 1930
Oil on canvas, 74.9 x 99.7 cm/
29¹/₂ x 39¹/₄"
Signed and dated: (l.l.) G. A. Reid 1930
Gift of the artist, 1944. MGS 622053

On loan to the Hamilton Normal School, from 1946 to 1979, when it was returned to Queen's Park.

The Picnic 1932
Oil on canvas, 76.5 x 63.8 cm/
30¹/₈ x 25¹/₈"
Signed and dated: (l.l.) G. A. Reid. 1932.
Inscribed: (on stretcher bars, verso) The Picnic, G. A. Reid, 1932, 25 x 30/
Galt 22449/Box 2 No. 4
Gift of the artist, 1944. MGS 622039

On loan to the Galt Collegiate and Vocational School, Cambridge, from 1946 to 1979, when it was returned to Queen's Park.

Untitled 1942
Oil on canvas, 74.9 x 62.9 cm/
29¹/₂ x 24³/₄"
Signed and dated: (l.l.) G. A. Reid 1942
Gift of the artist, 1944. MGS 619794

Landscapes
Northern Ontario

The Brook at Evening 1922
Oil on canvas, 76.2 x 63.5 cm/30 x 25"
Signed and dated: (l.r.) G. A. Reid 1922
Gift of the artist, 1944. MGS 624400

On loan to the Port Arthur Collegiate Institute, Thunder Bay, since 1946.

Magpie Falls, Michipierth Harbour
1927
Oil on board, 25.4 x 30.5 cm/10 x 12"
Signed and dated: (l.l.) G. A. Reid 27
Inscribed: (verso) Magpie Falls/
Michipierth Harbour/G. A. Reid 1927/
10 x 12
Gift of the artist, 1944. MGS 621208

Sawmill Interior, Searchmont
1927
Pastel on paper, 25.4 x 35.6 cm/10 x 14"
Signed and dated: (l.r.) G. A. Reid, 1927
Gift of the artist, 1944. MGS 626204

On loan to Oakwood Collegiate Institute, Toronto, since 1946.

The Ferguson Highway 1928
Oil on board, 25.4 x 30.5 cm/10 x 12"
Signed and dated: (l.l.) G. A. Reid. 28.
Inscribed: The Ferguson Highway/G. A. Reid 1928/10 x 12
Gift of the artist, 1944. MGS 621122

Kirkland Lake, The Mines 1928
Oil on board, 25.4 x 30.5 cm / 10 x 12"
Signed and dated: (l.r.) G. A. Reid, 1928.
Inscribed: (verso) Kirkland Lake The
Mines / G. A. Reid 1928 / 10 x 12
Gift of the artist, 1944. MGS 621188

Wright Hargreaves Mines 1928
Oil on board, 25.4 x 30.5 cm / 10 x 12"
Signed and dated: (l.r.) G. A. Reid, 1928.
Inscribed: (verso) Wright Hargreaves
Mines / G. A. Reid 1928 / 10 x 12
Gift of the artist, 1944. MGS 621187

Herridge Lake, Ferguson Highway
1929
Oil on board, 25.4 x 30.5 cm / 10 x 12"
Signed and dated: (l.r.) G. A. Reid. 1929.
Inscribed: (verso) Herridge Lake /
Ferguson Highway / G. A. Reid / 1929
10 x 12
Gift of the artist, 1944. MGS 621125

Dark Woods, Green, Radiant
1931
Oil on board, 25.4 x 30.5 cm / 10 x 12"
Signed and dated: (l.l.) G. A. Reid. 1931.
Inscribed: (verso) Dark Woods / Green,
Radiant / G. A. Reid 1931 / 10 x 12
Gift of the artist, 1944. MGS 621213

Lake Mindemoya 1931
Oil on board, 25.4 x 30.5 cm / 10 x 12"
Signed and dated: (l.l.) G. A. Reid 1931
Gift of the artist, 1944. MGS 622588

Ottawa River 1931
Oil on board, 25.4 x 30.5 cm / 10 x 12"
Signed and dated: (l.r.) G. A. Reid 31
Inscribed: (verso) Ottawa River / G. A.
Reid 1932 [sic] / 10 x 12
Gift of the artist, 1944. MGS 621173

Through the Heavy Timber 1932
Oil on board, 30.5 x 25.4 cm / 12 x 10"
Signed and dated: (l.l.) G. A. Reid.
193__[?]
Inscribed: (verso) Through the Heavy
Timber / G. A. Reid 1932 / 12 x 10
Gift of the artist, 1944. MGS 621172

Reflections 1934
Oil on board, 25.4 x 30.5 cm / 10 x 12"
Signed and dated: (l.l.) G. A. Reid 1934
Inscribed: (verso) Reflections / 1934 /
G. A. Reid / 10 x 12
Gift of the artist, 1944. MGS 621124

G.A. Reid, *Wood Trail*, 1934

Pines and Birches 1934
Oil on board, 30.5 x 25.4 cm / 12 x 10"
Signed and dated: (l.l.) G. A. Reid
19___[?]
Inscribed: (verso) Pines and Birches /
G. A. Reid, 1934 / 12 x 10
Gift of the artist, 1944. MGS 621135

Rocks and Water 1934
Oil on board, 25.4 x 30.5 cm / 10 x 12"
Inscribed: (verso) Rocks and Water /
G. A. Reid 1934 / 10 x 12
Gift of the artist, 1944. MGS 621123

Wood Trail 1934
Oil on board, 30.5 x 25.4 cm / 12 x 10"
Inscribed: (verso) Wood Trail /
G. A. Reid, 1934 / 12 x 10
Gift of the artist, 1944. MGS 621131

Canadian Northland 1936
Oil on canvas, 76.2 x 100.3 cm /
30 x 39¹/₂"
Signed and dated: (l.r.) G. A. Reid 1936
Gift of the artist, 1944. MGS 619710

Breeze Swept Lake 1933
Oil on canvas, 100 x 74.9 cm /
39¹/₄ x 29¹/₂"
Signed and dated: (l.r.) G. A. Reid, 1933.
Inscribed: (verso) Breeze Swept Lake /
G. A. Reid 1933
Gift of the artist, 1944. MGS 619812

G.A. Reid, *Lumber Piling (Algoma
Searchmont)*, 1927

G.A. Reid, *Across the Bay, Lake Nipigon*,
1929

Landscapes – Algoma

Agawa Canyon, Algoma 1925
Oil on board, 30.5 x 25.4 cm / 12 x 10"
Signed and dated: (l.r.) G. A. Reid 1925
Inscribed: Agawa Canyon / Algoma 1925 /
G. A. Reid 1925 / 12 x 10 / Study for large
50-40 / in Home Smith Collection
Gift of the artist, 1944. MGS 621209

G.A. Reid, *The Northern Entrance to Orient Bay, Lake Nipigon*, 1929

G.A. Reid, *Bridge at Jumping Caribou*, 1934

Trout Brook, Algoma, Study 1925
Oil on laminated board, 30.5 x 25.4 cm/
12 x 10"
Signed and dated: (l.l.) G. A. Reid. 25.
Inscribed: (verso) Trout Brook/Algoma/
G. A. Reid 1925/12 x 10/Study
Gift of the artist, 1944. MGS 621207

Agawa Canyon, Algoma 1926
Oil on board, 30.5 x 25.4 cm/12 x 10"
Signed and dated: (l.r.) G. A. Reid 1926;
Inscribed: (verso) Agawa Canyon/
[illegible]/G. A. Reid 1926/...
Gift of the artist, 1944. MGS 625893

*Autumn, Birches Among Rocks,
Michipicoten* 1927
Oil on board, 30.5 x 25.4 cm/12 x 10"
Signed and dated: (l.l.) G. A. Reid. 27.
Inscribed: (verso) Autumn/G. A. Reid/
$50.00/Birches Among Rocks/G. A.
Reid 1927/12 x 10/Michipicoten
Gift of the artist, 1944. MGS 621141

A Bend in the Magpie 1927
Oil on board, 25.4 x 30.5 cm/10 x 12"
Signed and dated: (l.l.) G. A. Reid. 1927.
Inscribed: (verso) A Bend in the Magpie/
G. A. Reid, 1927/10 x 12
Gift of the artist, 1944. MGS 621137

Lumber Piling (Algoma Searchmont)
1927
Oil on canvas, 30.5 x 25.4 cm/12 x 10"
Signed and dated: (l.l.) G. A. Reid 1927
Inscribed: (verso) Lumber Piling/
(Algoma Searchmont)/G. A. Reid
12 x 10
Gift of the artist, 1944. MGS 621201

Across the Bay, Lake Nipigon 1929
Oil on board, 30.5 x 25.4 cm/12 x 10"
Signed and dated: (l.l.) G. A. Reid. 1929
Inscribed: (verso) Across the Bay/Lake
Nipigon/G. A. Reid 1929/12 x 10
Gift of the artist, 1944. MGS 621138

The Dark Canyon 1929
Watercolour on paper, 51.4 x 33.7 cm/
20¼ x 13¼"
Signed and dated: (l.l.) G. A. Reid 1929
Gift of the artist, 1944. MGS 623331

The Little Bay Nipigon 1929
Oil on board, 25.4 x 30.5 cm/10 x 12"
Signed and dated: (l.r.) G. A. Reid. 1929
Inscribed: The Little Bay Nipigon/
G. A. Reid 1929/10 x 12
Gift of the artist, 1944. MGS 622590

Mouth of Abitibi Canyon 1929
Oil on board, 25.4 x 30.5 cm/10 x 12"
Signed and dated: (l.l.) G. A. Reid. 1929.
Inscribed: (verso) Mouth of Abitibi
Canyon/G. A. Reid/$50.00/10 x 12
Gift of the artist, 1944. MGS 621139

*The Northern Entrance to Orient
Bay, Lake Nipigon* 1929
Oil on canvas, 25.4 x 30.5 cm/10 x 12"
Signed and dated: (l.r.) G. A. Reid. 1929.
Inscribed: (verso) The Northern
Entrance to Orient Bay/Lake Nipigon/
G. A. Reid, 1929/10 x 12
Gift of the artist, 1944. MGS 621220

Virgin Falls, Lake Nipigon 1929
Oil on board, 25.4 x 30.5 cm/10 x 12"
Signed and dated: (l.r.) G. A. Reid. 1929.
Inscribed: (verso) Virgin Falls/Lake
Nipigon/G. A. Reid 1929/$50.00/
10 x 12
Gift of the artist, 1944. MGS 621140

G.A. Reid, *Fire Swept Rocks*, 1929

The Valley of the Agawa 1932
Oil on canvas, 101.6 x 127 cm/40 x 50"
Signed and dated: (l.r.) G. A. Reid 1932
Gift of the artist, 1944. MGS 619837

Bridge at Jumping Caribou 1934
Oil on board, 30.5 x 25.4 cm/12 x 10"
Inscribed: (verso) Bridge at Jumping
Caribou/G. A. Reid, 1934/12 x 10
Gift of the artist, 1944. MGS 621127

Untitled 1935
Oil on canvas, 45.7 x 61 cm/18 x 24"
Signed and dated: (l.l.) G. A. Reid 1935
Gift of the artist, 1944. MGS 619839

Landscapes – Temagami

Stunted Maples, Temagami 1927
Oil on board, 25.4 x 30.5 cm/10 x 12"
Signed and dated: (l.l.) G. A. Reid. 1927.
Inscribed: (verso) G. A. Reid/Stunted
Maples, Temagami/1927/10 x 12
Gift of the artist, 1944. MGS 621196

Temagami 1927
Oil on board, 25.4 x 30.5 cm/10 x 12"
Signed and dated: (l.l.) G. A. Reid. 1927.
Inscribed: (verso) Fireswept Rocks
[deleted]/Temagami/1929 [sic] G. A.
Reid/$50.00
Gift of the artist, 1944. MGS 621132

*Study for Temagami Forest,
A Quiet Inlet* 1928
Oil on board, 25.4 x 30.5 cm/10 x 12"
Signed and dated: (l.l.) G. A. Reid '28
Inscribed: (verso) Temagami Forest/A

G.A. Reid, *The Valley of the Agawa*, 1932

Quiet Inlet/(Temagami Forest)
[deleted]/1928 No. 4/10 x 12/(Study for
–); (diagram, verso) 1/2.34
Gift of the artist, 1944. MGS 621206

Arm of the Lake 1929
Oil on board, 30.5 x 25.4 cm/12 x 10"
Signed and dated: (l.r.) G. A. Reid, 1929
Inscribed: (verso) Arm of the Lake/
1929/G. A. Reid/12 x 10
Gift of the artist, 1944. MGS 621130

Autumn, Temagami Forest 1929
Oil on cardboard, 25.4 x 30.5 cm/
10 x 12"
Signed and dated: (l.r.) G. A. Reid. 1929
Inscribed: (verso) Autumn, Temagami
Forest/G. A. Reid 1929/10 x 12
Gift of the artist, 1944. MGS 621134

Evening, Montreal River 1929
Oil on canvas, 100.3 x 73.7 cm/
39 1/2 x 29"
Signed and dated: (l.l.) G. A. Reid. 1929.
Inscribed: (verso) Evening – Montreal
River 1926 [sic]
Gift of the artist, 1944. MGS 619795

Fire Swept Rocks 1929
Oil on board, 25.4 x 30.5 cm/10 x 12"
Signed and dated: (l.r.) G. A. Reid. 1929
Inscribed: (verso) Fire Swept Rocks/
Temagami [deleted] Burnt Hillside
[deleted]/G. A. Reid 1929/10 x 12
Gift of the artist, 1944. MGS 621205

*Study for Woodland, Temagami
Forest* 1929
Oil on board, 25.4 x 30.5 cm/10 x 12"
Signed and dated: (l.r.) G. A. Reid '29
Inscribed: (verso) Study for – Woodland,
Temagami Forest/(Red Pine Temagami
Forest) [deleted]/Temagami/(Study for
–) 10 x 12/Keep this little/Picture show
CNE/want to get it/Haines
Gift of the artist, 1944. MGS 621203

Wilson Lake, Temagami, Study
1929
Oil on board, 30.5 x 25.4 cm/12 x 10"
Signed and dated: (l.l.) G. A. Reid 1929
Inscribed: Wilson Lake, Temagami/
Ragged Birches [deleted]/G. A. Reid,
1929/12 x 10/Study
Gift of the artist, 1944. MGS 621126

G.A. Reid, *Evening, Lake Temagami*, 1941

G.A. Reid, *The Harbour, Tobermory*, 1931

G.A. Reid, *Quiet Water*, 1920

Red Pines, Lowell Lake, Temagami
1934
Oil on board, 30.5 x 25.4 cm/12 x 10"
Signed and dated: (l.r.) G. A. Reid 34
Inscribed: (verso) Red Pines, Lowell
Lake/Temagami/1934/G. A. Reid
12 x 10
Gift of the artist, 1944. MGS 621136

Study for Sunset on Lake Temagami
1934
Oil on board, 30.5 x 25.4 cm/12 x 10"

Signed and dated: (l.r.) G. A. Reid. 34.
Inscribed: (verso) Study for –/Sunset on
Lake Temagami/Study/1934/G. A. Reid
12 x 10/Temagami
Gift of the artist, 1944. MGS 621214

Sunset on Lake Temagami 1939
Oil on board, 61 x 45.7 cm/24 x 18"
Signed and dated: (l.l.) G. A. Reid. 1939.
Inscribed: (verso) SUNSET ON LAKE
TEMAGAMI/by G. A. Reid, R.C.A./
1929 [*sic*]/24 x 18 $75.00/This picture
has been waxed/and so should not be
varnished/unles [*sic*] wax is removed
with/turpentine G. A. Reid
Gift of the artist, 1944. MGS 632657

Evening, Lake Temagami 1941
Oil on canvas, 45.7 x 58.4 cm/18 x 23"
Signed and dated: (l.l.) G. A. Reid. 1941
Gift of the artist, 1944. MGS 619833

Landscapes – Central Ontario

Quiet Water 1920
Oil on canvas, 76.2 x 101.6 cm/30 x 40"
Signed and dated: (l.r.) G. A. Reid 1920
Gift of the artist, 1944. MGS 622037

Untitled 1921
Watercolour and pastel on paper,
22.2 x 32.4 cm/8³/₄ x 12³/₄"
Signed and dated: (l.l.) G. A. Reid. 1921.
Gift of the artist, 1944. MGS 621174

Upland Pasture 1926
Oil on canvas, 76.2 x 63.5 cm/30 x 25"
Signed and dated: (l.r.) G. A. Reid 1926
Inscribed: (verso) The Upland Pasture/
G. A. Reid/1926/25 x 30" [*sic*]
Gift of the artist, 1944. MGS 622620

Study for Ragged Birches 1929
Oil on board, 30.5 x 25.4 cm/12 x 10"
Signed and dated: (l.l.) G. A. Reid. 1929.
Inscribed: (verso) (Study for – Ragged
Birches/Inlet [deleted]/G. A. Reid 1929/
12 x 10/(Study)
Gift of the artist, 1944. MGS 621204

Evening Shadows 1930
Oil on board, 25.4 x 30.5 cm/10 x 12"
Signed and dated: (l.l.) G. A. Reid. 1930
Inscribed: Evening Shadows/G. A. Reid
1929 [*sic*]/10 x 12
Gift of the artist, 1944. MGS 621150

Breakers, Lion's Head 1931
Oil on board, 25.4 x 30.5 cm/10 x 12"
Signed and dated: (l.l.) G. A. Reid./1931.
Inscribed: (verso) Breakers, Lions [*sic*]
Head/G. A. Reid 1931/10 x 12
Gift of the artist, 1944. MGS 621144

The Harbour, Tobermory 1931
Oil on board, 25.4 x 30.5 cm/10 x 12"
Signed and dated: (l.l.) G. A. Reid. 1931.
Inscribed: The Harbour Tobermory/
G. A. Reid 1931/10 x 12
Gift of the artist, 1944. MGS 621143

G.A. Reid, *Dorset Village and Bridge*, 1936

G.A. Reid, *Lake through the Birches*, 1936

(Snake Fence,) Hope Bay, Bruce Peninsula 1931
Oil on board, 25.4 x 30.5 cm / 10 x 12"
Signed and dated: (l.l.) G. A. Reid. 1931.
Inscribed: (verso) (Snake Fence,) Hope Bay / Bruce Peninsula / G. A. Reid, 1931 / 10 x 12
Gift of the artist, 1944. MGS 621146

Turquoise Water 1931
Oil on board, 25.4 x 30.5 cm / .10 x 12"
Signed and dated: (l.r.) G. A. Reid, 1931
Inscribed: (verso) Turquoise Water / G. A. Reid 1931 / 10 x 12
Gift of the artist, 1944. MGS 621145

Birches on the Beach 1932
Oil on board, 25.4 x 30.5 cm / 10 x 12"
Signed and dated: (l.l.) G. A. Reid 1932
Gift of the artist, 1944. MGS 622586

Tree Boles 1932
Oil on board, 30.5 x 25.4 cm / 12 x 10"
Signed and dated: (l.r.) G. A. Reid. 1932.
Inscribed: (verso) Tree Boles / G. A. Reid 1932 / 12 x 10
Gift of the artist, 1944. MGS 621166

The Snake Fence 1934
Oil on canvas, 76.2 x 101.6 / 30 x 40"
Signed and dated: (l.l.) G.A. Reid 1934
Inscribed: (on stretcher) The Snake Fence / F.A. Reid 1934 / 30 x 40"
Gift of the artist, 1944. MGS 635406

The Sawmill at Dwight (Lake of Bays) 1935
Oil on board, 25.4 x 30.5 cm / 10 x 12"
Signed and dated: (l.r.) G. A. Reid 1935
Gift of the artist, 1944. MGS 621202

Trading Lake, Dorset 1935
Oil on board, 25.4 x 30.5 cm / 10 x 12"
Signed and dated: (l.r.) G. A. Reid. 1935.
Inscribed: (verso) Trading Lake / Dorset / G. A. Reid 1936 [*sic*] / 10 x 12
Gift of the artist, 1944. MGS 621118

Barrow Bay, Bruce Peninsula, Georgian Bay 1936
Oil on canvas, 25.4 x 30.5 cm / 10 x 12"
Signed and dated: (l.l.) G. A. Reid, 1936.
Inscribed: (verso) Barrow Bay / Bruce Peninsula / Georgian Bay / by G. A. Reid R.C.A. / 1931 [*sic*] / 10 x 12
Gift of the artist, 1944. MGS 621142

The Bay, Dorset No. 2 1936
Oil on board, 25.4 x 30.5 cm / 10 x 12"
Signed and dated: (l.l.) G. A. Reid. 1936.
Inscribed: (verso) Small Pictures Ex. 1941 [*sic*] / The Bay Dorset No. 2 / G.A. Reid 1936 / 10 x 12
Gift of the artist, 1944. MGS 621119

Dorset Sawmill 1936
Oil on board, 25.4 x 30.5 cm / 10 x 12"
Signed and dated: (l.r.) G. A. Reid. 1936. Dorset.
Inscribed: (verso) Dorset Sawmill / G. A. Reid 1936 / 10 x 12
Gift of the artist, 1944. MGS 621117

Dorset through the Trees 1936
Oil on wood panel, 25.4 x 30.5 cm / 10 x 12"

G.A. Reid, *The Marshes, Port Hope*, 1924

Signed and dated: (l.l.) G. A. Reid. 36
Inscribed: (verso) Dorset through the Trees / G. A. Reid 1936 / 10 x 12
Gift of the artist, 1944. MGS 621120

Dorset Village and Bridge 1936
Oil on board, 25.4 x 30.5 cm / 10 x 12"
Signed and dated: (l.r.) G. A. Reid. Dorset. 1936
Inscribed: (verso) Dorset Village and Bridge / G. A. Reid / 1936 / 10 x 12
Gift of the artist, 1944. MGS 621121

(Johnny Cake Bay) Lake of Bays
1936
Oil on board, 25.4 x 30.5 cm / 10 x 12"
Signed and dated: (l.r.) G. A. Reid. 1936.
Dorset.
Inscriptions: (verso) (Johnny Cake Bay) /
Lake of Bays / G. A. Reid 1936 / 10 x 12
Gift of the artist, 1944. MGS 621115

Lake through the Birches 1936
Oil on canvas, 55.9 x 91.4 cm / 22 x 36"
Signed and dated: (l.l.) G. A. Reid. 1936.
Gift of the artist, 1944. MGS 619840

Racing Water 1936
Oil on board, 25.4 x 30.5 cm / 10 x 12"
Signed and dated: (l.r.) G. A. Reid 1936
Inscribed: (verso) Racing Water / G. A.
Reid 1936 $40.00 / 10 x 12
Gift of the artist, 1944. MGS 621147

The Torrent 1936
Oil on board, 25.4 x 30.5 cm / 10 x 12"
Signed and dated: (l.l.) G. A. Reid. 1936
Inscribed: (verso) *The Torrent* / G. A.
Reid 1936 / 10 x 12
Gift of the artist, 1944. MGS 621148

Dorset Village 1937
Oil on board, 25.4 x 30.5 cm / 10 x 12"
Signed and dated: (l.r.) G. A. Reid. 37.
Inscribed: Dorset Village / G. A. Reid
1937 / 10 x 12 / Study
Gift of the artist, 1944. MGS 621116

Michaelmas Daisies 1937
Oil on board, 25.4 x 30.5 cm / 10 x 12"
Signed and dated: (l.r.) G. A. Reid. 1937.
Inscribed: (verso) Michaelmas Daisies /
G. A. Reid 1937 / 10 x 12
Gift of the artist, 1944. MGS 621165

Landscapes – Port Hope

The Marshes, Port Hope 1924
Oil on board, 30.5 x 25.4 cm / 12 x 10"
Signed and dated: (l.l.) G. A. Reid. 1924
Inscribed: (verso) The Marshes / Port
Hope / G. A. Reid / 1927 [*sic*] / 12 x 10
Gift of the artist, 1944. MGS 621156

Clover – Port Hope 1925
Oil on canvasboard, 19.7 x 29.2 cm /
7³/₄ x 11¹/₂"
Signed and dated: (l.l.) G. A. Reid. 1925.
Gift of the artist, 1944. MGS 622057

G.A. Reid, *The Waterfall*, 1927

Port Hope Mill Pond 1925
Oil on board, 25.4 x 30.5 cm / 10 x 12"
Signed and dated: (l.l.) G. A. Reid 1925.
Inscribed: (verso) Port Hope Mill Pond,
1925 / G. A. Reid / 10 x 12
Gift of the artist, 1944. MGS 621155

Ripening Fields near Port Hope
1925
Oil on board, 25.4 x 30.5 cm / 10 x 12"
Signed and dated: (l.l.) G. A. Reid. 1925.
Inscribed: (verso) Ripening Fields / G. A.
Reid / 1925 / Near Port Hope 10 x 12
Gift of the artist, 1944. MGS 621161

Glimpse of the...Port Hope 1926
Oil on board, 25.4 x 30.5 cm / 10 x 12"
Signed and dated: (l.l.) G. A. Reid. 1926.
Inscribed: (verso) Glimpse of the
[illegible] / G. A. Reid / 1926 / Port Hope
10 x 12
Gift of the artist, 1944. MGS 621149

Afternoon Clouds, Port Hope 1927
Oil on board, 25.4 x 30.5 cm / 10 x 12"

Signed and dated: (l.l.) G. A. Reid. 1927.
Inscribed: Midsummer Green
[deleted]1927 / Afternoon Sunlight
[deleted]...
10 x 12 / Afternoon Clouds / G. A. Reid
Port Hope
Gift of the artist, 1944. MGS 621154

Cedar Woods Near Port Hope 1927
Oil on board, 25.4 x 30.5 cm / 10 x 12"
Signed and dated: (l.r.) G. A. Reid 27
Inscribed: (verso) Cedar Woods / G. A.
Reid / 1927 / near Port Hope 10 x 12
Gift of the artist, 1944. MGS 621189

The Clover Field 1927
Oil on board, 25.4 x 30.5 cm / 10 x 12"
Signed and dated: (l.l.) G. A. Reid. 1927.
Inscribed: The Clover Field / 1927 /
10 x 12"
Gift of the artist, 1944. MGS 621151

On loan to the Collingwood Collegiate
Institute from 1946 to 1979, when it was
returned to Queen's Park.

G.A. Reid, *Lacy Willows, Toronto Environs,* 1933

G.A. Reid, *Wheat Harvest,* c. 1925

Rapids on the Ganaraska 1927
Oil on board, 25.4 x 30.5 cm / 10 x 12"
Signed and dated: (l.l.) G. A. Reid 1927.
Inscribed: (verso) Rapids on the
Generesca [*sic*] / G. A. Reid / 1927 / 10 x 12
Gift of the artist, 1944. MGS 621157

Ripening Fields, Port Hope 1927
Oil on board, 30.5 x 25.4 cm / 12 x 10"
Signed and dated: (l.l.) G. A. Reid, 1927.
Inscribed: (verso) Ripening Fields / G. A.
Reid / 12 x 10 / Port Hope / 1927
Gift of the artist, 1944. MGS 621160

The Rippling Stream 1927
Oil on board, 25.4 x 30.5 cm / 10 x 12"
Signed and dated: (l.l.) G. A. Reid. 1927
Inscribed: (verso) The Rippling Stream /
10 x 12 / 1927
Gift of the artist, 1944. MGS 621159

The Waterfall 1927
Oil on board, 25.4 x 30.5 cm / 10 x 12"
Signed and dated: (l.r.) G. A. Reid.
1927
Inscribed: (verso) The Waterfall / G. A.
Reid / 1927 / 10 x 12
Gift of the artist, 1944. MGS 621153

At Rice Lake 1928
Oil on board, 25.4 x 30.5 cm / 10 x 12"
Signed and dated: (l.r.) G. A. Reid. 1928
Inscribed: (verso) At Rice Lake / 10 x 12 /
G. A. Reid 1927 [*sic*]
Gift of the artist, 1944. MGS 621129

Rice Lake Shore 1929
Oil on board, 25.4 x 30.5 cm / 10 x 12"
Signed and dated: (l.r.) G. A. Reid. 1929
Inscribed: (verso) Rice Lake Shore / G. A.
Reid / 1927 [*sic*], 10 x 12
Gift of the artist, 1944. MGS 621128

Wheat Harvest 1935
Oil on canvasboard, 23.8 x 28.6 cm /
9³⁄₈ x 11¹⁄₄"
Signed: (l.r.) G. A. Reid
Inscribed: (verso) G. A. Reid / Port Hope /
C.N.E. 24 / Wheat Harvest / 10 x 12 1935
Gift of the artist, 1944. MGS 622050

On loan to the Owen Sound Collegiate
and Vocational Institute, since 1946.

Landscapes – Southern Ontario

Elm Trunks, Near Norval 1921
Oil on board, 30.5 x 25.4 cm / 12 x 10"
Signed and dated: (l.r.) G. A. Reid 1921
Inscribed: (verso) Elm Trunks / 1921 /
12 x 10 / Near Norval
Gift of the artist, 1944. MGS 621162

Clover Fields, Humber River 1922
Oil on board, 25.4 x 30.5 cm / 10 x 12"
Signed and dated: (l.l.) G. A. Reid. 1922.
Inscribed: (verso) Clover Fields / Humber
River / G. A. Reid 1922 / 10 x 12
Gift of the artist, 1944. MGS 621152

Overlooking the Pond
Oil on canvasboard, 14.3 x 21.3 cm /
5⁵⁄₈" x 8³⁄₈"
Signed and dated: (l.r.) G. A. Reid. 22;
Inscribed: (verso) Overlooking the
Pond / G. A. Reid 1922 / 6 x 9
Gift of the artist, 1944. MGS 622059

On loan to the Goderich District
Collegiate Institute, from 1946 to 1979,
when it was returned to Queen's Park.

*The Meadow Brook, near
Woodbridge* 1924
Oil on board, 25.4 x 30.5 cm / 10 x 12"
Signed and dated: (l.l.) G. A. Reid. 1924.
Inscribed: (verso) The Meadow Brook /
G. A. Reid 1924 / 10 x 12 / near
Woodbridge
Gift of the artist, 1944. MGS 621158

Edge of the Wood 1925
Oil on board, 25.4 x 30.5 cm / 10 x 12"
Signed and dated: (l.r.) G. A. Reid 1925
Inscribed: (verso) Edge of the Wood /
10 x 12 / 1925
Gift of the artist, 1944. MGS 622058

G.A. Reid, *Early Autumn on the Don*, 1941

G.A. Reid, *Champlain Market*, 1926

Edge of the Wood 1925
Oil on board, 30.5 x 35.6 cm / 12 x 14"
Signed and dated: (l.l.) G. A. Reid. 1925
Inscribed: (verso) Edge of the Wood /
G. A. Reid 1938 [sic] / 12 x 14
Gift of the artist, 1944. MGS 622018

Harvest Fields c.1925
Oil on canvas, 30.5 x 25.4 cm / 12 x 10"
Signed: (l.l.) G. A. Reid
Gift of the artist, 1944. MGS 622051
On loan to the Owen Sound Collegiate
and Vocational Institute, since 1946.

Ontario Pasture 1927
Oil on board, 25.4 x 30.5 cm / 10 x 12"
Signed and dated: (l.l.) G. A. Reid. 27.
Inscribed: (verso) Ontario Pasture / In the
Pasture [deleted] / G. A. Reid 1927 /
10 x 12
Gift of the artist, 1944. MGS 621163

The Lone Beech, Pioneer Roadway
1928
Oil on board, 30.5 x 35.6 cm / 12 x 14"
Signed and dated: (l.l.) G. A. Reid 1928
Inscribed: (verso) The Lone Beech / G. A.
Reid 1938 / 12 x 14 / Pioneer Roadway /
G. A. Reid
Gift of the artist, 1944. MGS 622024

*Study for Sunshine and Shower,
Belfountain* 1931
Oil on board, 25.4 x 30.5 cm / 10 x 12"
Signed and dated: (l.l.) G. A. Reid. 1931
Inscribed: (verso) (Study for – / Sunshine
and Shower / G. A. Reid, 1931 / 10 x 12
Belfountain / (Study)
Gift of the artist, 1944. MGS 621164

Lacy Willows, Toronto Environs
1933
Oil on board, 25.4 x 30.5 cm / 10 x 12"
Signed and dated: (l.l.) G. A. Reid 1933
Inscribed: (verso) Lacy Willows / G. A.
Reid, 1933 / 10 x 12 / Toronto Environs
Gift of the artist, 1944. MGS 621199

Fiery Autumn 1935
Oil on board, 30.5 x 25.4 cm / 12 x 10"
Signed and dated: (l.l.) G. A. Reid. 1935
Inscribed: (verso) Fier [deleted] / A
Glimpse of [deleted] Firy [sic] Autumn /
G. A. Reid 1935 / 12 x 10
Gift of the artist, 1944. MGS 622147

Afternoon Haze 1938
Oil on board, 29.2 x 34.3 cm /
11½ x 13½"
Signed and dated: (l.r.) G. A. Reid 1938
Inscribed: (verso) Afternoon Haze / G. A.
Reid 1938 / 12 x 14
Gift of the artist, 1944. MGS 622148

G.A. Reid, *La Petite Eglise, l'ile d'Orleans*,
1926

Autumn Contrasts 1939
Pastel on paper, 27.9 x 33.7 cm /
11 x 13¼"
Signed and dated: (l.r.) G. A. Reid 1939
Inscribed: (verso) Autumn Contrasts /
G. A. Reid 1939 / 12 x 14
Gift of the artist, 1944. MGS 622054
On loan to the F.E. Madill Secondary
School, Wingham from 1946.

Early Autumn on the Don 1941
Oil on canvas, 100.3 x 125.1 cm/
39¹/₂ x 49¹/₄"
Signed and dated: (l.r.) G. A. Reid. 1941.
Gift of the artist, 1944. MGS 693313

Landscapes – Quebec

Champlain Market 1926
Oil on board, 25.4 x 30.5 cm/10 x 12"
Signed and dated: (l.r.) G. A. Reid 1926
Inscribed: (verso) Champlain Market/
10 x 12/1926
Gift of the artist, 1944. MGS 621169

Champlain Street 1926
Oil on board, 25.4 x 30.5 cm/10 x 12"
Signed and dated: (l.r.) G. A. Reid. 1926.
Inscribed: (verso) Champlain Street/
1926/G. A. Reid/10 x 12
Gift of the artist, 1944. MGS 621171

Governor's Garden 1926
Oil on board, 25.4 x 30.5 cm/10 x 12"
Signed and dated: (l.l.) G. A. Reid 1926
Inscribed: (verso) Garden in Quebec/
G. A. Reid 1926/10 x 12
Gift of the artist, 1944. MGS 621197

Notre Dame des Victoires 1926
Oil on board, 30.5 x 25.4 cm/12 x 10"
Signed and dated: (l.l.) G. A. Reid. 1926.
Inscribed: (verso) Notre Dame des
Victoires/10 x 14/G. A. Reid 1926
Gift of the artist, 1944. MGS 621167

On the Terrace, Quebec 1926
Oil on wood panel, 30.5 x 25.4 cm/
12 x 10"
Signed and dated: (l.r.) G. A. Reid 1926;
Inscribed: (verso) On the Terrace,
Quebec/12 x 10/1924 [*sic*]
Gift of the artist, 1944. MGS 621170

La Petite Eglise, l'Ile d'Orleans
1926
Oil on canvasboard, 25.4 x 31.8 cm/
10 x 12¹/₂"
Signed and dated: (l.l.) G. A. Reid. 1926.
Inscribed: (verso) La Petite Eglise, l'Ile
d'Orleans, 1926, G. A. Reid
Gift of the artist, 1944. MGS 622020

On loan to the Oshawa Collegiate
Institute from 1946 to 1979, when it was
returned to Queen's Park.

G.A. Reid, *Tranquility*, 1906

G.A. Reid, *The Cumulus Cloud,* 1910

Sous le Cap 1926
Oil on wood panel, 30.5 x 25.4 cm/
12 x 10"
Signed and dated: (l.l.) G. A. Reid. 1926.
Inscribed: (verso) Sous le Cap,/Little
Champlain St. [*deleted*]/G. A. Reid/
1926
Gift of the artist, 1944. MGS 621168

Wolfesfield Garden 1926
Oil on board, 25.4 x 30.5 cm/10 x 12"
Signed and dated: (l.l.) G. A. Reid. 1926.
Inscribed: (verso) Wolfesfield Garden/
G. A. Reid 1926/10 x 12
Gift of the artist, 1944. MGS 621198

In the Park, Quebec 1927
Oil on canvas, 62.5 x 74.9 cm/
25⅝ x 29½"
Signed and dated: (l.l.) G. A. Reid. 1927.
Gift of the artist, 1944. MGS 623031

On loan to the Cornwall Collegiate and
Vocational Institute, from 1946 to 1979,
when it was returned to Queen's Park.

Landscapes - U.S.A. and Abroad

*A Mountain Village (Tannersville,
N.Y.), Onteora Catskill Mountain*
1892
Oil on board, 25.4 x 30.5 cm/10 x 12"
Signed and dated: (l.c.) G. A. REID. 1892
Inscribed: (verso) A Mountain Village/
(Tannersville, N.Y.)/G. A. Reid 1892/
10 x 12/Onteora Catskill Mountain
Gift of the artist, 1944. MGS 621186

Tranquility 1906
Oil on canvas, 132 x 104 cm/52 x 41"
Signed and dated: (l.r.) G. A. Reid. 1906.
Gift of the artist, 1944. MGS 622033

On loan to the Hamilton Normal School
from 1946 to 1979, when it was returned
to Queen's Park.

The Garden Path 1908
Oil on board, 30.5 x 25.4 cm/12 x 10"
Signed: (l.l.) G. A. Reid.
Inscribed: (verso) The Garden Path/
G. A. Reid 1908/12 x 10
Gift of the artist, 1944. MGS 621180

Oaks in Autumn 1908
Oil on canvas, 62.2 x 74.9 cm/
24½ x 29½"
Dated: (verso) 1908
Gift of the artist, 1944. MGS 619721

Across the Dyke, Walberswick
1910
Pastel on cardboard, 20.3 x 23.5 cm/
8 x 9¼"
Signed and dated: (l.l.) G. A. Reid 1910
Gift of the artist, 1944. MGS 621211

The Cumulus Cloud 1910
Oil on board, 30.5 x 25.4 cm/12 x 10"
Signed and dated: (l.l.) G. A. Reid. 1910.
Inscribed: 2. The Cumulus Cloud/G. A.
Reid/$75.00
Gift of the artist, 1944. MGS 621184

Hills in Distance 1911
Pastel on paper, 24.1 x 28.6 cm/
9½ x 11¼"
Signed and dated: (l.l.) G. A. Reid. 1911
Gift of the artist, 1944. MGS 621176

Sunlight in the Woods 1911
Pastel on paper, 25.4 x 30.5 cm/10 x 12"
Signed and dated: (l.r.) G. A. Reid 1911.
Gift of the artist, 1944. MGS 626201

Blossoms in the Valley 1912
Pastel on paper, 23.5 x 24.8 cm/
9¼ x 9¾"
Signed and dated: (l.l.) G. A. Reid 1912
Gift of the artist, 1944. MGS 621175

Oat Harvest 1912
Pastel on cardboard, 20.3 x 23.5 cm/
8 x 9¼"
Signed and dated: (l.l.) G. A. Reid 1912
Gift of the artist, 1944. MGS 621210

Afternoon 1913
Oil on canvas, 59.1 x 181.6 cm/
23¼ x 71½"
Signed and dated: (l.l.) G. A. Reid 1913
Gift of the artist, 1944. MGS 622100

On loan to the London Normal School
from 1946 to 1979, when it was returned
to Queen's Park.

The Valley Beyond c. 1913
Oil on canvas, 27.3 x 79.7 cm/
10¾ x 31⅜"
Inscribed: Study for Davenport House/
owned by T.K. Morrow/"The Valley
Beyond".
Gift of the artist, 1944. MGS 622101

On loan to the F.E. Madill Secondary
School, Wingham, from 1946.

Afternoon Clouds, Onteora, N.Y.
1914
Oil on board, 25.4 x 30.5 cm/10 x 12"
Signed and dated: (l.r.) G. A. Reid;
(l.l.) 1914
Inscribed: (verso) Afternoon Clouds/
G. A. Reid 1914/10 x 12/Onteora N.Y.
1914
Gift of the artist, 1944. MGS 621191

An American Village 1914
Oil on board, 25.4 x 30.5 cm/10 x 12"
Signed and dated: (l.r.) G. A. Reid. 1914
Inscribed: (verso) An American Village/
G. A. Reid 1914/10 x 12
Gift of the artist, 1944. MGS 621183

The Old Apple Tree 1914
Oil on board, 30.5 x 25.4 cm/12 x 10"
Signed and dated: (l.l.) G. A. Reid. 1914.
Inscribed: The Old Apple Tree/G. A.
Reid, 1914/10 x 12
Gift of the artist, 1944. MGS 621185

Hills and Clouds, Catskills 1914
Oil on board, 25.4 x 30.5 cm/10 x 12"
Signed and dated: (l.l.) G. A. Reid 1914
Inscribed: (verso) Hills and Clouds/
G. A. Reid 1914/10 x 12/Catskills
Gift of the artist, 1944. MGS 621192

Tannersville Village 1914
Oil on board, 25.4 x 30.5/10 x 12"
Signed and dated: (l.l.) G. A. Reid. 1914.
Inscribed (verso) Tannersville Village/
10 x 12/G. A. Reid, 1914
Gift of the artist, 1944. MGS 621177

Woodland Path 1914
Oil on board, 30.5 x 25.4 cm/12 x 10"
Signed and dated: (l.l.) G. A. Reid/1914.
Inscribed: (verso) Woodland Path/G. A.
Reid 1914/12 x 10
Gift of the artist, 1944. MGS 621179

Young Birches 1914
Oil on board, 30.5 x 25.4 cm/12 x 10"
Signed and dated: (l.l.) G. A. Reid 1914.
Inscribed: (verso) Young Birches/G. A.
Reid 1914/12 x 10
Gift of the artist, 1944. MGS 621190

The Cloud, Catskills 1915
Oil on board, 25.4 x 30.5 cm/10 x 12"
Signed: (l.r.) G. A. Reid.
Inscribed: (verso) The Cloud/G. A. Reid
1915/10 x 12/Catskills
Gift of the artist, 1944. MGS 621194

The Onteora Trail 1915
Oil on canvasboard, 30.5 x 25.4 cm/
12 x 10"
Signed and dated: (l.l.) G. A. Reid 1915
Inscribed: (verso) The Onteora Trail/
G. A. Reid 1914 [*sic*]/12 x 10
Gift of the artist, 1944. MGS 621181

Through the Woods, Onteora 1915
Oil on board, 25.4 x 30.5 cm/10 x 12"
Signed and dated: (l.l.) G. A. Reid 1915
Inscribed: (verso) Through the Woods/
G. A. Reid/Onteora/19154/10 x 12
Gift of the artist, 1944. MGS 621182

Church in the Valley c. 1916
Pastel on paper, 24.1 x 22.9 cm/9½ x 9"
Gift of the artist, 1944. MGS 621178

Dawn in the Willows 1917
Pastel on paper, 30.5 x 35.6 cm/12 x 14"
Signed and dated: (l.l.) G. A. Reid 1917
Inscribed: (verso) Dawn in the Willows/
1917
Gift of the artist, 1944. MGS 626203

Rocks and Surf, St. Ives 1924
Oil on board, 25.4 x 30.5 cm/10 x 12"
Signed and dated: (l.r.) G. A. Reid 1924
Inscribed: (verso) Rocks and Surf/St.
Ives/G. A. Reid 1924/10 x 12
Gift of the artist, 1944. MGS 622022

On loan to the Orillia Collegiate and
Vocational Institute from 1946 to 1979,
when it was returned to Queen's Park.

Saint Ives Harbour 1924
Oil on board, 25.4 x 30.5 cm/10 x 12"
Signed and dated: (l.l.) G. A. Reid 1924
Inscribed: (verso) St. Ives Harbour/
G. A. Reid 1924/10 x 12
Gift of the artist, 1944. MGS 622023

On loan to the Orillia Collegiate and
Vocational Institute from 1946 to 1979,
when it was returned to Queen's Park.

A Summer Shower 1925
Oil on board, 25.4 x 30.5 cm/10 x 12"
Signed and dated: (l.l.) G. A. Reid. 1925.
Inscribed: (verso) Rain [deleted]/
10 x 12/1925
Gift of the artist, 1944. MGS 621193

Streak of Sunlight 1916
Pastel on paper, 25.4 x 30.5 cm/10 x 12"
Signed and dated: (l.r.) G. A. Reid 1916
Gift of the artist, 1944. MGS 626202

Mary H. Reid, *A Harmony in Gray and Yellow*, 1897

Mary H. Reid, *Pines at Sunset*

Mary Augusta Hiester Reid,
O.S.A., A.R.C.A.
Born: Reading, Pennsylvania,
U.S.A., 10 April 1854
Died: Toronto, Ontario,
4 October 1921

Mary Augusta Hiester was a student of
the American artist Thomas Eakins at
the Pennsylvania Academy of Fine Arts
from 1883-85. In 1885 she married
fellow student George A. Reid and
moved with him to Toronto the
following year.

A Harmony in Gray and Yellow
1897
Oil on canvas, 34.3 x 90.2 cm/
13½ x 35½"
Signed and dated: (u.l.) MARY H. REID
1897
Purchase from the artist, 1897.
MGS 619739

Purchased from the 25th Annual O.S.A.
Exhibition (Toronto), 1897 (cat. no. 71)
as a "Ballot Picture."

A Poppy Garden
Oil on canvas, (later mounted on
masonite), 57.8 x 42.5 cm/22¾ x 16¾"
Signed: (l.l.) [illegible]
Purchase from the artist, 1900.
MGS 692728

Purchased from the 28th Annual O.S.A.
Exhibition (Toronto), 1900 (cat. no. 59)
as part of the Toronto Guild of Civic Art
Committee selection for the $800
Annual Grant. It remained at the
Toronto Normal School and was
returned to Queen's Park in 1979.

Pines at Sunset
Oil on canvas, 72.2 x 49.5 cm/
28⁷/₁₆ x 19½"
Signed: (l.l.) M. H. REID
Purchase from the artist, 1902.
MGS 622001

Purchased from the 30th Annual O.S.A.
Exhibition (Toronto), 1902 (cat. no. 70)
as part of the Toronto Guild of Civic Art
Committee selection for the $800
Annual Grant. It was on loan to the
London Normal School from 1912 and
was returned to Queen's Park in 1979.

Roses
Oil on canvas, 39.4 x 49.5 cm/
15½ x 19½"
Signed: (l.l.) MARY H. REID
Purchase from the artist, 1897.
MGS 623358

This work was on loan to the Ottawa
Normal School from 1912 and was
returned to Queen's Park at an unknown
date.

William Revell, O.S.A., A.R.C.A.
Born: Yorkshire, England, 1841
Died: Toronto, Ontario, 1902

Woodland Dell 1895
Watercolour on paper, mounted on
cardboard, 101.6 x 68.6 cm/40 x 27"
Signed and dated: (l.l.) W. REVELL 1895.
MGS 692949

Joseph Thomas Rolph,
O.S.A., A.R.C.A.
Born: London, England,
8 September 1831
Died: 1916

After the Shower (Dorking, Eng.)
c. 1898
Watercolour on paper, 33.7 x 50.2 cm/
13¼ x 19¾"
Signed: (l.l.) J. T. Rolph
Purchase from the artist, 1898/99.
MGS 692619

Purchased from the O.S.A. Normal
School Exhibition (Toronto), 1898/99
(cat. no. 19) as part of the Education
Department Committee selection for
the $800 Annual Grant. It is most likely
to have been painted on a trip to England
in the 1890s by the artist, who had
emigrated to Canada in 1857. The
watercolour shows the ancient market
town of Dorking, Surrey, located
southwest of London.

Humber River, Woodbridge
Watercolour on paper, 38.1 x 55.9 cm/
15 x 22"
Signed: (l.r.) j. t. Rolph
Purchase from the artist, 1898/99.
MGS 622081

Purchased from the O.S.A. Normal
School Exhibition (Toronto), 1898/99
(cat. no. 35) as part of the Education
Department Committee selection for

William Revell, *Woodland Dell*, 1895

Joseph Rolph, *After the Shower (Dorking, Eng.)*, c. 1898

the $800 Annual Grant. Woodbridge is a small town northwest of Toronto, at the junction of the west and east branches of the Humber River.

Christian Rost

Born: Germany

Died: Mount Vernon, New York, U.S.A., 1905

The Little Wanderer 1866
(after Thomas Faed, R.A., British, 1826-1900)
Engraving; 47 x 57.2 cm / 18½ x 22½"
(sight), 41.9 x 55.9 cm / 16½ x 22"
(image)
Inscribed: (l.l.) Published exclusively for members of the CROSBY OPERA HOUSE ART ASSOCIATION 1866 / Painted by Thos. Faed, A.R.A.; (l.c.) THE LITTLE WANDERER; (l.r.) Engraved by C. Rost.
MGS 620503

This work may have entered the collection around 1956 as a gift of Sigmund Samuel.

E. St. John

In the Tyrol
Watercolour on paper, 62.9 x 45.7 cm / 24¾ x 18"
Signed twice: (l.r., smudged) E. St. John; (l.r.) E. St. JOHN
Dated: (l.r.) _____?
MGS 623105

Unfortunately, no purchase records have yet been found to confirm this work's entry into the collection, or give the artist's full name. According to H.L. Maillalieu's *Dictionary of British Watercolour Artists Up to 1920* (Woodbridge, Suffolk: Antique Collectors' Club, 1976) an Edwin (or Edwina) St. John was "A prolific painter working in the 1880s and 1890s. He, or she, painted in Germany and Spain" and may have been the artist of this view of an unidentified town in the West Austrian province of Tyrol.

Frédéric or Friedrich Salathé

Born: 1793

Died: 1860

Niagara Falls, The Horse Shoe / Les Chutes du Niagara, Le Fer à Cheval c. 1852

(after Hippolyte Victor-Valentin Sebron, French, 1801-1879)
Colour aquatint and etching;
68.6 x 99.1 cm / 27 x 39" (sight),
59.1 x 94 cm / 23¼ x 37" (image)
Inscribed: (l.l.) PEINT PAR H. SEBRON. / LES CHUTES DU NIAGARA / LE FER A CHEVAL; (l.c.) Entered according to Act of Congress in the year 1852, by W. Shaus, in the Clerk's Office of the District Court of the United States for the southern District of New York. / Publié par GOUPIL & CIE Editeurs. / NEW-YORK PARIS LONDON BERLIN.; (l.r.) GRAVE PAR SALATHE. / NIAGARA FALLS / THE HORSE SHOE / Imp. par Goupil & Cie
Purchase, 1982. MGS 632962

Sebron, a pupil of Daguerre, was a portraitist and a painter of architectural and landscape subjects. While in North America between 1849 and 1855, he was mainly engaged in the painting of dioramas. He visited Niagara Falls in 1850.

Salathé produced a number of prints after Sebron's panoramic views of Niagara Falls. This aquatint is one of two large works after Sebron, given the overall title *Les Chutes du Niagara*. Its companion piece, also published by Goupil in 1852, is titled *Niagara Falls: General View*. A third aquatint by

Joseph Rolph, *Humber River, Woodbridge*

Salathé based on a large canvas by Sebron, *c.* 1850, shows *Niagara Falls from Table Rock*. (Copies of each of the above mentioned views of the Falls, along with the Sebron canvas of *Table Rock*, can be found in the Canadiana Collection of the Royal Ontario Museum.)

Julien Ruggles Seavey

Born: Boston, Massachusetts, U.S.A., 1857
Died: Hamilton, Ontario, 3 July 1940

Old Courtyard, 1812, Queenston
Watercolour on paper, 36.8 x 47.6 cm/ 14½ x 18¾"
Signed: (l.l.) J. R. Seavey
Inscribed: (l.r.) Old Courtyard, 1812/ Queenston.
MGS 622062

This work was on loan to the Stratford Normal School from 1912 and was returned to Queen's Park in 1978.

Queenston, on the Niagara River between Niagara-on-the-Lake and Niagara Falls, was the site of the Battle of Queenston Heights, an engagement in the War of 1812. On 13 October 1812, General Sir Isaac Brock was mortally wounded while leading an attack against the American forces occupying the hill south of this village.

Untitled
Oil on canvas, 44.5 x 74.9 cm/ 17½ x 29½"
Signed: (l.l.) J. R. Seavey.
MGS 623072

Seavey headed the art department of the Hamilton Normal School from 1908 to 1931 and probably donated the picture to that institution, where it hung until 1979 when it was returned to Queen's

Julien Seavey, *Untitled*

Park. The central element of the composition is the double line of pilings marking the old Desjardins Canal, built by Peter Desjardins and completed in 1832, which extended from the shore of Lake Ontario westward to the town of Dundas. Dundas itself had for some time been known as Coote's Paradise, a name derived from that of a nearby marsh (the setting chosen by Seavey for this work), which can still be observed off Highway 403 near Hamilton, adjacent to the Royal Botanical Gardens.

William Albert Sherwood,
O.S.A., A.R.C.A.

Born: Omemee, Canada West, 1 August 1855
Died: Toronto, Ontario, 5 December 1919

Indian Fishing by Torchlight
1899-1901
Oil on canvas, 74.9 x 100.3 cm/ 29½ x 39½"
Signed and dated twice: (l.r.) W. A. Sherwood, 1899.; W. A. Sherwood ARCA

1901.
MGS 622066

The title is derived from a Garfield Fine Art Gallery (Toronto) label formerly affixed to the reverse of the painting, which was presumably acquired from that source. The crudeness of the paint handling suggests that the work has been subject to considerable retouching. The composition is similar to that of Paul Kane's *Fishing by Torch Light (Fox River)*, in the Royal Ontario Museum. Sherwood, however, depicts his Indian fisherman in modern garb, including suspenders, while Kane's spearman was dressed in loincloth and leggings.

Klondike Miner 1905
Oil on canvas, 66 x 47 cm/ 26 x 18½"
Inscribed: (verso) (u.l.) Klondike Miner/ 1905; (l.r.) Painted by/ W. A. Sherwood/ 1905.
MGS 622036

This painting was on loan to the Stratford Normal School from 1912, and was returned to Queen's Park in 1978. The title is derived from a label attached to the back of the work.

Harry Spiers, *When the Day's Work is Done*, 1904

Attributed to **August Siegen**

Cairo by Moonlight
Oil on canvas, 95.3 x 134.6 cm / 37½ x 53″
Signed: (l.r.) Aug. Siegen. (?)
MGS 619835

No purchase records have yet been found for this work, although its exotic subject matter and the probable European origins of the artist suggest that it may have been acquired in Europe. Further research may confirm the signature on this canvas to be that of an August Siegen (otherwise unknown), one of whose paintings appears in a 1982 auction catalogue for the West Berlin firm of Leo Spik (Auktion 523, cat. no. 211, plate 33). The style and subject matter of this work, titled *Orientalische Stadt mit Moschee und Ruinen eines Römischen Markttores* (Oriental City with Mosque and Ruins of a Roman Market Gate), strongly suggest the present canvas, and may be by the same hand.

William St. Thomas Smith,
O.S.A., A.R.C.A.
Born: Belfast, Ireland, 30 March 1862
Died: St. Thomas, Ontario,
18 February 1947
Honours: LL.D.

Lobster Fisherman
Watercolour on paper, 38.1 x 55.9 cm /
15 x 22″
Signed: (l.r.) W. Smith
MGS 692616

William Sherwood, *Klondike Miner*, 1905

F.A. Verner, *Wiltshire Cottage*, 1894

W. St. Thomas Smith, *The Castle by the Sea*

The Castle by the Sea
Watercolour on paper, 44.5 x 59.7 cm/
17½ x 23½"
Signed: (l.l.) W. St. Thomas Smith
Purchase from the artist, 1911.
MGS 625813

Purchased from the 39th Annual O.S.A. Exhibition (Toronto), 1911 (cat. no. 181) as part of the Department of Education's Special Committee selection for the $800 Annual Grant. After the closing of the Ottawa Normal School to which it was on loan, it was transferred to Queen's Park in 1980.

Harry Spiers, O.S.A.

Born: Selsea, Sussex, England,
15 October 1869

Died: Dedham, Massachusetts,
U.S.A., c. 1936

Untitled
Watercolour on paper, 50.8 x 61 cm/
20 x 24".
MGS 692609

No purchase records have yet been found for this work. The subject is likely the Humber River at Meadow-vale, northwest of Toronto. The artist had painted in the area as early as 1898 and moved his studio there in 1903.

When the Day's Work is Done 1904
Pastel on paper, 67.3 x 91.4 cm/
26½ x 36"
Signed and dated: (l.r.) – HARRY SPIERS – 04
Purchase from the artist, 1904
MGS 619819

Marc-Aurèle de Foy Suzor-Coté, R.C.A.

Born: Arthabaska, Quebec,
5 April 1869

Died: Daytona Beach, Florida,
U.S.A., 27 January 1937

The River Magog 1913
Oil on canvas, 99.1 x 78.7 cm/39 x 31"
Signed and dated: (l.r.) A. Suzor-Coté/
1913
Purchase from the artist, 1914.
MGS 622109

Purchased from the 42nd Annual O.S.A.

Exhibition (Toronto), 1914 (cat. no. 19) by the Minister of Education's Special Committee. It was sent to the Hamilton Normal School in 1914 and was returned to Queen's Park in 1979.

An oil study for this painting exists and is titled *Magog River, Winter 1912* (private collection, Quebec). The study is stylistically related to both the present work and another large canvas, completed around the same time and titled *Early Winter, Magog River* (private collection, Quebec). The River Magog flows from the Rivière St. François into Lake Magog and Lake Memphremagog, in the Eastern Townships of Quebec.

Sydney Strickland Tully, O.S.A., A.R.C.A.

Born: Toronto, Canada West,
10 March 1860

Died: Toronto, Ontario,
18 July 1911

'At the Loom' – French Canadian Interior 1899
Oil on canvas, 24.8 x 61.9 cm/
9¾ x 24¾"
Signed: (l.l.) Sydney Strickland Tully 1899
Purchase from the artist, 1900.
MGS 623330

Purchased from the 28th Annual O.S.A. Exhibition (Toronto), 1900 (cat. no. 82) as a "Ballot Picture."

Frederick Arthur Verner, O.S.A., A.R.C.A.

Born: Sheridan, Upper Canada,
26 February 1836

Died: London, England, 6 May 1928

Founding member, O.S.A.

Wiltshire Cottage 1894
Watercolour on paper, 51.4 x 104.1 cm/
20¼ x 41"
Signed and dated: (l.r.) Verner/1894.
Purchase, 1896. MGS 692606

Verner exhibited several watercolour
scenes featuring English cottages at the
annual R.C.A. exhibitions between 1894
and 1898 and spent the latter years of his
life painting landscapes of the country-
side around London, England.

E. Walker

Sleigh Scene, Toronto Bay 1853
(after John Thomas Downman, British,
1780-1850)
Coloured lithograph; 59.7 x 79.7 cm/
23½ x 31⅜" (sight), 52.4 x 77.5 cm/
20⅝ x 30½" (image)
Inscribed: (l.l.) PAINTED BY MR. J.T.
DOWNMAN/Ackerman & Co. Direx[nt];
(l.c.) LONDON, PUBLISHED BY THE
PROPRIETOR MARCH 26th 1853
(PRIVATE PLATE)/SLEIGH SCENE,
TORONTO BAY/CANADA WEST/This
Print is dedicated by Permission to The
Officers of the 83rd Regiment/by the
Artist; (l.r.) LITHOGRAPHED BY MR.
E. WALKER/Printed by Day & Son
Lith[rs] to the Queen.
MGS 619737

Although no information is available on
the lithographer E. Walker, J.T.
Downman is identified as a British army
topographer who was stationed in
Toronto in the mid-nineteenth century.

Homer Ransford Watson,
O.S.A., R.C.A.
Born: Doon, Canada West,
24 January 1855
Died: Doon, Ontario, 30 May 1936
President, R.C.A. 1918-22
Honours: LL.D. (posthumous)

Untitled 1886
Oil on canvas, 68.6 x 99.1 cm/27 x 39"
Signed and dated: (l.l.) Homer Watson
1886.
MGS 632659

Purchase records have not yet been
found for this painting. Homer Watson
spent a lifetime studying and painting
the landscape around his home, the
village of Doon, south of Kitchener.
Although as yet untitled, this painting

Sydney Tully, *'At the Loom' — French Canadian Interior*, 1899

Homer Watson, *Untitled*, 1886

E. Walker, *Sleigh Scene, Toronto Bay*, 1853

suggests the geology and topography of south-central Ontario, and its pastoral subject matter is comparable to that found in the artist's many known "Doon landscapes."

George Harlow White,
O.S.A., R.C.A.
Born: London, England, 1817
Died: London, England, 1888

Entrance to the Lledr Valley, N. Wales, Storm Clearing Off 1876
Watercolour on paper, 50.2 x 77.5 cm/
19³/₄ x 30¹/₂"
Signed and dated: (l.l.) G. Harlow White
1876. MGS 619738

This watercolour may have been purchased from the 4th Annual O.S.A. Exhibition (Toronto), 1876 (cat. no. 177). White exhibited many views of his native Great Britain while resident in Ontario between 1871 and 1878.

The Market Place, Quebec 1877
Watercolour on paper, 40 x 27.9 cm/
15³/₄ x 11"
Signed and dated: (l.r.) G. Harlow White
1877. MGS 619740

No purchase records have yet been found for this work; however, it may have been acquired from the 5th Annual O.S.A. Exhibition (Toronto), 1877 (cat. no. 113). The subject is the Champlain Market of Quebec's *Bas-ville*.

Mary Wrinch, *Crocuses*

A. Curtis Williamson, *Interior*, 1896

Thomas Harrison Wilkinson
Born: England, December 1847
Died: Hamilton, Ontario,
9 August 1929

Railway by a Lakeside
Watercolour on paper,
21.6 x 36.8 cm / 8½ x 14½"
Signed: (l.l.) T.H.W.
Gift of Miss Agnes MacGillivray to the
Ontario Heritage Foundation, 1977. On
loan to the Government of Ontario.
MGS 634902

Albert Curtis Williamson,
O.S.A., R.C.A.
Born: Brampton, Canada West,
2 January 1867
Died: Toronto, Ontario,
18 April 1944

Interior 1896
Oil on canvas, 56.8 x 69.9 cm /
22⅜ x 27½"
Signed and dated: (l.r.) A Curtis
Williamson / –96.
MGS 619821

No purchase records have yet been
found for this canvas. It was painted at
the beginning of the decade Williamson
spent in Europe (1895-1905), during
which time he painted rural scenes,
genre subjects and domestic interiors in
Holland and other parts of the
Lowlands.

Mary Evelyn Wrinch,
O.S.A., A.R.C.A.
Born: Kirby-le-Soken, England, 1877
Died: Toronto, Ontario,
19 September 1969

In the 1890s, Mary Evelyn Wrinch was a

student of George Reid at the Ontario
College of Art and in the artist's private
studio classes. She became his second
wife in 1922.

Crocuses
Wood block print; 21 x 20.3 cm /
8¼ x 8" (sight), 17.8 x 17.8 cm / 7 x 7"
(image)
Signed: (l.r.) M. E. Wrinch
Inscribed: (l.l.) Crocuses.
MGS 622143

Stream and Shadows 1909
Oil on canvas, 59.7 x 50.8 cm /
23½ x 20"
Signed and dated: (l.r.) M. E. Wrinch. 09.
MGS 692958

Illustrating History

Walter Seymour Allward, R.C.A.

Born: Toronto, Ontario,
18 November 1875

Died: Toronto, Ontario, 24 May 1955

Honours: LL.D.; C.M.G.

*North-West Rebellion Monument
(1885)* 1895

Bronze on granite base; statue: 221 x 67.3
x 91.4 cm/87 x 26½ x 36", base: 391.2 x
311.2 x 311.2 cm/154 x 122½ x 122½"
Signed: (l.r., on base) W. S. Allward
Inscribed: (on base, recto) ERECTED/
TO THE MEMORY OF THE/OFFICERS
AND MEN/WHO FELL/ON THE
BATTLEFIELDS/OF THE NORTH-
WEST/IN 1885./DULCE ET
DECORUM EST/PRO PATRIA MORI.;
(on base, verso) *1885-1935*/50 YEARS
AFTER/THE SURVIVING MEMBERS/
OF THE/NORTH-WEST FIELD FORCE
1885/GATHERED IN JUBILEE RE-
UNION/AT TORONTO/JULY 26th
27th & 28th/-1935-/"THEY DID NOT
FORGET"
Commission, 1895. MGS 632702

This was Allward's first significant
commission, won through competition
at the age of 19. A second plaque was
added to the memorial in 1935
commemorating the fiftieth anniversary
of the rebellion.

The statue was erected to com-
memorate the quelling of the Northwest
Rebellion, led by the Métis spokesman
Louis Riel (1844-1885) in what is now
the province of Saskatchewan, between
March and May, 1885. The Métis,
angered by the federal government's
procrastination over giving them land
grants as a distinct people, were joined
by the Cree Indians, who had lost their
means of livelihood, the buffalo,
through the ever-increasing settlement
of their territory by white farmers. A
submission of grievances was forwarded
to Ottawa in December, 1884, following
which Riel resorted to arms. In March
1885, in a brief skirmish at Duck Lake,
Riel's "adjutant-general" Gabriel
Dumont defeated a North West
Mounted Police detachment. The
government then sent troops to
Saskatchewan, and at Frog Lake, Fish
Creek, and Cut Knife Hill several
skirmishes ensued. Finally, on 9 May, an

Walter S. Allward, *North-West Rebellion
Monument (1885)*, 1895

attack was launched by the government
forces, under General Frederick
Middleton, against the Métis troops at
the village of Batoche. The Métis held
out for three days. Riel surrendered, was
tried in July 1885, found guilty of high
treason, and hanged on 16 November.
Today he is regarded as the father of
Manitoba, and one of the heroes of the
struggle for native and French language
rights in the Canadian west.

Artist unknown

The Discovery May 1904
Silver; diameter: 10.3 cm/4⁴⁄₅",
circumference: 32.1 cm/15"

Inscribed: Above rim, near lower centre
of relief scene: THE DISCOVERY MAY
1904; (verso) Mappin and Webb, London
[and hallmark]; (verso) THIS PLAQUE
PRESENTED TO THE ONTARIO
DEPARTMENT OF MINES BY THE
ESTATE OF W.G. TRETHEWEY, THE
DISCOVERER OF THE TRETHEWEY
AND CONIAGUS MINES AT COBALT.
WAS MANUFACTURED FROM THE
FIRST HIGH-GRADE ORE BAGGED
FROM THE VEIN OF THE
TRETHEWEY MINE./IT IS A REPLICA
OF A PHOTOGRAPH TAKEN
SHORTLY AFTER THE DISCOVERY
OF THE TRETHEWEY VEIN AND IT
SHOWS THE DISCOVERER
STANDING WITH HIS HAND ON THE
"DISCOVERY POST"./BESIDE HIM IS
HIS SON GROUP CAPTAIN FRANK L.
TRETHEWEY R.C.A.F. (1939-1945).
BELOW HIM IS JOE SUTTON. SEATED
AT HIS RIGHT IS JOE FAIRBURN,
PROSPECTOR.
Gift of the Estate of W.G. Trethewey to
the Ontario Department of Mines.
MGS 632621

The Trethewey Silver-Cobalt Mine,
discovered in 1904, was worked almost
continously until 1920; since then it has
known several owners and has been
worked only irregularly.

William Maurice Carmichael

Born: Victoria, British Columbia,
1 March 1892

Died: Victoria, British Columbia,
3 August 1954

*Drum Major's Baton from H.M.C.S.
Ontario*
Wood and sterling silver; silver head:
30.5 x 11.1 cm/12 x 4³⁄₈", globe,
circumference: 34.9 cm/13³⁄₄"; mace,
overall: 167.6 x 11.1 cm/66 x 4³⁄₈"
Signed on globe support: MC
(monogram, appears twice)
Inscribed: Presented by the People of
Ontario/on the Occasion of the
Embarkation/of/Their Royal
Highnesses/The Princess Elizabeth and
The Duke of Edinburgh/November 9th
1951 (on cartouche).
Commission for H.M.C.S. *Ontario, c.*
1950. MGS 626222

Frederick Sproston Challener,
O.S.A., R.C.A.

Born: Whetstone, Middlesex,
England, 7 July 1869

Died: Toronto, Ontario,
30 September 1959

The Fathers of Confederation
c. 1917-19.

Oil on canvas, 353.1 x 603.9 cm/
139 x 237³/₄"

Commission, *c.* 1917-19. MGS 605057

By the mid-nineteenth century, the move toward Confederation in Canada was rapidly gaining strength. In central Canada, John A. Macdonald (Canada West) and George-Etienne Cartier (Canada East), although holding different views on the precise structure the new government should take, urged their followers toward federal unity. In the Atlantic region, the leaders were Dr. Charles Tupper (Nova Scotia) and Leonard Tilley (New Brunswick). The idea of a shared future was first broached at the Charlottetown Conference in September 1864. Although this meeting had originally been called to discuss Maritime union, eight leaders from central Canada joined their eastern colleagues to consider a larger federation, and the group agreed to hold another conference to discuss fully the issue of union. The delegates meeting at Quebec in the following month passed 72 resolutions embodying the proposed federal and provincial structures. When, in London in 1866, these terms were amended and presented to the British Crown, four regions — Nova Scotia, New Brunswick, Quebec (formerly Canada East), and Ontario (formerly Canada West) — remained committed to the union and became the first official provinces of the Dominion of Canada, created by the passage of the British North America Act in 1867.

The process of achieving national unity had been cumulative and complex. This complexity is reflected in paintings which illustrate the central event of Canadian history by telescoping the roster of participants at the various meetings at Charlottetown, Quebec, and London into composite group portraits. First among these paintings is Robert Harris' *Fathers of Confederation* commissioned by the Federal government for the House of Commons in 1883 to depict those taking part in the original Charlottetown Conference of

Robert Harris, *Cartoon for meeting of the Delegates of British North America to settle the terms of confederation, Quebec, October, 1864* Charcoal on paper, 60. × 326. cm/ 63 × 142" National Gallery of Canada, Ottawa

1864. Harris was later asked to change the setting to the Quebec Conference, and to add a number of figures. The painting was destroyed in the fire of 3 February 1916 which engulfed the Parliament Buildings. Harris was asked to repaint the work but, feeling himself to be, at sixty-seven, too old and infirm, he elected instead to touch up the original cartoon. In March 1980 this charcoal sketch was transferred from the Railway Committee Room to the National Gallery of Canada, after undergoing restoration. (An oil-on-canvas study and a preliminary graphite drawing, each dated 1883, from which the charcoal cartoon was produced, are in the Confederation Art Gallery and Museum, Charlottetown, P.E.I.).

Two copies of this major Harris work were later commissioned from Frederick Challener. The first, painted in 1914, hangs in the Hotel Macdonald, Edmonton. The second and larger copy was commissioned by the Government of Ontario about 1917-19, for hanging in the Legislative Building, Toronto. Challener had made a careful study of the Harris portrait group before its destruction by fire, noting for example Harris' use of the Toronto Normal School's windows in the background, instead of those found in the building in which Confederation was discussed. Although Challener's painting is faithful to the original in its portrait composition and its setting, there are clear differences between the two works, such as the high colour key and increased perspective effects of the Challener canvas.

Challener's painting was originally intended to hang in the Legislative Chamber, above the Speaker's Gallery, but the position there of a large clock meant that it was hung in one or another of the hallways of the building until 1950, when Premier Leslie Frost had it moved to its current site above the grand staircase in the Legislative Building.

Harris' composite reconstruction of the scene had included persons who did *not* attend the Quebec Conference, a deliberate distortion of history which Challener repeated. Later in this century, during the Diamond Jubilee Celebrations of 1927, Canada officially recognized three additional "fathers" who had attended the London meeting but were omitted from Harris' and Challener's paintings: W. P. Howland, representing Canada West; J. W. E. Ritchie, Nova Scotia; and R. D. Wilmot, New Brunswick. The three new "fathers" were inserted into the copy after Harris by Rex Woods (b. 1903), which was commissioned around 1965 by the Confederation Life Insurance Company as a Centennial gift to the nation to hang in the Parliament Buildings, Ottawa. In the extreme right of this picture Woods included a version of one of Harris' many self-portraits as a tribute to the original artist. Another Canadian artist, J. D. Kelly (1862-1958) also painted a version of Harris' group portrait, reversing the position of several key figures (reproduced in E. L. D. Daniher, *Britain and the Empire*, Toronto: Copp Clark, 1939).

Frederick S. Challener, *The Fathers of Confederation, c.* 1917-19

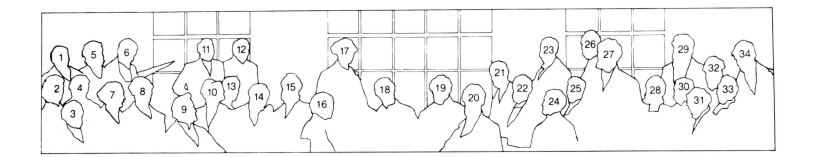

Key to

The Fathers of Confederation

1. *Hewitt Bernard* (1825-93) Secretary of the Conference; attended both the Quebec and London Conferences.

2. *William H. Steeves* (1814-73) New Brunswick: Liberal Member for Albert County, elected 1846. He gave his steady support to the Union.

3. *Edward Whelan* (1824-67) Prince Edward Island: elected 1846 as Member for King's County. Known for the publication, *The Union of the British Provinces* based on his notes from the Quebec Conference.

4. *Charles Fisher* (1808-80) New Brunswick: lawyer elected to the N.B. Legislature in 1837. A delegate to both the Quebec and London Conferences.

5. *William A. Henry* (1816-88) Nova Scotia: lawyer elected in 1865 as Liberal Member for Antigonish.

6. *Edward Palmer* (1809-89) Prince Edward Island: Attorney General of P.E.I., he attended both the Charlottetown and Quebec Conferences. Elected in 1835 as Member for Queen's County.

7. *Col. John H. Gray* (1812-87) Prince Edward Island: Leader of the Government for P.E.I. Before election as Member for Queen's County in 1858, he served as a cavalry officer in India and South Africa.

8. *George Coles* (1810-75) Prince Edward Island: Leader of the Opposition for P.E.I.; elected in 1842 for Queen's County.

9. *Samuel Leonard Tilley* (1818-96) New Brunswick: Provincial and Financial Secretary. First elected to the Assembly in 1850. Also attended the Charlottetown Conference.

10. *Jean-Charles Chapais* (1811-85) Canada East: Conservative Member for Kamouraska from 1851; Commissioner of Public Works for Canada East.

11. *Frederick B.T. Carter* (1819-1900) Newfoundland: Speaker of the Legislature and leader of the Newfoundland Delegation. Elected Member for Trinity County in 1885.

12. *Ambrose Shea* (1815-1905) Newfoundland: Leader of the Opposition (Liberal) in Newfoundland Legislature, elected 1848.

13. *Edward B. Chandler* (1800-80) New Brunswick: member of the Legislative Council, appointed 1827, for Westmoreland County.

14. *Alexander Campbell* (1822-92) Canada West: lawyer, Member of the Legislative Council of Canada West. Delegate to both Charlottetown and Quebec Conferences.

15. *Adam George Archibald* (1814-92) Nova Scotia: elected 1851. Delegate to all three Conferences.

16. *Hector Langevin* (1826-1906) Canada East: Conservative Member for County of Dorchester, elected 1857.

17. *John A. Macdonald* (1815-91) Canada West: the moving spirit in the scheme for Federal Union and Canada's first Prime Minister following Confederation. One of the founders of the Conservative Party, he was first elected for Kingston in 1844. Attended all three Conferences.

18. *George E. Cartier* (1814-73) Canada East: Attorney General for Canada East. First elected for Verchères in 1848. Co-founder of Conservative Party with J.A. Macdonald. Attended all three Conferences.

19. *Sir Etienne Taché* (1795-1865) Chairman — Canada East: Receiver General and Minister of Militia for Canada East. A physician, elected 1841 for L'Islet.

20. *George Brown* (1818-80) Canada West: President of the Executive Council, elected in 1851. Founder of *The Globe* newspaper.

21. *Thomas H. Haviland* (1822-95) Prince Edward Island: lawyer, elected to the Assembly in 1847.

22. *Alexander T. Galt* (1817-1893) Canada East: Minister of Finance, elected 1849 as an Independent for Sherbrooke. One of the first to seriously propose the Federal System.

23. *Peter Mitchell* (1824-99) New Brunswick: lawyer elected 1856. One of the N.B. delegates at the London Conference in 1866.

24. *Oliver Mowat* (1820-1903) Canada West: Postmaster General and Liberal Member for Ontario South, elected 1857. Later Premier and Lieutenant Governor of Ontario.

25. *James Cockburn* (1819-83) Canada West: Solicitor General and Member for Northumberland. Elected 1861.

26. *Robert B. Dickey* (1811-1903) Nova Scotia: lawyer appointed to the Legislative Council of Nova Scotia in 1858. A delegate to both Charlottetown and Quebec Conferences.

27. *Charles Tupper* (1821-1915) Nova Scotia: Provincial Secretary, a Conservative first elected in 1855. Nova Scotia's chief delegate to all three Conferences.

28. *John Hamilton Gray* (1814-89) New Brunswick: Liberal Member elected 1851. Published a book recording the principal events of the Conferences.

29. *William Henry Pope* (1825-79) Prince Edward Island: Provincial Secretary, a Conservative first elected in 1863.

30. *William McDougall* (1822-1905) Canada West: Member of the Legislative Assembly, elected 1858. Delegate to all three Conferences.

31. *Thomas D'Arcy McGee* (1825-1880) Canada East: Liberal Member, elected 1862 for Montreal West. Attended all three Conferences.

32. *Andrew A. Macdonald* (1829-1912) Prince Edward Island: Member of the Legislative Council, appointed, 1853. Attended the Charlottetown and Quebec Conferences.

33. *Jonathan McCully* (1809-77) Nova Scotia: Leader of the Opposition, appointed Member of the Legislative Council in 1848. Attended the Charlottetown and Quebec Conferences.

34. *John M. Johnson* (1818-68) New Brunswick: Attorney General and Liberal Member for Northumberland, N.B., elected 1850. Attended all three Conferences.

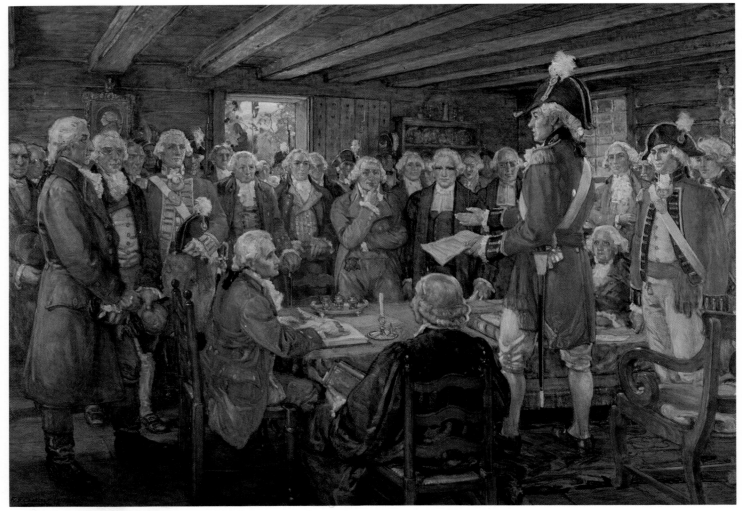

Frederick S. Challener, *The First Legislature of Upper Canada*, 1955

Key to *The First Legislature of Upper Canada*

1. *Colonel John Graves Simcoe,* Lieutenant Governor of Upper Canada 1791-1796.

2. *Lieutenant Thomas Talbot,* A.D.C. to Lieutenant Governor Simcoe and Secretary 1792-1794.

3. *The Rev. John Stuart,* first Church of England Missionary to the Western Settlements, Rector of St. George's, Kingston 1785-1811.

4. *Angus Macdonell,* Clerk to the House.

5. *The Honourable William Jarvis,* Provincial Secretary and Registrar General.

6. *The Honourable Peter Russell,* Member of the Executive and Legislative Councils, Receiver General and Auditor General.

7. *The Honourable William Osgoode,* Speaker of the Legislative Council, Chief Justice of Upper Canada.

8. *The Honourable James Baby,* Member of the Executive and Legislative Councils, Lieutenant Colonel of the Kent Militia.

9. *The Honourable Richard Cartwright,* Member of the Legislative Council.

10. *Major Edward Baker Littlehales,* Military and Private Secretary to the Lieutenant Governor.

11. *The Honourable John Munro,* Member of the Legislative Council.

12. *His Honour William Dummer Powell,* Judge of the Court of Common Pleas.

13. *The Honourable Robert Hamilton,* Member of the Legislative Council, the Land Board, and a Magistrate.

14. *The Honourable John Macdonell,* Member and first Speaker of the Legislative Assembly.

15. *The Honourable John White,* Member of the Legislative Assembly and Attorney General.

16. *Captain Joseph Brant-Thayendanegea,* Chief of The Six Nations Confederacy.

17. *Captain John McGill* of the Queen's Rangers and 16th Foot Regiment.

18. *The Honourable Alexander Grant,* Member of the Council and Commodore of the Fleet.

19. *Lieutenant David William Smith,* Deputy Surveyor General and Deputy Quartermaster General.

The First Legislature of Upper Canada 1955
Oil on canvas, 188 x 274.3 cm / 74 x 108"
Signed, dated and inscribed: (l.l.) F. S. Challener, 1955 / after sketch by / C. W. Jefferys.
Commission, *c.* 1955. MGS 619857

Upper Canada first became a political entity by the *Constitutional Act* of 1791, which provided for a government consisting of the Lieutenant Governor and his appointed Executive Council, along with an appointed Legislative Council and an elected Legislative Assembly. On 17 September 1792, the nine members of the Legislative Council and the sixteen-member Assembly met for the first time in Newark (now Niagara-on-the-Lake), Ontario. The exact site of this first meeting is not known, although speculation has focused on a group of log buildings called Navy Hall, which were located on the river bank below Fort George (and destroyed in 1813).

In 1955, Premier Leslie Frost commissioned Challener to execute a large painting commemorating this event, to be hung in the Executive Council Chamber of the Legislative Building. Challener's painting was based on a watercolour done by C. W. Jefferys. Wearing a plumed hat and military uniform, Colonel John Graves Simcoe, Lieutenant Governor of Upper Canada (1791-1796), can be seen addressing the Legislature.

Etienne Brulé at the Mouth of the Humber 1956
Oil on canvas, 166.4 x 135.9 cm / 65½ x 53½"
Signed, dated and inscribed: (l.l.) F. S. Challener. 1956 / after / sketch by / C. W. Jefferys.
Commission, *c.* 1956. MGS 619849

Etienne Brulé, explorer, interpreter and envoy of Champlain, arrived in Canada in the early 1600s. He gained fluency in several Indian languages, and travelled throughout the territories of modern Quebec, Ontario and New York, as far west as the western shores of Lake Huron. In 1615 he became involved in Champlain's disastrous plan to conquer the Iroquois Indians who lived in what is now New York State. Accompanied by a party of Hurons, Brulé was sent by Champlain to find allies among the Andastes, a tribe living on the upper Susquehanna River. Brulé's route led from Lake Couchiching, across Lake Simcoe to the Holland River, from which a portage took the party to the mouth of the Humber River. Brulé was therefore probably the first white man to see the great "inland sea" of Lake Ontario.

Challener was commissioned by Premier Leslie Frost to execute a painting which was to be hung in the Executive Council Chamber of the Legislative Building. Challener's painting is faithful to C. W. Jefferys' reconstruction of the scene, and shows the European adventurer and his Huron companions approaching the densely wooded shoreline at a point which would much later become part of metropolitan Toronto.

Chevalier Louis William Desanges
Born: London, England, 1822
Died: ?

Lieutenant Robert Dunn, V.C., at the Battle of Balaclava
Oil on canvas, 62.9 x 73.7 cm / 24¾ x 29"
Purchase, 1896. MGS 623523

Robert Dunn received his Victoria Cross from Queen Victoria on 26 June 1857, in recognition of his bravery in the Crimean War, when his quick action saved the lives of several comrades during the charge of the 11th Hussars (the Light Brigade) at the Battle of Balaclava, on October 25, 1854.

Lieutenant (later Colonel) Dunn (b. at York [Toronto], 1833; d. Abyssinia [Ethiopia], 1867) was educated at Upper Canada College, which possesses not only his Victoria Cross, but also General Wolfe's sword, which had been presented to Dunn.

The painting, formerly in the Victoria Cross Gallery, London, was probably acquired around 1895 by the Canadian soldier, portraitist and Upper Canada College alumnus, Sir Edmund Wyly Grier, according to a catalogue note written when the painting was exhibited with the Women's Art Association of

Frederick S. Challener, *Etienne Brulé at the Mouth of the Humber*, 1956

Canada's *Loan Portrait Exhibition*, Toronto, in 1899.

However, the *Public Accounts of Ontario* record that it entered the collection via purchase from Major-General Charles W. Robinson, the brother of the Hon. John Beverley Robinson, educated at Upper Canada College and at Trinity College, and serving with the Rifle Brigade in the Crimean War. No doubt he was an associate of Dunn's at Upper Canada College.

Chevalier Desanges completed two portraits of Robert Dunn: the work discussed above, and an oval head-and-shoulders portrait which was presented to Upper Canada College by the Lieutenant Governor of Manitoba, the Hon. James Colebrooke Patterson (1839-1929).

Allen Good

(fl. 1958)

Untitled c. 1954
Oil on canvas, 203.2 x 304.8 cm/
80 x 120"
Signed: (l.r.) Allen Good
Commission for the Ontario Pavilion, Canadian National Exhibition, Toronto, c. 1954. MGS 625820

Untitled c. 1954
Oil on canvas, 200.7 x 304.8 cm/
79 x 120"
Signed: (l.l.) Allen Good
Commission for the Ontario Pavilion, Canadian National Exhibition, Toronto, c. 1954. MGS 625819

Roy Greenaway

Born: Toronto, Ontario,
15 August 1891
Died: Toronto, Ontario,
18 November 1972

Death of General Brock 1960
Oil on canvas, 63.5 x 76.2 cm/25 x 30"
Signed and dated: (l.r.) Roy Greenaway '60
Gift of Mrs. Roy Greenaway, 1975.
MGS 623021

The composition of Greenaway's oil is based on C.W. Jefferys' watercolour, *Death of Isaac Brock*, which Greenaway

may have seen hanging in the Legislative Building, where he himself was permanently assigned in 1943 by the *Toronto Star.*

Paul Hardy

Died: Storrington, England, 1942

Nef 1927
Nickel and nickel alloys with cloisonné enamel work; 106.7 x 94 x 38.1 cm/ 42 x 37 x 15"
Signed and dated: (l.r. of r. end of base) Paul Hardy 1927
Gift of the Mond Nickel Company (now International Nickel Co.) to the Ontario Department of Mines, 1927.
MGS 625899

This ship-model, commissioned in England to mark the Mond Company's Silver Jubilee in 1925, was presented to the Ontario Department of Mines on the occasion of the Mining and Metallurgical Congress, 1927. It is one of several such models fabricated to test the malleability and decorative qualities of nickel and nickel alloys.

Paul Hardy was a painter and metalworker whose elaborate galleon can be related to a type of *objet d'art* known as a "nef" or cadena. These artifacts provided formal centrepieces, surmounted individual cutlery boxes (when executed on a smaller scale), or were used as open salt cellars. The ship itself is typical of those in Henry VIII's fleet of galleons. Its sails are embossed with the maple leaf of Canada, and with various Tudor badges, while its masts carry the flags of the cross of St. George, the Ancient Royal Standard, and the Tudor Rose.

Arthur Henry Howard Heming, O.S.A., A.R.C.A.

Born: Paris, Ontario, 17 January 1870
Died: Hamilton, Ontario, 30 October 1940

The Whiskey Smuggler 1931
Oil on canvas, 73.7 x 99.1 cm/29 x 39"
Signed and dated: (l.l.) Heming '31.
MGS 619868

No purchase records have yet been found to trace this work's entry into the

Chevalier Desanges, *Lieutenant Robert Dunn, V.C., at the Battle of Balaclava*

collection. Its subject matter is drawn from a crucial stage in the settlement of the Canadian west.

By 1872, whiskey-traders from Montana were openly trading whiskey with the Indians of the Northwest Territories (modern Alberta and Saskatchewan) as far north as the Saskatchewan River. Although ostensibly set up as fur-trading posts, such settlements as Slideout, Robber's Roost, Whiskey Gap and the notorious Fort Whoop-Up (near present-day Lethbridge) did their principal trade in cheap, vitriol-laced alcohol to the Plains Indians, who sold not only buffalo robes and furs but their horses, food and women to obtain it. Violence and murder were rife in the whiskey forts, and settlers were reluctant to homestead in the lawless territories.

In May 1873 Sir John A. Macdonald introduced a statute into Parliament which established, in August of that year, the North West Mounted Police. A

Paul Hardy, *Nef,* 1927

Arthur Heming, *Mackenzie Crossing the Rockies*

N.W.M.P. force was almost immediately dispatched to the west to control the illegal liquor traffic. By 1877, the force had greatly advanced the struggle against the smugglers, and had won the confidence of the western tribes. Partly as a result of the N.W.M.P. offer of protection against attacks from the south, the Blackfoot Confederacy of Plains Indians signed Treaty No. 7, ceding much of what is now southern Alberta to the Canadian government.

Mackenzie Crossing the Rockies
1932
Oil on canvas, 80 x 119.4 cm / 31½ x 47"
Signed and dated: (l.l.) Heming '32
Purchase from the artist, 1933.
MGS 619815

Sir Alexander Mackenzie (1764 - 1820) was an explorer and fur-trader for the North West Company, a powerful rival to the Hudson's Bay Company in the exploitation of the northern wilderness. Mackenzie sought a route to the Pacific, but in 1789 discovered that the river subsequently named after him, which he referred to as the "River of Disappointment," ran not to the Pacific, but into the Arctic Ocean. Spurred on by

the news that the British Admiralty was planning to send Captain George Vancouver to the coast of what became British Columbia to complete the explorations of Captain Cook, Mackenzie made a second expedition in order to establish his claim to being the first white man to reach the western sea by an overland route.

In May 1793 Mackenzie, a North West Company clerk, six French-Canadian voyageurs, and two Indian hunter/ interpreters set out from the junction of the Peace and Smoky Rivers in present-day Alberta. They followed an arduous route across the main chain of the Rocky Mountains and then the Continental Divide, beyond which all waters flowed into the Pacific. Having been advised by Indians to strike west across the Coastal Mountains, Mackenzie's party descended the Bella Coola River to North Bentinck Arm and on 21 July to Dean Channel (the closest they would get to the open Pacific), having travelled by canoe and on foot a distance of some 1287 kilometres. The next day Mackenzie recorded the achievement — that of being the first European to cross North America north of Mexico — by writing on a rock, in a mixture of vermilion pigment and

melted grease, "Alex Mackenzie / from Canada / by land / 22^d July 1793."

The subject of this painting is the rapids-running incident during Mackenzie's seventy-four-day journey to the Pacific in the 7.6 metre-long birchbark canoe depicted in Heming's canvas.

Charles William Jefferys,
O.S.A., R.C.A., C.S.P.W.C.
Born: Rochester, Kent, England, 25 August 1869
Died: York Mills, Ontario, 8 October 1951
President, O.S.A. 1913-19; Founding member, C.S.P.W.C.; President, 1928-31
Honours: LL.D.

C.W. Jefferys is best known as an historical illustrator although he was also an accomplished landscape painter and muralist, and a regular exhibitor at the annual exhibitions of the Societies to which he belonged.

The vast majority of Jefferys' historical drawings and watercolours were commissioned by the Department of Education as illustrations for public and secondary schools' history textbooks. Almost all of the works outlined in the catalogue entries which follow were reproduced in either or both Education Department publications, G.M. Wrong, *Ontario Public School History of Canada* (Toronto: Ryerson, 1921) and W. Stewart Wallace, *The First Book of Canadian History* (Toronto: Macmillan, 1928).

Jefferys' illustrations were sometimes based on ones he had earlier produced for various historical series, or were later re-worked for later publications. One of the most frequently reproduced of Canadian artists, Jefferys served as chief illustrator of the popular historical series *Makers of Canada* (Toronto: George N. Morang, 1903-11) and *Chronicles of Canada*, 32 vols. (Toronto: Brook & Co., 1914-1916). His illustrations appeared in such other publications as *A Few Facts* (Toronto: Imperial Life Assurance, 1912), *Nelson's Pictures of Canadian History* (Toronto: Thomas Nelson & Sons, 1927) and the three-volume *The Picture Gallery of Canadian History* (Toronto: Ryerson,

1942-50). The largest collection of original historical drawings and paintings by C.W. Jefferys was acquired by Imperial Oil Ltd. in the 1950s and was donated by the Corporation in 1972 to Public Archives Canada.

The Death of Brock at Queenston Heights c. 1908
Watercolour on paper, 25.4 x 38.1 cm / 10 x 15"
Signed: (l.r.) C. W. JEFFERYS
MGS 619871

Major-General Sir Isaac Brock was mortally wounded on 13 October 1812 at the Battle of Queenston Heights, one of the early and most critical engagements of the War of 1812 (see the biography of Brock in the *Portraits* section of this catalogue).

Alexander Mackenzie at the Pacific Ocean c. 1921
Pen and ink on paper mounted on cardboard, 26 x 33.7 cm / 10¼ x 13¼"
Signed: (l.l.) C. W. JEFFERYS
Commission by the Department of Education, c. 1921. MGS 621226

For an account of the expedition of Alexander Mackenzie (1755-1820) from Fort Chipewyan to the Pacific coast, see A. Heming, *Mackenzie Crossing the Rockies*. Jefferys made several illustrations of the explorations. In the Government of Ontario drawing, Jefferys shows Mackenzie and a number of his men at the mouth of the Bella Coola River where it empties into the Dean Channel. A larger gouache painting of the same subject was presented in *Nelson's Pictures*.

The Battle of Lundy's Lane c. 1921
Pen and ink, heightened with Chinese white, 29.2 x 36.8 cm / 11½ x 14½"
Signed: (l.r.) C. W. JEFFERYS
Inscribed: (l.c.) The Battle of Lundy's Lane
Commission by the Department of Education, c. 1921. MGS 621234

For an account of this crucial battle in the War of 1812, see the biography of Lieutenant General Sir Gordon Drummond, who was commander of the British forces defending Lundy's Lane at Niagara Falls. Jefferys had painted a large watercolour version of this subject in 1909 (Collection of the Corporation of the City of Toronto).

Arthur Heming, *The Whiskey Smuggler*

C.W. Jefferys, *The Death of Brock at Queenston Heights, c. 1908*

C.W. Jefferys, *The Battle of Lundy's Lane, c.* 1921

C.W. Jefferys, *The British Army at Dawn Climbing the Heights above Wolfe's Cove, c.* 1921

C.W. Jefferys, *Alexander Mackenzie at the Pacific Ocean, c.* 1921

Blockhouse and Battery in the Old Fort, Toronto, 1812 *c.* 1921

Pen and ink on paper, 29.2 x 36.8 cm/
11$\frac{1}{2}$ x 14$\frac{1}{2}$"
Signed: (l.l.) C. W. JEFFERYS
Inscribed: (l.c.) Blockhouse & Battery in the Old Fort Toronto 1812
Commission by the Department of Education, *c.* 1921. MGS 621228

The scene shows the Blockhouse at Fort York as it looked in 1812, based on, first, a watercolour by Elizabeth Simcoe (1766-1850), now in the Archives of Ontario, depicting Toronto Bay from the mouth of Garrison Creek, at the foot of present-day Bathurst Street; and second, the topographical details provided by the text of Mrs. Simcoe's *Diary* in which her watercolour sketch appears.

In May 1793, Lieutenant Governor John Graves Simcoe (1752-1806) ordered the erection of this squared-log blockhouse east of the site of the old French fort, Fort Toronto, which eventually gave its name to the city incorporated in 1834.

The British Army at Dawn Climbing the Heights above Wolfe's Cove *c.* 1921

Pen and ink on paper, 36.2 x 29.2 cm/
14$\frac{1}{4}$ x 11$\frac{1}{2}$"
Signed: (l.l.) C. W. JEFFERYS
Inscribed: (l.c.) The British Army at dawn climbing the heights above Wolfe's Cove.
Commission by the Department of Education, *c.* 1921. MGS 621233

For a description of the events surrounding Wolfe's landing at Quebec on the morning of 13 September, 1759, see the biographical notes for Major General James Wolfe and Louis Joseph, Marquis de Montcalm.

The Brothers La Vérendrye in Sight of the Mountains *c.* 1921

Pen and ink on paper, 27.9 x 41.9 cm/
11 x 16$\frac{1}{2}$"
Signed: (l.l.) C. W. JEFFERYS
Inscribed: (l.l. to l.r.) The brothers La Verendrye [*sic*] in sight of the Mountains – (probably the Rockies).;
(verso) The Brothers La Vérendrye in Sight of the Mountains.
Commission by the Department of Education, *c.* 1921. MGS 621237

In the spring of 1742 the Canadian explorers Louis Joseph de La Vérendrye (1717-1761) and François, Chevalier de La Vérendrye (1715-1794) took up a goal set by their father, and left from Fort La Reine (now Portage la Prairie) in search of a river system leading to the Pacific. On New Year's Day, 1743, they were within sight of a mountain range which blocked the way to the western ocean. Although they are often credited with discovering the Rocky Mountains on this expedition, it is possible that the La Vérendrye brothers had actually found the range of the Black Hills in western South Dakota.

C.W. Jefferys, *The Brothers La Vérendrye in Sight of the Mountains*, c. 1921

Jefferys produced at least eight known versions of this subject, including several whose composition can be directly related to this work. Its precursors included an ink drawing titled *Vérendrye Discovers the Rocky Mountains 1743*, which appeared in *Facts* (1912), and a watercolour of c. 1915, which was used for the frontispiece of volume V of *Chronicles*.

A Coureur de Bois c. 1921
Pen and ink on paper, 37.5 x 29.2 cm/
14³/₄ x 11¹/₂"
Signed: (l.r.) C. W. JEFFERYS
Inscribed: (l.l.) A Coureur de Bois
Commission by the Department of
Education, c. 1921. MGS 621239

Beginning in the seventeenth century, young adventurers from France came to the wilderness of North America to become fur traders. These *coureurs de bois* ("runners of the woods") quickly adopted the dress and weaponry essential to their harsh new homeland.

The Founding of Halifax c. 1921
Pen and ink on paper, 29.2 x 36.8 cm/
11¹/₂ x 14¹/₂"
Signed: (l.l.) C. W. JEFFERYS
Commission by the Department of
Education, c. 1921. MGS 621235

Halifax was founded in 1749 as a British defensive post intended to rival the fortress of Louisbourg, which had been restored to French control by the Peace of Aix-la-Chapelle in 1748. The deep, sheltered harbour was the ideal site to establish a community made up of 2500 settlers from England around the extensive military fortifications which

C.W. Jefferys, *The Founding of Halifax*, c. 1921

soon covered the top of the steep hill dominating the harbour.

In 1927, Jefferys painted a somewhat larger watercolour version of this scene for the *Nelson's Pictures* series, in commemoration of the Diamond Jubilee of Confederation.

Jacques Cartier Erects a Cross at Gaspé, 1534 c. 1921
Pen and ink on paper, 37.5 x 29.2 cm/
14³/₄ x 11¹/₂"
Signed: (l.l.) C. W. JEFFERYS
Inscribed: (l.c.) Jacques Cartier erects a
cross at Gaspé, 1534
Commission by the Department of
Education, c. 1921. MGS 621236

Jacques Cartier arrived at Gaspé in 1534, his first voyage to Canada, and erected a cross bearing a shield with the *fleur-de-lis*, the symbol of French sovereignty, and above it a tablet proclaiming the land for France. A watercolour later produced by Jefferys for *Nelson's Pictures* (1927) is directly based on this line drawing.

C.W. Jefferys, *Jacques Cartier erects a Cross at Gaspé, 1534*, c. 1921

C.W. Jefferys, *Loyalists Drawing Lots for the Land, c. 1921*

The Landing of Wolfe at Louisbourg in 1758 *c.* 1921

Pen and ink on paper, 39.4 x 28.6 cm/
15½ x 11¼"
Signed: (l.l.) C. W. JEFFERYS
Inscribed: (l.c.) The Landing of Wolfe at Louisbourg
Commission by the Department of Education, *c.* 1921. MGS 621230

Colonel James Wolfe was second in command to General Jeffrey Amherst at the siege of the fortress of Louisbourg in August 1758. Jefferys' figure of Wolfe is roughly based on an earlier painting by the artist, titled *General James Wolfe* (present location unknown), which depicted Wolfe on the Plains of Abraham and appeared in *The Quebec Tercentenary Commemorative History* compiled and edited by Frank Carrel and Louis Feiczewitz (Quebec: The Daily Telegraph Printing House, 1908). Jefferys used this figure of the British

leader in a watercolour of *c.* 1920, titled *Wolfe Wading Ashore Through the Surf at Louisbourg* in the Public Archives Canada.

Laura Secord on her Journey to Warn the British *c.* 1921

Pen and ink on paper, 37.1 x 29.2 cm/
14⅝ x 11½"
Signed: (l.l.) C. W. JEFFERYS
Inscribed: (l.c.) Laura Secord on her Journey to warn the British
Commission by the Department of Education, *c.* 1921. MGS 621223

Laura Secord (1775-1868), born Laura Ingersoll in Massachusetts, immigrated to Upper Canada with her Loyalist family and married James Secord. At the end of May, 1813, she walked about thirty kilometres from Queenston in Upper Canada to the British post at Beaver Dams, slipping past the enemy

to warn the British of an impending American attack. Subsequently, a clever ruse by the British and their Indian allies convinced the Americans that they had been surrounded by a much larger force, and caused them to surrender to the defending army.

Secord's largely symbolic deed was not rewarded until 1861, when she was presented with a prize of £100 by the Prince of Wales. Monuments to her were dedicated at Drummond Hill Cemetery in 1901 and at Queenston Heights in 1910. (See catalogue entry for Secord in the *Portraits* section of this book.)

Louisbourg, from a Drawing Made on the Spot in 1759 [sic] *c.* 1921

Pen and ink on paper, 15.2 x 27.9 cm/
6 x 11"
Initialed: (l.r.) C. W. J.
Inscribed: (l.c.) Louisbourg, from a drawing made on the spot in 1759;
(u.l. to u.r.) ISLAND/BATTERY
LIGHTHOUSE BRITISH FLEET IN GABARUS BAY/WHERE ARMY
LANDED/FORTRESS & CITY/
BRITISH CAMP/FRENCH FLEET IN HARBOUR
Commission by the Department of Education, *c.* 1921. MGS 621222

Construction of the great French fortress of Louisbourg at the north-eastern tip of Cape Breton Island (Nova Scotia) began in 1713 after the Treaty of Utrecht had ceded this highly strategic area to the French. Although it fell to the British in 1745 after a combined land and sea attack, the fortress was returned to French hands three years later by the Peace of Aix-la-Chapelle. During the Seven Years War (1756-63) the fortress was successfully besieged by British troops in August, 1758. The British took 6000 prisoners in this engagement, and eventually destroyed the fortress itself. It lay in ruins until 1980, when a restoration project was completed with the opening of Louisbourg National Historic Park.

This drawing is based on a sketch made by a British officer and later engraved by P. Canot for publication in 1762 by the Cartographer Royal, Thomas Jefferys, with the title *A View of Louisbourg...taken near the Light House when that City was besieged in 1758...*

C.W. Jefferys, *The Landing of Wolfe at Louisbourg in 1758, c. 1921*

C.W. Jefferys, *The Loyalist Fleet Leaving Boston, March 17, 1776, c. 1921*

Loyalists Drawing Lots for the Land

Watercolour on paper, 49.5 x 57.2 cm/
19½ x 22½"
Signed: (l.r.) C. W. JEFFERYS
MGS 623328

By early summer 1784, thousands of Loyalists had arrived to settle the newly surveyed townships along the St. Lawrence and Lake Ontario shores in what would later become Upper Canada. The distribution of land was achieved by drawing lots, and the size of individual grants was determined by the military rank of each settler (most were former soldiers).

It is not known how this watercolour entered the collection, although it is possible that the work was commissioned by the Department of Education. It was shown at the 50th Annual R.C.A. Exhibition (Toronto), 1928 (cat. no. 81), and was the basis for a pen-and-ink drawing (later tinted with watercolour and now in a private collection).

The Loyalist Fleet Leaving Boston, March 17, 1776 c. 1921

Pen and ink on paper, 29.2 x 36.8 cm/
11½ x 14½"
Signed: (l.l.) C. W. JEFFERYS
Inscribed: (l.c.) The Loyalist Fleet leaving Boston March 17th—1776
Commission by the Department of Education, c. 1921. MGS 621225

In the last months prior to the Declaration of Independence, the British were compelled to evacuate more than 1100 Loyalists from Boston by sea, to prevent their capture by the approaching American army. The exiles were taken to Halifax, and many of the Loyalist families settled permanently in the Maritime Provinces.

Loyalists on the Way to Canada
c. 1921

Pen and ink on paper, 27.9 x 36.2 cm/
11 x 14¼"
Signed: (l.l.) C. W. JEFFERYS
Inscribed: (verso) Loyalists on the Way to Canada
Commission by the Department of Education, c. 1921. MGS 621238

When war between the Americans and the British had become inevitable, thousands of Americans found themselves being drawn into a revolution they opposed. Many families who wished to remain loyal to Britain left their homes carrying only their most prized possessions, and began the long,

C.W. Jefferys, *Loyalists on the Way to Canada, c. 1921*

tedious journey to settle along the St. Lawrence River and the northern shore of Lake Ontario, and in the Niagara region near Lake Ontario. This drawing shows a group of Loyalists emerging from the woods along a rough road leading to a river, where a crude ferry awaits them.

The March of the Rebels upon Toronto in December, 1837 c. 1921

Pen and ink on paper, 25.4 x 36.8 cm/
10 x 14½"
Signed: (l.r.) C. W. JEFFERYS
Commission by the Department of Education, c. 1921. MGS 621229

C.W. Jefferys, *The March of the Rebels upon Toronto in December, 1837, c. 1921*

C.W. Jefferys, *Champlain at Georgian Bay, 1615, c. 1927*

Jefferys depicts an incident of December 5, 1837, when William Lyon Mackenzie (1795-1861) led a group of about 800 men on a march along Yonge Street and into Toronto, demanding widespread governmental reform. The rebellion failed, as Mackenzie and his followers were scattered by armed troops.

The Meeting of Brock and Tecumseh
c. 1921
Pen and ink on paper, 36.8 x 29.2 cm/ 14½ x 11½"
Signed: (l.r.) C. W. JEFFERYS
Inscribed: (l.c.) The Meeting of Brock & Tecumseh.
Commission by the Department of Education, *c.* 1921. MGS 621231

By 1812, General Isaac Brock (1769-1812) had established the headquarters for his British army at Fort George (Niagara-on-the-Lake) and had begun preparing for war against the Americans. He soon left Niagara via Lake Erie and landed at the mouth of the Detroit River, where he met the Chief of the Shawnee Indians, Tecumseh. The confiscation of Indian lands by American settlers had forced Tecumseh to fight on the British side. He collaborated with Brock to plan a joint Indian/British attack on Detroit. On 16 August 1812, their combined forces defeated the north-western American army. In Jefferys' drawing the two leaders are seen as they part after making their initial battle plans near Detroit. The drawing is based on a watercolour reproduced in Ethel T. Raymond's *Tecumseh: A Chronicle of the Last Great Leader of His People*, vol. 17 of the *Chronicles* series.

The Pioneer, 1784 c. 1921
Watercolour on paper, 71.1 x 51.4 cm/ 28 x 20¼"
Signed: (l.l.) C. W. JEFFERYS
MGS 623327

A Pioneer Settler Sowing Grain in his Clearing c. 1921
Pen and ink on paper, 24.4 x 35.6 cm/ 9⅝ x 14"
Signed: (l.l.) C. W. JEFFERYS
Inscribed: (verso) A Pioneer Settler Sowing Grain in his Clearing/C.W. Jefferys
Commission by the Department of Education, *c.* 1921. MGS 621232

This drawing is based on Jefferys' 1910

watercolour commissioned for reproduction in Duncan Campbell Scott's *John Graves Simcoe*, vol. 4 of the *Makers* series. See also Jefferys' *The Pioneer, 1784.*

A Seigneurial Mill at Verchères, on the St. Lawrence c. 1921
Pen and ink on board, 32.4 x 25.4 cm/
12³/₄" x 10"
Signed: (l.l.) C. W. JEFFERYS
Inscribed: (l.c.) A Seigniorial [*sic*] Mill at Verchères, on the St. Lawrence.
Commission by the Department of Education, *c.* 1921. MGS 621224

The seigneurial system of land granting in early French Canada obliged the lord *(seigneur)* to provide a mill at which his settlers *(habitants)* could grind their grain. It was one of these mills that Jefferys sketched at Verchères, on the south shore of the St. Lawrence River east of Quebec City, in November, 1900.

A View of Quebec, in 1760, from the Opposite Shore. From the Drawing by Short c. 1921
Pen and ink on paper, 14.6 x 22.2 cm/
5³/₄ x 8³/₄"
Initialled: (l.r.) C. W. J.
Inscribed: (l.c.) A View of Quebec, in 1760. From the Drawing by Short from the opposite shore. Cape Diamond The Citadel St. Charles River
Commission by the Department of Education, *c.* 1921. MGS 621221

This drawing is based on the engraving, *A General View of Quebec from Point Levy*, by P. Canot after Richard Short (active 1759-61). Short, a purser on H.M.S. *Prince of Orange*, was engaged in British action against Quebec, serving with Wolfe's army on the Plains of Abraham in September, 1759. He executed a series of topographical views of Quebec and scenes of its capture by the British.

Champlain at Georgian Bay, 1615 c. 1927
Watercolour on paper, 48.9 x 64.8 cm/
19¹/₄ x 25¹/₂"
Signed: (l.l.) C. W. JEFFERYS
Purchase from the artist, 1932-33.
MGS 622150

Samuel de Champlain (*c.* 1570-1635) was one of the first Europeans to see the Great Lakes. In the summer of 1615, he went with a party of Hurons up to the

C.W. Jefferys, *The Pioneer 1784, c.* 1921

Fergus Kyle, *"Our Hero Meets Tecumseh. 'This is a man',"* 1908

Ottawa River and across Lake Nipissing in search of the sea route to China. Instead, he found Georgian Bay on Lake Huron, and spent the winter among the Indians in one of the many villages lining the shores.

This watercolour is based on a pen-and-ink drawing (*c.* 1921) formerly in the collection but which is now lost.

John David Kelly, O.S.A.
Born: Gore's Landing, Canada West, 15 October 1862
Died: Toronto, Ontario, 27 December 1958

The Silver Lady *c.* 1914
Silver and silver ore, 69.9 x 25.4 x 33 cm/ 27½ x 10 x 13"
Commission by the Department of Mines, *c.* 1914. MGS 623620

Modelled on the classical female victory figure, *The Silver Lady* holds aloft the shield of Ontario. The sculpture was fashioned from a bar of Cobalt silver bullion and was made by Canadian Wm. A. Rogers Limited, an Ontario firm.

James Fergus Kyle
Born: Hamilton, Ontario, *c.* 1876
Died: Toronto, Ontario, 27 September 1941

"Our Hero Meets Tecumseh. 'This is a Man' " 1908
Charcoal on paper, 73.7 x 50.8 cm/ 29 x 20"
Signed and dated: (l.l.) FERGUS KYLE 08. MGS 620506

First published in Walter R. Nursey's *The Story of Isaac Brock* (Toronto: William Briggs, 1908). Nursey (p. 97) reports that Tecumseh's impulsive response to Brock's commanding presence was to proclaim to his followers, in a voice filled with admiration, "*This* is a man!"

Ross Reverdy Osgood
Born: Dereham, Oxford County, Canada West, 17 June 1867
Died: St. Thomas, Ontario, 16 July 1946

The artist regularly signed his paintings

"R.R. Osgoode," although his surname appears on official documents as "Osgood."

Old Union Jack [*Sir John A. Macdonald at a torchlight meeting*] 1910
74.9 x 90.2 cm / 29½ x 35½"
Signed and dated: (l.l.) R R Osgoode 1910.
MGS 692549

No government purchase records have yet been found for this work. The painting can be associated with a famous election ploy of Macdonald's. His posters, pamphlets and other forms of publicity often displayed the Union Jack in order to remind the voters of his Conservative party's continuing allegiance to Great Britain and the Empire, as opposed to Laurier's Liberals, who advocated trade reciprocity and closer relations with the United States.

La Porte Baudimont [or] *The Gates of Arras* 1918
Oil on canvas, 41.9 x 74.9 cm /
16½ x 29½"
Signed: (l.r.) R. R. Osgoode
Inscribed and dated: (l.l.) Arras /
Oct. 27 / 18. MGS 623107

Osgood painted this view of the great gate at Arras in northern France, while serving with the Engineers of the Canadian Overseas Expeditionary Force on the Western Front during World War I.

R.R. Osgood, *Old Union Jack* [Sir John A. Macdonald at a torchlight meeting]

Rev. Bowen P. Squire

Born: Middlesex, England,
31 August 1901

Barn Raising Bee, 1790
Oil on canvas, 39.8 x 49.5 cm /
15½ x 19½"
Signed: (l.r.) Squire
Gift of the artist to the Sir James Whitney School, Belleville, 1976.
MGS 622610

The Carrying Place, Kente 1794
Oil on canvas, 39.4 x 49.2 cm /
15½ x 19⅜"
Signed: (l.l.) Squire
Inscribed: (verso) ASA WELLER – C. 1794 / HAULED OVER BATEAUX / THE CARRYING PLACE – KENTE / (SQUIRE)
Gift of the artist to the Sir James Whitney School, Belleville, 1976.
MGS 622609

Clearing the Land, 1785
Oil on canvas, 54.3 x 74.6 cm /
21⅜ x 29⅜"
Signed: (l.l.) Squire
Gift of the artist to the Sir James Whitney School, Belleville, 1976.
MGS 622611

The First Reaping, 1790
Oil on canvas, 54.6 x 74.9 cm /
21½ x 29½"
Signed: (l.l.) Squire
Gift of the artist to the Sir James Whitney School, Belleville, 1976.
MGS 622612

The Gunshot Treaty at the Carrying Place, 1785
Oil on canvas, 54.6 x 74.3 cm /
21½ x 29¼"
Signed: (l.r.) Squire

Inscribed: (verso) THE GUNSHOT TREATY / AT THE CARRYING PLACE / C-1785-87 / SIR JOHN JOHNSON & MISSISSAUGA TRIBES / THE KINGS ROYAL YORK REGIMENT
Gift of the artist to the Sir James Whitney School, Belleville, 1976.
MGS 622614

Wellers Stage, 1830
Oil on canvas, 59.7 x 74.3 cm /
23½ x 29¼"
Signed: (l.l.) Squire
Gift of the artist to the Sir James Whitney School, Belleville, 1976.
MGS 622613

William Wilson Stallworthy

Born: Wells, Norfolk, England,
9 August 1880
Died: Brantford, Ontario, 2 June 1960

Rev. Bowen P. Squire, *Barn Raising Bee*, 1790

Rev. Bowen P. Squire, *The Gunshot Treaty at the Carrying Place*, 1785

Diamond Drilling 1930
Tempera on canvas, 210.8 x 477.5 cm/
83 x 188"
Inscribed: (l.r.) The Studio of/W. W.
Stallworthy 30
Commission for the Ontario Pavilion,
Canadian National Exhibition, Toronto,
1930. MGS 625818

Gold Mill 1930
Tempera on canvas, 210.8 x 477.5 cm/
83 x 188"
Inscribed: (l.r.) The Studio of/W. W.
Stallworthy 30
Commission for the Ontario Pavilion,
Canadian National Exhibition, Toronto,
1930. MGS 625817

Prospecting – Old Style c. 1930
Tempera on canvas, 210.8 x 477.5 cm/
83 x 188"
Commission for the Ontario Pavilion,
Canadian National Exhibition, Toronto,
1930. MGS 625816

Untitled c. 1930
Painted plaster (relief), 205.7 x 172.7 cm/
81 x 68"
Commission for the Ontario Pavilion,
Canadian National Exhibition, Toronto,
c. 1930. MGS 632682

Untitled c. 1930
Painted plaster (relief), 203.2 x 157.5 cm/
80 x 62"
Commission for the Ontario Pavilion,
Canadian National Exhibition, Toronto,
c. 1930. MGS 632695

Untitled c. 1930
Tempera on canvas, 210.8 x 477.5 cm/
83 x 188"
Commission for the Ontario Pavilion,
Canadian National Exhibition, Toronto,
1930. MGS 625815

William Woollett
Born: Kent, England, 15 August 1735
Died: London, England, 23 May 1785

The Death of General Wolfe 1776
(after Benjamin West, R.A., American,
1738-1820)
Copper engraving; 44.5 x 59.1 cm/
17½ x 23¼" (sight), 42.9 x 59.1 cm/
16⅞ x 23¼" (image)
Inscribed: (l.l.) Painted by B. West/
...Printe...His Majesty; (l.c.) To the
King's most excellent Majesty/This

William Woollett, *The Death of General Wolfe*, 1776

plate, The Death of General WOLFE, is with/His gracious Permission humbly dedicated by his Majesty's most dutiful Subject and Servant,/William Woollett; (l.r.) Engraved by Wm. Woollett/ Engraver to His Majesty/Published as the Act directs, January 1st., 1776/by

Messrs. Woollett, Boydell and Ryland, London.
MGS 622017

Woollett's print of the famous painting by Benjamin West not only became the best known work by this eminent engraver, but also helped to popularize

West's innovative composition. West's canvas depicts Major-General James Wolfe and his companions in contemporary dress, thus departing from the convention of clothing the figures (and the historical genre itself) in the studied drapery of the Neo-classical tradition.

(Facing Page) J.W.L. Forster, *Major-General Sir Isaac Brock, 1900*

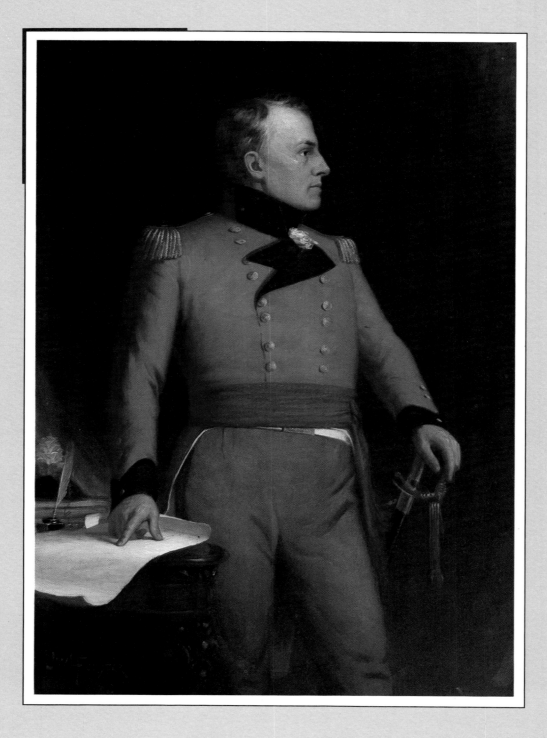

Faces of History

THE PORTRAIT COLLECTION

*H*istorically the acquisition by a government of a collection of fine art, in this instance Ryerson's copies and casts and the "contemporary" collection from the O.S.A., is in itself unusual. What is not unusual, however, and is traditional for governments almost everywhere, is the commissioning of portraits of prominent political figures.

The collection of portraits, plaster busts, and statues of the province's leading political figures and heroes is the best known part of the Ontario Collection. When, after Confederation, the government built a new Government House and a new Legislative Building, the tradition of portraiture reached its zenith and continued until the beginning of the First World War. This part of the collection is today the primary focus of the art at Queen's Park and is certainly the most visible.

The responsibility for collecting portraiture, as for other parts of the collection, has its personalities. The first is Lieutenant Governor the Hon. John Beverley Robinson, who started a collection of portraits of lieutenant governors of Upper Canada and governors general of the Province of Canada beginning with Colonel John Graves Simcoe and ending with himself, for the new Government House which had opened at the corner of King and Simcoe Streets. This program continued from 1880 to 1887. The second phase of commissioned portraiture was undertaken by the Minister of Education, the Hon. George Ross, whose similar program for the Educational Museum of plaster portrait busts of leading Canadian statesmen and citizens continued from 1887 to about 1905. In the meantime, with the Legislature's move to its new seat of government at Queen's Park in 1893, political portraits and those of the province's heroes were commissioned for display in the new building, and statues were ordered for the surrounding grounds. The responsibility for this program was largely shared by three successive premiers, the Hon. A.S. Hardy, the

Hon. George Ross, and the Hon. James Pliny Whitney. This flurry of commemorative activity continued until about 1914, when the seeming urgency of the portrait-collecting policy ceased. Portraits nevertheless continued to be commissioned after 1914; a tradition evolved of commissioning portraits of the Lieutenant Governor, the Premier, and the Speaker of the Ontario Legislature that is carried on to this day.

By the 1880s the government looked on its new province and those who strove to create it as worthy of commemoration. The educational value of portraiture was also a significant factor, and it clearly derives from the ideas espoused by Dr. Ryerson when he imported from Europe his collection of plaster casts of "famous men of all ages."

Portrait painting had flourished in Lower Canada from the early 1700s and, by the early nineteenth century, portraitists such as Jean Baptiste Roy-Audy and Antoine Plamondon were able to make a respectable living practising their art. Still later, such artists as Cornelius Krieghoff and Théophile Hamel flourished under the tradition of patronage long established among the clergy, the seigneurs, and the bourgeoisie. There was very little tradition in portraiture in Upper Canada until the 1840s. There were, however, a few artists who practised this art; William van Moll Berczy painted a few of the early lieutenant governors in the first decade of the 1800s, in watercolour and most likely not by commission. There were also a number of itinerant American portrait painters who criss-crossed the province; the most famous of these, and the most sought after by Toronto's elite, was Nelson Cook.

Cook gained considerable notice in Toronto when, in 1837, a local citizens' group commissioned him to execute a portrait of Lieutenant Governor Sir Francis Bond Head. The portrait was sent to England, for engravings to be made for distribution in support of the governor's stand on the troubles that later erupted into the

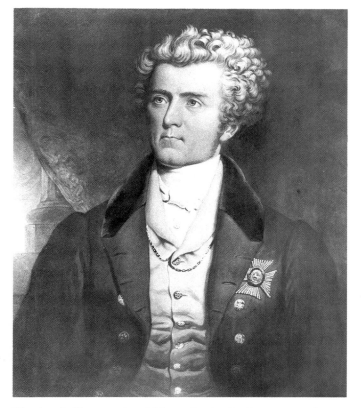

Charles A. Turner after Nelson Cook, *Sir Francis Bond Head, Bart., K.C.H.*, 1837 Mezzotint, John Ross Robertson Collection, Baldwin Room, Metropolitan Toronto Library

Rebellion of 1837. Queen Victoria, recognizing that Bond Head was unpopular and disapproving of his handling of colonial affairs, refused to have the engravings dedicated to her. Considering the royal reception of the first instance of official commission in Upper Canada, it is hardly surprising that a hiatus in the practice ensued.

In the 1850s some form of political stability had been achieved and the united Parliament of the Province of Canada began a program of official commissions of political portraits. Théophile Hamel was commissioned to paint the portraits of all of the Speakers of the Legislative Council of both Upper and Lower Canada since the Constitutional Act of 1791. Over a period of years Hamel followed the itinerant legislature from Montreal to Kingston to Quebec and to Toronto, where he had a studio in

1850-51. These portraits remained in the possession of the federal government following Confederation and today are part of the collection on Parliament Hill in Ottawa.

The most popular portrait artist in this province by the 1850s was Vienna-born George Theodore Berthon. The son of one of Napoleon I's 'court painters,' Berthon was born at the Austrian court in 1806, when his father was there to paint the official portrait of the Emperor of Austria. As a young man Berthon studied the art of portraiture in the studio of Jacques Louis David in Paris; by the age of 24 he had moved to England and had joined the staff of the British parliamentarian, Sir Robert Peel, to teach Peel's daughters drawing and French. During his stay in England Berthon was a frequent exhibitor at the Royal Academy. What possessed this artist to leave Europe for the frontier is not known. However, his training and credentials made him an instant favourite of Toronto society soon after his establishment there, probably in 1844. His first major commission, from the Law Society of Upper Canada, was a portrait of Chief Justice Sir John Beverley Robinson. Since its completion in 1845 it has hung in Osgoode Hall, marking the beginning of the Law Society's long tradition of commissioning portraits of Chief Justices, benchers, and others for Osgoode.

The first commissions of official portraiture for the province, in the 1880s, were intended for Government House, which had been officially opened in 1870. Located on the old site of Elmsley House, the residence of the lieutenant governors from 1814 to the time of the union of the two provinces, it was an impressive structure. Government House remained at this location until the residence was closed in 1912 and a new, more impressive mansion was erected in 1915 at Chorley Park in north Rosedale. By that time the portrait collection was substantial and directly attributable to the ingenuity of the Hon. John Beverley Robinson, son of the former Chief Justice.

During his term in office from 1880 to 1887 Robinson commissioned twenty-one portraits of his predecessors, beginning with the province's

Government House, King and Simcoe Streets, 1870-1912. The Last Garden Party, *c.* 1911

first Lieutenant Governor, Colonel John Graves Simcoe. The artist George Berthon completed twenty of these posthumous portraits, a difficult task because visual records of these long-dead officials had to be located. Robinson assumed responsibility for providing images to the artist from which to execute these portraits.

The Lieutenant Governor came from a line of United Empire Loyalists who had settled in Upper Canada in the 1780s. The second son of Chief Justice Robinson, he was born at Beverley House on February 20, 1820. He was educated at Upper Canada College, and at the age of seventeen he was aide-de-camp to Lieutenant Governor Sir Francis Bond Head. Robinson articled in law; however, more suited to public life than the courts, he then entered politics, serving at the municipal level before becoming a federal Conservative member in 1858. He was

appointed Lieutenant Governor of Ontario in 1880.

What precipitated the formation by Robinson of such a collection of portraits is not known. In all likelihood it was imagined that such a gallery of worthies would lend dignity to the new official residence, which in its ten-year life had had very little on its walls. Robinson was interested in history and what better way to express that interest than with a gallery of portraits of the men who had served to shape the province. It is significant to recall that it was Robinson's father, and his brother-in-law, Captain John Lefroy, who inspired Ryerson to bring the first portrait collection to Upper Canada in the form of plaster casts of famous ancients. The importation of European culture that characterized the cultural preoccupations of the late 1850s was superceded in the 1860s and

1870s by a determination to construct a cultural foundation on which a native tradition could be developed. While the aims of these periods were consistent, the interpretation of the means to achieve them was quite different.

Although the reasons for forming the collection are largely a matter for speculation, certain information survives.[1] Undoubtedly through discussions with Berthon, a standard size for each of the portraits was established, and a hanging policy was set. One of the few surviving photographs of the interior of Government House, taken in 1912 at the last state dinner held there, shows an array of Berthon portraits gracing the dining room walls.

As Berthon's portraits were primarily posthumous, the original images on which his portraits are based are largely a matter of speculation. A variety of images in oils or engravings abounded in private and public collections, including the Château Ramezay in Montreal. Several images are known to have

(*Above*) Government House, Chorley Park, Rosedale. The visit of the Prince of Wales, 1919

(*Below*) Government House, 1870-1912. Berthon's portraits of lieutenant governors line the walls of the dining room at the last State Dinner held there April 29th, 1912

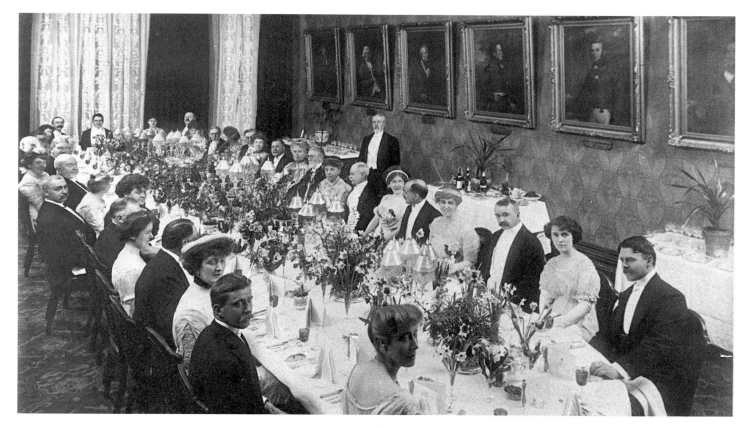

been based on photographs taken of originals located in private collections in England and provided by the diligent research of the Lieutenant Governor's brother, Colonel Charles W. Robinson. Three portraits, *Sir Isaac Brock*, *Sir Gordon Drummond* and *Sir Peregrine Maitland*, are the only ones with sources attested to in extant letters and documents.[2] Speculation as to the other portraits' sources is largely based on visual comparisons and the availability of images in the province at the time Berthon was working. The catalogue entries which follow detail these presumed sources.

Robinson and Berthon began their program soon after the Lieutenant Governor's installation in office in 1880. By 1881 Berthon had invoiced the government for his portrait of Colonel John Graves Simcoe, based on an ivory miniature owned by Dr. Henry Scadding. The portrait of Simcoe's successor, the Hon. Peter Russell, was completed the following year, evidently based on a small watercolour, painted about 1803-04 by William Berczy. The original oil on which Berthon's portrait of Francis Gore is presumably based is one which was brought to Canada by Gore in 1815 and given by him to Colonel James Givins when Gore returned to England in 1817.

Other images less accessible to Berthon were acquired in England. With the assistance of Robinson's brother, Charles, a suitable image was provided of Gore's successor, Sir Isaac Brock. Colonel (later Major-General) Robinson was teaching at the time at the Royal Military College, Sandhurst. He contacted the descendants of Brock in St. Peter Port, Guernsey, and managed to borrow a small coloured miniature of the General which then belonged to Mrs. Henry Tupper, descendant of one of Brock's brothers, Irving. This watercolour and pastel miniature has been attributed to William Berczy, who painted it in the province prior to Brock's death at Queenston Heights in 1812.

The work was sent up to England and Colonel Robinson commissioned a Miss Kerr Nelson to copy it in oils. This copy was then photographed at the Aldershot studio of the firm of Hills and Saunders. Several prints were made and Robin-

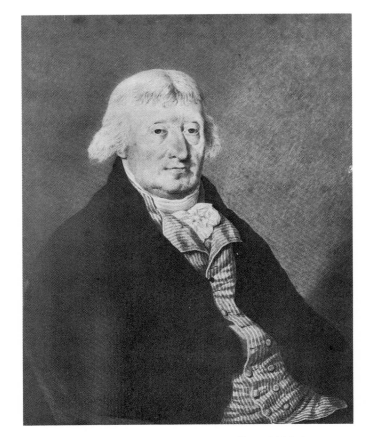

William Berczy, *The Hon. Peter Russell*, c. 1803-4
Watercolour on paper; 30.5 × 22.9 cm/ 12 × 9''
Private Collection, London, Ontario

son had one coloured with watercolour from the Berczy original. The original was then returned to Guernsey. Robinson was pleased with his efforts for he wrote his brother, the Lieutenant Governor, that the oil copy which Miss Kerr Nelson had made was:

> better than the original or the photograph, as the original was always, I fancy, a wishy-washy production, and I daresay has faded with age, making the face appear flat and whitish, except in one or two places where the colour is bright.[3]

The same original was the basis for the portrait of Sir Isaac Brock painted in the 1890s by J.W.L. Forster for the Legislative Building (see p. 164). Forster was more enterprising, for he went to Guernsey himself to see the original.

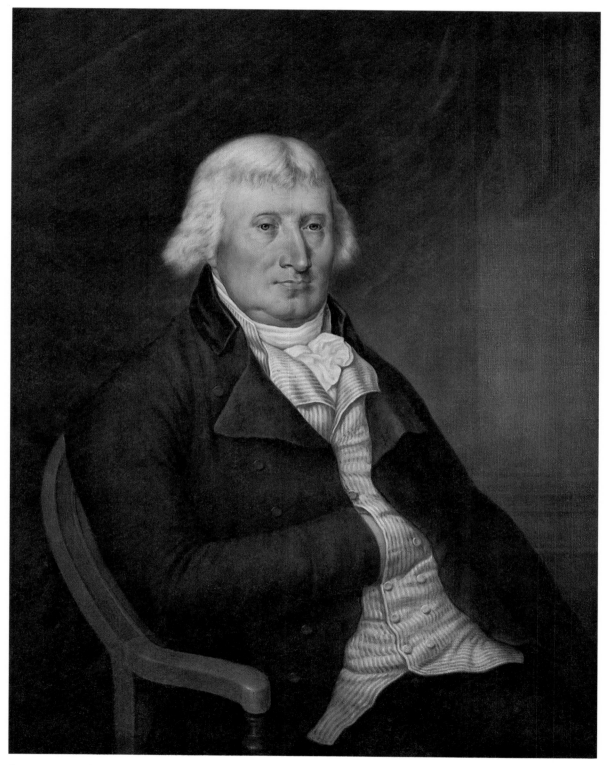

George T. Berthon, *The Hon. Peter Russell*, 1882

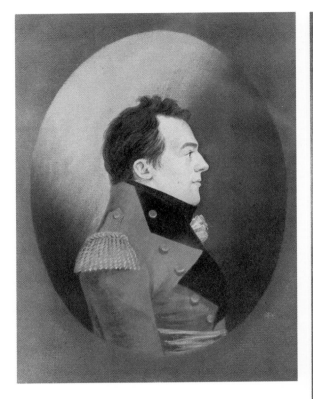

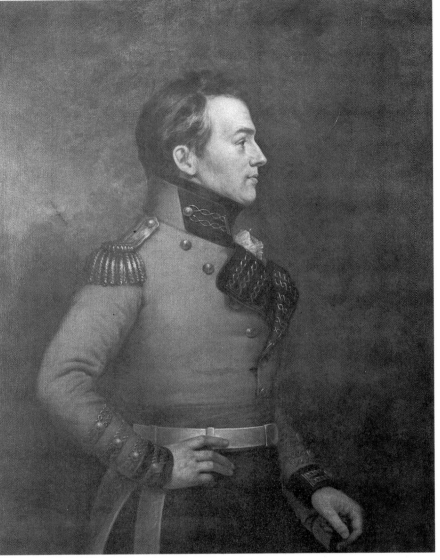

(*Right*) George T. Berthon, *Major-General Sir
Isaac Brock, K.C.B.*, 1883

(*Above*) William Berczy, *Major-General Sir
Isaac Brock, K.C.B.* Watercolour and pastel
on paper Captain Mellish Collection,
Guernsey

The copy and the coloured photograph
acquired by the Colonel were then sent back to
Canada along with coloured photographs of por-
traits of Brock's later successors, Sir Gordon
Drummond and Sir Peregrine Maitland. The
miniature which Colonel Robinson obtained
from Drummond's daughter Eliza, Countess of
Effingham, is still in the collection of the Drum-
mond family seat at Megginch Castle in Perth-
shire, Scotland. The similarity is so striking that
it leads one to speculate that Berthon did not

allow himself any artistic licence in his crea-
tions for Government House. This might be said
of other portraits as well; where sources can be
located, there is little doubt that Berthon did
not stray far from the originals.

The dates during which the portraits entered
the collection between 1880 and 1887 indicate
that they were painted in chronological order.
Portraits of lieutenant governors of Upper
Canada, such as that of Sir Francis Bond Head,
painted in 1883 and Major-General Philipse

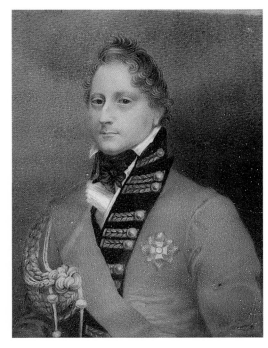

(*Above*) Artist unknown, *General Sir Gordon Drummond, G.C.B., c.* 1817 Oil on ivory; 6.4 × 3.8 cm./2 ½ × 1 ½" Drummond Collection, Megginch Castle, Perthshire, Scotland

(*Left*) George T. Berthon, *General Sir Gordon Drummond, G.C.B.,* 1883

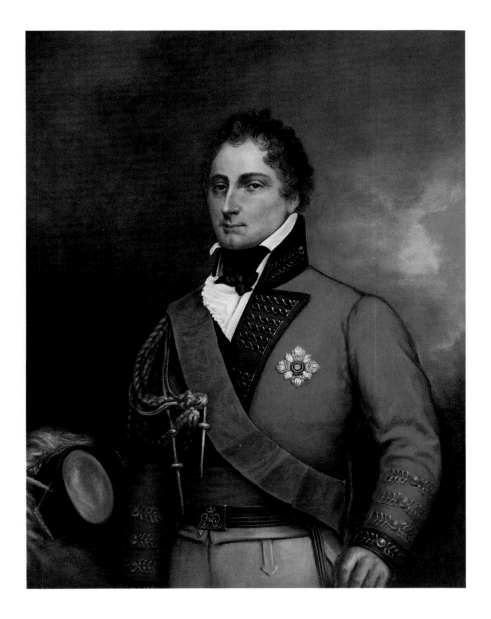

Robinson, painted in 1884, are followed by portraits of governors general of the Province of Canada during the time of the union. Although most of the vice-regal figures of the province during those time spans are represented, there are significant gaps in the collection; for example, such important figures as Roger Hale Scheaffe, who was President and Administrator of Upper Canada at a critical period of the War of 1812, and Sir Charles Bagot, Governor General from 1842 to 1843, are notably absent.

Perhaps images could not be found, or perhaps Robinson's retirement from office in 1887 left insufficient time.

Berthon was clearly busy during those seven years, having completed twenty portraits, including that of Robinson's predecessor, the Hon. Donald Alexander Macdonald. Robinson's last acquisition for his "hall of fame" was the portrait of Sir George Arthur — a copy after an original in England in the Arthur family collection — for which he was personally reimbursed

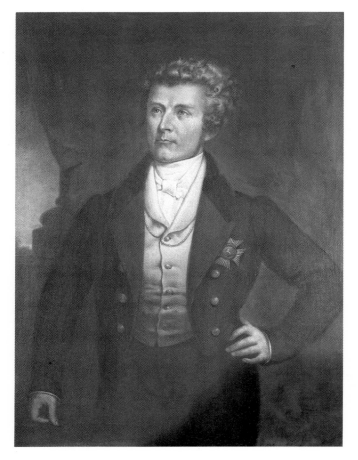

George T. Berthon, *Sir Francis Bond Head, Bart., K.C.H.,* 1883

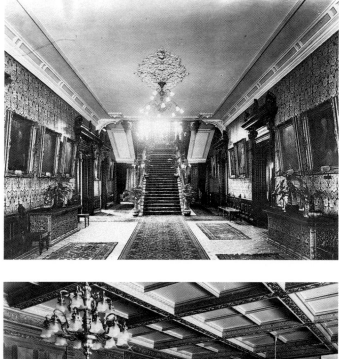

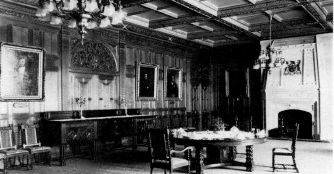

(*Above*) Government House, 1870-1912. Portraits of 19th century lieutenant governors line the walls of the main hall; *c.* 1912

(*Below*) Government House, 1915-1937, Chorley Park, Rosedale. Berthon's portraits line the walls of the dining room

following his retirement from office. Interestingly, Robinson did not commission Berthon to paint his own official portrait. This was completed a year before his death in 1896 by J.W.L. Forster.

Following Robinson's retirement it became an established tradition to have one's portrait painted upon retirement from the office of Lieutenant Governor. Unlike the Ryerson collection or the collection acquired from the Ontario Society of Artists, the portrait collection has remained virtually intact. When the government closed the old Government House in 1912, these portraits of lieutenant governors were hung in Chorley Park, the new official residence, which opened in 1915. When Ontario's last Govern-

ment House was closed in 1937, the collection of portraits was placed in the Lieutenant Governor's Suite in the Legislative Building at Queen's Park, where the collection continues to grow.

It is probably not coincidental that as a direct result of the commissioning program by Lieutenant Governor Robinson at Government House, the Department of Education began a similar program, in 1887, for the Educational Museum

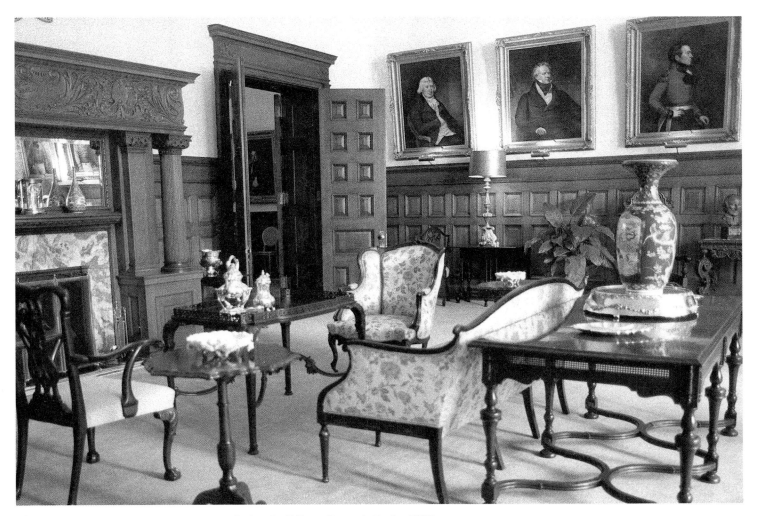

The Lieutenant Governor's Suite, Legislative Building, Queen's Park, 1937 to present

at the Toronto Normal School, albeit in the form of plaster portrait busts of notable Canadians. These acquisitions were largely the result of the efforts of the then Minister of Education, the Hon. George Ross, and the program continued until 1905.[4]

The plaster busts of living Canadians provide an interesting contrast to the collection assembled by Ryerson some thirty years previously. His collection of busts of "famous men from all ages" was to serve an educational purpose; students at the Normal School could see representations of the personalities they were to study in the classroom. However, with the stability that accompanied Confederation, the public become more readily disposed toward the veneration of contemporary notables. A growing sense of nationalism was surely a significant force behind the development of this collection of "modern worthies" and the selection of subjects for inclusion is enlightening.

There had been a few examples of portrait busts and portraits of Ontario "moderns" in the collection of the Normal School. It is known that Théophile Hamel's portrait of the founder of the school, Dr. Ryerson, was long on display as was the oval portrait of Chief Justice Sir John Beverley Robinson painted by Berthon some time in the late 1850s or early 1860s. A total of eleven plaster busts was already in the collection

Rosen, *The Rev. Dr. Adolphus Egerton Ryerson, D.D., LL.D.*, 1858

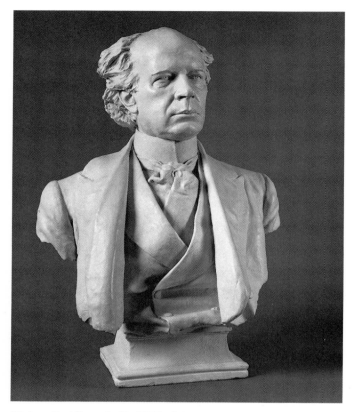

Walter S. Allward, *Sir Wilfrid Laurier, P.C., G.C.M.G.*, 1900

by 1884. These early busts, such as the Marshall Wood bust of Egerton Ryerson and F.A.T. Dunbar's plasters, *Sir John A. Macdonald* and *The Hon. George Brown*, were listed under the category of "Distinguished Canadians" in the catalogue of the Museum's collections published that year.[5] It is not likely that these early plasters in the collection were the result of a commissioning program instituted by the Department of Education, for a sculptor surnamed Rosen (his given name has now escaped us) intended to produce a series of busts of public men, the first two of which were to be of Egerton Ryerson and William Lyon Mackenzie. The Toronto *Globe* (April 10, 1858) commented on Rosen's venture:

> It is a laudable undertaking, and we trust that its success will not be endangered by the indifference of the citizens of Toronto to a new and very interesting branch of the Fine Arts in this city.

Certainly the Education Department was not indifferent, for it acquired Mr. Rosen's first two busts of public men. Under the auspices, however, of the Minister of Education, the Hon. George Ross, a full-fledged program developed and by 1905 a total of 78 plasters was on view in the museum. Although the personalities immortalized were primarily political figures, there was a fair sampling of leading educators, citizens, and other provincial notables of the time. These were displayed in groupings, much as Ryerson's collection of "famous men of all ages" had been grouped. The "Statesmen's Corner" shows a wide variety of political figures; the only ones from this "Corner" to remain are the plasters *The Hon. George Brown*, *The Hon. Alexander Mackenzie*, and *Sir Wilfrid Laurier*.

The commissioning program was largely the domain of three artists who were employed to

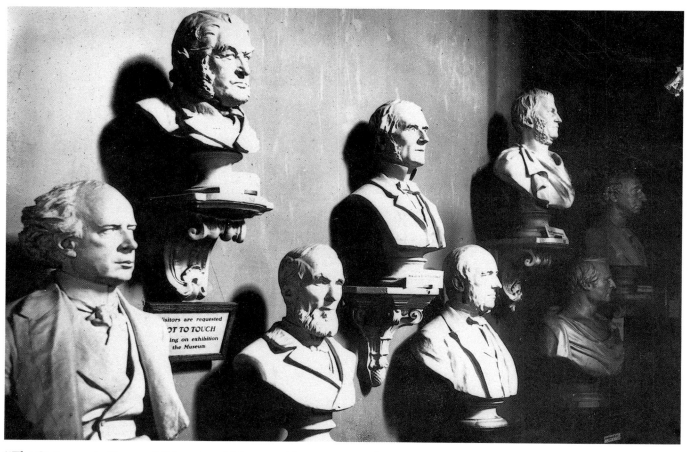

"The Statesmen's Corner," Educational Museum, Toronto Normal School.
Front row: Sir W. Laurier, The Hon. Alexander Mackenzie, The Hon. George Brown, The Hon. Edward Blake.
Back row: Sir Charles Tupper, The Hon. John Sandfield Macdonald, Sir Francis Hincks, Sir John Alexander Macdonald

that end by the department: Mildred Peel from London, Ontario, who was awarded the majority of commissions and who would later become Ross' third wife; Hamilton MacCarthy; and Walter S. Allward. Only a few busts were commissioned from other artists. The selection of the subject was the responsibility of the minister and his staff but they would assist the artists in obtaining the necessary sittings with the subjects since, by and large, all were sculpted from life. The department paid the artist's travelling expenses if the subject lived outside the city. There is a host of letters in the Archives of Ontario regarding artists' comments on the sitters, the work, and the fee payment. A particular complainer was Walter Allward, who

demanded more money for his plaster bust, *Sir Wilfrid Laurier*, and wrote to Ross:

> during an interview which I had with you some time ago, I understood that you were willing to give me more later on. The bust is over-lifesize and caused me considerable work.[6]

This gallery of "worthies" at the Educational Museum presaged the collecting of portraits and statuary for the Legislative Building when the Legislative Assembly made its home at Queen's Park in 1893. When the Museum's collections were dispersed in 1933, most of the remaining sixteen of the 78 originals which were commissioned were placed in the Legislative Building; they easily melded with the ambiance. By that time the building had a considerable number of

Legislative Building, Front St. W. A room adjacent to the Legislative Chamber showing the Legislative pages

portraits in the public halls, the result of a program begun in 1893.

When the Legislative Building at Queen's Park opened on April 4, 1893, *The Empire* newspaper captured the flavour of the day, describing it as ''legislators in fairyland;'' but, except for the new furnishings, fairyland was bare. A few early portraits were brought up from the old building on Front Street West, but they were indeed few as the Legislature did not then have a collection of political portraits. As had Lieutenant Governor Robinson, the Legislature set up a commissioning program to decorate Ontario's new parliament building with portraits of leading political figures and heroes of the province. The commissioning of these, which continued at an accelerating rate until 1914, is largely the result of pressure from three person-alities: Premiers Hardy (1896-99), Ross (1899-1905), and Whitney (1905-14). These three premiers were aided by a committee of Members of the Legislature, the Committee of the House for Art Purposes who allocated the ''art vote'' and the public at large, those interested citizens who played a part in aiding the formation of this collection by lobbying, fund-raising, and a generally positive spirit towards the program. The statues on the grounds of the park surrounding the building are the result of this private interest in Ontario's political heritage, although a few portraits were given by generous-spirited individuals.

Such was the case with the first official portrait to enter the collection in the new building, that of then Premier Sir Oliver Mowat. The painting by Robert Harris had been commissioned and donated by the ''friends of the Premier.'' It was officially unveiled in the Legislative Chamber after the delivery of the Speech from the Throne on the day of the opening of the new building.[7] A portrait of Mowat's predecessor, the Hon. Edward Blake similarly came into the collection four years later.[8] Donated by the Toronto General Loan Company, of which Blake had been first president, it was intended to complement the portrait of Mowat. Grier's portrait of Blake was

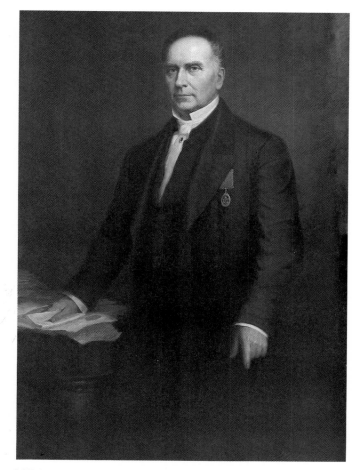

J.W.L. Forster, *The Hon. Robert Baldwin, C.B.,* 1906

intended to be an ''historical portrait;'' it was the intent of the artist to show the former Premier in the Legislative Chamber in the old Legislative Building on Front Street West, where he served as Premier from 1871 to 1872.

The notion of historical portraiture and the commissioning of political portraits occurred simultaneously during the years at the height of the program for the new building. The earliest portraits, however, to enter the collection were of political figures who had made some contri-bution to Ontario's legislative life. Portraits of former Conservative Leaders of the Opposition, Sir William Ralph Meredith and Sir Matthew Crooks Cameron, were acquired by the Liberal government in power at the turn of the century, demonstrating that the concern for portraiture

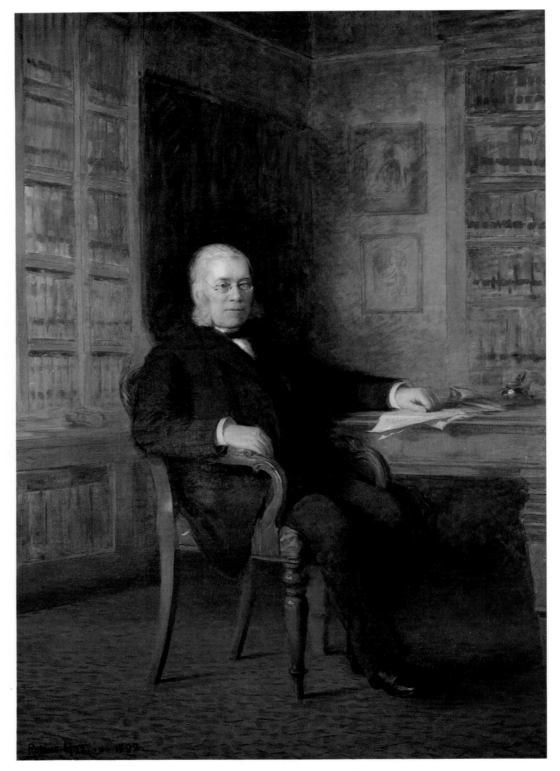

Robert Harris, *The Hon. Sir Oliver Mowat, G.C.M.G., Q.C., LL.D.*, 1892

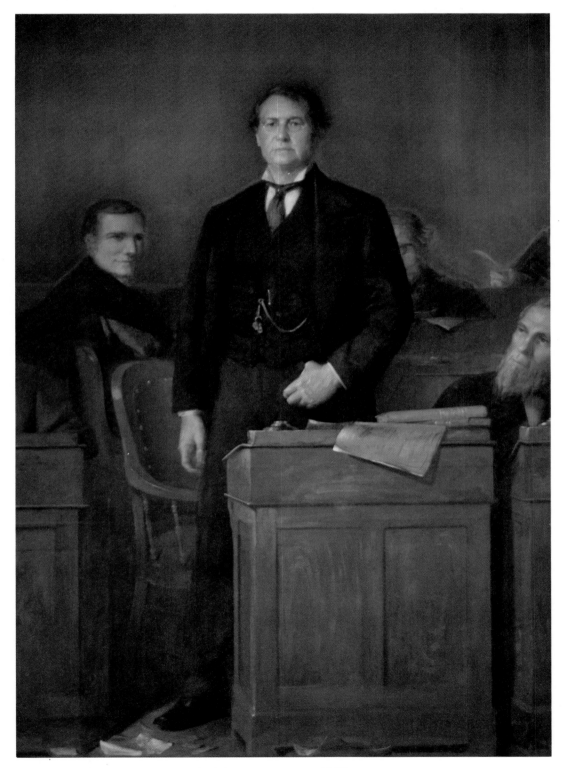

E. Wyly Grier, *The Hon. Edward Blake, Q.C., LL.D.*, 1897

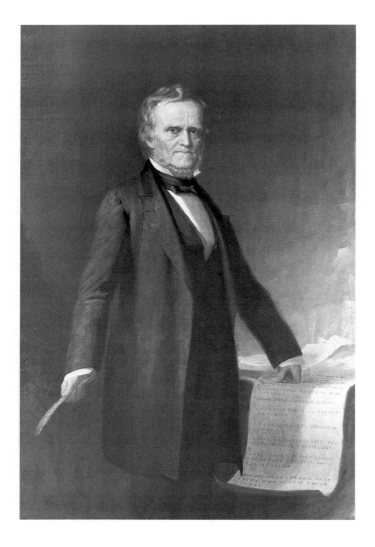

(*Left*) J.W.L. Forster, *William Lyon Mackenzie*, 1903
(*Above*) Legislative Building, Queen's Park, West Wing, "The Speaker's Corridor"

went well beyond party lines. The goal was a serious one: to acquire portraits of men who had made some contribution to the province regardless of political affiliation. Conservative Premier Whitney was responsible for the commissioning in 1906 of the portrait of the Hon. Robert Baldwin to hang alongside that of his companion in the struggle for responsible government, William Lyon Mackenzie. The Mackenzie portrait was acquired in 1903 by Premier Ross at the behest of a group of interested citizens who recommended the Legislature's purchase of the portrait for hanging in the building "in respect of his place in history"[9] in

the Legislature of Upper Canada and later Canada West.

The interest in parliamentary tradition was probably kindled at this time as Ross, while premier, inaugurated a program of commissioning portraits of the Speakers of the Legislature from the time of Confederation. As photography was by 1867 a common art form, these posthumous portraits of early Speakers are probably all derived from photographic sources. Two artists were engaged to this end: Miss Mildred Peel, who completed four portraits, and J.W.L. Forster, whose three works are far more appealing. Upon Ross' retirement as Liberal

leader, it became established tradition to add to this collection and each retiring Speaker must still have his portrait painted. This is true also of the portraits of premiers, a practice established in 1901 with the portrait of Premier Hardy.

It was during Hardy's administration that the idea of "historical portraiture" developed. Whether the idea of a portrait gallery of the province's heroes was the idea of the premier or of the artist J.W.L. Forster, who completed those in the collection, is a matter for speculation. It would seem, however, that the artist found successive premiers sympathetic to his interest in history. He completed four such portraits from the 1890s to 1903 – *Sir Isaac Brock, Major-General Wolfe, Major-General Aeneas Shaw*, and *Colonel John Graves Simcoe*. Much of Forster's adventures are recounted in his chatty and informative autobiography, *Under the Studio Light*.[10] He informs us of his intent to solicit commissions from the government:

> I sought to follow my eager wish for my choice career, history. . . . A series of historical studies were made and submitted to officers of state as an appeal for the decoration of state buildings.[11]

Although Forster also proposed a series of murals of historical events as decoration for the Legislative Building corridors, as had the Guild of Civic Art in 1901,[12] he seized the opportunity to submit sketches of General Brock and General Wolfe to premiers Hardy and Ross. Probably impressed not only with the works themselves, but with the artist's ingenuity, they awarded him commissions for larger portraits.

Forster, in painting his sketch for the commissioned portrait of Brock, was not satisfied to use Berthon's portrait which was then at Government House or the oil copy which Colonel Robinson had sent back to Canada for Berthon's use, which was still in the collection of the Robinson family; as noted previously, he wanted to see the original which was in Guernsey. Obtaining a letter of introduction from then-retired Hon. John Beverley Robinson to the Tupper family, the artist set off to St. Peter Port in Guernsey in 1897 to visit the General's descendants. The artist set up studio on the island and used as his model for his famous portrait the watercolour and pastel portrait which had served also as the basis for Berthon's portrait (see p. 152). The artist, however, expanded his portrait of Brock to full-length and included Brock's

> uniform, perforated by the musket balls which terminated his spectacular career and the letter which he wrote to Sir George Prevost during the night preceding that fatal morning.[13]

These items were still then in the collection of the family; the uniform used by Forster for his painting was given in this century by the family to the Public Archives Canada. Apparently, the sketch which Forster produced on Guernsey invited some favourable comments from the government in Guernsey and they commissioned him to execute a large portrait for their State House. This work still hangs in the Royal Court House in St. Peter Port. Upon his return, Forster showed his sketch to the government and obtained the commission; his portrait of Brock entered the collection in 1900.

While Forster was abroad he took the opportunity to research a possible portrait of Major-General Wolfe, victor of the Battle of the Plains of Abraham in 1759. He sought out private collections where portraits of the young general could be found and based his next sketch on a portrait of Wolfe by Joseph Highmore then in the collection of John S. Armstrong, Cornwall, England. Forster did further research on Wolfe in the Imperial War Records Office in London and included in his portrait a more accurate rendering of the type of uniform Wolfe would have worn at the time he was in Canada. The artist chose to represent him "in a boat approaching L'Anse au Foulon [Wolfe's Cove] in the dark of the morning."[14] Again the enterprising artist submitted his sketch to the government and obtained a commission. The portrait of Wolfe was acquired a year after the Brock portrait, in 1901.

Premier Ross then commissioned the artist to paint a portrait of the lesser-known Major-General Aeneas Shaw, which was completed in

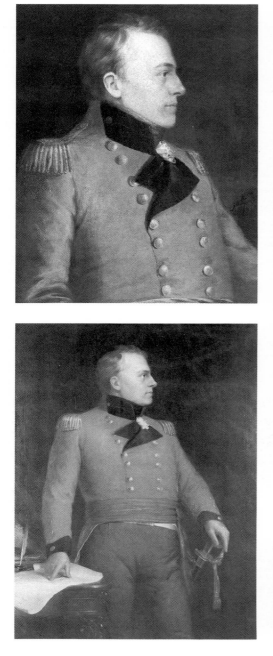

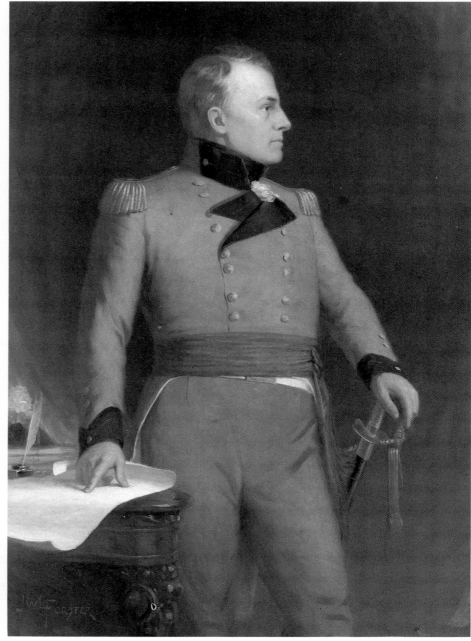

(*Above*) J.W.L. Forster, *Major-General Sir Isaac Brock, K.C.B.*, 1897, sketch for larger painting Oil on canvas; 76.2 × 60.96 cm/ 30 × 24″ Public Archives Canada Collection, Ottawa

(*Below*) J.W.L. Forster, *Major-General Sir Isaac Brock, K.C.B.*, 1897 Oil on canvas Royal Court House Collection, St. Peter Port, Guernsey

J.W.L. Forster, *Major-General Sir Isaac Brock, K.C.B.*, 1900

(*Above*) Joseph Highmore, *Major-General James Wolfe, c. 1742* Oil on canvas; 74.3 × 61.6 cm/ 29 ¼ × 24 ¼'' Public Archives Canada Collection, Ottawa

(*Right*) J.W.L. Forster, *Major-General James Wolfe*, 1901

1902. Shaw served under Colonel Simcoe in the Queen's Rangers and came to Upper Canada in 1792. Two years later Simcoe appointed him to the Legislative Council and during the War of 1812, Shaw was an important figure, serving as Adjutant-General of the Militia. In 1903 the portrait of Shaw's superior, Colonel John Graves Simcoe, entered the collection. It is still uncertain whether Forster proposed these two portraits to the government or whether he was asked to paint them for the Legislature.[15] The Simcoe portrait is derived from the same source used by Berthon over twenty years earlier — the ivory miniature of Simcoe which was then in the possession of Dr. Henry Scadding and which is now in the collection of the Law Society of

Upper Canada. Virtually no other such historical portraits were to enter the collection after this time except the controversial portrait of Laura Secord, which the government purchased from Mildred Peel in 1905.

Considerable scandal surrounds this painting of the legendary heroine of the War of 1812, for it was originally intended to be a political portrait — that of Premier George Ross, soon-to-be husband of the artist. The portrait of Secord for many years hung in a place of honour outside the Legislative Chamber and graced the boxes of chocolates of the firm bearing the heroine's name. However, during the 1930s Premier Mitchell Hepburn decided to investigate the rumour which had long circulated around the

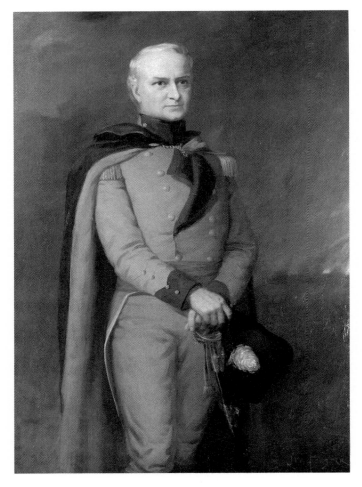

J.W.L. Forster, *Major-General The Hon. Aeneas Shaw*, 1902

Artist unknown, *Colonel John Graves Simcoe* Oil on
ivory; 12.1 × 8.9 cm/ 4¾ × 3½'' Law Society of Upper
Canada Collection, Osgoode Hall, Toronto

halls of Queen's Park that, in fact, ''Laura
Secord'' was ''George Ross.'' Hepburn had an
X-ray taken of the questionable portrait only to
reveal that rumours were true; underneath the
painting of Secord was a portrait of the premier.
News of this hit the press and throughout 1936
there was considerable debate about the portrait.
The headline of the Toronto *Telegram* on
February 24, 1936, read: ''X-Rays Show Laura
Secord in the Lap of Premier Ross.''

This, of course, caused considerable specula-
tion at the time; the premier had purchased the
Laura Secord portrait during his tenure and
surely knew its secret since he married Mildred
Peel, the artist, only two years after its acquisi-

tion by the government. There is still consider-
able debate as to the authorship of the original
portrait of Ross before it was overpainted by
Peel. Is it the work of Mildred Peel or of William
A. Sherwood?

Premier Hepburn in an interview recalled that
one of the Queen's Park Press Gallery reporters,
who used to stalk Premier Ross in his office late
at night in order to get scoops for his stories,
knew that Ross was having a portrait painted for
himself but that he did not like it and that
''Cabinet had refused to foot the bill.''[16] The
authorship of this portrait is unknown, and yet
it may have been the one painted by W.A.
Sherwood and given to the Premier by the Ross

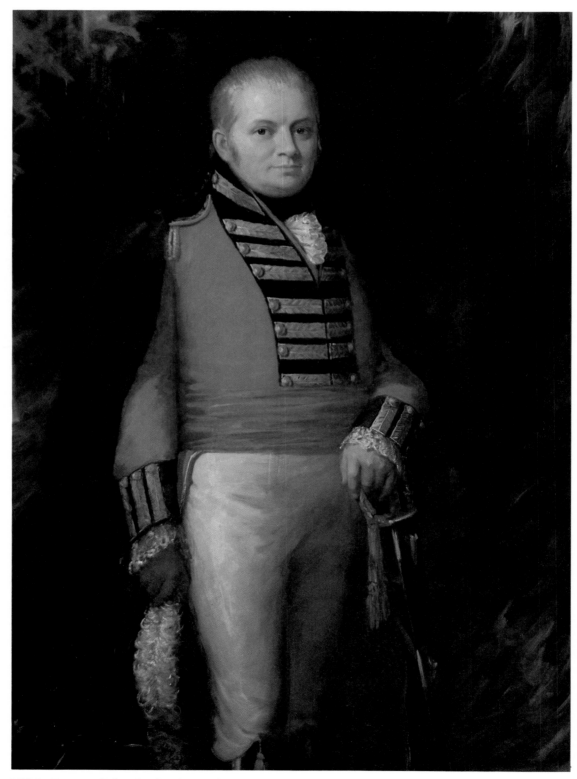

J.W.L. Forster, *Colonel John Graves Simcoe*, 1903

Mildred Peel, *Laura Secord* (detail)

X-ray of portrait of *Laura Secord* reveals underpainting of a portrait of the Hon. George Ross

Liberal Club, which the Premier did not like but which he kept at his St. George Street home.[17] Perhaps Miss Peel overpainted this portrait and submitted it as ''Laura Secord'' to the government for purchase. The identity of the artist of the ''George Ross'' portrait still remains the subject of debate.

Despite the controversy Hepburn left the painting hanging during his term of office. Some time in the 1940s it was placed in storage where it remained for nearly 40 years, until it was rediscovered — in the closet, one is tempted to say — in 1978. It now hangs in the Legislative Building in company with other historical portraiture, the last of the truly historical portraits to be acquired.

Premiers Ross and Whitney also perpetuated

the tradition instituted by the public of acquiring statuary for the lawn of Queen's Park. This good-spirited tradition at Queen's Park went back to 1860, long before the Legislature ever considered having a new home. The first statue erected was of Queen Victoria, in whose honour the park was named. Although the statue was returned to England a few years after its arrival in Toronto and was not re-instated in its position on the east side of the main entrance to the Legislative Building until 1903, it set a tone for future monuments. The statue of the Hon. George Brown, erected by public subscription in 1884, and the *North West Rebellion Monument*, unveiled in 1895, also a product of public involvement, represent the auspices through which most of the statues to follow came into being. After the Legislative Building was opened

Unveiling ceremony of Mario Raggi's statue of *Queen Victoria*, May 26, 1903, Queen's Park

in 1893 a series of other statues began to dot the lawn, erected both by the efforts of interested citizens and by funding assistance made available by the Legislature's "art vote." This practice continued well into the 1930s and the last monument erected on the property was the *William Lyon Mackenzie Memorial*. Although the tradition of public statuary is no longer a major factor in the visual arts today, it does express that great nineteenth-century mission which sought to provide a sense of history and dignity to the new country.

The tradition of portraiture in the province continues to this day. Portraits are commissioned of the three leading political personalities of the province, the Lieutenant Governor, the Premier, and the Speaker of the Legislature, even though the line of development was broken

in 1914 upon the death of Premier Sir James Pliny Whitney.

Whitney's successor, Premier William Howard Hearst (1914-19), did not choose to continue this commemorative tradition on a large scale, even though his administration is responsible for the commissioning of Challener's large copy of the destroyed Robert Harris painting of *The Fathers of Confederation*. Perhaps the advent of the First World War was the reason that all active collecting, not only of official portraiture but also of works for the contemporary collection, came to a halt in 1914. Nevertheless, a flurry of collecting activity can be seen in the 1950s during the administration of Premier Leslie Frost (1949-61). Frost is credited with acquiring the portrait, *The Hon. Louis Hippolite LaFontaine* to hang with that of *The Hon. Robert*

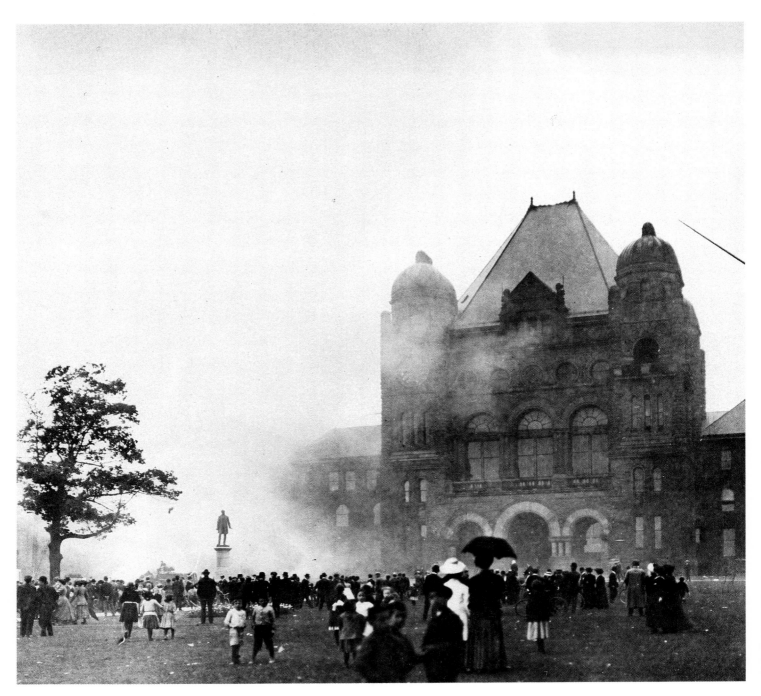

Charles Birch's statue of *The Hon. George Brown* stands unharmed while fire rages in the West Wing of the Legislative Building, Queen's Park, 1909

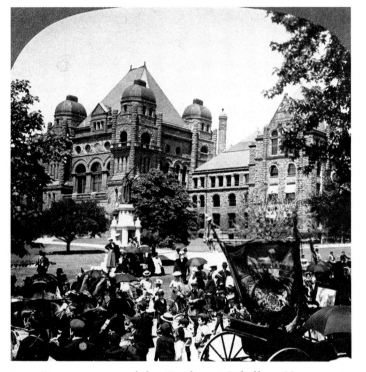

Unveiling ceremony of the *Northwest Rebellion Monument (1885)*, Queen's Park, 1895

Baldwin, acquired by Whitney fifty years earlier. The same is true of the portrait of the Marquis de Montcalm, French adversary of Major-General Wolfe at the battle of the Plains of Abraham. Interested as he was in the cultural duality of the country and the roots of the French people in the Province of Ontario, Frost chose to commission for the Executive Council Chamber two historic paintings by F.S. Challener after drawings by C.W. Jefferys: *Etienne Brulé at the Mouth of the Humber River* and *The First Legislature of Upper Canada*. While Frost had a particular interest in history and the seat of government, his influence upon the development of the collection is restricted to his contributions in the Legislative Building's holdings of political and historical portraits. His successor as Premier of Ontario was to become the next major personality behind the formation of the collection as we know it today. The Honourable John Parmenter Robarts, whose administration was responsible for the revival of collecting of fine art in 1966, led the way to a new era.

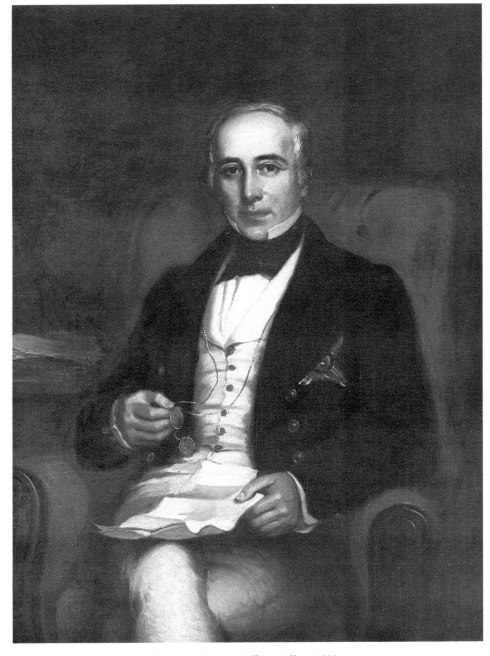

(*Above right*) Mildred Peel, *The Hon. George William Allan*, 1888

(*Above left*) Artist unknown, *Major General Sir George Arthur*, 1887

The Hon. George William Allan,
P.C., D.C.L., F.R.G.S.
(Mayor of Toronto, 1855-58; Speaker
of the Senate, 1888-91)

George William Allan (b. York
[Toronto], Upper Canada, 9 January
1822; d. Toronto, Ontario, 24 July 1901)
was educated at Upper Canada College
and called to the bar of Upper Canada in
1846. He was Mayor of Toronto from
1855 to 1858, and member for York
Division (appointed in 1858) in the
Legislative Council of Canada. A
member of the Senate of Canada from
1867, he served as that body's Speaker
from 1888 to 1891. Allan was also
Chancellor of the University of Trinity
College (1877-1901) and a fellow of the
Royal Geographical Society of England,
and held the presidency of the Ontario
Society of Artists, the Upper Canada
Bible Society, the Toronto Conservatory
of Music, and the Historical Society of
Ontario.

Artist: Mildred Peel
Plaster, 70 x 45.7 x 33 cm / 27½ x 18 x 13"
Commission for the Educational
Museum, Toronto Normal School, 1888.
MGS 619732

Sculpted from life.

Major-General Sir George Arthur, Bart., K.C.B.
(Lieutenant Governor of Upper Canada, 1838-41)

George Arthur (b. Plymouth, England, 21 June 1784; d., England, 19 September 1854) entered the 91st Highlanders in 1804, and earned several promotions through service in Italy, Egypt, Sicily and The Netherlands.

Following an eight-year post as Lieutenant Governor of Honduras (1814-22), Arthur was appointed Lieutenant Governor of Van Dieman's Land (Tasmania) from 1823 to 1835 where he improved the system of transporting criminals to his territory, and was credited with being the first to suggest confederation for the colonies of Australia.

In 1838, Arthur's reputation gained him the appointment as Lieutenant Governor of Upper Canada, a province still in uproar following William Lyon Mackenzie's 1837 Rebellion. Throughout Mackenzie's attempts to strengthen the ties between the province and the American Republic, his subsequent exile from and repeated incursions into Upper Canada, Arthur was able to maintain the government of the province. During the preliminary negotiations for the union of the two provinces, the Governor General at the time, Charles Edward Thomson, Baron Sydenham, relieved Arthur of his duties as Lieutenant Governor, while maintaining him as Deputy Governor. In February 1841, at Sydenham's request, Arthur returned to the vice-regal post, and remained in office until the union of the two provinces was achieved later that year. Subsequently, he was appointed Governor of Bombay and served for a brief period as Governor General of India.

Artist unknown
Oil on canvas, 109.2 x 81.3 cm/43 x 32"
Commission, 1887. MGS 693137

The identity of the artist who painted this work, based on a portrait of Arthur by the British artist Smart included in the *Victorian Exhibition* held at the New Gallery, London, England, in 1891-92 (cat. no. 287) is unknown. The owner is listed in the catalogue of that exhibition as J. Raynor Arthur, Esq. Several 18th and 19th century painters of portraits and portrait miniatures were named Smart.

An Order-in-Council dated 15 July 1887 states that "...a warrant for the sum of $152.07 be issued in favour of the Honourable J.B. Robinson to reimburse him the amount paid by him for the portrait of Sir George Arthur, acquired for Government House." The Hon. John Beverley Robinson may likely have commissioned this copy of the portrait in the Arthurs' family collection.

John Bain, B.Ed.
(Principal, Ontario Teacher Education College, Toronto, 1963-66; 1972-79)

Principal of the Toronto Teachers' College from 1963 to 1966, John Bain (b. 1920) again took on the duties of Principal in the same institution from 1972 to 1979, after it had been re-named the Ontario Teacher Education College.

Artist: Alan C. Collier
Oil on canvas, 100.3 x 85.7 cm/ 39½ x 33¾"
Signed and dated: (l.r.) Alan C. Collier '67
Inscribed: (verso) Alan C. Collier R.C.A., O.S.A.
Commission, c. 1967. MGS 623089

The Hon. Robert Baldwin, C.B.
(Joint Premier of the Province of Canada, 1842-43; 1848-51)

Robert Baldwin (b. York [Toronto], Upper Canada, 12 May 1804; d. Toronto, Canada West, 9 December 1858) was called to the bar of Upper Canada in 1825. He was elected to the Legislative Assembly of Upper Canada in 1829 as a moderate Reformer, but was defeated in the general elections of 1830. Although he did not hold elected office again until 1841, he remained vocal in the cause of responsible government for Canada, having, for example, submitted a memo upon that subject to the Colonial Office in England in 1836. After the Union of the Canadas was proclaimed in 1841,

Alan C. Collier, *John Bain*, 1967

Baldwin took two seats in the Legislative Assembly, serving as a Reform member for both Fourth York and Hastings while continuing his appointment as Solicitor General of Canada West. (He had held this position for Upper Canada since 1840.) The Governor General at the time was the Rt. Hon. Charles Edward Poulett Thomson, Baron Sydenham (1799-1841), whose exclusion of French-Canadian representation from the Executive Council caused Baldwin to resign from the Council in protest on 12 June 1841, and join the opposition.

Lord Sydenham's successor, Sir Charles Bagot, called upon Baldwin and a French-Canadian Reformer, Louis Hippolyte LaFontaine, to act as Attorneys General for Canada West and East respectively, and to form a Joint Administration of United Canada. This partnership lasted from September 1842 to November 1843. In 1848, a second Baldwin-LaFontaine administration was formed and held power until 1851. This coalition, often referred to as "The Great Ministry," confirmed the principle of responsible government in Canada and saw the passage of important legislation, such as the Rebellion Losses Bill and the Baldwin Act (which set the pattern for Ontario's municipal system).

Increasing radicalism within his party

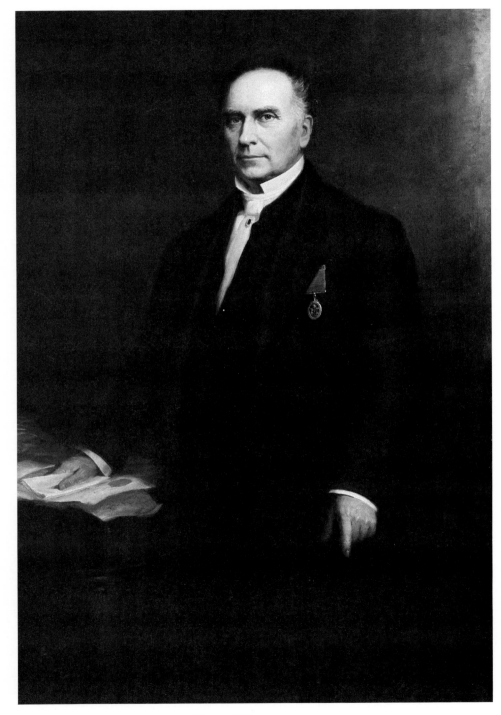

J.W.L. Forster, *The Hon. Robert Baldwin*, 1906

and his own failing health persuaded Baldwin to retire from politics at the age of 47. In 1854, he gave his blessing to the union of the Conservatives and the "Baldwin Liberals," which later became the party of John A. Macdonald and George-Etienne Cartier. Baldwin was a man of honesty and integrity whose political contributions earned him the designation of Companion of the Order of the Bath.

Artist: J. W. L. Forster
Oil on canvas, 165.7 x 113.7 cm/
65½ x 44¾"
Signed: (l.r.) J. W. L. Forster
Commission, 1906. MGS 693205

The face and pose of this likeness are probably derived from G.T. Berthon's large posthumous portrait of Baldwin, dated 1859, which hangs in the Benchers' Dining Room, Osgoode Hall, Toronto. As in Forster's canvas, the subject, depicted at three-quarter length, is shown turned slightly to the left. In his version, however, Forster has added documents to Baldwin's left hand, and presents the statesman as standing rather than seated.

The Hon. William Douglas Balfour
(Speaker of the Ontario Legislature, 1895-96)

William Douglas Balfour (b. Forfar, Scotland, 1851; d. Toronto, Ontario, 19 August 1896) entered Ontario politics as a Liberal M.P.P. for Essex South, serving that riding from 1882 until 1896. In 1895 he was appointed Speaker of the Ontario Legislature. In July of the following year he was made Provincial Secretary, an appointment cut short by his death one month later.

Artist: Mildred Peel
Oil on canvas, 75.6 x 62.2 cm/
29¾ x 24½"
Signed and dated: (u.r.) M. Peel./1904
Commission, 1904. MGS 692924
Presumably painted from photographic sources.

The Hon. Thomas Ballantyne
(Speaker of the Ontario Legislature, 1891-94)
Thomas Ballantyne (b. Peebles,

Scotland, 13 August 1829) came to Canada in 1852. He was a successful dairyman, and won the presidency of the Canadian Dairymen's Association and the Western Dairymen's Association. He declined a nomination to run for the House of Commons in 1872, and in 1875 became the Liberal member for Perth South in the provincial Legislature, a seat which he held until 1894. Ballantyne was Speaker of the Ontario Legislature from 1891-94.

Artist: J. W. L. Forster
Oil on canvas, 75.6 x 62.9 cm/ 29³/₄ x 24³/₄"
Signed and dated: (u.r.) J. W. L. Forster 1903
Commission, *c.* 1903. MGS 692925

The Hon. Jacob Baxter, M.D.
(Speaker of the Ontario Legislature, 1887-90)

Jacob Baxter (b. near Aquaduct [now Welland], Upper Canada, 6 June 1832; d. Cayuga, Ontario, 23 July 1912) attended medical schools in Toronto and New York City, graduating in 1866. He entered politics as a Liberal in the year of Confederation, when he was elected M.P.P. for Haldimand riding. Although defeated in 1894, Baxter was returned in a by-election in 1895, and kept his seat until 1898.

Artist: J. W. L. Forster
Oil on canvas, 75.6 x 62.2 cm/ 29³/₄ x 24¹/₂"
Signed: (l.l.) J. W. L. Forster
Commission, 1905. MGS 692926
Presumably painted from life.

The Hon. William David Black
(Speaker of the Ontario Legislature, 1927-29)

William David Black (b. Dundas County, Ontario, 17 October 1867; d. Ottawa, Ontario, 24 October 1944) served as a County Commissioner and Justice of the Peace before engaging in a long career as an M.P.P. He was first elected the Conservative member for Addington in 1911, and retained his seat through seven general elections before retiring in 1943.

Mildred Peel, *The Hon. William Douglas Balfour*, 1904

Artist: E. Wyly Grier
Oil on canvas, 125.7 x 90.2 cm/ 49¹/₂ x 35¹/₂"
Signed and dated: (l.r.) E. WYLY/ GRIER/1930
Commission, 1930. MGS 692719

The Hon. Edward Blake, K.C., LL.D.
(Premier of Ontario, 1871-72)

Edward Blake (b. Adelaide Township, Middlesex County, Upper Canada, 13 October 1833; d. Toronto, Ontario, 1 March 1912) attended Upper Canada College and the University of Toronto (B.A. 1854; M.A. 1858; LL.D. 1889). Regarded as an authority on consti-tutional law, Blake had been called to the bar in 1856 (Q.C., 1864) and served on the executive of the Law Society of Upper Canada.

Blake entered politics in 1867 as the Liberal member for both West Durham in the House of Commons, and for Bruce South in the Ontario Legislative Assembly. In 1869 he became Leader of the Liberal Opposition in Ontario, and gained the Premiership following the Liberal election victory in 1871. During his term in office, Blake demonstrated his belief in greater provincial autonomy and social responsibility. He set the stage for 34 years of Liberal government but resigned as Premier to remain in

J.W.L. Forster, *The Hon. Thomas Ballantyne*, 1903

J.W.L. Forster, *The Hon. Jacob Baxter*, 1905

federal politics following the abolition of dual representation in 1872. Blake's important posts included Chancellor of the University of Toronto, 1873-1900; Minister of Justice, 1875-77; President of the Council, 1877; and leader of the federal Liberal party, 1879-87. Blake spent a brief period in the British House of Commons, elected in 1892 as an Irish Nationalist and representing South Longford.

E. Wyly Grier, *The Hon. William David Black*, 1930

E. Wyly Grier, *The Hon. Edward Blake*, 1897

Artist: E. Wyly Grier
Oil on canvas, 231.1 x 161.3 cm /
91 x 63¹/₂″
Signed and dated: (l.r.) E. WYLY
GRIER/1897.
Gift of Toronto General Loan Company,
1897. MGS 693204

Commissioned as a gift to Blake on the
occasion of his retirement in 1896 from
the Toronto General Loan Company, of
which he was the first president, and
presented by his fellow directors to the
Legislative Assembly of Ontario. It was
intended that the painting be hung
alongside Robert Harris' portrait of
Oliver Mowat. The artist has presented
Blake as he appeared addressing the
Legislature in the old Parliament
Building (Front Street West) in
1871-1872 when he was Premier of
Ontario. To his left is the Hon.
Archibald McKellar, Minister of Agri-
culture, and to his right the Hon.
Alexander MacKenzie, then Provincial
Treasurer and future Prime Minister of
Canada. In order to make preparatory
sketches for this portrait, the artist was
given access to the Legislative Chamber
in the old building which was then
closed.

(*Above*) Linda Pilby, *Verschoyle Blake*, 1972

(*Below*) Alan C. Collier, *Harold A. Blanchard*, 1960

Hamilton P. MacCarthy, *The Right Hon. Sir Robert Laird Borden*

Verschoyle Blake
(Historian in the Historical Branch, Department of Public Records and Archives, Ontario)

Verschoyle Benson Blake (b. Toronto, Ontario, 26 May 1899; d. Toronto, Ontario, 6 April 1971) for many years worked in the Conservation Branch of the former Department of Planning and Development where he did historical research and wrote most of the department's conservation reports. He was also a founding member of the Architectural Conservancy of Ontario, and was on advisory committees for both Upper Canada Village and Black Creek Pioneer Village.

Artist: Linda Pilby
Pastel on paper, 59.7 x 49.5 cm / 23½ x 19½"
Signed and dated: (l.r.) Linda Pilby 72
Commission, 1971. MGS 634903

Executed from photographic sources.

Lilias Torrance Newton, *The Hon. Louis Orville Breithaupt*, 1957

Harold A. Blanchard, B. Paed.
(Principal, Division B of the
Toronto Teachers' College, 1952-59)

Harold A. Blanchard (b. near Alliston,
Simcoe County, Ontario, 1910) earned
degrees at Queen's University (B.A.
1941) and the University of Toronto (B.
Paed. 1950) after receiving his teaching
certificate from the Toronto Normal
School (1930). Blanchard's career in
educational administration included
seven years as Principal of Division B of
the Toronto Teachers' College (1952-59)
and an appointment as Principal of the
Lakeshore Teachers' College from 1959
to 1961. In 1961, Blanchard spent several
months in Ghana, Nigeria and Sierra
Leone as an educational advisor to the
Canadian International Development
Agency. In 1972, he was made Director
of the Teacher Education and Certifi-
cation Branch in the Ministry of
Education, and remained in that office
until 1974.

Artist: Alan C. Collier
Oil on canvas, 100.3 x 85.1 cm/
39½ x 33½"
Signed and dated: (l.r.) Alan C. Collier/
'60
Commission. MGS 623088

The Rt. Hon. Sir Robert Laird Borden,
P.C., G.C.M.G., K.C., D.C.L., LL.D.
(Prime Minister of Canada, 1911-20)

Robert Laird Borden (b. Grand Pré, Nova
Scotia, 26 June 1854; d. Ottawa,
Ontario, 10 June 1937) was called to the
bar in 1878 (Q.C., 1900). Borden entered
federal politics as a Conservative M.P.
for Halifax from 1896 to 1904, and was
Leader of the Opposition for ten years
(1901-1911). Although defeated in the
1904 election, in the following year
Borden won the seat for Carleton in a
by-election. In the Conservative victory
at the general election of 1911, Borden
won back his Halifax riding and became
Prime Minister of Canada. As Canada's
leader during World War I, the Rt. Hon.
Sir Robert Borden (G.C.M.G., 1914)
struggled to reach a consensus with the
Liberal Senate on a national defence
policy. Near the end of the war he
attended sessions of the Imperial War
Cabinet and Imperial War Conference.

Borden received many awards and honorary degrees, was made a Fellow of the Royal Society of Canada (1928), and acted as Chancellor of McGill (1918-20) and Queen's (1924-30) universities.

Artist: Hamilton Plantagenet MacCarthy
Plaster, 76.2 x 55.9 x 31.8 cm/ 30 x 22 x 12½"
Probably commissioned for the Educational Museum, Toronto Normal School. MGS 619735

Presumably sculpted from life. This plaster is not listed as part of the collection at the Educational Museum by 1905, but probably was commissioned soon after Borden's election as Prime Minister in 1911.

The Hon. Louis Orville Breithaupt, LL.D.
(Lieutenant Governor of Ontario, 1952-57)

Louis Orville Breithaupt (b. Kitchener, Ontario, 28 October 1890; d. Toronto, Ontario, 6 December 1960) was educated at Northwestern College in Illinois, and at the University of Toronto. Upon graduation he entered the family-owned leather business in Kitchener, and became President in 1930. Breithaupt was the third generation of his family to serve as Mayor of Kitchener (elected 1923), and the youngest in the city's history. Apart from his several business interests, Breithaupt was active in community and service groups such as the Board of Trade, the Rotary Club, the Y.M.C.A. and Red Cross. In 1940 he was elected to the House of Commons as a Liberal member for the riding of Waterloo North, and re-elected in 1945 and 1949. Breithaupt served as Lieutenant Governor from 1952 to 1957, before resuming his business career in Kitchener. He received honorary LL.D.s from McMaster, Queen's and the universities of Toronto and Western Ontario; in 1959 he was sworn in as Chancellor of Victoria University, Toronto.

Artist: Lilias Torrance Newton
Oil on canvas, 121.9 x 99.1 cm/48 x 39"
Signed and dated: (l.l.) Lilias Torrance Newton/1957
Commission, 1957. MGS 694147

J.W.L. Forster, *Major-General Sir Isaac Brock,* 1900

Hamilton P. MacCarthy, *Major-General Sir Isaac Brock*, 1896

George T. Berthon, *Major-General Sir Isaac Brock*, 1883

Major-General Sir Isaac Brock, K.B. (President and Administrator of Upper Canada, 1811-12)

Isaac Brock (b. St. Peter Port, Island of Guernsey, England, 6 October, 1769; d. Queenston Heights, Upper Canada, 13 October 1812) was educated in Southampton and Rotterdam before entering the British army at the age of 16. By age 28 he was a Lieutenant-Colonel. Brock commanded the 49th Regiment on an expedition to Holland in 1797, and in 1801 he was second in command of the land forces at the attack on Copenhagen by Lord Nelson. The next year, his regiment was ordered to Canada, where Brock was stationed successively at Fort York (Toronto), Quebec, and Kingston. In 1810 he was posted to Fort George (Niagara-on-the-Lake) to assume command of the troops in Upper Canada, and in June, 1811, the then Major-General Brock also assumed the civil duties of President and Administrator of Upper Canada, replacing Governor Francis Gore during the latter's absence.

Early in 1812, Brock realized the inevitability of war with the United States and began to prepare for the

defence of the province. Establishing his headquarters at Fort George, he strengthened ties with the Indians in the west and with their Chief, Tecumseh. Soon after the War of 1812 was declared, Brock led a force of Indians and militia to capture Detroit on August 15, 1812, an achievement for which he was knighted (K.B.).

On October 13, 1812, an American force under General Stephen Van Rensselaer crossed the Niagara River and ascended the 300-foot cliffs south of Queenston to attack the British soldiers and Canadian militiamen defending the Heights. General Brock was killed while leading his men in a daring counter-attack; however, that day, Brock's men rallied under General Roger Sheaffe and drove the Americans from the clifftops. For his role in the War of 1812 and especially at the important Battle of Queenston Heights, Isaac Brock has been termed Canada's first war hero. Today, a tall Corinthian column, finished in 1856, stands on the spot at Queenston Heights where Brock's body lies entombed.

Artist: George T. Berthon
Oil on canvas, 111.8 x 83.8 cm/44 x 33"
Commission, 1883. MGS 694158

In 1881, at the request of Col. C.W. Robinson, brother of Lieutenant Governor the Hon. John B. Robinson, an oil copy by a Miss Kerr-Nelson was made of an original watercolour and pastel miniature attributed to William Berczy (see p. 152). It was sent to Canada from England along with coloured photographs of the original to serve as the basis for Berthon's portrait. Berczy's original was then in the collection of one of Brock's descendants, Mrs. Henry Tupper of St. Peter Port, Guernsey.

Artist: Hamilton Plantagenet MacCarthy
Bronze-coated terracotta,
38.1 x 26.7 x 16.5 cm/15 x 10½ x 6½"
Signed and dated: (verso)
H. MacCarthy/Sculptor 1896
Inscribed: (recto) Brock; (verso) M
Purchase for the Educational Museum, Toronto Normal School, 1896.
MGS 619882

The provincial government records list payment of $30 for "2 Pair of Busts in Terra Cotta" by MacCarthy in September, 1896. These would represent the pairs of busts (one of each pair in bronze-coated terra cotta) of Sir Isaac Brock and Tecumseh. The catalogue of the 1896 *Toronto Industrial Exhibition* notes that these busts were executed for the Guild of Sculptors of Ontario; it is not certain which of the two copies acquired by the Educational Museum, Toronto, was on display in this exhibition (cat. no. 352) although presumably it would have been the bronze-coated one.

Artist: J. W. L. Forster
Oil on canvas, 150.5 x 109.2 cm/
59¼ x 43"
Signed: (l.l.) J. W. L. Forster
Commission, 1900. MGS 692993

In 1897 Forster went to Guernsey to see the original watercolour and pastel portrait of Brock, attributed to William Berczy, in the collection of the Tupper family (cf. Berthon's portrait of Brock). From this painting Forster made a sketch that is now in the collection of Public Archives Canada (see p. 164). A painting now in the Royal Court House, St. Peter Port, Guernsey (see p. 164), and the painting in the Government of Ontario Art Collection are based on this sketch, but Forster made some changes. While visiting Brock's family in Guernsey, Forster had access to a letter Brock had written to Sir George Prevost as well as a uniform in which Brock may have been killed (now in the collection of the Canadian War Museum) and Brock's sword. Forster has changed Brock's pose to include these in his painting. In 1900 the Forster portrait of Brock entered the collection.

Artist: F. May Simpson
Bronze-painted plaster,
52.7 x 40.6 cm/20¾ x 16"
Signed and dated: (verso) F. May Simpson 1912. MGS 619885

Anne Nelson Brown [?]
(Wife of the Hon. George Brown)

Anne Nelson (b. Aberdeen, Scotland, *c.* 1828; d. Edinburgh, Scotland, 18 June 1906) was a granddaughter of Thomas Nelson, founder of the Edinburgh publishing firm. She met George Brown in 1862 while he was vacationing in

Artist unknown, *Anne Nelson Brown* [?]

Britain following his defeat at the polls the year before. They married in Edinburgh on 27 November 1862. The Browns had three children; in 1877 the family took possession of "Lambton Lodge" in Toronto, so named in honour of John Lambton, Earl of Durham. Anne Brown returned to Scotland with her children soon after her husband's death in 1880, where she remained until her death.

Artist unknown
Oil on canvas, 91.4 x 66 cm/36 x 26"
Purchase by the Ontario Heritage Foundation, 1982; on loan to the Government of Ontario.
MGS 635027

The Hon. George Brown
(Leader, Coalition Government of 1864-65)

George Brown (b. Alloa, Scotland, 29 November 1818; d. Toronto, Ontario, 9 May 1880) was greatly influenced by his father, Peter Brown, a Whig-Liberal and a believer in civil and religious liberty.

Charles Birch, *The Hon. George Brown*, 1884

In 1837 he and his father travelled to New York, where they established a newspaper, the *British Chronicle*, before moving to Toronto in 1843. Brown's interest in the Reform party and his belief in responsible government prompted the founding of the *Globe* in 1844. The paper soon advanced from weekly to daily publication, which by 1852 had earned it both large circulation and powerful influence as a reformist newspaper. In 1851, George Brown was elected to the Legislative Assembly for the county of Kent as an Independent Reformer. Although defeated in 1861, Brown was returned to the Legislature in a by-election in South Oxford in March, 1863. Throughout his political career, he fought hard for "representation by population," the annexation of the northwestern British territories and, above all, federal unity. In 1864 Brown agreed, as chief western Reform leader, to enter into a coalition government with his Conservative opponents under John A. Macdonald. He played a major role at the Charlottetown and Quebec Conferences in 1864, at which Confederation was endorsed. Although he resigned in December 1865 in opposition to Macdonald and his views concerning reciprocity with the United States, Brown continued to support Confederation in the *Globe*, and was appointed to the Senate in 1873.

In 1880 Brown died, six weeks after being shot by a disgruntled former employee of the great newspaper he had founded.

Artist: F.A.T. Dunbar
Plaster, 73.7 x 66 x 38.1 cm/
29 x 26 x 15"

Dunbar began work on his bust of Brown in 1880. He exhibited this and a similarly proportioned bust of Sir John A. Macdonald in the 3rd Annual R.C.A. Exhibition, Montreal, 1882 (cat. nos. 283 and 284). Both works were widely distributed through reproduction as plaster replicas.

Artist: Charles Bell Birch
Bronze on granite base; statue:
327.7 x 147.3 x 96.5 cm/129 x 58 x 38";
base: (height precedes circumference)
335.3 x 250.2 cm/132 x 98½"
Signed and dated: (l.l.) C. B. Birch, S⸿

F.A.T. Dunbar, *The Hon. George Brown*

A.R.A. 1884
Inscribed: (l.l.) LONDON; (on base,
recto) GEORGE BROWN
Commission by the Brown Memorial
Committee, 1884. MGS 619880

Unveiled on 25 November 1884 by the
Hon. Alexander Mackenzie, this statue
was financed by public subscription of
4,267 people. It was modelled and cast
in England and shipped to Toronto,
accruing import duty to the amount of
$1,000. However, the Dominion
Government passed an Order-in-Council
waiving this sum, allowing the
monument to enter the country free of
charge.

Artist: John Colin Forbes
Oil on canvas, 177.8 x 125.1 cm/
70 x 49¼"
Gift of Mrs. George Brown, 1889.
MGS 692667

Presumably painted from life.

John Colin Forbes, *The Hon. George Brown*

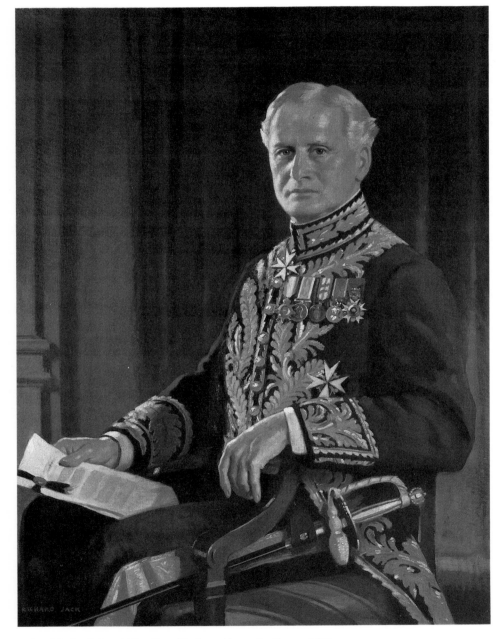

Richard Jack, *Colonel The Hon. Herbert Alexander Bruce*, 1938

Colonel The Hon. Herbert Alexander Bruce, M.D., R.A.M.C., L.R.C.P. (London), F.R.C.S. (England), LL.D. (Lieutenant Governor of Ontario, 1932-37)

Herbert Alexander Bruce (b. Blackstock, Ontario, 28 September 1868; d. Toronto, Ontario, 23 June 1963) entered the Medical Faculty of the University of Toronto in 1888, graduating in 1892 with the University Gold Medal and the Staff Silver Medal.

Dr. Bruce was a Professor of Surgery at the University of Toronto, and was President of both the Ontario Medical Association and the Academy of Medicine in Toronto. He was a Regent of the American College of Surgeons at its inception, and was elected a Fellow of the exclusive American Surgical Association. In 1911, with the assistance of Sir William Mulock and Sir Edmund Osler, he founded the Wellesley Hospital, and in 1946 Dr. Bruce made a gift of the hospital to the City of Toronto.

After his return from service in the Canadian Army Medical Corps during World War I, Dr. Bruce re-established his surgical practice. In October 1932, he at first refused the request of Prime Minister R. B. Bennett, to accept the appointment of Lieutenant Governor of Ontario. The Government House at Chorley Park had been unoccupied for almost a year following the extended leave of absence and illness of the Hon. William Donald Ross. Bennett was determined to avoid the possible constitutional effects of allowing the Lieutenant Governorship to lapse. Moreover, if in Depression-era Canada Ontario were not to accept the expense of maintaining the office of Lieutenant Governor, then less wealthy provinces should also be freed of this burden. For these reasons, Dr. Bruce was persuaded to accept Bennett's offer. He served as Lieutenant Governor from 1932 to 1937. At age 72 Herbert Bruce started a new career: in the general elections of 1940 and 1945 he won a Conservative seat in the House of Commons for the Toronto riding of Parkdale. Bruce resigned his Commons seat in 1946 to devote more time to his interests in medicine, business and writing.

Artist: Richard Jack
Oil on canvas, 111.8 x 86.4 cm / 44 x 34"
Signed: (l.l.) RICHARD JACK
Commission, 1938. MGS 694153

The Hon. Sir Matthew Crooks Cameron, K.C.B., Q.C.
(Chief Justice of the Court of Common Pleas, 1884)

Matthew Crooks Cameron (b. Dundas, Upper Canada, 2 October 1822; d. Toronto, Ontario, 25 June 1888) was educated at Upper Canada College, admitted to the bar in 1849, and entered political life in 1861. Cameron twice held a Conservative seat for North Ontario in the Legislative Assembly of Canada (1861-63; 1864-67). Although he had opposed Confederation, Cameron served for four years as M.P.P. for the Toronto East riding under John Sandfield Macdonald and was Provincial Secretary in the first Ontario government until 1871. With the defeat of the Macdonald government Cameron became leader of the Conservative Opposition until 1878 when he was appointed a judge of the Court of Queen's Bench. In 1884, he was appointed Chief Justice of the Court of Common Pleas, and was knighted two years later.

Artist: Mildred Peel
Oil on canvas, 231.1 x 154.9 cm / 91 x 61"
Commission, 1903. MGS 619807

This portrait was probably commissioned to complement that of another leader of the then Conservative Opposition, the Hon. Sir William Ralph Meredith, acquired by Premier A.S. Hardy in 1899. Both are the same size and with the same original frame.

The Hon. Sir Alexander Campbell, P.C., K.C.M.G., Q.C.
(Lieutenant Governor of Ontario, 1887-92)

Alexander Campbell (b. Hedon, Yorkshire, England, 9 March 1822; d. Toronto, Ontario, 24 May 1892), at two years of age emigrated to Canada with his family. While a law student, Campbell was fortunate enough to be a pupil of John A. Macdonald in Kingston. After earning admission to the bar in 1843 (Q.C., 1856), Campbell formed a partnership with Macdonald and in 1857 became a Bencher of the Law Society of Upper Canada.

Campbell was elected as a Conservative member of the Legislative Council of Canada for the Cataraqui Division in 1858 and was appointed Speaker of the

Mildred Peel, *The Hon. Sir Matthew Crooks Cameron*, 1903

Council in 1863. In the "Great Coalition" of 1864-67, Campbell held the office of Commissioner of Crown Lands. He was a strong advocate of Confederation and attended the Quebec Conference, October 1864. On July 1, 1867, he was sworn into the Privy Council and took the office of Postmaster General under his old leader, Sir John A. Macdonald.

Alexander Campbell was knighted (K.C.M.G.) in 1879, and assumed the responsibilities of Lieutenant Governor of Ontario in 1887.

Artist: Robert Harris
Oil on canvas, 124.5 x 99.1 cm / 49 x 39"
Signed: (l.r.) Robert Harris
Commission, 1889. MGS 693134

This portrait is based on another by Harris in the collection of The Senate, Parliament Hill, Ottawa.

Sir George-Etienne Cartier, Bart.
(Joint Prime Minister of the Province of Canada, 1857-62)

George-Etienne Cartier (b. St. Antoine,

Robert Harris, *The Hon. Sir Alexander Campbell*, 1889

County Verchères, Lower Canada, 6 September 1814; d. London, England, 20 May 1873) was compelled to take refuge in the United States after fighting as a supporter of Papineau during the Rebellion in Lower Canada in the summer of 1837, but returned to Canada in 1838. He was an elected member of the Legislative Assembly of Canada for the county of Verchères (1848-61), then a member for the riding of Montreal East (1861-67) and, finally, a representative in the Canadian House of Commons for this same riding, from 1867-73. During his long career in the Liberal-Conservative party, he held several Cabinet posts including Attorney General for Canada East, 1864, and from 1857-62 Cartier was the leader for the Lower Canadian section of the government in the Macdonald-Cartier administration. He was one of the Fathers of Confederation and was appointed Minister of the Militia following Confederation.

His enormous energy and administrative skill made Cartier a formidable force within French Canada, and a vital player in the movement toward Confederation. He was the leading French Canadian member of the "Great Coalition" and was a delegate to the Quebec conference in 1864. Cartier was created a baronet in 1868. At the end of

Louis-Philippe Hébert, *Sir George-Etienne Cartier*

his life he was implicated in the so-called "Pacific Scandal," but died in London before the verdict on that incident was reached.

Artist: Louis-Philippe Hébert
Bronze-painted plaster,
74.9 x 27.9 x 17.8 cm / 29½ x 11 x 7"
Signed: (l.r., r. side of base) Phillipe Hébert fecit
Inscribed: (on scroll) CONSTITUTION /
1867 / LE GOUVERMENT EST /
D'OPINION QUE LA CONFE /
DERATION EST NECES / SAIRE.
MGS 619887

This work was designed *c.* 1881-82 and, like the statuette of Sir John A. Macdonald, was manufactured by the firm of Carly and Petrucci, Montreal, in order to raise funds for, and attract attention to, the erection on Parliament Hill, Ottawa of statues by the artist of these two leaders. Hébert won the commission for the actual Cartier monument in 1883 and completed it in 1885. In 1965 gold-painted plaster replicas of four busts and statuettes by Hébert, including Cartier and Macdonald, were produced from the moulds prepared by Carly and Petrucci in an edition of 250 sets, to assist the Junior Chamber of Commerce organization to raise funds for its national headquarters.

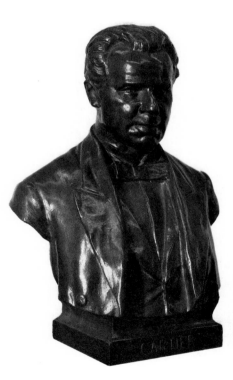

George W. Hill, *Sir George-Etienne Cartier*

Artist: George W. Hill
Bronze, 27.9 x 20.3 x 12.7 cm /
11 x 8 x 5"
Signed: (l.r., on base) Geo. W. Hill
Inscribed: (on base, recto) CARTIER.
MGS 619888

The Hon. Frederick McIntosh Cass,
Q.C.
(Speaker of the Ontario Legislature, 1968-71)

Frederick McIntosh Cass (b. Chesterville, Ontario, 5 August 1913) was first elected to the Ontario Legislature in 1955 as a Progressive Conservative member for Grenville-Dundas, and held several Cabinet posts, including that of Attorney General (1962-64).

Artist: Cleeve Horne
Oil on canvas, 133.4 x 104.1 cm /
52½ x 41"
Signed: (l.r.) CLEEVE / HORNE
Commission, 1971. MGS 619719

The Hon. William Andrew Charlton
(Speaker of the Ontario Legislature, 1903-04)

Thomas Charlton (b. Cattaraugus County, New York, U.S.A., 9 May 1841; d. Toronto, Ontario, 9 November 1930) entered Ontario politics in 1891, when he was elected as the Liberal member for Norfolk South. He was Speaker of the Ontario Legislature (1903-4) and Commissioner of Public Works (1904-5). Charlton won the federal riding of Norfolk in 1911, and retained this seat until the dissolution of Parliament in 1921, when he retired from public life.

Artist: Anna Rockwell Compton
Oil on canvas, 215.9 x 116.8 cm /
85 x 46"
Signed: (l.r.) A. Rockwell Compton
Commission, 1908. MGS 619808

This portrait may have been painted by a relative by marriage of the Speaker; his wife was Nellie Rockwell. Virtually nothing is known of the artist Anna Rockwell Compton; the *Public Accounts of Ontario* (1908) records payment to the Speaker as: "Portrait of self as Speaker."

The Rt. Hon. Sir Winston Leonard Spencer Churchill, K.G., P.C., O.M., C.H., F.R.S.
(Prime Minister of the United Kingdom, 1940-45, 1951-55)

Winston Leonard Spencer Churchill (b.

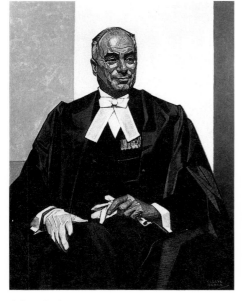

(Above) Cleeve Horne, *The Hon. Frederick McIntosh Cass*, 1970

(Right) A. Rockwell Compton, *The Hon. William Andrew Charlton*, 1908

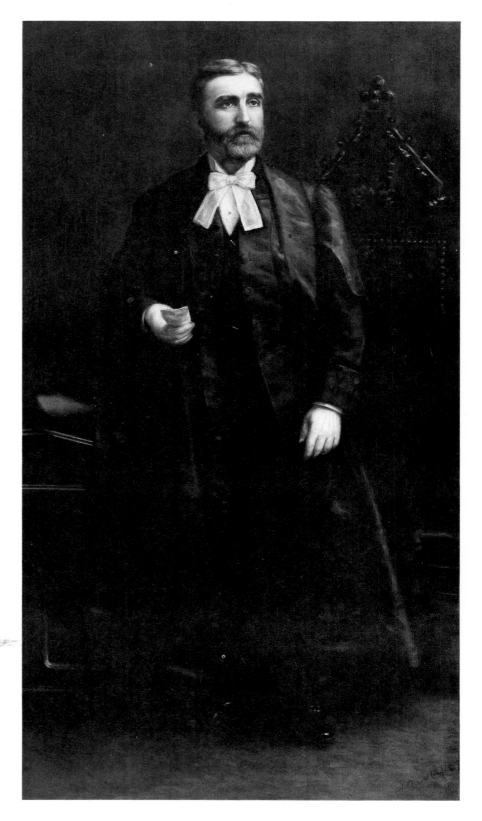

Blenheim Palace, Oxfordshire, England, 30 November 1874; d. London, England, 24 January 1965), the eldest son of Lord Randolph Churchill, was educated at Harrow and Sandhurst before entering the army in 1895. Having served in places as widely separated as Cuba and India, and having been regiment commander for the 6th Royal Scots Fusiliers in France in 1916, Churchill retired from the army with the rank of Lieutenant-Colonel in 1916.

Churchill's political career began almost concurrently with his military one. With the exception of two years (1922 to 1924) he was a member of Parliament for over sixty years, 1900 to 1964. During this time, he held many senior positions in public life, including Home Secretary (1910-11), First Lord of the Admiralty (1911-15; 1939-40) and Chancellor of the Exchequer (1924-29). Churchill was Britain's Prime Minister (Conservative) and Minister of Defence during World War II, and his forceful and inspiring leadership throughout that time have become legendary. Following a period as Leader of the Opposition after the war (1945-51), Sir Winston

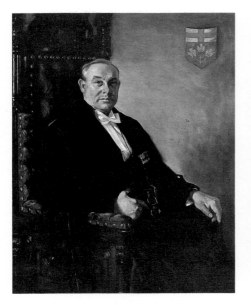

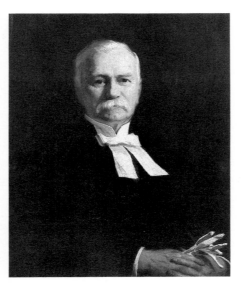

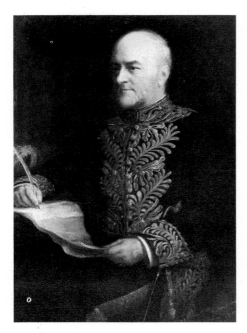

(*Above*) J. Ernest Sampson, *The Hon. James Howard Clark*, 1945

(*Below*) J.W.L. Forster, *Sir William Mortimer Clark*, 1907

(*Right*) J.W.L. Forster, *The Hon. Charles Clarke*, 1904

Churcill returned to the Prime Minister's office from 1951 to 1955.

Artist: Adrian Dingle
Oil on masonite, 40 x 49.5 cm/
15³/₄ x 19¹/₂″
Signed: (l.r.) ADRIAN DINGLE
Purchase, 1982. MGS 630312

The Hon. James Howard Clark, K.C.
(Speaker of the Ontario Legislature, 1939-43)

James Howard Clark (b. Ingersoll, Ontario, 11 May 1888; d. Windsor, Ontario, 24 August 1952) served in France with the Canadian Expeditionary Forces from 1916 to 1918. Clark was a lawyer who entered politics in 1934 as the Liberal M.P.P. for the riding of Windsor-Sandwich. He was appointed Speaker of the Ontario Legislature in 1939, and held office until the dissolution of the 21st Legislature in 1943.

Artist: J. Ernest Sampson
Oil on canvas, 125.7 x 99 cm/49¹/₂ x 39″
Signed: (l.l.) SAMPSON
Commission, 1945. MGS 692716

Sir William Mortimer Clark, Kt., K.C., LL.D.
(Lieutenant Governor of Ontario, 1903-08)

William Mortimer Clark (b. Aberdeen,

Scotland, 24 May 1836; d. Prout's Neck, Maine, U.S.A., 11 August 1917) emigrated to Canada in 1859 and continued in Toronto the legal studies he had begun after completing his B.A. at Edinburgh University. Clark was called to the bar in 1861 (Q.C., 1890). He gained a reputation as a corporation lawyer, and later established the law firm of Mortimer Clark, Grey and Baird.

Clark's numerous educational and philanthropic interests included the post of Senator of the University of Toronto for fifteen years, an advisory council member at Upper Canada College, and Honorary Governor of Toronto General Hospital. William Mortimer Clark was appointed by Sir Wilfrid Laurier to succeed Oliver Mowat as Lieutenant Governor of Ontario in 1903.

Before he retired from office in 1908, Clark was knighted in 1907, and honorary degrees were conferred by the University of Toronto (1902), and Queen's University, Kingston (1903).

Artist: J. W. L. Forster
Oil on canvas, 111.8 x 81.3 cm/44 x 32″
Signed and dated: (l.r.) J W L Forster/ 1907
Commission, 1907. MGS 694152

The Hon. Charles Clarke
(Speaker of the Ontario Legislature, 1880-86)

Charles Clark (b. Lincoln, England, 28 November 1826; d. Elora, Ontario, 6 April 1909) came to Canada in 1843. He owned a farm near Elora, west of Toronto, and was editor for several regional newspapers. Clarke was first elected in 1871 as a Liberal M.P.P. for Wellington Centre, and held this riding until 1891. From 1880-86, Clarke was Speaker of the Ontario Legislature, and from 1892 to 1907, Clerk of the Legislative Assembly of Ontario.

Artist: J. W. L. Forster
Oil on canvas, 75.6 x 62.2 cm/
29³/₄ x 24¹/₂″
Signed (l.l.) J W L Forster
Commission, 1904. MGS 692927

The Hon. Lionel Herbert Clarke
(Lieutenant Governor of Ontario, 1919-21)

Lionel Herbert Clarke (b. Guelph,

Ontario, 20 July 1859; d. Toronto, Ontario, 29 August 1921) was educated at Trinity College School, Port Hope and in Edinburgh, Scotland, following which he became a businessman in the grain trade and President of the Canadian Malting Company. In 1908 he was elected President of the Toronto Board of Trade.

Clarke, named Chairman of the Toronto Harbour Commission at its inception in 1911, held this office until his death ten years later. He was responsible for the harbour's development scheme and for "cleaning up" the Don River. Clark was also a member of the Niagara Parks Commission, defending the Niagara Falls electrical development works during World War I by surrounding the area with substantial fences. He expressed his passionate fondness for flowers by establishing rose gardens on the Falls parkland.

On December 1, 1919, Clark assumed the office of Lieutenant Governor of Ontario. In the spring of 1921, he was compelled by poor health to ask for leave from his public duties. He died after only one and one-half years in office.

Artist: E. Wyly Grier
Oil on canvas, 111.8 x 87.6 cm/
44 x 34½"
Signed: (l.r.) E. WYLY GRIER
Commission, 1921. MGS 694150

Colonel The Hon. Henry Cockshutt, LL.D.
(Lieutenant Governor of Ontario, 1921-27)

Henry Cockshutt (b. Brantford, Ontario, 8 July 1868; d. Brantford, Ontario, 26 November 1944) began at the age of 16 to work in the family's farm equipment business and was made managing director of the firm in 1893. By 1911, as President of the company, Cockshutt was known as the dean of the agriculture industry of Canada.

In 1899, Cockshutt became the youngest person on record to be elected Mayor of Brantford. During World War I he financed, recruited and commanded the 215th Infantry Battalion, although poor health prevented him from accompanying his unit overseas. Cockshutt was made Chancellor of the University of

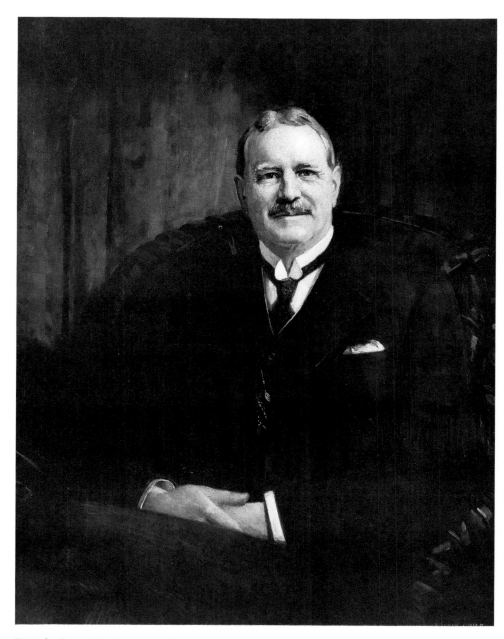

E. Wyly Grier, *The Hon. Lionel Herbert Clarke*, 1922

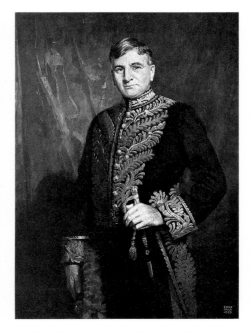

E. Wyly Grier, *Colonel The Hon. Henry Cockshutt*, 1925

Western Ontario in 1932 and received honorary degrees from that institution, as well as from the University of Toronto.

Colonel Cockshutt was appointed Lieutenant Governor of Ontario in September 1921, and served until 1927.

Artist: E. Wyly Grier
Oil on canvas, 125.7 x 94 cm/49½ x 37"
Signed and dated: (l.r.) E. WYLY/
GRIER/1925.
Commission, 1925. MGS 694159

Major-General Sir John Colborne,
G.C.B., G.C.M.G. (Baron Seaton)
(Lieutenant Governor of Upper
Canada, 1828-36)

John Colborne (b. Lyndhurst, Hampshire, England, 16 February 1778; d. Torquay, England, 17 April 1863) entered the British army with the rank of ensign in 1794. As an aide to the Duke of Wellington and commander of the 52nd Light Infantry at the Battle of Waterloo, his brilliant military career was rewarded with a knighthood in 1814. In 1825, Colborne was promoted to Major-General and appointed Lieutenant

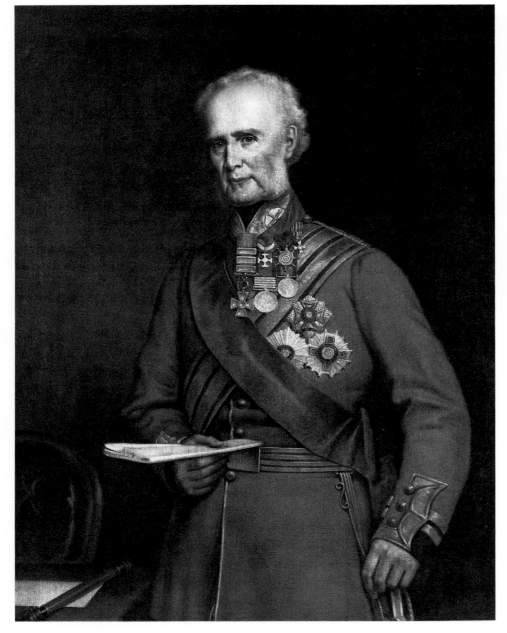

George T. Berthon, *Major-General Sir John Colborne (Baron Seaton)*, 1884

Governor of the Island of Guernsey.

Colborne, appointed Lieutenant Governor of Upper Canada in 1828, found the province in political turmoil stirred up by William Lyon Mackenzie's fiery articles in *The Colonial Advocate*. In 1834 Mackenzie was elected mayor of the newly incorporated City of Toronto, and in 1835 he was elected to the Legislative Assembly in the Reform government. Colborne was therefore placed in frequent confrontation with this intensely reformist public leader. Despite general political unrest, however, Colborne's accomplishments during his term of office were significant. For example, in 1832 he oversaw the completion on Front Street of the new Legislative Building, which replaced the structure destroyed by fire in 1824; he was to secure the long-expected remuneration for war losses suffered during the War of 1812; he initiated a program of public works, including extensive road repairs; and, in 1833, he saw the community at the Lake Erie end of the newly completed Welland Canal — Port Colborne — named in his honour.

After leaving office in January, 1836, Sir John Colborne became Commander-in-Chief of Upper and Lower Canada. In this capacity, he held the responsibility for suppressing the 1837 Rebellion in Upper Canada led by his old rival, William Lyon Mackenzie. For a brief period in 1839, Colborne was Governor General and, upon his return to England that same year, he was raised to the peerage as Baron Seaton.

Artist: George T. Berthon
Oil on canvas, 109.2 x 83.8 cm/43 x 33"
Commission, 1884. MGS 619851

According to his Sitters Notebook 1866-1890 (E.P. Taylor Reference Library, Art Gallery of Ontario), Berthon received payment for portraits of Colborne and Sir Frederick P. Robinson on 25 May 1884. The portrait of Colborne is probably based on an engraving by James Scott after a painting by G.W. Fisher, published 11 April 1864 by Henry Graves and Co., Publisher to the Queen. Fisher's portrait was painted for and dedicated to the members of the United Services Club, London. Berthon painted two other portraits of Colborne after this engraving: for Colborne Lodge, John Howard Collection, High Park,

George Lonn, *The Hon. Gordon D. Conant*

Marion Long, *Major-General Charles Francis Constantine*, 1963

Toronto (Toronto Historical Board), which was stolen in the 1960s; and for Upper Canada College, Toronto, where it still hangs.

The Hon. Gordon Daniel Conant,
K.C., LL.B.
(Premier of Ontario, 1942-43)

Gordon Daniel Conant (b. Oshawa, Ontario, 11 January 1885; d. Oshawa, Ontario, 2 January 1953) received his B.A. and LL.B. from the University of Toronto, studied law at Osgoode Hall and was called to the bar in 1912 (K.C., 1933). In 1916-1917 he served as Mayor of Oshawa and was elected to the Legislature in 1937 as the Liberal member for the Ontario riding that ran north from Lake Ontario to Lake Simcoe. He was appointed Attorney General in the Hepburn cabinet and, when Hepburn resigned on 21 October 1942, Conant became Premier.

During his short term as both Premier and Attorney General, Conant played an important role in initiating legal reforms to strengthen and improve law enforcement in the province. In addition he was instrumental in creating administrative bodies to improve the quality of municipal utilities. He retired from politics in May 1943 to become Master of the Supreme Court of Ontario.

Artist: George Lonn
Oil on canvas, 212.1 x 144.8 cm/
83½ x 57"
Signed and dated: (l.r.) George Lonn/44
Commission. MGS 605033.

Major-General Charles Francis Constantine, C.B., D.S.O.
(Adjutant-General of Canada, 1934)

Major-General Charles Francis Constantine (b. Winnipeg, Manitoba, 1883; d. Kingston, Ontario, 1953) served in World War I as Brigadier Major, Artillery and later commanded an artillery brigade in the field. He was awarded the Legion of Honour, France and both the C.B. and D.S.O. He joined the Royal Military College, Kingston in 1919 and was appointed Adjutant-General of Canada in 1934. After 39 years in the services, he retired in 1944.

Artist: Marion Long
Oil on canvas, 76.2 x 96.5 cm / 30 x 38"
Signed: (l.r.) MARION LONG
Gift of the artist, 1963. MGS 624429

The donation was made through the Ontario Institute of Painters for hanging in Ontario House, London, England; it was returned to Toronto in 1980.

The Hon. John Willoughby Crawford, Q.C.
(Lieutenant Governor of Ontario, 1873-75)

John Willoughby Crawford (b. County Cavan, Ireland, 1817; d. Toronto, Ontario, 13 May 1875) immigrated to Canada in 1824. He was educated in Toronto, was called to the Bar of Upper Canada in 1839 (Q.C., 1867) and practised banking and commercial law. In 1861 he was elected Conservative M.P.P. for East Toronto and represented that riding until 1863. In 1867, he was elected to the House of Commons for South Leeds, where he served until his appointment as Lieutenant Governor of Ontario in November 1873. His term was cut short by his sudden death in 1875.

Artist: George T. Berthon
Oil on canvas, 111.8 x 81.3 cm / 44 x 32"
Commission, *c.* 1887. MGS 693131
Probably painted from photographic sources.

The Hon. Thomas Crawford
(Speaker of the Ontario Legislature, 1907-11)

Thomas Crawford (b. County Fermanagh, Ireland, 14 August 1847; d. Toronto, Ontario [?], 1924) was first elected to the Ontario Legislature as the Conservative M.P.P. for Toronto West in 1894. He was Speaker of the Legislature from 1907 to 1911. Although he was defeated in the election of December 1911, he was returned as the member for Toronto Northwest — Seat "A" in 1914. From 1923 until his death in 1924 he served as Minister without Portfolio.

Artist: J. W. L. Forster
Oil on canvas, 127 x 87.6 cm / 50 x 34½"
Signed and dated: (l.l.) J. W. L. Forster 1910
Commission. MGS 692722

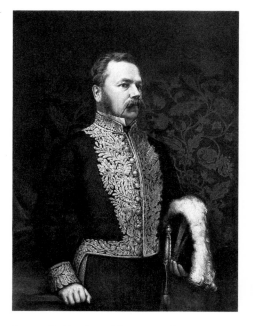

George T. Berthon, *The Hon. John Willoughby Crawford*

The Hon. James George Currie
(Speaker of the Ontario Legislature, 1871-73)

James George Currie (b. 1827) was called to the Bar of Upper Canada in 1853 and entered politics as mayor of St. Catharines (1859-62). In 1862, he was appointed to the Legislative Council of the Province of Canada for Niagara. Although he resigned three years later to protest the movement toward Confederation, Currie returned to public life from 1871 to 1879 as the Liberal M.P.P. for the riding of Welland.

Artist: Mildred Peel
Oil on canvas, 75.6 x 62.2 cm / 29¾ x 24½"
Signed and dated: (u.r.) M. Peel. / Dec. / 1903
Commission, 1903. MGS 692929

Presumably painted from photographic sources.

The Hon. Rev. Myroyn Cooke Davies
(Speaker of the Ontario Legislature, 1949-55)

Myroyn Cooke Davies (b. Aberavon,

J.W.L. Forster, *The Hon. Thomas Crawford*, 1910

Mildred Peel, *The Hon. James George Currie*, 1903

Wales, 26 May 1897; d. Windsor, Ontario, 30 December 1970) emigrated to Canada at the age of 22 and studied in Michigan and at Huron College in London, Ontario. During World War II, Davies, an Anglican clergyman, was active in the Chaplains' Service of the

Kenneth Forbes, *The Hon. Alfred Wallace Downer*, 1961

R.C.A.F. Rev. Davies sat in the provincial Legislature from 1945 to 1959 as the Progressive Conservative M.P.P. for the riding of Windsor-Walkerville. On February 10, 1949, he was appointed Speaker, an office which he held until 1955.

Artist: Kenneth Saltmarche
Oil on canvas, 137.2 x 88.9 cm/54 x 35"
Signed: (l.l.) K SALTMARCHE
Commission, 1959. MGS 692713

The Hon. Alfred Wallace Downer
(Speaker of the Ontario Legislature, 1955-59)

The Hon. Alfred Wallace Downer (b. Lefaivre's Corners, Simcoe County, Ontario, 1 May 1904) was a Church of England chaplain in the Canadian Army (from 1932-39 and 1942-45) who served in Canada, Newfoundland, England, Italy and North Africa. He was first elected to the Ontario Legislature in 1937 as the Conservative M.P.P. for Dufferin-Simcoe, and held that seat through seven general elections over the next thirty years. Downer was Speaker from 1955-1959.

Artist: Kenneth Forbes
Oil on canvas, 124.5 x 100.3 cm/
49 x 39½"
Signed: (l.r.) K. Forbes
Commission, 1961. MGS 692712

Kenneth Saltmarche, *The Hon. Rev. Myroyn Cooke Davies*, 1959

Frances Rachel Doyle
(wife of Dr. John George Hodgins)

Frances Rachel Doyle (b. Cloyne, County Cork, Ireland; d. probably Toronto, Ontario, 1883), in 1849 became the first wife of Dr. John Hodgins, the Irish-born teacher and historian, who had come to Canada in 1833 and who worked with Dr. Egerton Ryerson in the Department of Education.

Artist: Théophile Hamel
Oil on canvas, 91.4 x 67.3 cm/
36 x 26½"
Signed and dated: (l.r.) T. Hamel 1851
Gift of Mr. G. W. P. Hodgins [grandson of Dr. and Mrs. John George Hodgins], 1944. MGS 692679.

This work is a companion piece to Hamel's portrait of her husband, Dr. John George Hodgins. Painted by Hamel while he was maintaining a studio in Toronto, 1850-51, this work is not listed by Raymond Vézina in his *Catalogue des oeuvres de Théophile Hamel* (Montréal: Editions Elysée, 1976. Tome II).

The Hon. George Alexander Drew,
P.C., Q.C.
(Premier of Ontario, 1943-48)

George Alexander Drew (b. Guelph, Ontario, 7 May 1894; d. Toronto, Ontario, 4 January 1973) attended Upper Canada College, the University of Toronto, and Osgoode Hall Law School. He was called to the bar in 1920 (K.C., 1933). After serving in the Canadian Army in Europe during World War I, Drew practised law in Guelph, where he was elected mayor in 1925. In 1929 he became Master of the Supreme Court of Ontario. Drew won the leadership of the Ontario Conservative Party in 1938, became a member of the Legislative Assembly for Simcoe East in 1939, and was sworn in as Premier following the general election of 1943, in which he was elected to the Legislature for the riding of High Park; Drew also held the portfolio of Minister of Education.

As Premier of Ontario, Drew laid the groundwork for post-war growth in the province. To stimulate the economy, he encouraged highly skilled workers to emigrate from Britain, and brought Ontario's electrical system into con-formity with that of the United States,

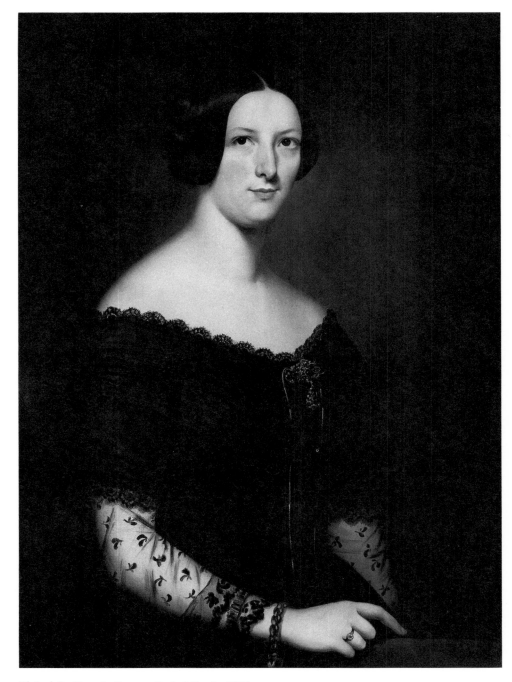

Théophile Hamel, *Frances Rachel Doyle*, 1851

Evan Macdonald, *The Hon. George Alexander Drew*

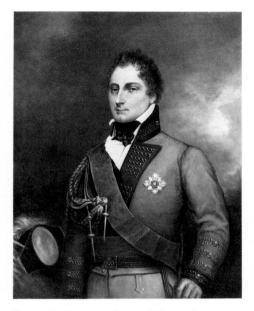

George T. Berthon, *General Sir Gordon Drummond*, 1883

thereby aiding industry and reducing consumer prices. In addition, the Drew government improved public works and public administration, revised the penal system to emphasize reform rather than punishment, enacted a new labour code, and initiated Canada's first anti-discrimination legislation.

Drew left provincial politics in 1948 to become leader of the federal Progressive Conservative Party, and took a seat in the House of Commons for the riding of Carleton. He was appointed to the Imperial Privy Council in 1953, and was made Canada's High Commissioner to the United Kingdom in 1957.

Artist: Evan Macdonald
Oil on canvas, 151.8 x 112.4 cm/
59³/₄ x 44¹/₄"
Signed: (l.r.) EVAN MACDONALD
Commission. MGS 605029

General Sir Gordon Drummond, G.C.B.
(Commander-in-Chief and Administrator of Upper Canada, 1813-14; of Upper and Lower Canada, 1814-16)

Drummond (b. Quebec, New France, 1771; d. London, England, 10 October

1854) had an outstanding military career overseas before returning to Canada as second in command to Lieutenant-General Sir George Prevost, Governor-in-Chief of Canada. In 1813, Drummond was appointed Commander-in-Chief and Administrator of Upper Canada. During the War of 1812, he was commander of the British forces defending Lundy's Lane, the main route between Niagara Falls and the head of Lake Ontario. In the Battle of Lundy's Lane (25 July 1814) both the Americans and the British claimed victory. The contest itself was inconclusive, but with the withdrawal of the American force, the threat of a large-scale incursion into British territory receded.

General Drummond became, in August 1814, Commander-in-Chief and Administrator-in-Chief of the two Canadas, with headquarters in Quebec. The last administrative act of Drummond's Canadian life was to give assent to an Act of Parliament which provided for the erection of a monument to Major-General Sir Isaac Brock at Queenston Heights.

Artist: George T. Berthon
Oil on canvas, 109.2 x 83.8 cm/43 x 33"
Commission, 1882-3. MGS 693127

Berthon's Sitters Notebook, 1866-1890, in the E.P. Taylor Reference Library, Art Gallery of Ontario, makes two references to receipt of payment for this painting on 10 March and 8 October 1883.

Based on a coloured photograph taken of an original miniature portrait of Drummond loaned to Col. Charles W. Robinson, brother of Lieutenant Governor, the Hon. John B. Robinson, from the collection of Drummond's daughter, Eliza, the Countess of Effingham. The miniature is in the collection of the Drummond family at Megginch Castle, Errol, Perthshire, Scotland (see p. 153).

The Hon. Ernest Charles Drury
(Premier of Ontario, 1919-23)

Ernest Charles Drury (b. Crown Hill, Ontario, 22 January 1878; d. Barrie, Ontario, 17 February 1968) grew up near Barrie and studied at the Ontario Agricultural College in Guelph (B.S.A., 1900). Drury's involvement with farming organizations led to his assumption of executive appointments:

J.W.L. Forster, *The Hon. Ernest Charles Drury*, 1923

Secretary of the Canadian Council of Agriculture in 1909, and first President of the United Farmers of Ontario (U.F.O.) in 1913.

From 1919 to 1923, as leader of the U.F.O. party and an M.P.P. representing Halton, Premier Ernest Drury headed Ontario's first minority government. His administration was one of the first in Canada to initiate welfare legislation, which included, for example, minimum wage laws, the widows' and children's allowances, and standardized adoption procedures.

Artist: J. W. L. Forster
Oil on canvas, 241.3 x 153.7 cm/
95 x 60½"
Signed (l.l.) J W L Forster
Commission, 1923. MGS 693208

Harold E. Elborn, LL.D.
(Principal of the Toronto Normal School, 1939-48)

Harold E. Elborn (b. Ardmore, Pennsylvania, U.S.A., 1903; d. Toronto, Ontario, 12 June 1968) received his early

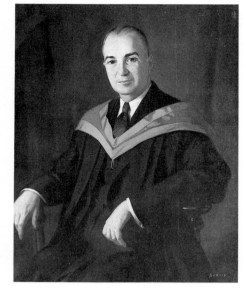

Archibald Barnes, *Harold E. Elborn*

education in Stratford, Ontario. He served as a Public School Inspector from 1930 until his appointment as Principal of the Toronto Normal School in 1939, a position he held until 1948. The Department of Education appointed him Inspector of Professional Training Schools in 1948 and Superintendent of Teacher Education in 1956. From 1961 until 1965 he was Deputy Minister of Education. In recognition of his outstanding work in the field of education, he was awarded an honorary LL.D. from Queen's University, Kingston, in 1965.

Artist: Archibald Barnes
Oil on canvas, 100.3 x 85.1 cm/
39½ x 33½"
Signed: (l.r.) BARNES
MGS 623071

James Bruce Elgin, K.T., G.C.B.,
eighth Earl of Elgin
(Governor General of Canada, 1847-54)

James Bruce Elgin (b. London, England, 20 July 1811; d. Dhurmsala, Himalayas, 20 November 1863) became the eighth Earl of Elgin in 1841. After four years as Governor of Jamaica, he was appointed Governor General of Canada in 1847 on the resignation of Earl Cathcart. It was

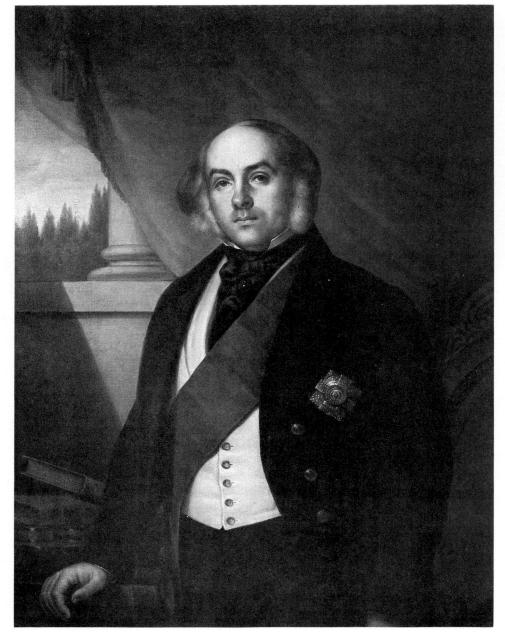

George T. Berthon, *James Bruce Elgin, eighth Earl of Elgin*, 1884

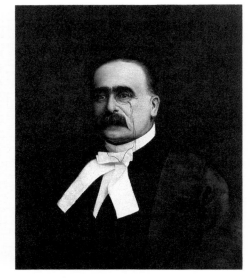

Mildred Peel, *Francis Eugene Alfred Evanturel*, 1903

his task to effect the policy of "responsible government" established by Sir Charles Bagot. The beginning of his tenure was a stormy period. He weathered personal attacks and the burning of the parliament buildings in Montreal in 1849, but he was able to establish " responsible government" as promised. During his period as Governor General the country became more prosperous through his promotion of growth and development in the public works, in schools, agriculture and navigation. He eradicated many evils and abuses of the system and through four changes of government he maintained good relations, establishing lines of future conduct of governors general in this country.

Artist: George T. Berthon
Oil on canvas, 109.2 x 82.6 cm/
43 x 32$\frac{1}{2}$"
Commission, 1884. MGS 693140

According to Berthon's Sitters Notebook 1866-1890 (E.P. Taylor Reference Library, Art Gallery of Ontario), the artist received payment for this portrait on 18 July 1884.

The source of Berthon's painting could be one of two very similar portraits. A contemporary three-quarter-length portrait of Lord Elgin attributed to Théophile Hamel (1817-1870) is in the

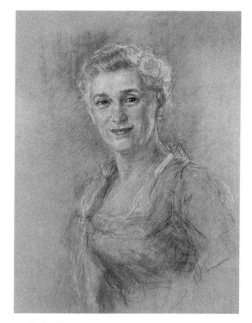

Nickola de Grandmaison, *The Hon. Ellen Louks Fairclough*

Elizabeth Holbrook, *The Hon. Ellen Louks Fairclough*

collection of the Château Ramezay, Montreal. A similar version by Cornelius Krieghoff (1815-1872) is in the McCord Museum, Montreal and more closely resembles Berthon's copy, especially in the similarity of the trees in the left background. J. Russell Harper indicates that in 1847 Krieghoff made four copies of portraits by other artists, one of which was the Earl of Elgin after Hamel (J.R. Harper, "Krieghoff's Work: A Summary," in *Cornelius Krieghoff*; Toronto: University of Toronto Press, 1979). Around 1850 a lithograph by F.

Davignan after Hamel's portrait of Lord Elgin (head-and-shoulders view only) was published in New York.

The Hon. Francis Eugene Alfred Evanturel, LL.B.
(Speaker of the Ontario Legislature, 1897-1902)

Francis (François) Eugene Alfred Evanturel (b. Quebec, Canada East, 31 August 1849; d. Alfred, Ontario, 15

November 1908) received an LL.B. from Laval University in 1869 and was called to the bar of Lower Canada in 1871. He later moved to Prescott, Ontario, the riding he was to represent as a Liberal M.P.P. from 1886 to 1905. Speaker of the Ontario Legislature from 1897 to 1902, his appointment was followed by a brief term as Minister without Portfolio in 1904-5.

Artist: Mildred Peel
Oil on canvas, 75.6 x 62.2 cm/
29³/₄ x 24¹/₂"
Signed and dated: (u.r.) M. Peel./1903
Commission, 1903. MGS 692923

The Hon. Ellen Louks Fairclough,
P.C., O.C., F.C.A., LL.D., U.E.
(Secretary of State, 1957-58; Minister of Citizenship and Immigration, 1958-62; Postmaster General, 1962-63)

Ellen Louks Fairclough (b. Hamilton, Ontario, 28 January 1905) was the first female member of the federal cabinet, serving as Secretary of State from June 21, 1957 to May 11, 1958. She began her career in public life as alderman on Hamilton city council in 1946, then as

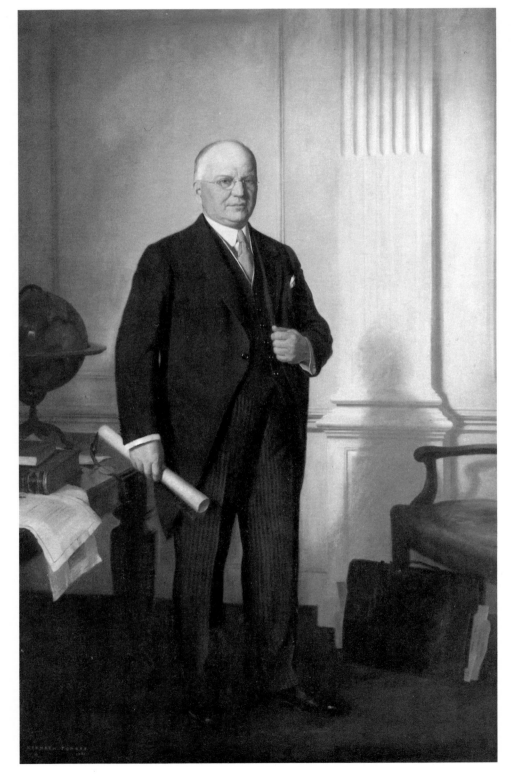

Kenneth Forbes, *The Hon. George Howard Ferguson*, 1931

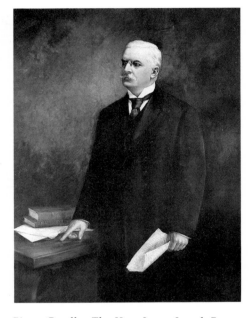

Pietro Corollo, *The Hon. James Joseph Foy*

controller and deputy mayor of that city until she was elected to the House of Commons as the Progressive Conservative member for Hamilton West riding in a by-election in 1950. Appointed a member of the United Nations Canadian delegation in 1950, she was Minister of Citizenship and Immigration from 1958 to 1962 and Postmaster General from 1962 until her defeat in the election of 1963 and her retirement from politics.

Ellen Fairclough has received many awards for her contribution to her country and community, including an LL.D. (McMaster University) in 1975, and the Order of Canada in 1978.

Artist: Nickola de Grandmaison
Pastel on sandpaper, 59.7 x 44.4 cm /
23^1/$_2$ x 17^1/$_2$'' (actual)
Signed: (l.r.) N. de Grandmaison
Gift of Mr. Cleworth W. Foster, 1982.
MGS 632658

Artist: Elizabeth Bradford Holbrook
Bronze on granite base; bust: 34.3 x 20.3 x 27.3 cm / 13^1/$_2$ x 8 x 10^3/$_4$'', base: 12.7 x 17.8 x 22.2 cm / 5 x 7 x 8^3/$_4$''
Inscribed: (on base of bust) R.B.W. INC.
Gift of the artist to the Ontario Heritage Foundation, 1982. On loan to the Government of Ontario. MGS 632972

Manfred Pirwitz, *Terrance Stanley Fox*, 1982

monument. A section of the Trans-Canada Highway was re-named the Terry Fox Courage Highway and the city of Thunder Bay donated city-owned land for the site of the monument. In June 1982, almost a year after his death, the Terry Fox monument was erected.

Artist: Manfred Pirwitz
Bronze; statue: 289.6 x 139.7 x 76.2 cm / 114 x 55 x 30", base: 213.4 x 701 x 182.9 cm / 84 x 276 x 72"
Inscribed: (Numerous inscriptions on granite base, including provincial coats of arms, trilliums and maple leaves, and dedicatory tablets.)
Commission, 1982. MGS 634255

Artist: Manfred Pirwitz
Bronze, 19 x 7 x 6.4 cm / 7$\frac{1}{2}$ x 2$\frac{1}{2}$ x 2$\frac{3}{4}$"
Signed and dated: (on base) Manfred 81
Commissioned gift edition (unknown quantity) for the official unveiling ceremony of the Terry Fox Monument, 1982. MGS 632701

The Hon. George Howard Ferguson, K.C., LL.B.
(Premier of Ontario, 1923-30)

George Howard Ferguson (b. Kemptville, Ontario, 18 June 1870; d. Toronto, Ontario, 21 February 1946) received his B.A. from the University of Toronto in 1891 and was called to the bar of Ontario in 1894 (K.C., 1908). He was a Conservative M.P.P. for Grenville riding from 1905 to 1930, serving as Minister of Lands and Mines from 1914 to 1919. In 1920 Ferguson was chosen leader of the Conservative Party and when, in 1923, the Conservatives formed the government, Ferguson became Premier of Ontario. Under his administration the Forestry Act of 1927 was passed and the Ontario Research Foundation was established in 1928. He served as Premier and Minister of Education until 1930 when he became Canadian High Commissioner in London, a post he held for five years.

Artist: Kenneth Forbes
Oil on canvas, 237.5 x 151.1 cm / 93$\frac{1}{2}$ x 59$\frac{1}{2}$"
Signed and dated: (l.l.) KENNETH FORBES / 1931
Commission. MGS 605038

Terrance Stanley Fox, C.C.

Terrance Stanley Fox (b. Winnipeg, Manitoba, 28 July 1958; d. New Westminster, British Columbia, 28 June 1981) earned international prominence through his "Marathon of Hope," a cross-country run to raise money for cancer research. Having lost his right leg to cancer when he was eighteen, the twenty-one-year-old Fox was determined to help make it possible to find a cure. He planned to run 5,300 miles along the Trans-Canada Highway, from the coast of Newfoundland to British Columbia. Setting out from St. John's on 12 April 1980 and running 26 miles a day, he reached Ontario in June. Although he was beginning to suffer from a recurrence of his disease, he continued to run to mile 3,339, near Thunder Bay, Ontario. He inspired hope and courage in millions of people and raised over 20 million dollars for cancer research.

Seven miles west of the spot where Terry Fox was forced to give up his "Marathon of Hope," the Ontario Ministry of Transportation and Communications and the Thunder Bay Terry Fox Committee created a Terry Fox Scenic Lookout for the erection of a

The Hon. James Joseph Foy, K.C., LL.D.
(Attorney General of Ontario, 1905-16)

James Joseph Foy (b. Toronto, Canada West, 22 February 1847; d. Toronto, Ontario, 13 June 1916) was educated in Toronto and in England, and was called to the bar in 1871 (Q.C., 1883). His political career began in 1898, with his election as the Conservative M.P.P. for Toronto South. In 1911 the riding was re-named Toronto North, Seat "A", the seat Foy continued to hold until 1916. In 1905, for a brief period, Foy was Commissioner of Crown Lands before being appointed Attorney General of Ontario, an office he held until his death. In 1902, he was awarded an honorary LL.D. by the University of Toronto.

Artist: Pietro Corollo
Oil on canvas, 147.3 x 111.8 cm / 58 x 44"
Signed: (l.l.) [illegible] P. Corollo [?]
MGS 619804

J.W.L. Forster, *The Hon. Christopher Finlay Fraser*

John Russell, *The Hon. John Morison Gibson*, 1911

The Hon. Christopher Finlay Fraser, Q.C.
(Provincial Secretary and Registrar, 1873-74; Commissioner of Public Works, 1874-94)

Christopher Finlay Fraser (b. Brockville, Upper Canada, October 1839; d. Toronto, Ontario, 24 August 1894) was born into the family of a Scottish Highlander who was one of the pioneers of the Brockville district. In his early career Fraser was a reporter, but in 1865 he was called to the bar (Q.C., 1876). From 1872 to 1879, he sat as the Liberal M.P.P. for Grenville South in the Legislative Assembly, and from 1879 until his death he held the provincial riding of Brockville. In 1873, Fraser was appointed Provincial Secretary and Registrar until April, 1874, when he was appointed Commissioner of Public Works. Under Fraser's direction, the new Legislative Building at Queen's Park was completed in 1893. Fraser was a tireless supporter of the separate schools system, and was a talented debater, whose rhetoric often combined ironic humour with a persuasive logic.

Artist: J. W. L. Forster
Oil on canvas, 106.7 x 120.7 cm/ 42 x 47½"
Commission, 1896. MGS 619800

It appears that this work was cut down from a larger portrait, a photograph of which is in the album of Photographs of Portrait Paintings by J.W.L. Forster (two binders) presented to the Art Gallery of Toronto Library by the Forster Estate in 1951. The photographed work shows the sitter seated at his desk, presumably in his office in the "new" Legislative Building at Queen's Park, opened in 1893. See also Forster's portrait of the Hon. Timothy Blair Pardee.

The Hon. Leslie Miscampbell Frost, P.C., C.C., Q.C., LL.D., D.C.L. (Prime Minister of Ontario, 1949-61)

Leslie Miscampbell Frost (b. Orillia, Ontario, 20 September 1895; d. Lindsay, Ontario, 4 May 1973) was educated at the University of Toronto and Osgoode Hall. He served in World War I with the Simcoe Regiment and was called to the bar in 1921 (K.C., 1933). After having set up a law practice in Lindsay, Ontario, he was elected to the Legislature as Conservative M.P.P. for Victoria in 1937. Financial critic of the Hepburn Government, he served on Select Committees dealing with the administration of justice, social security and hydro-electric power.

From 1943 to 1949 he served as Provincial Treasurer and Minister of Mines in both the Drew and Kennedy administrations. Elected leader of the Ontario Progressive Conservative Party in April 1949, he became Premier shortly after, retaining as well the position of Provincial Treasurer until 1955. Frost's term as Premier coincided with the post-war period of great expansion and economic prosperity in the province. His initiative prompted the construction of schools, hospitals and hydro-electric projects. A Department of Transportation was established

and roads were improved, highways extended and the St. Lawrence Seaway was built. During his term in office a Water Resources Commission was established and legislation was enacted to provide for a Human Rights Commission and a hospital insurance plan.

Artist: Kenneth Forbes
Oil on canvas, 125.7 x 99.7 cm/
49¹/₂ x 39¹/₄"
Signed and dated: (l.r.) K. FORBES/
1962
Commission, 1962. MGS 605019

Artist: Kenneth Forbes
Oil on canvas, 125.1 x 99.7 cm/
49¹/₄ x 39¹/₄"
Signed and dated: (l.r.) K. FORBES/
1962
Gift of the artist, 1963. MGS 622105

The donation was made through the Ontario Institute of Painters for hanging in Ontario House, London, England; it was returned to Toronto in 1980. The composition is identical to that of a portrait of Frost (MGS 605019) commissioned from the artist in the previous year.

The Hon. Sir John Morison Gibson,
K.C.M.G., K.G.St.J., K.C., LL.D.
(Lieutenant Governor of Ontario,
1908-14)

John Morison Gibson (b. Peel County, Canada West, 1 January 1842; d. Hamilton, Ontario, 3 June 1929) was educated in Hamilton, and at the University of Toronto, receiving an M.A. in 1864 and an LL.B. In 1869. He was called to the bar in 1867 (Q.C., 1890), and practised law for over 60 years in Hamilton.
　　Gibson was first elected to the Legislature in 1879 as Liberal member for Hamilton; from 1894 to 1898 he represented Hamilton West and from 1898 to 1905 represented East Wellington, holding many important posts, including Provincial Secretary, Commissioner of Crown Lands and, from 1899 to 1904, Attorney General. In 1905 the Liberals were defeated, and Mr. Gibson retired from public office due to ill-health.
　　Gibson returned to public life for a period of six years (1908-14) as Lieutenant Governor.
　　Gibson had a distinguished military

Kenneth Forbes, *The Hon. Leslie Miscampbell Frost*, 1962

J.W.L. Forster, *The Hon. John Morison Gibson*, 1915

career as well, serving in the Battle of Ridgeway with the Canadian Militia in 1866 and commanding the 15th Infantry Brigade with the rank of Brigadier-General. He was chosen a member of the Canadian contingent to Queen Victoria's Diamond Jubilee, and attended the coronations of both King Edward and King George. He also served as Honorary Aide-de-Camp to the governor generals Lords Aberdeen and Minto.

Artist: John Russell
Oil on canvas, 114.3 x 88.3 cm/
45 x 34³/₄"
Signed and dated: (l.r.) John Russell 11
Commission, 1911. MGS 619813

Artist: J. W. L. Forster
Oil on canvas, 153.7 x 111.8 cm/
60¹/₂ x 44"
Signed and dated: (l.r.) J. W. L. Forster 1915
Commission, 1915. MGS 619801

Francis Gore
(Lieutenant Governor of Upper Canada, 1806-11; 1815-17)

Francis Gore (b. Blackheath, Kent, England, 1769; d. Brighton, England, 3

George T. Berthon, *Francis Gore*, 1882

November 1852) began his public career in the army before being appointed Lieutenant Governor for Bermuda in 1804. After only two years in that post he was appointed Lieutenant Governor for Upper Canada.

His military background, particularly his conservative attitude towards the reform element in the province, made him unpopular with the people of Upper

Canada and in 1810 he was blamed by the British House of Commons for the discontent in the province. He returned to England in 1811 to defend himself against his enemies' charges, and returned to Upper Canada for a second term of office in 1815. Opposition to Gore continued during this term, with members of the Legislature opposing many of his opinions and ultimately

introducing a resolution to inquire into the state of the province. Gore was so enraged by this action that he closed the Legislative session and returned once more to England to defend himself, thus ending his involvement with Upper Canada.

Artist: George T. Berthon
Oil on canvas, 109.2 x 85.1 cm /
43 x 33½"
Commission, 1882. MGS 693125

According to Berthon's Sitters Notebook 1866-1890 (E.P. Taylor Reference Library, Art Gallery of Ontario) the artist received payment for this portrait on 22 April 1882. It is based on an undated, unsigned oil portrait of Gore in the John Ross Robertson Collection of the Metropolitan Toronto Library. According to Robertson, the picture was said to have been painted by Sir Thomas Lawrence in 1814, brought to Canada in 1815, and presented to Col. James Givins when Governor Gore returned to England.

Attribution to Lawrence (1769-1830) is not supported in D. E. Williams' *The Life and Correspondence of Sir Thomas Lawrence* (London: Henry Colburn and Richard Bentley, 1831), Kenneth Garlick's *Sir Thomas Lawrence* (Boston: Boston Book and Art Shop, 1955), or Garlick's *Catalogue of the paintings, drawings and pastels of Sir Thomas Lawrence* (Proceedings of the Walpole Society 39, 1962-64). It is possible that Gore might have had his portrait painted in England during his return there (1811-1815) and then brought it back with him to Canada. A portrait of Gore is listed in the *Catalogue of Paintings, Water-Colours and Engravings Exhibited in the Assembly Chamber, Parliament Buildings, Toronto, C.W.* (Toronto: Henry Rowsell, 1852), the owner being the Hon. William Allan (1770-1853).

Samuel T. Greene
(Founder and first president of the Ontario Society of the Deaf, 1886-1890)

Samuel T. Greene (b. Portland, Maine, U.S.A., 1844; d. February 1890), deaf from birth, was educated at the American School for the Deaf in Hartford, Conn., and at the National

Ambrose Mason, *Samuel T. Greene*

Cleeve Horne, *Vanamber Kenneth Greer*

Deaf Mute College, now Gallaudet College, receiving his B.A. in 1870. Shortly thereafter he moved to Canada to join the staff of the new Deaf and Dumb Institution (now the Sir James Whitney School) in Belleville. Greene founded the Ontario Society for the Deaf in 1886 and was its president until 1890.

Artist: Ambrose Mason
Oil on canvas: 101 x 74.9 cm/
39³/₄ x 29¹/₂"
Commission. MGS 622615

Vanamber Kenneth Greer, LL.D.
(Chief Inspector of Public and Separate Schools of Ontario, 1925-44)

Vanamber Kenneth Greer (b. Winchester, Ontario, 28 July 1885; d. 11 November 1945) received his first teacher training at the Hamilton Normal School and later earned a Master of Arts degree at Queen's University, Kingston. In 1916 he joined the staff of the Stratford Normal School and in 1919 became Inspector of Public Schools in the City of London. From 1925 to 1944, as Chief Inspector of Public and Separate Schools of Ontario, Greer sought to modernize the elementary school curriculum, and consolidated the province's scattered schools into administrative units.
 Greer's outstanding service to

education was recognized by an LL.D. from Queen's University in 1941. At the time of his death, Greer was Superintendent of Elementary Education for Ontario.

Artist: Cleeve Horne
Oil on canvas, 83.8 x 68.6 cm/33 x 27"
Signed and dated: (l.r.) Cleeve Horne/1940
Commission. MGS 622689

Albert Henry George Grey, fourth Earl of Grey, D.C.L., LL.D.
(Governor General of Canada, 1904-11)

Albert Henry George Grey, fourth Earl of Grey (b. St. James Palace, London, England, 28 November 1851; d. London, England, 29 August 1917) was educated at Harrow and Trinity College, Cambridge. He was elected Liberal representative of South Northumberland in the British House of Commons in 1880 and succeeded his uncle Henry, third Earl Grey, in the earldom in 1894. From 1894 to 1897 he was administrator of Rhodesia; in 1904 he was appointed Governor General of Canada where his term was extended twice at the request of the Canadian government. Earl Grey was one of the most popular governors Canada ever had, and is probably best remembered by Canadians for instituting the trophy for the Senior Amateur Rugby Championship of Canada, later known as the Grey Cup.

Artist: John Singer Sargent
Lithograph, 29.2 x 23.2 cm/11¹/₂ x 9¹/₈"
Signed: (l.l., on stone) John S. Sargent
Dated: (l.r., on stone) 1910
Inscribed: (l.c., in Grey's hand, on mat) Grey.
MGS 622008

Sir Casimir Stanislaus Gzowski, K.C.M.G.
(Administrator of the Province of Ontario, 1896-1897)

Casimir Stanislaus Gzowski (b. St. Petersburg, Russia, 5 March 1813; d. Toronto, Ontario, 24 August 1898), the son of a Polish nobleman, came to Canada in 1842 and became a British subject in 1846. Many works were constructed under his supervision as a government engineer. He won inter-

John Singer Sargent, *Albert Henry George Grey, fourth Earl of Grey*, 1910

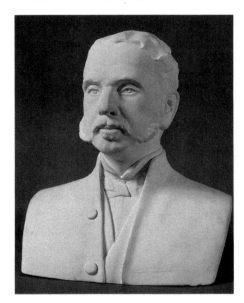

F.A.T. Dunbar, *Sir Casimir Stanislaus Gzowski*

national fame for his construction of the International Railway Bridge across the Niagara River linking Fort Erie and Buffalo. He was first chairman of the Niagara Falls Parks Commission, one of the founders of the Canadian Society of Civil Engineers (now the Engineering Institute of Canada), a Warden of St. James Cathedral, and a founder of

Wycliffe College, and in 1879 he was appointed honorary aide-de-camp to Queen Victoria, with the rank of Colonel. He was knighted by Queen Victoria in 1890 for his valuable service to Canada.

He served as Interim Administrator of the province of Ontario between the terms of Lieutenant Governors Sir George Kirkpatrick and Sir Oliver Mowat.

Artist: F.A.T. Dunbar
Plaster, 63.5 x 39.4 x 25.4 cm / 25 x 15¹/₂ x 10"
Commission for Educational Museum, Toronto Normal School, 1889.
MGS 622095

Sculpted from life.

Artist unknown
Lithograph, by Rolph Smith & Co.;
34.3 x 26.7 cm / 13¹/₂ x 10¹/₂" (sight),
24.1 x 18.4 cm / 9¹/₂ x 7¹/₄" (image)
Inscribed: (l.l.) Lith by Rolph Smith & Co. Toronto from Photo by Notman & Fraser.; (l.r.) C.S. Gzowski, J. B. Magurn, Publisher, Toronto
Gift of Captain Zdzislaw Przygoda, D.Sc., P.Eng., 1983. MGS 632660

The Hon. Arthur Sturgis Hardy, K.C.
(Premier of Ontario, 1896-99)

Arthur Sturgis Hardy (b. Mount Pleasant, near Brantford, Upper Canada, 14 December 1837; d. Toronto, Ontario, 13 June 1901) studied law in Brantford and Toronto, and was called to the bar in 1865 (Q.C., 1876). From 1873 to 1899, Hardy sat as the Liberal M.P.P. for Brant South in the Legislative Assembly; he was Provincial Secretary from 1877 to 1889 and Commissioner of Crown Lands from 1889-1896 in the Mowat administration. When Mowat resigned in 1896, Hardy became Premier and Attorney General of Ontario until poor health forced him to retire in 1899.

Hardy was responsible for the establishment of the Board of Health, the Bureau of Mines, and the vast expanse of Algonquin Park in northern Ontario.

Artist: J. W. L. Forster
Oil on canvas, 134.6 x 100.3 cm / 53 x 39¹/₂"
Signed: (l.l.) J W L FORSTER
Commission, 1901. MGS 693203

Painted from life.

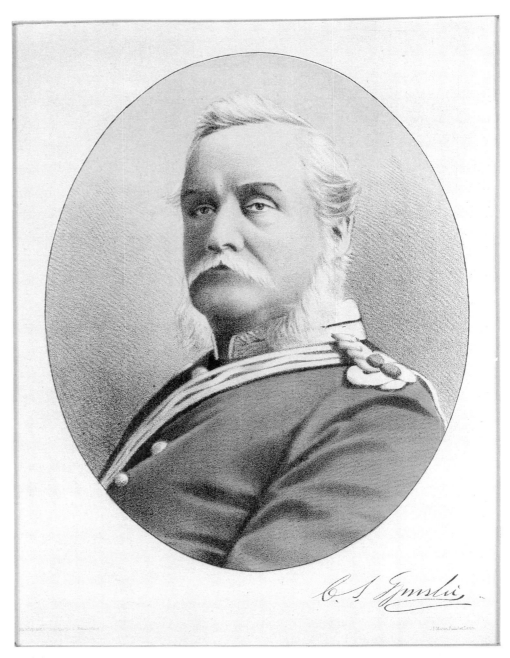

Rolph Smith & Co. (after Notman & Fraser), *Sir Casimir Stanislaus Gzowski*

207

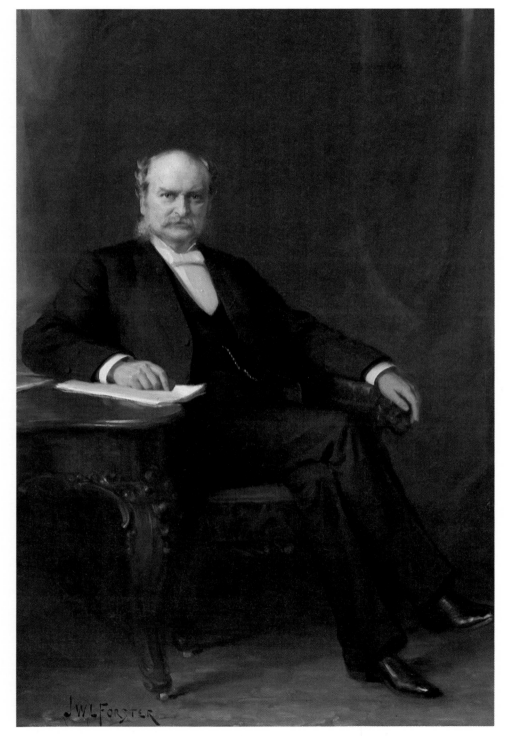

J.W.L. Forster, *The Hon. Arthur Sturgis Hardy*, 1901

Sir Edmund Walker Head, Bart.,
P.C., K.C.B.
(Governor General of Canada,
1854-61)

Edmund Walker Head (b. Wiarton Place,
Maidstone, England, 16 February 1805;
d. London, England, 28 January 1868)
was educated at Oriel College, Oxford
(M.A. 1830), and was an accomplished
scholar who became a fellow of Merton
College, Oxford (1830-37). From 1848 to
1854, Sir Edmund Walker Head (Bart.,
1838) was Lieutenant Governor of New
Brunswick, a post which he left to
become Governor General of British
North America. Head's seven-year
appointment occurred during a period of
increasing political turmoil and divisive
antagonism between Upper and Lower
Canada. He retired from office in 1861
and returned to England.

Head was made a Privy Councillor in
1857. He was created a Knight Com-
mander of the Bath in 1860, and was
awarded the degree of Doctor of Civil
Laws from Oxford University in 1862.

Artist: George T. Berthon
Oil on canvas, 109.2 x 81.3 cm / 43 x 32"
Commission, 1884. MGS 693141

According to Berthon's Sitters Notebook
1866-1890 (E.P. Taylor Reference Library,
Art Gallery of Ontario), the artist
received payment for this portrait on 18
July 1884. It is based on a portrait of
Head painted from life by Théophile
Hamel (1817-1870) in Government
House, Ottawa. Also related to this
work is an unsigned, undated crayon
head-and-shoulders portrait of Head in
the collection of the Château Ramezay,
Montreal.

Sir Francis Bond Head, Bart., K.C.H.
(Lieutenant Governor of Upper
Canada, 1836-38)

Francis Bond Head (b. Higham, Kent,
England, 1 January 1793; d. Croydon,
England, 20 July 1875) was educated at
the Royal Military Academy and served
as a military engineer under the Duke of
Wellington in the Battle of Waterloo.

Appointed Lieutenant Governor of
Upper Canada in 1836, he found himself
resident in a province soon to experience
the rebellion led in December, 1837 by
William Lyon Mackenzie and his
followers in the Reform party. Bond

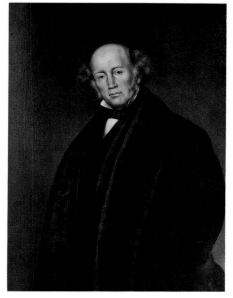

George T. Berthon, *Sir Edmund Walker Head*, 1884

Head quelled the uprising, although his own increasing clashes over policy with both the local government and the Colonial Office had already compelled him, in September 1837, to offer his resignation from the Lieutenant Governorship. He was not relieved of his duties until early in 1838, when he returned to England to pursue his love of writing.

Artist: George T. Berthon
Oil on canvas, 109.2 x 81.3 cm / 43 x 32"
Commission, 1883. MGS 606899

This painting, entered twice in Berthon's Sitters Notebook 1866-1890 (E.P. Taylor Reference Library, Art Gallery of Ontario), on 19 July 1883 and 8 October 1883, is probably based on a mezzotint (see p. 147) by the English engraver Charles A. E. Turner, A.R.A. (1773-1857) after a head-and-shoulders portrait of Sir Francis Bond Head by the itinerant American artist Nelson Cook (1817-1892). Cook's original is now in the collection of the National Gallery of Canada. Cook attracted much notoriety in Toronto when, in 1837, a local citizens' committee sent this portrait to England to be engraved. Queen Victoria refused to have it dedicated to her because of her displeasure at Head's handling of the 1837 Upper Canada Rebellion — instead it was dedicated to the citizens of Canada.

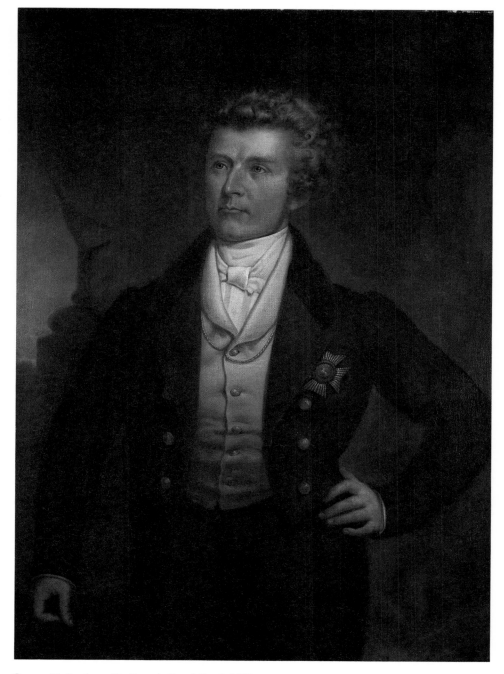

George T. Berthon, *Sir Francis Bond Head*, 1883

Austin Shaw, *The Hon. Sir William Howard Hearst*

The Hon. Sir William Howard Hearst, K.C.M.G., K.C.
(Premier of Ontario, 1914-19)

Sir William Howard Hearst (b. Arran, Bruce County, Canada West, 15 February 1864; d. Toronto, Ontario, 29 September 1941) received his education at Collingwood Collegiate and Osgoode Hall, and was called to the bar in 1888 (K.C., 1908). In 1908 Hearst was elected to the Ontario Legislature as the Conservative M.P.P. for Sault Ste Marie, serving the Whitney administration from 1911 to 1914 as Minister of Lands, Forests and Mines. In 1914 he succeeded Whitney, becoming the only premier to come from a northern riding. His party was defeated in 1919. Hearst was Premier during the years of World War I and although most of the government's efforts were devoted to matters of war, his administration was responsible for extending the franchise to women, for passing the Ontario Temperance Act, and for the establishment of the Child Welfare Bureau and the Department of Labour. Legislation to regulate housing and town planning was also introduced. He was created a K.C.M.G. in 1917.

Artist: Austin Shaw
Oil on canvas, 228.6 x 151.8 cm/ 90 x 59³/₄"
Signed: (l.r.) Austin Shaw
Commission. MGS 693207

Lieutenant-Colonel The Hon. Sir John Strathearn Hendrie, K.C.M.G., C.V.O.
(Lieutenant Governor of Ontario, 1914-19)

Sir John Hendrie (b. Hamilton, Canada West, 15 August 1857; d. Baltimore, Maryland, U.S.A., 18 July 1923) received his education at Hamilton Grammar School and Upper Canada College, Toronto, and worked first as a railway contractor, later becoming general manager of the Hamilton Bridge Works Company.
 Elected Mayor of Hamilton in 1901, in the following year he was elected as Conservative M.P.P. for Hamilton West, representing the riding until 1914. In 1905 he was Minister without Portfolio and in 1906 he was appointed to the Ontario Hydro-Electric Commission.

Hendrie had a distinguished military career, serving in the Canadian militia and commanding the Canadian Field Artillery from 1903 to 1909. He also owned a famous racing stable, and one of his horses won the King's Plate in 1910. Hendrie became Lieutenant Governor of Ontario in October 1914, serving throughout the war years. When he retired from office in 1919, he returned to his Hamilton home and his racing stables.

Artist: E. Wyly Grier
Oil on canvas, 113 x 86.4 cm/
44½ x 34"
Signed: (l.r.) E. Wyly Grier
Commission, 1915. MGS 694149

The Hon. George Stewart Henry, LL.D.
(Premier of Ontario, 1930-34)

George Stewart Henry (b. King Township, Ontario, 16 July 1871; d. Toronto, Ontario, 2 September 1958) was educated at Upper Canada College, the University of Toronto, and the Ontario Agricultural College, Guelph. He was elected in 1913 as the Conservative M.P.P. for York East which he represented until 1943. He held several portfolios before becoming Premier in 1930. He was Minister of Agriculture from 1918 to 1923, and of Public Works and Highways from 1923 to 1930; and while Premier he was also Minister of Education and Provincial Treasurer.

Henry's main concerns during the depression years of his administration were the problems of Ontario's farmers. Highways were improved during his administration, primarily through Henry's make-work projects. When the Conservatives were defeated in 1934, Henry became Leader of the Opposition until his retirement from political life in 1937.

Artist: John Russell
Oil on canvas, 221 x 146 cm/87 x 57½"
Signed and dated: (l.r.) John Russell. 37
Commission. MGS 605043

Visible through the window to Henry's right is the East Block, commonly known now as the Whitney Block, at Queen's Park in Toronto, officially opened in 1928, and Hamilton MacCarthy's statue of Sir John A. Macdonald.

E. Wyly Grier, *Lieutenant-Colonel The Hon. Sir John Strathearn Hendrie,* 1915

John Russell, *The Hon. George Stewart Henry*, 1937

The Hon. James de Congalton Hepburn
(Speaker of the Ontario Legislature, 1947-48)

James de Congalton Hepburn (b. Picton, Ontario, 23 April 1878; d. Picton, Ontario, 24 December 1955) was educated at Trinity College, University of Toronto. In private life Hepburn was active in the fuel and transportation industries, while from 1937 to 1948 he served as a Conservative member for Prince Edward-Lennox, and was Speaker of the Ontario Legislature from 1947 to 1948.

Artist: Kenneth Saltmarche
Oil on canvas, 125.7 x 88.9 cm/
49½ x 35"
Signed: (l.l.) KENNETH SALTMARCHE
Commission, 1950. MGS 619836

The Hon. Mitchell Frederick Hepburn
(Premier of Ontario, 1934-42)

Mitchell Frederick Hepburn (b. St. Thomas, Ontario, 12 August 1896; d. Yarmouth Township, Ontario, 5 January 1953) entered the House of Commons in 1926 as the Liberal member for East Elgin. His election as Leader of the Ontario Liberal Party in 1930 was followed in 1934 by his assumption of the Premier's office with his party's victory in the general election of that year. He represented the riding of Elgin in the Ontario Legislature until 1945. Hepburn resigned the Premiership 21 October 1942, but kept his seat in the Legislature. Under Hepburn's administration, the pasteurization of milk became compulsory and equity in the labour force was advanced with the passage of the Industrial Standards Act, which equalized rates of pay for similar jobs and was intended to ensure a decent standard of living.

Artist: Cleeve Horne
Oil on canvas, 113.7 x 86.4 cm/
44¾ x 34"
Signed: (l.l.) CLEEVE/HORNE
Commission, 1958. MGS 605037

Painted from photographic sources.

The Hon. Norman Otto Hipel
(Speaker of the Ontario Legislature, 1935-38)

Norman Otto Hipel (b. Waterloo Township, Ontario, 21 March 1890; d. Toronto, Ontario, 16 February 1953), a manufacturer, had a variety of local interests prior to his entry into provincial politics. He became mayor of the Town of Preston as well as President of the Board of Trade and a Director of both the Freeport Sanitarium and the South Waterloo Agricultural Society. In 1930 Hipel was elected as the Liberal M.P.P. for Waterloo South, holding this seat until 1943. In 1935 Hipel was appointed Speaker, resigning the office in 1938, to enter the provincial cabinet as Minister of Labour. He was appointed Minister of Lands in 1941, retaining both cabinet posts through 1942. During the years following his electoral defeat in 1943, Hipel returned to his early interest in agriculture, planting over 22,000 trees on his farm in Ayre as an experiment in reforestation.

Artist: J. Ernest Sampson
Oil on canvas, 124.5 x 97.8 cm/
49 x 38½"
Signed: (l.r.) SAMPSON
Commission, 1943. MGS 692717

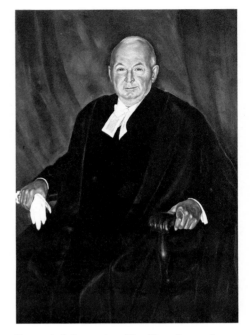

Kenneth Saltmarche, *The Hon. James de Congalton Hepburn*, 1950

John George Hodgins, LL.B., LL.D.
(Deputy Superintendent of Education for Canada West/Ontario, 1855-76; Deputy Minister of Education, 1876-89)

John George Hodgins (b. Dublin, Ireland, 21 August 1821; d. Toronto, Ontario, 23 December 1912) was educated at Victoria College, University of Toronto. In 1844 he was appointed chief clerk of the Department of Education, and by 1855 he was made Deputy Superintendent of Education under Rev. Dr. Egerton Ryerson. Hodgins was appointed Deputy Minister of Education upon Ryerson's retirement in 1876, when the position was passed on to the Executive Council and the position of Minister of Education was created. His last post was that of librarian and chief historiographer for the Department of Education, a position he held from 1889 to his death. Hodgins was the editor of the *Upper Canada Journal of Education*; he wrote and edited many articles and textbooks dealing with the history of education in Ontario, edited Ryerson's autobiography, *The Story of My Life* (Toronto: Briggs, 1883), and wrote the

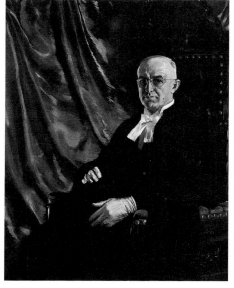

J. Ernest Sampson, *The Hon. Norman Otto Hipel*, 1943

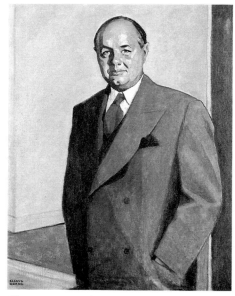

Cleeve Horne, *The Hon. Mitchell Frederick Hepburn*, 1958

28-volume *Documentary History of Education in Upper Canada 1791-1876* (Toronto: Warwick, 1894-1910). He received an LL.D. from the University of Toronto in 1870.

Artist: Théophile Hamel
Oil on canvas mounted on board, 83.4 x 64.8 cm / 33 x 25½"
Initialed and dated: (c.r.) T.H. 1851

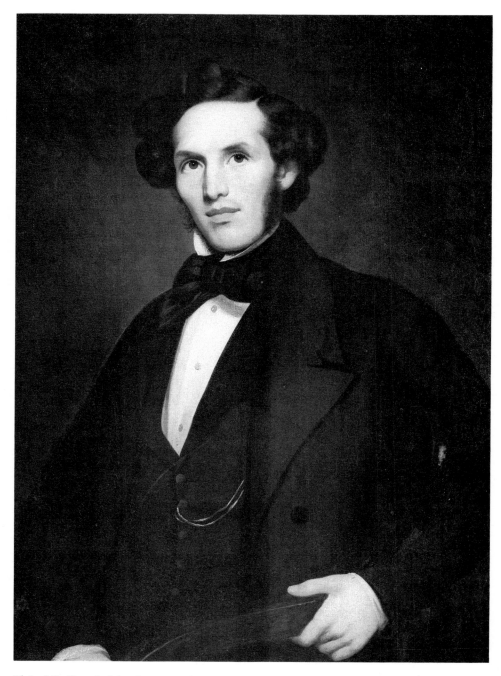

Théophile Hamel, *John George Hodgins*, 1851

Gift of Mr. G. W. P. Hodgins [grandson of Dr. and Mrs. John Hodgins], 1944. MGS 622701

This work is a companion piece to Hamel's portrait of Hodgins' first wife, Frances Rachel Doyle, painted by Hamel while he was maintaining a studio in Toronto, 1850-51. This portrait is not listed by Raymond Vézina in his *Catalogue des oeuvres de Théophile Hamel* (Montréal: Editions Elysée, 1976. Tome II).

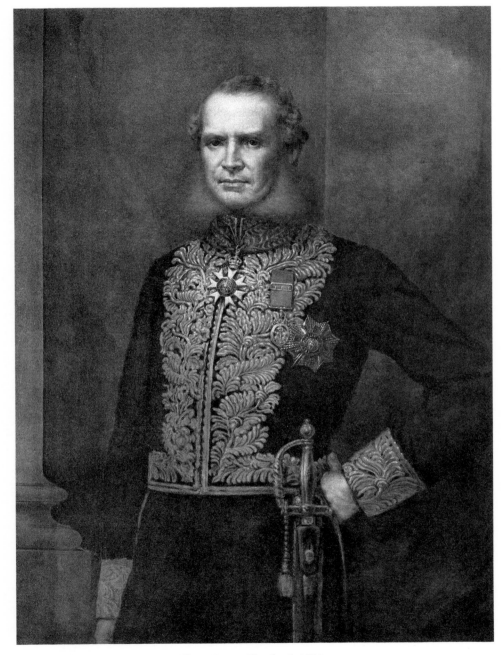

George T. Berthon, *The Hon. William Pearce Howland*, 1885

The Hon. William Pearce Howland,
K.C.M.G., C.B.
(Lieutenant Governor of Ontario,
1868-73)

William Pearce Howland (b. Paulings,
New York, 29 May 1811; d. Toronto,
Ontario, 1 January 1907) settled in
Canada in 1830. He became a merchant
and businessman, first in the village of
Cooksville and later in Toronto.
Howland was elected the Reform Party
member for West York in the Legislative
Assembly of Canada (1857-68). During
his career in politics, Howland held
several cabinet posts, including that of
Postmaster General in the "Great
Coalition" of 1864, succeeding
Oliver Mowat. He firmly supported
Confederation, and in 1866 was a
delegate at the London Conference held
to discuss the terms of the British North
America Act.

Howland retired from elected office in
1868, when he accepted an appointment
as Lieutenant Governor of Ontario.
After his term of office concluded in
1873, he held several executive positions
in the Toronto business world until his
retirement in 1894. Howland's services
to Canada during Confederation and
afterwards were recognized first in 1867,
when he was created a C.B. (civil), and
in 1879, when he received the
designation of K.C.M.G.

Artist: George T. Berthon
Oil on canvas, 109.2 x 81.3 cm / 43 x 32"
Signed and dated: (l.r.) Berthon 1885.
Commission, 1885. MGS 619845

According to Berthon's Sitters Notebook
1866-1890, the artist received payment
for a portrait of Howland on 1 June 1886.
This may have been painted from life.

Artist: Andrew D. Patterson
Oil on canvas, 124.5 x 87.6 cm /
49 x 34¹/₂"
Inscribed: (verso, not in artist's hand) A.
D. Patterson, R.C.A., painter 1893-1894
Purchase. MGS 619797

This painting may have been the
portrait of Howland exhibited in 1894 at
the R.C.A. Annual Exhibition, Ottawa
(cat. no. 90).

The Hon. William Henry Hoyle
(Speaker of the Ontario Legislature,
1912-14)

William Henry Hoyle (b. Barnstaple, Devonshire, England, 28 August 1842; d. Toronto, Ontario, 27 October 1918) represented the riding of Ontario North from 1898 to 1918 as a Conservative M.P.P. and from 1912 to 1914 was Speaker of the Ontario Legislature.

Artist: J. W. L. Forster
Oil on canvas, 127 x 90.2 cm / 50 x 35½"
Signed and dated: (l.r.) J. W. L. Forster 1914
Commission, 1914. MGS 692721

The Hon. David Jamieson
(Speaker of the Ontario Legislature, 1915-19)

David Jamieson (b. Puslinch, Wellington County, Canada West, 3 February 1856; d. 12 September 1942) was the Conservative M.P.P. for the riding of Grey South, serving from 1902 until 1919, and again from 1923 to 1926. Speaker of the Ontario Legislature from 1915 to 1919, he also served briefly as Minister without Portfolio in 1926 until his defeat in the general election of that year.

Artist: E. Wyly Grier
Oil on canvas, 128.3 x 90.2 cm / 50½ x 35½"
Signed: (l.r.) E. Wyly GRIER
Commission, 1917. MGS 692720

William Jarvis
(Provincial Secretary of Upper Canada, 1791-1817)

William Jarvis (b. Stamford, Connecticut, 11 September 1756; d. York [Toronto], Upper Canada, 13 August 1817) served with the Queen's Rangers under Lieutenant-Colonel John Graves Simcoe during the American Revolutionary War.

In 1791, the year of Simcoe's appointment as Lieutenant Governor of Upper Canada, Jarvis came with him as the Provincial Secretary of the province. He held this post until his death in 1817, by which time he had also been named Grand Master of the Freemasons in Upper Canada.

Artist: E. Wyly Grier
Oil on canvas, 48.9 x 41.3 cm / 19¼ x 16¼"
MGS 622592

J.W.L. Forster, *The Hon. William Henry Hoyle*, 1914

E. Wyly Grier, *The Hon. David Jamieson*, 1917

It would appear that Grier's painting is based on a portrait (now in the Canadiana Collection, Royal Ontario Museum) of William Jarvis and his son, the first Samuel Peters Jarvis, who died of diphtheria in 1792 at the age of five. The original portrait of Jarvis and his son has at various times been attributed to Sir Joshua Reynolds (1723-1792), Sir Thomas Lawrence (1769-1830), and John Hoppner (1758-1810), but is more likely the work of the Reverend Matthew William Peters, R.A. He presumably painted Jarvis in London around 1783, when Jarvis returned to England from Massachusetts.

Robert A. Johnston, B.Paed.
(Principal of Toronto Teachers' College, 1948-63)

Robert A. Johnston (b. Kincardine, Ontario, 26 April 1895; d. Toronto, Ontario, 18 March 1981) was educated at the Clinton Model School and the Toronto Normal School, and later graduated from the University of Toronto. Johnston was appointed to the staff of the Toronto Normal School in 1932. Excepting the year 1940-41, when he served as an Inspector of Public Schools, he remained a staff member of

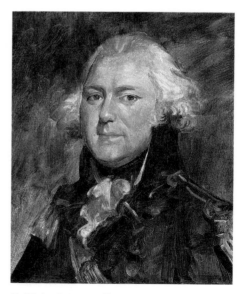

E. Wyly Grier, *William Jarvis*

the Normal School until 1948 when he was appointed its Principal. He remained as Principal of the institution until 1963.

Artist: Archibald Barnes
Oil on canvas, 99.7 x 84.5 cm / 39¼ x 33¼"
Signed: (l.l.) BARNES
MGS 623085

Archibald Barnes, *Robert A. Johnston*

Kenneth Forbes, *The Hon. Thomas Laird Kennedy*, 1950

The Hon. Thomas Laird Kennedy
(Prime Minister of Ontario, 1948-49)

After poor health forced him to withdraw from law studies at Osgoode Hall, Thomas Laird Kennedy (b. Dixie, Ontario, 15 August 1878; d. Dixie, Ontario, 13 February 1959) worked at his family's homestead near Mississauga. Kennedy was involved in municipal government and saw active service in World War I prior to his election as a Conservative M.P.P. for the riding of Peel, which he represented from 1919 to 1934, and from 1937-58. Between 1930 and 1952, Kennedy was Minister of Agriculture during four provincial administrations. He held this portfolio under Premiers Henry (1930-34) and Drew (1943-48), retained it during the seven months (1948-49) when he was himself Prime Minister of Ontario (following Drew's resignation from office), and continued as Minister of Agriculture under the Hon. Leslie Frost until 1952. Kennedy proved to be an administrator of ability and integrity, one who especially appreciated the needs of Ontario farmers and did much to promote agricultural reform.

Artist: Kenneth Forbes
Oil on canvas, 110.5 x 85.1 cm/
43½ x 33½"
Signed: (l.r.) K. Forbes
Commission, 1949-50. MGS 605030

The Hon. Thomas Ashmore Kidd
(Speaker of the Ontario Legislature, 1930-33)

Thomas Ashmore Kidd (b. Burritt's Rapids, Ontario, 1 May 1889; d. Kingston, Ontario, 19 December 1973) served in the Ontario Legislature as the Conservative M.P.P. for Kingston from 1926 to 1940, and from 1930 to 1933 was Speaker. He entered federal politics in 1945, holding a seat for Kingston in the House of Commons until 1949.

Artist: Archibald Barnes
Oil on canvas, 124.5 x 99.1 cm/49 x 39"
Signed and dated: (l.l.) Barnes/35
Commission, 1935. MGS 692718

The Hon. Sir George Airey Kirkpatrick, P.C., K.C.M.G., Q.C., LL.D.
(Lieutenant Governor of Ontario, 1892-97)

George Airey Kirkpatrick (b. Kingston, Canada West, 1 September 1841; d. Toronto, Ontario, 13 December 1899) was educated in Kingston and Quebec City, and at Trinity College, Dublin (LL.B., 1861). He was called to the bar in 1865 (Q.C., 1880). During the Fenian raids, he served as Adjutant of the Prince of Wales' Own Battalion and held the rank of Lieutenant-Colonel in the volunteer militia until 1890.

In 1870 Kirkpatrick succeeded his father as Conservative M.P. for Frontenac County. Speaker of the House of Commons from 1883 to 1887, he was called to the Queen's Privy Council of Canada in 1891. He held his parliamentary seat until appointed Lieutenant Governor of Ontario in 1892 and served in this capacity until 1897. Kirkpatrick was connected with a number of businesses and financial institutions, notably as a Director of the Canadian Pacific Railway, as well as a variety of educational and charitable organizations. The Hon. George Kirkpatrick was created K.C.M.G. in 1897, and received LL.D.s from the University of Dublin, 1884, Queen's University, 1893, and the University of Toronto, 1894.

Artist: Andrew D. Patterson
Oil on canvas, 108 x 87 cm/42½ x 34¼"
Signed and dated: (l.r.) A. D. Patterson/1898
Commission, 1898. MGS 694157

Archibald Barnes, *The Hon. Thomas Ashmore Kidd*, 1935

The Hon. Sir Louis Hippolyte LaFontaine, Bart.
(joint Premier of the Province of Canada, 1848-51)

Louis Hippolyte LaFontaine (b. near Boucherville, Lower Canada, 4 October 1807; d. Montreal, Canada East, 26 February 1864) was called to the bar of Lower Canada in 1828, and was elected as a reform member to the Legislative Assembly of that province for the riding of Terrebonne (1830-37).

While Louis-Joseph Papineau was in exile after the rebellion of 1837, LaFontaine became the leader of the French-Canadian Reformers. Although he was defeated in Terrebonne following the union of 1841, LaFontaine soon won a seat in the Assembly for Upper Canada, with the support of Robert Baldwin, the leader of the province's Reform party. This marked the beginning of a long and close friendship between the two men, and for ten years gave LaFontaine a voice in the Assembly, serving the ridings of Fourth York (1841-44), Terrebonne (1844-48) and Montreal (1848-51). When the Conservatives were defeated in 1842 and the first Baldwin-LaFontaine administration was formed, LaFontaine held the portfolio of Attorney General for Lower Canada. The reformers held office until November 1843, when nine out of ten ministers resigned in opposition to the repudiation of colonial self-government by Governor General Sir Charles Metcalfe.

With the Reform victory of 1848, the second Baldwin-LaFontaine administration, sometimes referred to as "Great Ministry," was formed. One of LaFontaine's most significant accomplishments was his introduction of the Rebellion Losses Bill in 1849. This legislation provided compensation to individuals for damages incurred during the rebellion in Lower Canada in 1837-38. Although it aroused controversy and antagonism among Upper Canadians, the bill's passage was an affirmation not only of the fact that the principle of responsible government could work in the united provinces of Canada, but also that it could work for the benefit of French Canadians, whose support of the union had been in danger of succumbing to Papineau's radicalism.

LaFontaine retired from politics in 1851. In 1853, he was appointed Chief Justice of Lower Canada, and in 1854 he was created a baronet.

Artist: June Forbes McCormack
Oil on canvas, 167 x 114.3 cm/65¾ x 45"
Signed and dated: (verso) June McCormack 1951
Inscriptions: (verso) Copy by June McCormack 1951/Original painted in 1848 by T. Hamel.
Commission or purchase, c. 1951. MGS 693209

Based on an oil portrait of LaFontaine by Théophile Hamel (1817-1870) — possibly the half-length likeness dated 1848 belonging to the Château Ramezay, Montreal. Other versions of this portrait by Hamel are in the Résidence des prêtres, Séminaire de Québec and the Musée du Québec. Like his portraits of Robert Baldwin, including the version in the Château Ramezay, the LaFontaine likenesses were painted to commemorate the second Baldwin-LaFontaine administration (1848-51).

McCormack's copy after Hamel was possibly commissioned in 1951, or else was purchased from the Laing Gallery, Toronto, as a 1950s government inventory annotation would seem to indicate.

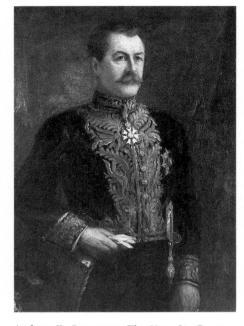

Andrew D. Patterson, *The Hon. Sir George Airey Kirkpatrick*, 1898

June Forbes McCormack, *The Hon. Sir Louis Hippolyte LaFontaine*, 1951

Sir John George Lambton, first Earl of Durham

(Governor General of British North America, 1838)

John George Lambton (b. London, England, 12 April 1792; d. Isle of Wight, England, 28 July 1840), heir to one of England's greatest fortunes, was educated at Eton and Cambridge before entering British politics as a Reform Party M.P. for the County of Durham. Although poor health forced his early retirement from the House of Commons, it did not dilute the quick temper and strength of conviction which he applied to foreign service, or to the liberal causes he supported. After being raised to the peerage in 1828 Lambton, the first Earl of Durham, served as Lord Privy Seal and as ambassador to Russia before accepting the volatile position of Governor General of British North America in 1838. Durham arrived in a country still shaken by recent violent rebellions in Upper and Lower Canada, and still unable to resolve the tensions between the two main cultural groups, the French and the English, and those created by the restrictive influence of colonial rule. He only held the vice-regal office for a few months, yet his presence

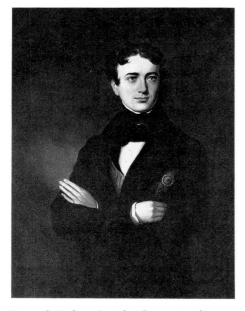

Kenneth Forbes, *Sir John George Lambton, first Earl of Durham*, 1956

was a vital factor in Canada's growth toward political self-determination.

Durham's "Report on the Affairs of British North America" was submitted to the British authorities early in 1839. The essential principle expressed was that of responsible government, structured on the British model, but autonomous in all matters relating directly to Canada. Durham also advocated unifying Upper and Lower Canada into one province, a re-organization which would, he believed, gradually "anglicize" the French-speaking Canadians. Although this latter goal was miscalculated, the suggested unification of the provinces did itself become a reality in 1841, when the first session of the united legislature met in the new capital, Kingston, under the direction of Durham's successor, Charles Poulett Thomson, Baron Sydenham. The principle of self-government was fully ratified 26 years later, with Confederation and the passage of the British North America Act.

Artist: Kenneth Forbes
Oil on canvas, 90.2 x 69.9 cm/
35$^{1}/_{2}$ x 27$^{1}/_{2}$"
Inscribed, on stretcher, verso: (u.c.) Lord Durham after Sir/T. Lawrence by/K. Forbes; (u.l.) Copy by/Kenneth Forbes Commission, 1956. MGS 605007

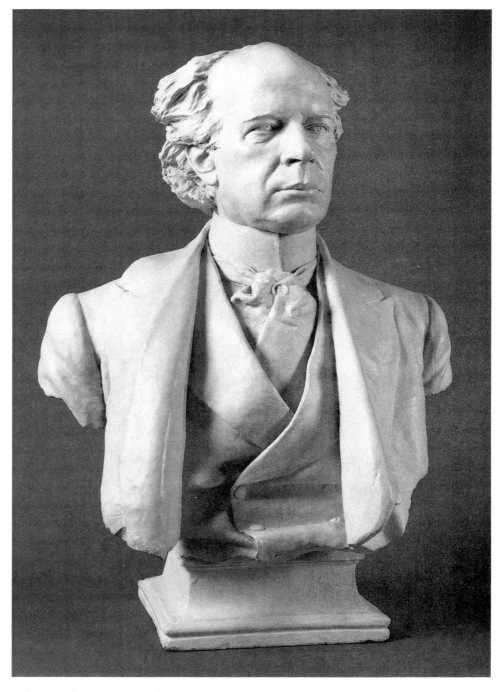

Walter S. Allward, *Sir Wilfrid Laurier*, 1900

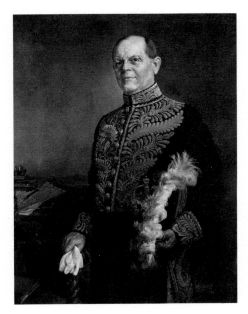

Demetrios Kokotsis, *Lt. Col. The Hon. Ray Lawson*, 1948

Forbes' portrait of Lord Durham is copied from a painting by an unknown artist in the collection of the Public Archives Canada (now hanging in Government House, Ottawa) which is derived from a painting by Sir Thomas Lawrence (1769-1830) dated 1829. Lawrence's painting was reproduced in a mezzotint by Charles A.E. Turner, A.R.A. (1773-1857) in 1831; in a line engraving by J. Cochran for Jerdan's *National Portrait Gallery*, 1832, published by Fisher, Son and Co., London; in a mezzotint by S. Cousins, 1837; and in another mezzotint by C.E. Wagstaff, 1838. Public Archives Canada owns an edition of this latter print.

The 1829 portrait by Lawrence — still in the collection of the subject's descendant, the present Earl of Durham — is listed by Kenneth Garlick in his *Sir Thomas Lawrence* (Boston: Boston Book and Art Shop, 1955; p. 128) and in his *Catalogue of the paintings, drawings and pastels of Sir Thomas Lawrence* (Proceedings of the Walpole Society 39, 1962-64; p. 72). It is reasonable to assume that Lord Durham commissioned copies of Lawrence's original for distribution among friends in Canada, and that subsequent copies should have been made for various Canadian institutions.

Sir Wilfrid Laurier, P.C., G.C.M.G., LL.D.
(Prime Minister of Canada, 1896-1911)

Wilfrid Laurier (b. St. Lin, L'Assomption, Canada East, 20 November 1841; d. Ottawa, Ontario, 17 February 1919) was educated at L'Assomption College and McGill University (B.C.L., 1864) and called to the bar of Lower Canada in 1864. While a law student in Montreal, he joined the Institut Canadien and the *parti rouge*. After some years alternately practising law and journalism, in 1871 he was elected to the Legislative Assembly of Quebec for Drummond and Arthabaska as a Liberal, resigning the seat in 1874 to run for the House of Commons. From this time to his death, he served as M.P., first representing Drummond and Arthabaska (1874-77), and then Quebec East (1877-1919).

Laurier entered the cabinet in 1877 as Minister of Inland Revenue, going into opposition the next year upon the government's defeat. He succeeded Edward Blake as Opposition Leader in 1887, and continued as Liberal leader until his death in 1919. The election of 1896 brought the Liberals to power and Laurier became Prime Minister. Forming a strong administration, described at the time as a "ministry of all the talents," Laurier retained power until 1911. As Leader of the Opposition with a majority in the Senate, he succeeded in defeating Borden's 1913 Navy Bill, but with the outbreak of World War I he fully supported the government's war effort. It has been speculated that at this point he was willing to join in a coalition government but the offer, finally made in the election year of 1917, was declined. Laurier's position against conscription lost the Liberals every province but Quebec in this election, and seriously divided the party. Though many of his allies became estranged from him, he never lost the high personal regard of both political friends and opponents.

The great prosperity during his administration was at least in part due to Laurier's aggressive immigration policy. In accordance with his theory of the Empire as "a galaxy of free states" he guided the country toward true national sovereignty. A Canadian navy was inaugurated during his

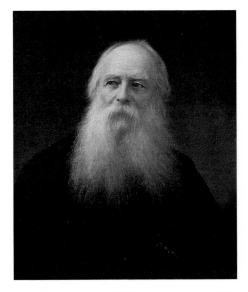

John Colin Forbes, *William Henry Lee*, 1876

administration, the last British troops left the country and the militia ceased to be under imperial command; Canada's right to negotiate independant commercial treaties was also gained. Sir Wilfrid Laurier received a number of honorary degrees from Canadian and British universities. In 1897 he was created a G.C.M.G., a privy councillor, and as well a grand officer of the Legion of Honour of France.

Artist: Walter S. Allward
Plaster, 80.6 x 63.5 x 43.2 cm / 31³/4 x 25 x 17"
Commissioned for the Educational Museum, Toronto Normal School, 1900.
MGS 619724

Sculpted from life.

Lt. Col. The Hon. Ray Lawson, O.B.E., K.G.St.G., LL.D., D.Cm.L.
(Lieutenant Governor of Ontario, 1946-52)

Ray Lawson (b. London, Ontario, 30 August 1888; d. Miami, Florida, U.S.A., 7 April 1980) was educated at the London Collegiate Institute, and later became a highly successful business-man, with interests in several printing firms. During World War II, Lawson headed the government-controlled airplane factory Federal Aircraft Limited, and dramatically increased its

output of war planes.

Lawson was appointed Lieutenant Governor of Ontario in 1946, and held office until 1952. From 1952 to 1955, Lawson was Canada's Consul General to New York. He travelled around the U.S. on speaking engagements and became known as "Canada's number one salesman." Throughout his life, Lawson gave abundant support to numerous educational and medical projects. He was instrumental in establishing the Lawson Memorial Library at the University of Western Ontario; he initiated a loan fund for medical students, sponsored post-graduate specialist courses in medicine, and contributed to hospital treatment and building programs.

Artist: Demetrios Kokotsis
Oil on canvas, 124.5 x 94 cm/49 x 37"
Signed and dated: (l.r.) D. l. Kokotsis/ 1948
Commission, *c.* 1948. MGS 694155

William Henry Lee
(Clerk, Executive Council of the Province of Canada, 1853-67; Clerk, Queen's Privy Council for Canada, 1867-72)

William Henry Lee (b. Three Rivers, Lower Canada, 26 June 1799; d. Ottawa, Ontario, 15 September 1878) began his career in 1821 as a clerk in the Executive Council offices of the Province of Upper Canada. In 1853, he became Clerk of the Executive Council of the United Provinces of Canada, holding this post until Confederation in 1867, when he was sworn in as Clerk of the Queen's Privy Council for Canada.

Artist: John Colin Forbes
Oil on canvas, 77.5 x 64.8 cm/ 30½ x 25½"
Signed and dated: (l.r.) J. C. Forbes/ 1876
Gift of Mr. E. Lee Cameron [great-grandson of William Henry Lee], 1975. MGS 620504

Major Alexander Cameron Lewis, Q.C., and Roderick Gilmour Lewis, Q.C.
(Clerks of the Legislative Assembly of Ontario, 1926-54; 1955 to present, respectively)

Allen Good, *Major Alexander Cameron Lewis and Roderick Gilmour Lewis*

Alex Cameron Lewis (b. Toronto, Ontario, 16 November 1875; d. Toronto, Ontario, 7 September 1961) held the office of Clerk of the Legislative Assembly of Ontario from 1926 to 1954, and was Chief Election Officer for the province from 1939 to 1954. Upon his retirement, the duties of Clerk were assumed by Lewis' son, Roderick Gilmour Lewis (b. Toronto, Ontario, 2 July 1911), who has been in office since 1955. Roderick Lewis was Ontario's Chief Election Officer from 1955 to 1982.

Artist: Allen Good
Oil on canvas, 108 x 81.3 cm/42½ x 32"
Signed: (l.l.) A. Good
Commission, *c.* 1950. MGS 619950

Richard Lewis
(Principal of the Old George Street School, 1856-76)

Richard Lewis (b. 1813; d. 1895) was principal of the Old George Street School from 1856 to 1876 and from 1882 to 1885 a teacher of elocution at the Toronto Normal School.

Artist: F. McGillivray Knowles
Oil on canvas, 90.2 x 69.9 cm/
35½ x 27½"
Gift of the pupils of 1856-76 of the Old George Street School. MGS 619798

H.R.H. Princess Louise, Duchess of Argyle

H.R.H. Princess Louise (b. Buckingham Palace, London, England, 18 March 1848; d. Kensington Palace, London, England, 3 December 1939) was the sixth child and fourth daughter of Queen Victoria. In 1871 she married Sir John Douglas Sutherland Campbell, Marquis of Lorne and heir to the eighth Duke of Argyle. The Marquis of Lorne, appointed Governor General of Canada in 1879, and Princess Louise were enthusiastic patrons of the arts, and were instrumental in founding the Royal Canadian Academy of Art in 1880.

Artist unknown
Lithograph, 64.8 x 50.2 cm/25½ x 19¾"
Inscribed: (l.l.) DEIGHTON & DUN-
THORNE LITH.; (l.c.) PUBLISHED BY SPECIAL PERMISSION OF HIS EXCEL-LENCY THE GOVERNOR GENERAL,

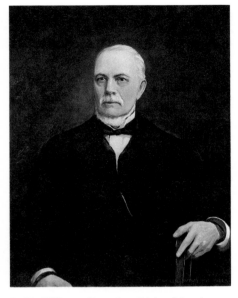

F. McGillivray Knowles, *Richard Lewis*

BY SCOTT & FRASER, 363 NOTRE DAME St. MONTREAL./IN THE DOMINION OF CANADA. OCTOBER 25th 1878.; (l.r.) Louise; (l.r.) M. & N. HANHART IMP.
MGS 632654

Archbishop John Joseph Lynch
(first Roman Catholic Archbishop of Toronto, 1870)

John Joseph Lynch (b. County Fermanagh, Ireland, 6 February 1816; d. Toronto, Ontario, 12 May 1888) studied in Dublin and Paris before being sent to Texas in 1846 as an ordained priest serving with a Roman Catholic mission-ary society. After his term as a "saddlebag preacher" in the American South, Lynch took up an assignment in Niagara Falls, New York, and in 1856 he founded the college now known as Niagara University.

In 1860, Lynch succeeded Armand de Charbonnel to become the third Bishop of Toronto. Between 1850 and 1880 a sudden increase in the Catholic popu-lation of Toronto strained the resources of the church and created often bitter tensions with the local Protestant community. A pivotal issue was edu-cation, and Bishop Lynch fully supported the passage of the Scott Act

Artist unknown, *H.R.H. Princess Louise, Duchess of Argyle*

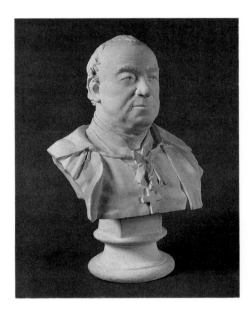

Mildred Peel, *Archbishop John Joseph Lynch*, 1888

(introduced by Richard William Scott), which formed the basis of the province's separate school system. In 1870, while attending the Vatican Council in Rome, Lynch was elevated to the status of first Archbishop of Toronto. His conserva-tism and his friendship with the Protes-

tant premier, Oliver Mowat, drew criticism from his more aggressive Catholic peers, but offered Lynch himself the chance to advise senior officials on education policy. Bishop Lynch's wide-ranging influence was also exercised through his diocesan, political and community activities, and his accomplishments included writing and lecturing, developing curriculum, and founding charitable institutions.

Artist: Mildred Peel
Plaster, 63.5 x 40.6 x 35.6 cm /
25 x 16 x 14"
Commissioned for the Educational Museum, Toronto Normal School, 1888.
MGS 619704

Probably sculpted from life.

Judge Bruce J. S. Macdonald, O.B.E.,
E.D., Q.C.
(Judge, County and District Courts of Ontario, 1961-77)

Bruce J. S. Macdonald (b. 2 June 1902) was City Solicitor for Windsor from 1930 to 1934. Following World War II, Macdonald was the Chief Prosecutor of War Crimes for the Canadian Armed Forces. He returned to the civilian courts and to Windsor as Crown Attorney for Essex County (1951-61) and was later appointed a Judge of the County and District Courts of Ontario, an office he held from 1961 to his retirement in 1967.

Artist: Daniel Boles
Bronze, 49.5 x 33 x 22.2 cm /
19¹/₂ x 13 x 8³/₄"
Signed and dated: (interior back) D. Boles '76
Gift of the Essex County Law Association, *c.* 1977. MGS 623001

The Hon. Donald Alexander Macdonald
(Lieutenant Governor of Ontario, 1875-1880)

Donald Alexander Macdonald (b. St. Raphael, Upper Canada, 17 February 1817; d. Montreal, Quebec, 10 June 1896) the younger brother of John Sandfield Macdonald, was a successful businessman before entering politics in 1857 as a Liberal member of the Legisla-

George T. Berthon, *The Hon. Donald Alexander Macdonald*

J.W.L. Forster, *The Rt. Hon. Sir John A. Macdonald*, 1906

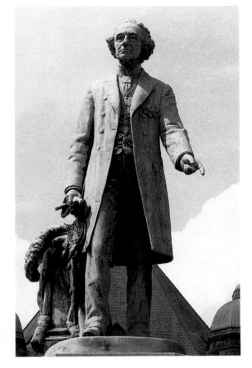

Hamilton P. MacCarthy, *The Rt. Hon. Sir John A. Macdonald*, 1894

tive Assembly for Glengarry County. After Confederation, Macdonald was elected Liberal M.P. for Glengarry in the newly formed House of Commons, and was appointed Postmaster General of Canada in the government of Alexander Mackenzie.

Macdonald left federal politics in 1875 to accept the office of Lieutenant Governor of Ontario. After serving a term he retired to Montreal in 1880.

Artist: George T. Berthon
Oil on canvas, 109.2 x 81.3 cm / 43 x 32"
Commission, *c.* 1887. MGS 693132
Probably painted from photographic sources.

The Rt. Hon. Sir John Alexander Macdonald, P.C., G.C.B., Q.C., D.C.L., LL.D.
(Prime Minister of Canada, 1867-73; 1878-91)

Sir John A. Macdonald (b. Glasgow, Scotland, 11 January 1815; d. Ottawa, Ontario, 6 June 1891), Canada's first

Prime Minister, emigrated to Canada with his parents in 1820 and was educated in Kingston. He was called to the bar of Upper Canada in 1836.

Macdonald's early career was as a lawyer and businessman, practising business and corporate law; serving on boards of financial institutions, insurance companies, building societies, gas and water companies, road, railway and canal companies; pursuing personal real estate development and shipping

Coeur-de-Lion MacCarthy, *The Rt. Hon. Sir John A. Macdonald*, 1908

F.A.T. Dunbar, *The Rt. Hon. Sir John A. Macdonald*, 1881

projects. He was elected alderman in Kingston in 1843 and became the representative for Kingston in the Legislative Assembly in 1844. Most of the first ten years were spent in opposition in the Legislature, although he was one of the acknowledged leaders of his party and served as a cabinet minister in the administration of William Henry Draper. In 1854 Macdonald was instrumental in the formation of the Liberal-Conservative coalition and he was appointed Attorney General for Canada West in the McNab-Morin government. His success as a politician was due in large part to his business and professional acumen and his penchant for hard work. Macdonald became leader for Canada West in the Taché-Macdonald ministry in 1856 and Prime Minister in 1858 in the Macdonald-Cartier government.

In 1864 the Liberal-Conservative coalition of Macdonald and Cartier was no longer viable, and the "Great Coalition" under Macdonald, Cartier and George Brown was formed with Macdonald taking the leading role in the preparation of the British North America Act. His belief in a centralized, unitary form of federal government was not totally popular with his Upper Canadian colleagues, but Macdonald maintained his view that social and economic unity was essential to the establishment of Canada as a nation.

When the British North America Act was passed in London in 1867, John A. Macdonald was given a knighthood in recognition of his services in preparing the constitution. With the exception of a period from 1873 to 1878, Macdonald was Prime Minister of Canada until his death in 1891. Throughout his years as Prime Minister, which saw the provinces of Manitoba (1870), British Columbia (1871) and Prince Edward Island (1873) join the union, Macdonald retained his personal, political and professional ties with the province of Ontario.

Artist: F.A.T. Dunbar
Bronze-painted plaster, 53.3 x 33 x 26.7 cm / 21 x 13 x 10½"
Signed and dated: (l.r.) F. DUNBAR / Sculp. / 1881
Purchase (?) *c.* 1882. MGS 619886

Louis-Philippe Hébert, *The Rt. Hon. Sir John A. Macdonald*

Dunbar returned to Toronto from Florence in June 1880, where he completed a bust of Macdonald that he had begun in Italy. He then began work on a companion piece, a portrait bust of Macdonald's old political adversary the Hon. George Brown, which was exhibited with this work in the third Annual R.C.A. Exhibition in 1882 (cat. nos. 283 and 284).

J.W.L. Forster, *The Hon. John Sandfield Macdonald*, 1904

Artist: Andrew D. Patterson
Photogravure, 61.1 x 44.4 cm /
24¹/₁₆ x 17¹/₂"
Initialed and dated: (l.r., within image)
ADP/1886
Inscribed: (l.l.) A. D. Patterson.24.; (l.c.)
Photogravure Goupil & Cie.; (l.r.) John
A Macdonald.
MGS 622002

Patterson painted his portrait of
Macdonald in 1886 and in 1888 took it
to Paris to be photo-engraved by the firm
of Goupil Cie., originators of the photo-
gravure process. An edition of 250 was
published on Indian paper, a quantity of
which were autographed by Macdonald.
By 1930, according to Patterson, none of
the photo-engravings was available,
having become rare collectors' items.
The original painting remained in the
artist's possession until its purchase by
Robert Meighen of Montreal. Meighen
bequeathed it to his son, Lieut. Colonel
Frank Meighen, who in turn presented it
to the Rt. Hon. Arthur Meighen, Prime
Minister of Canada in 1920-21 and 1926.

Artist: Louis-Philippe Hébert
Bronze-painted plaster, 73.7 x 30.5 x
22.9 cm / 29 x 12 x 9"
Signed: (l.r., on base) Philippe Hébert
fecit.
MGS 619892

This work, designed by the artist in
1886, like the statuette of Sir George-
Etienne Cartier was manufactured by
the firm of Carly and Petrucci,
Montreal, in order to raise funds for, and
attract attention to, the erection of
statues by the artist of these two
leaders, on Parliament Hill, Ottawa.
This small statuette anticipates Hébert's
statue of Macdonald unveiled on
Parliament Hill, Ottawa, in 1895. In
1965 gold-painted plaster replicas of four
busts and statuettes by Hébert,
including Cartier and Macdonald, were
produced from the moulds prepared by
Carly and Petrucci in an edition of 250
sets, to assist the Junior Chamber of
Commerce organization to raise funds
for its national headquarters.

**Artist: Hamilton Plantagenet
MacCarthy**
Bronze on granite base; statue:
292.1 x 152.4 x 132.1 cm / 115 x 60 x 52",
base: 345.4 x 317.5 x 317.5 cm / 136 x 125
x 125"
Signed and dated: (l.r., bronze base) H.
MacCarthy R.C.A. / sculptor 1894
Inscribed: (in raised letters on granite
base, recto) MACDONALD
Commission by the Macdonald
Memorial Committee, 1894.
MGS 632703

On 9 July 1891, shortly after
Macdonald's death, the inaugural
meeting of a committee for the erection
at Queen's Park of a memorial to
Canada's first prime minister was held
in Toronto. The designing of the statue
was awarded to Hamilton P. MacCarthy,
who chose to depict Macdonald in the
role of orator addressing a public
meeting. Cast and installed on a granite
pedestal designed and constructed by the
firm of D. McIntosh and Sons, Monu-
mental Sculptors, at a cost of $11,000,
the statue was unveiled on 13 October
1894 by Sir John Thompson, Prime
Minister of Canada from 1892 to 1894.
The "Minutes and Proceedings" of the
Macdonald Memorial Committee are in
the Metropolitan Toronto Library.

Artist: J. W. L. Forster
Oil on canvas, 179.1 x 125.7 cm /
70¹/₂ x 49¹/₂"
Signed: (l.r.) J W L FORSTER
Commission, 1906. MGS 605039

This portrait was probably painted from
photographs and other likenesses of
Macdonald, although Forster had had
first-hand experience of the sitter, a
character-sketch of whom he presents in
his autobiography, *Under the Studio
Light* (Toronto: Macmillan, 1928).

Artist: Coeur-de-Lion MacCarthy
Bronze-coated terracotta, 30.5 x 21.6 x
12.7 cm / 12 x 8¹/₂ x 5"
Signed and dated: (verso) Coeur-de-Lion
MacCarthy / 1908
Inscriptions: (in raised letters, recto)
MACDONALD; (verso) Coeur-de-Lion
MacCarthy / Sculptor / Copyt / 1908
Montreal.
MGS 619877

The Hon. John Sandfield Macdonald,
Q.C.
(Premier of Ontario, 1867-71)

John Sandfield Macdonald (b. St.
Raphael, Upper Canada, 12 December
1812; d. Cornwall, Ontario, 1 June 1872)
was called to the bar in 1840 (Q.C.,
1849) and became a barrister in
Cornwall. He entered politics as a
member of the Legislative Assembly of
Canada, representing Glengarry from
1841 to 1857 and Cornwall from 1857 to
1867. In 1844 Macdonald aligned himself
with the Reform Party. He held several
positions in the Assembly, among them
Solicitor General, 1849-51 and Speaker
of the House, 1852-54; in 1858 he
became Attorney General for Canada
West. From 1862 to 1864 he served as
joint Premier (with L.V. Sicotte) of
United Canada.
 Although he advocated moderate
reforms, Macdonald actively opposed
Confederation, thus creating friction
with his colleague, John A. Macdonald.
Nevertheless, once the British North
America Act was a reality, he accepted it
and agreed to become Ontario's first
post-Confederation Premier. He was
elected Conservative M.P.P. for
Cornwall in 1867 and formed a coalition
government which was instrumental in
moving provincial government beyond
the concept of a 'glorified city council.'
He supported the dual principle,

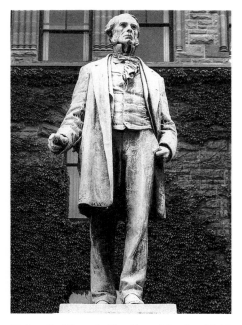

Walter S. Allward, *The Hon. John Sandfield Macdonald*, 1909

permitting the same man to sit in both the provincial and federal houses; as fostering greater national unity and maximizing the effectiveness of talented men. Although opposed to the secret ballot and universal suffrage for adult males, he did reduce the property requirement for voters. His government was defeated in the election of 1871, and he retired from public life.

Artist: J. W. L Forster
Oil on canvas, 217.2 x 134 cm/
85¹/₂ x 52³/₄"
Signed: (l.r.) J W L Forster
Commission, 1904. MGS 605040

As Macdonald died in 1872, this portrait was probably painted from photographs.

Artist: Walter S. Allward
Bronze on marble base; statue: 274.3 x 101.6 x 76.2 cm/108 x 40 x 30", base: 228.6 x 231.1 x 231.1 cm/90 x 91 x 91"
Signed and dated: (l.l.) Walter S. Allward 1909
Inscribed: (t., on base, recto) JOHN SANDFIELD/MACDONALD/PRIME MINISTER OF/ONTARIO 1867 1871; (t., on base, verso) SOLICITOR GENERAL 1849/Speaker 1852/ATTORNEY GENERAL 1858/PRIME MINISTER 1862-4
Commission, 1909. MGS 619879

This commission was begun in 1907, when the Government of Ontario appropriated $10,000 towards building the memorial. It was unveiled on 16 November 1909.

The Hon. William Ross Macdonald, P.C., C.D., Q.C., LL.D. (Lieutenant Governor of Ontario, 1968-74)

William Ross Macdonald (b. Toronto, Ontario, 25 December 1891; d. Brantford, Ontario, 28 May 1976) was educated at the University of Toronto and at Osgoode Hall Law School (K.C., 1934), and left his law practice for active service in Belgium and France during World War I. Macdonald held the federal riding of Brantford for the Liberal party from 1935 to 1953. While in the House of Commons, he was chosen Deputy Speaker in 1945, and became Speaker of the House in 1949. In 1953, Macdonald was made a Privy Councillor and was summoned to the Senate. A few months later, in 1954, he was appointed Solicitor General of Canada.

Macdonald resigned his Senate seat in 1967, and was sworn in as Lieutenant Governor of Ontario the following year. Macdonald retired from office in 1974, having served beyond the customary five-year term and represented Canada on official occasions ranging from the coronation of Queen Elizabeth II in 1953 to a 1966 pilgrimage to Canadian war graves in the Far East. He received honorary degrees from McMaster and Waterloo-Lutheran (now Sir Wilfrid Laurier) universities, and was installed as Chancellor of the latter institution in 1964.

Artist: Charles Comfort
Oil on canvas, 120.7 x 96.5 cm/
47¹/₂ x 38"
Signed and dated: (l.r.) Comfort/71
Commission, 1971. MGS 619712

Artist: Kenneth Jarvis
Bronze; two casts, each 34.9 x 19.7 x 21 cm/13³/₄ x 7³/₄ x 8¹/₄"
Signed: (on each, verso) Jarvis
Commission, 1974. MGS 610828;
Commission for the W. Ross Macdonald School for the Blind and Deaf, Brantford, Ontario, 1974. MGS 619969

Kenneth Jarvis, *The Hon. William Ross Macdonald*, 1974

Charles Comfort, *The Hon. William Ross Macdonald*, 1971

Kenneth Forbes, *Lieutenant-Colonel The Hon. John Keiller Mackay*, 1963

Lieutenant-Colonel The Hon. John Keiller Mackay, D.S.O., V.D., Q.C., D.C.L., LL.D.
(Lieutenant Governor of Ontario, 1957-63)

John Keiller Mackay (b. Plainfield, Nova Scotia, 11 July 1888; d. Toronto, Ontario, 12 June 1970) studied at St. Francis Xavier University in Antigonish, N.S. After serving overseas in World War I (with the rank of Lieutenant-Colonel at war's end) Mackay studied law at Dalhousie University, and was called to the bar of Nova Scotia in 1922. The following year he was admitted to the bar in Ontario (K.C., 1933) and became a partner in a prominent legal practice in Toronto.

He acted as Crown Counsel for both the provincial and dominion governments on many important cases and was appointed Royal Commissioner by the dominion government to investigate penitentiary conditions following the riots at Kingston Penitentiary in 1932. In July 1935 he was appointed Justice of the Supreme Court of Ontario and was appointed Chairman of the Board to review the findings of all Courts Martial of World War II. Appointed to the Court of Appeal of Ontario in 1950, he served for seven years until his appointment as Lieutenant Governor of Ontario in December 1957. Mackay was a strong advocate of the rights of the individual in society and received many honours for his humanitarian outlook. His popularity and contributions to the Canadian legal community were acknowledged by seven honorary degrees. He was a member of the Masonic and Ionic Lodges and he retained his love of Scots tradition throughout his life, holding membership in several Scottish heritage societies.

After his retirement from office in 1963 he remained active in public life, serving on the boards of a number of private companies, as Governor of the University of Toronto and Chancellor of the University of Windsor, as well as heading a provincial committee on the teaching of religion in Ontario's public schools. He continued these activities until his death at the age of 81.

Artist: Kenneth Forbes
Oil on canvas, 114.3 x 86.4 cm / 45 x 34"
Signed and dated: (l.r.) K. FORBES / 1963
Commission, *c.* 1963. MGS 694154

Hamilton P. MacCarthy, *The Rt. Hon. Alexander Mackenzie*, 1890

The Rt. Hon. Alexander Mackenzie, P.C.
(Prime Minister of Canada, 1873-78)

Alexander Mackenzie (b. Dunkeld, Perthshire, Scotland, 28 January 1822; d. Toronto, Ontario, 7 April 1892) came to Canada in 1842 and settled in Lambton, Ontario where he worked as a contractor and then editor of the *Lambton Shield*. He was elected to the Legislative Assembly of Canada for Lambton in 1861 as a liberal member and then as an M.P. for the same riding in 1867. In 1871 and 1872 he was M.P.P. for Middlesex West, serving as Treasurer of Ontario under John Sandfield Macdonald until his resignation to assume the leadership of the federal Liberal Party, a position he held from 1873 to 1880. He was appointed a member of the Privy Council on 7 November 1873 and was Prime Minister of Canada from that date until 1878. From 1880 to 1892 Mackenzie was the Liberal member in the House of Commons for the riding of York East.

Artist: Hamilton Plantagenet MacCarthy
Plaster, 68.6 x 40.6 x 30.5 cm/
27 x 16 x 12"
Signed: (verso) H. P. MacCarthy
Commission for the Educational Museum, Toronto Normal School, 1890.
MGS 619733
Sculpted from life.

William Lyon Mackenzie
(Member of the Legislative Assembly of Upper Canada/Canada West, 1828-31, 1835-36, 1851-58; first Mayor of Toronto, 1834-35)

William Lyon Mackenzie (b. Dundee, Scotland, 12 March 1795; d. Toronto, Canada West, 28 August 1861) came to Canada in 1820. In 1824 he founded *The Colonial Advocate*, the first of his series of newspapers, and began to expose the grievances of labourers and farmers, expressing his views in pro-American terms. In response to his attacks on the Family Compact, a band of young men raided his offices, destroying the premises and throwing some of the type into Toronto Bay. The resulting publicity made Mackenzie a popular hero and he became the effective leader of the radical wing of the Reform Party.

First elected to the Legislative Assembly of Upper Canada for the County of York in 1828, Mackenzie continued his fight for reform in the areas of agriculture and commerce and demanded the abolition of monopolies. In December 1831, his characterization of the Legislature as a "sycophantic office" earned him expulsion from that body, the comment being deemed "a libel constituting a breach of the privileges of this House." Though re-elected five times, he was each time expelled, and even declared incapable of sitting in the House. In 1832, he travelled to a reform-minded England, where he presented the reformers' petitions and pleaded his case to the Colonial Office, with some success.

When York became the City of Toronto on March 6, 1834, Mackenzie was elected its first mayor. After a term of nine months, he was defeated and returned to the Legislature. During this period he was the primary author of the *Seventh Report of the Committee on Grievances* of 1835. By 1837, frustration with constitutional means led Mackenzie to organize his famous rebellion in the name of reform. Unwilling despite clear warnings to accept the possibility of rebellion in Upper Canada, a government concerned more with the Lower Canadian *patriotes* left Toronto virtually undefended. The rebels' haphazard, albeit elaborate plans nevertheless led to a fiasco. The attack was delayed long enough for a group of loyalists finally to be organized, and the

Rosen and Melchers, *William Lyon Mackenzie*, 1858

ill-equipped farmers and labourers were easily dispersed on December 5 and 7, 1837.

Mackenzie fled to the United States where he was to serve a jail term for continued raids on the Canadian border. He returned to Toronto in 1850 under the amnesty of 1849. In 1851 he was elected to the Legislative Assembly of Canada and founded a new journal, *Mackenzie's Message* in 1853. He retired from public life in 1858 and ceased publication of his *Message* in 1860.

Artist: Rosen and Melchers
Plaster, 69.9 x 46.4 x 24.1 cm/
27½ x 18¼ x 9½"
Dated: (verso) 1858
Inscribed: (verso) Rosen & Melchers Sculp/Toronto 1858.
Purchase [?], 1858. MGS 619728

This bust was part of a proposed series of "Busts of Public Men," originated by the artist, Rosen, in 1858. The first work in the series was a bust of Rev. Dr. Egerton Ryerson.

The inscription on the verso of this bust is virtually illegible; however, another copy of the same work in Laurier House, Ottawa, is clearer, reading *Rosen & Melchers sculp/ Toronto 1858*. Nothing is known of the

J.W.L. Forster, *William Lyon Mackenzie*, 1903

Mildred Peel, *Provost Thomas Clark Street Macklem*, 1902

sculptor, Rosen; however, his collaborator, at least in the Mackenzie bust, was probably Julius Theodore Melchers (1829-1908), who worked as a carver, sculptor and art teacher in Detroit, Michigan from 1857 to 1908. The European-born and trained sculptor became well-known for his life-sized carvings of cigar-store Indians and later for marble and stone sculpture. From 1891 to 1895 he was a partner of Henry Siebert in the firm of Melchers and Siebert.

The copy of this bust in Laurier House (administered by Public Archives Canada) was donated by Prime Minister William Lyon Mackenzie King.

Artist: J. W. L. Forster
Oil on canvas, 167 x 113 cm/
65³/₄ x 44¹/₂"
Purchase from the artist, 1903.
MGS 606898

This painting is a second version of a portrait that Forster based on a daguerrotype by Eli J. or G. Palmer (*c.* 1821-fl. 1873) in which Mackenzie is shown seated. In 1901 the City of

Toronto bought Forster's first painting, in which Mackenzie is featured standing with a quill pen in his right hand; at his left hand is a table on which the famous petition of grievances (1835) is clearly visible. A group of citizens requested that the replica, which had been painted during the year 1900, be purchased by the Ontario Legislature for hanging in the Legislative Building, Toronto. The painting was acquired by the Province in 1903.

Artist: Walter S. Allward
Bronze and granite, two parts:
a) 119.4 x 66 x 50.8 cm/47 x 26 x 20",
b) 152.4 x 914.4 x 82.6 cm/60 x 360 x 32½"
Signed: (part 'b', verso) WALTER ALLWARD
Inscribed: (t., base of part 'a', recto) MACKENZIE; (t., base of part 'b', recto) TO COMMEMORATE THE STRUGGLE FOR RESPONSIBLE/ GOVERNMENT IN UPPER CANADA AND THE PIONEERS OF A/ POLITICAL SYSTEM WHICH/UNITES IN FREE ASSOCIATION THE NATIONS OF THE/BRITISH COMMONWEALTH .. IN MEMORY OF/WILLIAM LYON MACKENZIE .. 1795 .. 1861 ../FIRST MAYOR OF TORONTO 1834 .. MEMBER FOR/YORK IN THE LEGIS-LATURE OF UPPER CANADA 1828 1836/AND FOR HALDIMAND IN THE LEGISLATIVE/ASSEMBLY OF CANADA 1851 1858 ..
Commission by the William Lyon Mackenzie Centennial Committee, 1940. MGS 619873

This work is the result of a collaborative effort between the artist, the William Lyon Mackenzie Centennial Committee under the chairmanship of Senator Hardy, and the Ontario Department of Public Works, which donated the land in Queen's Park. The agreement between the Committee and the Department was ratified by an Order-in-Council dated 22 July 1937. Funds were raised through public subscription.
 The purpose of the statue was "To commemorate the struggle for responsible government in Upper Canada and the pioneers of the political system which unites in free association the nations of the British Commonwealth..." The reflecting pool originally in front of the sculpture was removed in July 1950 for safety reasons.

Walter S. Allward, *William Lyon Mackenzie Memorial*, c. 1940

Felix Weihs, *Agnes Campbell MacPhail*, 1939

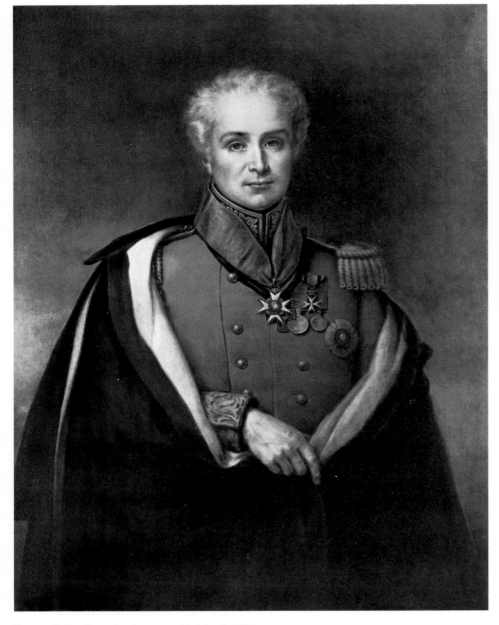

George T. Berthon, *Sir Peregrine Maitland*, 1883

J.W.L. Forster, *Robert Mathison*, 1923

Provost Thomas Clark Street Macklem, D.D., D.C.L., LL.D. (Provost and Vice-Chancellor of the University of Trinity College, 1900-21)

Thomas Clarke Street Macklem (b. 1862; d. Toronto, Ontario, 17 June 1944) was educated at Upper Canada College and at St. John's College, Cambridge from which he received his B.A. (1855), M.A. (1886) and D.D. (1901). Macklem was ordained a priest of the Church of England in 1885 and from 1900 to 1921 was Provost and Vice-Chancellor of the University of Trinity College. He was honoured by two Doctorates of Law (LL.D.).

Artist: Mildred Peel
Plaster, 61 x 45.7 x 25.4 cm/
24 x 18 x 10"
Commission for the Educational
Museum, Toronto Normal School, 1902.
MGS 619702

Sculpted from life.

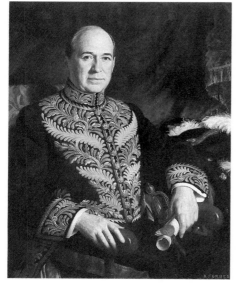

Kenneth Forbes, *The Hon. Albert Edward Matthews*, 1942

Agnes Campbell MacPhail
(first woman elected to the House of Commons; M.P., 1921-40; M.P.P., 1943-51)

Agnes Campbell MacPhail (b. Proton Township, Ontario, 24 March 1890; d. Toronto, Ontario, 13 February 1954) was educated at Owen Sound and Stratford Collegiates and at the Stratford Normal School. She was a director of the United Farmers Cooperative Company and a member of the National Executive of the Co-operative Commonwealth Federation (forerunner of the New Democratic Party). Elected as the C.C.F. federal member for Grey South East in 1921, MacPhail was the first woman to take a seat in the Canadian House of Commons. She continued to serve Grey South East until 1940, after which, from 1943 to 1951, she represented York East in the Ontario Legislature. At various times Agnes MacPhail was a member of the Progressive Party, the United Farmers of Ontario and the Labour Party, as well as the Co-operative Commonwealth Federation Party.

Artist: Felix Weihs
Bronze-painted plaster, 41.3 x 42.5 x 21 cm / 16¼ x 16¾ x 8¼"
Signed and dated: (verso) Felix Weihs 1939.
MGS 619890

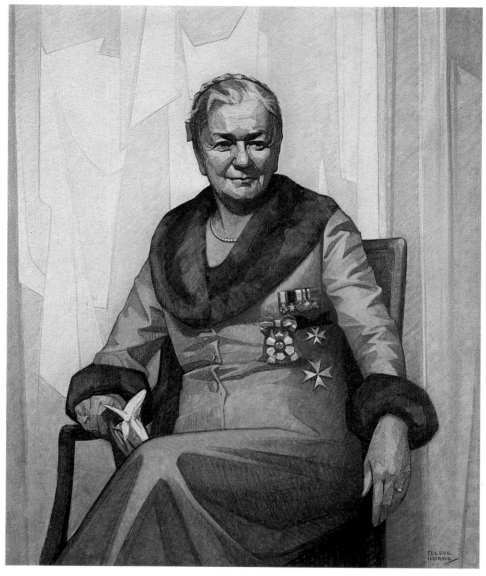

Cleeve Horne, *The Hon. Pauline M. McGibbon*

Sir Peregrine Maitland, K.C.B.
(Lieutenant Governor of Upper
Canada, 1818-28)

Peregrine Maitland (b. Longparish,
Hampshire, England, 1777; d. London,
England, 30 May 1854) served in the
British army through the Revolutionary
and Napoleonic Wars and commanded
the First British Brigade at the Battle of
Waterloo. For these services he was both
decorated and knighted (K.C.B., 1815).

Maitland was appointed Lieutenant
Governor of Upper Canada in 1818. He
refused to allow the growing discontent
within the province to challenge his
authority. In 1828 a denial of an
Assembly mandate led to his censure by
the Colonial Secretary, Sir George
Murray (an earlier Lieutenant
Governor). Maitland was transferred to
the Lieutenant Governorship of the
more settled colony of Nova Scotia,
leaving that office in 1834. He went on
to become Commander-in-Chief of the
Madras army (1834-38) and Governor of
the Cape of Good Hope (1844-47).

Artist: George T. Berthon
Oil on canvas, 109.2 x 82.6 cm/
43 x 32½"
Commission, 1882-3. MGS 693136

According to Berthon's Sitters Notebook
1866-1890, the artist received payment
for this portrait on 19 July 1883. The
portrait is based on a coloured
photograph of an original painting of
Maitland then in the collection of the
Maitland family. The original has not
yet been located.

Robert Mathison, M.A.
(Superintendant and Principal,
Ontario School for the Deaf,
Belleville, 1879-1906)

Artist: J. W. L. Forster
Oil on canvas, 125.7 x 90.8 cm/
49½ x 35¾"
Signed and dated: (l.l.) J. W. L. Forster/
1923
Gift of the friends of Robert Mathison to
the Sir James Whitney School,
Belleville, Ontario, 1924.
MGS 622616

The Hon. Albert Edward Matthews,
D.C.L., LL.D.
(Lieutenant Governor of Ontario,
1937-46)

Albert Edward Matthews (b. Lindsay,
Ontario, 17 May 1873; d. Windermere,
Ontario, 13 August 1949) was a success-
ful investment broker and the executive
officer of an number of financial
institutions. He was also active in a
variety of religious organizations and
keenly interested in education. He
received honorary degrees from several
universities and though not himself a
university graduate, served a long term
as Chairman of the Board of Governors
of McMaster University.

In 1937 a crisis between the Dominion
and Provincial governments over the
appointment of the Ontario Lieutenant
Governor and Premier Mitchell
Hepburn's closing of Chorley Park, the
official vice-regal residence, was
resolved by the appointment of
Matthews — an acceptable choice to
both sides. Matthews held the position
from November 1937 until 1946 when
he retired from both the vice-regal office
and his business activities.

Artist: Kenneth Forbes
Oil on canvas, 104.1 x 83.8 cm/41 x 33"
Signed and dated: (l.r.) K. FORBES./
1942
Commission. MGS 694161

The Hon. Pauline M. McGibbon,
O.C., LL.D., D.U., D.Hum.L.,
B.A.A. (Theatre), Hon.F.R.C.P.S.(C)
(Lieutenant Governor of Ontario,
1974-80)

Pauline M. McGibbon (b. Sarnia,
Ontario, 20 October 1910) was educated
at the University of Toronto (B.A., 1933)
and has long been a patron of the arts
and humanities. She has held numerous
chairmanships and presidencies of
cultural, educational and business
institutions, in many cases being the
first woman to do so. Among these, she
has been the President of the Canadian
Conference on the Arts, Chairman of
the Board of Governors of the National
Theatre School of Canada, and
Chancellor of the universities of Guelph

and Toronto. Her dedicated community
involvements have earned her many
honours, and she has also been created
D.St.J. (1974), D.C.L.J. (1972) and
O.C.M. (1978). The Hon. Pauline
McGibbon was appointed Lieutenant
Governor of Ontario in 1974 and served
until 1980.

Artist: Cleeve Horne
Oil on canvas, 119.4 x 101.6 cm/47 x 40"
Signed: (l.r.) CLEEVE/HORNE
Commission, 1980. MGS 625814

The Hon. John McMurrich
(Member of the Legislative Council
of Canada, 1862-64; first M.P.P. for
York North, 1867-71)

John McMurrich (b. near Paisley,
Scotland, 1804; d. Toronto, Ontario, 13
February 1883) came to Canada in 1833
as the representative of a Glasgow firm
of wholesale merchants, establishing
branches of the business in Toronto,
Kingston and Hamilton. In 1860 he
became a member of the Toronto City
Council and Chairman of Finance.
McMurrich became a member of the
Legislative Council of Canada in 1862
for the Saugeen Division, resigning in
1864. From 1867 to 1871 he was the
Liberal M.P.P. for York North.

Artist: John Colin Forbes
Oil on canvas, 81.5 x 65.8 cm/
32¹/₁₀ x 25⁹/₁₀"
Gift of Mr. J. R. McMurrich (great-
grandson of the Hon. John McMurrich)
to the Ontario Heritage Foundation,
1978; on loan to the Government of
Ontario. MGS 632973

Francis Walter Merchant
(Chief Director of Education of
Ontario, 1923-30; Chief Advisor to
the Minister of Education, 1930-34)

Francis Walter Merchant (b. 1855; d.
Toronto, Ontario, 29 January 1937) was
educated at Albert College and the
University of Toronto. In 1908 he was
appointed Chief Inspector of the public
and separate schools of Ontario and in
1911 was made Director of Industrial
Education. From 1923 to 1930 Merchant
served as Chief Director of Education,

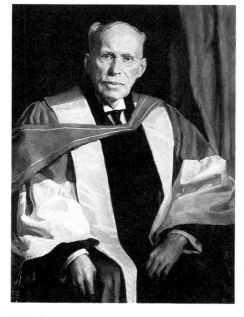

E. Wyly Grier, *Francis Walter Merchant*, 1935

and as Chief Advisor to the Minister of Education from 1930 to 1934.

Artist: E. Wyly Grier
Oil on canvas, 99.1 x 74.9 cm/39 x 29½"
Signed and dated: (l.l.) E. WYLY/
GRIER/1935
Commission. MGS 622702

The Hon. Sir William Ralph Meredith, K.C., LL.D.
(Chief Justice of the common pleas division of the High Court of Justice of Ontario, 1894-1923)

William Ralph Meredith (b. West-minster, Middlesex County, Upper Canada, 31 March 1840; d. Toronto, Ontario, 21 August 1923) was educated at the University of Toronto (LL.B., 1872) and called to the bar in 1861 (Q.C., 1875). Elected to the provincial Legislature as the Conservative M.P.P. for London in 1872, in 1878 he succeeded Matthew Crooks Cameron as Leader of the Opposition. In 1894 he was appointed Chief Justice of the common pleas division of the High Court of Justice of Ontario, a position he held until his death. From 1900 to 1923 he was also Chancellor of the University of

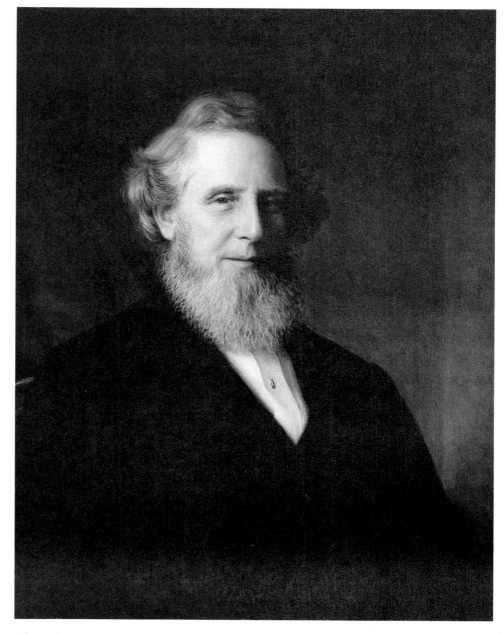

John Colin Forbes, *The Hon. John McMurrich*

J.W.L. Forster, *The Hon. Sir William Ralph Meredith*, 1897

Toronto. He was given an LL.D. by the University of Toronto in 1889 and was knighted in 1896.

Artist: J. W. L. Forster
Oil on canvas, 231.1 x 165.1 cm/91 x 65"
Signed: (l.r.) J. W. L. Forster
Commission by the Ontario Conservative Party and then purchased by the Government, 1897. MGS 619802

Apparently Premier A.S. Hardy, finding that the Ontario Conservative Party was commissioning a portrait of the former Leader of the Opposition, insisted the Government pay for it and hang it in the Legislative Building.

Sir Charles Theophilus Metcalfe, first Baron Metcalfe
(Governor General of Canada, 1843-45)

Charles Theophilus Metcalfe (b. Calcutta, India, 30 January 1785; d. Hampshire, England, 5 September 1846) was educated at Eton and received an appointment with the East India Company at the age of 15. He rose through the service, ultimately serving as Governor General of India from 1833 to 1838. He then returned to England, but in 1839 accepted a brief appointment as Governor General of Jamaica. His successful pacification of the island led to his appointment in 1843 as Governor General of the recently united Canadas.

 Though his predecessor Sir Charles Bagot had effectively agreed to the principle of responsible government, the British Colonial Office was as yet unprepared to accede to the Reformers' demands, and Metcalfe was unprepared to go further than directed. He made an initially good impression, but provoked the protest resignation of all but one of his ministers by making a minor official appointment in opposition to their recommendation. The Reformers dominated the Assembly and Cabinet and, invoking the principle of responsible government, wished to extract from Metcalfe a promise to follow cabinet recommendations concerning all future appointments. Metcalfe was unprepared to so limit the Crown's prerogative, lacking any precedent within the Empire to do so. He thus governed unaided for nine months before calling together a Conservative ministry. Metcalfe

enlisted the support of Egerton Ryerson, who vociferously intervened in the campaign, so that in the general election of 1844 his position on the constitutional issue, correct in accordance with contemporary practice, combined with certain unpopular measures taken by the previous Legislature to win a powerful majority for his candidates. Illness forced Metcalfe's resignation and return to England in 1845.

Attributed to Samuel Gardner, *Sir Charles Theophilus Metcalfe, c. 1847*

Artist: attributed to Samuel Gardner
Plaster, 78.1 x 55.9 x 30.5 cm/
30³/4 x 22 x 12"
MGS 619731

Attributed to Samuel Gardner on the basis of a report (Toronto *Herald*, 17 April 1845) that a bust of Metcalfe by that artist was on view in Hamilton and Toronto. In the 1847 Toronto Society of Arts exhibition (cat. no. 366) a bust of Metcalfe was exhibited "modelled," according to the catalogue entry, "in plaster from an original Bust by Gardner, Sculptor, Hamilton, C.W., the property of W. Thomas, Esq." — that is, the English-born architect, William Thomas (1800-1860), father of William T. Thomas, a Toronto architect, and president of the Toronto Society of Arts.

Artist: George T. Berthon
Oil on canvas, 109.2 x 81.3 cm/43 x 32"
Commission, 1885. MGS 693139

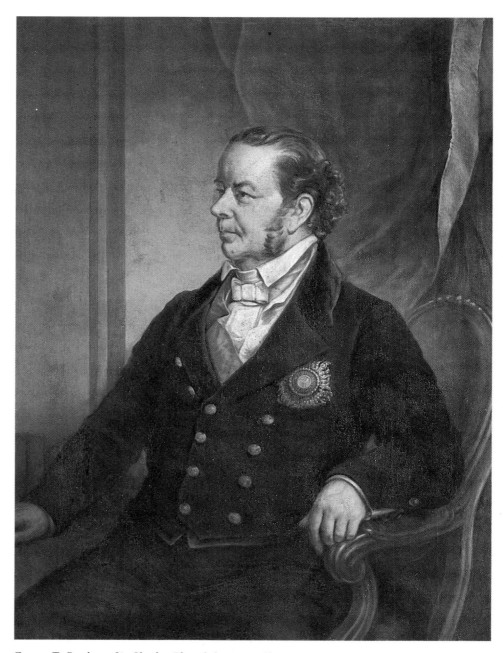

George T. Berthon, *Sir Charles Theophilus Metcalfe*, 1885

J.W.L. Forster, *Dr. Willet Green Miller*

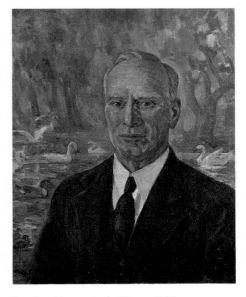

Stanley Moyer, *Jack Miner*, 1928

According to Berthon's Sitters Notebook 1866-1890, in the E.P. Taylor Reference Library, Art Gallery of Ontario, the artist received payment for a portrait of "Lord Metcalf" [*sic*] on 28 May 1885.

There are two possible sources for Berthon's painting. A portrait of Metcalfe by the American painter Alvah Bradish made in 1844 (present whereabouts unknown), served as the basis for an engraving by William Warner of Philadelphia. In the Château Ramezay, Montreal, there is a copy of Bradish's portrait (or possibly Warner's mezzotint) attributed to Cornelius Krieghoff (1815-1872). Berthon's portrait of Metcalfe may be based on either the Warner engraving, or the painting in Montreal attributed to Krieghoff.

Dr. Willet Green Miller
(first Provincial Geologist of Ontario, 1902-25)

Artist: J. W. L. Forster
Oil on canvas, 134 x 95.3 cm / 52³/₄ x 37¹/₂"
Signed: (l.l.) J. W. L. Forster
Commission. MGS 626223

According to the artist, Miller (b. 1855; d. Toronto, Ontario, 4 February 1925) is depicted in "field work" in the Cobalt

district of Northern Ontario *(Under the Studio Light)*.

Jack Miner

John (Jack) Thomas Miner (b. 10 April 1865; d. Gosfield South Township, Ontario, 3 November 1944) founded the Jack Miner Bird Foundation, consisting of a 2,000-acre bird sanctuary, at Kingsville, Ontario in 1932.

Artist: Stanley Moyer
Oil on canvas, 76.2 x 63.5 cm / 30 x 25"
Signed and dated: (l.l.) S G MOYER / 1928
Gift of the artist, 1963. MGS 624424

The donation was made through the Ontario Institute of Painters for hanging in Ontario House, London, England; it was returned to Toronto in 1980.

Louis Joseph, Marquis de Montcalm
(Commander-in-Chief of the French Forces in Canada, 1756-59)

Louis-Joseph, Marquis de Montcalm (b. Candiac, France, 28 February 1712; d. Quebec, New France, 14 September 1759) began his military career in 1732. Sent to Canada in 1756 as Brigadier General and Commander-in-Chief of the French forces there, he achieved considerable success against the British, gaining control of Lake Ontario, and winning a decisive victory against British Major-General James Abercromby at Carillon. Montcalm was promoted to Lieutenant Governor in 1758, reinforcing his position against Pierre de Rigaud de Vaudreuil, the Governor General of New France, with whom he had had a severe disagreement over military tactics.

In May 1759 British troops under James Wolfe landed at Quebec on the Ile d'Orleans. On the morning of 13 September, the British scaled the heights to the Plains of Abraham, taking the French by surprise. To prevent the English from consolidating their position, Montcalm attacked immediately. However, after only twenty minutes of fighting, Montcalm was mortally wounded, and the French retreated to the city. He died early the next morning and the articles of capitulation were signed on 18 September 1759.

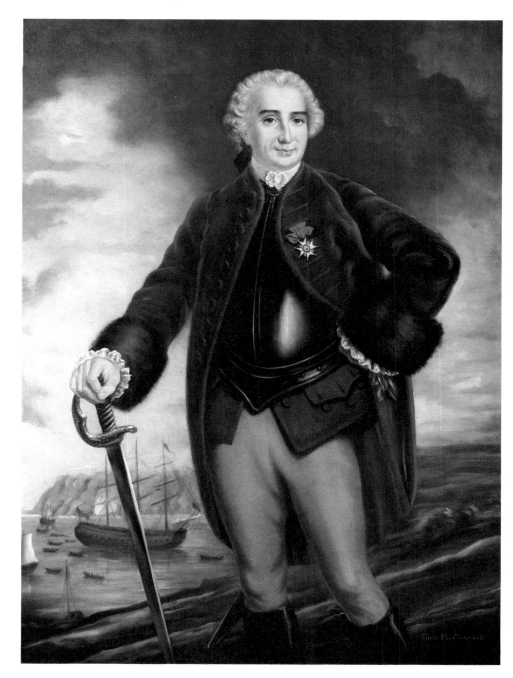

June Forbes McCormack, *Louis Joseph, Marquis de Montcalm*, 1956

Artist: June Forbes McCormack
Oil on canvas, 151.1 x 110.5 cm/
59½ x 43½"
Signed: (l.r.) JUNE McCORMACK
Commission, 1956. MGS 692992

McCormack based her painting on an anonymous early nineteenth century portrait of Montcalm in the Sigmund Samuel Canadiana Collection, Royal Ontario Museum, which formerly had belonged to the Archives of Ontario. McCormack has added a background rendering of Quebec's harbour and Cap Diamant; as in its source, Montcalm is shown wearing his decoration, the Croix de Saint-Louis.

The Hon. Donald Hugo Morrow
(Speaker of the Ontario Legislature, 1963-67)

Donald Hugo Morrow (b. Winchester Springs, Ontario, 19 December 1908) was educated at the Ottawa Teachers' College, Queen's University, the Ontario College of Education and the University of Toronto. Following a lengthy career as an educator — interrupted by military service during World War II — Morrow was a realtor and insurance agent. He began public life in 1948 as the Progressive Conservative M.P.P. for the riding of Carleton. From 1955 to 1977 he represented Ottawa West. The Hon. Donald Hugo Morrow was Speaker of the Ontario Legislature from 1963 to 1967.

Artist: Kenneth Forbes
Oil on canvas, 124.5 x 99.7 cm/
49 x 39¼"
Signed and dated: (l.l.) K. FORBES/
1967
Commission, c. 1967. MGS 619711

The Hon. Sir Oliver Mowat,
G.C.M.G., K.C., LL.D.
(Premier of Ontario, 1872-96;
Lieutenant Governor of Ontario, 1897-1903)

Sir Oliver Mowat (b. Kingston, Upper Canada, 22 July 1820; d. Toronto, Ontario, 19 April 1903) articled under John A. Macdonald and was called to the bar in 1841 (Q.C., 1856). He became

Kenneth Forbes, *The Hon. Donald Hugo Morrow*, 1967

politically active in 1857, first as an alderman for the City of Toronto and shortly thereafter as the Liberal member for South Ontario in the Legislative Assembly of Canada. Mowat became Provincial Secretary in the Brown-Dorion government of 1858 and was Postmaster General in both the Macdonald-Dorion government of 1863-64 and the "Great Coalition" of 1864. He was an active participant at the Quebec Confederation Conference of 1864. Mowat then left politics for a time. In 1872 he returned to political life. He became Leader of the Ontario Liberal party, won the seat for Oxford North and began a 23-year term as Premier and Attorney General of Ontario.

During his premiership, Mowat successfully enlarged both the powers of the provincial government and the territory under its jurisdiction. His administration was also responsible for extending the electoral franchise and introducing the ballot at both municipal and provincial levels.

In 1896 Mowat returned briefly to federal politics. He was elected the M.P. for Oxford North, entered Sir Wilfrid Laurier's cabinet as Minister of Justice and was named to the Senate, where he became government leader. The

following year Mowat was appointed Lieutenant Governor of Ontario, a post he held until his death. His distinguished achievements earned him two orders of knighthood (K.C.M.G., 1892; G.C.M.G., 1897) and honorary degrees from both Queen's University and the University of Toronto.

Artist: Robert Harris
Oil on canvas, 231.8 x 160 cm/
91¼ x 63"
Signed and dated: (l.l.) Robert Harris.
1892.
Gift of the friends of Oliver Mowat, 1893. MGS 605041

This portrait was officially unveiled in the Legislative Chamber after the delivery of the Speech from the Throne at the official opening of the Legislative Building on 4 April 1893. In 1897 a portrait of the Hon. Edward Blake was donated to the Legislature to be hung alongside it. In an undated entry in Harris' Sitter-book (Harris Papers, Confederation Art Gallery and Museum, Charlottetown), Harris wrote that he painted this full-length portrait of Sir Oliver Mowat from life, seated at a table in the library at his Toronto home.

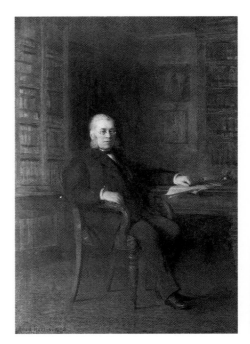

Robert Harris, *The Hon. Sir Oliver Mowat*, 1892

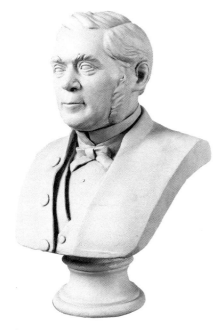

Walter S. Allward, *The Hon. Sir Oliver Mowat*, c. 1903

Artist: Walter S. Allward
Plaster, 62.9 x 36.2 x 30.5 cm /
24³/4 x 14¹/4 x 12"
Commission for the Educational
Museum, Toronto Normal School, 1900.
MGS 619725

Public Accounts of Ontario, 1900
indicates payment by the Committee of
the House for Art Purposes of $314, for a
bust of Mowat by Allward and, as part of
expenses incurred by the Department of
Education Library and Museum, $200
for (another?) bust. This double entry
suggests that probably *two* busts were
purchased by the government in 1900,
only one of which remains in the
collection. A comparison of this portrait
bust with the head of Mowat in
Allward's bronze statue of 1903-05 leads
to speculation that the bust may have
served as the basis for the statue
(completed after Mowat's death in
1903), and that the purchase of the bust
may have led to the commissioning of
the statue.

Artist: J. W. L. Forster
Oil on canvas, 111.8 x 83.8 cm / 44 x 33"
Commission, *c.* 1903. MGS 694151

This portrait depicts Mowat as
Lieutenant Governor, wearing the
traditional Windsor uniform.

Walter S. Allward, *The Hon. Sir Oliver Mowat*, 1903-05

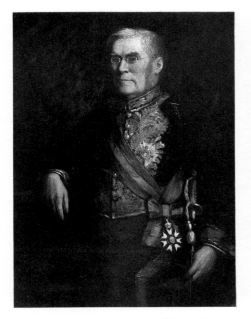

J.W.L. Forster, *The Hon. Sir Oliver Mowat*

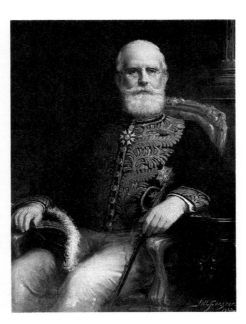

J.W.L. Forster, *The Hon. Sir William Mulock*, 1922

Artist: Walter S. Allward
Bronze on granite base; statue: 281.9 x
114.3 x 86.4 cm / 111 x 45 x 34", base:
340.4 x 444.5 x 444.5 cm / 134 x 175 x
175"
Signed: (on bronze, right side) WALTER
S. ALLWARD SCULPTOR; (on two
bronze friezes representing Justice and
History on right and left sides of granite
base, l.l.) W.S. Allward Sc.
Inscribed: (l.l., on pedestal): The Henry
Bonnard Founders N.Y. 1905; (on
pedestal): LIEUTENANT / GOVERNOR
... 1897-1903; PREMIER
OF / ONTARIO / ..1872-1896; MOWAT
Commission, 1903-05. MGS 619891

Cast by the Henry Bonnard Bronze Co.,
Founders, New York; the pedestal was
constructed by McIntosh, Gullett Co.
The statue, begun *c.* 1903, the year of
Mowat's death, was unveiled on 6
November 1905 by the Hon. William
Mortimer Clark, Lieutenant Governor
of Ontario.

The Hon. Sir William Mulock,
P.C., K.C.M.G., K.C., LL.D.
(Postmaster General of Canada,
1896-1905; Chief Justice of the Court
of Appeal of Ontario, 1923-36)

William Mulock (b. Bond Head, Canada
West, 19 January 1844; d. Toronto,
Ontario, 1 October 1944) was called to
the bar in 1868 (Q.C., 1890) and
practised law in Toronto before entering
politics as the Liberal M.P. for North
York in 1882. In 1896 he was appointed
Postmaster General, in which capacity
he found his suggestion of a penny
postage rate throughout the British
Empire accepted at the Imperial Postage
Conference. In 1900 he was appointed
Canada's first Minister of Labour,
having as his deputy William Lyon
Mackenzie King. He retired from
politics in 1905 to become Chief Justice
of the Exchequer division of the
Supreme Court of Canada. From 1923 to
1936 he was Chief Justice of the Court of
Appeal of Ontario. Mulock, who had
long been closely associated with the
University of Toronto, became its
Chancellor in 1924, holding this post
until his death. He was knighted
(K.C.M.G.) in 1902 and made Imperial
Privy Councillor in 1925.

Artist: J. W. L. Forster
Oil on canvas, 113 x 88.9 cm / 44½ x 35"
Signed and dated: (l.r.) J W L Forster /
1922
Commission. MGS 619855

Artist: E. Wyly Grier
Oil on canvas, 134.6 x 105.4 cm /
53 x 41½"
Signed and dated: (l.r.) E. Wyly Grier
1926
Purchase. MGS 619828

The Hon. William Murdoch
(Speaker of the Ontario Legislature,
1960-63)

William Murdoch (b. Leeds, England, 15
June 1904; d. Windsor, Ontario, 28 April
1984) emigrated to Canada in 1923
where he became active in the
community of Harrow as a member of
many local societies, the Public School
Board and the Town Council. He served
the riding of Essex South for twenty
years (1943-63) as Conservative M.P.P.
and was Speaker of the Ontario
Legislature from 1960 to 1963.

Artist: Kenneth Forbes
Oil on canvas, 125.7 x 100.3 cm /
49½ x 39½"
Signed and dated: (l.l.) K. FORBES /
1963
Commission, *c.* 1963. MGS 692725

Lieutenant-General Sir George
Murray, G.C.B.
(Provisional Lieutenant Governor of
Upper Canada, 1815)

Sir George Murray (b. Perthshire,
Scotland, 6 February 1772; d. London,
England, 28 July 1846) had a varied and
distinguished military career, in
recognition of which he was knighted
(K.B., 1813; G.C.B., 1815). In April 1815
he was sent to Upper Canada as both
military Lieutenant-General and Pro-
visional Lieutenant Governor of the
province. Napoleon's escape from Elba,
however, drew him away to active
service in July of the same year. As well
as holding many important military
posts through his career, Murray was
Secretary of State for War and the
Colonies from 1828 to 1830.

Artist: George T. Berthon
Oil on canvas, 109.2 x 83.8 cm / 43 x 33"
Commission, 1885. MGS 693129

According to Berthon's Sitters
Notebook, 1866-1890, in the E.P. Taylor
Reference Library, Art Gallery of

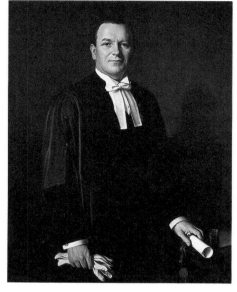

Kenneth Forbes, *The Hon. William Murdoch*, 1963

Ontario, the artist received payment for this portrait on 3 October 1885. It is probably based on a mezzotint or stipple engraving by Henry Meyer (*c*.1783-1847), the London-based father of the Canadian artist Hoppner Meyer (act. 1832-*c*.1862), after a canvas by Sir Thomas Lawrence (1769-1830). The mezzotint version was published by the London firm of Welch and Gwynne in 1841. The original portrait, dated 1812, was described in Kenneth Garlick's 1955 monograph on Lawrence as one of three "untraced" portraits of Murray.

Thornton Mustard, B. Paed.
(Principal of the Toronto Normal School, 1938-39)

Thornton Mustard (b. Brucefield, Ontario, 1886; d. at sea, 1939) was educated in Huron County and at the University of Toronto (B.A., B.Paed.). He was responsible for an expeditious overhaul and modernization of the Ontario elementary school curriculum. Mustard's appointment as Principal of the Toronto Normal School in 1938 was cut tragically short. A passenger aboard the *Athenia*, torpedoed on its return from England in one of the first acts of World War II, he died at sea.

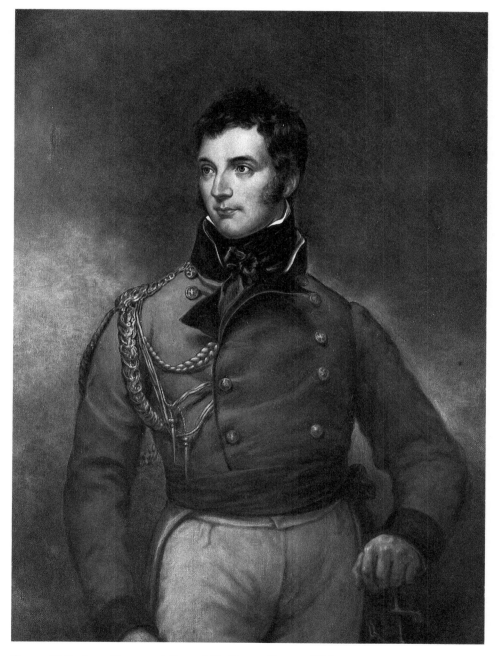

George T. Berthon, *Lieutenant-General Sir George Murray*, 1885

Charles MacGregor, *Thornton Mustard*

Artist: Charles MacGregor
Oil on canvas, 99.7 x 84.5 cm /
39¼ x 33¼"
Signed: (l.l.) C. MacGregor
Gift of the Teachers of Ontario.
MGS 623070

The Hon. Harry Corwin Nixon
(Premier of Ontario, 1943)

Harry Corwin Nixon (b. St. George,
Ontario, 1 April 1891; d. St. George,
Ontario, 22 October 1961) received his
B.S.A. from the Ontario Agricultural
College. Secretary for the Brant County
United Farmers of Ontario in 1918, as a
U.F.O. he served as M.P.P. for Brant
North from 1919 to 1926. From 1926-34
he served the riding of Brant County as a
member of the Progressive Party, as a
Liberal Progressive from 1934 to 1937,
and as the Liberal M.P.P. for Brant riding
from 1937-61. In 1934 Nixon joined
Mitchell Hepburn's cabinet as
Provincial Secretary and Registrar, and
Minister in charge of Game and
Fisheries. He resigned these positions to
succeed Conant as Premier of the
province in May, 1943. His government
was defeated in August of that year, but
Nixon continued to represent Brant in
the Legislature until his death in 1961.

Alan C. Collier, *The Hon. Harry Corwin Nixon*, 1962

Artist: Alan C. Collier
Oil on canvas, 115.6 x 88.9 cm/
45½ x 35"
Signed and dated: (l.r.) Alan C. Collier/
'62
Commission, 1961. MGS 605031
Painted posthumously from photographic sources.

The Hon. Timothy Blair Pardee, Q.C.
(Provincial Secretary, 1872-73; Commissioner of Crown Lands, 1873-89)

Timothy Blair Pardee (b. Grenville, Upper Canada, 11 December 1830; d. Sarnia, Ontario, 1 August 1889) was called to the bar in 1861 (Q.C., 1879), holding the position of County Attorney for Lambton for some time before entering the first Ontario Legislature. In 1867 he was elected the Liberal M.P.P. for Lambton and retained his seat until 1889, the year of his death. Pardee was made a member of the Executive Council in 1872, continuing as Provincial Secretary through 1873. He entered Oliver Mowat's cabinet in 1873, serving for 16 years as Chairman of the Private Bills Committee and Commissioner of Crown Lands.

Artist: J. W. L. Forster
Oil on canvas, 101.6 x 81.3 cm/40 x 32"
Commission, 1897. MGS 620507
Probably cut down from a larger portrait of Pardee by Forster, showing the subject seated at his desk, presumably at his office in the "new" Legislative Building at Queen's Park, opened in 1893. A photograph is in the album of Photographs of Portrait Paintings by J.W.L. Forster (two binders) that was presented to the Art Gallery of Toronto Library by the Forster Estate in 1951. See also Forster's portrait of Christopher Finlay Fraser.

The Hon. Nelson Parliament
(Speaker of the Ontario Legislature, 1920-23)

The Hon. Nelson Parliament (b. Ameliasburg, Ontario, 11 March 1877; d. [?]), was the Liberal M.P.P. for Prince Edward from 1914 to 1923, and Speaker of the Ontario Legislature from 1920 to 1923.

Artist: Curtis Williamson
Oil on canvas, 127 x 90.8 cm/
50 x 35¾"
Signed and dated: (l.r.) Curtis Williamson 25
Commission, 1925. MGS 619817

General Sir George Prevost, Bart.
(Governor-in-Chief of Canada, 1811-15)

Sir George Prevost (b. York, England, 19 May 1767; d. London, England, 5 January 1816), son of Major-General Augustin Prevost (who had served under General James Wolfe), was knighted in 1803 for his services in the West Indies during the Napoleonic Wars. He became Lieutenant Governor of Nova Scotia in 1808. From 1811 to 1815 he was Governor-in-Chief of Canada, and was made Commander-in-Chief of the British forces in Canada in 1812. Having been responsible for two unnecessary naval retreats during the War of 1812, he was recalled to England in 1815, and died shortly thereafter.

Artist: George T. Berthon
Oil on canvas, 109.2 x 81.3 cm/43 x 32"
Commission, 1885. MGS 693126

According to Berthon's Sitters Notebook, 1866-1890, in the E.P. Taylor Reference Library, Art Gallery of Ontario, the artist received payment for this work on 28 May 1885. The most likely source for the painting is a mezzotint by the British engraver Samuel William Reynolds (1773-1835) after a full-length portrait of Prevost, by an unknown artist, published in London in 1818. Reynolds also produced a half-length mezzotint portrait of the same subject.

Prevost was a patron of Robert Field (1769-1819), who came to Halifax within a month of the newly appointed Lieutenant Governor of Nova Scotia. Field painted a number of portraits — both full-length and head-and-shoulders versions — of Prevost, which may have served as the source for Reynolds' print and, subsequently, Berthon's portrait. A portrait of Prevost, based on a painting by Field, painted by Jean-Baptiste Roy-Audy (c. 1778-1848) and dated 1824, is in

J.W.L. Forster, *The Hon. Timothy Blair Pardee*, 1897

Curtis Williamson, *The Hon. Nelson Parliament*, 1925

the collection of the Château Ramezay, Montreal, and another by an unknown artist after Field is in the collection of the House of Commons, Ottawa.

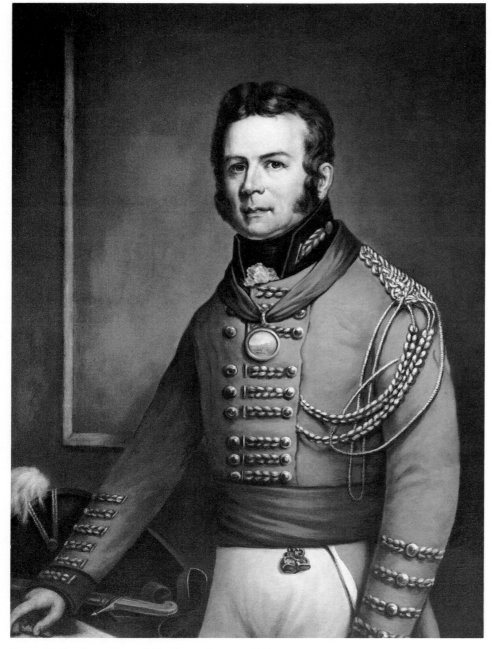

George T. Berthon, *General Sir George Prevost*, 1885

Dr. Samuel J. Radcliffe, D. Paed.
(Principal of the Toronto Normal
School, 1918-29)

Samuel J. Radcliffe (b. 1872; d. Toronto,
Ontario, 2 September 1929) was
appointed a Departmental Master at the
London Normal School in 1907 and
Principal of that institution the
following year. From 1918 to 1929 he
was Principal of the Toronto Normal
School.

Artist: E. Wyly Grier
Oil on canvas, 110.5 x 84.5 cm/
43¹/₂ x 33¹/₄"
Signed and dated: (l.r.) E. WYLY/
GRIER/1933
Commission. MGS 622005

The Hon. Allan Edward Reuter
(Speaker of the Ontario Legislature,
1971-74)

Allan Edward Reuter (b. Preston,
Ontario, 9 August 1914; d. Cambridge,
Ontario, 31 December 1982) was
politically active in his native
community of Preston prior to his entry
into provincial politics. From 1963 to
1975 he represented Waterloo South as a
Progressive Conservative M.P.P. He was
Speaker of the Ontario Legislature from
1971 to 1974, when ill health forced his
resignation.

Artist: Richard Miller
Acrylic on canvas, 135.9 x 99.1 cm/
53¹/₂ x 39"
Signed and dated: (l.l.) Miller 74
Commission, 1974. MGS 619717

The Hon. John Parmenter Robarts,
P.C., C.C., Q.C., D.C.L., LL.D.
(Prime Minister of Ontario, 1961-71)

John Parmenter Robarts (b. Banff,
Alberta, 11 January 1917; d. Toronto,
Ontario, 18 October 1982) was educated
at the University of Western Ontario
and Osgoode Hall, and called to the bar
in 1947 (Q.C., 1954). He was elected the
Progressive Conservative M.P.P. for
London North in 1951 and became
Minister without Portfolio in 1958.
From 1959 to 1961 Robarts was Minister
of Education. In 1961 he became Leader
of the Ontario Progressive Conserva-
tives and Prime Minister of Ontario.

E. Wyly Grier, *Dr. Samuel J. Radcliffe*, 1933

Robarts established the Ontario
Economic Council and the Ontario
Development Agency. His adminis-
tration concerned itself with judicial
reform and the extension of civil rights
and social services. Ontario's edu-
cational system in particular benefited
during his term of office, with the rapid
expansion of the post-secondary system
and the legislation of French language
training in the public schools. Robarts'
concern with national unity led him to
host the Confederation of Tomorrow
Conference in 1967, bringing together
the premiers of the provinces. He retired
from public life in 1971. Robarts
received honorary degrees from twelve
universities and was made a Privy
Councillor in 1967 and Companion of
the Order of Canada in 1972.

Artist: Roberto De'Seta
Oil on canvas, 127 x 106.7 cm / 50 x 42"
Signed: (l.r.) Roberto De'Seta
Gift of the friends of the Hon. John P.
Robarts to the Ontario Heritage
Foundation, 1983; on loan to the
Government of Ontario. MGS 632974

Thomas Jaffray Robertson, M.A.
(First Headmaster of the Toronto
Normal School, 1847-66)

Richard Miller, *The Hon. Allan Edward Reuter*, 1974

Roberto De'Seta, *The Hon. John Parmenter Robarts*, 1982

Thomas Jaffray Robertson (b. Ireland; d. Toronto, Canada West, 29 September 1866) founded a private school in Dublin following his graduation from Trinity College, and later became one of the Secretaries of the National Board of Education.

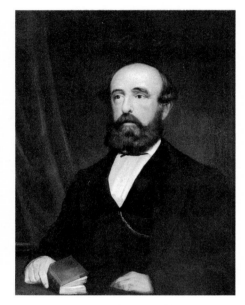

T. Mower Martin, *Thomas Jaffray Robertson*, 1868

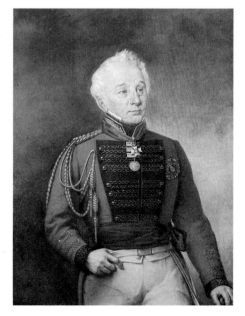

George T. Berthon, *Major-General Sir Frederick Philipse Robinson*, 1884

At that time Irish texts were used in Upper Canadian schools, and in 1846, in order to standardize teaching methods, the Irish Board was requested to select a Headmaster for a proposed Toronto Normal School. On their recommendation Robertson emigrated to Canada to become the first Headmaster of the Toronto Normal School in 1847, retaining this post until his death.

Artist: T. Mower Martin
Oil on canvas, 90.3 x 70.2 cm /
35⁹/₁₆ x 27⁵/₈"
Signed and dated: (l.l.) T. M. Martin /
1868
Commission. MGS 622003

Major-General Sir Frederick Philipse Robinson, K.C.B.
(Provisional Lieutenant Governor of Upper Canada, 1815)

Frederick Philipse Robinson (b. near New York, New York, 24 September 1763; d. Brighton, England, 1 January 1852), son of Colonel Beverley Robinson and related to Sir John Beverley Robinson, joined at the age of 13 a Loyalist military corps organized by his father. He later saw service in the British West Indies during the Peninsular War. In 1813 he was promoted to the rank of Major-General and in the following year was sent to Canada during the latter stages of the War of 1812. In July 1815 Robinson was appointed provisional Lieutenant Governor of Upper Canada until the return of Francis Gore in September of the same year. Knighted (K.C.B.) in 1815, he left Canada to further pursue his military career.

Artist: George T. Berthon
Oil on canvas, 106.7 x 81.3 cm / 42 x 32"
Commission, 1884. MGS 693128

According to Berthon's Sitters Notebook, 1866-1890, in the E.P. Taylor Reference Library, Art Gallery of Ontario, the artist received payment for this work on 25 May 1884.

To date, no source for this portrait has come to light, but Berthon must have worked from a contemporary portrait of Robinson or from an engraving based on one, as he did for his other portraits of the province's lieutenant governors.

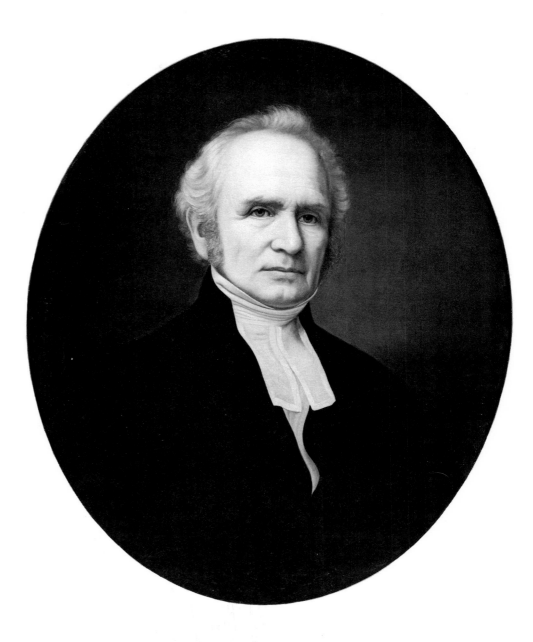

George T. Berthon, *Sir John Beverley Robinson*

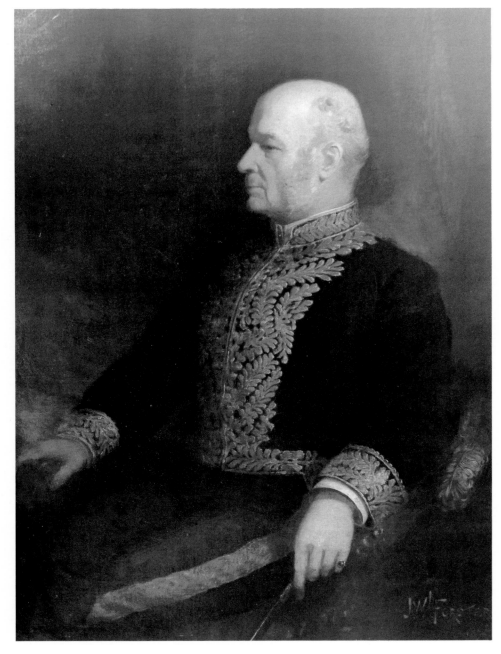

J.W.L. Forster, *The Hon. John Beverley Robinson*, 1895

Robinson is depicted wearing his K.C.B. medal and the uniform of Commander of the forces in Canada, indicating that the original portrait would have been painted *c.* 1815, the year he served as provisional Lieutenant Governor of Upper Canada.

Sir John Beverley Robinson,
Bart., C.B.
(Attorney General of Upper Canada, 1818-29; Chief Justice of Upper Canada, 1829-62)

Sir John Beverley Robinson (b. Berthier, Lower Canada, 26 July 1791; d. Toronto, Canada West, 31 January 1863), was the second son of Christopher Robinson, an officer of the Queen's Rangers during the American Revolutionary War. He was educated at Kingston and at Cornwall under John Strachan. Robinson served under Isaac Brock in the War of 1812 prior to an 1813 appointment as acting Attorney General of Upper Canada. With the conclusion of the war, Robinson became Solicitor General and in 1818, Attorney General. In 1821 he was elected to the Legislative Assembly of Upper Canada, holding this seat and continuing as Attorney General until his appointment, in 1829, as President of the Executive Council, Speaker of the Legislative Council, and Chief Justice of Upper Canada. He resigned the presidency of the Executive Council in 1832 and left the Legislative Council as Speaker at the union of the Canadas in 1841. In 1853 Robinson was elected first Chancellor of the University of Trinity College, Toronto. He remained Chief Justice until his appointment, in 1862, as first president of the Court of Error and Appeal. Robinson was made a C.B. in 1850 and created a baronet in 1854.

Artist: George T. Berthon
Oil on canvas, 73 x 60.3 cm /
28³/₄ x 23³/₄"

Probably painted from life prior to the Chief Justice's death in 1863. There were a great many paintings made of Robinson, alone and in group portraits, the most famous being at Osgoode Hall. The Department of Education seems to have owned another portrait of Robinson, very likely by Berthon, which

Walter S. Allward, *The Hon. Sir George William Ross*

appears to survive today only in photo-gravure form, in the John Ross Robertson Collection, Metropolitan Toronto Library.

The Hon. John Beverley Robinson
(Lieutenant Governor of Ontario, 1880-87)

John Beverley Robinson (b. York [Toronto], Upper Canada, 20 February, 1820; d. Toronto, Ontario, 19 June 1896), second son of Chief Justice Sir John Beverley Robinson, was educated at Upper Canada College. Becoming an aide-de-camp to Sir Francis Bond Head upon graduation in 1837, Robinson found himself with the Governor during the suppression of the rebellion of that year. In 1851 he began public life as an alderman for Toronto's St. Patrick Ward, and became Mayor of the city in 1857. The following year he was elected the Conservative Member of the Legislative Assembly of Canada for Toronto and continued to serve the city there and in the House of Commons for a time after Confederation. From 1872 to 1874 he was the federal M.P. for Algoma. Robinson was appointed City Solicitor for Toronto in 1876, a position he held through his last term as M.P. for the

Andrew D. Patterson, *The Hon. Sir George William Ross, c. 1902*

J.W.L. Forster, *The Hon. Sir George William Ross, c. 1904*

riding of Toronto West (1878-1880). In 1880 Robinson was appointed Lieutenant Governor of Ontario, holding this post until 1887.

Artist: J. W. L. Forster
Oil on canvas, 111.8 x 83.8 cm / 44 x 33"
Signed and dated: (l.r.) J W L Forster / 1895
Commission. MGS 693133

The Hon. Sir George William Ross, Kt., LL.D., F.R.S.C. (Premier of Ontario, 1899-1905)

George William Ross (b. near Nairn, Middlesex County, Canada West, 18 September 1841; d. Toronto, Ontario, 7 March 1914) was educated at the Toronto Normal School and Albert College. He worked as a teacher for a time and in 1872 was elected to the Federal House of Commons as a Liberal for Middlesex West. Ross was elected to the Ontario Legislature for the same riding in 1883. He was appointed Minister of Education in the same year, retaining this portfolio until 1899 at which time he became Premier and Provincial Treasurer. He held these positions until his government's defeat in 1905 — the end of 34 years of Liberal rule in the province. Ross then became Leader of the Opposition until his appointment to the Senate in 1907. In 1911 he became Liberal Leader in the Senate. Ross was called to the bar in 1887, but never took up a practice owing to his public commitments. He received honorary degrees from a number of universities, became a Fellow of the Royal Society of Canada in 1896, and was knighted in 1910.

Sir George William Ross oversaw the construction of the Temiskaming and Northern Railway which was instrumental in the settlement and development of northern Ontario. His government also introduced corporate taxation in the province and established the Ontario Power Commission.

Artist: Walter S. Allward
Plaster, 59.7 x 45.7 x 21.6 cm / 23$^1/_2$ x 18 x 8$^1/_2$"
Commission for the Educational Museum, Toronto Normal School, 1901.
MGS 619726

Richard Miller, *The Hon. Russell Daniel Rowe*, 1975

Artist: Andrew D. Patterson
Oil on canvas (laid on masonite),
100.3 x 73.7 cm/39½ x 29"
Inscribed: (verso, not in artist's hand)
The Hon. George William Ross/1883-
1899/by Patteson [sic]...1902
Commission. MGS 622699

Artist: J. W. L. Forster
Oil on canvas, 201.7 x 135.9 cm/
79½ x 53½"
Signed: (l.r.) J. W. L. Forster
Commission, 1904. MGS 693202

For the artist's comments on Premier
Ross, see Forster's *Under the Studio
Light.*

The Hon. William Donald Ross
(Lieutenant Governor of Ontario,
1927-32)

William Donald Ross (b. Little Bras
d'Or, Nova Scotia, 20 June 1869; d.
Toronto, Ontario, 25 June 1947) began
to work for the Bank of Nova Scotia at
the age of 15, eventually becoming a
director. From 1903 to 1914 he was
General Manager of the Metropolitan
Bank in Toronto and negotiated its
absorption into the Bank of Nova Scotia.

Ross was Lieutenant Governor of
Ontario from 1927 to 1932.

Artist: John Russell
Oil on canvas, 111.8 x 86.4 cm/44 x 34"
Signed and dated: (l.r.) John Russell/
193- [illegible]
Commission, *c.* 1931. MGS 694160

The Hon. Russell Daniel Rowe
(Speaker of the Ontario Legislature,
1974-77)

Russell Daniel Rowe (b. Campbellford,
Ontario, 1 December 1914) was educated
at Queen's University and served in the
R.C.A.F. during World War II before
entering the Legislature. He represented
Northumberland as a Progressive
Conservative from 1963 to 1981, and
from 1974 to 1977 was Speaker of the
Ontario Legislature.

Artist: Richard Miller
Acrylic on canvas, 139.1 x 101 cm/
54¾ x 39¾"
Signed and dated: (l.l.) Miller 75
Commission, 1975. MGS 622142

The Hon. William Earl Rowe,
P.C., LL.D., D.Sc.Soc.
(Lieutenant Governor of Ontario,
1963-68)

William Earl Rowe (b. Hull, Iowa,
U.S.A., 13 May 1894; d. Newton
Robinson, Ontario, 9 February 1984) was
brought to Canada at two years of age.
He became a member of Simcoe County
Council in 1918 and from 1919 to 1923
was Reeve of Gwillimbury Township. In
1923 he was elected the Conservative
M.P.P. for Simcoe South riding,
resigning in 1925 to run for the House of
Commons for Dufferin Simcoe. He won
this seat and remained in the House
until 1937. He was Minister without
Portfolio in R. B. Bennett's
administration from 1930 to 1935. Rowe
became Leader of the provincial
Conservatives in 1936 but he and his
party were unsuccessful in the election
of 1937. Resigning the leadership of the
provincial party in 1938, he returned to
federal politics, winning his former seat
in the House of Commons, which he
held until 1963. In that year he was
appointed Lieutenant Governor of

John Russell, *The Hon. William Donald Ross*, 1931

Cleeve Horne, *The Hon. William Earl Rowe, c.* 1970

Ontario, a post he would retain until
1968.

Artist: Cleeve Horne
Oil on canvas, 116.8 x 96.5 cm/46 x 38"
Signed: (l.r) CLEEVE/HORNE
Commission, 1970. MGS 619866

George T. Berthon, *The Hon. Peter Russell,* 1882

The Hon. Peter Russell
(President and Administrator of Upper Canada, 1796-99)

Peter Russell (b. Cork, Ireland, 11 June 1733; d. York [Toronto], Upper Canada, 30 September 1808) was educated for the clergy at St. John's College, Cambridge, but chose instead a military career. A general's secretary during the American Revolutionary War, Russell attained the rank of captain after 26 years in the British army. He left England to become John Graves Simcoe's Inspector-General in 1791. In 1796 he succeeded Simcoe as Administrator of Upper Canada and President of the Executive Council. As President of the Executive Council, Russell was authorized to grant each member of council 6,000 acres of land. Notwithstanding contemporary criticism, Russell himself legitimately acquired vast holdings in this way. A part of these extended from Queen Street to Bloor Street and occupied the site of present-day Spadina Avenue. Inherited by his sister Elizabeth and passing from her to the Baldwin family, this property has been considered to be the basis for that family's fortune.

Artist: George T. Berthon
Oil on canvas, 109.2 x 85.1 cm / 43 x 33½"
Commission, 1882. MGS 693124

Rosen, *The Rev. Dr. Egerton Ryerson,* 1858

Berthon's portrait is very likely based on a small watercolour, painted by William Berczy in Toronto during the years 1803-04 (Private Collection, London, Ontario, see p. 150).

The Rev. Dr. Adolphus Egerton Ryerson, D.D., LL.D.
(Chief Superintendent of Education for Canada West/Ontario, 1844-76)

Adolphus Egerton Ryerson (b. Norfolk County, Upper Canada, 24 March 1803; d. Toronto, Ontario, 19 December 1882) entered the ministry of the Methodist Church in 1825 and was later appointed secretary of the Wesleyan Methodist Missionary Society. From 1874 to 1878 he was the first president of the General Conference of the Methodist Church of Canada.

Ryerson was first active politically working with Marshall Bidwell, John Rolph and William Lyon Mackenzie for the secularization of the Clergy Reserves. Becoming disenchanted with Mackenzie's tactics during 1833, he finally moved to the Loyalist side in 1837 and supported the administration of Sir Charles Metcalfe during 1844.

The first Royal Charter for a non-Anglican institution was obtained by Ryerson for Cobourg's Methodist Upper Canada Academy in 1836. When the Academy became Victoria College in 1841, he was appointed its first president. From 1844 to 1876 Ryerson was Chief Superintendent of Education for Upper Canada, during which time the establishment of the Ontario education system was primarily his responsibility. 1857 saw the opening of his proposed Educational Museum, housing the collection gathered by him on his European tour of 1855 and 1856. In 1871 Ryerson's long-standing goal of free and universal education was realized.

A prolific writer, Ryerson published numerous books, pamphlets and articles. He was the first editor of the *Christian Guardian* (1829-40) and founder of the *Upper Canada Journal of Education* in 1848. He edited the latter periodical until 1876.

Artist: Théophile Hamel
Oil on canvas, 100.3 x 74.9 cm / 39½ x 29½"
Signed twice: (l.r.) T. Hamel/T. HAMEL [probably not in artist's hand].
Purchase [?], c. 1850-51. MGS 622107

Although undated, this portrait was probably painted in 1850 or 1851, when Hamel was maintaining a studio in Toronto. In 1851 Hamel also painted Ryerson's Deputy Superintendent, John George Hodgins and his wife, Rachel Frances Doyle, although Vézina's two-volume *Théophile Hamel, Peintre national* (Montréal: Editions Elysée, 1975) does not list either the Ryerson or the Hodgins and Doyle portraits.

Artist: Rosen
Plaster, 71.8 x 45.1 x 24.8 cm / 28¼ x 17¾ x 9¾"
Dated: (verso) 1858
Inscribed: (verso) [illegible] Toronto 1858.
Purchase [?] 1858. MGS 619729

This bust of Ryerson was the first of a proposed series of "Busts of Public Men," a project that was originated by the artist Rosen in 1858. Included in the series, also in this collection, is the bust of William Lyon Mackenzie. The recent attribution to this artist now indicates that an earlier attribution to "a German sculptor...Bosch" by C.B. Sissons is inaccurate (C.B. Sissons, *Egerton*

Théophile Hamel, *The Rev. Dr. Egerton Ryerson, c.* 1850-51

Ryerson: His Life and Letters, Vol. 2, Toronto: Clarke, Irwin, 1947).

Artist: Marshall Wood
Plaster, 83.8 x 60.3 x 36.2 cm/
33 x 23³/₄ x 14¹/₄"
Left [?] *c.* 1873 by the artist to the Toronto Normal School, for which his son, Percy Wood, received payment in 1886. MGS 622074

Executed on speculation by the artist in England, and sent to Toronto in the summer of 1873. The bust remained part of the collection of the Normal School in Toronto, until it was transferred to the Ontario Legislative Building on the closure of the Toronto Teachers' College in 1979. An identical bust, in marble, by the same artist, was transferred from the Department of Education to Ryerson Polytechnic Institute, Toronto, in whose collection it has remained.

The Hon. Joseph Wesley St. John
(Speaker of the Ontario Legislature, 1905-07)

Joseph Wesley St. John (b. Brock, Canada West, 18 July 1854; d. Toronto, Ontario, 7 April 1907) served York West riding as a Conservative M.P.P. from 1894 to 1907, and was Speaker of the Ontario Legislature from 1905 to 1907.

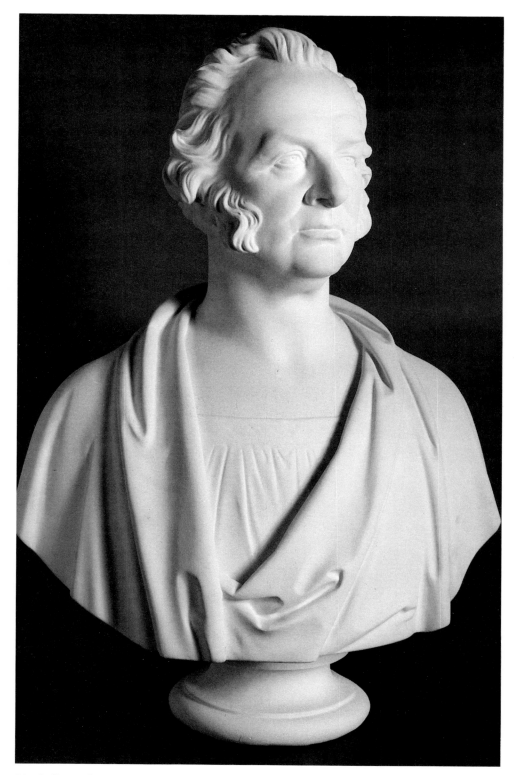

Marshall Wood, *The Rev. Dr. Egerton Ryerson, c.* 1873

J.W.L. Forster, *The Hon. Joseph Wesley St. John*

Artist: J. W. L. Forster
Oil on canvas, 125.7 x 89.5 cm /
49¹/₂ x 35¹/₄″
Signed: (l.r.) J. W. L. Forster
Commission, 1906. MGS 692922

The Hon. Sir Richard William Scott,
Kt., P.C., K.C., LL.D.
(Speaker of the Ontario Legislature,
1871)

Richard William Scott (b. Prescott,
Upper Canada, 24 February 1825; d.
Ottawa, Ontario, 23 April 1913) began
his public career early in life, winning
the Ottawa mayoral election in 1852. A
Liberal M.P.P. for Ottawa City between
1858 and 1863, he later represented the
riding of Ottawa as M.P.P. from 1867 to
1874. He introduced the Scott Act (1863)
which formed the basis of the province's
separate school system. In December
1871 Scott briefly held the office of
Speaker of the Ontario Legislature. In
1871 he was appointed Commissioner of
Crown Lands and in 1873 he was
appointed Minister without Portfolio.
He was called to the Senate in 1874,

George T. Berthon, *The Hon. Sir Richard William Scott, c. 1872*

serving as Secretary of State in that year and again from 1896 to 1908. Scott's honours included appointment to the Privy Council (1873) and Queen's Council (1867), knighthood (Knight Bachelor, 1909) and an LL.D. received from the University of Ottawa in 1889.

Artist: George T. Berthon
Oil on canvas, 61 x 49.5 cm / 24 x 19½"
Purchase [?], 1872. MGS 692930

According to Berthon's Sitters Notebook, 1866-1890, in the E.P. Taylor Reference Library, Art Gallery of Ontario, the artist received payment for a portrait of Scott on 29 May 1872. It appears that Berthon employed the device of applying oil pigments to a photosensitive canvas onto which a photographic image of the sitter had been projected and exposed — a practice not uncommon at the time.

William Scott, B.A.
(Principal of the Toronto Normal School, 1899-1919)

William Scott (b. Ashkirk, Roxburgh-shire, Scotland, 10 August 1845; d. Toronto [?], Ontario, 1 March 1920) came to Canada in 1854. He was educated at the Toronto Normal School and the University of Toronto. After a variety of teaching posts, he became in 1899 Principal of the Toronto Normal School, remaining in that position until 1919.

Artist: E. Wyly Grier
Oil on canvas, 110.5 x 85.4 cm / 43½ x 33⅝"
Signed: (l.r.) E. Wyly Grier
Commission, 1919. MGS 622004

Laura Secord
(Loyalist and heroine of the War of 1812)

Laura Ingersoll Secord (b. Great Barrington, Massachusetts, 13 September 1775; d. Chippawa, Ontario, 17 October 1868) came to Upper Canada with her Loyalist parents in 1793. Soon afterwards she married James Secord, a United Empire Loyalist, who served as a sergeant in the First Lincoln militia regiment in the War of 1812. In 1813 she

Mildred Peel, *Laura Secord*

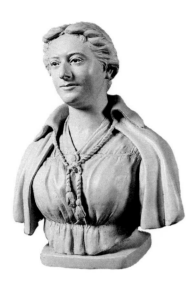

Mildred Peel, *Laura Secord*

overheard talk of an impending attack at Beaver Dam from American soldiers billetted with her during the Niagara invasion. She walked 19 miles to warn the British commander, Lieutenant James Fitzgibbon. He was aware of the plan, but she has nevertheless been acclaimed as a heroine of the Loyalist cause.

Artist: Mildred Peel
Plaster, 62.2 x 48.3 x 30.5 cm /
24¹/₂ x 19 x 12"
Commission for the Educational Museum, Toronto Normal School, 1901 or 1903. MGS 619701

A 'Replica Laura Secord bust' is listed in *Public Accounts of Ontario, 1901*, in the section devoted to the expenses of the "Departmental Library and Museum" of the "Ontario Normal College." However, *Public Accounts 1903* records that among the purchases and commissions of the Committee of the House for Art Purposes was a "Bust of 'Laura Secord'" by Mildred Peel. Only one of these busts remains in the collection.

It is possible that plaster "replicas" were cast from the original mould of, and produced to help finance, Peel's life-size bronze bust of Laura Secord, which was erected by the Ontario Historical Society at her grave in Drummond Hill Cemetery, Lundy's Lane, Ontario, and unveiled on 22 June 1901.

The model for this bust is said to have been Mildred Peel's childhood friend, Phoebe-Louise Laskey of London, Ontario, who was a grand-niece of Secord.

Artist: Mildred Peel
Oil on canvas, 170.2 x 114.3 cm / 67 x 45"
Signed and dated: (u.r.) M. Peel 1904
Purchase from the artist, 1905.
MGS 619796

Public Accounts of Ontario, 1905 lists, under the heading of "Committee of House for Art Purposes," payment of $500 to Mildred Peel for a portrait of Laura Secord. There has been a great deal of controversy over this portrait since an X-ray of the canvas, taken in February 1936, revealed an underpainting of a portrait of Premier George Ross.

The Hon. Mitchell Hepburn, Premier of Ontario from 1934-42, had been told by an artist that the hands of Laura Secord looked like those of a male; in 1936 he recalled a story told by the late Victor Ross, a former Queen's Park reporter for the *Globe*, of a portrait of Premier Ross that had been refused by Cabinet. Victor Ross had suggested that another painter had been hired to paint Laura Secord's portrait over the painting of Premier Ross. Hepburn ordered an X-ray and fluoroscope of the canvas, to determine what was beneath the surface (see p. 168). The X-rays did indeed reveal a portrait of the former Premier.

Government records clearly show Mildred Peel to be the author of the Laura Secord painting. Many sources believe that the original portrait of Premier Ross was also painted by Mildred Peel, but at least one source, A.E. Hacker — who in 1904 had been involved in the organization of the Ross Liberal Club — declared that the Ross portrait had in fact been painted by W.A. Sherwood (1859-1955), a painter, poet, teacher and chairman of the Toronto Conservative Club (Toronto *Daily Star*, 26 February 1936). This claim has never been confirmed, but H.J. Morgan's *The Canadian Men and Women of the Time* (Toronto: William Briggs, 1912) credits Sherwood with a portrait of Premier Ross which could be this work.

Allusions have been made to the fact that Ross disliked this portrait, whoever its author. Since two other commissioned portraits of Ross were already in

J.W.L. Forster, *Major-General The Hon. Aeneas Shaw*, 1902

the provincial collection by 1904 (see portraits by A.D. Patterson and J.W.L. Forster), it is in fact possible that Cabinet could have refused another portrait on grounds other than those of artistic merit.

For her Laura Secord painting, as well as her portrait bust (see above), Peel is said to have used Phoebe Laskey, a grand-niece of Laura Secord who bore a striking resemblance to the 1812 heroine, as her model. The features of the woman in the painting, however, are clearly those of an older woman than the woman portrayed in the bust.

Major-General The Hon. Aeneas Shaw
(Member of the Legislative Council of Upper Canada, 1794; Adjutant General of the Militia in the War of 1812)

Aeneas Shaw (b. Tordarroch, Scotland; d. near York [Toronto], Upper Canada, 15 February 1815) was born into an old military family and served as captain of the Queen's Rangers under Colonel John Graves Simcoe in the American

Revolutionary War. He arrived in Upper Canada with his company of Rangers in 1792, settling in York the following year. In 1794 he was appointed to the Legislative Council of Upper Canada, and subsequently to the Executive Council. He was promoted to the rank of Lieutenant-Colonel in 1799. From 1803 to 1807 he drew half pay from the army and was an honorary councillor of the Executive Council. In 1811 he was made a Major-General and became Adjutant-General during the War of 1812.

Artist: J. W. L. Forster
Oil on canvas, 153.7 x 102.9 cm/ 60½ x 40½"
Signed: (l.r.) J. W. L. Forster
Commission, 1902. MGS 605017

Presumably Forster based his painting on an engraving or lithograph after a contemporary painting.

George T. Berthon, *Colonel John Graves Simcoe*, 1881

Colonel John Graves Simcoe
(Lieutenant Governor of Upper Canada, 1791-1796)

John Graves Simcoe (b. Cotterstock, Northamptonshire, England, 25 February 1752; d. Exeter, England, 26 October 1806) was educated at Eton and Merton College, Oxford. He joined the British army in 1771 and was given command of the Queen's Rangers, a corps of Loyalists from the American colonies, during the Revolutionary War. He returned to England in 1781 where in 1790 he was elected to the House of Commons for St. Mawe's, Cornwall. The following year Simcoe was appointed the first Lieutenant Governor of Upper Canada. He arrived at Quebec in November 1791 and in 1792 established the capital for Upper Canada at Niagara [on-the-Lake], renaming it Newark. On September 17, 1792, he opened the first parliament there, and delivered the first Speech from the Throne. Due to its proximity to the American border, however, Newark was deemed insecure. Thus, the capital was moved in 1793, and the site of Toronto Bay was chosen. Simcoe named it York in honour of the Duke of York, the King's son.

Simcoe encouraged immigration of United Empire Loyalists and oversaw the construction of buildings and roads including Yonge Street, which was to link York with Lake Simcoe (named after his son) and Dundas Street. Under his administration and influence the Legislature of Upper Canada instituted the entire body of English Common Law and the first anti-slavery legislation in the English-speaking world. Simcoe's determination that the Church of England should be established as the state church and that the Clergy Reserves be set aside for this church alone brought him into conflict with both Dorchester and the non-Anglican majority of settlers. Thus, while laying the foundations for the future growth of the great British province he envisioned, some of Simcoe's measures — intended to stabilize the region — in fact contributed to the eruptions of later decades.

Simcoe was promoted to Major-General in 1794 and left Canada in 1796 to become Governor and Commander-in-Chief of San Domingo, returning to England the following year. In 1806 he was appointed Commander-in-Chief in India, but became ill on the voyage and was forced to return to England. He died shortly thereafter.

Walter S. Allward, *Colonel John Graves Simcoe*, 1902

Artist: George T. Berthon
Oil on canvas, 109.2 x 83.8 cm / 43 x 33"
Signed: (l.l.) G.T. Berthon
Commission, 1881. MGS 694156

According to Berthon's Sitters Notebook, 1866-1890, in the E.P. Taylor Reference Library, Art Gallery of Ontario, the artist received payment for this work on 19 September 1881.

Neither the immediate nor the ultimate source for this portrait is known for certain. However, Dr. Henry Scadding brought to Toronto a miniature portrait in ivory, copied from an oil painting in the collection of Capt. J. K. Simcoe, of Wolford, Devon, England (now in the collection of the Law Society of Upper Canada, Osgoode Hall, Toronto, see p. 166). Scadding had a steel engraving, based on the miniature, made for the frontispiece of his *Toronto of Old: Collections and Recollections* (Toronto: Adam, Stevenson and Co., 1873). Any of these published portraits, or Scadding's miniature could have served as the basis for Berthon's painting.

Another miniature portrait of Simcoe, in the collection of Mrs. F. J. Aumonier, Leatherhead, England, which closely resembles the copy commissioned by Dr. Scadding, has been tentatively attributed to William Berczy (1744-1873) by John Andre (*William Berczy: Co-Founder of Toronto*, Toronto: The Borough of York, 1967). This latter likeness may indeed be the *original* portrait-from-life on which subsequent copies were based, Berczy having been a personal acquaintance of Simcoe.

Artist: Walter S. Allward
Bronze on granite base; statue: 290.8 x 149.9 x 86.4 cm / 114¹/₂ x 59 x 34", base: 288.3 x 200.7 x 200.7 cm / 113¹/₂ x 79 x 79"
Signed: (l.r.) WALTER S. ALLWARD 1902
Inscribed: (in bronze, on base, recto) SIMCOE / Lieutenant-Colonel John / Graves Simcoe 1752-1806 / First Lieutenant-Governor / of Upper Canada 1791-1796 / Founder of the City of Toronto July 30th 1793.; (l.l.) THE HENRY BONNARD BRONZE CO. / FOUNDERS. N.Y. 1903.
Commission by the Ontario Historical Society, 1903. MGS 619876

This statue was paid for out of proceeds from the Simcoe Memorial Fund estab-

lished by the Ontario Historical Society in 1900. A request for assistance in fund-raising (the monument was expected to cost around $5000) was made to all teachers in the province who were asked to heighten their pupils' awareness of Simcoe's importance and to appeal for a modest contribution from each pupil. An initial legislative grant was made to the O.H.S. in the amount of $3000; an additional legislative grant of $500 was listed in *Public Accounts of Ontario, 1903*. Allward was chosen for the commission from among ten competitors. His sculpture was cast at the Henry Bonnard Bronze Co., Founders, New York and cutting of the pedestal inscription was by the McIntosh Granite Co., Toronto. The statue was unveiled on 27 May 1903 by His Excellency the Earl of Minto, with the Hon. William Mortimer Clark (and other dignitaries) in attendance.

Artist: J. W. L. Forster
Oil on canvas, 154.3 x 110.5 cm / 60³/₄ x 43¹/₂"
Signed: (l.l.) J. W. L. Forster
Commission, 1903. MGS 692994

A miniature portrait of Simcoe, obtained from Dr. Henry Scadding through Simcoe's family in England, served as a source for Forster's portrait. This miniature is now in the collection of the Law Society of Upper Canada, Osgoode Hall, Toronto.

Forster painted a half-length version of this portrait to serve as the frontispiece for Duncan Campbell Scott's *John Graves Simcoe*, in the special illustrated edition of the *Makers of Canada* series (Toronto and London: Oxford University Press, 1926); this painting is held by Public Archives Canada.

Lieutenant-Colonel Samuel Smith
(Administrator of Upper Canada, 1817-18; 1820)

Samuel Smith (b. Hempstead, Long Island, New York, 27 December 1756; d. York [Toronto], Upper Canada, 20 October 1826), born into a Loyalist family, joined the Queen's Rangers, being promoted to Captain by the age of 19. In 1815 Smith was appointed to the Executive Council of Upper Canada. On

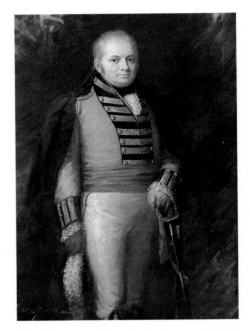

J.W.L. Forster, *Colonel John Graves Simcoe*, 1903

the retirement of Francis Gore in 1817 he became interim Administrator of the province until the arrival of Gore's successor, Sir Peregrine Maitland, the following year. The first act of the Legislature during this session imposed a duty upon the sale of alcoholic beverages as part of the effort to defray the costs of the recent war. In 1820 Smith again became Administrator for a brief period during Maitland's absence.

Artist: George T. Berthon
Oil on canvas, 109.2 x 81.3 cm / 43 x 32"
Commission, 1886. MGS 619844

According to Berthon's Sitters Notebook, 1866-1890, in the E.P. Taylor Reference Library, Art Gallery of Ontario, the artist received payment for this portrait on 1 June 1886. Berthon's source has yet to be determined, but it is likely that he copied a contemporary engraved or painted portrait of Smith.

John Dulmage Stennett, M.A.
(Principal, Toronto Teachers' College, 1966-72)

John Dulmage Stennett (b. Ridgetown, Ontario, 19 February 1915) was Principal

of the Toronto Teachers' College from 1966 to 1972.

Artist: Alan C. Collier
Oil on canvas, 100.3 x 85.1 cm/
39½ x 33½"
Signed and dated: (l.r.) Alan C. Collier
'73
Commission. MGS 623091

The Hon. John Stevenson
(Speaker of the Ontario Legislature, 1867-71)

John Stevenson (b. Hunterdon County, New Jersey, U.S.A., 12 August 1812; d. Napanee, Ontario, April 1884) emigrated with his family to the County of Leeds, Ontario. Stevenson later moved to Napanee, where he became successful as a merchant and businessman, and served as a Justice of the Peace, Reeve of Napanee and first Warden of the County of Lennox and Addington. From 1867 to 1871, he represented Lennox as a Reform M.P.P. On December 27, 1867, Stevenson was appointed the first speaker of the Ontario Legislature, a post he held for the duration of his term as M.P.P. Many of his Rules of Procedure still remain in effect.

Artist: E.A. Crossman
Charcoal and chalk on paper mounted on canvas, 125.7 x 80 cm/49½ x 31½"
Signed: (l.r.) E.A. Crossman/Artist/London
Purchase, 1887. MGS 606897

The significance of the figures "74" barely legible on the scroll held in Stevenson's left hand cannot yet be determined.

The Hon. William James Stewart, C.B.E.
(Speaker of the Ontario Legislature, 1944-47)

William James Stewart (b. Toronto, Ontario, 13 February 1889; d. Toronto, Ontario, 28 September 1969) was active in Toronto civic politics, becoming the city's Mayor (1931-34) prior to his election to the Ontario Legislature as a Progressive Conservative in 1938. He won successive elections in his riding of Parkdale, being defeated in 1948 but returned in 1951, 1955 and 1959. Following his retirement from politics, Stewart became Chairman of the

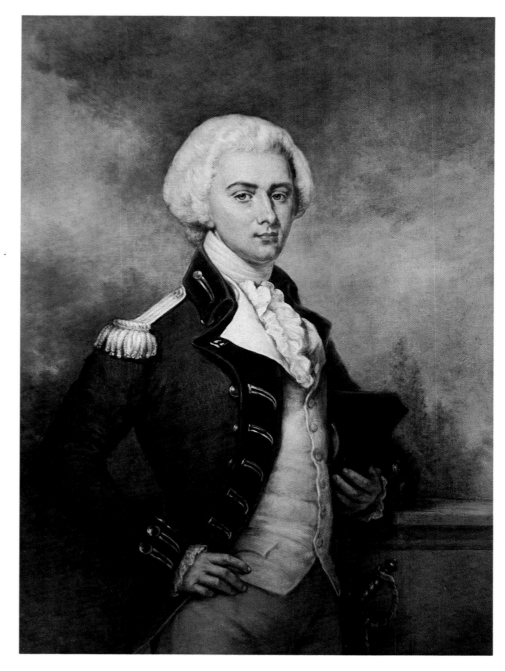

George T. Berthon, *Lieutenant-Colonel Samuel Smith*, 1886

Toronto Historical Board, a position he retained to his death. He was made a C.B.E. in 1935.

Artist: Archibald Barnes
Oil on canvas, 125.7 x 99.1 cm/
49½ x 39"
Signed: (l.l.) Barnes
Commission, 1950. MGS 692715

Major-General The Hon. Sir Henry William Stisted, K.C.B.
(Lieutenant Governor of Ontario, 1867-68)

Henry William Stisted (b. St. Omer, France, 1817; d. Surrey, England, 10 December 1875) was educated at Sandhurst and entered the British army in 1835. In recognition of his service in the eastern empire, he was created a C.B. in 1858. In 1864 he was promoted to the rank of Major-General.

In 1866 Stisted was appointed to a divisional command in Canada. It had been decided that following Confederation the chief imperial military officer should be the provisional Lieutenant Governor of each province, Stisted was appointed to that position for the new province of Ontario in 1867. He returned to England in 1868. In 1871, Stisted was created a K.C.B.

Artist: George T. Berthon
Oil on canvas, 109.2 x 82.6 cm/
43 x 32½"
Commission, c. 1887. MGS 693142
Probably painted from photographic sources.

The Hon. John Edward Stokes
(Speaker of the Ontario Legislature, 1977-81)

John Edward Stokes (b. Schreiber, Ontario, 17 February 1923) was first employed by the Canadian Pacific Railway in 1941 and became a railway conductor in 1950. In 1967 he was elected the New Democratic Party member for Lake Nipigon, Ontario's largest geographic constituency. From 1975 to 1977 Stokes served as Deputy Speaker and Chairman of the Committee of the Whole House and

Alan C. Collier, *John Dulmage Stennett*, 1973

from 1977 to 1981 held the office of Speaker of the Ontario Legislature.

Artist: Lynn Donoghue
Oil on canvas, 151.8 x 120 cm/
59¾ x 47¼"
Signed and dated: (l.l.) Donoghue 1978
Commission, 1978. MGS 622006

Bishop John Strachan, D.D., LL.D.
(first Anglican Bishop of Toronto)

John Strachan (b. Aberdeen, Scotland, 12 April 1778; d. Toronto, Ontario, 1 November 1867) was educated at the universities of Aberdeen (D.D., 1811) and St. Andrews (LL.D., 1827) before emigrating to Upper Canada in 1799. For a time he was a teacher in Kingston but in 1803 he was ordained a priest of the Church of England and appointed to the church at Cornwall, where he also ran a school. In 1812 he moved to York (now Toronto), was made Rector of York and master of the Home District Grammar School. He resigned the latter post upon his appointment in 1823 as General Superintendant of Education for Upper Canada. He was a member of the Executive Council from 1817 to 1836 and the Legislative Council from 1820 to 1841. In 1827 he was made archdeacon

E.A. Crossman, *The Hon. John Stevenson*

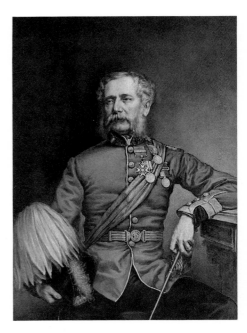

George T. Berthon, *Major-General The Hon. Sir Henry William Stisted*

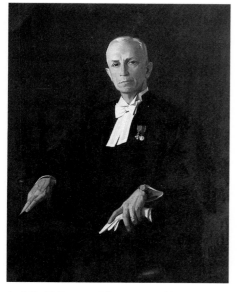

Archibald Barnes, *The Hon. William James Stewart*, 1950

of York and first president of King's College, and in 1839 he became the first Anglican bishop of Toronto.

Artist: George T. Berthon
Oil on canvas, 74.3 x 62.2 cm/
29¼ x 24½"
Commission, 1880. MGS 619822

Berthon's Sitters Notebook, 1866-1890, in the E.P. Taylor Reference Library, Art Gallery of Ontario, lists payment of $15 for a portrait of Strachan on 7 June 1880. This notation — the only reference to a Strachan portrait by Berthon — may indicate payment "on account," as Berthon's fees for official portraits were usually far higher than this amount. Since Strachan died in 1867, is it likely that this portrait would have been painted from photographic sources.

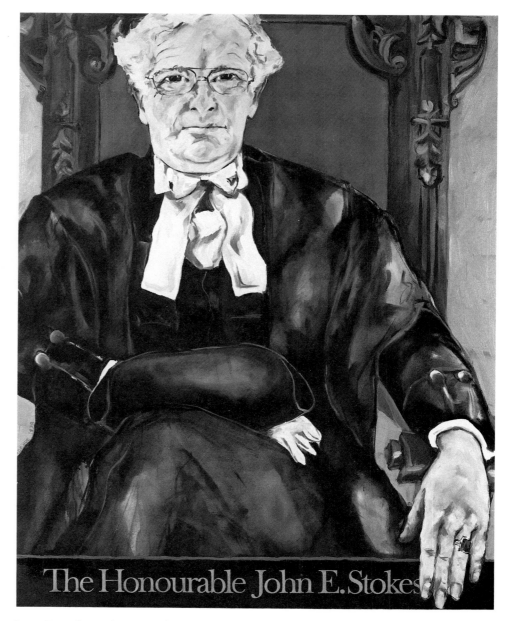

Lynn Donoghue, *The Hon. John Edward Stokes*, 1978

Tecumseh
(Shawnee Indian Chief, ally of the British in the War of 1812)

Tecumseh (b. on the banks of the Mad River, a tributary of the Ohio River, 1768; d. Moraviantown, near Detroit, U.S.A., 6 October 1813) was a chief of the Shawnee Indians who commanded

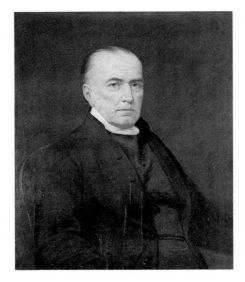

George T. Berthon, *Bishop John Strachan*, 1880

considerable influence among the Indians of the region. He sided with the British in the War of 1812. He was killed in the battle of Moraviantown and was buried in an unmarked grave near the battleground.

Artist: Hamilton Plantagenet MacCarthy
Two casts; each: 43.2 x 27.3 x 17.8 cm/ 17 x 10³/₄ x 7":
i) Bronze-coated terracotta
Signed and dated: (verso) H. MACCARTHY/SCULPT 1896
MGS 619883
ii) Terracotta
Signed and dated: (verso) H. MacCARTHY/SCULPT 1896
MGS 619884
Inscribed: (on base, each cast, recto) TECUMSEH
Purchase for the Educational Museum, Toronto Normal School, 1896.

The provincial government records list payment of $30 for "2 Pair of Busts in Terra Cotta" by MacCarthy in September 1896. These would represent the pair of busts of Sir Isaac Brock and Tecumseh. The catalogue of the 1896 *Toronto Industrial Exhibition* notes that these busts were executed for the Guild of Sculptors of Ontario. It is not certain which of the two copies acquired by the Educational Museum, Toronto, was on

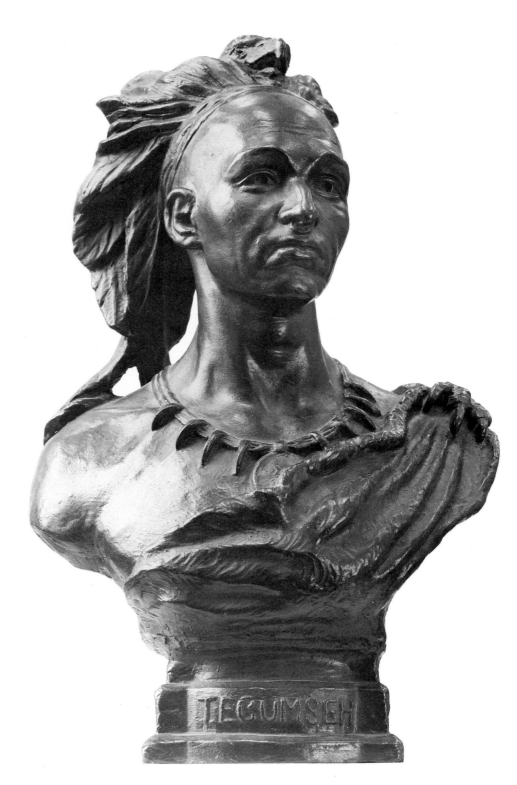

Hamilton P. MacCarthy, *Tecumseh*, 1896

display in this exhibition (cat. no. 353), although presumably it would have been the bronze-coated one.

Father John Reed Teefy, B.A., LL.D. (Superior of St. Michael's College, University of Toronto, 1880-1903)

John Reed Teefy (b. Richmond Hill, Canada West, 21 August 1848; d. Toronto, Ontario, 10 June 1911) was educated at the University of Toronto. In 1878 he was ordained a priest of the Roman Catholic Church and joined the staff of St. Michael's College, University of Toronto, becoming Superior of the College in 1889. He left this position in 1903 to become pastor of Holy Rosary Church. Teefy was appointed a member of the Board of Governors of the University in 1906.

Artist: Mildred Peel
Plaster, 61 x 43.2 x 33 cm/
24 x 17 x 13"
Signed and dated: (verso) M. Peel June 30, 1902
Commission for the Educational Museum, Toronto Normal School, 1902.
MGS 619703

Probably sculpted from life.

George T. Berthon, *The Rt. Hon. Charles Edward Poulett Thomson, Baron Sydenham,* 1885

Mildred Peel, *Father John Reed Teefy,* 1902

E. Wyly Grier, *Captain The Hon. Joseph Elijah Thompson*, 1927

Captain The Hon. Joseph Elijah Thompson
(Speaker of the Ontario Legislature, 1924-26)

Captain Joseph Elijah Thompson (b. Toronto, Ontario, 19 July 1867; d. Toronto, Ontario, 16 March 1941) served as the Conservative M.P.P. for Toronto Northeast — Seat "B" from 1919 to 1926. He was Speaker of the Ontario Legislature from 1924 to 1926, when he was elected the representative for the riding of St. David in the provincial Legislature. He continued to represent this riding until 1929.

Artist: E. Wyly Grier
Oil on canvas, 127 x 88.9 cm / 50 x 35"
Signed and dated: (l.l.) E. WYLY/GRIER/1927
Commission, 1927. MGS 692724

The Rt. Hon. Charles Edward Poulett Thomson, Baron Sydenham of Kent and Toronto
(Governor General of Canada, 1839-41)

Charles Edward Poulett Thomson (b. Wimbledon, Surrey, England, 13 September 1799; d. Kingston, Canada West, 19 September 1841), son of a wealthy timber merchant, was elected to the British House of Commons as a Liberal member for Dover in 1826. He was later appointed to Cabinet, holding this post until appointed Lord Durham's successor as Governor General of Canada in 1839.

Thomson was to implement Durham's recommendations concerning the unification of the two Canadas. He took up the duties of Lieutenant Governor of Upper Canada during the initial period of negotiations for unification, requesting Sir George Arthur to reassume the post in February 1840. Adopting a non-partisan approach, Thomson gained the confidence and respect of both the Reform party and moderate Tories, and quickly set in motion the process that would lead to responsible government in the Canadas. The Act of Union became effective in February 1841. The same year, municipal institutions were established in Upper Canada and the Clergy Reserves were redistributed on a more equitable basis. Notwithstanding widespread and violent opposition in Lower Canada, Thomson opened the first Parliament of Canada in Kingston. His health failing, Thomson tendered his resignation in July 1841, as the closing session of the new Parliament drew near. On the eve of his intended return to England, however, he was thrown from his horse and received severe injuries from which he died two weeks later.

In honour of his achievements, Thomson was created Baron Sydenham of Kent and Toronto.

Artist: George T. Berthon
Oil on canvas, 109.2 x 81.3 cm / 43 x 32"
Commission, 1885. MGS 693138

According to Berthon's Sitters Notebook, 1866-1890, in the E.P. Taylor Reference Library, Art Gallery of Ontario, the artist received payment for this portrait on 3 October 1885. It is based on an engraving by W.H. Mote after a portrait by Sir George Hayter (1792-1871), who included Lord Sydenham in his huge *The First Meeting of the First Reformed Parliament*, of 1833-43 (National Portrait Gallery, London). The engraving was published in Saunders' *Portraits and Memoirs of Eminent Living Political Reformers* (London: John Saunders, Jr., 1840).

Queen Victoria
(Queen of Great Britain and Ireland, 1837-1901)

Alexandrina Victoria (b. London, England, 24 May 1819; d. Osbourne, Isle of Wight, 22 January 1901) was the only child of Edward Augustus, Duke of Kent, fourth son of George III, and Victoria Mary Louisa, daughter of the Duke of Saxe-Saalfeld-Coburg. Her parents left Franconia, their home, so that Victoria would be English-born. Although an intelligent child, demonstrating in later life a considerable grasp of politics and international affairs, she did not benefit from a broad education. Upon the death of William IV on June 20, 1837, Victoria began the longest reign in British history — lasting more than 63 years.

Despite her long-lasting political liberalism, Victoria's antipathy to William Gladstone (Liberal Prime Minister, 1868-74; 1880-85; 1886; 1892-94) led her to make strenuous and nearly unconstitutional efforts to prevent his becoming Prime Minister in 1880. Also questionable was her great reliance upon Benjamin Disraeli (Prime Minister, 1868; 1874-1880) who introduced the bill naming her Empress of India in 1876.

Victoria married Prince Albert of Saxe-Coburg-Gotha in 1840, and while he was alive she was very active in society and public affairs. She was the first monarch to visit the British industrial centres and in the late 1840s and 1850s she successfully intervened in the political confusion following the 1846 repeal of the Corn Laws. Being personally close to many European rulers, Victoria opposed the efforts of Lord Palmerston (Foreign Secretary, 1846-51) to strengthen the democratic movements on the Continent. Palmerston's departure from the cabinet was in part due to her disapproval of him. Victoria's attempts to prevent the Crimean War cost her some of her popularity, but when war broke out in 1854, she became active in organizing relief for the wounded.

Albert's death in 1861 deprived her of an able advisor and the changing course of events found her gradually less effective politically. Victoria nevertheless retained the near adulation of her subjects to the end of her reign.

Artist: F. A. T. Dunbar
Bronze, 77.5 x 47 x 25.4 cm/
30½ x 18½ x 10"
Signed and dated: (verso) F. A. T.
Dunbar 1889
Inscribed: (verso) Copied (the head and
shoulders)/From the bust by J. E.
Boehm/from the life by F. A. T.
Dunbar/Sculptor/London 1889
Commission for Government House,
Toronto, 1889. MGS 626224

Based on a bust of Queen Victoria by
Viennese-born British sculptor Sir
Joseph E. Boehm (1834-1890), dated *c.*
1887, a version of which is in the
National Portrait Gallery, London. In
May 1879 Dunbar left Ottawa to study
in Europe, carrying letters of introduc-
tion from his patron the Governor
General, the Marquis of Lorne, to
Boehm, who was then living and
working in Florence. Dunbar returned to
Toronto and is recorded as being
resident there from 1900 to 1903. He
executed two other busts of Queen
Victoria which were rejected by the
Toronto Guild of Civic Art.

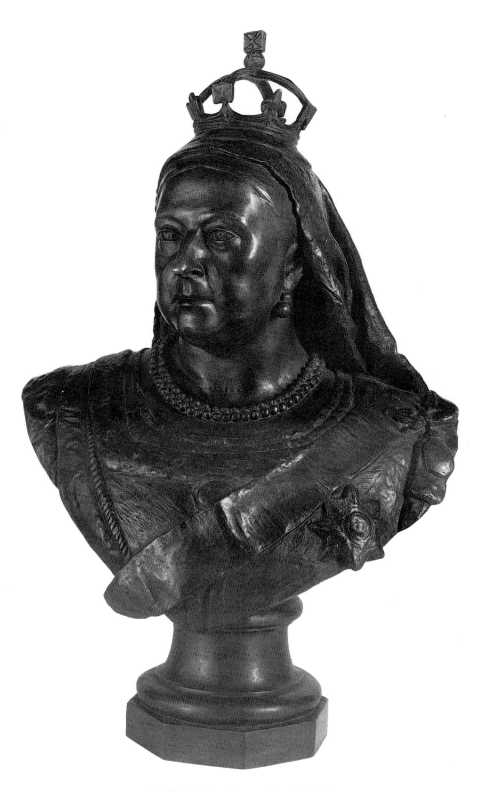

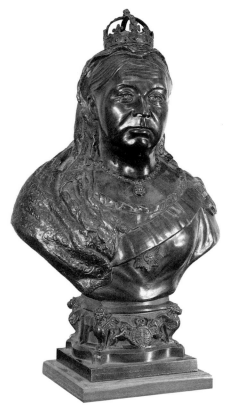

Hamilton P. MacCarthy, *Queen Victoria*,
1897

F.A.T. Dunbar, *Queen Victoria*, 1889

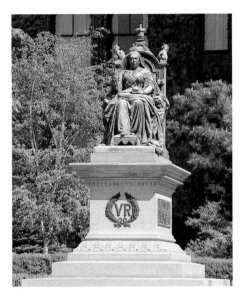

Mario Raggi, *Queen Victoria*

Artist: Hamilton Plantagenet MacCarthy
Bronze-coated terracotta, 43.2 x 27.9 x 17.8 cm / 17 x 11 x 7"
Signed and dated: (verso) H. MACCARTHY, R.C.A./SCULPTOR/ REG'D 1897
Inscribed: (verso) H. M.; [Royal Coat of Arms]
Purchase from the artist for the Educational Museum, Toronto Normal School, 1897. MGS 619881

In the creation of this likeness, MacCarthy used photographs of the Queen taken about ten or twelve years before the Jubilee. He possibly executed his portrait for the Guild of Sculptors of Ontario, as he did his busts of Isaac Brock and Tecumseh. Two copies of this work were acquired for the Educational Museum, Toronto Normal School in July 1897, but only one bust has survived.

Artist: Mario Raggi
Bronze on granite base; statue: 279.4 x 139.7 x 193 cm / 110 x 55 x 76", base: 274.3 x 320 x 396.2 cm / 108 x 126 x 156"
Signed: (l.r., on bronze base, west side) M. Raggi Sc.
Inscribed: (in bronze relief, on granite base, south side) VR (royal monogram, surrounded by a bronze wreath)
Statue: purchase from the artist, 1901;

pedestal: commission from the McIntosh Granite and Marble Co., 1902. MGS 619874

On the east and west sides of the pedestal are affixed two bronze plaques in low relief representing, respectively, Victoria's first council at Kensington Palace, 20 June 1837, and her lying-in-state (framed by two angels).

The foundation stone for this monument was laid by the Prince of Wales during his Royal Visit of 1860 at the entrance to Queen's Park where the monument to Sir John A. Macdonald now stands. In 1870 the City of Toronto brought Raggi's statue of Queen Victoria from England and had it installed on the foundation stone laid ten years earlier. The Queen Victoria statue remained there only a few years before it was returned to England because of the inability of the City of Toronto to raise sufficient funds. In 1894 the monument to Sir John A. Macdonald was erected in its place.

In 1901, the same bronze statue of Queen Victoria was purchased from the artist by the Ontario Government. The McIntosh Marble Co. prepared a suitable base which was completed in the spring of 1902 and the statue was unveiled 26 May 1903 by Hon. Richard Harcourt, Minister of Education.

Field Marshal, the Duke of Wellington, K.G., P.C., G.C.B.

Arthur Wesley (later Wellesley) (b. Dublin, Ireland, 1 May 1769; d. Walmer Castle, near Dover, Kent, England, 14 September 1852) was educated at Chelsea and Eton. In 1787 he began his military career as aide-de-camp to the Lord-Lieutenant of Ireland, a post he held until 1793. From 1790 to 1797 he held a seat in the Irish parliament for Trim. In April 1793, wishing to see action against revolutionary France, Wellesley purchased a majority in the 33rd Foot, becoming the regiment's Lieutenant-Colonel within five months. Following the British rout at Bremen in 1795, Wellesley returned to Ireland.

From 1797 to 1805, Wellesley served in India, where he attained the rank of Major-General. For his contributions to the defence of British interests there, Wellesley was created a K.B. in 1805, just prior to his return to England.

Between 1806 and 1809 he saw further

Mildred Peel, *The Hon. Rupert Mearse Wells*, 1903

J.W.L. Forster, *The Hon. Sir James Pliny Whitney*, 1906

action in Europe and was intermittently Chief Secretary for Ireland. In 1809 he began an extended term in Europe, remaining until the conclusion of the Peninsular War. In 1814, among many other honours, Wellesley received the

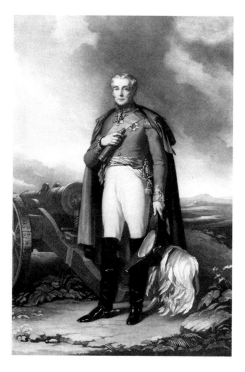

John Lucas, *Field Marshal, the Duke of Wellington*

K.G., was created the Duke of Wellington and made ambassador to the court of Louis XVIII (who had been installed by the Treaty of Paris). He was present at the Congress of Vienna when, in March 1815, the European powers received news of Napoleon's escape from Elba. Commanding the allied army of 150,000 men, and receiving reinforcements from the Prussian army of 115,000 only at the last minute, Wellington defeated Napoleon at Waterloo on 18 June 1815. Wellington was commander-in-chief of the occupation forces in France until 1818.

Returning to England, he re-entered political life, becoming Prime Minister in 1828. His opposition to parliamentary reform contributed to the defeat of his government and earned him continued unpopularity throughout the agitation for the Reform Bill. In 1834 he served briefly as Prime Minister during Robert Peel's absence and in 1841 joined the latter's second ministry, supporting the repeal of the corn laws as a political necessity. Although retiring from

political life with the fall of this government, Wellington remained commander-in-chief, thus organizing the defence of London against the Chartists in 1848. He was buried next to Lord Nelson at St. Paul's Cathedral.

Artist: John Lucas
Hand-tinted mezzotint, 73.7 x 45.7 cm / 29 x 18" (sight); 67.3 x 43.2 cm / 26½ x 17" (image)
Inscribed: (typeset, l.c.) FIELD MARSHAL, THE DUKE OF WELLINGTON / From the original Picture presented by His Grace / to his distinguished Friend and Companion in Arms the Marquis of Anglesey / Painted and engraved by John Lucas.
MGS 619718

The Hon. Rupert Mearse Wells, K.C. (Speaker of the Ontario Legislature, 1874-79)

Rupert Mearse Wells (b. 1835; d. Toronto, Ontario, 11 May 1902) was educated at the University of Toronto (B.A., 1854) and called to the bar in 1857 (Q.C., 1876). He practised law in Toronto prior to his election as a Liberal M.P.P. in the by-election of 1872 in Bruce South. The Hon. Rupert Mearse Wells held the office of Speaker of the Ontario Legislature from 1874 to 1879. In 1882 he resigned his seat in the Legislature in order to run for the House of Commons, where he represented the riding of Bruce East from 1882 until his electoral defeat in 1887.

Artist: Mildred Peel
Oil on canvas, 75.6 x 62.2 cm / 29³/4 x 24¹/2"
Signed and dated: (u.r.) M. Peel. / 1903
Commission, 1903. MGS 692928
Presumably painted from photographic sources.

The Hon. Sir James Pliny Whitney, K.C.M.G., K.C., D.C.L., LL.D. (Premier of Ontario, 1905-14)

James Pliny Whitney (b. Williamsburg, Canada West, 2 October 1843; d. Toronto, Ontario, 25 September 1914) was educated in Cornwall and called to the bar in 1876 (Q.C., 1890). Whitney, who practised law in Morrisburg, was elected to the Legislature in 1888 as the

Conservative member for Dundas, becoming Leader of the Opposition in 1896. In 1905 his party, revitalized largely due to his own efforts, came to power and Whitney became both Premier and President of the Council, positions he retained until his death. During his administration, northern Ontario was developed and educational facilities were augmented while political patronage and electoral abuses diminished. With his minister, Adam Beck, Whitney was responsible for establishing the Ontario Hydro-Electric Power Commission. He strongly supported Canadian involvement in the first World War, but his death in September preceded Ontario's major commitment to the war. Whitney was knighted (K.C.M.G.) in 1908.

Artist: J. W. L. Forster
Oil on canvas, 218.4 x 134 cm / 86 x 52³/4"
Signed: (l.r.) J. W. L. Forster
Commission, 1906. MGS 693206

Artist: Hamilton Plantagenet MacCarthy
Bronze on limestone base; statue: 261.6 x 142.2 x 152.4 cm / 103 x 56 x 60", base: 397.5 x 365.8 x 365.8 cm / 156¹/2 x 144 x 144"
Signed: (l.l., on bronze base) Hamilton MacCarthy R.C.A. Sculptor
Inscribed: (on limestone base, recto) WHITNEY
Commission, 1927. MGS 619875

This work was unveiled on 20 May 1927 by the Hon. W.D. Ross, Lieutenant Governor of Ontario. The monument's pedestal was constructed by the McIntosh Granite Co., Toronto. *Public Accounts of Ontario 1919-20* records an amount paid to Walter S. Allward for designing and modelling a monument to the late Sir James Whitney; however, records from 1923 to 1927 show payments to Hamilton MacCarthy for the Whitney monument. It is possible that Allward was originally commissioned to design the statue, and MacCarthy was called in to execute it, either from his own designs or from Allward's.

David Whyte, B.Paed. (Principal of the Hamilton Normal School, 1926-29; Principal of the Toronto Normal School, 1929-38)

Charles MacGregor, *David Whyte*

Hamilton P. MacCarthy,
Sir Daniel Wilson, 1890

David Whyte (b. 1870; d. 1954) was
Principal of the Hamilton Normal
School from 1926 until his transfer to
the Toronto Normal School, where he
served as Principal from 1929 until his
resignation in 1938.

Artist: Charles MacGregor
Oil on canvas, 100.3 x 85.1 cm/
39¹/₂ x 33¹/₂"
Signed: (l.l.) C. Macgregor.
Commission. MGS 623325

Sir Daniel Wilson, Kt., F.R.S.C.
(President of University College,
1880-92; President of the University
of Toronto, 1887-92; President of the
Royal Society of Canada, 1885-92)

Daniel Wilson (b. Edinburgh, Scotland,

5 January 1816; d. Toronto, Ontario, 6
August 1892) was educated at Edinburgh
University. He emigrated to Canada in
1853 to assume the chair of history and
English literature at University College,
Toronto. In 1880 he was appointed
President of University College and in
1887 became President of the
University, holding both posts until his
death. Sir Daniel Wilson was created a
knight bachelor in 1888 and was
President of the Royal Society of Canada
from 1885 to 1892.

*Artist: Hamilton Plantagenet
MacCarthy*
Plaster, 71.1 x 57.2 x 34.3 cm/
28 x 22¹/₂ x 13¹/₂"
Commission for the Educational
Museum, Toronto Normal School, 1890.
MGS 619734.

Sculpted from life.

Major-General James Wolfe
(Commander-in-Chief of the British
Forces, 1759, at the taking of
Quebec)

James Wolfe (b. Westerham, England, 2
January 1727; d. Quebec, New France,
13 September 1759) entered the military
in 1741, becoming a Colonel by 1756. In
1758 he served under Jeffrey Amherst
during the successful seige of Louis-
bourg on Ile Royale (Cape Breton
Island). On 12 January 1759, Wolfe was
appointed Major-General and
Commander-in-Chief of the land forces
to campaign against Quebec. He
launched his first major attack in July at
the Montmorency River, but was forced
to withdraw. Wolfe was loath to attempt
another frontal attack; however, his
naval support maintained a heavy
bombardment of the city from the
opposite shore of the St. Lawrence. By
13 September conditions seemed
favourable for another assault.
 British warships, firing upon the city
from immediately below, led the
Marquis de Montcalm, Commander-in-
Chief of the French forces, to believe an
attack from this direction to be
imminent. But Wolfe's troops landed on
the Anse au Foulon (Wolfe's Cove) some
distance upstream, and quickly climbed
the heights to the Plains of Abraham.
Lest the British forces set up camp and

Hamilton P. MacCarthy, *The Hon. Sir James Pliny Whitney*, 1927

perhaps take the city by storm, Montcalm attacked immediately, but the French forces were routed in less than twenty minutes fighting. Wolfe himself was killed in the battle, and Montcalm was mortally wounded. The city surrendered on 18 September, 1759.

Artist: J.W.L. Forster
Oil on canvas, 153 x 110.5 cm/
60¼ x 43½"
Signed: (l.r.) J W L Forster
Commission, 1901. MGS 692991

Forster based his sketch for the portrait on a painting by Joseph Highmore (1692-1780), thought to have been done in 1742, of Wolfe as a young lieutenant. Forster's painting portrays Wolfe, in a different uniform, standing in a boat approaching the Anse au Foulon in the dark of early morning.

The portrait of Wolfe by Highmore, from which Forster's is derived, was acquired by Prime Minister William Lyon Mackenzie King in 1923 and is now in the Public Archives Canada. Another version, acquired in 1953, is in the Canadiana Collection of the Royal Ontario Museum. Public Archives Canada owns a copy by Forster after the Ontario Government's portrait of Wolfe.

J.W.L. Forster, *Major-General James Wolfe*, 1901

THE PORTRAIT ARTISTS

Walter Seymour Allward, R.C.A.,
F.R.A.I.C.
Born: Toronto, Ontario,
18 November 1875
Died: Toronto, Ontario, 24 May 1955
Honours: LL.D.; C.M.G.

Archibald George Barnes, O.S.A.,
R.C.A.
Born: London, England,
19 March 1887
Died: Toronto, Ontario,
18 November 1972

George Theodore Berthon, O.S.A.,
R.C.A.
Born: Vienna, Austria, 3 May 1806
Died: Toronto, Ontario,
18 January 1892

Charles Bell Birch, A.R.A.
Born: London, England, 1832
Died: London, England,
16 October 1893

Daniel Boles
Born: Oakland, California, U.S.A.,
1 April 1929

Alan Caswell Collier, O.S.A., R.C.A.
Born: Toronto, Ontario,
19 March 1911
President, O.S.A. 1958-60

Charles Fraser Comfort, C.S.P.W.C.,
O.S.A., R.C.A., F.R.S.A.
Born: Edinburgh, Scotland,
22 July 1900
President, C.S.P.W.C. 1950-52; R.C.A.
1957-60
Honours: LL.D.

Anna Rockwell Compton
Born: Port Hope, Canada West, 1853
Died: 1928

Pietro Corollo
fl. 1916

E.A. Crossman
fl. 1884

Nickola de Grandmaison
Born: Russia, 1892
Died: Calgary, Alberta,
23 March 1978

Roberto De'Seta
Born: Rome, Italy,
25 January 1937

John Darley Adrian Dingle, O.S.A.,
R.C.A., O.I.P.
Born: Barmouth, North Wales,
4 February 1911
Died: Toronto, Ontario,
22 December 1974

Janet Lynn Donoghue
Born: Red Lake, Ontario,
20 April 1953

Frederick Alexander Turner Dunbar,
A.R.C.A., O.S.A.
Born: Guelph, Canada West, 1849
Died: Wilmington, Delaware, U.S.A.
1921

John Colin Forbes, O.S.A., R.C.A.
Born: Toronto, Canada West,
23 January 1846
Died: Toronto, Ontario,
28 October 1925

Kenneth Keith Forbes, O.S.A., R.C.A.
Born: Toronto, Ontario, 4 July 1892
Died: Toronto, Ontario,
25 February 1980
Honours: O.C.

John Wycliffe Lowes Forster, O.S.A.,
A.R.C.A., R.C.I.
Born: Norval, Canada West,
31 December 1850
Died: Toronto, Ontario,
24 April 1938

Samuel Gardner
Born: Kingston, Ontario, c. 1816
Died: Woodhouse Township, Ontario, 6
February 1893

Allen Good
fl. 1958

Edmund Wyly Grier, R.C.A., O.S.A.
Born: Melbourne, Australia,
26 November 1862
Died: Toronto, Ontario,
7 December 1957
President, O.S.A. 1908-13; R.C.A.
1929-39
Honours: Kt., D.C.L.

Théophile Hamel
Born: Ste-Foy, Lower Canada,
8 November 1817
Died: Quebec, Quebec,
23 December 1870

Robert Harris, O.S.A., R.C.A.
Born: Cydd, Wales,
18 September 1849
Died: Montreal, Quebec,
27 February 1919
President, O.S.A. 1880; R.C.A.
1893-1906
Honours: C.M.G.

Louis-Philippe Hébert, R.C.A.
Born: Ste. Sophie d'Halifax, Canada
East, 27 January 1850
Died: Montreal, Quebec,
13 June 1917
Honours: Canadian Government
Confederation Medal, Knight of the
Legion of Honour, C.M.G.

George William Hill, R.C.A.
Born: Shipton County, Canada East, 8
May 1862
Died: Montreal, Quebec,
17 July 1934

Elizabeth Mary Bradford Holbrook,
O.S.A., R.C.A.
Born: Hamilton, Ontario,
7 November 1913

Arthur Edward Cleeve Horne, O.S.A.,
R.C.A.
Born: Jamaica, B.W.I., 9 January 1912
President, O.S.A. 1949-51

Richard Jack, A.R.A.
Born: Sunderland, England, 1866
Died: Montreal, Quebec,
30 June 1952

Kenneth Jarvis
Born: Toronto, Ontario,
2 December 1926

Farquhar McGillivray Strachan Stewart Knowles, O.S.A., R.C.A.
Born: Elora, Canada West,
22 May 1859
Died: Toronto, Ontario, 9 April 1932

Demetrios Kokotsis
Born: Crete [?]
fl. 1948

Marion Long, O.S.A., R.C.A.
Born: Toronto, Ontario,
19 September 1882
Died: Toronto, Ontario,
17 August 1970

George Lonn, O.I.P.
Born: Rockanville, Saskatchewan,
24 November 1914
President, O.I.P. 1972

John Lucas, R.A.
Born: London, England, 1807
Died: London, England, 1874

Coeur-de-Lion MacCarthy
Born: England
Died: 22 January 1979

Hamilton Thomas Carleton Plantagenet MacCarthy, O.S.A., R.C.A.
Born: London, England, 28 July 1847
Died: Ottawa, Ontario,
24 October 1939

Evan Weekes Macdonald, O.S.A., A.R.C.A.
Born: Guelph, Ontario, 9 June 1905
Died: Guelph, Ontario,
22 January 1972
Honours: LL.D.

Charles MacGregor, O.S.A., A.R.C.A.
Born: Edinburgh, Scotland,
4 November 1893
Died: 1978

June Forbes McCormack
Born: London, England,
6 June 1921
Died: Toronto, Ontario, 28 June 1961

Thomas Mower Martin, O.S.A., R.C.A.
Born: London, England,
5 October 1838
Died: Toronto, Ontario,
15 March 1934

Ambrose Wilcock Mason
Born: Bickleigh, Devonshire, England,
16 February 1851

Julius Theodore Melchers
Born: Soest, Westphalia,
Prussia, 1829
Died: Detroit, Michigan, U.S.A.,
1908

Richard Robert Miller
Born: Windsor, Ontario, 4 July 1931

Stanley Gordon Moyer
Born: Mildmay, Bruce County, Ontario,
22 December 1887
Died: Guelph, Ontario, 22 May 1968

Lilias Torrance Newton, R.C.A.
Born: Montreal, Quebec,
3 November 1896
Died: Cowansville, Quebec,
10 January 1980

Andrew Dickson Patterson, O.S.A., R.C.A.
Born: Picton, Canada West, 30 June 1854
Died: Montreal, Quebec, 31 July 1930

Amelia Margaret Mildred Peel, O.S.A.
Born: London, Canada West,
26 October 1856
Died: Laguna Beach, California, U.S.A.,
29 February 1920

Linda Pilby
fl. 1968

Manfred Pirwitz
Born: Berlin, Germany, 31 July 1939

Mario Raggi
Born: Carrara, Italy, 1821
Died: Farnham, Surrey, England, 26 November 1907

John Wentworth Russell
Born: Binbrook, Ontario,
28 August 1879
Died: Toronto, Ontario,
5 November 1959

Kenneth Charles Saltmarche
Born: Cardiff, Wales,
29 September 1920
Honours: LL.D.

Joseph Ernest Sampson, O.S.A., A.R.C.A.
Born: Liverpool, England,
11 July 1887
Died: Toronto, Ontario,
29 October 1946

John Singer Sargent, R.A., R.W.S.
Born: Florence, Italy, 1856
Died: London, England,
15 April 1925

Austin Shaw
fl. 1919

F. May Simpson
fl. 1912

Felix Weihs
fl. 1939

Albert Curtis Williamson, O.S.A., R.C.A.
Born: Brampton, Canada West,
2 January 1867
Died: Toronto, Ontario,
18 April 1944

Marshall Wood
Died: Brighton, England, July 1882

(Facing Page) Barbara Astman, *Red*, 1980

Robarts and Renewal

THE NEW ART PROGRAMS

*O*n December 16, 1968, Premier
John Robarts rose in the Legislature
in response to a question regarding the proce-
dures for the selection of art for the new civil
service complex, the Macdonald Block, at
Queen's Park. The two vying artistic factions,
the *avant-garde* and the traditionalists, were up
in arms over the selections made for the "art-in-
architecture" program instituted by the Depart-
ment of Public Works for the new complex. The
Premier aptly commented in the House that "it
takes more than a mere mortal to solve this
particular problem," but that the government
would do everything in its power to make deci-
sions with a minimum of friction. Ultimately,
as he suggested, one solution to the controversy
might well be "to have no art at all."[1] Luckily
Premier Robarts did not buckle to controversy
and cancel the art program — rather, he began
one. Robarts is the figure principally responsible
for the contemporary collection as we know it
today. In 1966, he resurrected an art-buying
program for the collection after a hiatus that had
lasted more than fifty years.

The new program, instituted in 1966, involved
the commissioning of works of art for an archi-
tectural environment, namely works specifically
designed by the artist for a particular site. This
program is still in effect almost twenty years
after its inception.[2]

The Macdonald Block controversy in which
Premier Robarts found himself involved raged
over the usual issue, selection procedures. At
the suggestion of the architectural consortium
which designed the buildings, a percentage of
the construction cost was allocated for the com-
missioning of works of art — murals and
sculptures — by Canadian artists for the public
areas of the complex. The Department of Public
Works, under whose jurisdiction the project fell,
co-ordinated the program and was eager to enter
into a relationship of artist and architect, suc-
cessful precedents for which had already been
set by the federal government and the private
sector. When the project was finally completed,

most of it in 1968 (one sculpture, Gerald Glad-
stone's *Three Graces*, was not completed until
1972), twenty-three murals and six large sculp-
tures had been commissioned for a total outlay
of $328,550. The intent of the Queen's Park
Project, as outlined by Robarts, was "to promote
a greater appreciation of the work of Canadian
artists and to enhance the architecture of the
building."[3] This philosophy is maintained to the
present day and is the informing principle
behind the government's collection of
contemporary art, now numbering more than
500 works.

The controversy at the inception of the devel-
opment of the contemporary collection revolved
around not only the selection procedures and the
works selected, but also the committee choosing
the works. All these factors are by now, to the
reader, not unfamiliar, for they hark back to the
same criticisms of the Ontario Society of Artists
in the collecting phase at the turn of the cen-
tury. A three-man committee, "The Art Consul-
tant Committee for the Queen's Park Project,"
appointed by the Department of Public Works,
was the focus of contention. The decision-
making power of the committee rested exclus-
ively with members of the "old guard" of the
artistic community, the Royal Canadian
Academy — the chairman was portrait painter
Cleeve Horne, and the other two adjudicators
were artists Peter Haworth and Clare Bice.
Although there were representatives on the
committee from both the Department of Public
Works and the architectural consortium, all
decisions regarding the commissions for works
of art were made primarily by these three
artists.

It had originally been intended that competi-
tions for the commissions be held; however, the
committee soon decided against this procedure
as it would inevitably be time-consuming,
costly, and ineffectual. Although the works of
more than 700 artists were reviewed, one of the
primary objections, particularly from the *avant-
garde* community, was that the three committee

Artist Herb Ariss in front of his mural, *Untitled*, 1968

Jack Bush, *Untitled, c.* 1966-68

Harold Town, *Untitled*, c. 1966-68

members belonged to the R.C.A. and, as they were artists in their own right, it was considered likely that biases and prejudices would be involved in any selection. Furthermore, it was thought that the committee would select artists from the R.C.A. and that they represented the kind of taste that favoured ''middle-of-the-road,'' traditional art.

These concerns were evidently valid. Most of the artists whose works are represented were in fact members of the Royal Canadian Academy or members of some artists' society. Probably half of the selections could now be termed, as they were by the art critics in the 1960s, ''middle-of-the-road.''Despite the fact that the majority of the works are abstract, the decorative elements in many, particularly in the case of the relief murals, make them appear less characteristic of the various art movements of the radical 1960s. The most significant works, perhaps more so today looking at the selections in retrospect, are those by artists such as Ralph Allan, Herb Ariss, Jack Bush, Kazuo Nakamura, Harold Town and York Wilson.

These murals are quite indicative of those artists' work of the 1960s, for they were not given themes or subject matter to follow. However, three artists of the group were given subject themes. A.J. Casson, the well-known member of the Group of Seven, was asked to produce a mural depicting some aspect of social commentary. He chose to show the rural environment of Ontario's farming and village communities. The economic theme was given to Alan Collier, whose *Mining in Ontario* is reflective of the province's great mineral resources and industry. The cultural theme was given to Donald Lewis, familiar to many as a set designer for the Stratford Shakespearean Festival, who chose to represent that aspect of the province's cultural life. Although on the whole these three panels are successful in the particular environment of the Macdonald Block, they are not completely indicative of the kind of work these artists were producing at the time. The imposition of themes on artists' work in any ''art-in-architecture'' program necessarily

(Above) Artist Donald Lewis in front of his mural, *Stratford*, 1968

(Right) Artist A.J. Casson in front of his mural, *Untitled*, 1968

limits creativity to some degree. This stricture is less the case in the commissioning of large sculpture.

Competitions are a natural solution for contemporary sculpture. Commissions for large public sculpture provide creative scope that would be impossible under normal studio circumstances. Four of the six sculptures selected for the project were positioned at the major entrances to the complex; for example, Walter Yarwood's *Pines* at the entrance to the Ferguson Block and Louis Archambault's *Man and*

The artist Walter Yarwood installs his sculpture, *Pines*, 1968

Woman at the entrance to the Hepburn Block. E.B. Cox's mixed-media *The Days of the Year* was placed in the courtyard, and Gerald Gladstone's *Untitled* sculpture of acrylic cubes in the interior. By late 1968 it was decided that another sculpture should be added outside the main entrance of the Macdonald Block on Bay Street.

The Art Consultant Committee for the Queen's Park Project, in conjunction with the Fédération des Co-operatives du Nouveau-Québec, acquired a soapstone carving by the Inuit artist Paulosie Kanayook of Povungnituk, Quebec. The artist's soapstone was used as a model for an enlarged reproduction, carved in rough out of black granite by Louis Temporale. Kanayook was flown to Toronto and spent a week finishing the work which Temporale had copied and enlarged at his firm, Canadian Art Memorials Limited. The work sparked its own controversy, presumably because the artist had been asked to cope with such instruments as power drills and other modern machinery in order to complete the work — a far cry from the simple tools he had used to carve his original *Hunter with Seal*.

The artist Louis Archambault installs his sculpture, *Man and Woman*, 1968

Despite these concerns the Kanayook/Temporale work is perhaps the best-known of the outdoor sculptures which surround the complex.

Although controversy raged well into 1969, the Queen's Park Project set the tone for collect-

ing which is still in effect today. Not only does the program support the visual arts in the province and give increased visibility to Ontario artists, it serves also to provide a superior work environment, as noted by the Deputy Minister of Public Works in a 1968 interview with Arnold Edinborough of *The Financial Post*:

> Put people in a scruffy building and soulless surroundings and you'll get sloppy work and a soulless work force. Put them in a building that shows their employer cares about them and they'll show they care about you. [4]

Aptly, Edinborough's article was titled "Office Art, Canadian-style: it helps keep civil servants civil." This official's idea of the effect of art harks back to the concept of the benefits of art as first proposed for the province by that greatest of all public servants, Egerton Ryerson. The "art-in-architecture" program in this first instance might also be favourably compared to the development of the portrait collection, where, with the erection of a new Government House in 1870 and the Legislative Building at Queen's Park in 1893, expanses of empty wall space had to be filled. The 1960s and 1970s saw a flurry of construction activity for new government buildings throughout the province, structures also with many empty walls. This practical need, coupled with a desire to support the visual artists of the province, is perhaps the reason that the initial project for the Queen's Park complex had significant impact to ensure the continuation of the program.

The precedent set by art for the Macdonald Block was followed in 1974 in the next major project, whereby art was commissioned for a new provincial complex, the George Drew Building, Centre for Forensic Science, on Grosvenor Street in Toronto. As the nature of the building limited public access to some degree, only two sites were suggested for public art, the main entrance and the lobby on the first floor. After a lengthy competition, two artists were selected to execute large scale works; Ted Bieler's aluminum sculpture, *Mudra*, stands at the exterior entrance, while James Spencer's monumental acrylic mural, *Mountain #4*

The artist Paulosie Kanayook puts finishing touches to the granite sculpture, *Hunter with Seal*, with Louis Temporale, 1968

James B. Spencer,
Mountain #4, c. 1975-77

dominates the interior lobby space. The Drew Building competition, although limited in scope, was an important project and set the terms for the development of a firm policy which would take effect in 1975. The policy, although revised many times over the years, today still serves as the basis for the growth of the collection by means of commissions through public competitions for the "art-in-architecture" program.

In broad terms the working policy that developed is to encourage the work of Ontario artists, even though the first project, that for the Macdonald Block complex, was more national in scope, selecting artists from across Canada. Art competitions are held by the Ministry of Government Services (the successor to the Department of Public Works) for major capital projects, that is, large, new government buildings. For each project an Art Advisory Committee is appointed by the ministry. Two or three government representatives are permanent members, along with the architect of the project and a number of persons knowledgeable in the

field of contemporary visual arts. These latter typically include the director of the local art gallery where the building is being constructed, and a representative of the Ontario Arts Council.

Although the allocation of funding has varied over the years it is generally maintained at about 0.5 per cent of the construction cost of the project. (The Queen's Park Project expended 0.7 per cent of the cost for the entire project.) Since 1966, due to the expanded committee structure, the level of complexity of the selection process has increased. Unlike the original Macdonald Block project, where the three-member committee selected virtually all the artists, current projects now involve more democratic procedures. All competitions are announced in the media across the province. The two-step process following advertisement is, first, that artists are requested to submit a number of slides indicative of their most recent works. These are reviewed by the committee which selects a number of artists to compete

Daphne Odjig, *Roots*, 1979

Gino Lorcini, *Themes*, 1974

against one another for specific areas in the building designated for works of art. Each of these artists prepares a ''maquette,'' a site-specific design proposal for the work intended for the area. These maquettes, for which a fee is paid, are retained in the art collection. These proposals have become, over the years, important historical records of the various competitions, and are invaluable in making comparative analyses of the completed commissioned works. Often the commissioned pieces are considerably altered from the maquette stage as the artist devises solutions to problems arising from a particular site. Maquettes are also considered to

be works of art in themselves and form an important aspect of the contemporary collection holdings. In the second step, following submission of the maquettes, the committee reviews the designs and then awards the commission to one artist for each area selected.

The two-stage competition is a longer process than outright commissions, but the method has proved to be the most viable way of selecting public art. This is the case not only for governments across the country but for the private sector as well, for more and more corporations are commissioning art as a matter of course for their new headquarters. This corporate involvement offsets, in part, the fact that the federal government's once extremely active ''art-in-architecture'' program was called to a halt in the late 1970s.

One of the Ontario government's most successful projects was for the Middlesex County Court House and Land Registry Office in London, Ontario, in 1974. For the elevator lobbies on each floor of the building, a total of seven large floor-to-ceiling murals was commissioned through competition, and two large outdoor sculptures were installed at either entrance to the Court House. The emphasis in this particular project, as decided by the Art Advisory Committee, was to be regional in orientation. London, one of the major artistic centres in the province, provided a proliferation of excellent artists to compete in the project. Included among the successful artists were Margot Ariss, Claude Breeze, and Don Bonham. Perhaps the most notable participant was Jack Chambers, whose large mural of graphite on photography, *Impression—Trees*, was one of his last large-scale works before his death in 1978. The outdoor sculpture competitions were won by two London, Ontario sculptors, Walter Redinger and Gino Lorcini.

Although there have been many projects since the Middlesex County Court House, the program has altered somewhat to include as well the acquisition of works on paper and original prints, and other smaller works of art not necessarily built into the architectural fabric of the

Robert Markle, *Mohawk*, 1981-82

building. Such was the case with the acquisitions for the Ontario Police College in Aylmer in 1976 and several more recent examples, such as the works for the Ontario Government Buildings in Sudbury in 1980, in Hamilton in 1981, and in Oshawa in 1983. In addition to the proliferation of smaller works of art throughout the public areas of these latter two complexes, both also have large-scale works in the main entrance lobbies. Daphne Odjig's acrylic on canvas triptych, *Roots*, forms the centrepiece for the office building in Sudbury, while Robert Markle's aluminum and neon wall relief, *Mohawk*, enlivens the lobby in the Hamilton building.

Many of the projects developed during the late 1970s are characterized by a flurry of commissioning of large-scale outdoor sculpture. Some examples of these are Ed Zelenak's fibreglass

sculpture, *Apporia*, which was commissioned in 1978 for the Waterloo County Court House and Land Registry Office in Kitchener, and Haydn Davies' *Space Composition Red* for the Ontario Government Building in Windsor, also in 1978.

Unlike nineteenth-century portrait statuary, the commissioning of which inspired public support and funding rather than outcry, modern public sculpture inevitably invokes a considerable degree of controversy. However, it is now generally accepted that public art may legitimately provoke some degree of controversy and that the role of a public institution should be to look upon art as a means not to satisfy the traditional expectations of the majority but to expand those expectations to include an appreciation of how art is evolving today. Presumably the purchases made by the government in the late nineteenth century, of "contemporary" art from

289

The artist Haydn Davies installs his sculpture, *Space Composition, Red,* 1978

Colette Whiten, *Cutouts*, 1978

members of the Ontario Society of Artists, served just that same purpose.

One of the most dynamic sculpture competitions arranged over the past few years by the Ministry of Government Services was held for an outdoor site at the new Queen Street Mental Health Centre, erected on the site of architect John Howard's demolished Mental Asylum, 999 Queen Street (1846-49). Many of the best sculptors working in Toronto competed for the

commission and the selection committee had great difficulty in awarding the commission to only one artist. The competition was eventually won by Colette Whiten for her environmental wood sculpture, *Cutouts*. Competing against Whiten were John MacGregor, Robert Downing, Peter Kolisnyk, Nobuo Kubota and Mia Westerlund Roosen. The maquettes prepared by these artists, now part of the collection, are indicative of the high degree of creativity with

Mia Westerlund Roosen, *Muro VII, c.* 1978

Peter Kolisnyk, *White Square, c.* 1977-78

which each of these artists approached the spatial problem of a large open park area in front of the Mental Health Centre.

Several major projects have been underway since Premier Robarts first introduced to Ontario the concept of collecting "art-in-architecture" by

commission. Many projects are still in process, such as those for the new Macdonald-Cartier Building in Kingston and the new Court House and Land Registry Office in St. Catharines, and in years to come many more are likely to be undertaken. The contemporary collection is today the largest part of the Ontario Collection.

The current program to encourage additions to the collection is a direct result of the concern for art by the people of Ontario. Appreciation of the contemporary policy is also reflected in the recent government commission on the state of the arts, the Special Committee for the Arts in Ontario. Its report of 1984 recommends further government support to the visual arts by an increase in the allocation for the "art-in-architecture" program to one per cent of the construction budget for any new capital project and by the establishment of a provincial art bank. These are excellent ideas to encourage public appreciation of the visual arts and are indicative of government commitment to the visual arts, support it has given since the establishment of a policy of collecting "contemporary" Ontario art in 1875.

Today's funding for acquisitions to the collection is, however, necessarily limited to the "art-in-architecture" approach. It is consequently difficult to add to the historical areas, particularly to fill gaps left by lost works of art. Concern that the Ontario Collection be as complete and interesting as possible is evident in the increasing number of donations made, through the generosity of public-spirited individuals, to the Ontario Heritage Foundation. In recent years donations ranging from historical works of the nineteenth century, official portraiture, such as the portrait by Roberto de'Seta of the Hon. John Robarts, and modern works of art have made it possible for the collection to grow. Such contemporary works as the 1958 painting by Jock Macdonald, *Crimson Cavern*, serve as a link to those artists' works represented by the collection of the Queen's Park Project, many of whom were taught by this leader of abstract painting in Ontario. Kosso Eloul's monumental stainless-steel sculpture, *Salut*, has also recently been

Kosso Eloul, *Salut, c.* 1975

placed by the Foundation into the collection at Ontario Place. Through the Ontario Heritage Foundation's shared mandate for preserving Ontario's artistic heritage in the public trust, combined with its role as official recipient of gifts and bequests to the Crown, the Foundation has become an enthusiastic partner in ensuring the present and future dynamism of the Ontario Collection.

Ralph Allen, *Untitled, c. 1966-68*

Robert Brian Achtemichuk
Born: Yorkton, Saskatchewan,
30 March 1948

Temptation of Pope John Paul 1979
Etching, 51.4 x 69.2 cm / 20¹/₄ x 27¹/₄″
(actual)
Signed: (l.r.) ACHTEMICHUK;
numbered and dated: (l.c.) 10/20 1979
Inscribed: (l.l.) TEMPTATION OF POPE
JOHN PAUL
Purchase for the Michael Starr Building,
Oshawa, 1983. MGS 632639

Laurence Acland
Born: Salt Lake City, Utah, U.S.A.,
21 September 1949

Structure Votive 1977
Etching, 80 x 39.4 cm / 31¹/₂ x 15¹/₂″
(sight); 70.5 x 34.9 cm / 27³/₄ x 13³/₄″
(image)
Signed and dated: (l.r.) Acland 77
Inscribed and numbered: (l.l.) 2/40;
(l.c.) Structure Votive
Purchase from the artist for the
Waterloo County Court House and Land
Registry Office, Kitchener, 1977.
MGS 619996

Marie Aiken
Born: Alix, Alberta, 1 July 1926

Solstice c. 1977
Watercolour, plastic sheet, magic
marker, crayon on paper;
46.4 x 11.4 cm / 18¹/₄ x 4¹/₂″
Commission proposal for the Simcoe
County Court House and Land Registry
Office, Barrie, 1977. MGS 619747

Solstice 1977
Hand-stitched silk appliquéd to cotton;
two panels: a) 411.5 x 182.9 cm / 162 x
72″; b) 457.2 x 182.9 cm / 180 x 72″
Inscribed: (verso, l.r. on right panel)
Tower Studio Gravenhurst / Marie Aiken
1977
Commission for the Simcoe County
Court House and Land Registry Office,
Barrie, 1977. MGS 619743

Ralph Allen, O.S.A., A.R.C.A.
Born: Raunds, Northamptonshire,
England, 6 December 1926

Untitled *c.* 1966-68
Wood, gesso, sheet plastic, gold leaf,
copolymer (mural relief);
266.7 x 299.7 cm / 105 x 118"
Commission for the Queen's Park
Project, 1966-68. MGS 619782

Sandra Rochelle Altwerger,
C.S.P.W.C., O.S.A.
Born: Toronto, Ontario,
30 November 1942

Mother of Thousands
Serigraph; 64.8 x 48.3 cm / 25½ x 19"
(sight), 38.1 x 38.1 cm / 15 x 15" (image)
Signed: (l.r.) S. Altwerger
Inscribed and numbered: (l.l.) Mother of
Thousands 6/16
Purchase, 1976. MGS 619938

George Franklin Arbuckle, O.S.A.,
R.C.A.
Born: Toronto, Ontario,
17 February 1909

Beaver Dam Rockies
Oil on board, 29.2 x 39.4 cm /
11½ x 15½"
Signed: (l.r.) FRANKLIN / ARBUCKLE
Inscribed: (verso) Beaver Dam near Mt.
Edith, / Banf [*sic*] AL.
MGS 632661

*Farmhouse and Tower, Guadagni's
Valley, Italy*
Oil on board, 29.2 x 40 cm / 11½ x 15¾"
Signed: (l.r.) FRANKLIN / ARBUCKLE
MGS 632662

Untitled *c.* 1966-68
Mixed media on cardboard,
43.2 x 49.5 cm / 17 x 19½"
Signed: (l.l.) Franklin / Arbuckle
Commission proposal for the Queen's
Park Project, 1966-68. MGS 619896

Untitled 1968
Acrylic on canvas (mural),
266.7 x 299.7 cm / 105 x 118"
Signed and dated: (l.l.) FRANKLIN /
ARBUCKLE / '68
Commission for the Queen's Park
Project, 1966-68. MGS 619783

Franklin Arbuckle, *Untitled*, 1968

**Louis de Gonzague Pascal
Archambault,** R.C.A.
Born: Montreal, Quebec, 4 April 1915
Honours: O.C.

Man and Woman *c.* 1966-68
Bronze; two figures: a) 398.8 x 243.8 x
86.4 cm / 157 x 96 x 34", b) 355.6 x 198.1
x 99.1 cm / 140 x 78 x 39"
Commission for the Queen's Park
Project, 1966-68. MGS 619781

Herbert Joshua Ariss, C.S.P.W.C.,
O.S.A., R.C.A.
Born: Guelph, Ontario,
29 September 1918

Untitled *c.* 1966-68
Plaster, burlap, on wood panel,
83.8 x 25.4 cm / 33 x 10"

Commission proposal for the Queen's
Park Project, 1966-68. MGS 619902

Untitled *c.* 1966-68
Styrofoam, plaster, gesso, cotton cloth,
on welded rods (mural relief); 264.2 x
198.1 cm / 104 x 78"
Signed: (l.r., in raised letters) h. j. ariss
Commission for the Queen's Park
Project, 1966-68. MGS 619780

Homage to Eadweard Muybridge
1975
Graphite on paper, 168 x 73.5 cm /
66³⁄₁₆ x 28⁹⁄₁₆"
Signed and dated: (l.r.) H. J. ARISS / 75
Inscribed: (verso) Homage to Eadweard
Muybridge / Panel completed 1976 /
Herbert Joshua Ariss, London / 1977
Purchase from the artist for the Ontario
Police College, Aylmer, 1977.
MGS 618675

Louis Archambault, *Man And Woman*, c. 1966-68

In the 1880s Eadweard Muybridge (1830-1904) began photographic studies of humans and animals in motion. In his panel, Ariss has adapted the runner and shotputter from Muybridge's famous studies of the human figure in motion (1901).

Margot Philipps Ariss
Born: Belleville, Ontario, 14 September 1929

Words 1974
Ceramic on laminated gesso-coated board (mural relief), 231.1 x 429.3 cm/ 91 x 169"
Signed and dated: (l.c.) Margot Ariss '74
Commission for the Middlesex County Court House and Land Registry Office, London, 1974. MGS 616944

This mural transcribes an excerpt from the diary of Major Edward Baker Little-hales, military secretary to Lieutenant Governor Simcoe, who wrote about London during Simcoe's inspection tour

of the territory in 1793. The small letters tell how Simcoe and his party lived during the trip, while the large ones describe the city of London itself.

Stephen J. Arthurs
Born: Saint John, New Brunswick, 30 April 1951

Enigma: Ensemble-Entente 1980
Acrylic on paper, 24.1 x 34.3 cm/ 9½ x 13½"
Signed: (l.r.) S. ARTHURS
Inscribed: (on label, verso) 1980
Purchase from the artist for the Ellen Fairclough Building, Hamilton, 1981.
MGS 630168

Agonizing Their Indecisiveness, They Were Seized With a Fear of the Unknown 1981
Acrylic on paper, 24.1 x 29.2 cm/ 9½ x 11½"
Signed: (l.r.) S. ARTHURS
Inscribed: (on label, verso) 1981
Purchase from the artist for the Ellen Fairclough Building, Hamilton, 1981.
MGS 630166

Freely Admitting Their Secret, They Stood to be Corrected 1981
Acrylic on paper, 24.1 x 29.2 cm/ 9½ x 11½ "
Signed: (l.r.) S. ARTHURS
Inscribed: (on label, verso) 1981
Purchase from the artist for the Ellen Fairclough Building, Hamilton, 1981.
MGS 630167

Who Benefits, That A Whole Generation Is Pacified? 1981
Acrylic on paper, 24.1 x 31.8 cm/ 9½ x 12½"
Signed: (l.r.) S. ARTHURS
Inscribed: (on label, verso) 1981
Purchase from the artist for the Ellen Fairclough Building, Hamilton, 1981.
MGS 630164

Artist unknown

Walrus Hunter c. 1958-59
Soapstone, 31.1 x 15.2 x 21.6 cm/ 12¼ x 6 x 8½"
Inscribed: (underside) E9-109 [transaction number]; Inuit syllabics [artist's name].
MGS 623084

This carving was made by an unknown

Herbert Ariss, *Homage to Eadweard Muybridge*, 1975

Stephen Arthurs, *Agonizing Their Indecisiveness, They Were Seized With a Fear of the Unknown*, 1981

artist (possibly named Charlie), from the Quebec Inuit community of Sugluk.

Barbara Astman

Born: Rochester, New York, U.S.A., 12 July 1950

Red 1980
SX-70 Ektacolour mounted on masonite; 121.9 x 121.9 cm/48 x 48"
Inscribed: (verso) B. Astman 80
Purchase for the Ellen Fairclough Building, Hamilton, 1981. MGS 630163

This work is part of Barbara Astman's series of twenty life-size SX-70 Polaroid photographic blowups. In the works Astman sets up a tableau of everyday objects, all sprayed in one colour — here red is chosen — and stands impassively before them holding two other objects in her hands. The layering of images and colour in the photo is paralleled by a multiplicity of associations and reactions in the viewer.

Isa Audaluk

Born: 1954

Untitled c. 1975
Soapstone, 25.4 x 13.4 x 12.7 cm/ 10 x 5¼ x 5"
Signed: (on base), in Inuit syllabics: Isaaud
Inscribed: (underside) in Inuit syllabics [artist's name]: ISA AUD; 3733 [transaction number].
MGS 623326

This artist is from the Quebec Inuit community of Povungnituk.

Ekaluksituk Ayagutaina [also known as Arrogtaniak]

Spear Fisher 1964
Stonecut, 86.4 x 55.9 cm/34 x 22"
Signed, dated and inscribed: in Inuit syllabics (l.l. to l.r.)...1964
Numbered: (l.l.) 19/30
Gift. MGS 634360

The Inuit inscription has been translated to give us the name of the artist, the title of the work, and its origin, Povungnituk, Quebec.

Walter Joseph Gerard Bachinski

Born: Ottawa, Ontario, 6 August 1939

Mother Holding Child c. 1977
Wood, gesso, cement fondu, gold paint; 20.3 x 48.3 x 15.2 cm/8 x 19 x 6"
Commission proposal for the Waterloo County Court House and Land Registry Office, Kitchener, 1977. MGS 619966

Barbara Astman, *Red*, 1980

Ronald Arnott Baird, R.C.A., O.S.A.
Born: Toronto, Ontario,
29 March 1940

Blind Toad with his Stash 1977
Etching; 55.9 x 50.8 cm / 22 x 20"
(sight), 38.7 x 37.8 cm / 15¹/₄ x 14⁷/₈"
(image)
Signed and dated: (l.r.) Baird '77
Inscribed: (l.l.) BLIND TOAD WITH
HIS STASH AP
Purchase from the artist, 1977.
MGS 619906

Night Flight 1977
Etching; 46.4 x 37.5 cm / 18¹/₄ x 14³/₄"
(sight), 32.4 x 24.8 cm / 12³/₄ x 9³/₄"
(image)
Signed and dated: (l.r.) R. Baird '77
Inscribed and numbered: (l.l.) A.P. 5/5;
(l.c.) 'NIGHT FLIGHT'
Purchase from the artist, 1977.
MGS 619912

Untitled c. 1977
Spray-painted cardboard and wood;
32.1 x 66 x 20.6 cm / 12⁵/₈ x 26 x 8¹/₈"
Commission proposal for the Simcoe
County Court House and Land Registry
Office, Barrie, 1977. MGS 618688

Untitled c. 1977
Stelcoloy; three parts:
a) 609.6 x 152.4 x 304.8 cm / 240 x 60 x
120", b) 365.8 x 152.4 x 304.8 cm / 144 x
60 x 120", c) 487.7 x 152.4 x 304.8 cm /
192 x 60 x 120"
Commission for the Simcoe County
Court House and Land Registry Office,
Barrie, 1977. MGS 619742

Untitled c. 1979
Wood; 16.5 x 35.6 x 17.1 cm /
6¹/₂ x 14 x 6³/₄"
Commission proposal for the York
North County Court House and Land
Registry Office, Newmarket, 1979.
MGS 623337

Anne Meredith Barry, O.S.A.
Born: Toronto, Ontario,
31 August 1932

Northern Pattern #6 – Quiet Pool
Collograph; 58.7 x 52.4 cm /
23¹/₈ x 20⁵/₈" (sight),
52.7 x 50.2 cm / 20³/₄ x 19³/₄" (image)

Mother Holding Child 1977
Bronze (mural relief); 137.2 x 114.3 cm /
54 x 45"
Initialed, dated and numbered: (l.r.) WB
77 1/3
Commission for the Waterloo County
Court House and Land Registry Office,
Kitchener, 1977. MGS 619974

Red Begonias 1981
Pastel on paper; 148.6 x 155.6 cm /
58¹/₂ x 61¹/₄"
Signed and dated: (l.r.) W. Bachinski 81
Inscribed: (verso) Walter Bachinski /
"Red Begonias" / 1981 / Pastel Dwg. /
58¹/₂(L) x 61¹/₄(W)
Purchase for the Ellen Fairclough
Building, Hamilton, 1981. MGS 630151

Daisy Bailey
Born: Toronto, Ontario,
15 March 1921
Died: 1972

Blizzard / Thaw c. 1966-68
Enamel on copper mounted on wood;
65.4 x 49.5 cm / 25³/₄ x 19¹/₂"
Commission proposal for the Queen's
Park Project, 1966-68. MGS 619904

Blizzard / Thaw c. 1966-68
Enamel on copper, mounted on wood
(mural relief); two panels, each 264.2 x
99.1 cm / 104 x 39"
Commission for the Queen's Park
Project, 1966-68. MGS 619779

Signed: (l.r.) A. Meredith Barry
Inscribed and numbered: (l.l.) Northern
Pattern #6 – Quiet Pool; (l.c.) 1/50
Purchase, 1977. MGS 619954

Twilight
Collograph; 54.6 x 43.1 cm/21½ x 17"
(sight), 50.8 x 40.3 cm/20 x 15⅞"
(image)
Signed: (l.r.) A. Meredith Barry
Inscribed: (l.l.) Twilight; (l.c.) Artist's
Proof I
Purchase, 1977. MGS 619953

Donald Barton, O.S.A.
Born: Oakville, Ontario, 13 April 1944

Twilight c. 1979
Tapestry of linen blended with
handspun, vegetable-dyed wool; three
segments, connected by weft threads:
a) 106.7 x 34.3 cm/42 x 13½",
b) 106.7 x 48.9 cm/42 x 19¼",
c) 106.7 x 34.3 cm/42 x 13½";
overall: 106.7 x 139.7 cm/42 x 55"
Purchase from the artist for the Ontario
Government Building, Sudbury, 1980.
MGS 625782

Edward John Bartram, O.S.A., R.C.A.
Born: London, Ontario,
21 March 1938

Cycle c. 1968
Multi-viscosity etching; 52.7 x 41.9 cm/
20¾ x 16½" (sight), 49.5 x 40 cm/
19½ x 15¾" (image)
Signed: (l.r.) Bartram
Inscribed: (l.l.) A.P.; (l.c.) Cycle.
MGS 622678

Bronze Relief 1970
Multi-viscosity etching; 73.7 x 57.2 cm/
29 x 22½" (sight), 69.9 x 55.2 cm/
27½ x 21¾" (image)
Signed and dated: (l.r.) Bartram/70
Inscribed: (l.l.) Artist's Proof;
(l.c.) Bronze Relief.
MGS 622670

Glacial Intrusions, Georgian Bay
1971
Etching and aquatint; 73.7 x 57.2 cm/
29 x 22½" (sight), 69.2 x 55.2 cm/
27¼ x 21¾" (image)
Signed and dated: (l.r.) Bartram/71
Inscribed and numbered: (l.l.) 5/30;
(l.c.) Glacial Intrusions, Georgian Bay.
MGS 622671

Ekaluksituk Ayagutaina, *Spear Fisher*, 1964

Walter Bachinski, *Red Begonias*, 1981

Walter Bachinski, *Mother Holding Child*, 1977

Orange Lichen, Canadian Shield
1971
Multi-viscosity etching; 58.4 x 78.4 cm/
23 x 28½" (sight), 55.2 x 69.8 cm/
21¾ x 27½" (image)
Signed and dated: (l.r.) Bartram/71
Inscribed and numbered: (l.l.) 14/30;
(l.c.) Orange Lichen Canadian Shield.
MGS 622681

Island North c. 1977
Etching; 97.8 x 70.5 cm/38½ x 27¾"
(sight), 78.7 x 57.8 cm/31 x 22¾"
(image)
Signed: (l.r.) Bartram
Inscribed and numbered: (l.l.) 17/40;
(l.c.) Island North
Purchase, 1977. MGS 619925

*Rockscape #9 – Northern Image
Series* 1977
Etching; 71.1 x 102.9 cm/28 x 40½"
(sight), 59.7 x 89.5 cm/23½ x 35¼"
(image)
Signed and dated: (l.r.) Bartram/77
Inscribed and numbered: (l.l.) 18/40;
(l.c.) Rockscape #9 – Northern Image
Series
Purchase, 1977. MGS 619924

Robert Bateman

Born: Toronto, Ontario,
24 May 1930

At Long Point c. 1969
Egg tempera on board; 90.2 x 60.3 cm/
35½ x 23¾"
Signed: (l.r.) Robert Bateman
Purchase from the artist, 1969.
MGS 631232

Bonnie Bauman

Born: London, Ontario,
28 July 1940

Effusion 1976
Serigraph; 86.4 x 61 cm/34 x 24"
Signed and dated: (l.r.) BAUMAN/76
Inscribed and numbered: (l.l.) Serigraph
3-5; (l.c.) Effusion
Purchase from the artist for the Ontario
Police College, Aylmer, 1977.
MGS 618680

Aba Bayefsky, C.S.P.W.C., R.C.A.
Born: Toronto, Ontario, 7 April 1923

Untitled 1967
Pastel, crayon on paper, 41.9 x 29.8 cm/
16½ x 11¾"
Initialed and dated: (l.r.) AB/67
Commission proposal for the Queen's
Park Project, 1966-68. MGS 619903

Indian Legends 1968
Acrylic polymer on plaster (mural);
264.2 x 199.4 cm/104 x 78½"
Initialed and dated: (l.r.) AB/68
Commission for the Queen's Park
Project, 1966-68. MGS 619777

Bayefsky has based the shapes and forms
found in this mural on a synthesis of his
understanding of the natural and super-
natural forces found in Canadian Indian
mythology and legend.

Carl Beam
Born: West Bay, Manitoulin Island,
24 May 1943

Untitled
Acrylic on ¼" plexiglas with photocopy
transfer; 186.7 x 124.5 cm/73½ x 49"
Signed: (l.r.) Carl Beam
Purchase from the artist for the Ontario
Government Building, Sudbury, 1980.
MGS 625787

Inter-Stellar Village Communion
1980
Etching; 76.2 x 56.5 cm/30 x 22¼"
(actual), 62.9 x 45.1 cm/24¾ x 17¾"
(image)
Signed and dated: (l.r., below image)
Carl Beam '80
Inscribed: (l.l., below image) A/P;
(l.c., below image) Inter-Stellar Village
Communion
Purchase from the artist for the Ontario
Government Building, Sudbury, 1980.
MGS 625786

Secret Geometry 1980
Watercolour and photocopy transfer on
paper; 80.6 x 58.4 cm/31¾ x 23"
Signed and dated: (l.r.) Carl Beam '80
Purchase from the artist for the Ontario
Government Building, Sudbury, 1980.
MGS 625784

Ron Baird, *Untitled*, 1977

Robert Bateman, *At Long Point, c.* 1969

Aba Bayefsky, *Indian Legends*, 1968

Secret Geometry II 1980
Watercolour and photocopy transfer on
paper; 81.6 x 60.3 cm / 32^1/$_8$ x 23^3/$_4$"
Signed and dated: (l.r.) Carl Beam '80
Purchase from the artist for the Ontario
Government Building, Sudbury, 1980.
MGS 625783

Secret Geometry, Triangles 1980
Watercolour and photocopy transfer on
paper; 81.9 x 59.7 cm / 32^1/$_4$ x 23^1/$_2$"
Signed and dated: (l.r.) Carl Beam '80
Purchase from the artist for the Ontario
Government Building, Sudbury, 1980.
MGS 625785

Micheline Beauchemin, R.C.A.
Born: Longueuil, Quebec, 1930
Honours: O.C.

AB-1 1968
Watercolour on paper; 35.6 x 27.3 cm /
14 x 10^3/$_4$"
Signed: (l.r., within image) Micheline
Beauchemin
Inscribed: (l.l.) "AB-1" TORONTO –
QUEEN'S PARK PROJECT; (l.r., below
image) Micheline Beauchemin 1968
Commission proposal for the Queen's
Park Project, 1966-68. MGS 619997

Carl Beam, *Untitled, c.* 1980

AB-1 1968
Various woven materials, acrylic fibres,
transparent acrylic beads;
433.1 x 327.7 cm / 170½ x 129"
Signed: (l.r., stitched) M Beauchemin
Commission for the Queen's Park
Project, 1966-68. MGS 619778

Clare Bice, O.S.A., R.C.A.
Born: Durham, Ontario,
24 January 1909
Died: St. John's, Newfoundland,
18 May 1976
Honours: C.M., LL.D.

London, Ontario c. 1952
Oil on board; 60.3 x 80.6 cm /
23¾ x 31¾"
Signed: (l.r.) CLARE BICE
Gift of The House of Seagram for
Ontario House, London, England,
c. 1977. MGS 624438

Originally commissioned in 1951 by The
House of Seagram as part of the Seagram
Collection of Paintings, for exhibition in

Carl Beam, *Secret Geometry,* 1980

Ted Bieler, *Mudra*, c. 1975

Micheline Beauchemin, *AB-1*, 1968

the *Cities of Canada* series. Twenty-two leading Canadian artists were commissioned to portray on canvas a total of 26 Canadian cities, from St. John's, Newfoundland to Victoria, B.C. These paintings were widely exhibited and reproduced, both nationally and internationally.

Bice's *London* is reproduced in colour in *Cities of Canada: Reproductions from the Seagram Collection of Paintings* (privately published by The House of Seagram in 1953), with the caption *London, with view of St. Paul's.* In 1977, Seagram's sent the painting to Ontario House, which had recently been refurbished and was to re-open officially in June 1978.

André-Charles Biéler,
C.G.P., O.S.A., R.C.A., C.S.P.W.C.
Born: Lausanne, Switzerland,
8 October 1896
Honours: LL.D.

Apollo
Relief print; 68.6 x 52.1 cm / 27 x 20½″ (sight), 65.4 x 49.5 cm / 25¾ x 19½″ (image)

Signed: (l.r.) André Biéler
Inscribed and numbered: (l.l.) Apollo
12-14
Purchase, 1977. MGS 619957

Untitled
Relief print; 68.6 x 52.7 cm/27 x 20³/₄"
(sight), 64.8 x 49.5 cm/25¹/₂ x 19¹/₂"
(image)
Signed: (l.r.) André Biéler
Numbered: (l.l.) 13-16
Purchase, 1977. MGS 619958

These prints are examples of Biéler's
long fascination with experimental
printmaking; they were pulled from a
press which he invented in 1967-68, and
which allowed him to obtain prints with
a deep relief from cast cement plates.

Theodore (Ted) André Charles Bieler, R.C.A.

Born: Kingston, Ontario, 23 July 1938

Mudra c. 1975
Stainless steel, 614.7 x 393.7 x 299.7 cm/
242 x 155 x 118"
Commission for the George Drew
Building, Toronto, 1974-75.
MGS 619699

"Mudra" is a Sanskrit word whose
rough translation is "gesture," defining
both ceremonial postures and
formalized movements with symbolic
intent.

David Charles Bierk

Born: Appleton, Minnesota, U.S.A.,
6 September 1944

Untitled 1983
Acrylic on canvas; 360 x 210 cm/
141³/₄ x 82¹/₂"
Signed and dated: (l.r.) David Bierk 1983
Purchase from the artist for the Michael
Starr Building, Oshawa, 1982-83.
MGS 632601

The *trompe-l'oeil* effect of a constantly
changing three-dimensional mass of
rock and fabric is created in this
painting. It combines two of Bierk's
earlier techniques: highly realistic
exploration of the effects of rock
surfaces, and the "fold" paintings,
where paint was sprayed onto
unstretched canvas that when stretched
retained the impressions of its earlier
folds and creases.

Clare Bice, *London, Ontario, c.* 1952

Jane Bingham

Born: Charlottetown, Prince Edward
Island, 5 July 1952

Alexandra Park 1982
Batik painting on cotton broadcloth;
151.1 x 237.5 cm/59¹/₂ x 93¹/₂"
Signed and dated: (l.r.) J. M. BINGHAM
82
Purchase from the artist for the Michael
Starr Building, Oshawa, 1982.
MGS 632602

Having originally painted imported cars
in the foreground of this work, the artist
subsequently changed the automobiles
and other details to reflect Oshawa's
main industry.

Diana Birkenheier

Born: Toronto, Ontario, 1942

Mrs. Spillane's Cottage – Tralee Bay
1980

Serigraph, 50.8 x 59.7 cm/20 x 23¹/₂"
Signed and dated: (l.r.) Diana
Birkenheier '80
Inscribed and numbered: (l.l.) 3/25;
(l.c.) Mrs. Spillane's Cottage
Trallee [sic] Bay
Purchase for the Michael Starr Building,
Oshawa, 1983. MGS 632604

Boboli Gardens – Florence 1981
Serigraph, 30.5 x 71.1 cm/12 x 28"
(sight), 25.7 x 67.9 cm/10¹/₈ x 26³/₄"
(image)
Signed and dated: (l.r.) Diana
Birkenheier 1981
Inscribed and numbered: (l.l.) 2/20
Boboli Gardens – Florence
Purchase for the Michael Starr Building,
Oshawa, 1983. MGS 632603

David Lloyd Blackwood, O.S.A., R.C.A., C.S.P.W.C.

Born: Wesleyville, Newfoundland,
7 November 1941

David Bierk, *Untitled*, 1983

David Blackwood's prints are concerned with Newfoundland's past and the harsh realities of the difficult and often tragic lives of the people living in its coastal outports. Survival in such a hostile environment depended on the inhabitants' sense of community, and Blackwood emphasizes this aspect in his work.

March North Atlantic 1971
Etching, 52.1 x 54 cm / 20^1/$_2$ x 21^1/$_4$" (sight), 47.6 x 50.8 cm / 18^3/$_4$ x 20" (image)
Signed and dated: (l.r.) David Blackwood 1971
Inscribed: (l.l.) March North Atlantic Artists proof
Purchase for the Michael Starr Building, Oshawa, 1983. MGS 632607

Captain Job Barbour Dreams 1979
Etching, 53.3 x 43.2 cm / 21 x 17" (sight), 50.2 x 40 cm / 19^3/$_4$ x 15^3/$_4$" (image)
Signed and dated: (l.r.) David Blackwood 1979
Inscribed and numbered: (l.l.) Captain Job Barbour dreams. a/p 6/10 Ed. 50
Purchase for the Michael Starr Building, Oshawa, 1983. MGS 632665

Three Mummers on Windsor's Point 1979
Etching, 53.3 x 83.8 cm / 21 x 33" (sight), 50.2 x 80.6 cm / 19^3/$_4$ x 31^3/$_4$" (image)
Signed and dated: (l.r.) David Blackwood 1979
Inscribed and numbered: (l.l.) Three mummers on Windsor's Point 25/50
Purchase for the Michael Starr Building Oshawa, 1983. MGS 632608

Mumming is a Newfoundland Christmastime tradition of British origin. On the twelve nights between December 25 and January 6, groups of fantastically costumed men and women go from house to house in the outports, accepting hospitality in return for performing short plays.

Wesleyville: Seabird Hunters Crossing the Reach 1981
Etching, 54 x 83.8 cm / 21^1/$_4$ x 33" (sight), 50.2 x 80.6 cm / 19^3/$_4$ x 31^3/$_4$" (image)
Signed and dated: (l.r.) David Blackwood 1981
Inscribed and numbered: (l.l.) Wesleyville: seabird hunters crossing the reach 38/50
Purchase for the Michael Starr Building, Oshawa, 1983. MGS 632674

Captain Alb and Aunt Nance 1982
Etching, 83.8 x 53.3 cm / 33 x 21" (sight), 80.6 x 50.8 cm / 31^3/$_4$ x 20" (image)
Signed and dated: (l.r.) David Blackwood 1982
Inscribed and numbered: (l.l.) Captain Alb & Aunt Nance 21/50
Purchase for the Michael Starr Building, Oshawa, 1983. MGS 632666

The Family 1982
Etching, 83.8 x 53.3 cm / 33 x 21" (sight), 80.6 x 50.5 cm / 31^3/$_4$ x 19^7/$_8$" (image)
Signed and dated: (l.r.) David Blackwood 1982
Inscribed and numbered: (l.l.) The family 21/5
Purchase for the Michael Starr Building, Oshawa, 1983. MGS 632605

Man Warning Two Boys 1982
Etching, 54 x 83.8 cm / 21^1/$_4$ x 33" (sight), 50.2 x 80.6 cm / 19^3/$_4$ x 31^3/$_4$" (image)
Signed and dated: (l.r.) David Blackwood 1982
Inscribed and numbered: (l.l.) Man warning two boys 20/50
Purchase for the Michael Starr Building, Oshawa, 1983. MGS 632606

Night Passage 1982
Etching, 54 x 83.8 cm / 21^1/$_4$ x 33" (sight), 50.8 x 80.6 cm / 20 x 31^3/$_4$" (image)
Signed and dated: (l.r.) David Blackwood 1982
Inscribed and numbered: (l.l.) Night Passage 43/50
Purchase for the Michael Starr Building, Oshawa, 1983. MGS 632664

The Red Gate, Templeman B. Bay, Nfld 1982
Etching, 38.7 x 88.9 cm / 15^1/$_4$ x 35" (sight), 35.3 x 86 cm / 13^7/$_8$ x 33^7/$_8$" (image)
Signed and dated: (l.r.) David Blackwood 1982
Inscribed and numbered: (l.l.) The red gate, Templeman B. Bay, Nfld 50/50
Purchase for the Michael Starr Building, Oshawa, 1983. MGS 632667

William Gardner Blackwood

Born: Kilcreggan, Dumbartonshire, Scotland, 26 March 1892

David Blackwood, *Three Mummers on Windsor's Point*, 1979

River in Spring
Watercolour on paper, 31.8 x 24.1 cm/
12½ x 9½"
Signed: (l.l.) W. BLACKWOOD
MGS 619829

Untitled
Watercolour on paper, 24.1 x 31.8 cm/
9½ x 12½"
Signed: (l.l.) W. Blackwood
MGS 632663

Thérèse Bolliger
Born: Walde, Switzerland, 28 April 1944

Landscape Screen XIII 1979
Watercolour and graphite on paper,
52.1 x 69.9 cm/20½ x 27½"
Signed: (l.r.) Bolliger
Inscribed: (l.r.) Landscape Screen XIII;
(on label, verso) 1979
Purchase from the artist for the Ellen
Fairclough Building, Hamilton, 1981.
MGS 630159

Landscape Screen XXI 1979
Watercolour and graphite on paper,
50.8 x 70.5 cm/20 x 27¾"
Signed: (l.r.) Bolliger
Inscribed: (l.r.) Landscape Screen XXI;
(on label, verso) 1979
Purchase from the artist for the Ellen
Fairclough Building, Hamilton, 1981.
MGS 630169

Landscape Screen XXVI 1979
Watercolour and graphite on paper,
47.6 x 71.1 cm/18¾ x 28"
Signed and dated: (l.r.) Bolliger '79
Inscribed: (l.r.) Landscape Screen XXVI
Purchase from the artist for the Ellen
Fairclough Building, Hamilton, 1981.
MGS 630160

David Blackwood, *Man Warning Two Boys*, 1982

Landscape Screen XXX 1979
Watercolour and graphite on paper,
50.8 x 69.9 cm/20 x 27½"
Signed and dated: (l.r.) Bolliger '79
Inscribed: (l.r.) Landscape Screen XXX
Purchase from the artist for the Ellen
Fairclough Building, Hamilton, 1981.
MGS 630158

Ronald William Bolt, O.S.A.
Born: Toronto, Ontario,
13 October 1938

Elm Tree Variations c. 1979
In three parts:
a) watercolour on folded card, 22.2 x
70.5 x 10.2 cm/8¾ x 27¾ x 4" (image);
b) photographs and ink on paper, 13.7 x
64.5 cm/5⅜ x 25⅜" (image);
c) graphite and ink on paper,
80.6 x 80.6 cm/31¾ x 31¾"
Inscribed: a) (l.l.) ELM TREE
VARIATIONS – SKETCH FOR COLOUR
RANGE; b) (u.c.) "THE ELM TREE
VARIATIONS" – PHOTOGRAPHIC
IMAGES ARE BASE FOR PATTERN OF
PAINTED PANELS; c) 1. (u.c.) *DETAIL
– PANEL CONSTRUCTION &
FRAMING.*; (u.r.) *DETAIL –
INSTALLATION,* 2. (u.r.) *"THE ELM
TREE VARIATIONS" SITE PLAN – 3RD
FLOOR – AREA 7 – NEWMKT CR.
HOUSE 1" = 1'*

Commission proposal for the York
North Court House and Land Registry
Office, Newmarket, 1979.
MGS 623339

Elm Tree Variations 1980
Acrylic on plywood (mural), 6 panels
(l. to r.):
a) 166.4 x 36.8 cm/65½ x 14½";
b) 166.4 x 74.9 cm/65½ x 29½";
c) 166.4 x 120.7 cm/65½ x 47½";
d) 166.4 x 222.3 cm/65½ x 87½";
e) 166.4 x 181.6 cm/65½ x 71½";
f) (perpendicular on adjoining wall)
166.4 x 97.8 cm/65½ x 38½"
Signed and dated: (u.r., panel 'f') Ron
Bolt 80
Commission for the York North Court
House and Land Registry Office,
Newmarket, 1980. MGS 624994

Ron Bolt chose to commemorate the
elm tree, which before its decimation by
Dutch Elm Disease was an important
feature of the southern Ontario
landscape.

Glacial Shore 1981
Serigraph, 62.2 x 64.1 cm/24½ x 25¼"
(sight), 58.1 x 60 cm/22⅞ x 23⅝"
(image)
Signed and dated: (l.r.) Ron Bolt/81
Inscribed: (l.l.) Glacial Shore; (l.c.) Bon
A Tirer
Purchase for the Michael Starr Building,
Oshawa, 1983. MGS 632655

Ron Bolt, *Elm Tree Variations*, 1980

Jordi Bonet, *Untitled*, c. 1966-68

Jordi Bonet, R.C.A.

Born: Barcelona, Spain, 7 May 1932
Died: Montreal, Quebec,
25 December 1979

Untitled c. 1966-68
Fired clay (mural relief),
657.7 x 934.7 cm / 259 x 368"
Signed: (l.l.) Jordi Bonet
Commission for the Queen's Park
Project, 1966-68. MGS 619776

Don Bonham, R.C.A.

Born: Oklahoma City, Oklahoma,
U.S.A., 9 November 1940

*Hermen Goode Aesthetics Racing
Team* c. 1974
Acrylic paint, photographs, laminated
wood and plexiglas (mural relief), 191.8
x 372.1 cm / 75½ x 146½"
Commission for the Middlesex County
Court House and Land Registry Office,
London, 1974. MGS 616946

In Bonham's mural a photographic
enlargement of Dundas Street in
London, Ontario, painted in bright
detail, forms a background for the team
portrait, which consists of a silver car
cut from laminated wood and overlaid
by three enlarged pictures of the artist.
The Aesthetics Racing Team (A.R.T.)
was active in London for several years in
the early 1970s. Hermen Goode is a
fictional name, and the team members
— Hermen, Leroy and B. J. — were all
realized in the person of the artist
himself. The "team's" participation in
various sporting events has been filmed
to become part of Bonham's oeuvre.

Janet Bourgeau

Born: Sherbrooke, Quebec,
11 August 1941

Rock Study 1979
Acrylic on paper, 43.2 x 57.8 cm /
17 x 22¾"
Signed and dated: (l.r.) J BOURGEAU 79
Purchase from the artist for the Ontario
Government Building, Sudbury, 1980.
MGS 625791

Claude Herbert Breeze, R.C.A.

Born: Nelson, British Columbia,
9 October 1938

Canadian Atlas: Position of London
1974
Acrylic on canvas (mural), 170.2 x 260.4 cm/67 x 102¹/₂"
Signed and dated: (l.r.) Breeze '74
Commission for the Middlesex County Court House and Land Registry Office, London, 1974. MGS 616943

Breeze initiated his *Canadian Atlas* series after his move from British Columbia to London, Ontario in 1972. He worked on the series, about 60 paintings in all, until 1974. The early works had a definite horizon but later works favoured cartographical and organic forms. In the final phase, of which this work is one, the emphasis is on visual and metaphoric relationships between waterways and the human cardio-vascular systems.

Coast Channel No. 1 1976
Serigraph, 63.5 x 45.7 cm/25 x 18" (sight), 59.7 x 42.5 cm/23¹/₂ x 16³/₄" (image)
Signed and dated: (l.r.) Breeze '76
Inscribed and numbered: (l.l.) 31/50; (l.c.) Coast Channel No. 1
Purchase, 1977. MGS 619926

Coast Channel No. 2 1976
Serigraph, 63.2 x 45.4 cm/24⁷/₈ x 17⁷/₈" (sight), 59.7 x 42.5 cm/23¹/₂ x 16³/₄" (image)
Signed and dated: (l.r.) Breeze '76
Inscribed and numbered: (l.l.) 5/50; (l.c.) Coast Channel No. 2
Purchase, 1977. MGS 619927

Eighth Journey No. 1 1976
Acrylic, china marker and graphite on canvas; diptych, each panel: 167.6 x 83.8 cm/66 x 33"; overall: 167.6 x 167.6 cm/66 x 66"
Inscribed: (on stretcher, verso) Eighth Journey No. 1 1976 Claude Breeze
Purchase from the artist for the Ontario Police College, Aylmer, 1976.
MGS 618686

Christopher Broadhurst

Born: London, England,
24 March 1953

Untitled
Oil on board, 36.8 x 110.5 cm/14¹/₂ x 43¹/₂"
Commission proposal for the Macdonald-Cartier Building, Kingston, 1982. MGS 630950

Claude Breeze, *Canadian Atlas: Position of London*, 1974

Susan Jane Buckles

Born: Toronto, Ontario,
16 December 1941

Untitled c. 1977
Watercolour, ink and fabric on paper; three parts: a) 52.7 x 61 cm/20¹/₄ x 24", b) and c) 45.7 x 58.4 cm/18 x 23" (each)
Signed: (l.r., part 'c', on mat)
Presentation by Jane Buckles
Commission proposal for the Waterloo County Court House and Land Registry Office, Kitchener, 1977.
MGS 619968

Jack Hamilton Bush,

C.S.P.W.C., O.S.A., A.R.C.A.
Born: Toronto, Ontario,
20 March 1909
Died: Toronto, Ontario,
24 January 1977
President, C.S.P.W.C. 1945-46
Honours: O.C.

Bush worked as a designer for many years while struggling to develop a unique style that could challenge what he considered to be the most important painting being done in the United States. The paintings made in the last 15 years of his life received international recognition, and his example has served as a catalyst to many young Canadian artists who were developing their styles in the 1960s and early 1970s.

Untitled c. 1966-68
Acrylic polymer on canvas (mural), 261.6 x 198.1 cm/103 x 78"
Commission for the Queen's Park Project, 1966-68. MGS 619775

Bush explained that his work was "solely about colour and colour juxtapositions." He regretted the fact that viewers are unwilling to allow themselves to respond to abstract art with an open mind and let the formal factors in the painting — the colours and shapes — speak for themselves, without any reference to objects in the natural world.

Green Loop 1971
Serigraph, 64.1 x 85.1 cm/25¹/₄ x 33¹/₂"
Signed, dated and numbered: (l.r.) Jack
Bush 1971 81/100.
MGS 635343

Jane Buyers

Born: Toronto, Ontario, 27 May 1948

Succulent Cacti
Lithograph and etching, 73.7 x 100.3 cm/
29 x 39¹/₂" (sight), 58.4 x 83.8 cm/
23 x 33" (image)
Signed: (l.r.) Buyers
Inscribed and numbered: (l.l.) 2/15;
(l.c.) Succulent Cacti
Purchase from the artist for the Ellen
Fairclough Building, Hamilton, 1982.
MGS 630145

Alex Cameron

Born: Toronto, Ontario, 6 May 1947

Untitled 1980
Lithograph, 106.7 x 78.7 cm/42 x 31"
(actual)
Signed, dated and numbered: (l.l.)
16/30; (l.r.) Alex Cameron 1980
Purchase for the Michael Starr Building,
Oshawa, 1983. MGS 632640

Alfred Joseph Casson,
O.S.A., C.S.P.W.C., C.G.P., R.C.A.
Born: Toronto, Ontario, 17 May 1898
President, O.S.A. 1940-45;
President, R.C.A. 1948-52
Honours: LL.D.

Untitled c. 1966-68
Oil on board, 63.5 x 48.9 cm/25 x 19¹/₄"
Signed: (l.r.) A. J. Casson
Commission proposal for the Queen's
Park Project, 1966-68. MGS 619894

Untitled c. 1966-68
Oil on linen canvas (mural),
261.6 x 200.7 cm/103 x 79"
Signed: (l.r.) A. J. CASSON
Commission for the Queen's Park
Project, 1966-68. MGS 619772

Farm House
Serigraph, 15.5 x 19 cm/6¹/₈ x 7¹/₂"
(sight), 10.8 x 14.6 cm/4¹/₄ x 5³/₄"
(image)

Alex Cameron, *Untitled*, 1980

Signed, inscribed and numbered: (l.l.)
23/100; (l.c.) Farm House; (l.r.) A J
Casson
Purchase for the Michael Starr Building,
Oshawa, 1983. MGS 632803

First Snow
Serigraph, 15.5 x 19 cm/6¹/₈ x 7¹/₂"
(sight), 10.8 x 14.6 cm/4¹/₄ x 5³/₄"
(image)
Signed, inscribed and numbered: (l.l.)
23/100; (l.c.) First Snow; (l.r.) A J
Casson
Purchase for the Michael Starr Building,
Oshawa, 1983. MGS 632804

Forest Edge
Serigraph, 15.5 x 19 cm/6¹/₈ x 7¹/₂"
(sight), 10.8 x 14.6 cm/4¹/₄ x 5³/₄"
(image)
Signed, inscribed and numbered: (l.l.)
23/100; (l.c.) Forest Edge; (l.r.) A J
Casson
Purchase for the Michael Starr Building,
Oshawa, 1983. MGS 632805

March Day
Serigraph, 15.5 x 19 cm/6¹/₈ x 7¹/₂"
(sight), 10.8 x 14.6 cm/4¹/₄ x 5³/₄"
(image)
Signed, inscribed and numbered: (l.l.)
23/100; (l.c.) March Day; (l.r.) A J
Casson
Purchase for the Michael Starr Building,
Oshawa, 1983. MGS 632806

Jeannie Catchpole

Born: Welland, Ontario, 3 March 1953

Memories of Beachwalking 1978
Watercolour on paper, 62.9 x 48.9 cm/
24³/₄ x 19¹/₄"
Signed and dated: (l.r.) JEANNIE
CATCHPOLE/'78
Purchase from the artist for the Ontario
Government Building, Sudbury, 1980.
MGS 625793

Anton Cétin

Born: Zagreb, Yugoslavia,
18 September 1936

Eve and the Moon Series c. 1977
Mixed media and collage on paper,
35.6 x 35.6 cm/14 x 14"
Initialed: (l.l.) AC [monogram]
Purchase from the artist, 1977.
MGS 619909

Eve Series 1977 No. 2 c. 1977
Serigraph, 75.9 x 56.5 cm/
29⁷/₈ x 22¹/₄" (sight); 71.1 x 53.3 cm/
28 x 21" (image)
Signed: (l.r.) A. Cétin
Inscribed: (l.l.) A/P Eve Series 1977
No. 2
Purchase from the artist, 1977.
MGS 619910

Eve Series 1977 No. 5 c. 1977
Serigraph, 76.2 x 56.5 cm/30 x 22¹/₄"
Signed: (l.r.) A. Cétin
Initialed: (l.c.) AC [embossed
monogram]
Inscribed: (l.l.) A/P Eve Series 1977
No. 5
Purchase from the artist, 1977.
MGS 619911

Cétin emigrated from his native
Yugoslavia in 1966, where he had begun
to develop the theme that has pre-
occupied him since: that of Eve and the
moon. He continued to explore this
symbolic subject-matter after settling in
Toronto in 1968.

John (Jack) Richard Chambers, R.C.A.
Born: London, Ontario,
25 March 1931
Died: London, Ontario,
13 April 1978
Honours: LL.D.

Impression – Trees *c.* 1974
Photograph and graphite on white vinyl (mural), 219.7 x 372.1 cm / 86½ x 146½"
Commission for the Middlesex County Court House and Land Registry Office, London, 1974. MGS 616948

In the last ten years of his life, Jack Chambers sought to express a synthesis of his two worlds — the physical and the spiritual — through an almost literal rendering of the things most important to him, particularly his family and his surroundings in the city of London.

Merton Francis Chambers

Born: Exeter, Ontario, 15 March 1929

Untitled *c.* 1966
Ceramic mosaic and watercolour on paper, 61 x 45.7 cm / 24 x 18"
Commission proposal for the Queen's Park Project, 1966-68. MGS 619999

Blue Mosaic *c.* 1966-68
Ceramic, unglazed terracotta with Egyptian paste (mural relief), 261.6 x 401.3 cm / 103 x 158"
Commission for the Queen's Park Project, 1966-68. MGS 619774

Thomas Frederick Haig Chatfield

Born: Toronto, Ontario, 19 August 1921

Black River Falls
Oil on canvas, 78.7 x 99.7 cm / 31 x 39¼"
Signed: (l.l.) THOMAS F. CHATFIELD
Purchase for the Oaklands Regional Centre, Oakville, 1975. MGS 614962

David James Chavel, O.S.A.

Born: Woodstock, Ontario, 29 June 1942

Untitled *c.* 1966-68
Brass, bronze, aluminum, wood, stone, Montz metal (mural relief); two panels, each 264.2 x 99.1 cm / 104 x 39"
Signed: (l.r., each panel) chavel
Commission for the Queen's Park Project, 1966-68. MGS 619771

A.J. Casson, *Untitled, c.* 1966-68

Paraskeva Clark, *Algonquin Morning*, 1954

Marjorie L. Child, O.I.P.

Companions
Oil on canvas, 74.9 x 54.6 cm/
29½ x 21½"
Gift of the artist, 1963. MGS 624437
The donation was made through the
Ontario Institute of Painters for hanging
in Ontario House, London, England; it
was returned to Toronto in 1980.

Janet Clark
Born: Toronto, Ontario, 12 June 1947

Sky Bands
Various fabrics, quilted; three panels:
l. to r.: a) 86.4 x 28.6 cm/34 x 11¼";
b) 86.4 x 44.5 cm/34 x 17½";
c) 86.4 x 28.6 cm/34 x 11¼";
overall: 86.4 x 109.2 cm/34 x 43"
Purchase from the artist for the Ontario
Government Building, Sudbury, 1980.
MGS 625794

Moira Clark
Born: Toronto, Ontario,
14 December 1950

Cool Magnolias 1980
Etching and aquatint; 75.6 x 55.2 cm/
29¾ x 21¾" (actual), 59.7 x 43.8 cm/
23½ x 17¼" (image)
Signed and dated: (l.r.) Moira Clark 80
Inscribed: (l.l.) Bon a Tirer; (l.c.) Cool
Magnolias
Purchase for the Michael Starr Building,
Oshawa, 1983. MGS 632609

The Edge of the Tide 1981
Etching and aquatint; 55.9 x 75.6 cm/
22 x 29¾" (actual), 44.4 x 60.3 cm/
17½ x 23¾" (image)
Signed and dated: (l.r.) Moira Clark 81
Inscribed and numbered: (l.l.) 12/14;
(l.c.) The Edge of the Tide
Purchase for the Michael Starr Building,
Oshawa, 1983. MGS 632610

Egyptian Oasis 1981
Etching and aquatint; 55.2 x 75.6 cm/
21¾ x 29¾" (actual), 44.4 x 59.7 cm/
17½ x 23½" (image)
Signed and dated: (l.r.) Moira Clark 81
Inscribed and numbered: (l.l.) 22/25;
(l.c.) Egyptian Oasis
Purchase for the Michael Starr Building,
Oshawa, 1983. MGS 632611

Sunlight through Glass 1982
Etching and aquatint; 55.9 x 69.9 cm/
22 x 27¹/₂″ (actual), 44.4 x 57.2 cm/
17¹/₂ x 22¹/₂″ (image)
Signed and dated: (l.r.) Moira Clark 82
Inscribed and numbered: (l.l.) 7/15;
(l.c.) Sunlight through Glass

Purchase for the Michael Starr Building,
Oshawa, 1983. MGS 632612

Paraskeva Plistik Clark, C.G.P.,
C.S.P.W.C., O.S.A., R.C.A.
Born: Leningrad, Russia,
28 October 1898
President, C.S.P.W.C. 1948

Algonquin Morning 1954
Oil on canvas, 91.4 x 78.7 cm/36 x 31″
Signed and dated: (l.r.) paraskeva clark/
'54.
MGS 619709

The scene in this painting is the view
from musician and art-collector Murray
Adaskin's summer cottage on Canoe
Lake in Algonquin Provincial Park.

Barbara Claus
Born: Toronto, Ontario, 3 May 1953

Hard Rain 1981
Acrylic on canvas, 121.9 x 104.8 cm/
48 x 41¹/₄″
Inscribed: (verso) B. Claus '81
Purchase from the artist for the Michael
Starr Building, Oshawa, 1982.
MGS 632613

Denis Anthony Cliff, R.C.A.
Born: Victoria, British Columbia,
8 August 1942

Untitled c. 1979
Acrylic on canvas on board; two panels:
a) 53.3 x 69.9 cm/21 x 27¹/₂″,
b) 53.3 x 71.1 cm/21 x 28″
Inscribed: (each panel, verso) Denis Cliff
Commission proposal for the York
North Court House and Land Registry
Office, Newmarket, 1979.
MGS 623345

Alan C. Collier, *Mining in Ontario,* 1968

Blake Debassige, *Root Digger*

Jon C. Coles

Parry Sound (Burk's Falls) 1948
Oil on canvas, 40.6 x 50.8 cm / 16 x 20"
Inscribed: (verso) Jon C. Coles June
30/48; Parry Sound (Birks [sic] Falls).
MGS 605044

The site of this work is probably Burk's
Falls, a village in Armour Township,
located east of Parry Sound on
Highway 11.

Alan Caswell Collier, O.S.A., R.C.A.

Born: Toronto, Ontario,
19 March 1911
Honours: President, O.S.A. 1958-60

Grounded
Oil on canvas, 120.7 x 151.1 cm /
47½ x 59½"
Signed: (l.r.) Alan C. Collier
Inscribed: (verso) On Labrador Coast
Near Venison Island / Alan C. Collier,
R.C.A., O.S.A. / F28 – grounded
Purchase for the Toronto Teachers'
College, 1971. MGS 623090

Mining in Ontario c. 1966
Gouache, pastel and graphite on board,
64.1 x 48.3 cm / 25¼ x 19"
Commission proposal for the Queen's
Park Project, 1966-68. MGS 619899

Mining in Ontario 1968
Acrylic emulsion on linen canvas
(mural), 261.6 x 198.1 cm / 103 x 78"
Signed and dated: (l.r.) Alan C. Collier /
'68
Commission for the Queen's Park
Project, 1966-68. MGS 619773

Elford Bradley Cox, O.S.A., A.R.C.A., S.S.C.

Born: Botha, Alberta, 16 July 1914

Bear c. 1962-63
Crystalline limestone,
91.4 x 152.4 x 91.4 cm / 36 x 60 x 36"
Commission for the Ernest C. Drury
School for the Blind and Deaf, Milton,
c. 1962-63. MGS 623842

Buffalo c. 1962-63
Crystalline limestone,
137.2 x 167.6 x 81.3 cm / 54 x 66 x 32"
Commission for the Ernest C. Drury
School for the Blind and Deaf, Milton,
c. 1962-63. MGS 623843

Bunny c. 1962-63
Crystalline limestone,
66 x 134.6 x 58.4 cm / 26 x 53 x 23"
Commission for the Ernest C. Drury
School for the Blind and Deaf, Milton,
c. 1962-63. MGS 623844

Fawn c. 1962-63
Crystalline limestone,
88.9 x 109.2 x 104.1 cm / 35 x 43 x 41"
Commission for the Ernest C. Drury
School for the Blind and Deaf, Milton,
c. 1962-63. MGS 623845

Ram c. 1962-63
Crystalline limestone,
109.2 x 180.3 x 71.1 cm / 43 x 71 x 28"
Commission for the Ernest C. Drury
School for the Blind and Deaf, Milton,
c. 1962-63. MGS 623846

Swan c. 1962-63
Crystalline limestone,
91.4 x 134.6 x 86.4 cm / 36 x 53 x 34"
Commission for the Ernest C. Drury
School for the Blind and Deaf, Milton,
c. 1962-63. MGS 623847

Turtle c. 1962-63
Crystalline limestone,
91.4 x 134.6 x 86.4 cm / 36 x 53 x 34"
Commission for the Ernest C. Drury
School for the Blind and Deaf, Milton,
c. 1962-63. MGS 623848

Jane Dixon, *Dream Unicorn*, 1982

The Days of the Year c. 1966
Metal and glass, disassembled
Commission proposal for the Queen's
Park Project, 1966-68. MGS 622582

The Days of the Year c. 1966-68
Bronze and glass, 182.9 x 302.3 x
317.5 cm / 72 x 119 x 125"
Commission for the Queen's Park
Project, 1966-68. MGS 619770

Untitled c. 1968
White granite,
157.5 x 238.8 x 81.3 cm / 62 x 94 x 32"
Commission for the Peel County Court
House, Brampton, 1968. MGS 623849

Judith Coxe

Born: Toronto, Ontario,
21 August 1937

Picul
Acrylic and oil pastel on paper,
76.2 x 53.4 cm / 30 x 21"
Purchase from the artist for the
Waterloo County Court House and Land
Registry Office, Kitchener, 1977.
MGS 619993

The title of this work coincides with the
artist's continuing interest in themes of
ambiguity and variation — a picul is a
Chinese weight (133⅓ lb). The word

was selected at random from a list of variable weights and measures.

Thomas (Tom) C. Cummings
Born: 1 December 1904

Milk, Medals and Memories
Oil on masonite, 74.9 x 62.2 cm/
29¹⁄₂ x 24¹⁄₂"
Signed: (l.l.) T. Cummings
Inscribed: (verso) from dwg. in a
military hospital
Purchase from the artist for the Ontario
Government Building, Sudbury, 1980.
MGS 625795

Oliver Davey
Born: Moose River Crossing,
Ontario, 30 July 1958

Canada Goose 1979
Serigraph; 63.5 x 47 cm/25 x 18¹⁄₂"
(sight), 49.5 x 34.9 cm/19¹⁄₂ x 13³⁄₄"
(image)
Signed and dated: (l.r.) OLIVER DAVEY
79
Inscribed and numbered: (l.l.)
Weneebaykook [in Cree syllabics]
35/38; (l.c.) CANADA GOOSE
Purchase from Weneebaykook
Workshop for the Ontario Government
Building, Moosonee, 1980.
MGS 635001

Fighting Moose 1979
Serigraph; 59.7 x 87.6 cm/23¹⁄₂ x 34¹⁄₂"
(sight), 44.4 x 73.7 cm/17¹⁄₂ x 29"
(image)
Signed and dated: (l.r.) OLIVER E.
DAVEY "79"
Inscribed and numbered: (l.l.)
Weneebaykook [in Cree syllabics]
21/30; (l.c.) "Fighting Moose" [in Cree
syllabics]
Purchase from Weneebaykook
Workshop for the Ontario Government
Building, Moosonee, 1980.
MGS 635002

The Wolf 1979
Serigraph; 68.6 x 82.6 cm/27 x 32¹⁄₂"
(sight), 52.7 x 67.9 cm/20³⁄₄ x 26³⁄₄"
(image)
Signed and dated: (l.r.) Oliver Davey '79
Inscribed and numbered: (l.l.)
Weneebaykook [in Cree syllabics]
16/75; (l.c.) The Wolf

Purchase from Weneebaykook
Workshop for the Ontario Government
Building, Moosonee, 1980.
MGS 635003

Haydn Llewellyn Davies, R.C.A.
Born: Rhymney, Wales,
11 November 1921

Space Composition, Red c. 1977
In two parts: a) gauge steel, primer,
74.9 x 59.7 x 35.6 cm/29¹⁄₂ x 23¹⁄₂ x 14";
b) ink and wash on silver print,
54.6 x 69.9 cm/21¹⁄₂ x 27¹⁄₂"
Signed and dated: (l.r., on part 'b')
HAYDN DAVIES – DEC. 77
Commission proposal for the Ontario
Government Building, Windsor, 1978.
MGS 622116

Space Composition, Red c. 1978
Aluminum, brake-formed, welded and
painted; 1097.3 x 609.6 x 548.6 cm/
432 x 240 x 216"
Commission for the Ontario
Government Building, Windsor, 1978.
MGS 623850

The artist thought of this sculpture as an
arrangement of elements — a compo-
sition in space — that would be flexible
and constantly changing according to
the position of the spectator viewing the
work.

Mary MacGowan Davies, O.S.A.
Born: Truro, Nova Scotia,
19 March 1925

The Catalyst
Lithograph, 73.7 x 60 cm/29 x 23⁵⁄₈"
(actual), 61 x 48.9 cm/24 x 19¹⁄₄"
(image)
Signed: (l.r.) Mary Davies
Inscribed and numbered: (l.l.) 2/20;
(l.c.) the catalyst
MGS 622680

Marks – II
Lithograph, 75.6 x 56.5 cm/29³⁄₄ x
22¹⁄₄" (sight), 69.9 x 45.1 cm/27¹⁄₂ x
17³⁄₄" (image)
Signed: (l.r.) Mary Davies
Inscribed and numbered: (l.l.) 8/25;
(l.c.) Marks – II
MGS 622679

Option
Serigraph, 59.1 x 44.5 cm/23¹⁄₄ x 17¹⁄₂"
(sight), 63.5 x 47.6 cm/25 x 18³⁄₄"
(image)
Signed: (l.r.) Mary Davies
Inscribed and numbered: (l.l.) 29/30;
(l.c.) option
MGS 622676

Laura Van Vechten Davis, O.I.P.
Born: U.S.A., 19 March 1911

Elizabeth
Oil on canvas, 61 x 50.8 cm/24 x 20"
Signed: (l.l.) L. Van Vechten Davis
Gift of the artist, 1963. MGS 624435
The donation was made through the
Ontario Institute of Painters for hanging
in Ontario House, London, England; it
was returned to Toronto in 1980.

Joseph R. De Angelis
Born: Providence, Rhode Island,
U.S.A., 22 April 1938

Untitled c. 1978
In three parts: a) painted wood,
50.8 x 111.8 x 26.7 cm/20 x 44 x 10¹⁄₂";
b) photographs mounted on board,
90.2 x 38.7 cm/35¹⁄₂ x 15¹⁄₄" (sight);
c) photographs mounted on board,
67.3 x 43.8 cm/26¹⁄₂ x 17¹⁄₄" (sight)
Commission proposal for the Ontario
Government Building, Windsor, 1978.
MGS 623002

Untitled c. 1978
Metal reinforced fibreglas, polyester
resin (mural relief), 609.6 x 640.1 cm/
240 x 252"
Commission for the Ontario
Government Building, Windsor, 1978.
MGS 623851

Blake Debassige
Born: West Bay, Manitoulin
Island, 23 June 1956

Root Digger
Acrylic on canvas, 90.2 x 69.9 cm/
35¹⁄₂ x 27¹⁄₂"
Signed: (l.r.) b. debosegai [Ojibway
spelling]
Purchase from the artist for the Ontario
Police College, Aylmer, 1979.
MGS 623993

Ron Eccles, *Line Stone Garden*, 1981

Man Floating 1976
Serigraph, 56.5 x 86.4 cm / 22¼ x 34"
Signed and dated: (l.r.) B. Debassige;
(l.r.) 1/10/76
Inscribed and numbered: (l.l.) [Ojibway
syllabics]; 61/95; (l.c.) "Man Floating"
Purchase from the artist, *c.* 1979.
MGS 623799

Peter R. Dennis, S.S.C.
Born: London, England, 1943

Canadian Shield *c.* 1977
In three parts: a) aluminum, 11.4 x 47 x
12.7 cm / 4½ x 18½ x 5"; b) watercolour
and graphite on paper, 38.1 x 53.3 cm /
15 x 21"; c) watercolour and graphite on
paper, 35.6 x 50.8 cm / 14 x 20"
Signed and dated twice: (l.r., on 'b') P.
DENNIS/76 (c.r., on 'c') P. DENNIS./
77
Commission proposal for the Simcoe
County Court House and Land Registry
Office, Barrie, 1977. MGS 619323

Jane Dixon
Born: Toronto, Ontario, 1929

Dream Unicorn 1982
Fabric appliqué, 129.5 x 96.5 cm / 51 x 38"
Signed and dated: (l.r., stitched) Jane
Dixon 1982
Purchase from the artist for the Michael
Starr Building, Oshawa, 1982.
MGS 632614

Malvern Dollack, O.I.P.
Born: Toronto, Ontario,
24 March 1924

Dentonia Park, Toronto
Oil on canvas, 50.8 x 61 cm / 20 x 24"
Signed: (l.r.) Malvern Dollack
Gift of the artist, 1963. MGS 624434

The donation was made through the
Ontario Institute of Painters for hanging
in Ontario House, London, England; it
was returned to Toronto in 1980.
Dentonia Park, one of the summer

homes of the Massey family, was
located near what is now the inter-
section of Danforth and Main in
Toronto.

Langley Thomas Donges, O.I.P.
Born: Toronto, Ontario,
17 January 1901

Early Snow, Erindale
Oil on canvas, 59.1 x 71.8 cm /
23¼ x 28¼"
Signed: (l.r.) LANGLEY/DONGES
Gift of the artist, 1963. MGS 624433

The donation was made through the
Ontario Institute of Painters for hanging
in Ontario House, London, England; it
was returned to Toronto in 1980.
Erindale was a milling community
established in the 1820s at the junction
of the Credit River and the Dundas
Highway. The village was given its
present name early in the twentieth
century — "Erindale" was the estate
built by an Irishman, the Rev. James
Magrath, who was the district's first
Anglican clergyman. The village is now
part of the City of Mississauga, west of
Toronto.

Robert (Bob) James Downing,
O.S.A., R.C.A.
Born: Hamilton, Ontario, 1 August
1935

Inner Clarity *c.* 1978
Wax, 31.1 x 38.1 x 38.1 cm /
12¼ x 15 x 15"
Commission proposal for the Queen
Street Mental Health Centre, Toronto,
1978. MGS 622581

Kenneth William Drysdale
Born: Arnprior, Ontario, 1906
Died: 1972

Untitled
Oil on masonite, 73.6 x 59.7 cm /
29 x 23½"
Signed: (l.r.) K. W. Drysdale
MGS 625900

This work was probably a gift from
former students or graduating students
at the Ottawa Normal School, where
Drysdale began teaching in 1947. The
school was closed in 1974, and the
painting was returned to Queen's Park
in 1980.

Michael Durham

Born: Leeds, England,
12 February 1944

Untitled c. 1974
Acrylic on canvas, four adjacent panels.
Overall: 219.7 x 419.1 cm / 86½ x 165"
Commission for the Middlesex County
Court House and Land Registry Office,
London, 1974. MGS 616947

Michael Earle

Born: Montreal, Quebec, 9 June 1952

Rain Birds c. 1982
Serigraph, 48.3 x 66 cm / 19 x 26"
(actual)
Signed and numbered: (l.c.) 8/17; (l.r.)
M. Earle
Purchase for the Michael Starr Building,
Oshawa, 1983. MGS 632615

Robin 1982
Serigraph; 54 x 73 cm / 21¼ x 28¾"
(sight), 52.4 x 71.8 cm / 20⅝ x 28¼"
(image)
Signed and dated: (l.r.) M. Earle '82
Inscribed and numbered: (l.l.) Robin;
(l.c.) 2/38
Purchase for the Michael Starr Building,
Oshawa, 1983. MGS 632616

Ronald (Ron) Kenneth Eccles

Born: Oshawa, Ontario,
11 January 1944

Line Stone Garden 1981
Oil on canvas, 162.6 x 182.9 cm / 64 x 72"
Inscribed: (verso) R. K. Eccles 81
Purchase from the artist for the Michael
Starr Building, Oshawa, 1982.
MGS 632617

Moses Echalook

Born: 1931

Mother and Child
Soapstone, 43.2 x 38.1 x 40.6 cm /
17 x 15 x 16"
Inscribed: (underside) in Inuit syllabics
[artist's name]; E 91585 [transaction
number]
MGS 626471

This sculptor works in the Inuit
community of Inukjuak, formerly called
Port Harrison, in northern Quebec.

Michael Earle, *Robin*, 1982

Una Mavis Ehlert, S.S.C.

Born: Bristol, England,
30 January 1922

Quiet Moment
Bronze, 24.1 x 10.8 x 13.3 cm /
9½ x 4¼ x 5¼"
Inscribed: (on base, verso) M. Ehlert
Gift of the students of 1967-68 to the
Hamilton Teachers' College, Hamilton,
1978. MGS 623098

Douglas Ferguson Elliott, O.I.P.

Born: Woodstock, Ontario,
21 July 1916

Summer Mood, Bronte
Oil on masonite, 50.8 x 66 cm / 20 x 26"
Signed: (l.r.) DOUGLAS ELLIOTT
Gift of the artist, 1963. MGS 624432

The donation was made through the
Ontario Institute of Painters for hanging
in Ontario House, London, England; it
was returned to Toronto in 1980. Bronte
is a small fishing village on the north
shore of Lake Ontario, between Oakville
and Burlington, in Halton County.

Kosso Eloul, R.C.A.

Born: Mourom, Russia,
22 January 1920

The giant stainless steel or aluminum
sculptures of Kosso Eloul, usually
consisting of two or more large
rectangular blocks precariously balanced
together, are notable in their
combination of simplicity and
complexity.

Salut c. 1975
Stainless steel, 365.8 x 365.8 x 182.9 cm /
144 x 144 x 72"
Commission by Mr. Harry Klamer for
Cleanol Headquarters, Toronto, 1975;
Gift of Mr. and Mrs. Klamer in memory
of Mr. Klamer's brother-in-law and
sister, Doctor and Mrs. Saul Fainstein,
to the Ontario Heritage Foundation,
1983; on loan to the Government of
Ontario. MGS 633338

Untitled c. 1979
In two parts: a) painted wood, 11.4 x
41.3 x 24.8 cm / 4½ x 16¼ x 9¾";
b) wood and marble, 24.1 x 41.3 x
28.3 cm / 9½ x 16¼ x 11⅛"

Commission proposal for the York North Court House and Land Registry Office, Newmarket, 1979. MGS 623338

Leo Etherington
Born: Attawapiskat, Ontario,
8 July 1953

Untitled
Serigraph on cotton, 108 x 97.8 cm/
42¹/₂ x 38¹/₂" (actual)
Signed: (l.c.) Leo Etherington [in Cree syllabics]
Inscribed and numbered: (l.l.) Weneebaykook [in Cree syllabics] 11/70
Purchase from Weneebaykook Workshop for the Ontario Government Building, Moosonee, c. 1980.
MGS 635005

Untitled
Serigraph on cotton, 116.8 x 149.9 cm/46 x 59"
Signed: (l.r.) Leo Etherington [in Cree syllabics]
Inscribed and numbered: (l.l.) Weneebaykook [in Cree syllabics] 1/5 A/P
Purchase from Weneebaykook Workshop for the Ontario Government Building, Moosonee, c. 1980.
MGS 635006

Untitled
Serigraph on cotton, 149.9 x 116.8 cm/46 x 59"
Signed: (l.r.) Leo Etherington [in Cree syllabics]
Inscribed and numbered: (l.l.) Weneebaykook [in Cree syllabics] 12/70
Purchase from Weneebaykook Workshop for the Ontario Government Building, Moosonee, c. 1980.
MGS 635007

Untitled
Serigraph on cotton, 105.4 x 70.5 cm/41¹/₂ x 27³/₄"
Signed: (l.r.) Leo Etherington [in Cree syllabics]
Inscribed and numbered: (l.l.) Weneebaykook [in Cree syllabics] A/P
Purchase from Weneebaykook Workshop for the Ontario Government Building, Moosonee, c. 1980.
MGS 635008

WEH-HEOW-PEESIM 1980
Serigraph; 70.5 x 52.1 cm/27³/₄ x 20¹/₂"
(sight), 55.9 x 36.8 cm/22 x 14¹/₂"

(image)
Signed and dated: (l.r.) Leo Etherington/80
Inscribed and numbered: (l.l.) Weneebaykook [in Cree syllabics] 4/60; (l.c.) WEH-HEOW-PEESIM
Purchase from Weneebaykook Workshop for the Ontario Government Building, Moosonee, 1980.
MGS 635009

Fishers 1980
Serigraph; 50.8 x 67.3 cm/20 x 26¹/₂" (sight), 37.5 x 54.6 cm/14³/₄ x 21¹/₂" (image)
Signed and dated: (l.r.) Leo Etherington/80
Inscribed and numbered: (l.l.) Weneebaykook [in Cree syllabics] 14/70; (l.c.) The Fishers [in both English and Cree syllabics]
Purchase from Weneebaykook Workshop for the Ontario Government Building, Moosonee, 1980.
MGS 635004

William Paterson Ewen, R.C.A.
Born: Montreal, Quebec, 7 April 1925

Thunder Cloud as a Generator 1976
Lithograph, 78.1 x 56.5 cm/30³/₄ x 22¹/₄" (actual)
Signed, dated and numbered (within image): (l.l.) P Ewen/76; (l.r.) 42/50
Inscribed (within image): (l.c.) Thunder Cloud as a Generator
Purchase, 1977. MGS 619942

This print is based on a painting of 1971, entitled *Thunder Cloud as Generator No. 1* in the collection of the London Regional Art Gallery.

Patricia Mary Fairhead,
C.S.P.W.C., O.I.P.
Born: Hull, Yorkshire, England,
23 February 1927

Kemptville
Oil on canvas, 40.6 x 50.8 cm/16 x 20"
Signed: (l.r.) PATRICIA/FAIRHEAD
Gift of the artist, 1963. MGS 624431

The donation was made through the Ontario Institute of Painters for hanging in Ontario House, London, England; it was returned to Toronto in 1980. Kemptville is situated on Kemptville Creek in Oxford County, south of Ottawa and east of Smiths Falls, Ontario.

Edward George Falkenberg,
O.S.A., S.S.C.
Born: Edmonton, Alberta,
30 March 1936

Daybreak (Horizon Series) 1979
Steel, cardboard and wood, 21.6 x 144.8 x 31.8 cm/8¹/₂ x 57 x 12¹/₂"
Signed and dated: (u.r.) Edward Falkenberg/Sculptor Aug. 31, 1979
Commission proposal for the York North Court House and Land Registry Office, Newmarket, 1980.
MGS 623348

George Sarras Fanais, O.I.P.
Born: Windsor, Ontario,
25 December 1922

Ontario Hunter 1959
Oil on canvas, 96.5 x 81.3 cm/38 x 32"
Signed and dated: (u.r.) G. Fanais '59
Gift of the artist, 1963. MGS 624430

The donation was made through the Ontario Institute of Painters for hanging in Ontario House, London, England; it was returned to Toronto in 1980.

Five Potters Studio
Group formed in Toronto, 1956
Group members:
Bailey Leslie (born: Lodz, Poland, 14 June 1904);
Marion Lewis (born: Poland, 15 February 1910);
Mayta Markson, R.C.A. (born: Winnipeg, Manitoba, 24 March 1931);
Dorothy Midanik (born: Bradford, Ontario, 21 July 1925);
Annette Zakuta (born: Montreal, Quebec).

Untitled c. 1968
Ceramic panels (mural relief), 121.9 x 1066.8 cm/48 x 420"
Inscribed: (b.) SALUS POPULI; (u.r.) EST SUPREMA LEX
Commission for the Peel County Court House and Land Registry Office, Brampton, 1968. MGS 623857

The inscription, which translates as "The welfare of the people is the highest law," is a dictum said to have been derived from the Laws of the Twelve Tables at Rome.

A. G. Fleming

Toronto from the Island
Oil on canvas, 40.6 x 55.9 cm / 16 x 22″
Signed: (l.r.) A. G. FLEMING
MGS 624402

Possibly a gift of the artist, 1963, made
through the Ontario Institute of Painters
for hanging in Ontario House, London,
England; it was returned to Toronto in
1980.

Karen Fletcher

Born: Moose Jaw, Saskatchewan,
8 May 1952

Hands and Nest 1977
Brown and white ink on blue-green
paper, 49.5 x 39.4 cm / 19½ x 15½″
Signed and dated: (u.l.) KAREN
FLETCHER; (u.r.) 1977
Purchase from the artist for the
Waterloo County Court House and Land
Registry Office, Kitchener, 1977.
MGS 619976

Hands and Skull 1977
Brown and white ink on blue-green
paper, 49.5 x 39.4 cm / 19½ x 15½″
Signed and dated: (u.l.) KAREN
FLETCHER; (u.r.) 1977
Purchase from the artist for the
Waterloo County Court House and Land
Registry Office, Kitchener, 1977.
MGS 619977

Jean Mary Edgell Forbes, A.R.C.A.,
O.I.P.

Born: Karachi, India (now Pakistan),
18 May 1897

Across the Valley, Willowdale
Watercolour on paper, 31.8 x 38.1 cm /
12½ x 15″
Signed: (l.r.) JEAN FORBES
Gift of the artist, 1963. MGS 624403

The donation was made through the
Ontario Institute of Painters for hanging
in Ontario House, London, England; it
was returned to Toronto in 1980.
Willowdale is a suburb of the city of
North York, part of Metropolitan
Toronto. Jean Forbes was the wife of
painter Kenneth Forbes, and mother of
June McCormack.

Paterson Ewen, *Thunder Cloud as a Generator*, 1976

Vera Frankel, *Big X-Window Suite*, 1975-76

Michael Foster
Born: Runcorn, Cheshire, England,
15 January 1943

Interplay c. 1979
In two parts: a) black and white
photographs, 44.5 x 61 cm/17½ x 24";
b) ink on paper, 55.9 x 71.1 cm/22 x 28"
Commission proposal for the York
North Court House and Land Registry
Office, Newmarket, 1979.
MGS 623341

Interplay c. 1980
Photographs mounted on panels, three
sections (t. to b.): a) 50.8 x 914.4 cm/
20 x 360"; b) 50.8 x 519.4 cm/
20 x 204½"; c) 50.8 x 609 cm/
20 x 239¾"
Commission for the York North Court
House and Land Registry Office,
Newmarket, 1980. MGS 624993

Henry Fountain
Born: 1 October 1950

Hamilton Railroad Tracks
Pen and ink on cardboard,
50.5 x 76.2 cm/19⅞ x 30"
Signed: (l.r.) Henry Fountain
MGS 622014

Untitled 1970
Oil on canvas, 60 x 90.5 cm/23⅝ x 35⅝"
Signed and dated: (l.r.) H Fountain 70
Gift of the graduating class to the staff of
the Teacher Education Centre, Sir James
Whitney School, Belleville, 1971.
MGS 622604

Barbara Fournier
Born: Sault Ste Marie, Ontario,
18 September 1946

Great Horned Owl 1977
Linocut, 38 x 33 cm/15 x 13" (sight);
34.9 x 30.5 cm/13¾ x 12" (image)
Signed, dated and numbered: (l.l.) B.
Fournier/77 39/100
Inscribed: (l.r.) Great Horned Owl
Purchase from the artist for the Ministry
of Northern Affairs, Northeastern
Regional Office, Sault Ste Marie, *c.*
1978. MGS 635331

Common Loon 1977
Linocut, 38 x 33 cm/15 x 13" (sight);
34.9 x 30.5 cm/13³/₄ x 12" (image)
Signed, dated and numbered: (l.l.) B.
Fournier/77; (l.c.) 59/100
Inscribed: (l.r.) Common Loon
Purchase from the artist for the Ministry
of Northern Affairs, Northeastern
Regional Office, Sault Ste Marie, *c.*
1978. MGS 635332

Ruffed Grouse 1977
Linocut, 38 x 33 cm/15 x 13" (sight);
34.9 x 30.5 cm/13³/₄ x 12" (image)
Signed, dated and numbered: (l.l.) B.
Fournier/77; (l.c.) 39/100
Inscribed: (l.r.) Ruffed Grouse
Purchase from the artist for the Ministry
of Northern Affairs, Northeastern
Regional Office, Sault Ste Marie,
c. 1978. MGS 635344

Paul Fournier

Born: Simcoe, Ontario,
11 October 1939

Lakeside #3 1967
Oil and lucite on canvas, 76.8 x 86.4 cm/
30¹/₄ x 34"
Signed and dated: (l.r.) Paul Fournier '67
Inscribed: (verso) Paul Fournier 1967/
Lakeside #3/oil and lucite/300.
Gift of the students of 1966/67 to the
Hamilton Teachers' College, Hamilton,
1967. MGS 623079

Lagoon 1979
Acrylic on canvas, 73.7 x 304.8 cm/
29 x 120"
Inscribed twice: (verso) Paul Fournier
Jan '79
Purchase for the Ellen Fairclough
Building, Hamilton, 1981. MGS 630156

In his early paintings, Fournier was
interested in the various light effects
found in landscape, rather in the manner
of the English landscape painter J.M.W.
Turner. In more recent years Fournier's
work has been characterized by a combi-
nation of abstract colour painting and
drawing with colour.

Graham A. D. Fowler

Born: Halifax, Nova Scotia,
15 February 1952

Gerald Gladstone, *The Three Graces, c.* 1972

Lilies in the Formation of X 1980
Oil on canvas, 94 x 73.7 cm/37 x 29"
Signed and dated: (l.r.) G Fowler 80
Purchase, 1982. MGS 632677

Upright Lily 1980
Oil on canvas, 94 x 73.7 cm/37 x 29"
Signed and dated: (l.r.) G. Fowler 80
Purchase, 1982. MGS 632676

Vera Frenkel

Born: Bratislava, Czechoslovakia,
10 November 1938

Big X-Window Suite 1975-76
Lithograph (suite of four), each
108 x 75.6 cm/42¹/₂ x 29³/₄"
Signed and dated four times: (l.r., part
'a') Frenkel/75; (l.r., parts 'b', 'c' and
'd') Frenkel/76
Numbered: (l.l., each part) 40/70
Purchase from the artist for the Ellen
Fairclough Building, Hamilton, 1982.
MGS 630141

In her prints, as in her video and
performance art, Vera Frenkel is
concerned with ambiguity. The window,
always an important image in her work,

can be an opening or frame through
which to view the outside world, or an
interval in the space and time between
objects. In this series of lithographs, the
"Big X" can be seen as both the image of
the work, and a large cross obscuring an
image which is, perhaps, on the other
side of the window.

Donald R. Frost

Born: Peterborough, Ontario,
1 July 1950

Equinox 1982
Fibreglas with steel core,
161.6 x 13.3 x 13.3 cm/63⁵/₈ x 5¹/₄ x 5¹/₄"
(including base)
Signed and dated: (on base) Frost 82
Commission proposal for the Michael
Starr Building, Oshawa, 1982.
MGS 632673

Equinox 1983
Fibreglas and steel,
1524 x 243.8 x 304.8 cm/600 x 96 x 120"
Signed and dated: (on base) Frost 83
Commission for the Michael Starr
Building, Oshawa, 1983. MGS 632618

Gerald Gladstone, *Untitled, c.* 1966-68

(sight), 59.7 x 39.4 cm/23¹/₂ x 15¹/₂"
(image)
Signed, dated and numbered: (l.l.)
gamble/83; (l.r.) 26/30
Inscribed: (l.c.) RED BOAT
Purchase for the Michael Starr Building,
Oshawa, 1983. MGS 632650

Audrey Elaine Garwood,
O.S.A., R.C.A.
Born: Toronto, Ontario, 7 July 1927

Yosemite 1975
Serigraph; 81.3 x 54 cm/32 x 21¹/₄"
(sight), 76.8 x 50.8 cm/30¹/₄ x 20"
(image)
Signed, dated and numbered: (l.l.)
39/80; (l.r.) A GARWOOD '75
Inscribed: (l.l.) YOSEMITE
Purchase for the Michael Starr Building,
Oshawa, 1983. MGS 632643

Northern California Seasons –
(Spring) c. 1976
Serigraph; 80.6 x 63.5 cm/31³/₄ x 25"
(sight), 76.2 x 58.4 cm/30 x 23" (image)
Signed and numbered: (l.l.) 20/125;
(l.r.) A GARWOOD
Inscribed: (l.l.) NORTHERN
CALIFORNIA SEASONS – SPRING
Purchase for the Michael Starr Building,
Oshawa, 1983. MGS 632642

Dennis Geden
Born: North Bay, Ontario,
25 April 1944

Twins 1977
Oil on canvas, 127 x 76.2 cm/50 x 30"
Signed and dated: (l.r.) Geden/77
Purchase from the artist for the Ontario
Government Building, Sudbury, 1980.
MGS 625796

James (Jim) Gillies
Born: London, Ontario,
31 August 1951

Abraxis Series #3 c. 1976
Latex, paper collage, oil and pastel on
paper, 89.9 x 64.5 cm/35³/₈ x 25³/₈"
Purchase from the artist for the Ontario
Police College, Aylmer, 1977.
MGS 618684

Gianguido Fucito
Born: Venice, Italy, 9 June 1938

Chromaxie 6 1979
Pastel on paper, 74.9 x 105.4 cm/
29¹/₂ x 41¹/₂" (actual)
Signed and dated: (l.r.) Fucito '79
Inscribed: (l.l.) Chromaxie 6
Purchase for the Michael Starr Building,
Oshawa, 1983. MGS 632641

Encounter in Color 1981
Watercolour on paper, 99.1 x 69.8 cm/
39 x 27¹/₂" (actual)
Signed and dated: (l.r.) Fucito 81
Inscribed: (l.r.) ENCOUNTER IN
COLOR
Purchase for the Michael Starr Building,
Oshawa, 1983. MGS 632670

Conrad Stephen Furey
Born: Baie Verte, Newfoundland,
22 August 1954

Untitled
Acrylic on masonite, 48.6 x 58.4 cm/
19¹/₈ x 23"
Signed: (l.l.) C. Furey
Purchase from the artist, 1977.
MGS 622013

Erik Gamble
Born: Toronto, Ontario,
14 October 1950

Red Boat 1983
Serigraph; 64.8 x 45.7 cm/25¹/₂ x 18"

Abraxis Tilt 2 c. 1978
Stainless steel, two parts: a) 26.7 x 34.2 x 8.9 cm/10½ x 13½ x 3½", b) 38.1 x 35.6 x 11.4 cm/15 x 14 x 4½"
Commission proposal for the Peel County Land Registry Office, Brampton, 1978. MGS 622134

Gillies understood the word "Abraxis" to denote a "god of gods, over even Zeus," and chose this title for the sculptural and two-dimensional works in this series because he thought they were very bold and seemed powerful and commanding. Other works in this series include *Abraxis Tilt # 1* (commissioned by the Department of Public Works, Ottawa, for the Canada Employment Centre in Barrie, Ontario), and the maquette listed above.

Gerald Gladstone, R.C.A., O.S.A.
Born: Toronto, Ontario,
7 January 1929

Untitled c. 1966-68
Steel and illuminated acrylic blocks, 153 x 140.3 x 77.5 cm/60¼ x 55¼ x 30½"
Commission for the Queen's Park Project, 1966-68. MGS 619769

The Three Graces c. 1972
Cast bronze and steel, in three sections; 259.1 cm/102" (overall height); 1,620 kg/3,600 lbs (overall weight)
Signed: (bottom of right foot of one Grace) Gladstone
Commission for the Queen's Park Project, 1971. MGS 619768

In this bronze group, the three sister goddesses of Greek mythology, said to be the givers of charm and beauty, are the focal point of a dramatic water sculpture.
Gladstone was determined to have his first major sculpture in bronze fabricated entirely in Ontario. He contracted Mid Canadian Investment Castings Ltd. near Georgetown to fashion the trio of muses, the first time a sculpture of such size had been cast in the province.

Ontario Outstanding Amateur Athletic Achievement Sculpture c. 1975
Bronze on marble obelisk, 194.3 x 88.9 x 76.2 cm/76½ x 35 x 30"

Inscribed: (on face of obelisk, below bronze forms) ONTARIO/OUTSTAND-ING/AMATEUR ATHLETIC/ACHIEVEMENT/1975/JEROME PETER DRAYTON/1976/KATHY KREINER/1977/SUSAN NATTRASS/1978/CATHY SHERK/1979/GORDON SINGLETON/1980/STEVE PODBORSKI/1981/STEVE PODBORSKI – ALEX BAUMANN/1982/MILTON OTTEY
Commission, 1975. MGS 622619

This bronze symbolizes the act of striving toward spiritual and physical achievement, and is a model for the smaller, individually sculpted awards which are presented each year to the province's outstanding amateur athletes.

Mark Gomes
Born: Sarnia, Ontario, 18 May 1949

Untitled c. 1978
Wood, cardboard and mixed media, 17.8 x 55.9 x 44.5 cm/7 x 22 x 17½"
Commission proposal for the Halton County Court House and Land Registry Office, Milton, 1978. MGS 622124

Hortense Mattice Gordon, A.R.C.A.
Born: Hamilton, Ontario,
24 November 1887
Died: Hamilton, Ontario,
6 November 1961

Derelict No. 7
Watercolour, pencil, gouache and collage on paper, 66 x 99.1 cm/26 x 39"
Signed: (l.r.) HORTENSE M. GORDON.
Gift of the students to the Hamilton Teachers' College, Hamilton.
MGS 623080

A member of Painters Eleven, the Toronto group of abstract artists in the 1950s, Hortense Gordon knew and appreciated the paintings of the School of Paris. She began to make abstract paintings in the 1930s.

Judith (Judy) Mary Gouin
Born: Farnsborough, Hampshire, England, 28 February 1947

Snowdrift 1976
Serigraph; 74.9 x 80 cm/29½ x 31½" (sight); 64.8 x 62.2 cm/25½ x 24½" (image)
Signed, dated and numbered: (l.l.) 9/20; (l.r.) Judy Gouin '76
Inscribed: (l.l.) Snowdrift
Purchase, 1976. MGS 619937

Beaver Swamp, Spring Snow I 1977
Serigraph; 74.6 x 74 cm/29⅜ x 29⅛" (sight), 64.1 x 64.1 cm/25¼ x 25¼" (image)
Signed, dated and numbered: (l.l.) 2/35; (l.r.) Judy Gouin '77
Inscribed: (l.l.) Beaver Swamp, Spring Snow I
Purchase, 1977. MGS 619928

Beaver Swamp, Spring Snow III 1977
Serigraph; 74.6 x 73.7 cm/29⅜ x 29" (sight), 64.1 x 64.8 cm/25¼ x 25½" (image)
Signed, dated and numbered: (l.l.) 2/35; (l.r.) Judy Gouin '77
Inscribed: (l.l.) Beaver Swamp, Spring Snow III
Purchase, 1977. MGS 619929

Helen Graham
fl. 1977

Untitled
Watercolour on paper, 33.7 x 50.4 cm/13¼ x 19⅞"
Signed: (l.r.) Helen Graham
Gift of the staff to the Teacher Education School, presented in memory of Miss Marjorie I. Hegle (1907-1977), teacher of the deaf (1937-1950) and Principal of the Junior School (1950-1972), Sir James Whitney School, Belleville, 1977. MGS 622605

Kathleen M. Graham, R.C.A.
Born: Hamilton, Ontario,
13 September 1913

In her art, K.M. Graham combines the long tradition of Canadian landscape painting with the influence of the painting of Jack Bush. Abstract impressions of the landscape are interpreted through the startling colour and light of the Arctic, a favourite subject in her work.

Hortense Gordon, *Derelict No. 7*

High Arctic I 1975
Lithograph, 43.2 x 55.6 cm / 17 x 22"
(actual)
Signed and dated: (l.r.) K. M. Graham /
75
Inscribed and numbered: (l.r.) High
Arctic I 8 / 10
Purchase, 1977. MGS 619951

Out from Cape Dorset I 1975
Lithograph, 43.2 x 55.9 cm / 17 x 22"
(actual)
Signed and dated: (u.r.) K. M. Graham /
75
Inscribed and numbered: (u.r.) Out from
Cape Dorset I 5 / 25
Purchase, 1977. MGS 619952

Jersey Kate 1976
Acrylic on canvas, 204.5 x 194.3 cm /
80¹/₂ x 76¹/₂"
Inscribed three times: (verso) K. M.
Graham
Dated three times: (twice, verso) '76;
(verso) 1976
Purchase for the Ellen Fairclough
Building, Hamilton, 1981.
MGS 630157

Kathleen Florence Gray

Born: Montreal, Quebec,
21 January 1919

Images Due South
Watercolour on paper, 39.4 x 73.7 cm /
15¹/₂ x 29"
Signed: (l.r.) K. GRAY.
Purchase from the artist for the Ellen
Fairclough Building, Hamilton, 1981.
MGS 630155

Otto N. Grebze

Born: Latvia, 10 August 1910

Otto Grebze arrived in Canada from
Germany in 1947, and worked for almost
a year at Ontario Hydro's Des Joachims
generating plant. He continued to work
for the Hydro Commission for approxi-

mately 20 years, after which he was employed by the Ministry of Transportation and Communication until his retirement in 1975. During his years at Hydro, Grebze was frequently hired by the Commission to paint scenes of the hydro-electric developments in Ontario.

Des Joachims Development 1948
Oil on canvas, 68.6 x 76.2 cm / 27 x 30"
Signed and dated: (l.r.) O. N. Grebze 1948
Inscribed: (verso) Des Joachim's [*sic*] Cofferdam
MGS 624404

Probably commissioned by Ontario Hydro, this work was hung in Ontario House, London, England; it was returned to Toronto in 1980.
 The Des Joachims generating station at Rolphton is the largest such facility on the Ottawa River. It has been in service since 1950, and has a total capacity of 360,000 kw. The local name (pronounced "Dah Swisha") comes from two Indian boys (family name Joachim) who drowned in the rapids in the early 1800s.

The International Rapids Section of the St. Lawrence River as it will be upon Completion of the Seaway and Power Project 1956
Oil on canvas, 100.3 x 151.1 cm / 39¹/₂ x 59¹/₂"
Signed and dated: (l.r.) O. N. Grebze 1956
Commission by Ontario Hydro in honour of its Golden Jubilee; presented by Hydro to Premier Leslie M. Frost, 1956. MGS 692880

The Saint Lawrence Seaway was officially opened in 1959. At the International Rapids section, where the river marks the Canada-United States boundary, a total of 2,200,000 horsepower is divided equally between Ontario Hydro and the Power Authority of the State of New York.

Canadian Horseshoe Falls
Oil on canvas, 61 x 76.2 cm / 24 x 30"
Signed: (l.r.) O. N. Grebze
MGS 624406

Probably commissioned by Ontario Hydro, this work was hung in Ontario House, London, England; it was returned to Toronto in 1980.

K.M. Graham, *Jersey Kate*, 1976

Roy Greenaway, *Royal Oak Tavern*

Roy Greenaway, *Winter Twilight, Holy Trinity Church, Toronto*

Winter Glow, Haliburton
Oil on canvas, 63.5 x 76.2 cm / 25 x 30"
Signed: (l.r.) Phillip Green
Gift of the artist, 1963. MGS 624408

The donation was made through the Ontario Institute of Painters for hanging in Ontario House, London, England; it was returned to Toronto in 1980.

Roy Greenaway, O.I.P.
Born: Toronto, Ontario,
15 August 1891
Died: Toronto, Ontario,
18 November 1972

Roy Greenaway was a journalist with the Toronto *Daily Star* for more than forty years, over twenty of which were spent as a member of the Press Gallery at the Ontario Legislature, Queen's Park. Greenaway was also a prolific artist and many of his paintings were executed during overseas journeys. For example, the Venetian scenes in this collection are the product of a visit to Italy in 1957. Greenaway spent many summers painting in Gloucester, Massachusetts and Portsmouth, New Hampshire, and the seascapes and depictions of fishing villages and boats in harbour catalogued below are representative of his American work.

Children in Alley
Oil on canvas, 48.2 x 58.4 cm / 19 x 23"
Signed: (l.l.) Roy Greenaway
Gift of Mrs. Roy Greenaway, 1975.
MGS 623024

Sir Adam Beck's #2, From Brown's Hotel 1956
Oil on canvas, 64.8 x 80.6 cm /
25½ x 31¾"
Signed and dated: (l.l.) O. N. Grebze
1956
MGS 624405

Probably commissioned by Ontario Hydro for its Golden Jubilee in 1956, this work was hung in Ontario House, London, England; it was returned to Toronto in 1980. The subject is a hydro-electric plant below Niagara Falls, on the Niagara River, Ontario. Sir Adam Beck (1857-1925) for whom the plant is named, was Conservative M.P.P. for London (1902-19; 1923-25) and was appointed a commissioner to investigate the development and distribution of power from Niagara Falls in 1903. He introduced into the Ontario Legislature the bill creating the Hydro-Electric Power Commission of Ontario, and

from 1906 to his death was chairman of that Commission (re-named Ontario Hydro in 1974).

Norma Green, O.I.P.
fl. 1960s

The Quiet Lake, Haliburton
Oil on canvas, 50.8 x 61 cm / 20 x 24"
Signed: (l.r.) Norma Green
Gift of the artist, 1963. MGS 624407

The donation was made through the Ontario Institute of Painters for hanging in Ontario House, London, England; it was returned to Toronto in 1980. The County of Haliburton is located in south-central Ontario, north of Peter-borough County and east of Muskoka.

Phillip Green, O.I.P.
fl. 1960s

Church on a Corner
Oil on canvas, 48.3 x 58.4 cm / 19 x 23"
Signed: (l.l.) ROY/GREENAWAY
Gift of Mrs. Roy Greenaway, 1975.
MGS 623025

City Scene in Winter
Oil on canvas, 48.6 x 58.7 cm /
19¹/₈ x 23¹/₈"
Initialled: (l.l.) RG [monogram]
Gift of Mrs. Roy Greenaway, 1975.
MGS 623023

The subject is a Toronto street or alleyway, with the Canadian Bank of Commerce (now Canadian Imperial Bank of Commerce) tower in the background.

Fishing Boats in Harbour
Oil on canvas, 71.1 x 86.4 cm / 28 x 34"
Signed: (l.r.) Roy Greenaway
MGS 623354

Horses and Barn
Oil on canvas, 48.6 x 58.4 cm / 19¹/₈ x 23"
Signed: (l.r.) Roy Greenaway
Gift of Mrs. Roy Greenaway, 1975.
MGS 623026

Ice Fishing
Oil on canvas, 47.9 x 58.4 cm / 18⁷/₈ x 23"
Signed: (l.l.) Roy Greenaway
Gift of Mrs. Roy Greenaway, 1975.
MGS 623028

Lobster Boats
Oil on canvas, 69.2 x 85.1 cm /
27¹/₄ x 33¹/₂"
Signed: (l.r.) Roy Greenaway
Gift of Mrs. Roy Greenaway, 1975.
MGS 623017

McSorley's Bar, N. Y.
Oil on canvas, 64.1 x 75.6 cm /
24¹/₄ x 29¹/₄"
Signed: (l.r.) Roy Greenaway
Gift to the Queen's Park Press Gallery by Major the Hon. Rev. John W. Foote, V.C.
(M.P.P. Durham, 1948-59).

Peonies
Oil on canvas, 63.5 x 63.5 cm / 25 x 25"
Signed: (l.r.) Roy Greenaway
Gift of Mrs. Roy Greenaway, 1975.
MGS 619706

Fred Haines, *Autumn, Denbigh*

Rough Sea, No. 4, Gloucester, Massachusetts
Oil on canvas, 59.1 x 74.9 cm /
23¹/₄ x 29¹/₂"
Signed: (l.r.) Roy Greenaway
MGS 635333

Rough Waters
Oil on canvas, 62.2 x 74.9 cm /
24¹/₂ x 29¹/₂"
Signed: (l.l.) Roy Greenaway
Gift of Mrs. Roy Greenaway, 1975.
MGS 623019

Royal Oak Tavern
Oil on canvas, 47.9 x 58.7 cm /
18⁷/₈ x 23¹/₈"
Signed: (l.l.) Roy Greenaway
Gift of Mrs. Roy Greenaway, 1975.
MGS 623022

Located at the corner of Dundas and Ontario Streets, Toronto, this tavern still bears the name, The Royal Oak.

Shaftesbury Memorial, Piccadilly Circus
Oil on canvas, 48.3 x 58.4 cm / 19 x 23"
Signed: (l.r.) Roy Greenaway

Gift of Mrs. Roy Greenaway, 1975.
MGS 623027

Trees and Snow
Oil on canvas, 48.6 x 58.4 cm / 19¹/₈ x 23"
Signed: (l.r.) Roy Greenaway
Gift of Mrs. Roy Greenaway, 1975.
MGS 623018

Untitled
Oil on canvas, 69.8 x 85.1 cm /
27¹/₂ x 33¹/₂"
Signed: (l.l.) Roy Greenaway
Gift of the artist. MGS 632679

White Peonies
Oil on canvas, 49.5 x 59.7 cm /
19¹/₂ x 23¹/₂"
Signed: (l.r.) Roy Greenaway
Gift of Mrs. Roy Greenaway, 1975.
MGS 619707

Winter Twilight, Holy Trinity Church, Toronto
Oil on canvas, 50.2 x 59.7 cm /
19³/₄ x 23¹/₂"
Signed: (l.r.) Roy Greenaway
Purchase from the artist, 1957.
MGS 619865

Hubert Haisoch, *Wallet – India Pale Ale*, 1977

Last Covered Bridge in Ontario
c. 1954
Oil on canvas, 49.5 x 58.4 cm / 19½ x
23"
Signed: (l.r.) Roy Greenaway
Purchase from the artist. MGS 619816

Erected in 1881 over the Grand River,
the West Montrose bridge in Waterloo
County is Ontario's last remaining
covered bridge. Greenaway repeated this
composition for a somewhat later
painting called *Covered Bridge, West
Montrose.*

Rain on the Piazza, Venice c. 1957
Oil on canvas, 57.1 x 74.9 cm /
22½ x 29½"
Signed: (l.r.) Roy Greenaway
Gift of Mrs. Roy Greenaway, 1975.
MGS 623029

Untitled c. 1957
Oil on canvas, 69.9 x 85.7 cm /
27½ x 33¾"
Signed: (l.l.) Roy Greenaway
Gift of the artist. MGS 632678

Rough Sea 1959
Oil on canvas, 50.8 x 61 cm / 20 x 24"
Signed and dated: (l.r.) Roy Greenaway
'59.
Gift of Mrs. Roy Greenaway, 1975.
MGS 623069

Covered Bridge, West Montrose
Oil on canvas, 50.8 x 61 cm / 20 x 24"
Signed: (l.r.) Roy Greenaway
Gift of the artist, 1963. MGS 624409

The donation was made through the
Ontario Institute of Painters for hanging
in Ontario House, London, England; it
was returned to Toronto in 1980.

Fred Greene, Sr. (Greenefeather)
Born: Carl Bay, Shoal Lake, Ontario,
3 April 1920

Birch Trees 1978
Pen-and-ink and wash on paper,
45.1 x 60.6 cm / 17¾ x 23⅞"
Signed and dated: (l.r.) Greenefeather /
78
Purchase for the Ontario Ministry of
Northern Affairs, Northwestern
Regional Office, Kenora, 1978.
MGS 622009

Mallard Ducks 1978
Pen-and-ink and wash on paper,
45.4 x 60.6 cm / 17⅞ x 23⅞"
Signed and dated: (l.r.) Greenefeather /
78
Purchase for the Ontario Ministry of
Northern Affairs, Northwestern
Regional Office, Kenora, 1978.
MGS 622010

Untitled 1979
Pen-and-ink and wash on paper,
44.5 x 59.7 cm / 17½ x 23½"
Signed and dated: (l.r.) Greenefeather /
79
Purchase for the Ontario Ministry of
Northern Affairs, Northwestern
Regional Office, Kenora, 1979.
MGS 635334

Untitled 1979
Pen-and-ink and wash on paper,
34.3 x 49.5 cm / 13½ x 19½"
Signed and dated: (l.r.) Greenefeather /
79
Purchase for the Ontario Ministry of
Northern Affairs, Northwestern
Regional Office, Kenora, 1979.
MGS 635335

Mark MacIntosh Grenville
Born: Clinton, Ontario,
23 August 1950

Desert Sun 1977
Mixed media on paper, 76.2 x 54.6 cm /
30 x 21½"
Signed and dated: (l.r.) Grenville '77
Purchase from the artist for the
Waterloo County Court House and Land
Registry Office, Kitchener, 1977.
MGS 619992

Robert Frederick (Fred) Hagan,
O.S.A.

Born: Toronto, Ontario, 21 May 1918

Untitled c. 1979
In two parts: a) ceramic on board,
15.9 x 33.7 cm / 6¼ x 13¼";
b) six lithographs on paper,
I: 52.1 x 40 cm / 20½ x 15¾";
II: 52.7 x 40 cm / 20¾ x 15¾";
III: 52.7 x 39.4 cm / 20¾ x 15½";
IV: 47 x 32.4 cm / 18½ x 12¾";
V and VI: 40.6 x 52.1 cm / 16 x 20½"
Signed: (l.r., on each lithograph)
Frederick Hagan
Inscribed: (l.l., on lithographs I, II, IV,
V, VI) Artist's Proof; (l.l., on III) Printing
Proof
Commission proposal for the York
North Court House and Land Registry
Office, Newmarket, 1979. MGS 623344

Frederick Stanley Haines, O.S.A.,
R.C.A., C.S.P.W.C., O.I.P.

Born: Meaford, Ontario,
31 March 1879

Died: Toronto, Ontario,
21 November 1960

Founding member, O.I.P.

Autumn, Denbigh
Oil on canvas, 61 x 81.3 cm / 24 x 32"
Signed: (l.r.) FRED. S. HAINES
Inscribed: (on frame, verso) Autumn,
Denbigh
Gift of the artist, 1963. MGS 624412

The donation was made through the
Ontario Institute of Painters for hanging
in Ontario House, London, England; it
was returned to Toronto in 1980.
Denbigh is a village in eastern Ontario,
west of Bancroft and northwest of
Kingston, in the county of Lennox and
Addington.

Hubert Haisoch, O.S.A.

Born: Milwaukee, Wisconsin,
U.S.A., 28 December 1933

Fossil 1975
Etching, collage, rubber stamp on paper;
29.8 x 34.3 cm / 11¾ x 13½" (sight),
24.8 x 32.4 cm / 9¾ x 12¾" (image)
Signed and dated: (l.r.) Hubert Haisoch
1975
Inscribed: (l.l.) Fossil
Purchase from the artist for the

April Hickox, *Buckets*, 1982

Waterloo County Court House and Land
Registry Office, Kitchener, 1977.
MGS 619986

The *Wallet* series (seven items) are all
collograph and mixed media collage on
paper, 19.1 x 22.9 cm / 7½ x 9" (sight);
image size varies.

Green Wallet – Ritmeester 1975
Collograph and mixed media collage on
paper, 17.1 x 21 cm / 6¾ x 8¼" (image)
Signed and dated: (l.r.) Hubert Haisoch
1975
Inscribed: (l.l.) Green Wallet –
Ritmeester
Purchase from the artist for the
Waterloo County Court House and Land
Registry Office, Kitchener, 1977.
MGS 619984

Wallet – Underberg # 5
Collograph and mixed media collage on
paper, 17.1 x 21 cm / 6¾ x 8" (image)
Signed: (l.l., within image) H. Haisoch
Purchase from the artist for the

Waterloo County Court House and Land
Registry Office, Kitchener, 1977.
MGS 619985

Wallet – Castilla 1975
Collograph and mixed media collage on
paper, 17.1 x 20.3 cm / 6¾ x 8" (image)
Signed and dated: (l.c.) Hubert Haisoch;
(l.r.) 1975
Inscribed: (l.l.) Wallet – Castilla
Purchase from the artist for the
Waterloo County Court House and Land
Registry Office, Kitchener, 1977.
MGS 619979

Wallet – Military # 5 1976
Collograph and mixed media collage on
paper, 17.1 x 21 cm / 6¾ x 8¼" (image)
Signed and dated: (l.c.) Hubert Haisoch;
(l.r.) 1976
Inscribed: (l.l.) Wallet – Military # 5
Purchase from the artist for the
Waterloo County Court House and Land
Registry Office, Kitchener, 1977.
MGS 619980

Wallet – X 1976
Collograph and mixed media collage on
paper, 17.1 x 22.2 cm / 6³/₄ x 8³/₄" (image)
Signed and dated: (l.c.) Hubert Haisoch;
(l.r.) 1976
Inscribed: (l.l.) Wallet – X
Purchase from the artist for the
Waterloo County Court House and Land
Registry Office, Kitchener, 1977. MGS
619981

Wallet – India Pale Ale 1977
Collograph and mixed media collage on
paper, 17.1 x 22.2 cm / 6³/₄ x 8³/₄" (image)
Signed and dated: (l.r.) Hubert Haisoch
1977
Inscribed: (l.l.) Wallet – India Pale Ale
Purchase from the artist for the
Waterloo County Court House and Land
Registry Office, Kitchener, 1977.
MGS 619982

Wallet – Military #20 1977
Collograph and mixed media collage on
paper, 17.1 x 21 cm / 6³/₄ x 8¹/₄" (image)
Signed and dated: (l.r.) Hubert Haisoch
1977
Inscribed: (l.l.) Wallet – Military #20
Purchase from the artist for the
Waterloo County Court House and Land
Registry Office, Kitchener, 1977.
MGS 619983

Barbara Hall
Born: Bronxville, New York, U.S.A.,
22 December 1942

Chair with Pyramids 1978
Serigraph; 44.4 x 54 cm / 17¹/₂ x 21¹/₄"
(sight), 40.6 x 50.8 cm / 16 x 20" (image)
Signed, dated and numbered: (l.l.)
80/100; (l.r.) B. Hall '78
Purchase for the Michael Starr Building,
Oshawa, 1983. MGS 632644

Susanne Michel Harlander, O.S.A.
Born: Stuttgart, Germany,
28 November 1920

Continuity c. 1978
Ceramic, two parts: (a) 41.3 x 41.3 x
26.7 cm / 16¹/₄ x 16¹/₄ x 10¹/₂", (b) 41.3 x
41.3 x 20.3 cm / 16¹/₄ x 16¹/₄ x 8"
Commission proposal for the Halton
County Court House and Land Registry
Office, Milton, 1978. MGS 622121

John Kenneth Harman, R.C.A.
Born: Vancouver, British Columbia,
31 July 1927

Mother and Child c. 1966
Bronze, 15.2 x 2.5 cm / 6 x 1"
Commission proposal for the Queen's
Park Project, 1966-68. MGS 619696

Mother and Child 1968
Bronze, 182.9 x 152.4 x 91.4 cm /
72 x 60 x 36"
Signed and dated: (l.r., verso) Harman
1968
Commission for the Queen's Park
Project, 1966-68. MGS 619767

Robert H. Haynes
Born: Sudbury, Ontario, 3 April 1947

No Parking Zone / Elgin St. 1980
Acrylic on canvas, 85.1 x 54.6 cm /
33¹/₂ x 21¹/₂"
Signed and dated: (l.r.) R. Haynes Jan/80
Purchase from the artist for the Ontario
Government Building, Sudbury, 1980.
MGS 625797

Lynda Hayward-Baird
Born: Toronto, Ontario,
1 August 1941

Hayward-Baird's landscape and
botanical subjects are drawn from the
area around the farm owned by herself
and her husband, sculptor Ron Baird, at
Goodwood, in the Uxbridge Hills
northeast of Toronto.

Becoming Apple Trees 1980
Hand-dyed and painted, quilted cotton
silkscreen, with poly fibrefill and cotton
backing; three panels, each
221 x 188 cm / 87 x 74"
Signed and dated: (l.r., each panel)
Lynda Hayward-Baird 1980
Purchase from the artist for the York
North County Court House and Registry
Office, Newmarket, 1980. MGS 625699

Untitled 1983
Hand-dyed and painted, quilted cotton
silkscreen, with poly fibrefill and cotton
backing; two panels, each
182.9 x 121.9 cm / 72 x 48"
Signed and dated: (l.r. of right panel,
stitched) Lynda Baird 1983
Commission for the Michael Starr
Building, Oshawa, 1982. MGS 632619

Robert Burns Hedrick, A.R.C.A.
Born: Windsor, Ontario, 1 May 1930

Untitled c. 1978
Cardboard, 34.3 x 41.9 x 11.4 cm /
13¹/₂ x 16¹/₂ x 4¹/₂"
Commission proposal for the Ontario
Government Building, Windsor, 1978.
MGS 622118

Ursula Heller
Born: Eglisau, Switzerland, 1949

Untitled c. 1979
In two parts: a) black and white
photographs mounted on board,
100 x 200 cm / 39³/₈ x 78³/₄";
b) sample of mount, 43.8 x 43.8 cm /
17¹/₄ x 17¹/₄"
Commission proposal for the York
North Court House and Land Registry
Office, Newmarket, 1979. MGS 623349

April Ann Hickox
Born: Toronto, 24 April 1955

Buckets 1982
Photo-etching, 55.9 x 76.2 cm /
22 x 30" (sight) 33.7 x 48.9 cm /
13¹/₄ x 19¹/₄" (image)
Signed and dated: (l.r.) April Hickox 82'
Inscribed: (l.l.) "Red and Blue Bucket
Specimens" (l.c.) Artist's proofs
Purchase for the Michael Starr Building,
Oshawa, 1983. MGS 632620

Watering Cans 1982
Photo-etching, 55.9 x 105.4 cm /
22 x 41¹/₂" (sight), 26.7 x 74.9 cm /
10¹/₂ x 29¹/₂" (image)
Signed, dated and numbered: (l.c.) 2/7;
(l.r.) April Hickox 82'
Inscribed: (l.l.) "Watering Cans"
Purchase for the Michael Starr Building,
Oshawa, 1983. MGS 632621

Marlene Hilton-Moore
Born: White's Cove, New
Brunswick, 4 July 1944

Seated Man V – "The Warrior"
1981
Oil on canvas, 121.9 x 91.4 cm / 48 x 36"
Signed and dated: (l.l.) Hilton '81
Inscribed: (verso) April 10 '81 / Harold's
Concert tonight / Seated Man #5 / Linda /
"The Warrior" / Matthew / July '30 /

D. Mackay Houstoun, *Pre-Cambrian Landscape*, 1968

81 Joseph/Full Moon
Purchase from the artist for the Michael
Starr Building, Oshawa, 1982.
MGS 632622

Barry Hodgson
Born: Vineland Station, Ontario,
29 January 1954

Sumach 1982
Serigraph; 48.3 x 66 cm / 19 x 26" (sight),
45.7 x 63.5 cm / 18 x 25" (image)
Signed, dated and numbered: (l.l.)
26/30; (l.r.) Barry Hodgson '82
Inscribed: (l.c.) Sumach
Purchase for the Michael Starr Building,
Oshawa, 1983. MGS 632651

John Joseph Trevor Hodgson
Born: England, 27 April 1931

Kite 2
Acrylic on masonite, 121.9 x 92.7 cm /
48 x 36½"
Signed: (l.r.) Hodgson
Purchase from the artist for the Ellen
Fairclough Building, Hamilton, 1981.
MGS 630153

Andrea Hoffmann

Freeway Madness
Photograph, 33 x 49.5 cm / 13 x 19½"
Purchase from the artist for the Ontario
Government Building, Sudbury, 1980.
MGS 625798

Sleepy Hollow
Photograph, 33 x 49.5 cm / 13 x 19½"
Purchase from the artist for the Ontario
Government Building, Sudbury, 1980.
MGS 625799

John Hofstetter
Born: North Bay, Ontario,
23 September 1952

Flow Thru 1975
Serigraph; 50.2 x 31.1 cm / 19¾ x 12¼"
(sight), 47 x 29.2 cm / 18½ x 11½"
(image)
Signed, dated and numbered: (l.l.) 2/14;
(l.r.) John Hofstetter/75
Inscribed: (l.c.) Flow Thru
Purchase from the artist for the
Waterloo County Court House and Land
Registry Office, Kitchener, 1977.
MGS 619988

Stephen James Hogbin
Born: London, England, 4 April 1942

Leonard Hutchinson, *Burlington Bay*

Binary Spirit c. 1979
White pine and black walnut, 84.5 x
163.2 x 21.6 cm / 33¼ x 64¼ x 8½"
Commission proposal for the York
North Court House and Land Registry
Office, Newmarket, 1979.
MGS 623350

Binary Spirit c. 1980
Poplar and walnut (mural relief), two
sections of seventeen units, each
section: 335.3 x 462.3 cm /
132 x 182"
Commission for the York North Court
House and Land Registry Office,
Newmarket, 1979. MGS 624992

This mural relief, originally commis-
sioned for the entranceway of the York
North County Court House in 1979, was
moved in 1980 to the Macdonald Block,
Queen's Park.

The work consists of two spirals, each

shaped and segmented from a six-foot
diameter poplar or walnut disc. The
centre of energy, the core of the spiral, is
an abstract shape which evolves into
birds in flight moving progressively
higher and further from the wall on
which they are mounted. The duality of
the spirit is symbolized in the contrast-
ing colours of the wood, and the birds
symbolize the spirit's soaring in search
of a higher plane of understanding.

Donald (Don) Holman

Born: Kansas City, Missouri, 1946

Serpent's Coil / Southern Ontario
Lithograph, 106.7 x 71.1 cm / 42 x 28"
(actual)
Signed and numbered: (l.l.) 11/20; (l.r.)
D. Holman
Purchase, 1983. MGS 634454

Douglas Hook

Born: Toronto, Ontario,
21 December 1943

Untitled
Watercolour on paper, 36.2 x 51.4 cm /
14¼ x 20¼"
Signed: (l.l.) Doug Hook
Purchase from the artist for the Ministry
of Northern Affairs, Northeastern
Regional Office, Sault Ste Marie, c.
1978. MGS 635336

Donald Mackay Houstoun, O.S.A., C.S.P.W.C., R.C.A.

Born: Stephensville, Ontario,
27 November 1916

Untitled 1966
Acrylic on canvas, 68.6 x 132.1 cm /
27 x 52"
Signed and dated: (l.r.) Houstoun '66
Commission proposal for the Queen's
Park Project, 1966-68. MGS 619697

Pre-Cambrian Landscape 1968
Acrylic on canvas (mural),
261.6 x 502.9 cm / 103 x 198"
Signed and dated: (l.r.) Houstoun '68
Commission for the Queen's Park
Project, 1966-68. MGS 619766

Barbara Howard

Born: Toronto, Ontario,
10 March 1926

Ash Grove 1981
Serigraph; 47.6 x 65.7 cm / 18¾ x 25⅞"
(sight), 45.7 x 63.5 cm / 18 x 25" (image)
Signed and dated: (l.r.) BARBARA
HOWARD-'81
Inscribed: (l.l.) PRINTER'S PROOF 2/3;
(l.c.) ASH GROVE
Purchase for the Michael Starr Building,
Oshawa, 1983. MGS 632652

Spring Island 1981
Serigraph; 47.6 x 65.7 cm / 18¾ x 25⅞"
(sight), 45.7 x 63.5 cm / 18 x 35" (image)
Signed and dated: (l.r.) BARBARA
HOWARD '81
Inscribed: (l.l.) PRINTERS PROOF 2/3;
(l.c.) SPRING ISLAND
Purchase for the Michael Starr Building,
Oshawa, 1983. MGS 632653

E. J. (Ted) Howorth

Born: Regina, Saskatchewan,
19 August 1943

Park Lady 1982
Serigraph; 50.2 x 73.7 cm/19³/₄ x 29"
(sight), 48.3 x 71.1 cm/19 x 28" (image)
Signed and dated: (l.r.) E J HOWORTH
82
Inscribed: (l.l.) Park Lady; (l.c.) A.P.
Purchase for the Michael Starr Building,
Oshawa, 1983. MGS 632623

Stanley Wilbert Hughes

Born: New Westminster, British
Columbia, 8 December 1940

*Untitled Landscape (Shoreline with
Island)*
Acrylic on canvas (triptych),
each panel: 101.6 x 137.2 cm/40 x 54";
overall: 101.6 x 411.5 cm/40 x 162"
Signed: (c.r., right-hand panel) Hughes
Purchase from the artist for the Ellen
Fairclough Building, Hamilton, 1981.
MGS 630148

David Peter Hunsberger

Born: Waterloo, Ontario,
25 September 1950

Sky 1977
Serigraph; 45.1 x 59.7 cm/17³/₄ x 23¹/₂"
(sight), 43.2 x 57.8 cm/17 x 22³/₄"
(image)
Signed, dated and numbered: (l.l.) 1977;
2/20; (l.r.) D. P. Hunsberger
Inscribed: (l.c.) Sky
Purchase from the artist for the
Waterloo County Court House and Land
Registry Office, Kitchener, 1977.
MGS 619987

Leonard Hutchinson, O.S.A., R.C.A.

Born: Manchester, England,
8 April 1896

Burlington Bay
Woodcut (colour); 24.1 x 27.3 cm/
9¹/₂ x 10³/₄" (sight), 21.6 x 25.4 cm/
8¹/₂ x 10" (image)
Signed: (l.r.) Leonard Hutchinson
Inscribed and numbered: (l.l.)
BURLINGTON BAY 9/100.
MGS 622090

Burlington Bay is at the extreme

Katja Jacobs, *Parade #2*, 1980

Franz Johnston, *Winter Ideal*

Paulosie Kanayook, *Hunter with Seal*

Algonquin Swamp – Spring
Oil on masonite, 50.2 x 61 cm / 19³/₄ x 24"
MGS 624410

Possibly a gift of the artist, 1963, made through the Ontario Institute of Painters for hanging in Ontario House, London, England; it was returned to Toronto in 1980.

Francis Hans (Franz) Johnston,
O.S.A., A.R.C.A., C.S.P.W.C.
Born: Toronto, Ontario, 19 June 1888
Died: Toronto, Ontario, 9 July 1949

Winter Ideal
Oil on canvas, 55.9 x 76.2 cm / 22 x 30"
Signed: (l.l.) Franz Johnston
Purchase, 1951. MGS 623356

Johnston's main concern was light and its effects in his paintings. A member of the original Group of Seven, he exhibited with them until he decided in October 1924 to work independently. In 1926 he chose to combine his two given names "Francis Hans" into one, "Franz," closing the files on his earlier work as "Frank" Johnston.
 The undated work in this collection was formerly known as *Winterscape* and was probably painted in the 1940s in Simcoe County near Georgian Bay.

John Joy
Born: Toronto, Ontario,
22 February 1925

Northland 1962
Oil on masonite, 76.2 x 101 cm /
30 x 39³/₄"
Signed and dated: (l.r.) John / Joy / 62
MGS 624411

western end of Lake Ontario. The view may be from Burlington across the bay towards Hamilton Mountain. Hutchinson was a long-time resident of Hamilton, and served as curator of the Art Gallery of Hamilton from 1936 to 1947. For another, more recent view of the Bay, see James Spencer, *Landscape # 1.*

Kenneth (Ken) William Jackson
Born: London, Ontario, 24 April 1944

Black Cherry 1976
Egg tempera on masonite,
59.7 x 75.6 cm / 23¹/₂ x 29³/₄"
Signed and dated: (l.r.) K. Jackson 2/76
Inscribed: (verso) 676 Ken W. Jackson / 1976 / Title: Black Cherry / Location: Concession II, Littlewood, Ont. / Medium: Egg Tempera / Size: 29⁷/₈" x 29¹/₂" / Date: Mar. 76, / Artist: Ken W. Jackson / London, Ont.
Purchase from the artist for the Ontario Police College, Aylmer, 1977.
MGS 618685

Katja Jacobs
Born: Wilhemshaven, Germany,
19 May 1939

Parade # 2 1980
Acrylic on canvas, 205.7 x 174.6 cm /
81 x 68³/₄"
Inscribed: (verso) Katja Jacobs
November '80
Purchase for the Ellen Fairclough Building, Hamilton, 1981. MGS 630161

Constance (Connie) M. Jefferess
Born: London, Ontario, 1930

Untitled c. 1974
Tapestry of jute, sisal and spun yarn, dyed; 518.2 x 731.5 cm / 204 x 288"
Commission for the Middlesex County Court House and Land Registry Office, London, 1974. MGS 616941

Kathleen Beatrice Johnson, O.S.A.
Born: York Township, Ontario,
4 July 1917

Possibly a gift of the artist, 1963, made through the Ontario Institute of Painters for hanging in Ontario House, London, England; it was returned to Toronto in 1980.

Goyce Kakegamic

Born: Sandy Lake Reserve, Ontario, 1948

Birds at the Campfire
Serigraph, 76.2 x 55.9 cm/30 x 22"
Signed and numbered: (l.l.) IV/V;
(l.r.) Goyce Kakegamic
Inscribed: (l.c.) Birds at the Campfire
Purchase from the artist through the Triple K Co-operative, Red Lake, for the Ontario Ministry of Northern Affairs, Northwestern Regional Office, Kenora, 1977. MGS 635337

Joshim (Josh) Kakegamic

Born: Sandy Lake Reserve, Ontario, 1952

Bear 1975
Serigraph, 55.9 x 76.2 cm/22 x 30"
(actual)
Signed, dated and numbered: (l.l.)
20/65; (l.r.) Josh Kakegamic/75
Inscribed: (l.l.) [artist's name in Cree syllabics]; (l.c.) Bear
Purchase from the artist through the Triple K Co-operative, Red Lake, for the Ontario Ministry of Northern Affairs, Northwestern Regional Office, Kenora, 1977. MGS 635338

Conjurors 1975
Serigraph, 76.2 x 55.9 cm/30 x 22"
(actual)
Signed, dated and numbered: (l.l.) A/P
II/III; (l.r.) Josh Kakegamic/75
Inscribed: (l.l.) [artist's name in Cree syllabics]; (l.c.) Conjurors
Purchase from the artist through the Triple K Co-operative, Red Lake, for the Ontario Ministry of Northern Affairs, Northwestern Regional Office, Kenora, 1977. MGS 635339

Family 1975
Serigraph, 88.9 x 73.7 cm/35 x 29"
Signed, dated and numbered: (l.l.)
37/57; (l.r.) Josh Kakegamic/75

Inscribed: (l.c.) Family; (l.r.) [artist's name in Cree syllabics]
Purchase from the artist through the Triple K Co-operative, Red Lake, for the Ministry of Northern Affairs, Northeastern Regional Office, Sault Ste Marie, 1977. MGS 635340

Dependance 1977
Serigraph, 62.2 x 75.6 cm/24¹/₂ x 29³/₄"
(actual)
Signed, dated and numbered: (l.l.) III/III
AP; (l.r.) Josh Kakegamic/77
Inscribed: (l.c.) Dependance
Purchase from the artist through the Triple K Co-operative, Red Lake, for the Ministry of Northern Affairs, Northeastern Regional Office, Sault Ste Marie, 1977. MGS 635341

Demolish 1977
Serigraph, 38.1 x 52.7 cm/15 x 20³/₄"
(actual)
Signed, dated and numbered: (l.l.) AP
VI/VII; (l.r.) Josh Kakegamic/77
Inscribed: (l.c.) Demolish
Purchase from the artist through the Triple K Co-operative, Red Lake, for the Ontario Ministry of Northern Affairs, Northeastern Regional Office, Sault Ste Marie, 1977. MGS 635342

Lloyd Kakepetum

Sandy Lake Reserve, Ontario

Bear on the Hunt
Serigraph, 44.4 x 57.8 cm/17¹/₂ x 22³/₄"
(actual)
Signed and numbered: (l.l.) 75/90; (l.r.)
Lloyd Kakepetum
Inscribed: (l.c.) BEAR ON THE HUNT
MGS 623801

Richard Kamalatisit

Born: Moosonee, Ontario,
14 December 1959

Pack of Wolves 1981
Acrylic on board, 61 x 50.8 cm/24 x 20"
Signed and dated: (l.r.) Richard/
Kamalatisit '81
Purchase from the artist, c. 1981.
MGS 635010

Polar Bears 1978
Serigraph; 55.9 x 77.5 cm/22 x 30¹/₂"
(sight), 40.6 x 63.5 cm/16 x 25" (image)
Signed and dated: (l.r.) Richard
Kamalatisit '78
Inscribed and numbered: (l.l.)
Weneebaykook [in Cree syllabics]
70/75; (l.c.) Polar Bears [in Cree syllabics]
Purchase from Weneebaykook
Workshop for the Ontario Government Building, Moosonee, 1980.
MGS 635011

Sundown 1978
Serigraph; 57.8 x 71.1 cm/22³/₄ x 28"
(sight), 40.6 x 55.9 cm/16 x 22" (image)
Signed and dated: (l.r.) Richard
Kamalatisit '78
Inscribed and numbered: (l.l., within image) Weneebaykook [in Cree syllabics]; (l.c.) Sundown
Purchase from Weneebaykook
Workshop for the Ontario Government Building, Moosonee, 1980.
MGS 635012

Wolves 1978
Serigraph; 56.5 x 77.5 cm/22¹/₄ x 30¹/₂"
(sight), 40.6 x 62.9 cm/16 x 24³/₄"
(image)
Signed and dated: (l.r.) Richard
Kamalatisit '78
Inscribed and numbered: (l.l., within image) Weneebaykook [in Cree syllabics]; (l.l.) 33/83; (l.c.) "Wolves"
Purchase from Weneebaykook
Workshop for the Ontario Government Building, Moosonee, 1980.
MGS 635013

Paulosie Kanayook

Born: 1937

Hunter with Seal
Soapstone, 30.5 x 50.8 x 27.9 cm/
12 x 20 x 11"
Purchase from artist as commission proposal for the Queen's Park Project, 1966-68. MGS 619698

Hunter With Seal c. 1966-68
Canadian black granite, 182.9 x 121.9 x
121.9 cm/72 x 48 x 48"
Signed: (l.c., on base) PAULOSIE
KANAYOOK/LOUIS TEMPORALE
Inscribed: (l.c., on base) [Inuit syllabics]
Commission for the Queen's Park Project, 1966-68. MGS 619765

Harold Klunder, *Tiger Brand*, 1980

Since the small scale of traditional Inuit sculpture did not lend itself to the monumental setting desired for this work, Louis Temporale of Canadian Art Memorials Ltd. was commissioned to execute an enlargement in granite of Kayanook's soapstone carving. When the large model was almost ready for installation, Kanayook was brought to Toronto from his home in Povungnituk, Quebec, to complete the work.

Tuktu 1961
Stencil print, 21.6 x 28.6 cm / 8½ x 11¼"
Signed, dated and inscribed: (l.l.)
Kanayook; '61; Povungnituk; (l.r.)
23/50 CP
Gift to the Hamilton Teachers' College by the students of 1942-43. MGS 623093

Brian Kelley
Born: 1946

Close Tulips
Lithograph, 55.9 x 76.2 cm / 22 x 30"
(actual)
Signed: (l.r.) Kelley
Inscribed and numbered (l.l.) Close
Tulips 3/5
Purchase for the Michael Starr Building, Oshawa, 1983. MGS 632646

Untitled
Lithograph; 35.6 x 43.8 cm / 14 x 17¼"
(sight), 29.8 x 38.7 cm / 11¾ x 15¼"
(image)
Numbered and signed: (l.l.) 16/25;
(l.r.) Kelley
Purchase for the Michael Starr Building, Oshawa, 1983. MGS 632645

Roger John Kerslake
Born: Devon, England,
11 November 1938

Untitled
In three parts: a) unglazed porcelain-type clay on painted white wood backing,
45.7 x 152.4 cm / 18 x 60";
b) watercolour and graphite on paper,
49.5 x 64.8 cm / 19½ x 25½";
c) watercolour, graphite and affixed photograph on paper, 49.5 x 64.8 cm /
19½ x 25½"

Inscribed: (u.l., on 'b') Roughs for possible MURAL/COURT HOUSE. BARRIE; (l.r. on 'c') [specifications for proposal]
Commission proposal for the Simcoe County Court House and Land Registry Office, Barrie, 1977. MGS 619750

Untitled c. 1977
Ceramic tiles on pine board (mural relief), 221 x 330.2 cm / 87 x 130"
Commission for the Simcoe County Court House and Land Registry Office, Barrie, 1977. MGS 619745

Claire Kerwin, O.S.A., A.R.C.A.
Born: Belgium, 25 July 1919

Contrainte
Collograph, 78.1 x 58.4 cm / 30¾ x 23"
Signed; (l.r.) Claire Kerwin
Inscribed: (l.l.) AP Contrainte.
MGS 622669

Liberation
Collograph, 68 x 58.4 cm / 26¾ x 23"
Signed: (l.r.) Claire Kerwin
Inscribed: (l.l.) AP Liberation.
MGS 622695

Kilopa

Mother and Child
Soapstone, 25.4 x 12.7 x 9.5 cm /
10 x 5 x 3¾"
Signed: (on base) Kilopak
Inscribed: (underside) 4350 [transaction number]
Gift to the Hamilton Teachers' College, Hamilton, by the students of 1964-65.
MGS 623102

The sculptor, also known as Kelupak, is from the Inuit community of Inukjuak, formerly Port Harrison, Quebec.

Harold Klunder
Born: Deventer, The Netherlands,
14 October 1943

Tiger Brand 1980
Lithograph, 233.7 x 92.7 cm / 92 x 36½"
(actual)
Signed and dated: (l.r.) H. Klunder 80
Purchase for the Ellen Fairclough Building, Hamilton, 1981.
MGS 630162

Nobuo Kubota, *Columns, c.* 1977

Helen Harriet Knights
Born: Toronto, Ontario,
20 January 1912

Pine Bay
Etching; 40.6 x 47.3 cm / 16 x 18⅝″
(sight), 22.9 x 30.5 cm / 9 x 12″ (image)
Signed and dated: (l.r.) Helen Knights
1974
Inscribed and numbered: (l.l.) Pine Bay
5/25
Purchase from the artist for the Ontario
Government Building, Thunder Bay,
1975. MGS 615419

Pleasant Hill
Etching; 40.6 x 47 cm / 16 x 18½″
(sight), 22.9 x 29.8 cm / 9 x 11¾″
(image)
Signed and dated: (l.r.) Helen Knights
1971
Inscribed and numbered: (l.l.) Pleasant
Hill 7/50
Purchase from the artist for the Ontario
Government Building, Thunder Bay,
1975. MGS 615418

Snowbound
Etching; 40.6 x 47 cm / 16 x 18½″
(sight), 22.9 x 30.5 cm / 9 x 12″ (image)
Signed and dated: (l.r.) Helen Knights
1974
Inscribed and numbered: (l.l.)
Snowbound 6/25
Purchase from the artist for the Ontario
Government Building, Thunder Bay,
1975. MGS 615421

Nobuo Kubota, *The Third Wave*, 1979-80

Sunlight and Shadow
Etching; 40.6 x 46 cm / 16 x 18⅛″
(sight), 22.9 x 29.8 cm / 9 x 11¾″
(image)
Signed and dated: (l.r.) Helen Knights
1972
Inscribed and numbered: (l.l.) Sunlight
and Shadow 11/25
Purchase from the artist for the Ontario
Government Building, Thunder Bay,
1975. MGS 615420

Reimi Kobayashi
Born: Toronto, Ontario,
16 November 1951

Mountain Plains c. 1977
Wool and silk woven hanging, 121.9 x
243.8 cm / 48 x 96″
Commission for the Norfolk County
Court House and Land Registry Office,
Simcoe, 1977. MGS 619689

Peter Henry Kolisnyk, C.S.P.W.C.,
O.S.A., R.C.A.
Born: Toronto, Ontario,
30 November 1934

White Square c. 1977-78
In three parts: a) painted steel square
(white) and steel bolts, 20.3 x 30.5 x
22.9 cm / 8 x 12 x 9″ (including base);
b) and c) photograph and collage, each
19 x 24.1 cm / 7½ x 9½″
Commission proposal for the Queen
Street Mental Health Centre, Toronto,
1977-78. MGS 622138

Nobuo Kubota, A.R.C.A.
Born: Vancouver, British Columbia,
27 June 1932

Kubota graduated and worked as an
architect, so it is fitting that his
sculpture should so easily adapt to or be
specifically designed for architectural
settings.

Evan Macdonald, *Frood Open Pit, International Nickel*

Columns c. 1977
Rocks (15), chalk cylinders (9) and
fibreboard, 56.8 x 54.9 x 7 cm/
22³/₈ x 21⁵/₈ x 2³/₄"
Signed: (l.r., front) Nobuo Kubota
Commission proposal for the Queen
Street Mental Health Centre, Toronto,
1977-78. MGS 622137

The Third Wave 1979
In two parts: a) wooden model with 7
sections of suspended tubular brass rods
(11 rods per section), 57.2 x 121.9 x 85.7
cm/22¹/₂ x 48 x 33³/₄"; b) colour slides
(10) in container
Signed and dated: (on cover of 'b'):
Nobuo Kubota 9/7/79
Commission proposal for the York
North Court House and Land Registry
Office, Newmarket, 1979-80.
MGS 623353

The Third Wave c. 1979-80
Aluminum tubes, acrylic lacquer, nylon
fishing line; seven separate sections of
11 tubes each; each tube 152.4 x 3.81
cm/60 x 1¹/₂"; overall: 1097.3 x 152.4 x
548.6 cm/432 x 60 x 216"
Commission for the York North Court
House and Land Registry Office,
Newmarket, 1979-80. MGS 624996

The Third Wave (Wave I and *Wave II*
were commissioned by the National
Science Library, in Ottawa, 1973) is
composed of seven groups of lightweight
aluminum tubes floating in descending
waves from the lobby ceiling into the
stairwell of the Court House. For
Kubota the "wave" motif, commonly
associated with the marine imagery of
Japanese woodblock art, is also a graphic
statement of the energy of sound waves,
particularly the structure of musical
expression. The artist's architectural
studies of geometry and wave motion

are combined with the image, also
derived from Japanese prints, of figures
floating in a void.

Jiri Ladocha
Born: Prague, Czechoslovakia,
24 April 1942

Flowers 1976
Etching; 39.7 x 50.2 cm/15⁵/₈ x 19³/₄"
(image), 52.1 x 62.9 cm/20¹/₂ x 24³/₄"
(actual)
Signed and dated: (l.r.) Jiri Ladocha 76
Numbered and inscribed: (l.l.) 4/5.
Flowers
Purchase from the artist, 1977.
MGS 619944

The Flowers 1976
Watercolour on paper, 48.3 x 68.6 cm/
19 x 27"
Signed and dated: (l.r.) Jiri Ladocha 76
Purchase from the artist, 1977.
MGS 619943

Harry Horsfal Leeming
Born: England, 14 August 1898
Died: Toronto, Ontario,
23 November 1971

Split Rock, Nipigon River
Oil on canvas, 62.2 x 75.6 cm/
24¹/₂ x 29³/₄"
Signed: (l.l.) H. H. LEEMING
MGS 623106

The artist was an employee of Ontario
Hydro, probably based at Cameron Falls
between 1925 and 1935. When he
retired, he was the Executive Director of
Engineering for the company. He was a
personal friend of Premier Leslie Frost,
and the presence of *Split Rock* in the
Ontario Collection may be a product of
this acquaintance. Split Rock is located
in the Nipigon River, just upstream of
Lake Jessie, in Nipigon township of the
Thunder Bay District of Ontario.

Donald Lewis
Born: Toronto, Ontario, 1935

Stratford Festival 1968
Gouache on cardboard, 64.8 x 50.2 cm/
25¹/₂ x 19³/₅"
Signed and dated: (l.l.) Lewis '68
Commission proposal for the Queen's
Park Project, 1966-68. MGS 619897

Stratford c. 1968
Acrylic on canvas, 259.1 x 198.1 cm/
102 x 78"
Signed: (l.c.) lewis
Commission for the Queen's Park
Project, 1966-68. MGS 619764

Lewis joined the Stratford
Shakespearean Festival Theatre in 1957
and worked for three years in its
property department before making his
debut as an actor (stage name, Lewis
Gordon) in 1960. He has also contri-
buted costume and poster designs to the
Festival. He was commissioned by
Festival artistic director Michael
Langham in 1964 and 1965, to execute
two murals based on the Shakespearean
history cycle that begins with *Richard II*.
Lewis continued to explore the
decorative juxtapositioning of words and
images that he developed in these
murals when he made the mural for the
Macdonald Block, in which the close
relationship between the arts and life in
the Stratford area is conveyed through
the layering of images and words from
the Festival and from the city itself.
 The quotation in the lower right
corner is from Act II, Scene vii of
Shakespeare's *As You Like It.*

Rex Lingwood

Born: Toronto, Ontario, 5 July 1946

Untitled c. 1979
Stainless steel and leather,
50.8 x 7 x 7 cm/20 x 2³/₄ x 2³/₄"
Commission proposal for the York
North Court House and Land Registry
Office, Newmarket, 1979-80.
MGS 623333

Lorna Livey

Born: Quebec, Quebec, 13 July 1951

In Memory of Chris 1975
Etching, 76.2 x 57.2 cm/30 x 22¹/₂"
(sight), 60.9 x 45.7 cm/24 x 18" (image)
Signed, dated and numbered: (l.l.) 6/10;
(l.r.) L. Livey/75
Inscribed: (l.c.) In Memory of Chris
Purchase, 1976. MGS 619939

J.W.G. Macdonald, *Crimson Cavern*, 1958

Manly MacDonald, *Northland*

Orr Lake Stairs 1981
Etching; 64.8 x 48.3 cm / 25¹/₂ x 19"
(sight), 60.3 x 44.4 cm / 23³/₄ x 17¹/₂"
(image)
Signed, dated and numbered: (l.l.)
15/18; (l.r.) L. Livey / 81
Inscribed: (l.c.) Orr Lake Stairs
Purchase for the Michael Starr Building,
Oshawa, 1983. MGS 632624

A second copy of this print
(MGS 634456, numbered 17/18) was
purchased in 1983.

Winter Bouquet 1982
Etching; 64.8 x 48.3 cm / 25¹/₂ x 19"
(sight), 60.3 x 44.4 cm / 23³/₄ x 17¹/₂"
(image)
Signed, dated and numbered: (l.l.)
12/30; (l.r.) L. Livey / 82
Inscribed: (l.c.) Winter Bouquet
Purchase for the Michael Starr Building,
Oshawa, 1983. MGS 632625

A second copy of this print

(MGS 634457, numbered 16/30) was
purchased in 1983.

Cabin View – Hanwell Lake 1983
Etching / stencilled relief; 79.4 x 62.2 cm /
31¹/₄ x 24¹/₂" (sight), 59.7 x 44.4 cm /
23¹/₂ x 17¹/₂" (image)
Signed, dated and numbered: (l.l.) 4/15;
(l.r.) L. Livey / 83
Inscribed: (l.c.) Cabin view – Hanwell
Lake
Purchase, 1983. MGS 634455

Winter Wonder Flower 1983
Etching; 80 x 63.5 cm / 31¹/₂ x 25"
(sight), 59.7 x 44.4 cm / 23¹/₂ x 17¹/₂"
(image)
Signed, dated and numbered: (l.l.) 7/22;
(l.r.) L. Livey / 83
Inscribed: (l.c.) Winter wonder flower
Purchase, 1983. MGS 634458

Kenneth Campbell Lochhead
Born: Ottawa, Ontario, 22 May 1926

File # 157 1971
Lithograph, 57.2 x 76.2 cm / 22¹/₂ x 30"
Signed, dated and numbered: (l.c.) K.
Lochhead '71 26/45
Purchase, 1977. MGS 619923

Gino Lorcini, A.R.C.A.
Born: Plymouth, England, 7 July 1923

Themes c. 1974
Stelcoloy weathering steel,
299.7 x 248.9 x 50.8 cm / 118 x 98 x 20"
Commission for the Middlesex County
Court House and Land Registry Office,
London, 1974. MGS 616950

Untitled c. 1978
In two parts: a) wood and steel,
47 x 53.3 x 137.2 cm / 18¹/₂ x 21 x 54";
b) wood and cardboard, 15.2 x 77.5 x
66 cm / 6 x 30¹/₂ x 26"
Signed: (on end of base, part 'a') G.
LORCINI
Commission proposal for the Ontario
Government Building, Windsor, 1978.
MGS 622115

Evan Weekes Macdonald, O.S.A.,
A.R.C.A., O.I.P.
Born: Guelph, Ontario, 9 June 1905
Died: Guelph, Ontario,
22 January 1972
Honours: LL.D.

Frood Open Pit, International Nickel
Oil on canvas, 48.3 x 58.4 cm / 19 x 23"
Signed: (l.r.) EVAN MACDONALD
Gift of the artist, 1963. MGS 624428

The donation was made through the
Ontario Institute of Painters for hanging
in Ontario House, London, England; it
was returned to Toronto in 1980.
 A smaller version, possibly a
preliminary sketch of this painting,
titled *Frood, Open Pit, International
Nickel, Sudbury,* is in the University of
Guelph Collection / Macdonald Stewart
Art Centre. The Frood Nickel Mine,
discovered by a trapper named William
Nelson, was registered in 1884 by
Thomas Frood and James Cockburn,
although development of the mine did
not occur until 1925.
 Judith Nasby, in *The University of
Guelph Art Collection* (University of

Guelph, 1980) traces Macdonald's interest in mines as a subject to 1938, when he illustrated B. F. Townsley's *Mine Finders: The History and Romance of Canadian Mineral Discoveries* (Toronto: Saturday Night Press, 1938).

James (Jock) Williamson Galloway Macdonald, C.S.P.W.C., O.S.A., A.R.C.A.

Born: Thurso, Caithness-shire, Scotland, 31 May 1897

Died: Toronto, Ontario, 3 December 1960

President, C.S.P.W.C. 1953-4

Crimson Cavern 1958
Oil on board, 91.4 x 68.6 cm / 36 x 27"
Signed and dated: (l.l.) Jock Macdonald / 58
Gift of Dr. and Mrs. Edward Pomer to the Ontario Heritage Foundation 1983; on loan to the Government of Ontario.
MGS 632975

Jock Macdonald's influence as an artist and teacher was felt in Western Canada in the 1930s and 1940s and in Toronto after his move there in 1947. He was an important figure in the development of abstract art in Ontario, through his teaching at the Ontario College of Art from 1947 to 1960 and by his example as a member of the Toronto abstract artists' group, Painters Eleven. This work, painted in 1958, is representative of Macdonald's later paintings, where abstracted landscape forms combine with the earlier, spiritual abstract shapes to create a sense of an immaterial psychical landscape.

Manly Edward MacDonald, O.S.A., R.C.A., O.I.P.

Born: Pointe Anne, Ontario, 15 August 1889

Died: Toronto, Ontario, 10 April 1971

Untitled
Oil on canvas, 49.8 x 64.8 cm / 19⁵/₈ x 25¹/₂"
Signed: (l.r.) MANLY MACDONALD
Gift of the Arthur Robert Atkinson Estate to the Sir James Whitney School, Belleville, 1948. MGS 622606

Manly MacDonald, *Untitled*

Untitled
Oil on canvas, 49.5 x 64.5 cm / 19¹/₂ x 25"
Signed: (l.l.) MANLY MACDONALD
Gift in memory of Arthur Robert Atkinson to the Sir James Whitney School, Belleville, 1948. MGS 622608

Delta Mill
Oil on canvas, 74.9 x 101 cm / 29¹/₂ x 39³/₄"
Signed: (l.r.) MANLY MACDONALD
Commissioned by the Ontario St. Lawrence Development Commission.
MGS 623619

Delta Mill was built about 1845 in Leeds County, Ontario.

Newburgh on the Napanee River, Ontario
Oil on canvas, 61 x 81.3 cm / 24 x 32"
Signed: (l.l.) MANLY MACDONALD
Inscribed: (on frame, verso) 24 x 32 /

M. MacDonald
Gift of the artist, 1963. MGS 624427

The donation was made through the Ontario Institute of Painters for hanging in Ontario House, London, England; it was returned to Toronto in 1980. Newburgh is a village in Camden Township, Lennox and Addington County, southeastern Ontario.

Northland Lake
Oil on canvas, 59.7 x 74.9 cm / 23¹/₂ x 29¹/₂"
Signed: (l.l.) MANLY MACDONALD
MGS 619863

Untitled
Oil on canvas, 38.7 x 48.9 cm / 15¹/₄ x 19¹/₄"
Signed: (l.r.) MANLY MACDONALD
Gift of the Dr. H. E. Amoss Estate to the Sir James Whitney School, Belleville, c. 1965. MGS 622603

Don MacKay, *Thorns*, 1974

Untitled
Oil on canvas, 39.4 x 48.9 cm/
15¹/₂ x 19¹/₄"
Signed: (l.l.) MANLY MACDONALD
Gift of the Kathryn Daly Estate to the
Sir James Whitney School, Belleville,
1978. MGS 622602

Kenneth M. MacDougall
Born: Richard's Landing, Ontario,
9 April 1933

Untitled 1977
Watercolour on paper, 43.8 x 33.7 cm/
17¹/₄ x 13¹/₄"
Signed and dated: (l.r.) K. MacDougall 77
Purchase from the artist for the Ontario
Ministry of Northern Affairs, North-
eastern Regional Office, Sault Ste Marie,
c. 1978. MGS 635345

Early Morning Leaves 1979
Watercolour on paper, 38.1 x 58.4 cm/
15 x 23"
Signed and dated: (l.r.) K. MacDougall
'79
Purchase from the artist for the Ontario
Government Building, Sudbury, 1980.
MGS 625801

John MacGregor
Born: Dorking, England,
12 January 1944

Untitled *c.* 1978
Wood, plastic and mixed media, 49.5 x
106.7 x 86.4 cm/19¹/₂ x 42 x 34"
Commission proposal for the Queen
Street Mental Health Centre, Toronto,
1978. MGS 622136

Donald Ian MacKay
Born: Jahnsi, India,
26 September 1937

Thorns 1974
Coloured ink on paper, 101 x 74.9 cm/
39³/₄ x 29¹/₂"
Signed and dated: (l.r.) Don MacKay '74
Purchase from the artist for the
Waterloo County Court House and Land
Registry Office, Kitchener, 1977.
MGS 619991

Cradle 1977
Coloured ink on paper, 54.6 x 54.6 cm/
21¹/₂ x 21¹/₂"
Signed and dated: (l.r.) Don MacKay
1977
Purchase from the artist for the
Waterloo County Court House and Land
Registry Office, Kitchener, 1977.
MGS 619990

Untitled c. 1977
In two parts: a) wood,
44.4 x 47 x 22.9 cm/17¹/₂ x 18¹/₂ x 9";
b) watercolour on black and white
photograph, 32.4 x 26.7 cm/12³/₄ x 10¹/₂"
Commission proposal for the Waterloo
County Court House and Land Registry
Office, Kitchener, 1977. MGS 619963

Sheila Anne Maki, O.S.A.
Born: Sudbury, Ontario,
31 August 1932

Fugue with Orange
Serigraph; 41.9 x 52.1 cm/16¹/₂ x 20¹/₂"
(sight), 39.4 x 50.2 cm/15¹/₂ x 19³/₄"
(image)
Signed: (l.r.) Sheila Maki
Inscribed: (l.l.) "Fugue with Orange"
A/P.
MGS 622673

Northern Symphony
Lithograph; 52.1 x 41.3 cm/20¹/₂ x 16¹/₄"
(sight), 50.2 x 39.4 cm/19³/₄ x 15¹/₂"
(image)
Signed: (l.r.) Sheila Maki
Inscribed: (l.l.) "Northern Symphony"
A/P.
MGS 622665

Joan (Jo) Elizabeth Manning
Born: Sidney, British Columbia,
12 November 1923

Prairie II 1974
Etching; 48.3 x 62.9 cm/19 x 24³/₄"
(sight), 45.1 x 60.3 cm/17³/₄ x 23³/₄"
(image)
Signed and dated: (l.r.) Jo Manning '74
Inscribed and numbered: (l.l.) 26/75;
(l.c.) Prairie II
Purchase, 1983 MGS 632672

*The Fencepost Grew Black with
Winter* 1977
Etching; 62.2 x 47 cm/24¹/₂ x 18¹/₂"
(sight), 59.7 x 44.4 cm/23¹/₂ x 17¹/₂"
(image)
Signed and dated: (l.r.) Jo Manning '77
Inscribed and numbered: (l.l.) 4/75;
(l.c.) "The fencepost grew black with
winter"
Purchase, 1977. MGS 619955

Woodlot II 1977
Etching; 62.2 x 47 cm/24¹/₂ x 18¹/₂"
(sight), 59.7 x 44.4 cm/23¹/₂ x 17¹/₂"
(image)
Signed and dated: (l.r.) Jo Manning '77
Inscribed and numbered: (l.l.) 7/75;
(l.c.) Woodlot II
Purchase, 1977. MGS 619956

Woodlot VIII 1979
Etching; 78.7 x 59.7 cm/31 x 23¹/₂"
(actual), 49.5 x 39.4 cm/19¹/₂ x 15¹/₂"
(image)
Signed and dated: (l.r.) Jo Manning '79
Inscribed and numbered: (l.l.) 11/75;
(l.c.) Woodlot VIII
Purchase, 1983. MGS 632671

Douglas Maracle
Born: Six Nations Indian Reserve,
Brantford, Ontario (fl. 1973)

Eagle Dancer
Soapstone, 30.5 x 29.9 x 21.6 cm/
12 x 11³/₄ x 8¹/₂"
Signed: (on left of base) Maracle
Purchase, 1979. MGS 619641

Robert N. Markle
Born: Hamilton, Ontario,
25 August 1936

Mohawk c. 1981-82
Gouache and paper collage on board,
25.4 x 64.8 cm/10 x 25¹/₂"
Commission proposal for the Ellen
Fairclough Building, Hamilton,
1981-82. MGS 632961

Mohawk c. 1981-82
Mirrored stainless steel and neon (mural
relief); five sections, overall:
304.8 x 701 cm/120 x 276"
Commission for the Ellen Fairclough
Building, Hamilton, 1981-82.
MGS 630152

Coloured neon light flowing through the
elements of this mural sculpture
enhances the flowing stainless steel
shapes.

May Marx, S.S.C.
Born: Toronto, Ontario,
16 January 1928

Concord 1977
In two parts: a) bronze, 11.4 x 12.7 x
12.7 cm/4¹/₂ x 5 x 5" (including base);
b) ink on paper, 71.1 x 73.3 cm/
28 x 28⁷/₈"
Signed: (l.r., part 'b') May Marx
Inscribed: (on label under base, part 'a')
"Concord"/May Marx/77
Commission proposal for the Halton
County Court House and Land Registry
Office, Milton, 1977-78. MGS 622120

Concord 2 c. 1979
Plaster on board base, 20.3 x 21 x
16.5 cm/8 x 8¹/₄ x 6¹/₂" (including base)
Commission proposal for the York
North Court House and Land Registry
Office, Newmarket, 1979. MGS 623332

Robert Vincent Mason
Born: Tillsonburg, Ontario,
15 January 1933

79-12 1979
Acrylic on masonite, 152.4 x 121.9 cm/
60 x 48"
Inscribed: (on stretcher, verso) Mason;
79-12
Purchase from the artist for the Ellen
Fairclough Building, Hamilton, 1981.
MGS 630150

Thomas Mathews, O.I.P.
Born: Montreal, Quebec, 7 July 1920

The Maple Tree
Oil on canvas, 40.6 x 50.8 cm/16 x 20"
Signed: (l.r.) TOM MATHEWS
Gift of the artist, 1963. MGS 624423

The donation was made through the
Ontario Institute of Painters for hanging
in Ontario House, London, England; it
was returned to Toronto in 1980.

Gray Mills, *Kinetic Wind Piece*, 1978

Ursula Matrosovs, O.S.A.
Born: Kassel, Germany, 30 May 1941

Horizon
Tapestry, Soumak technique,
152.4 x 101.6 cm / 60 x 40"
Inscribed: (verso, l.l., stitched)
MATROSOVS
Purchase from the artist for the York
North Court House and Land Registry
Office, Newmarket, 1980.
MGS 625698

Soumak, an ancient rug or tapestry
technique, came into prominence in the
19th and 20th centuries and is used by
weavers to produce a raised, diagonal
herringbone or knitted effect.

Bryan John Maycock
Born: Newmarket, England,
24 July 1944

Tomiko Rose
Acrylic and lacquer on canvas,
139.7 x 139.7 cm / 55 x 55"
Purchase from the artist for the Ontario
Government Building, Sudbury, 1980.
MGS 625802

Eugene Mazzei

Demispheres 1973
Etching; 64.8 x 49.5 cm / 25$\frac{1}{2}$ x 19$\frac{1}{2}$"
(sight), 36.8 x 30.5 cm / 14$\frac{1}{2}$ x 12"
(image)
Signed and dated: (l.r.) E. Mazzei 73
Inscribed and numbered: (l.l.)
Demispheres 13/15
Purchase, 1976. MGS 619940

Alec McCauley
Born: Moose River Crossing,
Ontario, 28 September 1951

The Trapper
Serigraph, 31.8 x 43.2 cm / 12$\frac{1}{2}$ x 17"
(sight)
Signed and numbered: (l.l.) 19/77;
(l.r.) ALEC McCAULEY
Inscribed: (l.l.) [the artist's name in Cree
syllabics]; (l.c.) [Cree syllabics]; "THE
TRAPPER"
Purchase from the artist for the Ministry
of Northern Affairs Northeastern
Regional Office, Sault Ste Marie,
c. 1978. MGS 624045

Life Cycle 1979
Serigraph; 63.5 x 50.8 cm / 25 x 20"
(sight), 45.7 x 36.2 cm / 18 x 14$\frac{1}{4}$"
(image)
Signed and dated: (l.r.) Alec McCauley
'79
Inscribed and numbered: (l.l., within
image) Weneebaykook [in Cree
syllabics]; (l.l.) 7/55; (l.c.) "Life-cycle"
Purchase from Weneebaykook
Workshop for the Ontario Government
Building, Moosonee, 1980.
MGS 635014

Northward Bound 1974
Serigraph; 59.7 x 44.4 cm / 23$\frac{1}{2}$ x 17$\frac{1}{2}$"
(sight), 48.3 x 35.6 cm / 19 x 14" (image)
Signed and dated: (l.r.) Alec McCauley,
1974
Inscribed and numbered: (l.l., within
image) Weneebaykook Working Place
[in Cree syllabics]; (l.l. to l.c.)
Northward Bound [in both English and
in Cree syllabics], Moosonee; (l.r.,
within image) AMc
Purchase from Weneebaykook
Workshop for the Ontario Government
Building, Moosonee, c. 1980.
MGS 635015

Ravens
Serigraph; 59.7 x 73.7 cm / 23$\frac{1}{2}$ x 29"
(sight), 41.9 x 58.4 cm / 16$\frac{1}{2}$ x 23"
(image)
Signed: (l.r.) Alec McCauley
Inscribed and numbered: (l.l., within
image) Weneebaykook [in Cree
syllabics]; (l.l.) 59/60; (l.c.) "THE
RAVENS" [both in English and in Cree
syllabics]
Purchase from Weneebaykook
Workshop for the Ontario Government
Building, Moosonee, 1980.
MGS 635016

Shaking Tent 1980
Serigraph; 63.5 x 51.4 cm/25 x 20½"
(sight), 45.7 x 36.2 cm/18 x 14¼"
(image)
Signed and dated: (l.r.) Alec McCauley
'80
Inscribed and numbered: (l.l., within
image) Weneebaykook [in Cree
syllabics]; (l.l.) 31/70; (l.c.) "THE
SHAKING TENT"
Purchase from Weneebaykook
Workshop for the Ontario Government
Building, Moosonee, 1980.
MGS 635017

Edward McCormack, O.I.P.

The Forks of the Credit River
Oil on canvas, 50.2 x 60.3 cm/
19¾ x 23¾"
Signed: (l.r.) EDWARD McCORMACK
Gift of the artist, 1963. MGS 624426

The donation was made through the
Ontario Institute of Painters for hanging
in Ontario House, London, England; it
was returned to Toronto in 1980. The
location of the Forks of the Credit River
is north of Toronto, near Caledon.

John Wilson (Jack) McLaren, O.S.A.
Born: Edinburgh, Scotland, 1896

Haliburton, Ontario
Oil on board, 30.5 x 38.1 cm/12 x 15"
Signed: (l.r.) McLaren
Inscribed: (verso) Haliburton, Ontario/
J. W. McLaren O.S.A./Benmiller.
Gift of the artist, 1981. MGS 627876

Peter Milton McLay
Born: near Lion's Head, Ontario,
31 March 1952

Untitled 1977
Ink and watercolour on paper,
59.7 x 49.5 cm/23½ x 19½"
Signed and dated: (c.r.) P. McLay 77
Purchase from the artist for the
Waterloo County Court House and Land
Registry Office, Kitchener, 1977.
MGS 619995

Donald Ivan McLeod, O.I.P.
Born: Owen Sound, Ontario, 1886
Died: 1967

Ontario Silver Birches
Oil on canvas, 63.5 x 76.2 cm/25 x 30"
Signed: (l.l.) D. I. McLeod
Inscribed: (on stretcher, verso) Ontario
Silver Birches D. I. McLeod
Gift of the artist, 1963. MGS 624425

The donation was made through the
Ontario Institute of Painters for hanging
in Ontario House, London, England; it
was returned to Toronto in 1980.

Len McLeod
Born: 1951

Untitled c. 1974
Latex and acrylic on canvas,
219.7 x 419.1 cm/86½ x 165"
Commission for the Middlesex County
Court House and Land Registry Office,
London, 1974. MGS 616945

Lise Melhorn
Born: 12 December 1955

Strata #3
Hand-made paper and poured pulp,
74.9 x 54.6 cm/29½ x 21½"
Signed and dated: (l.r.) Lise Melhorn '80
Purchase from the artist for the Ontario
Government Building, Sudbury, 1980.
MGS 625803

Gray Hoye Mills, C.S.P.W.C.,
O.S.A., A.R.C.A.
Born: Cleveland, Ohio, U.S.A.,
23 February 1929

Untitled 1977
Pencil on paper, 48.3 x 61 cm/19 x 24"
Signed and dated: (l.r.) Mills 77
Commission proposal for the Peel
County Land Registry Office, Brampton,
1978. MGS 623013

Kinetic Wind Piece 1978
Aluminum, corTen steel, and stainless
steel, 213.4 x 426.7 cm/84 x 168"
Signed and dated: (arc welded on base)
Mills 1978
Commission for the Peel County Land
Registry Office, Brampton, 1978.
MGS 623854

Gilbert Bertrum Moll
Born: London, Ontario,
23 October 1948

Cloud Ship 1974
Watercolour and enamel (spray-
stencilled) on paper, 56.5 x 75.6 cm/
22¼ x 29¾"
Signed and dated: (l.r.) Moll '74
Purchase from the artist for the Ontario
Police College, Aylmer, 1977.
MGS 618690

*Descend – To Go Downward – To
Sink* 1974
Watercolour and enamel (spray-
stencilled) on paper, 74.9 x 56.5 cm/
29½ x 22¼"
Signed and dated: (l.r.) Moll '74
Purchase from the artist for the Ontario
Police College, Aylmer, 1977.
MGS 618689

Dorothy Morrison
Born: Moose Factory, Ontario,
27 July 1957

Baby in a Swing 1979
Serigraph; 46.4 x 55.2 cm/18¼ x 21¾"
(sight), 33 x 41.9 cm/13 x 16½" (image)
Signed and dated: (l.r.) Dorothy
Morrison 79
Inscribed and numbered: (l.l.)
Weneebaykook [in Cree syllabics] 32/54
(l.c.) Baby in a Swing [in Cree syllabics]
Purchase from Weneebaykook
Workshop for the Ontario Government
Building, Moosonee, 1980.
MGS 635018

Circle of Friendship 1978
Serigraph; 78.7 x 64.8 cm/31 x 25½"
(sight), 56.5 x 45.7 cm/22¼ x 18"
(image)
Signed and dated: (l.r.) Dorothy
Morrison '78
Inscribed and numbered: (l.l.) 43/70
Weneebaykook Workshop, Moosonee,
Ontario
Purchase from Weneebaykook
Workshop for the Ontario Government
Building, Moosonee, 1980.
MGS 635019

The Hunter & His Wife 1980
Serigraph; 66.7 x 50.2 cm/26¼ x 19¾"

Norval Morrisseau, *Life Regenerating*, 1977

(sight), 50.8 x 35.6 cm / 20 x 14" (image)
Signed and dated: (l.r.) Dorothy
Morrison, 80
Inscribed and numbered: (l.l.)
Weneebaykook [in Cree syllabics]
57/60; (l.c.) The Hunter & His Wife
[both in English and in Cree syllabics]
Purchase from Weneebaykook
Workshop for the Ontario Government
Building, Moosonee, 1980.
MGS 635020

Norval Morrisseau, A.R.C.A.
Born: Beardmore, Ontario,
19 March 1932
Honours: O.C., LL.D.

Life Regenerating 1977
Acrylic on canvas, 99.1 x 149.9 cm /
39 x 59"
Signed: (l.r.) [artist's name in Ojibway
syllabics]
Inscribed: (on label, verso) 1977
Purchase for the Ontario Government
Building, Dryden, 1978. MGS 623855

An Ojibway who has developed pictorial
forms to illustrate the heritage of his
tribal legends, Norval Morrisseau has
led the field in the development of
Native Indian art in Ontario.

Joseph P. Morse
Born: Windsor, Ontario,
19 February 1960

The Bench 1982
Lithograph; five panels, each
55.9 x 76.2 cm / 22 x 30"; overall:
55.9 x 381 cm / 22 x 150"
Signed and dated: (l.r., each panel) J P
Morse '82
Inscribed: (l.c., each panel 'a' to 'e') The
Bench, [Nos. 1 - #5]; (l.l., each panel) AP
Purchase from the artist for the Michael
Starr Building, Oshawa, 1983.
MGS 632696

Rowley Walter Murphy, O.S.A.,
R.C.A.
Born: Toronto, Ontario,
28 May 1891
Died: Toronto, Ontario,
2 February 1975

Joseph P. Morse, *The Bench*, 1982

S. S. Patella, Norwegian Whaling Factory, Entrance to Halifax Harbour
Gouache on paper, 47 x 62.9 cm/
18¹/₂ x 24³/₄"
Signed: (l.r.) Rowley Murphy
Gift of the class of 1963 to the Hamilton Teachers' College, Hamilton, 1963.
MGS 623103

Kazuo Nakamura, C.S.P.W.C.
Born: Vancouver, British Columbia,
13 October 1926

Two Horizons 1968
Oil on canvas (mural), 261.6 x 196.9 cm/103 x 77¹/₂"
Signed and dated: (l.r.) K. Nakamura '68
Commission for the Queen's Park Project, 1966-68. MGS 619763

Nakamura's paintings use tonal contrasts and geometric shapes to illustrate the theory that the physical universe and human perceptions have their origin in mathematics. The artist was a member of Painters Eleven, the Toronto group of abstract artists who exhibited together from 1954 to 1960.

Frieda Nelson
Born: Duluth, Minnesota, U.S.A.,
18 June 1940

October Drawing 1974
Ink and watercolour on gold coloured paper, 65.4 x 50.2 cm/25³/₄ x 19³/₄"
Signed and dated: (l.r.) FRIEDA NELSON 1974

Inscribed: (l.l.) OCTOBER DRAWING
Purchase from the artist for the Waterloo County Court House and Land Registry Office, Kitchener, 1977.
MGS 619994

Jean D. Newman-Urquhart, O.I.P.
Died: Toronto, Ontario,
5 October 1971

Clearing Skies near Actinolite, Ontario 1962
Oil on canvas, 40.6 x 50.8 cm/16 x 20"
Signed: (l.l.) NEWMAN
Inscribed: (verso) July 1962./
Clearing Skies/near Actinolite;
Ontario/Jean D. Newman.
Gift of the artist, 1963. MGS 624422

The donation was made through the Ontario Institute of Painters for hanging in Ontario House, London, England; it was returned to Toronto in 1980.
Actinolite is located in Hastings County at Highway 7 north of Belleville.

John Neil Newton, R.C.A.
Born: Montreal, Quebec,
30 October 1933

Untitled 1979
Photographs and tempera on illustration board, 40.6 x 50.8 cm/16 x 20"
Signed and dated: (l.r.) Neil Newton/79
Commission proposal for the York North Court House and Land Registry Office, Newmarket, 1979. MGS 623340

Muriel Elizabeth Newton-White,
O.I.P.
Born: Robillard Township, Timiskaming, Ontario, 21 January 1928

Lake Timiskaming
Oil on masonite, 28.6 x 38.1 cm/
11¹/₄ x 15"
Initialed: (l.r., in pencil) M.E.N.W.
Gift of the artist, 1963. MGS 624421

The donation was made through the Ontario Institute of Painters for hanging in Ontario House, London, England; it was returned to Toronto in 1980. According to the artist's label, this work was painted from the rocks on the shore below Haileybury. Located in Timiskaming County, Haileybury is north-east of Cobalt on the shore of Lake Timiskaming, in Northern Ontario.

Kiatainaq Ningluq
Born: 1918

Seal Hunter
Soapstone, 17.1 x 33 x 15.2 cm/
6³/₄ x 13 x 6"
Inscribed: (underside) E 91291 [transaction number].
MGS 622663

This sculptor, whose name was formerly spelled "Ningiok" or "Ningeeyook," works in the Quebec Inuit community of Wakeham Bay.

Kazuo Nakamura, *Two Horizons*, 1968

Henry Nizio

Born: Toronto, Ontario,
29 April 1952

To Sea What I Could See
Collage, serigraph and lithograph,
80.6 x 58.4 cm / 31³/₄ x 23" (actual)
Signed: (l.r.) HENRY NIZIO
Inscribed and numbered: (l.l.) 3/8; (l.c.)
TO SEA WHAT I COULD SEE
Purchase for the Michael Starr Building,
Oshawa, 1983. MGS 632647

Hank Noestheden

Born: Holland, 25 November 1948

White Arch and *"Y"* 1977
In four parts: a) wood, painted white
(White Arch), 30.5 x 47 x 6.4 cm /
12 x 18¹/₂ x 2¹/₂";
b) wood, painted white ("Y"),
36.5 x 45.7 x 6.4 cm / 14³/₈ x 18 x 2¹/₂";
c) pencil on paper (White Arch),
67.9 x 102.2 cm / 26³/₄ x 40¹/₄";
d) pencil on paper ("Y"), 67.3 x 102.2 cm /
26¹/₂ x 40¹/₄"
Signed and dated: (l.r., parts 'c' and 'd')
HANK NOESTHEDEN 29-11-77
Commission proposal for the Ontario
Government Building, Windsor,
1978. MGS 622117

Harold V. Norrington

Born: Toronto, Ontario,
15 December 1940

Olive Blues 1968
Serigraph; 53.3 x 71.1 cm / 21 x 28"
(sight), 49.5 x 68.6 cm / 19¹/₂ x 27"
(image)
Signed and dated: (l.c.) H Norrington;
(l.r.) 1968
Inscribed: (l.l.) Olive Blues; (l.c.) artists
proof
MGS 622667

Is Victory Worth the Battle? 1969
Serigraph, 74.9 x 50.8 cm / 29¹/₂ x 20"
Signed and dated: (l.r.) H Norrington
1969
Inscribed and numbered: (l.l.) is victory
worth the battle? 6/10.
MGS 622692

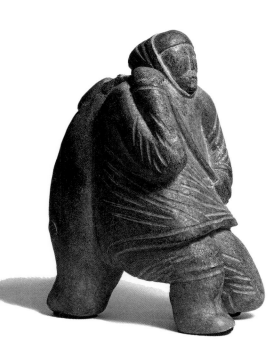

Artist unknown, *Walrus Hunter*

Tibor Nyilasi
Born: Kesztolc, Hungary,
1 September 1936

The Melody
Egg tempera on masonite,
213.4 x 792.5 cm/84 x 312"
Gift of the artist, 1963. MGS 624010

Daphne Odjig
Born: Wikwemikong Indian Reserve,
Manitoulin Island, Ontario, 1925

Roots 1979
Acrylic on canvas, three panels, each
152.4 x 121.9 cm/60 x 48";
overall: 152.4 x 365.8 cm/60 x 144"
Signed and dated: (l.l., left panel)
Odjig/79
Purchase for the Ontario Government
Building, Sudbury, 1980. MGS 625804
The artist relates the mythological roots
of her people, the Odawa, using highly
stylized human and animal forms.

Steven Osterlund
Born: Akron, Ohio, U.S.A., 1943

Interior 1976
Pastel on paper, 49.5 x 62.2 cm/
19¹/₂ x 24¹/₂"
Signed and dated: (l.c.) Osterlund 1976
Purchase from the artist for the Ontario
Police College, Aylmer, 1977.
MGS 618683

Guttorn Otto
Born: Lodz, Poland, 1919

Fall Scene in the Woods
Oil on canvas, 71.1 x 95.3 cm/28 x 37¹/₂"
Signed: (l.l.) G. OTTO
Purchase from the artist, c. 1970.
MGS 619825

John Palchinski
Born: Cudworth, Saskatchewan,
12 March 1940

Painted Roses 1976
Serigraph; 65.4 x 81.3 cm/25³/₄ x 32"
(sight), 58.1 x 74 cm/22⁷/₈ x 29¹/₈"
(image)
Signed, dated and numbered: (l.r.) J
Palchinski 76 9/35
Inscribed: (l.l.) Painted Roses
Purchase from the artist, 1977.
MGS 619905

Frank Shirley Panabaker, A.R.C.A.,
O.I.P.
Born: Hespeler, Ontario,
16 August 1904

Georgian Bay
Oil on masonite, 40 x 50.8 cm/15³/₄ x 20"
Signed: (l.r.) FRANK PANABAKER
Inscribed: (verso) Georgian Bay/Frank
Panabaker
Gift of the artist, 1963. MGS 624420

The donation was made through the
Ontario Institute of Painters for hanging
in Ontario House, London, England; it
was returned to Toronto in 1980.

E. Jane Perry
Born: Toronto, Ontario, 1948

Northern Lights
Woven wood, mohair chenille with open
warp, and plexiglas insert, 127 x 101.6 x
7.6 cm/50 x 40 x 3"

Purchase from the artist for the Ontario
Government Building, Sudbury, 1980.
MGS 625806

Margaret Ann Peter
Born: Leamington, Ontario,
13 June 1943

Wallflower 1976
Viscosity collograph, 58.4 x 44.4 cm/
23 x 17¹/₂"
Signed and dated: (l.r.) Margaret Peter 76
Inscribed and numbered: (l.l.) 24/50
Viscosity Collograph; (l.c.) Wallflower
Purchase from the artist for the
Waterloo County Court House and Land
Registry Office, Kitchener, 1977.
MGS 619975

Mother Earth 1977
Viscosity collograph; 38.1 x 49.5 cm/
15 x 19¹/₂" (sight), 36.8 x 47 cm/
14¹/₂ x 18¹/₂" (image)
Signed and dated: (l.r.) Margaret Peter
77
Inscribed and numbered: (l.l.) 19/20
Viscosity Collograph; (l.c.) Mother
Earth
Purchase from the artist for the
Waterloo County Court House and Land
Registry Office, Kitchener, 1977.
MGS 619978

Barry Peters
Born: Pikangikum, Ontario, 1958

Untitled 1976
Acrylic on canvas, 100.3 x 82.6 cm/
39¹/₂ x 32¹/₂"
Signed, dated and inscribed: (l.c.)
BARRY PETERS/ /76 [the artist's name
in Cree syllabics].
MGS 625693

Josef Petriska
Born: Arad, Romania, 29 March 1929

Rye
Bronze and oil on board, 71.1 x 40.6 cm/
28 x 16"
Signed: (l.l.) J. Petriska
Purchase from the artist for the
Oaklands Regional Centre, Oakville,
1975. MGS 614972

Angelo di Petta, York County, 1980

Angelo di Petta
Born: Colle d'Anchise, Italy,
6 April 1948

York County 1979
In three parts: a) ceramic tile sample,
26.7 x 21.6 cm / 10¹/₂ x 8¹/₂";
b) cardboard model,
19.1 x 91.4 x 41.9 cm / 7¹/₂ x 36 x 16¹/₂";
c) photographs and drawing on board,
38.1 x 50.8 cm / 15 x 20"
Signed and dated: (l.r., part 'b' and 'c')
A. di Petta 9 Sept. 79
Commission proposal for the York
North Court House and Land Registry
Office, Newmarket, 1979.
MGS 623346

York County c. 1980
White stoneware and earthenware tiles,
painted slips (mural relief), overall:
190.5 x 533.4 cm / 75 x 210"
Commission for the York North Court
House and Land Registry Office,
Newmarket, 1980. MGS 624991

This ceramic mural loosely depicts
maps, landforms and the countryside of
York County. It is made from a
technique developed by the artist in
which earthenware clay is fired on a slab
of stoneware clay, to form a thick glaze-
like surface on the stoneware. The
ceramic tiles resulting from this process
can contain precise yet subtle designs
while achieving a thickness appropriate
for a mural of this size.

Walter W. Pranke
Born: Czechoslovakia, 1925

Untitled
Oil on canvas, 59.7 x 90.2 cm /
23¹/₂ x 35¹/₂"
Signed: (l.r.) W. PRANKE
MGS 619715

George J. Prouse
Born: 7 February 1914

Redstone Lake, Haliburton
Oil on canvas, 76.2 x 101.6 cm / 30 x 40"
Signed: (l.l.) PROUSE
MGS 624418

Possibly a gift of the artist, 1963,
through the Ontario Institute of Painters
for hanging in Ontario House, London,
England; it was returned to Toronto in
1980. Haliburton County is famous for
its beautiful lakes and rivers.

George Kestutis Rackus
Born: Kalvarija, Lithuania,
29 May 1927

Dimensions Extended
Serigraph; 62.2 x 45.1 cm / 24¹/₂ x 17³/₄"
(sight), 58.4 x 43.2 cm / 23 x 17" (image)
Signed and numbered: (l.l.) 17 / 50;
(l.r.) Rackus
MGS 622666

Divided One 1969
Serigraph; 58.4 x 45.7 cm / 23 x 18"
(sight), 55.9 x 43.2 cm / 22 x 17" (image)
Signed, dated and numbered: (l.l.) 1 / 5;
(l.r.) Rackus / 69
MGS 622677

Gordon Rayner
Born: Toronto, Ontario, 14 June 1935

Untitled 1979
Lithograph, 60.3 x 89.5 cm / 23³/₄ x 35¹/₄"
Signed, dated and numbered: (l.r.)
Rayner '79 20 / 27
Purchase for the Michael Starr Building,
Oshawa, 1983. MGS 632648

Stephanie Rayner

Born: Toronto, Ontario, 1946

Leda 1982
Embossed etching; 105.4 x 74.9 cm/
41½ x 29½" (actual), 97.2 x 63.5 cm/
38¼ x 25" (image)
Signed and dated: (l.r.) S. Rayner 82
Inscribed and numbered: (l.l.) 9/15;
(l.c.) "Leda"
Purchase, 1983. MGS 634459

Now is the Place 1982
Embossed etching; 105.4 x 74.9 cm/
41½ x 29½" (actual), 86.4 x 61 cm/
34 x 24" (image)
Signed and dated: (l.r.) S. Rayner 82
Inscribed and numbered: (l.l.) 3/15;
(l.c.) Now is The Place
Purchase, 1983. MGS 634460

Winter's West Wall 1982
Embossed etching; 74.9 x 105.4 cm/
29½ x 41½" (actual), 61 x 90.2 cm/
24 x 35½" (image)
Signed and dated: (l.r.) S. Rayner 82
Inscribed and numbered: (l.l.) 12/15;
(l.c.) Winter's West Wall
Purchase, 1983. MGS 634461

Walter Redinger

Born: Wallacetown, Ontario,
6 January 1940

Untitled c. 1974
Fibreglas mounted on concrete, seven
sections: a) sculpture: 116.8 x 91.4 x
38.1 cm/46 x 36 x 15"; base: 132.1 x
132.1 x 61 cm/52 x 52 x 24"
b) sculpture: 167.6 x 63.5 x 63.5 cm/
66 x 25 x 25"; base: 106.7 x 91.4 x
91.4 cm/42 x 36 x 36"
c) sculpture: 167.8 x 86.4 x 50.8 cm/
66 x 34 x 20"; base: 127 x 106.7 x
61 cm/50 x 42 x 24"
d) sculpture: 121.9 x 91.4 x 45.7 cm/
48 x 36 x 18"; base: 109.2 x 132.1 x
66 cm/43 x 52 x 26"
e) sculpture: 152.4 x 121.9 x 45.7 cm/
60 x 48 x 18"; base: 111.8 x 104.1 x
61 cm/44 x 41 x 24"
f) sculpture: 274.3 x 50.8 x 55.9 cm/
108 x 20 x 22"; base: 121.9 x 66 x
55.9 cm/48 x 26 x 22"
g) sculpture: 152.4 x 38.1 x 35.6 cm/
60 x 15 x 14"; base: 106.7 x 91.4 x
76.2 cm/42 x 36 x 30"
Commission for the Middlesex County
Court House and Land Registry Office,
London, 1974. MGS 616949

Gordon Rayner, *Untitled*, 1979

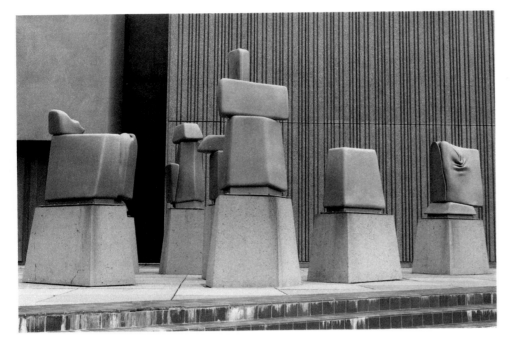

Walter Redinger, *Untitled*, 1974

This imposing assembly of seven totemic sculptures in lightweight, cast fibreglas occupies a space outside the Court House. The ambiguous monumental formations of inter-relating shapes raise complex associations in the viewer.

John Barrie Rennie, O.I.P.

Born: Toronto, Ontario

White Trilliums 1962
Oil on canvas, 91.4 x 61 cm / 36 x 24"
Signed: (l.l.) J. Barrie Rennie
Inscribed: (verso) J B Rennie / 62
Gift of the artist, 1963. MGS 624417

The donation was made through the Ontario Institute of Painters for hanging in Ontario House, London, England; it was returned to Toronto in 1980.

John Reuben

Born: Moosonee, Ontario,
9 February 1959

Broken Earth 1980
Serigraph; 70.5 x 50.8 cm / 27³/₄ x 20"
(sight), 55.2 x 36.8 cm / 21³/₄ x 14¹/₂"
(image)

Signed and dated: (l.r.) J. REUBEN / 80
Inscribed and numbered: (l.l.) 25 / 60;
(l.c.) "BROKEN EARTH"
Purchase from Weneebaykook Workshop for the Ontario Government Building, Moosonee, 1980.
MGS 635021

Lost Culture 1979
Serigraph; 49.5 x 67.3 cm / 19¹/₂ x 26¹/₂"
(sight), 36.8 x 54 cm / 14¹/₂ x 21¹/₄"
(image)
Signed and dated: (l.r.) J. REUBEN / 79
Inscribed and numbered: (l.l.) Weneebaykook [in Cree syllabics] 23 / 37; (l.c.) Lost Culture
Purchase from Weneebaykook Workshop for the Ontario Government Building, Moosonee, 1980.
MGS 635022

Migration 1979
Serigraph; 69.2 x 74.9 cm / 27¹/₄ x 29¹/₂"
(sight), 53.3 x 61 cm / 21 x 24" (image)
Signed and dated: (l.r.) JOHN REUBEN / 79
Inscribed: (l.l.) ARTIST PROOF; (l.c.) "MIGRATION"
Purchase from Weneebaykook Workshop for the Ontario Government Building, Moosonee, 1980.
MGS 635023

Phil Richards

Born: Toronto, Ontario,
12 March 1951

Families 1979
Acrylic, mixed media on canvas, 54 x 120 cm / 21¹/₄ x 47¹/₄"
Inscribed: (verso) "FAMILIES" / 21" x 47" 1979 / Phil Richards / Acrylic paints, metallic pigments, / modelling paste, pumice stone, / cotton canvas mounted on 3-ply.
Commission proposal for the York North Court House and Land Registry Office, Newmarket, 1979. MGS 623343

Gayle Richardson

Born: Toronto, Ontario,
5 January 1950

Autumn Banquet 1976
Etching; 55.9 x 67.3 cm / 22 x 26¹/₂"
(sight), 44.5 x 60.3 cm / 17¹/₂ x 23³/₄"
(image)
Signed and dated: (l.r.) Gayle Richardson '76
Inscribed and numbered: (l.l.) 8 / 9;
(l.c.) Autumn Banquet
Purchase, 1976. MGS 619935

Moon, Sand, Starfish 1982
Etching; 47 x 62.9 cm / 18¹/₂ x 24³/₄"
(sight), 44.4 x 60.3 cm / 17¹/₂ x 23³/₄"
(image)
Signed and dated: (l.r.) RICHARDSON '82
Inscribed and numbered: (l.l.) 2 / 15;
(l.c.) MOON, SAND, STARFISH
Purchase for the Michael Starr Building, Oshawa, 1983. MGS 632649

Henry K. Ripplinger

Born: Kendal, Saskatchewan, 1939

Early Winter 1982
Serigraph; 60.3 x 80 cm / 23³/₄ x 31¹/₂"
(sight), 40 x 62.2 cm / 15³/₄ x 24¹/₂"
(image)
Signed and dated: (l.r.) Henry K. Ripplinger / 82J
Inscribed and numbered: (l.l.) 82 / 200;
(l.c.) "EARLY WINTER"
Purchase, 1983. MGS 634462

Heading to the Rink 1982
Serigraph; 89.5 x 69.2 cm / 35¹/₄ x 27¹/₄"
(sight), 69.8 x 50.8 cm / 27¹/₂ x 20"
(image)

Phil Richards, *Families*, 1979

Signed and dated: (l.r.) Henry K.
Ripplinger / 82J
Inscribed and numbered: (l.l.) 59/200;
(l.c.) "HEADING TO THE RINK"
Purchase, 1983. MGS 634463

Theresa Ann Roberts

Born: Durban, South Africa,
27 August, 1936

From Old Bones New Life Begins
1977
In four parts: a) ceramic and plaster on
board, 50.8 x 81.3 cm/20 x 32";
b) ceramic and plaster on board,
22.2 x 36.8 cm/8³/₄ x 14¹/₂"; c) ceramic
and plaster on board, 27.3 x 24.1 cm/
10³/₄ x 9¹/₄"; d) watercolour on paper,
35.6 x 53.3 cm/14 x 21"
Signed: (l.r., part 'a') Ann Roberts
Signed and dated: (l.l., part 'd') Ann
Roberts / Aug 77.
Inscribed: (l.r., part 'a') [artist's
specifications]/MAQUETTE for
CERAMIC MURAL/by Ann Roberts.;
(l.l., part 'd') DESIGN for a CERAMIC
MURAL [artist's specifications]; Ann
Roberts / for KITCHENER COURT HOUSE.
Commission proposal for the Waterloo
County Court House and Land Registry
Office, Kitchener, 1977. MGS 619965

From Old Bones New Life Begins
1977
Glazed and unglazed ceramic,
200.7 x 487.7 cm/79 x 192"
Signed and dated: (l.r. of horizontal arm)
Ann Roberts 1977
Commission for the Waterloo County
Court House and Land Registry Office,
Kitchener, 1977. MGS 619973

Thomas Keith (Tom) Roberts,
O.S.A., R.C.A.

Born: Toronto, Ontario,
22 December 1908

Birches at Kaminiskeg Lookout
c. 1974
Oil on board, 50.8 x 66 cm/20 x 26"
Signed: (l.l.) TOM ROBERTS
Purchase, 1975. MGS 625894

Mild March Day c. 1974
Watercolour on paper, 30.5 x 40.6 cm/
12 x 16"
Signed: (l.l.) TOM ROBERTS
Purchase, 1975. MGS 625896

The Silent Lake c. 1974
Watercolour on paper, 30.5 x 40.6 cm/
12 x 16"

Signed: (l.l.) TOM ROBERTS
Purchase, 1975. MGS 625895

Mia Westerlund Roosen

Born: New York, New York,
U.S.A., 20 September 1942

Muro VII
In two parts: a) concrete, 31.8 x 34.3 x
4.4 cm/12¹/₂ x 13¹/₂ x 1³/₄";
b) and c) black and white photographs,
each 38.1 x 48.3 cm/15 x 19"
Commission proposal for the Queen
Street Mental Health Centre, Toronto,
1978. MGS 622139

William Ernest Ross

Born: Ponoka, Alberta,
16 December 1947

Big Apple
Serigraph; 72.4 x 57.8 cm/28¹/₂ x 22³/₄"
(sight), 43.2 x 43.2 cm/17 x 17" (image)
Signed: (l.r.) W E Ross
Inscribed and numbered: (l.l.) 3/20;
(l.c.) Big Apple.
MGS 626470

James B. Spencer, *Landscape #1 (Hamilton, 1981)*, 1981

Johanna (Hanni) Eleonore Rothschild

Born: Berlin, Germany,
8 December 1921

Ballet
Bronze, 24.4 x 30.5 cm/9⁵/₈ x 12"
Signed (on right leg of tallest dancer): H.
Rothschild
Presented to the Hamilton Teachers'
College, Hamilton, by the students of
1965-66, *c.* 1966. MGS 623104

Erica Rutherford

Born: Edinburgh, Scotland,
1 February 1923

Iowa Landscape 1973
Serigraph; 74.3 x 85.1 cm/29¹/₄ x 33¹/₂"
(sight), 53.3 x 64.8 cm/21 x 25¹/₂"
(image)
Signed and dated: (l.r.) Rutherford '73
Inscribed and numbered: (l.l.) "Iowa
Landscape"; 9/65
Purchase, 1983. MGS 634465

Sunset P.E.I. 1973
Serigraph; 73.7 x 85.1 cm/29 x 33¹/₂"
(sight), 54 x 67.3 cm/21¹/₄ x 26¹/₂"
(image)
Signed and dated: (l.r.) Rutherford '73
Inscribed and numbered: (l.l.) "Sunset
PEI"; 3/68
Purchase, 1983. MGS 634467

Earnscliff P.E.I. 1978
Serigraph; 59.1 x 55.9 cm/23¹/₄ x 22"
(sight), 55.9 x 54 cm/22 x 21¹/₄" (image)
Signed and dated: (l.r.) Rutherford '78
Inscribed and numbered: (l.l.) 24/80
Earnscliff P.E.I.
Purchase for the Michael Starr Building,
Oshawa, 1983. MGS 632627

A second copy of this print
(MGS 634464, numbered 20/80) was
purchased in 1983.

Still Life with Red 1978
Serigraph; 87.6 x 69.8 cm/34¹/₂ x 27¹/₂"
(sight), 69.8 x 54 cm/27¹/₂ x 21¹/₄"
(image)

Krystyna Sadowska, *Homage to the Legendary and Modern Woman*, 1967

Signed and dated: (l.r.) Rutherford '78
Inscribed and numbered: (l.l.) 16/70
"Still Life with Red"
Purchase, 1983. MGS 634466

Talia Sees 1980
Serigraph; 72.4 x 55.9 cm/28¹/₂ x 22"
(sight), 69.9 x 53.3 cm/27¹/₂ x 21"
(image)
Signed and dated: (l.r.) Rutherford '80
Inscribed and numbered: (l.l.) 41/75
Talia Sees
Purchase for the Michael Starr Building,
Oshawa, 1983. MGS 632628

Trellis 1980
Serigraph; 55.9 x 73 cm/22 x 28³/₄"
(sight), 53.3 x 69.8 cm/21 x 27¹/₂"
(image)
Signed and dated: (l.r.) Rutherford '80
Inscribed and numbered: (l.l.) 92/100
Trellis
Purchase for the Michael Starr Building,
Oshawa, 1983. MGS 632629

The Chair 1982
Serigraph; 56.5 x 73.7 cm/22¹/₄ x 29"
(sight), 53.3 x 70.5 cm/21 x 27³/₄"
(image)
Signed and dated: (l.r.) Rutherford '82
Inscribed and numbered: (l.l.) "The
Chair" 44/50
Purchase for the Michael Starr Building,
Oshawa, 1983. MGS 632626

Jaoann (John) Woldemar Saarniit, O.I.P.
Born: Voru, Estonia, 11 May 1912

Sudbury Mines 1962
Oil on canvas, 50.8 x 76.2 cm/20 x 30"
Signed and dated: (l.r.) John Saarniit 62
Gift of the artist, 1963. MGS 624416
The donation was made through the
Ontario Institute of Painters for hanging
in Ontario House, London, England; it
was returned to Toronto in 1980. The
subject of the picture is the nickel mines
of Sudbury, in Northern Ontario.

Samuel Freder Sackaney
Born: McInnis Siding, Ontario, 18
June 1951

Neiskah Peesim
Serigraph on cotton; 108 x 108 cm/
42¹/₂ x 42¹/₂"
Signed: (l.r.) Sammy Sackaney [in Cree
syllabics]
Inscribed and numbered: (l.l.)
Weneebaykook [in Cree syllabics] 16/70
Purchase from Weneebaykook
Workshop for the Ontario Government
Building, Moosonee, 1980.
MGS 635026

Akusguk 1979
Serigraph; 105.4 x 74.9 cm/41¹/₂ x 29¹/₂"
(sight), 95.2 x 65.4 cm/37¹/₂ x 25³/₄"
(image)
Signed and dated: (l.r.) Sammy
Sackaney/79.
Inscribed and numbered: (l.l.)
Weneebaykook [in Cree syllabics]
57/70; (l.c.) "Akusguk"
Purchase from Weneebaykook
Workshop for the Ontario Government
Building, Moosonee, 1980.
MGS 635024

Identity 1979
Serigraph; 50.2 x 67.3 cm/19³/₄ x 26¹/₂"
(sight), 36.2 x 54.6 cm/14¹/₄ x 21¹/₂"
(image)
Signed and dated: (l.r., within image)
Sammy Sackaney/79.
Inscribed and numbered: (l.l., within
image) Weneebaykook [in Cree
syllabics] 43/85; (l.c.) "Identity"
Purchase from Weneebaykook
Workshop for the Ontario Government
Building, Moosonee, 1980.
MGS 635025

Krystyna K. Sadowska, O.S.A.
Born: Lublin, Poland, 2 June 1912

*Homage to the Legendary and
Modern Woman* 1967
Welded bronze (mural relief),
261.6 x 302.3 cm/103 x 119"
Signed and dated: (l.l., vertically, in
raised characters) KRYSTYNA/
SADOWSKA 1967
Commission for the Queen's Park
Project, 1966-68. MGS 619762

Lillian Sarafinchan
Born: Vegreville, Alberta,
17 April 1935

Untitled #13 1969
Oil on canvas, 136.5 x 136.5 cm/
53³/₄ x 53³/₄"
Signed and dated: (l.r.) Sarafinchan/69
Purchase. MGS 632680

Ivan Sarossy
Born: Hungary, 1926

Deliberation c. 1977
Watercolour, felt pen, ink and graphite
on paper, 32.4 x 41.9 cm/12³/₄ x 16¹/₂"
Commission proposal for the Simcoe
County Court House and Land Registry
Office, Barrie, 1977. MGS 619746

Oryst H. Sawchuk
Born: Winnipeg, Manitoba,
23 February 1928

Hardrock 1979
Pen and ink on board, 37.5 x 49.5 cm/
14³/₄ x 19¹/₂"
Signed and dated: (l.c.) O. Sawchuk
79/1/10
Purchase from the artist for the Ontario
Government Building, Sudbury, 1980.
MGS 625807

Bernice Schwartz
Born: Zimbabwe

Peonie Day I
Etching; 76.8 x 67.9 cm/30¹/₄ x 26³/₄"
(sight), 34.9 x 27.3 cm/13³/₄ x 10³/₄"
(image)
Signed: Bernice Schwartz
Inscribed and numbered: (l.l.) 9/30;
(l.c.) Peonie Day I
Purchase, 1983. MGS 634468

Louis Stokes, *Starsong*, 1980

Peonie Day II
Etching; 76.8 x 67.9 cm/30¹/₄ x 26³/₄"
(sight), 34.9 x 27.3 cm/13³/₄ x 10³/₄"
(image)
Signed: Bernice Schwartz
Inscribed and numbered: (l.l.) 9/30;
(l.c.) 'Peonie Day II'
Purchase, 1983. MGS 634469

Campbell Scott
Born: Milngavie, Scotland,
5 October 1930

Tangled Forms 1968
Copper engraving; 43.2 x 51.8 cm/
17 x 20³/₈" (sight), 40 x 49.5 cm/
15³/₄ x 19¹/₂" (image)
Signed and dated: (l.r.) Campbell Scott 68
Inscribed and numbered: (l.l.) CS
[stylized monogram] 19/30;
(l.c.) Tangled Forms.
MGS 623077

One World 1970
Colour etching; 47 x 59 cm/18¹/₂ x 23¹/₄"
(sight), 44.5 x 58.4 cm/17¹/₂ x 23"
(image)
Signed and dated: (l.r.) Campbell Scott 70
Inscribed and numbered: (l.l.) CS
[stylized monogram] 8/30; (l.c.) One
World.
MGS 623078

Gerald Leslie Sevier, O.S.A., R.C.A.
Born: Hamilton, Ontario,
25 January 1934
President, O.S.A., 1969-72

Vista #125 c. 1982
Oil on canvas, 91.4 x 127 cm/36 x 50"
Signed: (l.r.) Sevier
Purchase from the artist for the Michael
Starr Building, Oshawa, 1982.
MGS 632630

Richard George Sewell
Born: St. Louis, Missouri, U.S.A.,
1942

Rosetta Stone 1980-81
Lithograph, serigraph and etching; 47.6
x 79.4 cm/18³/₄ x 31¹/₄" (sight), 43.2 x
76.2 cm/17 x 30" (image)
Signed and dated: (l.r.) R Sewell Toronto
80-81
Inscribed and numbered: (l.l.) Rosetta
Stone 6/12
Purchase for the Michael Starr Building,
Oshawa, 1983. MGS 632631

Ben Shadrock

Untitled
Serigraph, 61 x 45.7 cm/24 x 18"
Signed and numbered: (l.l.) 64/300;
(l.r.) Ben Shadrock
Purchase, 1976. MGS 619931

Untitled
Serigraph, 50.8 x 66 cm/20 x 26"
Signed and numbered: (l.l.) 36/250;
(l.r.) Ben Shadrock
Purchase, 1976. MGS 619933

Stuart Clifford Shaw
Born: Collingwood, Ontario, 1896
Died: Brampton, Ontario, 19 July 1970

Maple Sugar Time
Oil on canvas, 55.3 x 69.9 cm/
21³/₄ x 27¹/₂"
Signed: (l.c.) S. C. Shaw
MGS 692620

Bonnie Sheckter
Born: Edmonton, Alberta, 1951

Chromatic Interlude 1982
Lithograph; 62.9 x 62.9 cm/24³/₄ x 24³/₄"
(sight), 59.1 x 59.1 cm/23¹/₄ x 23¹/₄"
(image)
Signed and dated: (l.r.) Bonnie Scheckter
'82
Inscribed and numbered: (l.l.) 7/15
Chromatic Interlude
Purchase for the Michael Starr Building,
Oshawa, 1983. MGS 632632

Illusions Cast by Shadows 1982
Lithograph; 63.2 x 63.2 cm / 24⁷/₈ x
24⁷/₈" (sight), 58.7 x 58.7 cm / 23¹/₈ x
23¹/₈" (image)
Signed and dated: (l.r.) Bonnie Sheckter
82
Inscribed and numbered: (l.l.) 8/15
Illusions Cast by Shadows
Purchase for the Michael Starr Building,
Oshawa, 1983. MGS 632633

Donna J. Siltanen-Pickering

Born: Sault Ste Marie, Ontario,
30 September 1948

Motherhood 1978
Woodblock print; 29.2 x 42.7 cm / 11¹/₂ x
18" (sight), 28.6 x 45.1 cm / 11¹/₄ x 17³/₄"
(image)
Signed and dated: (l.r.) Silt 78
Inscribed and numbered: (l.l.)
Motherhood; (l.c.) 4/5
Purchase from the artist for the Ontario
Government Building, Sudbury, 1980.
MGS 625808

Donald Applebe Smith

Born: London, England, 18 July 1917

Untitled
Serigraph, 120 x 83.8 cm / 47¹/₄ x 33"
(actual)
Signed: (l.l.) Donald Smith
Inscribed: (l.l.) [two monogram-like
symbols within squares].
MGS 622668

Untitled
Serigraph, 91.4 x 76.2 cm / 36 x 30"
(actual)
Signed: (l.r.) Donald Smith
Inscribed: (l.r.) [two monogram-like
symbols within squares].
MGS 622682

Gordon Hammond (Gord) Smith,
R.C.A., O.S.A.

Born: Montreal, Quebec,
8 October 1937

Untitled c. 1978
Wood and cardboard, 23.5 x 55.9 x
10.2 cm / 9¹/₄ x 22 x 4"
Commission proposal for the Ontario
Government Building, Windsor, 1978.
MGS 623003

John Harold Thomas Snow, A.R.C.A.

Born: Vancouver, British Columbia,
12 December 1911

Alicante
Lithograph; 38.1 x 48.3 cm / 15 x 19"
(sight), 35.6 x 45.7 cm / 14 x 18" (image)
Signed: (l.r.) John Snow
Inscribed and numbered: (l.l.) Alicante;
(l.c.) 11/25.
MGS 610455

Lyons
Lithograph; 48.3 x 38.1 cm / 19 x 15"
(sight), 44.5 x 35.6 cm / 17¹/₂ x 14"
(image)
Signed: (l.r.) John Snow
Inscribed and numbered: (l.l.) Lyons;
(l.c.) 24/26.
MGS 610454

Plant Blue Bowl
Lithograph; 48.3 x 38.1 cm / 19 x 15"
(sight), 45.7 x 35.6 cm / 18 x 14" (image)
Signed: (l.r.) John Snow
Inscribed and numbered: (l.l.) Plant Blue
Bowl; (l.c.) 22/29.
MGS 610453

Michael James Alek Snow, A.R.C.A.

Born: Toronto, Ontario,
10 December 1929
Honours: LL.D.

*Stop the Spadina Expressway. Don't
Let The Future Kill You Now.*
Photolithograph; 57.8 x 83.2 cm /
22³/₄ x 32³/₄" (sight), 54 x 81.3 cm / 21¹/₄
x 32" (image)
Inscribed: (l.l., typeset, below image)
Stop the Spadina Expressway. Don't let
the future kill you now.; (l.r., typeset,
below image) This poster by Michael
Snow has been donated by the artist to
assist the Spadina Review Corporation.
It has been reproduced by Herzig-
Somerville Ltd. in an edition limited to
350 copies. Production, Allan Fleming.
MGS 633130

Michael Sowdon

Born: Yorkton, Saskatchewan,
30 September 1948

Ontario 1979
In two parts: a) collage of sepia toned
photographs, 24.1 x 47.9 cm / 9¹/₂ x 18⁷/₈";
b) four sample photographs in box
frame, 27 x 26.4 cm / 10⁵/₈ x 10³/₈"
Inscribed: (part 'a', verso) M. Sowdon;
(part 'b', verso) M. Sowdon 1979
Commission proposal for the York
North Court House and Land Registry
Office, Newmarket, 1979.
MGS 623336

James Burton Spencer

Born: Wolfville, Nova Scotia,
8 October 1940

Mountain c. 1975
Lithograph, 41.9 x 65.4 cm / 16¹/₂ x 25³/₄"
(actual)
Signed and numbered: (l.l.) J B Spencer
25/50
Purchase for the Michael Starr Building,
Oshawa, 1983. MGS 632697

Mountain #4 1975-77
Acrylic on plywood, 548.6 x 868.7 cm /
216 x 342"
Signed (l.l.) J. B. Spencer
Commission for the George Drew
Building, Toronto, 1974-75.
MGS 619700

*Landscape #1 (Hamilton,
1981)* 1981
Acrylic on panel, 106.7 x 168.9 cm /
42 x 66¹/₂"
Inscribed: (on crossbar, verso) James
Spencer/Landscape #1 (Hamilton,
1981)/Liquitex on panel
Commission for the Ellen Fairclough
Building, Hamilton, 1981.
MGS 630154

Fernando Nicola Spina

Born: North Bay, Ontario,
6 December 1949

Memories of '63 1979
Oil on canvas, 91.4 x 91.4 cm / 36 x 36"
Signed and dated: (l.l.) Spina 79
Purchase from the artist for the Ontario
Government Building, Sudbury, 1980.
MGS 625809

Guérite Féra Steinbacher

Born: Amsterdam, Holland,
29 November 1904

Maurice Stubbs, *Byzantine Still Life*, 1966

Orange Aid c. 1976
Raw wool, linen, artificial raffia,
213.4 x 91.4 cm / 84 x 36"
Purchase from the artist for the Ontario
Police College, Aylmer, 1977.
MGS 618677

Palm Trees c. 1977
Raw wool, linen, sisal, dried and
sprayed sections of palm tree trunks;
76.2 x 182.9 cm / 30 x 72"
Purchase from the artist for the Ontario
Police College, Aylmer, 1977.
MGS 618676

David Murray McCheyne Stewart
Born: Toronto, Ontario,
12 December 1919

Spring Ice – Eagle Lake c. 1962
Oil on canvas, 60.3 x 74.9 cm /
23³/₄ x 29¹/₂"
Purchase. MGS 619827

There are no fewer than 22 Eagle Lakes
listed in the Canadian Permanent
Committee on Geographical Names'
Gazetteer of Ontario (Ottawa: 1974).

Louis W. Stokes, R.C.A.
Born: New York, New York,
U.S.A., 23 June 1941

Star Spiral c. 1978
Aluminum, 20.3 x 163.5 x 138.7 cm /
8 x 64³/₈ x 54⁵/₈" including base
Commission proposal for the Peel
County Land Registry Office, Brampton,
1978. MGS 622141

Helix Evolve c. 1980
Painted wood, 53.3 x 121.9 x 10.2 cm /
21 x 48 x 4"
Commission proposal for the York
North County Court House and Land
Registry Office, Newmarket, 1979.
MGS 623347

Starsong c. 1980
Laminated hickory and white oak, metal
bolts, transparent colour stain (mural
relief), 304.8 x 609.6 x 45.7 cm / 120 x
240 x 18"
Commission for the York North Court
House and Land Registry Office,
Newmarket, 1979. MGS 624995

The artist felt that spiral formations —
the symbol for order and eternity —
were particularly relevant to the judicial
setting for which the work was
commissioned.

Maurice Claude Stubbs
Born: Geraldtown, Australia,
5 October 1924

Byzantine Still Life 1966
Oil on masonite, 91.4 x 121.9 cm /
36 x 48"
Signed and dated: (l.r.) Maurice Stubbs
'66
Inscribed: (verso) "Byzantine Still Life" /
oil 36" x 48" / Maurice Stubbs / M. Stubbs
Purchase from the artist for the Ontario
Police College, Aylmer, 1977.
MGS 618678

Rain I 1975
Watercolour on paper, 38.1 x 56.5 cm /
15 x 22¹/₄"
Signed and dated: (l.r.) Maurice Stubbs
'75
Inscribed: (verso) Maurice Stubbs /
"Rain I" 1975 / Watercolour / 15" x 22¹/₄" /
From Manitoulin Island
Purchase from the artist for the Ontario
Police College, Aylmer, 1977.
MGS 618679

Lorraine Joy Surcouf, O.S.A.,
C.S.P.W.C.
Born: Winnipeg, Manitoba,
21 July 1933

Winter Landscape 1980
Egg tempera on canvas, 80 x 120.6 cm /
31¹/₂ x 47¹/₂"
Signed and dated: (l.r.) Surcouf / 80
Purchase from the artist for the Michael
Starr Building, Oshawa, 1982.
MGS 632634

Aiko Suzuki

Born: Vancouver, British Columbia,
22 October 1937

Untitled 1977
In three parts: a) acrylic fabric, wood
and cardboard, 14 x 81.3 x 45.1 cm/
5$\frac{1}{2}$ x 32 x 17$\frac{3}{4}$"; b) and c) felt pen and
watercolour on paper, 50.8 x 76.2 cm/
20 x 30" (each)
Signed and dated: (on base, part 'a') Aiko
Suzuki/77
Signed twice: (l.r., part 'b' and 'c', each)
Aiko Suzuki
Commission proposal for the Waterloo
County Court House and Land Registry
Office, Kitchener, 1977. MGS 619970

Thaddeus Szepielewicz

Born: Toronto, 15 January 1955

Untitled
Bronze, two parts: a) 52.7 x 15.9 cm/
20$\frac{3}{4}$ x 6$\frac{1}{4}$", b) 33.3 x 24.4 cm/
13$\frac{1}{8}$ x 9$\frac{5}{8}$"
Gift of the artist, 1982. MGS 632971

Betty L. Tapanila

Born: Montreal, Quebec, 1948

Summer Reverie 1974
Acrylic on canvas, 107.3 x 122.6 cm/
42$\frac{1}{4}$ x 48$\frac{1}{4}$"
Inscribed: (on stretcher, verso) B.
Tapanila Nov. '74
Purchase from the artist for the Ontario
Government Building, Sudbury, 1980.
MGS 625811

*Between the Ottawa and the St.
Lawrence* 1975
Acrylic on canvas, 76.2 x 183.5 cm/
30 x 72$\frac{1}{4}$"
Inscribed: (on stretcher, verso) B. L.
Tapanila May, 1975
Purchase from the artist for the Ontario
Government Building, Sudbury, 1980.
MGS 625810

Roy Harvey Thomas

Born: Long Lac Region, Thunder
Bay, Ontario, 12 December 1949

Roy Harvey Thomas, *Medicine Man and His Power*, 1977

Gerald Tooke, *Untitled, c. 1966-68*

Medicine Man and His Power 1977
Acrylic on canvas, 101 x 101 cm/
39³/₄ x 39³/₄"
Signed, dated and inscribed: (l.r.) Roy
Thomas/1977; [Eagle insignia]
Purchase for the Ontario Government
Building, Dryden, 1977. MGS 623856

My Dad on Loon Island 1977
Acrylic on canvas, 101 x 101 cm/
39³/₄ x 39³/₄"
Signed, dated and inscribed: (l.r.) Roy
Thomas/1977; [Eagle insignia]
Purchase for the Ontario Government
Building, Dryden, 1977. MGS 623858

George Thomson, O.S.A.

Born: near Claremont, Ontario,
10 February 1868
Died: Owen Sound, Ontario,
21 July 1965

Summer Clouds 1952
Oil on canvas, 50.8 x 61 cm/20 x 24"
(actual)
Signed and dated: (l.r.) Geo. Thomson
'52
Inscribed: (verso) Summer Clouds/by/
Geo Thomson
Gift of the Deaf in memory of C. B.
Coughlin, M.D., to the Sir James
Whitney School, Belleville.
MGS 622607

Judith Tinkl

Born: Wolverhampton, England,
26 June 1943

Untitled c. 1980
Stitched wall hanging of polyester and
fibre fill, eight panels, each
218.4 x 105.4 cm/86 x 41¹/₂"
Inscribed: (l.r., each panel, verso)
Wildwork Quilt
Commission, 1980. MGS 625697

This work was originally commissioned
for the Ministry of Natural Resources,
Huronia District Office, Midhurst,
Ontario, but relocated about six months
later to Queen's Park.

Victor Tinkl

Born: Czechoslovakia, 1937

*Balanced Hanging for Children's
Play Area* 1979
India ink and pencil on paper, 35.6 x
42.5 cm/14 x 16³/₄"
Signed and dated: (u.r.) V. Tinkl/79
Inscribed: (u.r.) BALANCED HANGING
FOR/CHILDREN'S PLAY AREA
Commission proposal for the York
North Court House and Land Registry
Office, Newmarket, 1979.
MGS 623335

Gerald Ernest Tooke, R.C.A.

Born: London, England, 1930

Untitled c. 1966
Mixed media on board, 52 x 61 x 7.6 cm/
20¹/₂ x 24 x 3"
Commission proposal for the Queen's
Park Project, 1966-68. MGS 619998

Untitled c. 1966-68
Glass, epoxy resin, steel, fluorescent
lighting, 251.5 x 335.3 cm/99 x 132"
Commission for the Queen's Park
Project, 1966-68. MGS 619761

Harold Barling Town, O.S.A., R.C.A.

Born: Toronto, Ontario, 13 June 1924
Honours: D. Litt.

A member of Painters Eleven, the
Toronto group of abstract artists in the
1950s, Harold Town has continued to
create series of works in a variety of
themes and with a wide range of
inventiveness.

Untitled c. 1966
Watercolour and graphite on paper,
49.5 x 78.7 cm/19¹/₂ x 31"
Inscribed: (typewritten, u.r.) [Artist's
specifications]; *REVISED
PRESENTATION DRAWING/
QUEEN'S PARK PROJECT. PHASE (1)/
ART PANEL H. TOWN*
Commission proposal for the Queen's
Park Project, 1966-68. MGS 619901

Untitled 1968
Oil and acrylic lacquer on linen canvas (mural), 274.3 x 762 cm / 108 x 300"
Signed and dated: (l.r.) Town. 1968.
Commission for the Queen's Park Project, 1966-68. MGS 619760

The artist wanted this mural, which is located in the corridor outside the cafeteria in the Macdonald Block, Queen's Park, Toronto, to be seen from the cafeteria in autonomous sections to break the horizontal line of the wall. The work is divided into compartments, creating a strong horizontal grid reinforcing the natural perspective on the long view of the hall. The mural gives a sense of doors and windows opening into another space, while keeping the two-dimensional character of the wall intact.

Central Section, Ontario Place Poster 1970
Oil and acrylic lacquer on canvas, 121.9 x 121.9 cm / 48 x 48"
Inscribed and dated, verso: (u.l.) Town / Central Section / Ontario Place / Poster; (l.l.) Town Feb-July / 1970; (u.r.) Town 70 / Lucite Varnish / oil and lucite 44 / Grumbacher — Windsor and Newton / & Belloni-colour [sic]; (l.r.) Town 70 / Feb-July / signature / scratched in / second blue square / at bottom / Town 70
Commission, 1970. MGS 626062

Commissioned for reproduction as a poster to celebrate the official opening of Ontario Place, Toronto, on 27 May 1971. The poster is signed and dated (l.l.) "Town 70." The artist describes this work as belonging to his "Silent Lights" period. The central image on which his design is based is the trillium logotype used by Ontario Government organizations and programs, as adapted by Norman B. Hathaway and Associates, Toronto.

Gerald Trottier, C.S.P.W.C.
Born: Ottawa, Ontario, 9 September 1925

Untitled c. 1966-68
Acrylic on paper, 25.4 x 25.4 cm / 10 x 10"
Commission proposal for the Queen's Park Project, 1966-68. MGS 619895

Harold Town, *Central Section, Ontario Place Poster*, 1970

Untitled c. 1966-68
Mixed stone mosaic (mural relief), 264.2 x 302.3 cm / 104 x 119"
Commission for the Queen's Park Project, 1966-68. MGS 619759

Robert James (Jim) Tughan
Born: Montreal, Quebec, 26 October 1949

Bracer 1977
Pastel and carbon pencil on cardboard, 45.1 x 70.5 cm / 17³/₄ x 27³/₄"
Signed and dated: (l.r.) tughan 77
Purchase from the artist for the Waterloo County Court House and Land Registry Office, Kitchener, 1977. MGS 619989

Anthony (Tony) Morse Urquhart, C.S.P.W.C., O.S.A., A.R.C.A.
Born: Niagara Falls, Ontario, 9 April 1934

Early in his career Urquhart's subject matter was drawn from the landscape. By the mid-1960s he had begun to work as a sculptor, but the landscape references remained strong. Characteristic of his sculpture are boxes with many hinged openings that conceal / reveal the contents — again, mainly landscape elements.

Niagara Falls with a Collection of Famous Daredevils c. 1966-68
Acrylic on board, 33 x 25.4 cm / 13 x 10"
Commission proposal for the Queen's Park Project, 1966-68. MGS 619900

Niagara Falls with a Collection of Famous Daredevils 1968
Acrylic on chipboard (mural), 261.6 x 198.1 cm / 103 x 78"
Inscribed: (l.c.) Urquhart 1968
Commission for the Queen's Park Project, 1966-68. MGS 619758

The Great Ontario Barn Door 1977
Watercolour and ink on paper, 36.8 x 56.5 cm / 14³/₄ x 22¹/₄"
Signed, dated and inscribed: (u.l.) Tony Urquhart / PROPOSAL FOR FOYER MURAL / KITCHENER COURT HOUSE / July 29, 1977; (u.c.) The Great Ontario Barn Door; (u.c. to c.) [specifications for proposal]
Commission proposal for the Waterloo County Court House and Land Registry Office, Kitchener, 1977. MGS 619967

Waterloo County c. 1977
Mixed media on wood, three parts; central panel: 198.1 x 182.9 cm / 78 x 72", two roundels; each 66 cm / 26" diameter
Commission for the Waterloo County Court House and Land Registry Office, Kitchener, 1977. MGS 619972

Waterloo County, originally entitled *The Great Ontario Barn Door* in the maquette for the proposed mural, deals with landscape elements painted on wood, or sculpted in relief. Two roundels of landscape scenes flank a barn door over a stone foundation. Strips of painted wood applied to an arch-shaped board form the barn door, while the landscape elements — painted on wooden strips and applied to the roundels — are enhanced by routed portions exposing the rough sub-surface.

Klaas Willem Verboom
Born: London, Ontario, 26 April 1948

Passing By
Mixed media on canvas, 76.8 x 109.9 cm / 30¹/₄ x 43¹/₄"
Purchase from the artist for the Ontario Police College, Aylmer, 1977. MGS 618682

Tony Urquhart, *Niagara Falls with a Collection of Famous Daredevils*, 1968

Horace Valentine Vick, O.I.P.
Born: Beeton, Ontario,
14 February 1914

Abandoned House, Cape Croker,
Bruce Peninsula
Oil on canvas, 39.4 x 49.5 cm/
15½ x 19½"
Signed: (l.r.) VICK/H. V.
Gift of the artist, 1963. MGS 624415

The donation was made through the
Ontario Institute of Painters for hanging
in Ontario House, London, England; it
was returned to Toronto in 1980.

Bernice Vincent
Born: Woodstock, Ontario,
6 March 1934

Cloud Calendar, September 1975
Acrylic on board, 174 x 96.5 cm/
68½ x 38"
Initialed: (c.r.) BV
Inscribed: (c.l.) THERE BENEATH THE
BLUE SUBURBAN SKIES – LENNON –
McCARTNEY; (c.) LOOKING NORTH
EAST ACROSS OREGON ROAD,
LONDON, ONTARIO, SEPTEMBER 29,
1975; (verso) Liquitex Titanium under
diluted Hyplar matte medium
Purchase from the artist for the Ontario
Police College Aylmer, 1977.
MGS 618687

Joy Walker
Born: Tacoma, Washington, U.S.A.,
17 July 1942

Canadiana 1972
Serigraph, 56.5 x 66.7 cm/22¼ x 26¼"
(actual)
Signed: (l.r.) Joy
Inscribed, dated and numbered: (l.l.)
27/30; (l.c.) Spring 72 "Canadiana"
Purchase, 1977. MGS 619946

Helps You Grow 1972
Serigraph, 55.9 x 72.4 cm/22 x 28½"
(actual)
Signed: (l.r.) Joy
Inscribed, dated and numbered: (l.l.)
11/14; (l.c.) Fall 72 Helps You Grow
Purchase, 1977. MGS 619945

Tony Urquhart, *Waterloo County*, 1977

Robert Walker
Born: Montreal, Quebec, 8 June 1945

Poseidon 1971
Lithograph, 63.5 x 45.4 cm / 25 x 17⁷/₈"
(sight)
Initialed and dated: (l.r.) R. W. 15.6.71
Inscribed and numbered: (l.l.) 9/10;
(l.c.) POSEIDON.
MGS 622686

Aztec #1 1972
Serigraph, 63.5 x 41.9 cm / 25 x 16¹/₂"
(sight)
Initialed, dated and numbered: (l.c.) RW
72 4/15
Inscribed: (l.l.) AZTEC #1.
MGS 622683

Don Wallace
Born: Oil Springs, Ontario, 1921

Untitled c. 1966-68
Metal and anodized aluminium (mural
relief), 261.6 x 299.7 cm / 103 x 118"

Commission for the Queen's Park
Project, 1966-68. MGS 619757

George Burton Wallace, A.R.C.A.
Born: Sandy Cove, County Dublin,
Ireland, 7 June 1920

The Balancing Act c. 1978
In two parts: a) wax, wood and wire on
board, 62.2 x 123.2 x 43.8 cm /
24¹/₂ x 48¹/₂ x 17¹/₄"; b) graphite on
paper, 37.5 x 45 cm / 14³/₄ x 17³/₄"
Signed: (u.r., part 'b') George Wallace
Inscribed: [Artist's specifications for
proposal]
Commission proposal for the Halton
County Court House and Land Registry
Office, Milton, 1978. MGS 622140

The Balancing Act c. 1979-80
Bronze and heavy gauge copper piping,
251.5 x 477.5 x 215.9 cm / 99 x 188 x 85"
Commission for the Halton County
Court House and Land Registry Office,
Milton, 1980. MGS 625898

For Wallace, planning a work for the
Halton County Courthouse where cases
of criminal, civil and family law are
dealt with daily, it seemed natural to
choose the theme of justice and its
precarious balance. In this work the
woman holds the balance on the
tightrope, just as the traditional scales of
justice are held by a woman. The man
holds the wall for support while the
youth attempts a somersault, upsetting
the tenuous balance and almost tipping
the whole family over.

Christopher Robert Wallis
Born: London, England,
4 August 1930

Mirrors c. 1974
Convex mirror disks on black lucite
(mural relief), 203.2 x 434.3 cm /
80 x 171"
Commission for the Middlesex County
Court House and Land Registry Office,
London, 1974. MGS 616942

George Wallace, *The Balancing Act*, 1979-80

Sydney Hollinger Watson,
O.S.A., R.C.A.
Born: Toronto, Ontario, 6 April 1911
Died: Toronto, Ontario, 1981

Untitled c. 1966
Mixed media on cardboard, 57.2 x 47 cm/
22^{1}/$_2$ x 18^{1}/$_2$"
Inscribed: (c.r.) [typed text attached to
board, describing proposed work]
Commission proposal for the Queen's
Park Project, 1966-68. MGS 619898

Province of Ontario 1967
Mosaic tile mural, 264.2 x 502.9 cm/
104 x 198"
Signed and dated: (l.r.) SYDNEY H.
WATSON '67
Commission for the Queen's Park
Project, 1966-68. MGS 619756

Kay Murray Weber, O.S.A., A.R.C.A.
Born: Ayr, Ontario, 5 November 1911

Calendar with Dark 19th
Serigraph, 49.5 x 47 cm/19^{1}/$_2$ x 18^{1}/$_2$"
(actual)
Signed: (l.r.) Kay Murray Weber
Inscribed and numbered: (l.l.) 1/1
Calendar with dark 19th.
MGS 622664

Gustav Oswald Weisman,
O.S.A., A.R.C.A.
Born: Lithuania, 26 April 1926

Untitled c. 1979
Acrylic on aluminum, 29.2 x 50.8 cm/
11^{1}/$_2$ x 20"
Inscribed: (verso) GUSTAV WEISMAN
Commission proposal for the York
North Court House and Land Registry
Office, Newmarket, 1979.
MGS 623351

Ivan Trevor Wheale, C.S.P.W.C.
Born: Sunderland, England,
9 November 1934

Ridge on Fox Island
Oil on canvas, 121.9 x 182.9 cm/48 x 72"
Signed: (l.r.) Wheale
Inscribed: (verso) Ridge on Fox Island/
by Wheale/Ivan T. Wheale
Purchase for the Ontario Government
Building, Sudbury, 1980. MGS 625812

Colette Margaret Whiten
Born: Birmingham, England,
7 February 1945

Cutouts c. 1978
Wood, 26.7 x 139.7 x 62.2 cm/10^{1}/$_2$ x 55
x 24^{1}/$_2$" (including base)
Commission proposal for the Queen
Street Mental Health Centre, Toronto,
1978. MGS 623798

Cutouts c. 1978
Wood, seven parts: a) 224.8 x 797.6 x
76.2 cm/88^{1}/$_2$ x 314 x 30"; b) 224.8 x
487.7 x 76.2 cm/88^{1}/$_2$ x 192 x 30";
c) 171.8 x 75.6 x 24.8 cm/67^{5}/$_8$ x 29^{3}/$_4$ x
9^{3}/$_4$"; d) 166.4 x 123.5 x 24.8 cm/65^{1}/$_2$ x
48^{5}/$_8$ x 9^{3}/$_4$" e) 184.8 x 77.2 x 24.8 cm/
72^{3}/$_4$ x 30^{3}/$_8$ x 9^{3}/$_4$"; f) 184.8 x 139.1 x
24.8 cm/72^{3}/$_4$ x 54^{3}/$_4$ x 9^{3}/$_4$"; g) 171.5 x
60.3 x 24.8 cm/67^{1}/$_2$ x 23^{3}/$_4$ x 9^{3}/$_4$";
h) 175.6 x 68.6 x 24.8 cm/69^{1}/$_8$ x 27 x
9^{3}/$_4$"; i) 183.5 x 65.7 x 24.8 cm/72^{1}/$_4$ x
25^{7}/$_8$ x 9^{3}/$_4$"; j) 173.4 x 111.1 x 24.8 cm/
68^{1}/$_4$ x 43^{3}/$_4$ x 9^{3}/$_4$"
Commission for the Queen Street
Mental Health Centre, Toronto, 1978.
MGS 623797

Whiten's focus on the value of
relationship extends to the presence and
absence of people. In this work a large
block of wood, from which figures have
been removed, stands on the grass. The
cut-out figures, randomly placed around
the area, seem to merge with patients
and visitors strolling through the
grounds, while the block serves as a
constant reminder of the cut-outs'
origins.

Joyce Wieland, R.C.A.
Born: Toronto, Ontario, 30 June 1931

Soroseelutu, Artist of Cape Dorset
1979
Lithograph; 34 x 33 cm/13^{3}/$_8$ x 13"
(sight), 28.2 x 29.5 cm/11^{1}/$_8$ x 11^{5}/$_8$"
(image)
Signed, dated, inscribed and numbered:
(l.c.) Soroseelutu, Artist of Cape
Dorset/Joyce Wieland 27/50 1979
Purchase for the Michael Starr Building,
Oshawa, 1983. MGS 632635

Sally Anne Wildman, O.S.A., R.C.A.
Born: Tynemouth, England,
2 August 1939

Trillium Triptych c. 1979
Watercolour on board, 39.4 x 85.1 cm/
15^{1}/$_2$ x 33^{1}/$_2$"

Colette Whiten, *Cutouts*

Commission proposal for the York
North Court House and Land Registry
Office, Newmarket, 1979.
MGS 623342

Jon Wilkinson

Born: Hamilton, Ontario, 1940

Night Ship
Serigraph; 48.3 x 71.1 cm / 19 x 28"
(sight), 45.7 x 68.6 cm / 18 x 27" (image)
Signed: (l.r.) JON WILKINSON
Inscribed and numbered: (l.l.) Night
Ship 9 / 100
Purchase for the Michael Starr Building,
Oshawa, 1983. MGS 632668

When She Shines
Serigraph; 42.8 x 68.2 cm / 16⁷/₈ x 26⁷/₈"
(sight), 40 x 66 cm / 15³/₄ x 26" (image)
Signed: (l.r.) JON WILKINSON
Inscribed and numbered: (l.l.) When She
Shines 4 / 100
Purchase for the Michael Starr Building,
Oshawa, 1983. MGS 632669

Beverley Anne Williams

Born: Montreal, Quebec, 4 July 1946

Milky Way 1982
Hand-woven fabric, four panels: a) 129.5
x 58.4 cm / 51 x 23", b) 172.1 x 61 cm /
67³/₄ x 24", c) 167 x 61 cm / 65³/₄ x 24",
d) 114.3 x 53.3 cm / 45 x 21";
overall: 175.3 x 251.5 cm / 69 x 99"
Inscribed: (panel 'd', verso) Beverley A.
Williams; (on panels 'a', 'b', 'c', each
verso) 1982.
Commission for the Michael Starr
Building, Oshawa, 1982. MGS 632636

Joyce Wieland, *Soroseelutu, Artist of Cape Dorset*, 1979

Alan Dent Wilson, *Canadian Sea Cadet*

Paul Williams, *The Ridges of Durham*, *c*. 1982

Paul Stanley Williams

Born: Toronto, Ontario,
8 October 1949

The Ridges of Durham *c*. 1982
Leather (relief panel), 300 x 182 cm/
118 x 72"
Commission for the Michael Starr
Building, Oshawa, 1982. MGS 632637

Saul John Williams

Born: North Caribou Lake, Ontario,
20 April 1954

Berrypicking 1975
Serigraph, 73.7 x 87.6 cm/29 x 34¹/₂"
(actual)
Signed and dated: (l.r.) Saul Williams 75
Inscribed and numbered: (l.l.) 34/40;
(l.c.) Berrypicking
Purchase from Triple K Co-operative,
Red Lake, Ontario, for the Ontario
Ministry of Northern Affairs
Northwestern Regional Office, Kenora,
1977. MGS 635346

Mother Love 1976
Serigraph, 76.2 x 55.9 cm/30 x 22"
(actual)
Signed and dated: (l.r.) Saul Williams 76
Inscribed and numbered: (l.l.) Mother
Love; (l.c.) 39/60
Purchase from the Triple K Co-
operative, Red Lake, Ontario, for the
Ontario Ministry of Northern Affairs
Northeastern Regional Office, Sault Ste
Marie, 1977. MGS 635347

Alan Dent Wilson, O.I.P.

Born: Toronto, Ontario,
5 August 1923

Canadian Sea Cadet
Watercolour on paper, 78.1 x 55.9 cm/
30³/₄ x 22"
Signed: (l.r.) A. D. WILSON.
Gift of the artist, 1963. MGS 624414

The donation was made through the
Ontario Institute of Painters for hanging
in Ontario House, London, England; it
was returned to Toronto in 1980.

Ronald York Wilson, O.S.A., R.C.A.

Born: Toronto, Ontario,
6 December 1907

Died: Toronto, Ontario,
10 February 1984

Ontario *c.* 1966-68
Vinyl acetate on canvas (mural),
261.6 x 505.5 cm/103 x 199"
Signed: (l.l.) York Wilson
Commission for the Queen's Park
Project, 1966-68. MGS 619755

This non-figurative mural pays tribute
to the province of Ontario. The colours
represent the various natural resources:
the lakes, rivers and waterfalls, the
trees, and the minerals found through-
out the province.

Jan Winton

Born: Toronto, Ontario, 1954

Syncopation 1980
Etching and serigraph; 55.9 x 76.2 cm/
22 x 30" (actual), 44.4 x 64.1 cm/
17¹/₂ x 25¹/₄" (plate)
Signed and dated: (l.r.) J. Winton '80
Inscribed and numbered: (l.l.) 14/50
"Syncopation"
Purchase for the Michael Starr Building,
Oshawa, 1983. MGS 632638

Walter Hawley Yarwood,
O.S.A., A.R.C.A.

Born: Toronto, Ontario,
19 September 1917

Pines *c.* 1966
Bronze, 24.8 x 54 x 3.8 cm/
9³/₄ x 21¹/₄ x 1¹/₂"
Commission proposal for the Queen's
Park Project, 1966-68. MGS 620000

R. York Wilson, *Ontario, c.* 1966-68

Edward Zelenak, *Apporia, c.* 1977

Pines 1967
Bronze, 274.3 x 548.6 x 34.3 cm/
108 x 216 x 13¹/₃″
Signed and dated: (on bronze plaque,
south end of sculpture) W Yarwood/67
Commission for the Queen's Park
Project, 1966-68. MGS 619754

Untitled c. 1967
Cast iron, three parts: a) 166.4 x 19 x
20.3 cm/65¹/₂ x 7¹/₂ x 8″, b) 182.9 x 45.7
x 45.7 cm/72 x 18 x 18″, c) 167.6 x 30.5
x 30.5 cm/66 x 12 x 12″
Commission proposal for the Ontario
Pavilion, Expo '67, Montreal, Quebec,
1967. MGS 626471

Gwynyth Young

Windward #3 1973
Serigraph, 95.9 x 66 cm/37³/₄ x 26″
Signed and dated: (l.r.) Gwynyth Young/
73
Inscribed and numbered: (l.l.) 7/7;
(l.c.) Windward #3
Purchase from the artist for the
Oaklands Regional Centre, Oakville,
1975. MGS 614960

Bogdan Kasimierz Zarski
Born: Germany, 9 June 1949

Mechanics Léger 1976
Acrylic on canvas, 153.7 x 136.9 cm/
60¹/₂ x 53⁹/₁₀″
Inscribed: (verso) Zarski '76
Purchase from the artist for the Ontario
Police College, Aylmer, 1977.
MGS 618674

The title of this painting refers to the
work of the 20th century French Cubist
painter, Fernand Léger (1881-1955).

Gerald Zeldin
Born: Toronto, Ontario,
6 October 1943

August Chestnut 1976
Pastel and graphite on coloured paper,
101.6 x 81.3 cm/40 x 32"
Signed and dated: (l.r.) ZELDIN 76
Inscribed: (verso) Zeldin/media/mixed/
August Chestnut
Purchase from the artist for the Ellen
Fairclough Building, Hamilton, 1981.
MGS 630149

July Elm 1976
Pastel and graphite on coloured paper,
101.6 x 81.3 cm/40 x 32"
Signed and dated: (l.r.) ZELDIN 76
Inscribed: (verso) Zeldin/media/mixed/
"July Elm"/
Purchase from the artist for the Ellen
Fairclough Building, Hamilton, 1981.
MGS 630146

June Walnut 1976
Pastel and graphite on coloured paper,
101.6 x 81.3 cm/40 x 32"
Signed and dated: (l.r.) ZELDIN 76

Inscribed: (verso) Zeldin/media/mixed/
June Walnut/
Purchase from the artist for the Ellen
Fairclough Building, Hamilton, 1981.
MGS 630147

Edward John Zelenak, A.R.C.A.
Born: St. Thomas, Ontario,
9 November 1940

Apporia c. 1977
Watercolour and silver print,
35.6 x 50.8 cm/14 x 20"
Commission proposal for the Waterloo
County Court House and Land Registry
Office, Kitchener, 1977. MGS 619961

Apporia c. 1978
Laminated fibreglas, 442 x 701 x
365.8 cm/174 x 276 x 144"
Commission for the Waterloo County
Court House and Land Registry Office,
Kitchener, 1978. MGS 619971

For this work, Zelenak chose fibreglass
because of its flexibility, its buoyancy,
and its lightness. The shapes, while
appearing as solid as stone, are like
drawings in space, creating a sense of
mobility in contrast to the static
horizontal and vertical elements of the
buildings surrounding them.
 The title "Apporia" was invented by
the artist to give a graphic parallel to the
spatial convolutions of the sculpture.

Louise Zurosky
Born: Toronto, Ontario, 1942

Begonia 1982
Lithograph, 76.2 x 57.2 cm/30 x 22½"
(actual)
Signed and dated: (l.r.) Louise Zurosky
'82
Inscribed and numbered: (l.l.) 32/40;
(l.c.) Begonia
Purchase, 1983. MGS 634470

NOTES

CHAPTER ONE

1 The account of Ryerson's tour of Europe in 1855-56 is reconstructed from a series of letters written by Ryerson to his Deputy Superintendent of the Education Department in Toronto, Dr. John George Hodgins. These are published, in highly edited form, in John George Hodgins, *Documentary History of Education in Upper Canada from the Passing of the Constitutional Act of 1791 to the Close of Rev. Dr. Ryerson's Administration of the Education Department in 1876*, vol. 12 (Toronto: Warwick Bros. & Rutter Printers, 1894-1910), pp. 97-138. In addition to these, the *Annual Report of the Chief Superintendent of Education* (Toronto: Ontario Department of Education, 1856-1876) includes reports of the tour and the resulting Museum. Only one article has been devoted to Ryerson's formation of the Museum, F. Henry Johnson, "A Colonial Canadian in Search of a Museum," *Queen's Quarterly* 77 (Summer 1970): 217-30. See also, Fern Bayer, "The 'Ontario Collection' and the Ontario Society of Artists, Policy and Purchases, 1873-1914," *RACAR* 8 (1981), 32-54.

2 *The Educational Museum and School of Art and Design for Upper Canada with a Plan of the English Educational Museum, Etc., Etc., From the Chief Superintendent's Report for 1856 to Which is Added an Appendix* (Toronto: Lovell & Gibson, 1858), p. 15. This catalogue of the collection of copies and casts acquired by Ryerson during his tour of 1855-56, an indispensible guide to the collection, also provides a floor-plan of the Museum's exhibition galleries.

3 Of the numerous articles and books written on the life of Egerton Ryerson, the most succinct is R.D. Gidney's entry, "Egerton Ryerson," for the *Dictionary of Canadian Biography*, vol. 11 (Toronto: University of Toronto Press, 1982), pp. 783-95. Other important sources are C.B. Sissons, *Egerton Ryerson: His Life and Letters*, 2 vols. (Toronto: Clarke, Irwin, and Oxford University Press, 1937-1947) and *"The Story of My Life," by the late Rev. Egerton Ryerson, D.D., LL.D.*, edited by J. George Hodgins (Toronto: William Briggs, 1883). Additional sources are included in the bibliography.

4 Provisions for the erection of the Normal School and the School of Art were made by *An Act for the better establishment and maintenance of Public Schools in Upper Canada and for repealing the present School Act*, 1849, Statutes of the Province of Canada, 12 Vict., c. 83, s. 78. Provision for funding for the Museum did not receive Royal Assent until the passing of *An Act Supplementary to the Common School Act for Upper Canada of 1850*, 1853, Statutes of the Province of Canada, 16 & 17 Vict., c. 185, s. 23. The official laying of the cornerstone ceremony is reported in Hodgins, *History*, vol. 10, pp. 1-14.

5 *Report of the Chief Superintendent of Education for 1857*, reprinted in Hodgins, *History*, vol. 13, p. 207.

6 Hodgins, *History*, vol. 11, p. 169.

7 Hodgins, *History*, vol. 12, p. 97.

8 Lefroy (1817-1890) was an engineer who in 1842-43 made a magnetic survey of British North America. From 1844 to 1853 he was in charge of the magnetic observatory in Toronto. He assisted Ryerson in the establishment of meteor-ological stations at the Grammar Schools in Canada West during those years and later, after their meetings in London, England, during the summer of 1855. After leaving Toronto, Lefroy held a number of important posts with the British Army before retiring with the rank of full general in 1882. Lefroy married Chief Justice Robinson's daughter, Emily, on 16 April 1846, the same day that the Hon. G.W. Allan married another of the Chief Justice's daughters, Louisa. The famous portrait of *The Misses Robinson*, by G.T. Berthon, now in the Collection of the Art Gallery of Ontario, was a gift to Mrs. Robinson on the occasion of the marriage of Emily and Louisa. A portrait of Lefroy is located in the Royal Canadian Institute, Toronto.

9 Capt. Lefroy to Ryerson, London, 28 August 1855, reprinted in Hodgins, *History*, vol. 12, p. 123.

10 Ryerson to Provincial Secretary George-Etienne Cartier, Munich, 1 January 1856, reprinted in Hodgins, *History*, vol. 12, p. 127.

11 See footnote 1 above.

12 The Account Book, entitled "Record of Purchases for the Educational Museum and Library, 1853-1861," is located in the Ontario Department of Education Records, R.G. 2, Series L-3, vol. 15, Archives of Ontario, Toronto. The catalogue of the Museum was published in 1858 (see footnote 2 above).

13 A guide to the selections available at Sydenham is found in Owen Jones, *The Statuary of the Crystal Palace*, 4 vol. in 1 (London: Bradbury & Evans, 1854). Contents include Jones' "The Greek Court Erected in the Crystal Palace," his "The Roman Court (Including the Antique Sculptures in the Nave) Erected in the Crystal Palace"; Mrs. Jameson's "A Handbook to the Courts of Modern Sculpture"; and Samuel Phillips, "The Portrait Gallery of the Crystal Palace." Ryerson would certainly have used this manual to aid in his selections (see pages 22 and 23).

14 Ryerson to Hodgins, Paris, 21 November 1855, reprinted in Hodgins, *History*, vol. 12, p. 108.

15 Franz Theodor Kugler, *Handbook of Painting: The German, Flemish, Dutch, Spanish and French Schools, Partly Translated from the German of Kugler by a Lady*, edited by Sir Edmund Head, Baronet, 2 vols. (London: John Murray, 1854) and *Handbook of Painting: The Italian Schools, Translated from the German of Kugler by a Lady*, 3d ed., edited by Sir Charles Eastlake, 2 vols. (London: John Murray, 1855). Ryerson's references to Kugler are many and are found in Hodgins, *History*, vol. 12, pp. 110-28.

16 Ryerson to Hodgins, Antwerp, 5 December 1855, reprinted in Hodgins, *History*, vol. 12, p. 109.

17 Ryerson to Hodgins, Frankfurt-on-the-Main, 18 December 1855. Reprinted in Hodgins, *History*, vol. 12, p. 111. The "originals" and copies purchased in Antwerp are listed in Ryerson's Account Book, pp. 45-57. In addition, the Educational Museum catalogue (1858) lists these originals, pp. 35-39.

18 See footnote 10 above, p. 126.

19 John Murray, *Handbook for Travellers in Central Italy including the Papal States, Rome, and the Cities of Etruria* (London: John Murray, 1843) and *Murray's Handbook to Tuscany, Lucca*

and Florence, 7th ed. (London: John Murray, 1858).

20 George-Etienne Cartier to Ryerson, Toronto, 14 January 1856, reprinted in Hodgins, *History*, vol. 12, p. 128.

21 Malcolm Baker, *The Cast Courts* (London: Victoria and Albert Museum, n.d.). Ryerson's notations of his purchases from Brucciani are found in his Account Book, pp. 81-85.

22 Hodgins, *History*, vol. 12, pp. 151-257.

23 "The Normal School Picture Gallery," *Grumbler* (Toronto), 6 June 1863, p. 1.

24 Details of this trip are recorded in Hodgins, *History*, vol. 13, pp. 193-94.

25 The account of Hodgins' trip and his acquisitions for the Museum in 1867 are found in Hodgins, *History*, vol. 20, pp. 1-28.

26 Charles P. Mulvany, "Egerton Ryerson," *Week* (Toronto), 10 January 1884, p. 87.

27 Egerton Ryerson, *The Loyalists of America and Their Times: From 1620 to 1816*, 2 vols. (Toronto: William Briggs, 1880; reprint ed., New York: Haskell House, 1970).

28 Robert F. Gagen, "Ontario Art Chronicle," typescript, [*c.* 1918-26], Toronto, Archives of Ontario, Ontario Society of Artists Papers, Series 1-5, Box 3, p. 14.

29 Nathanael Burwash, *Egerton Ryerson* (Toronto: George N. Morang, 1903), p. 185.

CHAPTER TWO

1 A complete account of the various purchasing policies, legislation and a listing of the works of art selected by the Government during those years is found in Fern Bayer, "The 'Ontario Collection' and the Ontario Society of Artists, Policy and Purchases, 1873-1914," *RACAR* 8 (1981): 32-54. Much of this information is based on documents, the Ontario Department of Education Records, R.G. 2, in the Archives of Ontario, Toronto, and the Ontario Society of Artists' Minutes, Minute Books on the O.S.A. Papers, also in the Archives.

2 *Canadian Illustrated News* (Montreal), 13 May 1873, p. 215.

3 See Joan Murray, *Ontario Society of Artists: 100 Years, 1872-1972* (Toronto: Art Gallery of Ontario, 1972) and the archival records of the Society (Ontario Society of Artists Papers, Archives of Ontario).

4 "The Fine Arts in Ontario," *Canadian Monthly and National Review* 3 (January-June 1873): 545.

5 Ibid., p. 546.

6 Minutes, Minute Book, 5 December 1878, Ontario Society of Artists Papers.

7 The history of the School of Art is discussed in Robert F. Gagen, "Ontario Art Chronicle," typescript, [*c.* 1918-26], Toronto, Archives of Ontario, Ontario Society of Artists Papers, Series 1-5, Box 3, pp. 41-51. Countless references are recorded in the O.S.A. Minutes as well. See also: *100 Years Evolution of the Ontario College of Art* (Toronto: Art Gallery of Ontario, 1977).

8 Jimmie Rembrandt, "Art and Artists," *Saturday Night*, 3 December 1887, p. 10.

9 S.P. May, "O.S.A. Historical Sketch," Ontario Department of Education Records, R.G. 2, Box 51, XV, item 40, Archives of Ontario.

10 "Studio & Gallery," *Saturday Night*, 2 July 1898, p. 9.

11 J.A. Radford, "Canadian Art and Its Critics," *Canadian Magazine* 29 (October 1907): 515.

12 "The Front Window: The O.S.A. Annual Exhibition," *Canadian Magazine* 30 (April 1908): 579-80. The critic was in fact wrong, for only seven pictures were selected, two "Ballot Pictures" at $100 each and five for the $800 annual grant.

13 "Thirty-Eighth Annual Exhibition of the O.S.A.," *Saturday Night*, 12 March 1910, p. 6.

14 "Some O.S.A. Canvases," *Canadian Magazine* 28 (April 1907): 611.

15 The original distribution lists of 1912 for London, North Bay and Stratford Normal Schools are the only three to survive. These are located in the Ontario Department of Education Records, R.G. 2, P-2, Box 50, XIV, item 15, Archives of Ontario. There are inventory lists for all the Normal School holdings taken in 1934, Ontario Department of Public Works Records, R.G. 15, S-6. Comparison between the distribution lists for the three schools for which the 1912 lists exist, shows that a considerable number of works were already missing after the 22 year period they were on loan. The distribution of 1912 was prefigured in 1905 when Minister of Education, the Hon. Richard Harcourt, removed a substantial number of the Old Master copies from the exhibition galleries and placed them in the classrooms of the Toronto Normal School. A disgruntled "Letter to the Editor" of the *Mail and Empire*, (Toronto) 5 January 1905, complained of the Minister's actions in destroying Ryerson's collection. (Presumably the anonymous author was Ryerson's faithful Deputy, John George Hodgins, who was still working at the Education Department.) Harcourt's successor as Minister in 1905, Pyne, reinstated the copies to their galleries.

16 See Appendix III.

17 See Appendix III.

18 *Catalogue of Paintings, Engravings, Statuary, and Egyptian and Assyrian Antiquities: also of Miscellaneous Material, including Great Seals of England and of Great Britain, Fictile Ivory Fac-similes, etc. in the Ontario Provincial Museum, St. James' Square, Toronto* (Toronto: L.K. Cameron, 1905). This catalogue was reprinted without changes in 1907. This last art catalogue was preceded by the Catalogue of 1858 (see Chapter 1, footnote 2) and one in 1884: *Catalogue of Plaster Casts, Paintings, Engravings, and Other Reproductions of Works of Art in the Museum of the Education Department, Ontario* (Toronto: C. Blackett Robinson, 1884). Under David Boyle's administration of the Museum (1905-1911), several catalogues of other collections were published: *Checklist of Vertebrates of Ontario: Catalogue of Specimens in the Biological Section of the Provincial Museum: Batrachians, Reptiles and Mammals* (Toronto: King's Printer for the Ontario Department of Education, 1905). A second volume of the same title but subtitled *Birds*, was published the same year, and in 1908, a third volume, subtitled *Fishes*, was published.

19 Provincial Museum at St. James Square Papers, R.G. 17, Archives of Ontario.

20 See F. Henry Johnson, "The Fate of Canada's First Art Museum," *Queen's Quarterly* 78 (Summer 1971): 241-49. In the early 1970s Johnson, in compiling his article, was assisted with information provided by Miss Sybille Pantazzi, the late, long-time Chief Librarian of the Art Gallery of Ontario. Letters between the two exist in the E.P. Taylor Reference Library, Art Gallery of Ontario, under the file heading: Toronto. Education Museum and Provincial Museum, Normal School, 1856. Efforts were made in the late 1970s and the early 1980s to track down again some of these items distributed in 1933 but with no more luck than Johnson had, as recounted in his article.

CHAPTER THREE

1 C.W. Robinson to "John," South Camp, Aldershot, 8 August 1882, Sir John Beverley Robinson Papers, Archives of Ontario, Toronto. This is with regard to the portraits of *Sir Isaac Brock, Sir Gordon Drummond*, and *Sir Peregrine Maitland*. With reference to the portrait of Brock, see Lady Edgar, "General Brock's Portrait," *Canadian Magazine* 31 (July 1908): 262-65. The entire collection of Berthon portraits commissioned for Government House is discussed in William Colgate, "George Theodore Berthon: A Canadian Painter of Eminent Victorians," *Ontario Historical Society Papers and Records* 34 (1942): 2-21. In addition, G.T. Berthon's "Sitters Notebook, 1866-1890," in the Archives of the E.P. Taylor Reference Library, Art Gallery of Ontario, records the portraits commissioned. This "Notebook" makes for interesting comparison with *Public Accounts of Ontario*, where payment to the artist is also recorded. The *Accounts* do not always, however, specify the name of the portrait and often annotations of payment to Berthon are recorded under the heading for Government House, simply as "furniture and furnishings."

2 See above, C.W. Robinson to "John," and Lady Edgar, "General Brock's Portrait."

3 C.W. Robinson to the Hon. John Beverley Robinson, 3 December 1881, reprinted in Lady Edgar, "General Brock's Portrait," p. 263.

4 "Busts in, List of, Purchases from 1879, Ontario Provincial Museum," 13 May 1901, Ontario Department of Education Records, R.G. 2, Box 51, XV, item 9, Archives of Ontario. The memo states that no records were found for the years 1879 to 1887 for this program although *Public Accounts of Ontario* attest to the purchase of busts from artists from time to time. Those surviving are recorded in the catalogue entries.

5 See Chapter 2, footnote 18.

6 W.S. Allward to Hon. George Ross, 30 March 1900, Ontario Department of Education Records, R.G. 2, Box 50, XIV, item 10.

7 "Legislators in Fairyland, Lieutenant-Governor Kirkpatrick Opens the Ontario Assembly, in the New Pile in Queen's Park. The Scene within the Chamber was Unrivalled for Splendor, Toronto's 400 Were All There," *Empire* (Toronto), 5 April 1893. The *Globe* (Toronto), 15 April 1893, also recounts the official opening ceremonies of the new building, but makes no reference to the portrait of Sir Oliver Mowat.

8 E. Wyly Grier to Hon. Edward Blake, Toronto, 6 April 1896, and another, ? January 1897, both in the Edward Blake Papers, Archives of Ontario. See also "Art," *Saturday Night*, 28 November 1896, p. 9. I am indebted to Mr. Charles Hill, National Gallery of Canada, for bringing to my attention the reference in the Blake Papers.

9 A copy of the Memorial is located in the Ontario Department of Education Records, R.G. 2, P-2, Box 50, XIV, no. 24, Archives of Ontario. There is also correspondence between Forster and the Minister of Education, the Hon. Richard Harcourt, regarding a suitable location to hang the portrait. Although the commissioning of political portraits was largely the responsibility of the Premier and the Committee of the House for Art Purposes, Forster kept up a busy correspondence with the Education Minister regarding these questions. See also "Portrait of Mackenzie," *Ottawa Free Press*, 28 June 1907.

10 J.W.L. Forster, *Under the Studio Light* (Toronto: Macmillan, 1925). A few glimpses into the portrait collection can also be found in the artist's *Sight and Insight* (Toronto: Oxford University Press, 1941).

11 Forster, *Sight and Insight*, p. viii.

12 J.W.L. Forster to Hon. George Ross, 25 May 1901, Ontario Department of Education Records, R.G. 2, P-2, Box 50, XIV, item 22. The Guild's proposal for mural decorations is in the George Reid Scrapbook, E.P. Taylor Reference Library, Art Gallery of Ontario. The Minutes of the Toronto Guild of Civic Art's meetings are located in the Metropolitan Toronto Library. See also Fern Bayer, "The Ontario Collection" in Eric Arthur's *From Front Street to Queen's Park: The Story of Ontario's Parliament Buildings* (Toronto: McClelland and Stewart, 1979), pp. 133-34.

13 Forster, *Under the Studio Light*, p. 140. Considerable debate is still underway as to the authenticity of the uniform now in the Public Archives Canada Collection, on loan to the Canadian War Museum. See Ludwig Kosche, "Relics of Brock: An Investigation," *Archivaria*, no. 9 (Winter 1979-1980): 33-103. See also Forster, *Sight and Insight*, p. viii.

14 Forster, *Under the Studio Light*, p. 139, also J.W.L. Forster to Hon. R. Harcourt, 27 April 1900, Ontario Department of Education Records, R.G. 2, P-2, Box 50, XIV, item 35, Archives of Ontario.

15 Forster, *Under the Studio Light*, p. 141.

16 "X-Ray Laura Secord's Picture to Find over Whose Portrait That of Heroine was Painted," *Telegram* (Toronto), 22 February 1936. Several articles were written regarding this revelation; see *Toronto Star*, 24 February 1936, "Ontario Will Keep Secord Portrait," *Montreal Gazette*, 23 March 1936. It was City Controller, A.E. Hacker, who was the first to declare in print that the artist of the original portrait of Ross was W.A. Sherwood in, "Lady Ross Repainted Picture, Says Hacker," *Toronto Star*, 26 February 1936. See also, "Letter to the Editor," *Mail and Empire* (Toronto), 2 March 1936. The radiologist, Percy Ghent, who took the x-ray, also wrote of the picture in *Ontario Radiographer*, 2 July 1941. Laura Secord's most recent biographer, Ruth Mackenzie, in *Laura Secord: The Legend and the Lady* (Toronto: McClelland and Stewart, 1971), pp. 113-14, also refers to this famed portrait.

17 "Lady Ross Repainted Picture, Says Hacker," *Toronto Star*, 26 February 1936. In 1905, when the portrait of *Laura Secord* was acquired by the government, Lady Ross was, of course, Miss Mildred Peel.

CHAPTER FOUR

1 Debates of the Ontario Legislature, *Hansard*, 16 December 1968, pp. 690-91.

2 Records on the initial Queen's Park Project and all subsequent art-in-architecture projects to date are housed in the Archives of Ontario. A study of the Ministry's projects can be found in Jeanne Parkin, *Art in Architecture: Art for the Built Environment in the Province of Ontario* (Toronto: Visual Arts Ontario, 1982), pp. 29-35, 77-83, 116. Much of the source material for this was culled from the Ministry files.

3 "Statement by the Honourable John Robarts, Prime Minister of Ontario Regarding Works of Art in the Macdonald Block," 5 December 1968. File copy in the Project Files of the Art Consultant Committee, for Queen's Park Project, Department of Public Works, Archives of Ontario.

4 Arnold Edinborough, "Office Art, Canadian-Style: It Helps Keep Civil Servants Civil," *Financial Post*, 13 February 1971, p. 18.

APPENDIX I

Lieutenant Governors, Premiers and Speakers in the Portrait Collection

A. LIEUTENANT GOVERNORS, ADMINISTRATORS AND GOVERNORS GENERAL

Name	Office	Dates
Colonel John Graves Simcoe	Lieutenant Governor of Upper Canada	1791-96
The Hon. Peter Russell	President and Administrator of Upper Canada	1796-99
Francis Gore	Lieutenant Governor of Upper Canada	1806-11 1815-17
Major-General Sir Isaac Brock, K.B.	President and Administrator of Upper Canada	1811-12
General Sir Gordon Drummond, G.C.B.	Commander-in-Chief and Administrator of Upper Canada; of Upper and Lower Canada	1813-14 1814-16
Lieutenant-General Sir George Murray, G.C.B.	Provisional Lieutenant Governor of Upper Canada	1815
Major-General Sir Frederick Philipse Robinson, K.C.B.	Provisional Lieutenant Governor of Upper Canada	1815
Lieutenant-Colonel Samuel Smith	Administrator of Upper Canada	1817-18 1820
Sir Peregrine Maitland, K.C.B.	Lieutenant Governor of Upper Canada	1818-28
Major-General Sir John Colborne, G.C.B., G.C.M.G. (Baron Seaton)	Lieutenant Governor of Upper Canada	1828-36
Sir Francis Bond Head, Bart., K.C.H.	Lieutenant Governor of Upper Canada	1836-38
Major-General Sir George Arthur, Bart., K.C.B.	Lieutenant Governor of Upper Canada	1838-41
The Rt. Hon. Charles Edward Poulett Thomson, Baron Sydenham of Kent and Toronto.	Governor General of Canada	1839-41
Sir Charles Theophilus Metcalfe, First Baron Metcalfe	Governor General of Canada	1843-45

Name	Office	Dates
James Bruce Elgin, K.T., G.C.B., 8th Earl of Elgin	Governor General of Canada	1847-54
Sir Edmund Walker Head, Bart., P.C., K.C.B.	Governor-in-Chief of Canada	1854-61
Major-General The Hon. Sir Henry William Stisted, K.C.B.	Lieutenant Governor of Ontario	1867-68
The Hon. William Pearce Howland, K.C.M.G., C.B.	Lieutenant Governor of Ontario	1868-73
The Hon. John Willoughby Crawford, Q.C.	Lieutenant Governor	1873-75
The Hon. Donald Alexander Macdonald	Lieutenant Governor of Ontario	1875-80
The Hon. John Beverley Robinson	Lieutenant Governor of Ontario	1880-87
The Hon. Sir Alexander Campbell, P.C., K.C.M.G., Q.C.	Lieutenant Governor of Ontario	1887-92
The Hon. Sir George Airey Kirkpatrick P.C., K.C.M.B., Q.C., LL.D.	Lieutenant Governor of Ontario	1892-97
The Hon. Sir Oliver Mowat, G.C.M.G., K.C., LL.D.	Lieutenant Governor of Ontario	1897-1903
The Hon. Sir William Mortimer Clark, Kt., K.C., LL.D.	Lieutenant Governor of Ontario	1903-08
The Hon. Sir John Morison Gibson, K.C.M.G., K.G.St.J., K.C., LL.D.	Lieutenant Governor of Ontario	1908-14
Lt. Col. The Hon. Sir John Strathearn Hendrie, K.C.M.G., C.V.O.	Lieutenant Governor of Ontario	1914-19
The Hon. Lionel Herbert Clarke	Lieutenant Governor of Ontario	1919-21
Colonel The Hon. Henry Cockshutt, LL.D.	Lieutenant Governor of Ontario	1921-27

Name	Office	Dates
The Hon. William Donald Ross	Lieutenant Governor of Ontario	1927-32
Colonel The Hon. Herbert Alexander Bruce, M.D., R.A.M.C., L.R.C.P. (London), F.R.C.S. (England), LL.D.	Lieutenant Governor of Ontario	1932-37
The Hon. Albert Edward Matthews, D.C.L., LL.D.	Lieutenant Governor of Ontario	1937-46
Lt. Col. The Hon. Ray Lawson, O.B.E., K.G.St.G., LL.D., D.Cm.L.	Lieutenant Governor of Ontario	1946-52
The Hon. Louis Orville Breithaupt, LL.D.	Lieutenant Governor of Ontario	1952-57
Lt. Col. The Hon. John Keiller Mackay, D.S.O., V.D., Q.C., D.C.L., LL.D.	Lieutenant Governor of Ontario	1957-63
The Hon. William Earl Rowe, P.C., LL.D., D.Sc.Soc.	Lieutenant Governor of Ontario	1963-68
The Hon. William Ross Macdonald, P.C., C.D., Q.C., LL.D.	Lieutenant Governor of Ontario	1968-74
The Hon. Pauline M. McGibbon, O.C., LL.D., D.U., D.Hum.L., B.A.A. (Theatre), Hon. F.R.C.P.S.(C).	Lieutenant Governor of Ontario	1974-80

B. PREMIERS OF ONTARIO

Name	Dates
The Hon. John Sandfield Macdonald, Q.C.	1867-71
The Hon. Edward Blake, K.C., LL.D.	1871-72
The Hon. Sir Oliver Mowat, G.C.M.G., K.C., LL.D.	1872-96
The Hon. Arthur Sturgis Hardy, K.C.	1896-99
The Hon. Sir George William Ross, Kt., LL.D., F.R.S.C.	1899-1905
The Hon. Sir James Pliny Whitney, K.C.M.G., K.C., D.C.L., LL.D.	1905-14
The Hon. Sir William Howard Hearst, K.C.M.G., K.C.	1914-19

Name	Dates
The Hon. Ernest Charles Drury	1919-23
The Hon. George Howard Ferguson, K.C., LL.B.	1923-30
The Hon. George Stewart Henry, LL.D.	1930-34
The Hon. Mitchell Frederick Hepburn	1934-42
The Hon. Gordon Daniel Conant, K.C., LL.B.	1942-43
The Hon. Harry Corwin Nixon	1943
The Hon. George Alexander Drew, P.C., Q.C.	1943-48
The Hon. Thomas Laird Kennedy	1948-49
The Hon. Leslie Miscampbell Frost, P.C., C.C., Q.C., LL.D., D.C.L.	1949-61
The Hon. John Parmenter Robarts, P.C., C.C., Q.C., D.C.L., LL.D.	1961-71

C. SPEAKERS OF THE ONTARIO LEGISLATURE

Name	Dates
The Hon. John Stevenson	1867-71
The Hon. Sir Richard William Scott, P.C., K.C., LL.D.	1871
The Hon. James George Currie	1871-73
The Hon. Rupert Mearse Wells, K.C.	1874-79
The Hon. Charles Clarke	1880-86
The Hon. Jacob Baxter, M.D.	1887-90
The Hon. Thomas Ballantyne	1891-94
The Hon. William Douglas Balfour	1895-96
The Hon. Francis Eugene Alfred Evanturel, LL.B.	1897-1902
The Hon. William Andrew Charlton	1903-04
The Hon. Joseph Wesley St. John	1905-07
The Hon. Thomas Crawford	1907-11
The Hon. William Henry Hoyle	1912-14
The Hon. David Jamieson	1915-19
The Hon. Nelson Parliament	1920-23
Captain The Hon. Joseph Elijah Thompson	1924-26
The Hon. William David Black	1927-29
The Hon. Thomas Ashmore Kidd	1930-33
The Hon. Norman Otto Hipel	1935-38
The Hon. James Howard Clark, K.C.	1939-43
The Hon. William James Stewart, C.B.E.	1944-47
The Hon. James de Congalton Hepburn	1947-48
The Hon. Rev. Myroyn Cooke Davies	1949-55
The Hon. Alfred Wallace Downer	1955-59
The Hon. William Murdoch	1960-63
The Hon. Donald Hugo Morrow	1963-67
The Hon. Frederick McIntosh Cass, Q.C.	1968-71
The Hon. Allan Edward Reuter	1971-74
The Hon. Russell Daniel Rowe	1974-77
The Hon. John Edward Stokes	1977-81

APPENDIX II

Vice-Regal Residences and Legislative Buildings

A. OFFICIAL VICE-REGAL RESIDENCES

Place	Year	Site
Newark	1792-94	Navy Hall
York	1794-96	Lieutenant Governor Simcoe's "Canvas House" erected near Garrison Creek at the foot of present-day Bathurst Street near Fort York. The Simcoes built their private residence "Castle Frank" on a site overlooking the Don River near present-day Bloor Street and the Don Valley.
	1796-99	"Russell Abbey," the residence of Lieutenant Governor the Hon. Peter Russell at the corner of Princess and Front Streets.
	1800-13	Government House, located near the present-day Bathurst Street by Fort York (destroyed during the invasion of York in 1813).
York/Toronto	1814-41	Government House, also known as "Elmsley House," located at the corners of King and Simcoe Streets (destroyed by fire, 1862).
Kingston	1841-44	Alwington House
Montreal	1844-49	Château Ramezay and also Monklands
Toronto	1849-51	Government House, often called "Elmsley Villa," located in the area west of present-day Yonge Street near Wellesley (demolished 1875).

Place	Year	Site
Quebec	1852-55	Spencer Wood, later called Bois de Coulonge
Toronto	1855-59	Government House
Quebec	1859-67	Spencer Wood
Toronto	1870-1912	Government House, King and Simcoe Streets (demolished 1915).
	1915-1937	Government House, known as "Chorley Park;" in North Rosedale at the head of Douglas and Roxborough Drives (demolished 1961).
	1937-present	The Lieutenant Governor's Suite, Legislative Building, Queen's Park. Official reception rooms and offices occupy a portion of the west wing of the Legislative Building.

B. SEATS OF THE LEGISLATURE

Place	Year	Site
Newark	1792-1796	Contemporary writings provide various locations including Governor Simcoe's official residence, Navy Hall, the upper room in the Freemasons' Hall, and under an oak tree on the property known as the Anchorage.
York	1797-1813	Two brick buildings called the "Palace of Government" located near the present-day Front Street East and Berkeley Street (burned by the American forces during the invasion of York in 1813).

Place	Year	Site	Place	Year	Site
	1814-1820	The Legislature met in several private buildings including the ''Ball Room'' in Jordan's York Hotel.	Montreal	1844-1849	Parliament Building, Marché Ste. Anne (in 1846, the building on Front Street in Toronto was used by the university and medical schools for lectures. In 1848 and 1849, the buildings were temporarily used for a lunatic asylum.)
	1820-1824	A 2-storey brick structure occupying the site of the old Parliament Building. (destroyed by fire, 1824).			
	1825-1828	The old General Hospital, King and Hospital (Richmond) Streets, west of the original Upper Canada College.	Toronto	1849-1851	Parliament Building, Front Street West
			Quebec	1852-1854 1854-1855	L'Hôtel du Parlement Quebec Music Hall
			Toronto	1856-1859	Parliament Building, Front Street West
	1829-1832	The old Court House, bordered by King, Church, Court, and Toronto Streets.	Quebec	1859-1866	L'Hôtel du Parlement (from 1861-1867, the Front Street building in Toronto was used as military barracks.)
York/Toronto	1832-1841	Parliament Building, Front Street West, bordered by Wellington, Simcoe and John Streets.	Toronto	1867-1893	Parliament Building, Front Street West (demolished 1900).
Kingston	1841-1844	Kingston General Hospital	Toronto	1893 to present	Legislative Building, Queen's Park

APPENDIX III

Gifts to Other Institutions

A. *Art Gallery of Ontario, 1968-1972*

William Armstrong
Reception of H.R.H. the Prince of Wales at Toronto, Canada West, September 7, 1860 1860
Watercolour on paper, 37.5 × 58.4 cm/ 14¾ × 23''

John William Beatty
Fishing Boats, North Sea 1909
Oil on canvas, 69.9 × 82.9 cm/ 27½ × 32 ⅝''
Purchase from the artist, 1912

Archibald Browne
Moonrise 1898
Oil on canvas, 148.6 × 71.1 cm/ 58½ × 28''
Purchase from the artist, 1898

Florence Carlyle
The Tiff
Oil on canvas, 183.8 × 134.6 cm/ 72⅜'' × 53''
Purchase from the artist, 1902

Frederick S. Challener
When Lights are Low 1898
Oil on canvas, 55.9 × 36.2 cm/ 22 × 14¼''
Purchase from the artist, 1899

William Nicol Cresswell
Pigeon River
Watercolour on paper, 21.6 × 31.8 cm/ 8½ × 12½''

William Nicol Cresswell
Rocky Beach with Indians and Birds 1877
Watercolour on paper, 36.3 × 59.5 cm/ 14⁵⁄₁₆ × 23⁷⁄₁₆''

Ernest Lawson
Winding Road [Spring Landscape]
Oil on canvas, 63.5 × 76.8 cm/ 25 × 30¼''
Purchase from the artist, 1913

Laura Muntz Lyall
Interesting Story 1898
Oil on canvas, 81.3 × 100.3 cm/
32 × 39½''
Purchase from the artist, 1901

J.E.H. MacDonald
Morning Shadows 1912
Oil on canvas, 71.8 × 91.4 cm/
28¼ × 36''
Purchase from the artist, 1912

Lucius R. O'Brien
Camping Out 1896
Watercolour on paper, 38.4 × 55.6 cm/
15⅛ × 21⅞''

Lucius R. O'Brien
Carrying Hay 1891
Watercolour on paper, 31.1 × 54 cm/
12¼ × 21¼''

Lucius R. O'Brien
Dutch Ships and Harbour 1889
Watercolour on paper, 28.6 × 49.5 cm/
11¼ × 19½''

Lucius R. O'Brien
Lords of the Forest 1874
Watercolour on paper, 74.3 × 49.9 cm/
29¼ × 19⅝''
Purchase from the artist, 1875

Lucius R. O'Brien
Niagara Falls 1892
Watercolour on paper, 71.1 × 55.2 cm/
28 × 21¾''

Paul Peel
After the Bath 1890
Oil on canvas, 147.3 × 110.5 cm/
58 × 43½''

George A. Reid
Ragged Birches 1929
Oil on canvas, 102.2 × 76.8 cm/
40¼ × 30¼''
Gift of the artist, 1944

Michael Snow
Walking Woman
Stainless steel & wood, 11 component parts
Commission for the Ontario Pavilion,
Expo '67, 1967

Tom Thomson
Northern Lake
Oil on canvas, 69.8 cm × 101.6 cm/
27½ × 40''
Purchase from the artist, 1913

Richard Turner
Foetus
Steel, cement fondu; 274.3 × 127 ×
45.7 cm/108 × 50 × 18''
Commission for the Ontario Pavilion,
Expo '67, 1967

Frederick A. Verner
A Prairie Sunset 1877
Watercolour on paper, 32.7 × 52.4 cm/
12⅞ × 20⅝''

B. *Art Gallery of Peterborough, 1973*

Artist unknown
(after Annibale Carracci, Italian,
1560-1609)
The 'mangiafagioli' or The Bean-eater
Oil on canvas, 78.7 × 101.6 cm/
31 × 40''
Purchase, Rome or Florence, Italy, 1856

Artist unknown
(after Correggio, Italian, 1489-1534)
Madonna Adoring the Child
Oil on canvas, 66.7 × 82.6 cm/
26¼ × 32½''
Purchase, Florence, Italy, 1856

Artist unknown
(after Raphael, Italian, 1483-1520)
The Transfiguration
Oil on canvas, 198.1 × 137.2 cm/
78 × 54''
Purchase, Rome, Italy, 1856

Artist unknown
(after Peter Paul Rubens, Flemish,
1577-1640)
Presentation of Christ at the Temple
Oil on canvas, 116.8 × 144.8 cm/
46 × 57''
Purchase, Antwerp, Belgium, 1855

Artist unknown
(after David Teniers, the Younger,
Flemish, 1610-1690)
Jesus at the House of Mary and Martha
Oil on canvas, 123.2 × 167.6 cm/
48½ × 66''
Purchase, Antwerp, Belgium, 1855

W.E. Atkinson
Solitude in the Moors 1906
Watercolour on paper, 71.1 × 88.9 cm/
28 × 35''
Purchase from the artist, 1906

Frederick M. Bell-Smith
Island Park *c.* 1895
Oil on canvas, 44.4 × 85.1 cm/
17½ × 33½''

Simon Van Dow
Horses and Cattle Fair
Oil on canvas, 83.8 × 121.9 cm/
33 × 48''
Purchase, Antwerp, Belgium, 1855

A.M. Fleming
*A Crab Catcher at Low Tide,
Banffshire, Scotland*
Oil on canvas, 68.6 × 119.4 cm/
27 × 47''
Purchase from the artist, 1909

Fred S. Haines
A Watch Dog
Oil on canvas, 50.8 × 66 cm/
20 × 26''
Purchase from the artist, 1913

Fred S. Haines
Boy and Dog
Oil on canvas, 76.2 × 91.4 cm/
30 × 36''
Purchase from the artist, 1908

Laura Muntz Lyall
On the River, Holland 1893
Oil on canvas, 69.8 × 90.2 cm/
27½ × 35½''
Purchase from the artist, 1899

Edward Ratti
Dante and Beatrice
Oil on canvas, 101.6 × 137.2 cm/
40 × 54''
Purchase, Rome, Italy, 1856

George Agnew Reid
A Spanish Castle, Segovia 1926
Oil on canvas, 101.6 × 149.9 cm/
40 × 59''
Gift of the artist, 1944

George Agnew Reid
A Village Byway 1915
Oil on canvas, 76.2 × 101.6 cm/
30 × 40''
Gift of the artist, 1944

George Agnew Reid
Magpie Falls 1936
Watercolour on paper, 40.6 × 50.8 cm/
16 × 20''
Gift of the artist, 1944

George Agnew Reid
Winter Sunset 1915
Oil on canvas, 45.7 × 61 cm/
18 × 24''
Gift of the artist, 1944

Owen Staples
Cow and Cowherd 1898
Oil on canvas, 53.3 × 86.4 cm/
21 × 34''

C. Nipissing University College, North Bay, 1974

Artist unknown
(after Carlo Dolci, Italian, 1616-1686)
The Remorse of St. Peter
Oil on canvas, 34.3 × 33.7 cm/13½ ×
13¼'' (fragment of a larger painting)
Purchase, Florence, Italy, 1856

Artist unknown
(after Rotari, Italian, 1707-1762)
Apollo and the Muses
Oil on canvas, 74.9 × 135.9 cm/
29½ × 53½''
Purchase, Florence, Italy, 1856

J.W. Beatty
In the Laurentians 1906
Oil on canvas, 76.2 × 91.4 cm/
30 × 36''
Purchase from the artist, 1906

F.S. Challener
A Quiet Old Road 1906
Oil on canvas, 101.6 × 101.6 cm/
40 × 40''
Purchase from the artist, 1906

Maurice Cullen
Laurentian Hills
Oil on canvas, 58.4 × 72.4 cm/
23 × 28½''

Thomas Fripp
On the trail to Sentinel Pass, Cdn. Rockies 1912
Watercolour on paper, 38.1 × 55.3 cm/
15 × 21''
Purchase from the artist, 1914

Laura Muntz Lyall
Drawing Water 1900
Oil on canvas, 73.7 × 61 cm/
29 × 24''
Purchase from the artist, 1901

G.A. Reid
Brown and Gold 1908
Oil on canvas, 61 × 121.9 cm/
24 × 48''
Gift of the artist, 1944

G.A. Reid
In the Orchard 1914
Oil on canvas, 40.6 × 50.8 cm/
16 × 20''
Gift of the artist, 1944

G.A. Reid
Indian Honeymoon 1914
Oil on canvas, 101.6 × 131.4 cm/
40 × 51 ¾''
Gift of the artist, 1944

G.A. Reid
The Berry Pickers 1890
Oil on canvas, 167.6 × 127 cm/
66 × 50''
Purchase from the artist, 1900

G.A. Reid
White Birches 1929
Oil on canvas, 40.6 × 50.8 cm/
16 × 20''
Gift of the artist, 1944

W.A. Sherwood
Evening
Watercolour on paper, 51.4 × 76.8 cm/
20¼ × 30¼''

Owen Staples
Road Through the Caledon Hills 1909
Watercolour on paper, 50.8 × 69.2 cm/
20 × 27¼''
Purchase from the artist, 1910

Marc A. Suzor-Coté
Village at Cernay, France 1899
Oil on canvas, 38.1 × 61 cm/
15 × 24''
Purchase from the artist, 1913

Sydney Strickland Tully
Jeanne
Oil on canvas, 38.1 × 45.7 cm/
15 × 18''
Purchase from the artist, 1899

Mary Wrinch
Yellow Water Lilies
Oil on canvas, 33 × 24.8 cm/
13 × 9¾''
Purchase from the artist, 1905

D. Ryerson Polytechnical Institute, Toronto, c. 1951

Hamilton P. MacCarthy
The Rev. Dr. Egerton Ryerson 1889
Bronze; 294.6 × 127 × 101.6 cm/116
× 50 × 40'' (statue), 279.4 × 203.2 ×
203.2 cm/110 × 80 × 80'' (base)
Gift of the friends of Dr. Ryerson, 1889

Marshall Wood
The Rev. Dr. Egerton Ryerson
Marble; 83.8 × 60.3 × 36.2 cm/33 ×
23¾'' × 14¼''
Left [?], by the artist to the Toronto
Normal School, 1873

E. University of Toronto, 1983

Philip Aziz
The Hon. John Parmenter Robarts 1973
Egg tempera on masonite, 182.2 ×
120.6 cm/71¾ × 47½''
Commission, 1971

APPENDIX IV

Honours, Orders, Degrees and Societies

A.R.A.	Associate, Royal Academy of Arts
A.R.C.A.	Associate, Royal Canadian Academy of Arts
B.A.	Bachelor of Arts
B.A.A.	Bachelor of Applied Arts
Bart.	Baronet
B.Ed.	Bachelor of Education
B.Paed.	Bachelor of Paedagogy
C.B.	Companion of the Bath
C.B.E.	Commander of the Order of the Bath
C.C.	Companion of the Order of Canada
C.D.	Canadian Forces Decoration
C.G.M.	Conspicuous Gallantry Medal
C.G.P.	Canadian Group of Painters
C.H.	Companion of Honour
C.M.	Medal of Courage of the Order of Canada
C.M.G.	Companion of the Order of St. Michael and St. George
C.S.P.W.C.	Canadian Society of Painters in Water Colour
C.St.J.	Commander of the Order of St. John
C.V.O.	Commander of the Royal Victorian Order
D.C.L.	Doctor of Civil Law
D.C.L.J.	Dame Commander of the Order of St. Lazarus of Jerusalem
D.Cm.L.	Doctor of Canon Law
D.D.	Doctor of Divinity
D.Hum.L.	Doctor of Humane Letters
D.Litt.	Doctor of Letters
D.Paed.	Doctor of Paedagogy
D.Sc.	Doctor of Science
D.Sc.Soc.	Doctor of Social Sciences
D.S.O.	Distinguished Service Order
D.St.J.	Dame, Order of St. John
D.U.	Doctor, University of Ottawa, University of Laval
E.D.	Efficiency Decoration
F.C.A.	Fellow of Institute of Chartered Accountants
F.R.A.I.C.	Fellow of the Royal Architectural Institute of Canada
F.R.C.P.	Fellow of the Royal College of Physicians
F.R.C.P.S.	Fellow of the Royal College of Physicians and Surgeons
F.R.C.S.	Fellow of the Royal College of Surgeons
F.R.G.S.	Fellow of the Royal Geographical Society
F.R.S.	Fellow of the Royal Society
F.R.S.A.	Fellow of the Royal Society of Arts
F.R.S.C.	Fellow of the Royal Society of Canada
G.B.E.	Knight Grand Cross of the Order of the British Empire
G.C.B.	Knight Grand Cross of the Order of the Bath
G.C.M.G.	Knight Grand Cross of the Order of St. Michael and St. George
G.C.V.O.	Knight Grand Cross of the Royal Victorian Order
K.B.	Knight of the Bath
K.B.E.	Knight Commander of the Order of the British Empire
K.C.	King's Counsel
K.C.B.	Knight Commander of the Order of the Bath
K.C.H.	Knight Commander of the Guelphic Order of Hanover
K.C.M.G.	Knight Commander of the Order of St. Michael and St. George
K.C.V.O.	Knight Commander of the Royal Victorian Order
K.G.	Knight Commander of the Order of the Garter
K.G.St.G.	Knight of Grace, Order of St. George
K.G.St.J.	Knight of Grace, Order of St. John
K.J.St.J.	Knight of Justice, Order of St. John
Kt.	Knight
K.T.	Knight of the Order of the Thistle
LL.B.	Bachelor of Laws
LL.D.	Doctor of Laws
L.R.C.P.	Licentiate of the Royal College of Physicians
M.A.	Master of Arts
M.B.E.	Member of the Order of the British Empire
M.D., C.M.	Doctor of Medicine, Master of Surgery
M.E.I.C.	Member of the Engineering Institute of Canada
M.P.	Member of Parliament
M.P.P.	Member of Provincial Parliament
O.B.E.	Officer of the Order of the British Empire
O.C.	Officer of the Order of Canada
O.C.A.	Ontario College of Art
O.I.P.	Ontario Institute of Painters
O.M.	Order of Merit
O.St.J.	Officer, Order of St. John
O.S.A.	Ontario Society of Artists
P.C.	Privy Councillor
Ph.D.	Doctor of Philosophy
Q.C.	Queen's Counsel
R.A.	Royal Academy of Arts
R.A.M.C.	Royal Army Medical Corps
R.C.A.	Royal Canadian Academy of Arts
R.C.I.	Royal Canadian Institute
R.S.A.	Royal Scottish Academician
R.W.S.	Royal Society of Painters in Water Colours
S.C.A.	Society of Canadian Artists
S.S.C.	Sculptors Society of Canada
U.E.	United Empire Loyalist
V.C.	Victoria Cross
V.D.	Volunteer and Colonial Auxiliary Forces Officers' Decorations

BIBLIOGRAPHY

Chapter 1

Baker, Malcolm. *The Cast Courts.* London: Victoria and Albert Museum, n.d.

Barr, Robert. *The Measure of the Rule.* Toronto: University of Toronto Press, 1973.

Bayer, Fern. "The 'Ontario Collection'." In Eric Arthur, *From Front Street to Queen's Park: The Story of Ontario's Parliament Buildings*, pp. 127-42. Toronto: McClelland and Stewart, 1979.

Brown, Frank P. *South Kensington and Its Art Training.* London: Longmans, Green & Co., 1912.

Burwash, Nathanael. *Egerton Ryerson.* Toronto: George N. Morang, 1903.

Canada at the Universal Exhibition of 1855. Toronto: John Lovell, 1856.

Canadian Almanac and Repository of Useful Knowledge for the Year 1850. Toronto: Scobie & Balfour, 1850.

Cochrane, Honora M., ed. *Centennial Story of the Board of Education for the City of Toronto, 1850-1950.* Toronto: Thomas Nelson & Sons, 1950.

Damania, Laura. *Egerton Ryerson.* The Canadians. Don Mills, Ont.: Fitzhenry & Whiteside, 1975.

Downing, John. "History of Ryerson." Typescript. Archives, Ryerson Polytechnical Institute, Toronto.

Fay, C.R. *Palace of Industry, 1851: A Study of the Great Exhibition and Its Fruits.* Cambridge: Cambridge University Press, 1951.

"Frederick W. Cumberland, 1820-1881." In *Historical Sketches of Ontario*, vol. 3, pp. 7-10, 49. Toronto: Ministry of Culture and Recreation, Heritage Administration Branch, 1975-1977.

Gidney, R.D. "Egerton Ryerson." In *Dictionary of Canadian Biography*, vol. 11, pp. 783-95. Toronto: University of Toronto Press, 1982.

Guthe, Carl E., and Grace M. *The Canadian Museum Movement.* Ottawa: Canadian Museums Association, 1958.

Hall, Roger, and Dodds, Gordon. *A Picture History of Ontario.* Edmonton: Hurtig, 1978.

Hodgins, John George. *Documentary History of Education in Upper Canada from the Passing of the Constitutional Act of 1791 to the Close of Rev. Dr. Ryerson's Administration of the Education Department in 1876.* 28 vols. Toronto: Warwick Bros. & Rutter Printers, 1894-1910.

_____. *The Legislation and History of Separate Schools in Upper Canada.* Toronto: William Briggs, 1897.

_____. *Ryerson Memorial Volume: Prepared on the Occasion of the Unveiling of the Ryerson Statue in the Grounds of the Education Department on the Queen's Birthday, 1889.* Toronto: Warwick & Sons, 1889.

Johnson, Henry F. "A Colonial Canadian in Search of a Museum." *Queen's Quarterly* 77 (Summer 1970): 217-30.

Jones, Owen. *The Statuary of the Crystal Palace.* London: Bradbury & Evans, 1854. Partial contents: Owen Jones, "The Greek Court Erected in the Crystal Palace," and "The Roman Court (Including the Antique Sculptures in the Nave) Erected in the Crystal Palace;" Mrs Jameson, "A Handbook to the Courts of Modern Sculpture;" and Samuel Phillips, "The Portrait Gallery of the Crystal Palace."

Knight, Charles. *The Pictorial Gallery of Arts.* 2 vols. London: London Printing and Publishing Co., 1858.

Kugler, Franz Theodor. *Handbook of Painting: The German, Flemish, Dutch, Spanish and French Schools. Partly Translated from the German of Kugler, by a Lady.* Edited by Sir Edmund Head. 2 vols. London: John Murray, 1854.

_____. *Handbook of Painting: The Italian Schools. Translated from the German of Kugler by a Lady.* Edited by Sir Charles Eastlake. 2 vols. 3d ed. London: John Murray, 1855.

Mulvaney, Charles Pelham. "Egerton Ryerson." *Week* (Toronto), 10 January 1884, pp. 86-87.

Murray, John. *Handbook for Travellers in Central Italy, Including the Papal States, Rome and the Cities of Etruria.* London: John Murray, 1843.

_____. *A Handbook of Rome and Its Environs.* London: John Murray, 1869.

"The Normal School Picture Gallery." *Grumbler* (Toronto), 6 June 1863, p. 1.

Ontario. Department of Education. *Annual Report of the Normal, Model, and Common Schools in Upper Canada for the Year 1850.* Toronto: Ontario Department of Education, 1850.

_____. *Annual Report of the Chief Superintendent of Education.* Toronto: Ontaric Department of Education, 1856-1876.

Paris Universal Exhibition of 1855. *Catalogue of the Works Exhibited in the British Section of the Exhibition with Notices of the Commercial Progress of the United Kingdom, under the Respective Classes, in French and English; together with Exhibitors' Prospectuses Prices Current, etc.* London: Chapman & Hall, 1855.

Peroco, Guido. *Ippolito Caffi, 1809-1866.* Venice: Museo d'arte moderna, Ca' Pesaro, 1979.

Rembrandt, Jimmie. "Art and Artists." *Saturday Night*, 3 December 1887, p. 10.

Richardson, E.P. *Painting in America: The Story of 450 Years.* New York: Thomas Y. Crowell, 1956.

Ryerson, Egerton. *"The Story of My Life," by the late Rev. Egerton Ryerson, D.D., LL.D.* Edited by John George Hodgins. Toronto: William Briggs, 1883.

Sissons, C.B. *Egerton Ryerson: His Life and Letters.* 2 vols. Toronto: Clarke, Irwin, and Oxford University Press, 1937-1947.

_____, ed. *My Dearest Sophia: Letters from Egerton Ryerson to His Daughter.* Toronto: Ryerson, 1955.

Tomkins, Calvin. *Merchants and Masterpieces: The Story of the Metropolitan Museum of Art.* New York: E.P. Dutton, 1970.

Toronto. Archives of Ontario. Ontario Department of Education Records. R.G. 2, Series L-3, Vol. 15. "Record of Purchases for the Educational Museum and Library, 1853-1861".

Venturi, Lionello. *History of Art Criticism.* Translated from the Italian by Charles Marriott. New York: E.P. Dutton, 1964.

Waagen, Gustav Friedrich. *Treasures of Art in Great Britain: Being an Account of the Chief Collections of Paintings, Drawings, Sculptures, Illuminated Manuscripts, &c., &c.* 3 vols. London: John Murray, 1854.

Whitehall, Walter Muir. *Independent Historical Societies: An Inquiry into Their Research and Public Functions and Their Financial Future.* Boston: Boston Athenaeum, 1962.

Wilson, Bruce. *As She Began.* Toronto: Dundurn, 1981.

Chapter 2

Adams, Robert. "Lost Art Treasure Unearthed in Dusty Queen's Park Attic." *Toronto Daily Star,* 31 December 1966.

"Art in Canada." *Canadian Monthly and National Review* 3 (January-June 1873): 261-62.

Bayer, Fern. "The 'Ontario Collection' and the Ontario Society of Artists Policy and Purchases, 1873-1914." *RACAR* 8 (1981): 32-54.

"Broke Up in a Big Row, Lively Meeting of the Toronto Art School." *Empire* (Toronto), 22 October 1890.

"By the Way." *Canadian Architect and Builder* 13 (February 1900): 3.

Canadian Illustrated News (Montreal), 13 May 1873, p. 215.

Carrel, Frank, and Feiczewitz, Louis, eds. *The Quebec Tercentenary Commemorative History.* Quebec: Daily Telegraph Printing House, 1908.

Catalogue of Oil Paintings, Water Colours, Engravings and Photographs, from the Private Collection of Gentlemen of Toronto, Exhibited in Romain's Buildings, King Street West, in Aid of the Building Fund for St. Paul's Church, Yorkville. [Toronto, 1858].

Catalogue of Paintings, Water-Colours and Engravings, Exhibited in the Assembly Chamber, Parliament Buildings, Toronto, C.W., September, 1852. Toronto: Henry Rowsell, 1852.

Chronicles of Canada. 32 vols. Toronto: Brook & Co., 1914-1916. Reprint ed. Toronto: University of Toronto Press, 1964.

Colgate, William. *Canadian Art: Its Origin and Development.* Reprint. Toronto: McGraw Hill, 1967.

Currelly, Charles T. *I Brought the Ages Home.* Toronto: Ryerson, 1956.

"David Boyle, 1842-1911." In *Historical Sketches of Ontario,* vol. 2, pp. 5-7. Toronto: Ontario Ministry of Culture and Recreation, Heritage Administration Branch, 1975-1977.

Dempsey, Lotta. "Artist Model — 76 Years Ago." *Toronto Daily Star,* 25 January 1967.

"A Departure in Art Criticism." *Maclean's* (May 1911): 63-72.

Fairburn, Margaret L. "The Art of George A. Reid." *Canadian Magazine* 22 (November 1903): 3-9.

_____. "A Decade of Canadian Art." *Canadian Magazine* 17 (May-October 1901): 159-63.

Farr, Dorothy. *J.W. Beatty, 1869-1941.* Kingston: Agnes Etherington Art Centre, Queen's University, 1981.

A Few Facts. Toronto: Imperial Life Assurance, 1912.

"The Fine Arts in Ontario." *Canadian Monthly and National Review* 3 (January-June 1873): 545-46.

"For Provincial Art Gallery, $1345. Spent Upon Pictures to Adorn the Parliament Buildings and the Normal School." *World,* 7 January 1899.

Forsey, William C. *The Ontario Community Collects.* Toronto: Art Gallery of Ontario, 1975.

"The Front Window: The O.S.A. Annual Exhibition." *Canadian Magazine* 30 (April 1908): 480-83; 575-80.

Gagen, Robert F. "Ontario Art Chronicle." Typescript, [*c.* 1918-26]. Toronto, Archives of Ontario, Ontario Society of Artists Papers.

Gibbon, Murray J. *Scots in Canada: A History of the Settlement of the Dominion from the Earliest Days to the Present Time.* London: Kegan Paul, Trench, Trübner and Co., 1911.

"Glimpses of the Collection in the Provincial Museum and Art Gallery in the Normal School." Unsourced newspaper clipping [*c.* 1909] from the George Reid Scrapbook, E.P. Taylor Reference Library, Art Gallery of Ontario, Toronto.

Grant, Jean. "Studio & Gallery." *Saturday Night,* 23 June 1900, p. 9.

Harper, J. Russell. *Early Painters and Engravers in Canada.* Reprint. Toronto: University of Toronto Press, 1976.

_____. *Painting in Canada: A History.* 2d ed. Toronto: University of Toronto Press, 1977.

Hoover, Dorothy. *J.W. Beatty.* Canadian Art Series. Toronto: Ryerson, 1948.

Hubbard, Robert H. *The Artist and the Land: Canadian Landscape Painting, 1670-1930.* Madison: Elvehjem Art Center, University of Wisconsin, 1973.

Jefferys, C.W. *The Picture Gallery of Canadian History.* 3 vols. Toronto: Ryerson, 1942-1950.

Johnson, Henry F. "The Fate of Canada's First Art Museum." *Queen's Quarterly* 78 (Summer 1971): 241-49.

Killan, Gerald. *David Boyle: From Artisan to Archaeologist.* Toronto: University of Toronto Press, 1983.

Lord, Barry. *The History of Painting in Canada: Toward a People's Art.* Toronto: NC Press, 1974.

MacCarthy, H. "The Encouragement of the Fine Arts and the Embellishment of Canadian Cities." *Massey's Magazine* 1 (March 1896): 152-59.

MacDonald, Colin S. *A Dictionary of Canadian Artists.* 6 vols. Ottawa: Canadian Paperbacks Publishing, 1967-

MacTavish, Newton. *The Fine Arts in Canada.* Toronto: Macmillan, 1928.

Makers of Canada. Toronto: George N. Morang, 1903-1911.

Mavor, James. *Notes on Appreciation of Art and on Art in Ontario with Remarks on the Ontario Society of Artists MDCCCXCVIII.* Toronto: George N. Morang, 1898.

_____. *Notes on the Objects of the Toronto Guild of Civic Art and the Exhibition of Prints and Mural Paintings with Condensed Catalogue.* Toronto: Rowsell and Hutchinson, 1898.

McLeish, John A.B. *September Gale: A Study of Arthur Lismer and the Group of Seven.* Toronto: J.M. Dent & Sons, 1955.

Miner, Muriel Miller. *G.A. Reid: Canadian Artist.* Toronto: Ryerson, 1946.

"Moving a Museum." *Canadian Courier* (Toronto), 31 August 1912, p. 13.

"Mural Decoration in the Jarvis Collegiate Institute, Toronto." *Journal,* Royal Architectural Institute of Canada 7 (June 1931): 239-45.

Murray, Joan. *Ontario Society of Artists: 100 Years, 1872-1972.* Toronto: Art Gallery of Ontario, 1972.

Nelson's Pictures of Canadian History. Toronto: Thomas Nelson & Sons, 1927.

"The New Rooms of the O.S.A., Recently Opened." Sketch by F.M. Bell-Smith. *Canadian Illustrated News* (Montreal), 15 July 1876, p. 37.

Nursey, Walter R. *The Story of Isaac Brock.* Toronto: William Briggs, 1908.

On the Need for an Art Museum in Toronto and Some Suggestions on how It Might be Founded. Toronto: Ontario Society of Artists, 1899.

100 Years Evolution of the Ontario College of Art. Toronto: Art Gallery of Ontario, 1977.

"The O.S.A. Exhibition, Thirty-ninth Annual Display of the Ontario Society of Artists." *Saturday Night,* 8 April 1911, p. 25.

Ontario Teachers Manuals. *History of Education.* Toronto: United Press, 1915.

Patterson, Norman. "Mr. & Mrs. G.A. Reid." *Canadian Courier,* 18 March 1911, p. 7.

Pepall, Rosalind. "Architect and Muralist, G.A. Reid in Onteora, New York," *Canadian Collector* 19 (July/August 1984): 44-47.

Phipson, R.M. "Art in Toronto: Blobbs and I at the Normal School Museum." *Saturday Night,* 8 July 1893, p. 6.

"Provincial Art Museum, Reproductions of Old Masters were Removed." *Daily Mail and Empire* (Toronto), 5 January 1905.

"Queen's Park Crate had $25,000 Secret." *Toronto Daily Star,* 11 January 1967.

Radford, J.A. "Canadian Art and Its Critics." *Canadian Magazine* 29 (October 1907): 513-19.

Reid, Dennis. *A Concise History of Canadian Painting.* Toronto: Oxford University Press, 1973.

_____. *Our Own Country Canada: Being an Account of the Nationalist Aspirations of the Principal Landscape Artists in Montreal and Toronto 1860-1890.* Ottawa: National Gallery of Canada, 1979.

Reid, G.A. "The Evolution of Two of My Pictures." *Massey's Magazine* 1 (January 1896): 14.

Simmins, Geoffrey, and Parke-Taylor, Michael. *Edmund Morris "Kyaiyii" 1871-1913.* Regina: Norman Mackenzie Art Gallery, 1984.

Smith, Frances K. *Daniel Fowler of Amherst Island, 1810-1894.* Kingston: Agnes Etherington Art Centre, Queen's University, 1979.

_____. *George Harlow White, R.C.A.* Kingston: Agnes Etherington Art Centre, Queen's University, 1975.

"Some O.S.A. Canvases." *Canadian Magazine* 28 (April 1907): 611-12.

Stacey, Robert. "C.W. Jefferys Section." *Northward Journal,* No. 20 (1981): 7-50.

_____. *Charles William Jefferys, 1869-1951.* Kingston: Agnes Etherington Art Centre, Queen's University, 1976.

_____. "A Contact in Context: The Influence of Scandinavian Landscape Painting on Canadian Artists Before and After 1913." *Northward Journal,* No. 18/19 (1980): 36-56.

Staley, John E. "Reid: Painter of Canadian Character." *Maclean's* (March 1913): 123-30.

"Studio & Gallery." *Saturday Night,* 30 October 1897, p. 9; 15 January 1898, p. 9; 2 July 1898, p. 9.

"Thirty-Eighth Annual Exhibition of the O.S.A." *Saturday Night,* 12 March 1910, p. 6.

Toronto. Archives of Ontario. Ontario Department of Education Records. R.G. 2, P-2, Boxes 50-51.

_____. Ontario Department of Education Records. R.G. 2, P-2, Box 50, XIV, Item 15. "Distribution Lists, Provincial Normal Schools, 1912."

_____. Ontario Department of Education Records. R.G. 2, P-2, Box 51, XV, Item 40. "O.S.A. Historical Sketch" (by S. Passmore May).

_____. Ontario Department of Public Works Records. R.G. 15, S-6. "Inventory Lists, Provincial Normal Schools."

_____. Ontario Society of Artists Papers.

_____. Ontario Society of Artists Papers. Annual Exhibition Catalogues.

_____. Ontario Society of Artists Papers. Minutes, Minute Books.

_____. Ontario Society of Artists Papers. President's Annual Reports.

_____. Provincial Museum at St. James Square Papers. R.G. 17.

Toronto. Art Gallery of Ontario, E.P. Taylor Reference Library. File, Education Museum and Provincial Museum, Normal School, Toronto, 1856.

_____. George Reid Scrapbook.

"Toronto Normal School, 1847-1947." Toronto: Toronto School of Graphic Arts, 1947.

Toronto Society of Arts: First Exhibition, 1847. Toronto, 1847.

Tulchinsky, G.J.J. *The River and the Bush: The Timber Trade in the Ottawa Valley, 1800-1900.* Montreal: McCord Museum, McGill University, 1981.

Wallace, W. Stewart. *A First Book of Canadian History.* Toronto: Macmillan, 1928.

Wetherell, J.E., and Jefferys, C.W. *Handbook to Nelson's Pictures of Canadian History.* Toronto: Thomas Nelson & Sons, 1927.

"Will Interview Dr. Pyne: Art School Authorities Want to Know Where They are At." *Evening Telegram* (Toronto), 15 February 1905.

Wrong, George M. *Ontario Public School History of Canada.* Toronto: Ryerson, 1921.

_____. *Public School History of Canada*, Toronto: Ryerson, 1921.

Chapter 3

Andre, John. *William Berczy: Co-Founder of Toronto.* Toronto: Borough of York, 1967.

"Art." *Saturday Night*, 28 November 1896, p. 9.

Arthur, Eric. *From Front Street to Queen's Park: The Story of Ontario's Parliament Buildings.* Toronto: McClelland and Stewart, 1979.

_____. *No Mean City.* Toronto: University of Toronto Press, 1964.

Bayer, Fern, and Margles, Judith. "A New Look for Ontario's Vice-Regal Suite." *Canadian Collector* 15 (November/December 1980): 45-47.

Berthon, George. Sitters Notebook, 1866-1890. Archives, E.P. Taylor Reference Library, Art Gallery of Ontario, Toronto.

Burns, Florence M. *William Berczy.* Toronto: Fitzhenry & Whiteside, 1977.

Careless, J.M.S. *The Pre-Confederation Premiers: Ontario Government Leaders, 1841-1867.* Toronto: University of Toronto Press, 1980.

Charlottetown. Confederation Art Gallery and Museum. Robert Harris Papers.

Colgate, William. "George Theodore Berthon: A Canadian Painter of Eminent Victorians." *Ontario Historical Society Papers and Records* 34 (1942): 2-21.

Dendy, William. "Government House Toronto, 1866-70." *Canadian Collector* 12 (September/October 1977): 21-25.

_____. *Lost Toronto.* Toronto: Oxford University Press, 1978.

Dent, John Charles. *Canadian Portrait Gallery.* 4 vols. Toronto: J.B. Magurn, 1880-81.

Kilbourn, William. *The Firebrand: William Lyon Mackenzie and the Rebellion in Upper Canada.* Toronto: Clarke, Irwin, 1956.

Kirby, William. *Annals of Niagara.* Toronto: Macmillan, 1927.

Kosche, Ludwig. "Relics of Brock: An Investigation." *Archivaria*, No. 9 (Winter 1979-1980): 33-103.

Kyte, E.C. *Old Toronto.* Toronto: Macmillan, 1954.

"Lady Ross Repainted Picture, Says Hacker." *Toronto Daily Star*, 26 February 1936.

"Laura Secord Portrait Under X-Rays." *Toronto Daily Star*, 24 February 1936.

"Laura Secord Portrait Under X-Ray Reveals Head of Former Ontario Premier." *Ottawa Citizen*, 25 February 1936.

"Legislators in Fairyland, Lieutenant-Governor Kirkpatrick Opens the Ontario Assembly, in the New Pile in Queen's Park, The Scene Within the Chamber was Unrivalled for Splendor, Toronto's 400 Were All There." *Empire* (Toronto), 5 April 1893.

Loan Portrait Exhibition. Toronto: Women's Art Association of Canada, 1899.

"London and Precincts." *London Advertiser*, 5 June 1890.

Mackenzie, Ruth. *Laura Secord: The Legend and the Lady.* Toronto: McClelland and Stewart, 1971.

Margles, Judy, and Bayer, Fern. "A History of the Furniture and Furnishings in the Lieutenant-Governor's Suite, Parliament Building, Queen's Park, Toronto." Typescript. Legislative Library, Queen's Park, Toronto.

Martyn, Lucy Booth. *The Face of Early Toronto.* Sutton West, Ont.: Paget Press, 1982.

_____. *Toronto: 100 Years of Grandeur.* Toronto: Pagurian Corporation, 1978.

Edgar, Lady. "General Brock's Portrait." *Canadian Magazine* 31 (July 1908): 262-65.

Farr, Dorothy. *Lilias Torrence Newton, 1896-1980.* Kingston: Agnes Etherington Art Centre, Queen's University, 1981.

Forman, Debra, ed. *Legislators and*

Legislatures of Ontario: A Reference Guide. 3 vols. Toronto: Legislative Library, 1984.

Forster, J.W.L. "Photographs of Portrait Paintings." 2 binders. E.P. Taylor Reference Library, Art Gallery of Ontario, Toronto.

_____. *Sight and Insight.* Toronto: Oxford University Press, 1941.

_____. *Under the Studio Light.* Toronto: Macmillan, 1925.

"From Old to New." *Globe* (Toronto), 18 May 1889.

Garlick, Kenneth, ed. "Catalogue of Paintings, Drawings and Pastels of Sir Thomas Lawrence." *Walpole Society* 39 (1962-1964).

Ghent, Percy. *Ontario Radiographer*, 2 July 1941.

"The Great New Building in the Park: The Noble Pile in which Ontario's Legislators are Now in Session." *Globe*, 15 April 1893.

Herrington, W.S. "Some Notes on the First Legislative Assembly of Ontario and Its Speaker, Hon. John Stevenson." Royal Society of Canada, *Proceedings and Transactions* 9 (December 1915): 223-46.

Hubbard, R.H. *Rideau Hall.* Montreal: McGill-Queen's University Press, 1977.

James, C.C. *The First Legislators of Upper Canada.* Toronto: Copp Clark, 1902.

Lewis, Roderick, ed. *Centennial Edition of a History of the Electoral Districts, Legislatures and Ministries of the Province of Ontario, 1867-1968.* Toronto: Queen's Printer, 1967.

"Modern Science Reveals Beaver Dam Heroine is Bearded." *Evening Telegram* (Toronto), 24 February 1936.

Morgan, Henry James, ed. *The Canadian Men and Women of the Time: A Handbook of Canadian Biography of Living Characters.* 2d ed. Toronto: William Briggs, 1912.

Nasgaard, Susan, and Bayer, Fern. "A Critical Summary of Archival Material Relating to the History of the Parliament Buildings, Toronto." Typescript. Legislative Library, Queen's Park, Toronto.

Ontario. Department of Treasury. *Public Accounts of the Province of Ontario.* Toronto: Queen's Printer, 1867- .

Ontario. Office of the Speaker of the Legislative Assembly. Files, Committee of the House for Art Purposes.

"Ontario Will Keep Secord Portrait." *Montreal Gazette*, 23 March 1936.

"Ontario's New Government House, Chorley Park, Rosedale, Toronto, The Site of the Lieutenant-Governor's Palatial Residence." *Construction Magazine* 9 (February 1916): 37-51.

"A Portrait Likeness, Suitable for Hall Staircases, Libraries, Etc." *Globe*, 26 November 1884.

"Portrait of Mackenzie." *Ottawa Free Press*, 28 June 1907.

"The Prince in Toronto." *Globe*, 12 September 1860.

Province of Canada. Department of Finance. *Public Accounts of the Province of Canada*. Montreal; Toronto: Queen's Printer, 1841-1867.

"The Queen's Park and Surroundings Fifty Years Ago." *Mail and Empire* (Toronto), 2 September 1895.

Read, Colin, and Forster, Donald. " 'Opera Bouffe': Mackenzie King, Mitch Hepburn, the Appointment of The Lieutenant-Governor, and the Closing of Government House, Toronto, 1937." *Ontario History* 69 (December 1977): 239-56.

Robertson, John Ross, ed. *Landmarks of Toronto*. 6 vols. Toronto: John Ross Robertson, 1894-1914.

_____. *Old Toronto: A Selection of Excerpts from Landmarks of Toronto*. Toronto: Macmillan, 1954.

Robinson, Major-General C.W. *The Life of Sir John Beverley Robinson, Bart*. Toronto: George N. Morang, 1904.

Ross, G.W. *Getting into Parliament*. Toronto: William Briggs, 1913.

Ross, Margaret. *George W. Ross: A Biographical Study*. Toronto: Ryerson, 1923.

Scadding, Henry. *Toronto of Old*. Toronto: Adam, Stevenson & Co., 1873.

Schull, Joseph. *Ontario Since 1867*. Toronto: McClelland and Stewart, 1978.

Simcoe, Elizabeth Posthuma Gwillim. *The Diary of Mrs. John Graves Simcoe*. With notes and a biography by John Ross Robertson. Toronto: William Briggs, 1911.

Strong, Roy. *A Pageant of Canada*. Ottawa: National Gallery of Canada, 1967.

Swan, Conrad. *Canada: Symbols of Sovreignty*. Toronto: University of Toronto Press, 1977.

Toronto. Archives of Ontario. Ontario Department of Public Works Records. R.G. 15, V-5, Box 2. "Auction Catalogue, Chorley Park, 1937."

_____. Ontario Department of Education Records. R.G. 2, Box 51, XV, Item 9. "Busts in, List of, Purchases from 1879, Ontario Provincial Museum."

_____. Edward Blake Papers. Part II, Section 12.

_____. Government Records Section. R.G. 15. "Portraits of Members of the House."

_____. Hearst Papers. R.G. 3, 15-24. "Committee of the House for Art Purposes: The Art Vote, 1895-1905." (Memo from Arthur H. Sydere to Premier Whitney, 25 October 1905).

_____. Records of the Prime Minister's Office. R.G. 3.

_____ Sir John Beverley Robinson Papers. "C.W. Robinson, South Camp, Aldershot, to 'John,' 8 August 1882."

_____. Picture Collection. Inventory of the Lawrence Hayward Collection on Canadian Sculptors.

Toronto Guild of Civic Art. *Report on a Comprehensive Plan for Systematic Civic Improvements in Toronto*. Toronto: Toronto Guild of Civic Art, 1909.

Toronto. Metropolitan Toronto Library. Toronto Guild of Civic Art Papers.

Van Steen, Marcus. *Governor Simcoe and His Lady*. Toronto: Hodder and Stoughton, 1968.

Vezina, Raymond. *Théophile Hamel: peintre national (1817-1870)*. 2 vols. Montréal: Editions Elysée, 1975-1976.

Vogel, Peter, and Bayer, Fern. "Conservation Problems within the Legislative Building in Toronto." In *Preprints of the Contributions to the Vienna Congress*, 7-13 September 1980, pp. 64-68. Edited by N.S. Brommelle, Garry Thomson and Perry Smith. London: International Institute for Conservation of Historic and Artistic Works, 1980.

"Walter Seymour Allward, R.C.A., 1876-1955." In *Historical Sketches of Ontario*, vol. 1, pp. 8-9. Toronto: Ministry of Culture and Recreation, Heritage Administration Branch, 1975-1977.

Williamson, Moncrieff. *Robert Harris (1849-1919)*. Ottawa: National Gallery of Canada, 1973.

"X-Ray Laura Secord's Picture to Find Over Whose Portrait That of Heroine was Painted." *Evening Telegram*, 22 February 1936.

"X-Rays Show Laura Secord on the Lap of Premier Ross." *Evening Telegram*, 24 February 1936.

Yeigh, Frank. *Ontario's Parliament Buildings, or a Century of Legislation, 1792-1892: A Historical Sketch*. Toronto: Williamson Book Co., 1893.

Young, James. *Public Men and Public Life in Canada*. 2 vols. Toronto: William Briggs, 1912.

Chapter 4

Art Consultant Committee for Queen's Park Project. Files of the Chairman [Arthur Edward Cleeve Horne].

Art in Queen's Park: The Macdonald Block. Toronto: Queen's Printer, [c. 1969].

Burnett, David, and Schiff, Marilyn. *Contemporary Canadian Art*. Edmonton: Hurtig, 1983.

Crawford, Lenore. "Art Moves into the Courts." *London Free Press*, 20 July 1974.

Duval, Paul. *Four Decades: The Canadian Group of Painters and Their Contemporaries*. Toronto: Clarke, Irwin, 1972.

Edinborough, Arnold. "Office Art, Canadian-Style: It Helps Keep Civil Servants Civil." *Financial Post*, 13 February 1971, p. 18.

Hale, Barrie. *Toronto Painting: 1953-1965*. Ottawa: National Gallery of Canada, 1972.

McLuhan, Elizabeth, and Hill, Tom. *Norval Morrisseau and the Emergence of the Image Makers*. Toronto: Art Gallery of Ontario and Methuen, 1984.

Nasby, David. *Art for Architecture: Selections from the Government of Ontario Collection, 1966-1981.* Toronto: Macdonald Gallery, Queen's Park, 1982.

Parkin, Jeanne. *Art in Architecture: Art for the Built Environment in the Province of Ontario.* Toronto: Visual Arts Ontario, 1982.

Sisler, Rebecca. *Passionate Spirits: A History of the Royal Canadian Academy of Arts, 1880-1980.* Toronto: Clarke, Irwin, 1980.

Swinton, George. *Sculpture of the Eskimo.* Toronto: McClelland and Stewart, 1972.

Toronto. Archives of Ontario. Government Records Section. Department of Public Works. Art Consultant Committee for Queen's Park Project. Files, Queen's Park Project, 1964-1972. R.G. 42.

_____. Government Record Section. Ministry of Government Services. Art Advisory Committee Project Files. R.G. 42.

Withrow, William. *Contemporary Canadian Painting.* Toronto: McClelland and Stewart, 1972.

Zemans, Joyce. *Jock Macdonald: The Inner Landscape: A Retrospective Exhibition.* Toronto: Art Gallery of Ontario, 1981.

Catalogues and Checklists of the Collection

The Educational Museum and School of Art and Design for Upper Canada with a Plan of the English Educational Museum, Etc., Etc., From the Chief Superintendent's Report for 1856 to Which is Added an Appendix. Toronto: Lovell & Gibson, 1858.

Catalogue of Plaster Casts, Paintings, Engravings, and Other Reproductions of Works of Art in the Museum of the Education Department, Ontario. Toronto: C. Blackett Robinson, 1884.

Catalogue of Specimens in the Ontario Archaeological Museum, Toronto. Toronto: Warwick Bros. & Rutter Printers, 1897.

Catalogue of Paintings, Engravings, Statuary, and Egyptian and Assyrian Antiquities: also of Miscellaneous Material, including Great Seals of England and of Great Britain, Fictile Ivory Fac-similes, etc. in the Ontario Provincial Museum, St. James' Square, Toronto. Toronto: L.K. Cameron, 1905. Reprint ed., 1907.

Checklist of Vertebrates of Ontario: Catalogue of Specimens in the Biological Section of the Provincial Museum: Batrachians, Reptiles and Mammals. Toronto: King's Printer for the Ontario Department of Education, 1905.

Checklist of Vertebrates of Ontario: Catalogue of Specimens in the Biological Section of the Provincial Museum: Birds. Toronto: King's Printer for the Ontario Department of Education, 1905.

Checklist of Vertebrates of Ontario: Catalogue of Specimens in the Biological Section of the Provincial Museum: Fishes. Toronto: King's Printer for the Ontario Department of Education, 1908.

"In the Government House Here and Identify It as the Property of the Ontario Government." List of Pictures in Chorley Park, 1922.

"Catalogue of Collection of Paintings in Oil, Watercolour and Pastel, Engravings, Sketches, Etchings, Lithographs and Photographs." Checklist [c. 1950s].

"Catalogue of the Collection of Paintings in Oil, Water Colour, and Pastel Hanging in the Parliament Buildings at Queen's Park, Toronto." Checklist [c. 1950s].

"Works of Art Collected by Services Branch, Department of Public Works, Ontario Government." Checklist [c. 1959].

Johnson, Halhed W. "Official Catalogue of Oil Paintings and Works of Art Owned by Government of Ontario, Compiled and Evaluated by Halhed W. Johnson." Checklist, June 1965.

Legislation Regarding the Art Collection

The Common School Act of Upper Canada, 1846, Statutes of the Province of Canada, 16 Vict., c. 185, s. 28.

An Act for the better establishment and maintenance of Public Schools in Upper Canada, and for repealing the present School Act, 1849, Statutes of the Province of Canada, 12 Vict., c. 83, s. 78.

An Act for the better establishment and maintenance of Common Schools in Upper Canada, 1850, Statutes of the Province of Canada, 13 & 14 Vict., c. 48, s. 39, 41.

An Act supplementary to the Common Schools Act for Upper Canada of 1850, 1853, Statutes of the Province of Canada, 16 Vict., c. 185, s. 23.

The Agriculture and Arts Act, 1877, Statutes of Ontario, 40 Vict., c. 17, s. 85-88 (The Act was consolidated, Revised Statutes of Ontario, 1877, c. 35, s. 85-88).

An Act to amend the Agriculture and Arts Act, 1880, Statutes of Ontario, 43 Vict., c. 5, s. 2; later altered by *An Act representing Mechanics' Institutes and Arts Schools,* 1886, 49 Vict., c. 35, s. 28.

The Public Libraries Act, 1895, Statutes of Ontario, 58 Vict., c. 45, s. 21.

INDEX